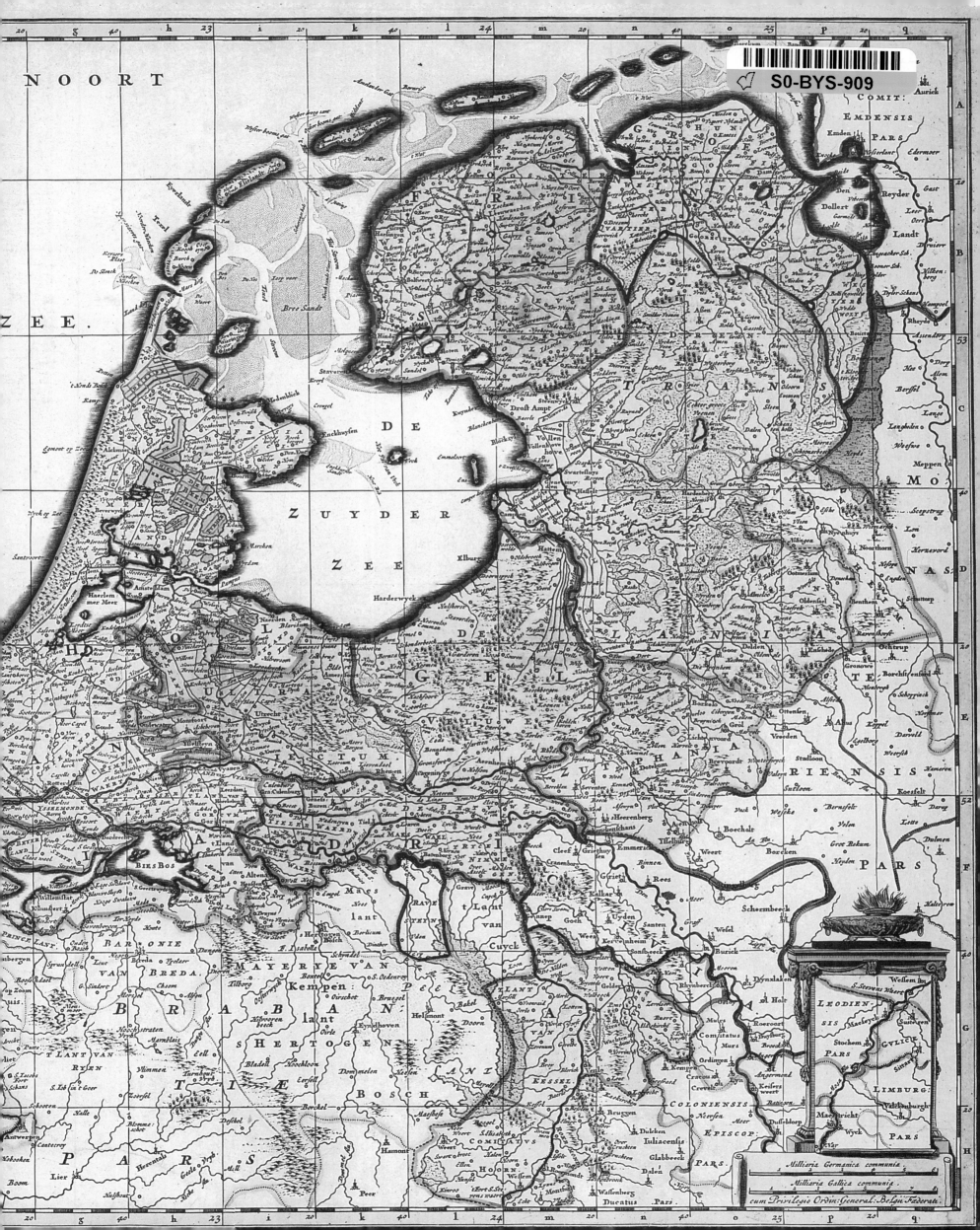

S0-BYS-909

The Golden Age

Dutch Painters of the Seventeenth Century

Bob Haak

The Golden Age

Dutch Painters of the Seventeenth Century

Translated from the Dutch and edited by Elizabeth Willems–Treeman

Published with the cooperation of
the Prince Bernhard Foundation

Harry N. Abrams, Inc., Publishers, New York

Project Director: Andreas Landshoff
Designer: Renée van de Griend
Rights and Reproductions: H.J. Scheepmaker

Library of Congress Cataloging in Publication Data
Haak, B.
 The Golden Age.

 Bibliography: p.
 Includes index.
 1. Painting, Dutch. 2. Painting, Modern—17th–18th
centuries—Netherlands. I. Willems-Treeman, Elizabeth.
II. Title.
ND646.H3 1984 759.9492 83–25657
ISBN 0–8109–0956–1

ND
646
H3
1984

Text © 1984 B. Haak

Published in 1984 by Harry N. Abrams, Incorporated, New York,
in association with Meulenhoff/Landshoff, Amsterdam.
All rights reserved. No part of the contents of this book may be
reproduced without the written permission of the publishers

Printed and bound in Italy by Amilcare Pizzi S.p.A., Milan

Contents

84-113-34

Preface

The need for a survey of seventeenth-century painting in the Northern Netherlands—the Golden Age of Dutch art—will be clear to everyone acquainted with this subject. Nearly half a century has elapsed since the Dutch scholar W. Martin published his two-volume *De Hollandsche Schilderkunst in de zeventiende eeuw* in 1935 and 1936. Since then a stream of new data has appeared about painters, paintings, and everything pertaining thereto, and more important, new ideas have emerged about the essence of Dutch painting. At the same time, historians have refined the overall view of the Golden Age.

Yet these new data and changing insights have not been assimilated in any recent survey devoted exclusively to this period. In 1966 the Harvard University art historians Jakob Rosenberg and Seymour Slive discussed seventeenth-century Dutch painting in *Dutch Art and Architecture: 1600 to 1800,* in the Pelican History of Art series. Although they covered a good deal of ground in some two hundred pages, their main focus on the "big three"—Hals, Rembrandt, and Vermeer—precluded a full account of the shifts in evaluating other groups of painters, such as the classically oriented history painters. In his 1972 review of the book,[1] J. Bruyn pointed out the formidable difficulties in writing any handbook of the period, and strongly implied his doubt that it could be done at all at present.

That I decided nevertheless to undertake this task stems largely from the stimulating conversations I had about 1970 with Andreas Landshoff of Harry N. Abrams, Inc., and the late Milton S. Fox, then editor in chief. We played with the thought of a book that would not only survey the development of painting but also encompass the economic and social situation, the political environment, and the daily life of the time, projecting a rounded, nuanced picture of the period that had brought forth such remarkable art. But a work much larger than the present volume would be required to do justice to a theme so comprehensive, and it would moreover entail a team of specialists in many fields. In a limited way, however, something of the original idea has remained. Because I am fascinated by the links that join political, economic, and social circumstances with the production of paintings, I have inserted historical sketches throughout the book.

There is no one ideal plan for the organization of such a vast amount of material. My overall scheme is chronological. The stage is set in Part I for the major developments with a discussion of their sixteenth-century antecedents, followed by a digression on the artists' social position, their patrons, and the categories of subject matter. Part II covers the period from about 1580 to 1625 and introduces the round of Dutch art centers which I continue to pursue in the rest of the book as a valid way of tying things together. The years of greatest glory in Dutch painting are treated in Parts III and IV, the first from 1625 to 1650, the second from 1650 to about 1680—arbitrary dates where painting is concerned, yet coinciding conveniently with well-marked events in the history of the Netherlands.

Regarding the shifts in the interpretation of paintings, I have relied on the basic research of the late Professor J.A. Emmens and of Professor E. de Jongh, both of Utrecht University, and their pupils and followers. Their investigations have been aimed primarily at bringing the highly praised realism of seventeenth-century Dutch art into truer perspective. Parallel with this objective runs the study of seventeenth-century theories of art, but publications on this subject are rare and far from comprehensive. Therefore I am delighted that I was able to enlist Beatrijs Brenninkmeyer-de Rooij, an authority in this field, to write the chapter on art theory in Part I.

This book is extraordinarily rich in illustration because I am convinced that readers like to have reproductions on the same page with the paintings being discussed. I have tried always to select paintings that are signed and if possible dated, that I know from my own

observation, and that have an authenticity I do not doubt. In general I sought good examples in public collections, but since I wished also to reproduce less familiar pictures, I turned as well to private collections and the art market.

The titles by which the paintings are currently known are seldom the original ones and are often variously cited from author to author. I have usually employed the most commonly accepted titles, but at times I have felt free to suggest alternatives that seem more closely to reflect the painter's probable intention. The spelling of artists' names can also be a problem, insofar as variant spellings are both possible and correct. Seventeenth-century spelling is erratic, and many a painter spelled his own name with little regard for consistency; I have had to make a choice and stick with it. The same applies to vital statistics; I have chosen what I deemed the most accurate available. To avoid a clutter of dates in the text, the birth and death dates of each artist accompany his name in the index. And since it was impossible to make cross-references to all the unavoidable overlappings, I urge the reader to make good use of the index.

The extensive bibliography was compiled by Ellinoor Bergvelt, of the University of Utrecht, and Michiel Jonker, librarian at the Amsterdam Historical Museum. In it are listed seventeenth-century sources, but it presents primarily recent publications in the history and art of the period. It is intended to complement and supplement the notes, which I have tried to keep to a minimum.

During the long course of writing this book, I have endeavored always to make the text readable for nonprofessionals by avoiding art-historical jargon as much as possible. My goal is to give the reader the information necessary for a fuller enjoment of the seventeenth-century Dutch art so copiously displayed in our museums today.

The assistance, good advice, and cooperation of many people were indispensable to me. Besides those colleagues already mentioned, I am deeply indebted to my fellow members on the Rembrandt Research Project. The discussions at our weekly meetings often went far beyond Rembrandt alone, and I have many times made direct or indirect use of the almost encyclopedic knowledge of Professor J.G. van Gelder of Utrecht, whose recent death we all lament. The other members of the project will forgive me if I also single out Professor J. Bruyn of the University of Amsterdam as a source of knowledge from which I have abundantly profited.

Professor E. de Jongh very kindly read the manuscript and gave me valuable criticism, as did Clara E. van der Waals-Nachenius, who kept an eye out for readability.

The translator and editor Elizabeth Willems-Treeman provided more than a capable translation. Her many comments and queries helped to tighten the text, and her wide reading enabled her to amplify some passages, particularly in the historical sections, for the benefit of the non-Dutch reader. The final preparation of the manuscript for the printer as well as the compilation of the index was handled with great competence and distinction by H.J. Scheepmaker of Abrams' Dutch office.

The book was designed by Renée van de Griend. Her solution of the many problems posed by the layout and by my special wishes is nothing short of excellent.

The international economic situation altered drastically while I was writing this book, and when the manuscript was finished there was no certainty that it could be published because of the rise in production costs and the changes in the book market. We were able to proceed thanks to a generous grant from the Prince Bernhard Foundation of Amsterdam, permitting the simultaneous publication of the book in the Netherlands, the United States, Great Britain, and West Germany.

During the long years from manuscript to finished book, Andreas Landshoff has never flagged in his efforts and encouragement, and I am particularly grateful for the many ways in which he has lightened my task.

Finally, I wish to mention the late art dealer D.A. Hoogendijk of Amsterdam, my first teacher in the field of seventeenth-century Dutch painting. His great sensitivity to this art laid the basis for what I have tried to pass on, in my turn.

1. J. Bruyn in *The Art Bulletin* 54 (1972), pp. 219–22.

PART I

Introduction

Paintings, drawings, and prints, furniture, articles of silver, pottery—so much has survived from the Netherlands of the seventeenth century that our knowledge of the art of that place and time might seem nearly complete. Moreover, so much information is available about the artists themselves—their dates of birth and death, places of residence, marriages—that they almost come alive for us, and even more so when we view their world as reflected in their pictures. In these we see the townsfolk in their homes, the peasants at the inns; here are the clothes they wore, the utensils they used, the things they ate, the flowers they loved; their villages and cities, with streets and squares and canals; waterways and ports filled with boats and ships of every description, and more ships fighting at sea or wrecked on distant shores. The landscape evolves before our eyes: the forests, dunes, streams and lakes, the flat countryside. And the visual arts are supplemented by innumerable written sources: histories, travel accounts and logs, prose and poetry, and an overwhelming abundance of official documents.

The material is so voluminous that we could well become blind to the many uncertainties and lacunae that still exist, for, on closer examination, the image that seemed so clear becomes rather vague. It is laden with the accretions of intervening time and with differing, sometimes unduly romantic interpretations. To obtain an accurate view of seventeenth-century Dutch art, we must identify the gaps and attempt to fill them in, and weed away the inexactitudes. At the outset two important questions arise. First, what are the data concerning the origin of the paintings, the artists' intentions, and the wishes of the patrons? Second, how representative and trustworthy is the extant material?

To answer the first question: hard and fast information about the genesis of paintings is extremely rare. In contrast to artists in Italy and Flanders, Dutch painters only sporadically referred to their work in writing.

Practically no written commissions have been preserved, and only a few records of payment. Clues to patrons' wishes and demands are therefore scanty, a phenomenon in itself indicative of the religious, social, and political atmosphere in which the paintings originated. The Dutch Republic was newly Protestant and newly independent; the Calvinist Church eschewed adornment as a matter of principle and therefore did not patronize artists; and neither the stadholder's court (with the exception of Frederik Hendrik's) nor the nobility contributed significantly to the production of art. The major customers were, rather, the citizens themselves and their civic organizations. Indeed the greater number of paintings was created not on commission but for the free market.

Little is known even about the titles of paintings. Most descriptions in sales catalogs, inventories, and other documents are lamentably sparse and often confusing—the compiler of an inventory may not know the meaning of a biblical or mythological subject, or the name of the artist.

There are also gaps in our understanding of art theory, partly because the writings are so few and far between. Karel van Mander's *Schilder-Boeck* (Book of Painting) was published in 1604; more than fifty years elapsed before Cornelis de Bie published his *Gulden Cabinet van de Edele vrij Schilder-Const* (Golden Cabinet of the Noble Free Art of Painting) in 1661–62. This was followed, in 1678, by Samuel van Hoogstraeten's *Inleyding tot de Hooge Schoole der Schilderkonst* (Introduction to the Advanced School of Painting). But in between these full-length works, Philips Angel's *Lof der Schilder-Konst* (Praise of Painting) of 1642 is the printed text of a speech that gives a very limited impression of contemporary ideas, and the eleven

rules of art compiled on a single page by Pieter de Grebber in 1649 are skimpy indeed.

The regrettable dearth of contemporary material has sometimes tempted art historians into far-fetched interpretations, which, unchecked, have come to be accepted as truths. To cite a well-known example: about 1800, Rembrandt's civic-guard painting, its coats of varnish darkened with age, was mistakenly yet apparently ineradicably dubbed *The Night Watch*. In other instances, such as the matter of seventeenth-century realism, the absence of documentation regarding an artist's intentions can lead to a complete misreading of his pictures: what looks like a portrayal of virtue may rather have been intended to point a finger at vice.

The second question, concerning the reliability of the material, including the paintings,

1 Jan Steen
 Woman at Her Toilet
 Signed. Panel, upper corners rounded off,
 37 × 27.5 cm. Rijksmuseum, Amsterdam
 a. Before restoration
 b. After restoration

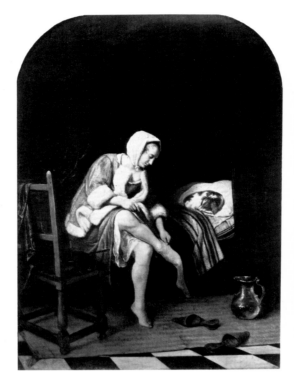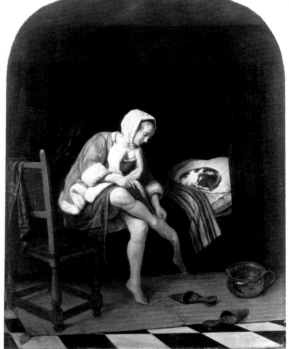

the extant documents, and other sources, cannot be given a single answer and must be examined anew in each case. Yet this question must be asked, for when we want to form an opinion about a seventeenth-century painting, we need to be certain of its authenticity. If it is signed, we must be convinced that the signature is genuine. There are many instances of paintings from which the original signature has been removed and replaced by that of a painter whose name assured a higher price. Yet even a genuine signature is not absolute proof: in the seventeenth century a master was permitted to sign his pupil's work and sell it under his own name.

Alterations of other kinds may have been made to a painting when changing tastes or standards so demanded. A recent cleaning of Jan Steen's little panel *Woman at Her Toilet* revealed that the woman's chamber pot was transformed in the past into a "respectable" pitcher, and the view up her skirt camouflaged with a drooping petticoat (fig. 1). Skulls and other images that might hamper sales were often removed from paintings. If a picture of a church interior was thought to look empty, figures were simply painted in (fig. 2). Profit-seeking owners sometimes vandalized large paintings by trimming the edges to a more salable size, or, if the composition permitted, by cutting up a painting into two or more separate works.[1] To pair up two paintings of different sizes, one solution was to add extra strips to the sides of the smaller canvas. Even responsible owners have caused incalculable damage to paintings by allowing careless cleaning or restoration.

Then there are the matters of copying and forgery. Copies were frequently made for all sorts of reasons in the seventeenth century. The training of pupils included copying the works of masters past and present, and it was normal practice for art dealers to order and to sell copies of a successful painting. Since then, copies have often been made for either business or pleasure. The forger differs from the copier mainly in his motivation, his intent to deceive for gain. Various court cases in the seventeenth century indicate that forgers were even then busy. Falsifications of the work of highly prized masters can be expected to turn up in any century.

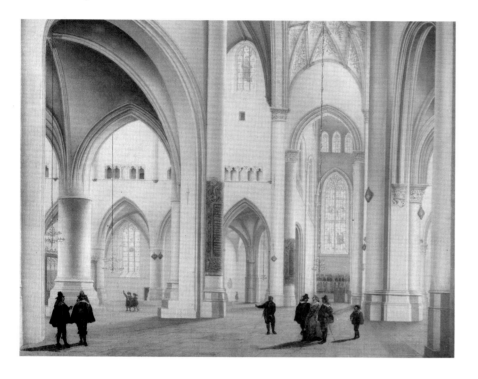
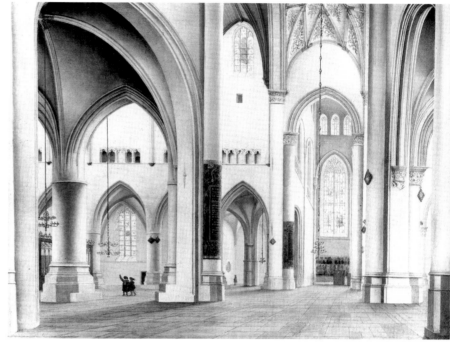

2 Pieter Saenredam
Interior of the St. Bavo Church, Haarlem
Signed and dated 1628. Panel, 37 × 49 cm.
Formerly Collection J.H.C. Heldring,
Oosterbeek
a. Before restoration
b. After restoration

It is often difficult to distinguish copies and forgeries from genuine paintings, especially when the original work has disappeared. Even with the technical aids now available, judgments are possible only if it can be demonstrated that the materials used were not known in the seventeenth century; decisions on specimens from within that period remain problematical. "Connoisseurship" has often provided the deciding opinion, and the exceedingly subjective standards of connoisseurs can lead to disparities of all sorts.

Other factors have to be considered in determining whether the available material is representative or not. Exceptionally, there are a few seventeenth-century painters whose work is so well documented—paintings signed and often dated—that an insight can be gained into their development and accomplishments. Jan van Goyen is one of these. His paintings almost always bear a signature or monogram, and they usually are dated, as are most of his many extant drawings; accurate dates can also be assigned to several of his sketchbooks. But far less is known about the majority of artists.

The fewer the data, the more we must suspect the opinion that we form about any particular artist. Our evaluation of Hercules Segers as a painter, for instance, is based on no more than ten identifiable paintings. Yet, in 1644, the Amsterdam art dealer Johannes de Renialme had in hand at least forty works by Segers.[2] Assuming that all these were original, we must conclude that our image of Segers cannot be complete, and that he may have produced paintings markedly different from the ten we know.

The written sources, too, must be treated with caution. The otherwise abundant materials in Dutch archives (notarized documents, inventories, and so on) are usually deficient when they concern works of art. The descriptions in many inventories are so laconic that we cannot be certain—especially when no measurements are given—that a painting we are examining is identical with the one in a document. An uncritical approach to the sources can lead one dangerously astray.

Factual data about the artists themselves are in general rather complete. Vital statistics and places of work have been well established, for this information was recorded by contemporaries and has since been verified, corrected, and amplified by thorough

documentary research. Considerably less trustworthy, however, are the stories that have made the rounds about artists. Arnold Houbraken, in particular, seems to have given his imagination free rein when he wrote his *Groote Schouburgh der Nederlantsche Konstschilders en Schilderessen* (Great Theater of Dutch Men and Women Painters), published in three volumes between 1718 and 1721. His tales have been trusted too much, but he remains a major and indispensable source of information about seventeenth-century painters.

It goes without saying that the many scholars who have devoted themselves over the years to seventeenth-century Dutch art have combined their research with their accumulated knowledge to achieve as true a view as possible of this art. Yet any view can become time-bound and prejudicial. Patriotic sentiments have led to emphasis on the "typical Dutchness" of Dutch landscape painters. Some of Jan van Goyen's pupils of limited talent have received more attention than have considerably better artists who chose their subjects in Italy; the same can be said of a number of Adriaen van Ostade's followers, at the expense of more classically oriented figure painters. The eighteenth century strongly preferred "refined" painters like Frans van Mieris, while the late nineteenth, after the rise of Impressionism, favored those with freer style and technique. This shift is in itself normal, but when a personal preference or reigning fashion is not coupled with an attempt to fathom the ideas and circumstances of the period under study, it can produce a serious distortion.

Let us begin with a glance at the historical background of the Netherlands, to set the stage as it were for the developments in art. To a greater or lesser degree, every artist participates in the life of his times. Yet it may be said at the outset that, however sweeping were the events in the Northern Netherlands during the sixteenth and seventeenth centuries, causal links between these events and the evolution of painting can seldom be established.

Preliminaries, Historical and Artistic

The great flowering of the Northern Netherlands in the seventeenth century can be understood only in the light of the tremendous changes that took place during the sixteenth century in the political, economic, religious, social, and cultural spheres. In 1500 Charles V, future king of Spain and Holy Roman Emperor, was born at Ghent; in 1600 a Dutch army led by the stadholder Maurits of Nassau defeated Spanish forces under Archduke Albert of Austria in the Battle of Nieuwpoort. What happened between these dates is so vast in scope and so confusing that it is difficult to summarize. We will here emphasize those facets which led in 1568 to the revolt of the Netherlands, both north and south, against Spanish rule, with the ensuing Eighty Years' War and the founding in the north of an independent nation, the Republic of the United Netherlands, and its recognition in 1648.

The Northern Netherlands was not a political entity at the beginning of the sixteenth century. Its most important regions were the counties of Holland and Zeeland, the bishopric of Utrecht, the duchy of Gelderland, and the lordships of Friesland and Groningen, all loosely tied to the Hapsburg sovereign (after the Burgundian overlords died out) by bonds reflecting the vagaries of dynastic marriage and death. There was no question of national unity, not even when these areas came under the rule of Charles V, who was determined to expand and consolidate his realm. Between 1524 and 1543, by persuasion, purchase, and force, he gained control of the last holdouts in the north and made the seventeen provinces of the Netherlands (cpl. 3) a cornerstone of his vast empire.

Foremost among the king's plans for the Netherlands were the centralization of government, a stringent tax policy, reorganization and expansion of the bishoprics, and the suppression of heresy. He had made a good start on all of these, except the new bishoprics, before failing health forced him to abdicate his Spanish and Netherlandish kingdom, in late 1555, in favor of his son, Philip II. The electors of the Holy Roman Empire denied Philip the imperial throne, however, and gave it to Charles's brother, Ferdinand I.

Philip was completely different in character from his father, but well trained to rule. In each of the seventeen provinces he was ceremoniously installed as the king of Spain and as their particular count, duke, or lord, but not as king of the Netherlands, a title that did not exist. Nor were the pledges of allegiance completely whole-hearted, for each province (along with many of the cities and towns) cherished certain rights and privileges granted in

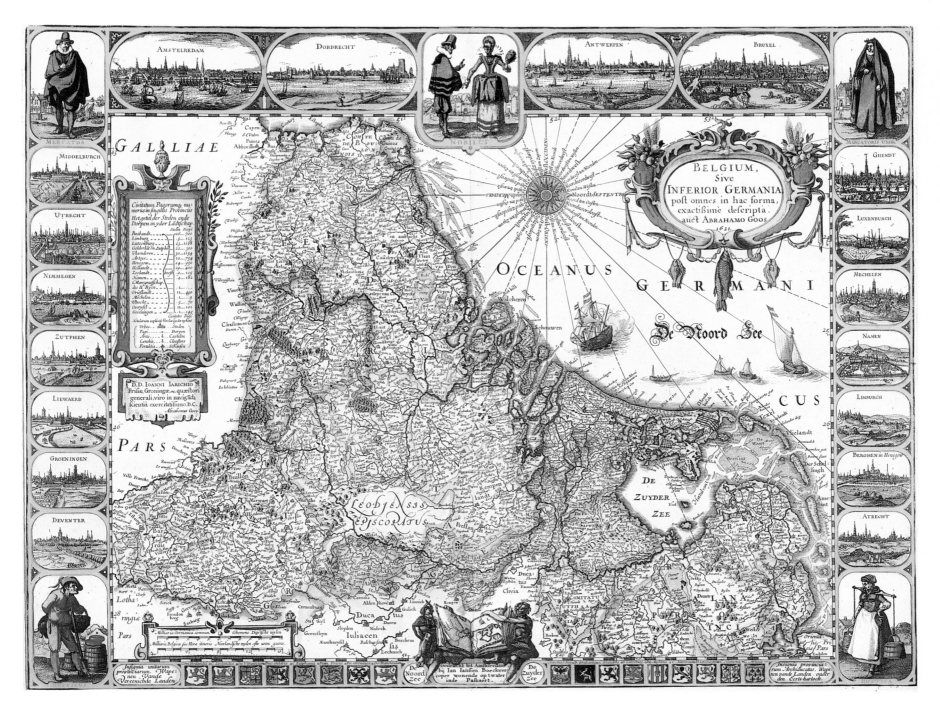

3 Abraham Goos
 Map of the Seventeen Provinces
 1621

the Middle Ages and considered inviolable; these the new king now swore to uphold. There was another reason for uneasiness: Charles V had been born and brought up in Flanders and was therefore counted a native son (with the divine rights of kingship, to be sure), whereas Philip was thoroughly Spanish in culture and attitude. He was accepted nevertheless as the "natural prince."

 The king took up residence in Brussels, the center of government. The governmental apparatus comprised a council of state for political policy, a council of finance for fiscal matters, and a privy council concerned with the day-to-day supervision of judicial and legislative matters. All these councils served as advisers to the king and were his mouthpiece, or, in his absence, spoke for his personally appointed regent or governor-general, customarily a female member of the family. The king also appointed a stadholder or viceroy to be his administrative and military representative in each province. The stadholder had the right to name certain magistrates and to convene the "States" of his province, a representative assembly of nobles and clergy (in some larger cities, leading patricians were also allowed to hold seats). These in turn sent delegates to the sessions of the States-General, the "national" assembly or parliament convened by the king about every three years, mainly to discuss new tax proposals, which the delegates could accept or reject only with the approval of their provincial assemblies. This requirement caused delays, at times prolonged. Since one of Philip's characteristics was an inability to reach decisions quickly, the potential loomed large for unresolved problems.

 At the local level, the municipalities were governed by two or more burgomasters (elected annually) and the town council (elected for life), a self-perpetuating body made up

of the richest or most distinguished citizens. Legal and police matters were in the hands of a board of magistrates, presided over by a bailiff appointed by the crown, and a sheriff and his men. Finally, there were a dike reeve and a water board to maintain control of inland waters and vigilance against the sea. All these officials, fearing encroachment by the sovereign, were protective of their ancient privileges, which usually included the right to collect tolls, hold annual market fairs, build town walls, and try citizens in the local court.

This broad system of governmental organization had developed gradually, and it continued in effect in the Southern Netherlands for the next two centuries. From it also originated part of the subsequent framework in the north, where, as power shifted from the top to the middle, the provincial States and the States-General carried on as of old. The stadholder, too, was retained as head of the army and navy, and had the prerogative of naming certain municipal officers; since he no longer stood in lieu of a higher power, his title had become anachronistic, but he was carefully kept from claiming sovereignty.

All this, however, was in the future, and in 1556 the system was under attack. In Brussels, the Netherlands nobles saw themselves increasingly supplanted in the high councils by the king's Spanish cronies; in the religious community, the creation of fourteen new bishoprics to replace the traditional four threatened the old ecclesiastical power base; and in the villages and towns, the central government sent out bureaucrats and soldiers to collect more and more taxes, confiscate property and crops in default of payment, and torture suspected Protestants for their religion, ignoring civil and civic rights. Placards with harsh messages were posted constantly. The king's acts stemmed from his conception of his regal rights and the dictates of his Catholic faith, but preachers of the new faith were everywhere sowing doubts.

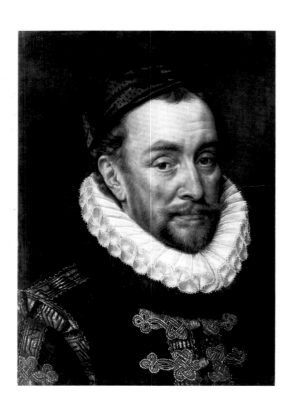

4 Adriaen Key
Portrait of William, Prince of Orange
Panel, 48 × 35 cm. Rijksmuseum, Amsterdam

The economic development of the Netherlands was closely linked to the changes that took place in Europe at the end of the fifteenth century. The Portuguese, led by Vasco da Gama in 1498, had opened up the sea lanes to the Far East; the New World, discovered by Columbus in 1492, shortly proved to be a veritable mine of gold and silver for Spain. The noble metals that came on the market caused long-lasting price rises, which strongly stimulated the economy, albeit at the cost of the common people, who could barely afford the necessities of life. The trade routes shifted swiftly from the land, so difficult of passage by geography and incessant warfare, to the sea; even the small ships of the day could transport many a cartload in their holds. The traditional trading centers in northern Italy were soon supplanted as commerce moved to ports on the Atlantic seaboard, to Lisbon and especially to Antwerp, which lay at the cross-point of the east-west and north-south routes. The sovereign also favored Antwerp, for money could be borrowed much more freely there than in the Flemish textile towns, still entrenched in medieval autonomy. As trade increased, so did traffic in money, and Antwerp soon outstripped all other European cities as a financial center. The arts and sciences kept pace with the economic development. By 1560, three hundred artists were registered in the local guild, which operated its own sales room, the first organized art market in northern Europe.[1]

The character of trade was changing at the same time; capitalism in its early forms began to develop, bringing an increasing gap between rich and poor. The Netherlands was an agricultural region but experienced a chronic shortage of food and had therefore to depend largely on imports. Grain prices fluctuated unpredictably, affected by the dislocations of war and by reduced harvests in the drought-stricken Baltic area, where low water in the rivers also hampered barging to the seaports. Wealthy merchants profited from the situation, buying up grain when it was plentiful and withholding it from sale until prices rose. In some Flemish towns there were bread riots and raids on warehouses. Hunger and poverty contributed as much as politics did to popular unrest.

The religious upheavals in the sixteenth century are so well known that only a few comments are needed here. The dissatisfaction with the Roman Catholic Church brought about a reorientation within the Church, but not before many members had broken away; these found new leaders in Luther, Zwingli, and Calvin. Calvin in particular rejected papal authority and stressed the virtues of thrift, industry, sobriety, and responsibility as the path to salvation, and it was his doctrine that fired a "reformed" faith crucial to the further development of the Northern Netherlands. The message was propagated by young preachers sent out from Geneva and by Huguenots fleeing from France. At first they went

to work clandestinely, but they came more into the open as their adherents grew. Indeed, the open air of the countryside was often the safest place for services, for congregations could scatter quickly if danger threatened.

These "heretics" were in real danger. Charles V had instituted a relatively mild form of the Inquisition during his reign; Philip II went much further, issuing edict after edict against heresy and setting severe penalties for those apprehended. Although most of the people were still Catholic, there was a common revulsion against the persecution and often bloody execution of their fellowmen—many of them family members or friends—who had chosen the new religion.

King Philip departed from the Netherlands for Spain in 1559, never, as it would turn out, to return. He left behind him as regent his half sister Margaret of Parma, and in addition a hard core of Spanish officials to keep her in line, restive nobles more or less led by William I, prince of Orange and stadholder of Holland, Zeeland, and Utrecht (fig. 4), a distracted clergy, and a seething populace. On the last night of December 1564, William of Orange, at the time a devout Catholic and loyal servant of his sovereign, addressed his fellow noblemen with challenging words: "The king goes astray if he thinks that the Netherlands, in the midst of lands where freedom of religion exists, can continue to endure the blood-stained edicts; just as elsewhere, much must here be condoned. No matter how strongly I am attached to the Catholic faith, I cannot approve of princes who wish to govern the souls of their subjects and to deprive them of their liberty in matters of conscience and religion." A battle for freedom was at hand.

To trace what was happening in art during this time, we need to dip back to the end of the fifteenth century, when painting began to assume its definite form in the Northern Netherlands. It was in the towns of Holland—Haarlem, Delft, Leiden, and somewhat later Amsterdam—that the artists' traditional anonymity first gave way to individuality. The founder of the school of painters in Haarlem was probably Albert Ouwater, who worked there from about 1440 to 1460 and produced masterpieces of early Netherlandish realism; his work was continued by Geertgen tot Sint Jans and Jan Mostaert. At the same time there was a painter in Delft whose work we know but not his name: the Master of the Virgin among Virgins, so called after the title of one of his paintings. In Leiden the slightly younger Cornelis Engebrechts was active, and from about 1500 Amsterdam had a painter of some importance, Jacob Cornelisz van Oostsanen.

Cornelis Engebrechts and Jacob Cornelisz each maintained a workshop where a number of pupils were trained. Engebrechts' most talented pupil was Lucas van Leyden, who became a trailblazer in Dutch art. Lucas' work bears virtually no trace of his teacher's influence; on the contrary, Engebrechts' later paintings show the influence of his pupil. Apart from Lucas' complete mastery of engraving and woodcut and his great talent as a painter, his importance lies in his open eye for all the new Renaissance forms; he took examples from the work of Albrecht Dürer, Marcantonio Raimondi, and Jan Gossaert. He knew Dürer and Gossaert personally, having met Dürer in 1521 in Antwerp and exchanging prints with him, and, six years later, touring with Gossaert through Zeeland and Flanders. In his ideas of composition and choice of subject matter, Lucas was also a pioneer. His small paintings depicting chessplayers and cardplayers (fig. 5) introduced a new element into Dutch art.

The Flemish artist Jan Gossaert, sometimes called Mabuse after his birthplace, exerted a powerful influence on Northern Netherlandish painting. Gossaert entered the service of Philip of Burgundy and traveled in 1508 with the duke's court to Italy, visiting Verona, Padua, Florence, and Rome. He was the first Netherlands painter to study ancient sculpture systematically, and also to see the work of Raphael and Michelangelo at close range. When Duke Philip became bishop of Utrecht in 1517 and took up residence there, northern artists had the opportunity to learn from Gossaert the ideas and the new world of form that he had found in Italy and himself expressed in paintings with mythological themes and large nude figures (fig. 6). In 1524 his patron died, and Gossaert moved to Middelburg, capital of Zeeland, remaining in the service of Adolf of Burgundy, Philip's nephew. Gossaert's influence on Lucas van Leyden, and consequently on the Leiden school, was a natural outcome of the tour the two artists made together in 1527.

Just as important for Dutch art was the contact between Gossaert and Jan van Scorel.

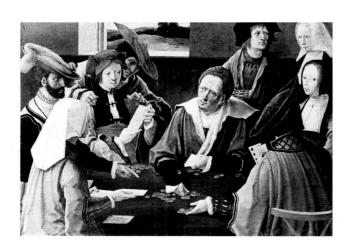

5 Lucas van Leyden
The Cardplayers
c. 1517. Panel, 33.5 × 47.5 cm. Collection the Earl of Pembroke, Wilton House, Salisbury, Wiltshire

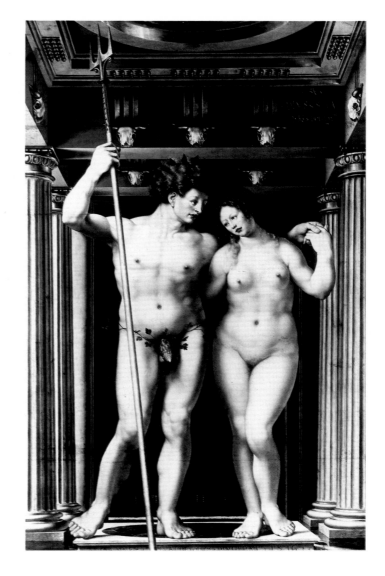

6 Jan Gossaert
 Neptune and Amphititre
 Panel, 188 × 124 cm. Gemäldegalerie, Staatliche
 Museen, East Berlin

7 Jan van Scorel
 Mary Magdalen
 Panel, 67 × 76.5 cm. Rijksmuseum, Amsterdam

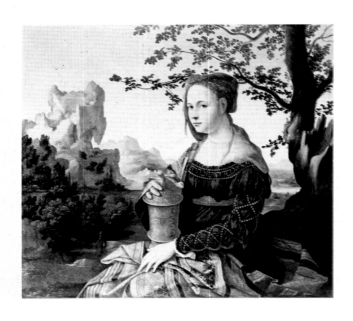

Scorel's apprenticeship was in Alkmaar and in Amsterdam under Jacob Cornelisz van Oostsanen. He worked in Gossaert's studio in Utrecht from about 1517 to 1519, and it was surely at that master's urging that he went to Rome, after first stopping along the way in Germany and Venice, followed by a pilgrimage to the Holy Land—a journey that had enormous significance for Dutch painting. In Rome the newly elected, Utrecht-born pope, Adrian VI, appointed him Raphael's successor as curator of the Vatican's collection of antique art, a post he held from 1522 until the pope's death in 1524. Returning to Utrecht, he took with him not only a thorough knowledge of the newest trends of Italian Renaissance art, but also a new technique of painting still unknown in the north: he sketched his composition in charcoal or chalk on the prepared panel, then painted with rapid, flowing strokes, using very thin paint, and laying colors on top of each other to create subtle shades and transparent effects.[2]

His contemporaries immediately recognized his talent, and he did not lack for patrons, especially after he was ordained canon in the Utrecht chapter of St. Mary. As a cleric he enjoyed many privileges, including the right to refuse membership in (and thus come under the restrictions of) the local guild. To avoid a power struggle between church and civic authorities in Utrecht in 1527–30, he moved to Haarlem and while there presumably painted the beautiful *Mary Magdalen* (fig. 7), demonstrating his mastery of composition and style. Then he went back to Utrecht, where he worked industriously until his death in 1562.

Jan van Scorel's work was decisive for Northern Netherlandish art during the second and third quarters of the sixteenth century, for he brought to an end the medieval painting traditions. The Renaissance spirit had already penetrated the literary world of the north, and now it attained visible form in art. This was expressed, among other ways, in an understanding of linear perspective for representing depth, and in the study of anatomy, which went hand in hand with a lively desire to portray the nude human body—a desire realized in mythological and even biblical compositions. Artists also gained knowledge of the classical orders of architecture and developed a conscious feeling for harmonious proportions.

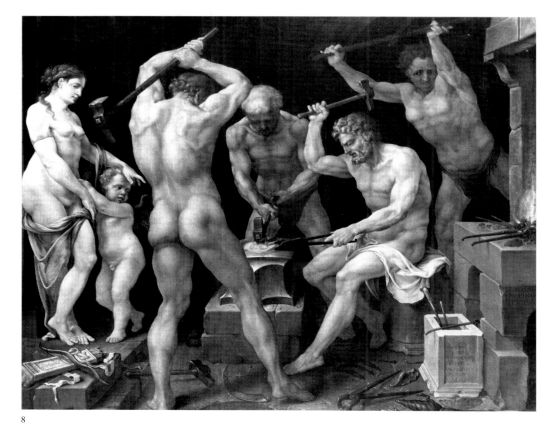
8

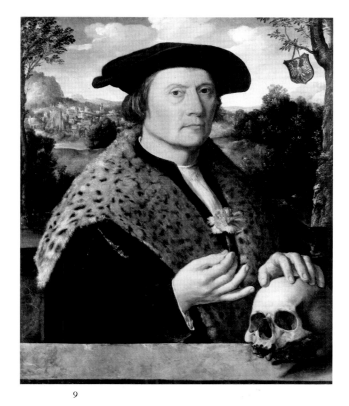
9

8 Maerten van Heemskerck
Venus and Cupid in Vulcan's Forge
Signed and dated 1536. Canvas, 166.5 × 207 cm.
Národní Galerie, Prague

9 Dirck Jacobsz
Portrait of Pompeius Occo
c. 1531. Panel, 66 × 54 cm. Rijksmuseum,
Amsterdam

10 Dirck Barendsz
Amsterdam Crossbowmen of Squad G
Dated 1562. Panel, 143 × 183 cm. Amsterdams
Historisch Museum, Amsterdam

Outside of Utrecht, Scorel's influence was seen in Leiden and Gouda, where Aertgen van
Leyden and Jan Swart worked, and in Haarlem, where Maerten van Heemskerck proved to
be an adept follower of great originality. Heemskerck worked in Italy from 1532 to 1536
and was, next to Scorel, the most important disseminator of Renaissance ideals, as
exemplified by his *Venus and Cupid in Vulcan's Forge* of 1536 (fig. 8). In addition to his
paintings, his graphic work was of lasting importance; many seventeenth-century painters
turned back to his prints. After Heemskerck died in Haarlem in 1574, there remained no
other painter of note to assure continuity of his style.

Jan van Scorel influenced Amsterdam artists as well. Without his example, Dirck Jacobsz,
son of Jacob Cornelisz, would never have painted his 1531 portrait of the wealthy banker
Pompeius Occo (fig. 9). Portraiture was an important form of art in Amsterdam; in contrast
with most other cities, the Amsterdam tradition continued unabated until well into the

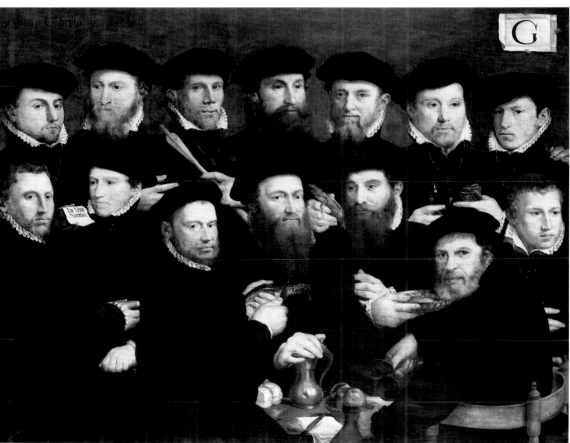
10

11 Dirck Barendsz
 The Adoration of the Shepherds (central panel of
 altarpiece)
 Panel, 246 × 221 cm. Municipal Museum Het
 Catharina-Gasthuis, Gouda

12 Pieter Aertsen
 The Egg Dance
 Dated 1557. Panel, 84 × 172 cm. Rijksmuseum,
 Amsterdam

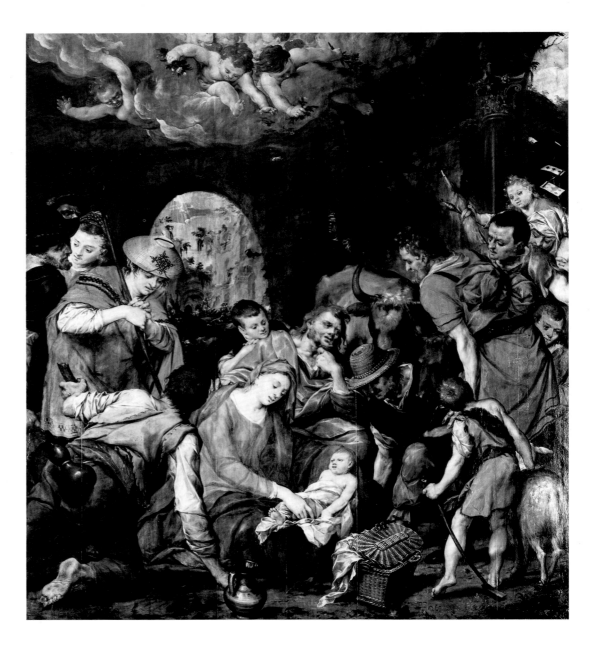

seventeenth century. Undoubtedly the city's growing prosperity and the increasing number of wealthy burghers and merchants affected this development.

Group portraits evolved alongside individual portraits. Members of the marksmen's guild gathered together to have their pictures painted, for use as decoration in their meeting halls. Dirck Jacobsz was one of the first to make such group portraits (see fig. 183). In the next generation, Dirk Barendsz became by far the most gifted painter in this genre (fig. 10). As a young man he spent seven years in Venice, working in Titian's studio. When he returned home in 1562, he brought along new pictorial ideas and worked them into his portraits and biblical compositions. His Venetian training is clearly evident in the large altarpiece *The Adoration of the Shepherds* (fig. 11), which he painted with great freedom of composition and color for the church of the Brothers of the Common Life in Gouda.

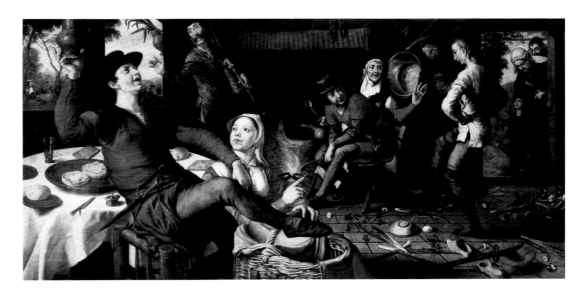

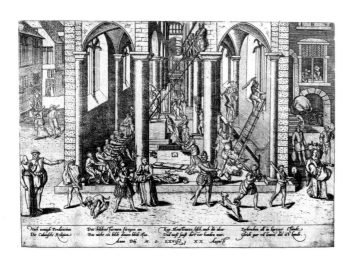

13 Frans Hogenberg
The Iconoclastic Fury, 1566
Engraving

A few years earlier, in 1566, another native Amsterdammer, Pieter Aertsen, had returned from more than two decades spent in Antwerp; his style had a strongly Flemish character. From his paintings of country folk such as *The Egg Dance* of 1557 (fig. 12), Dutch art received a new impetus stemming directly from Pieter Bruegel the Elder. Aertsen's peasants and serving girls feast or work together in kitchens overladen with food and equipment. In the background there is almost always a small biblical scene, and the symbolism is so pervasive that no study of Netherlandish art is complete without an examination of it. We shall return to this subject from time to time.

This brief summary shows us that fifteenth-century painting was of significance in only a few places—Haarlem, Delft, and Leiden—but during the sixteenth the activity broadened steadily. Amsterdam, a relatively young city with a rapid economic growth, began to take a leading position in art toward the end of the century, just when artistic developments in other centers were slowing down.

Iconoclasm and Revolt: 1566–1588

William of Orange's speech on New Year's Eve of 1564 did not go unheeded, and the lower nobility, many of whom were Protestants, in particular supported Prince William in calling the king to task. Among other acts, a petition signed by four hundred nobles was presented some months later to Margaret of Parma for forwarding to Spain; it requested that the edicts against heresy (the hated placards) be mitigated and the Inquisition be discontinued. While awaiting Philip II's reply, Margaret agreed to greater leniency in prosecuting Protestantism, thereby restoring peace for a time. The answer from the king, for once acquiescing to moderation, finally arrived on August 12, 1566, but it was too late, for on the tenth a revolt had broken out in a storm of iconoclasm. For months the Calvinists, mostly from the middle classes and many in exile in England or Germany, had been supporting the open-air preachers in fomenting rebellion among the common people, whose condition was undeniably miserable. Unemployment was high among the peasants, displaced from their land, and among the dockworkers and manual laborers in the ports, where shipping was almost at a standstill. The previous winter had been extremely severe, with ice blocking all the harbors; grain prices had risen out of sight, and the sicknesses attendant upon filth and hunger lurked in every city and town.

The revolt of August 10 was aimed at the symbolic source of misery: the Catholic Church. As a contemporary print (fig. 13) shows, religious buildings were stripped of all ornament; plundering was not the goal, but the destruction of heathen idols. Some works of art, such as the van Eyck brothers' *Adoration of the Lamb* altarpiece in St. Bavo, Ghent, were safely hidden away in time, but countless others were defaced or demolished. The "storm" raged through the industrial region of Flanders, then moved on almost day by day through Antwerp, Ghent, and, via 's-Hertogenbosch in Brabant, to the north, reaching Amsterdam, Utrecht, and The Hague on August 23, 24, and 25, respectively, Leeuwarden on September 6, and finally Groningen on September 18. Among the works of art lost in Amsterdam were, according to Karel van Mander, altarpieces by Pieter Aertsen in the Oude Kerk and the Nieuwe Kerk, and another by Anthonie Blocklandt in the Franciscan monastery, depicting the death and funeral of Francis of Assisi.[1]

Politically, the iconoclastic outbreak was disastrous for William of Orange. It ran counter to his aims and intentions and cost him many allies. Although his Catholic supporters had

been by and large as opposed as he to the royal policies and practices, they now deserted him. King Philip was shocked into action by a situation rapidly moving toward civil war; to put down the insurgents he dispatched an expeditionary force of Spanish troops under the command of the aging, gouty, yet still powerful Ferdinando Alvarez de Toledo, duke of Alva (fig. 14). Devoted to Philip II and to the Catholic faith, Alva arrived in the Netherlands early in August 1567, with a well-defined task: to suppress the rebellion, eliminate heresy, restore the absolute power of the monarch, and administer the policy of centralization. He held strictly to orders. One of his first acts was to institute a special court to try all rebels and heretics. This Council of Troubles—quickly redubbed the Council of Blood—exercised its duties with merciless zeal. A record of one hundred death sentences per day is attributed to it. In the ten years of its existence, its victims, of whom only the counts of Egmont and Hoorne are remembered by name today, are estimated to have totaled approximately seven thousand.

William of Orange had meanwhile fled to Germany, where he worked at the only remedy left: to mount an armed offensive against the king, an invasion that must bring freedom to the Netherlands. How much the issues meant to him is evident from the financing of his mercenary army: sixty-five percent came from his own and his family's fortunes; thirty-four percent from the Protestant nobles (many now also refugees) who remained faithful to him, and from sympathizing German Protestants; and only one percent from the Netherlands.

The campaign began with a battle at Heiligerlee, in the province of Groningen, on May 23, 1568, the date later reckoned as the official start of the Eighty Years' War. Alva's troops were defeated by Lodewijk (Louis) of Nassau, William of Orange's brother, but thereafter nothing went well for the rebels. Lodewijk's army was totally routed at nearby Jemmingen on the Eems estuary a couple of months later, and Orange was unable to make any military progress at all in the Southern Netherlands. It was Alva's actions at this time rather than William's that kept the rebellion from stranding entirely. The people had reacted rather passively to Orange's efforts, but were determinedly opposed to the exorbitant taxes levied by the duke and to the relentless persecution. Therefore, slowly and almost despite Orange's failures, the balance began to weigh in his favor.

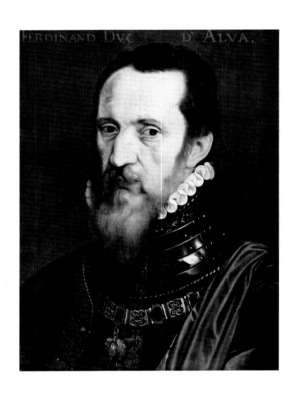

14 Copy after Willem Key
Portrait of Ferdinando Alvarez de Toledo, Duke of Alva
Panel, 49 × 38 cm. Rijksmuseum, Amsterdam

Guerrilla forces known as the *Geuzen* or Beggars (from the French *gueux*) proved to be a potent yet unpredictable factor. The name was first used in 1566, when Margaret of Parma, terrified by a group of the lower nobility who forced an audience with her, was reassured by one of her ministers not to be afraid of a "troop of beggars." The epithet was picked up by the rebel lords, who began to wear felt caps and rough clothing, and to carry beggars' attributes. Later they had medallions cast, with Philip's portrait on one side and, on the other, two hands clasped over a beggar's bag with the motto "True to the king as far as the purse." As hostilities increased, land-based or Forest Beggars began to make raids and forays. Another group in Holland and Zeeland managed to scrape together a little fleet and styled themselves the Sea Beggars. All in all, it was a motley collection of refugees— disgruntled noblemen, dispossessed merchants, adventurous fishermen, and various riffraff— bent on opposition to Spain in general and on their own profit in particular. Most of them being destitute, they spared neither friend nor foe in their search for provisions and loot. William of Orange, desperate for support of any kind, made contact with them and granted them letters of marque, which amounted to license for piracy; in return they were to harass Spanish shipping, which they did with a vengeance, and other shipping as well. They also raided the coasts of Holland and Zeeland, blockading harbors and terrorizing the inhabitants. Still, they were lending vital aid to the Orangist cause, and their surprise capture of the Zeeland port of Den Briel on April 1, 1572, made them popular heroes. From this new base they stepped up their activities, aided by reinforcements and supplies sent in by Orange and others, especially militant Calvinist groups.

The course of the long conflict can only be outlined here. The war was one of attrition; sharp skirmishes and prolonged sieges were interspersed with periods of stalemate as one or the other side ran out of funds, then rallied to continue. The decade of the 1570s was the most perilous and critical for the towns of the north that had been or were to become centers of art. In the autumn of 1572, Alva decided to stamp out the revolt quickly by pursuing a policy of "beastliness." After ravaging Mechelen in Flanders, he sacked and burned Zutphen, an old Gelderland town on the IJssel River, into the cold waters of which

his troops forced eight hundred citizens bound back to back and watched them drown. The Spanish army then marched on Naarden, a Zuider Zee town east of Amsterdam, and apparently accepted the frantic offer to capitulate, then treacherously massacred the entire population and applied the torch. Amsterdam, although loyal to Philip, had refused up to this time to accept a royal garrison. Now it became Alva's headquarters, and from there, with his son Don Frederico in command, he launched a siege against Haarlem on December 11, 1572.

The siege lasted through the winter. Sea Beggars managed to abet the city by ferrying in provisions and ammunition via the Haarlemmermeer, the large shallow body of water that then lay between Haarlem and Amsterdam. On May 26, however, this lifeline was broken when a Spanish fleet defeated the Sea Beggars in the Battle of Haarlem Lake (see fig. 119); a few days later the Spaniards captured a couple of carrier pigeons bearing Orange's plan to relieve the starving town, and thus thwarted his efforts. Haarlem capitulated on July 12, with Alva's promise that it would be spared. There was little destruction, but to teach the town—and all the northern rebels—a lesson, a score of magistrates and the entire civic guard of some three hundred men were summarily executed.

Alva next sent sixteen thousand veteran troops to besiege Alkmaar, northwest of Amsterdam. Despite fearful assaults, the town refused to surrender, and Orange ordered the dikes around it to be broached. Fearing inundation, the Spanish abandoned the siege and withdrew. The Dutch dated the beginning of their victory from that time—"from Alkmaar." Three days later they had a real victory to celebrate: on October 11 the Sea Beggars avenged their earlier defeat on Haarlem Lake by crushing a Spanish fleet and capturing its commander in the Battle of the Zuider Zee.

The siege of Leiden, the last and longest of the war in the north, was also broken by water. Alva initiated it in October 1573, and it was maintained for a year by his successor, Don Luis de Requesens. In early spring the siege was briefly lifted by a counterattack near Nijmegen led by William of Orange's brothers Lodewijk and Hendrik of Nassau, both of whom were killed. The loss of these two capable, loyal commanders was a severe blow to the prince personally and to his small fighting force. The siege was resumed. During the summer the Orangists broached all the dikes between Leiden and the Lek River and flooded the countryside; a fleet of flat-bottomed Beggar boats lay to, awaiting a "Protestant" wind from the south. Within the city walls the situation was desperate; an estimated one third of the population perished in the siege. Emergency money was issued bearing the words *Haec libertatis ergo* (This is for freedom); there were those who believed the message should have read *Haec religionis ergo* (This is for religion). The question of what the war was really about continued to be argued by the Dutch for generations.

At the beginning of October 1574, the wind shifted at last, and the Beggar fleet could set sail. The Spanish troops, fearing to meet their match, stole away in the night; their campfires and meager pots of food were discovered next morning by the starving survivors of the siege. The next year Leiden was awarded a university, the first in the Northern Netherlands, not because it had withstood the siege, as is often thought, but because Philip II had finally gotten around to granting a request made long before by his "beloved cousin" William of Orange.

By this time, nearly all the cities and towns of Holland and Zeeland—except for Amsterdam, with its pro-Spanish magistracy—had willingly or at least bloodlessly joined the revolt. Catholic municipal officials had been forced from office and replaced by members of the Calvinist minority. The Sea Beggars were shaping up into something like a navy, and were attracting volunteers who would later become national leaders. Yet danger continued to menace from every side, and loyalties were uncertain. The north was licking its wounds and wondering where the next blow would fall when relief came as William of Orange had hoped it would: in September 1575, Philip II, his financial sources drained dry not only by the war in the Netherlands but also by his campaigns in the Mediterranean against the Turks, was compelled to declare bankruptcy and to suspend all payments to his armies. When funds were insufficient for the funeral of Don Luis de Requesens, who died suddenly in March 1576, the Spanish troops understood that suspended pay meant no pay. Decamping from their captured positions in the Northern Netherlands, they marched south to Flanders; there, in a state of well-organized mutiny, they freely avenged themselves on the populace, brutally sacking town after town. The rampage ended in early November in

Antwerp, leaving nearly eight thousand people dead, a thousand buildings gutted by fire, and countless works of art lost forever.

Only after the "Spanish Fury" hit Antwerp did the south seek contact with the north. There was immediate reconciliation, and before the end of 1576 the seventeen northern and southern provinces joined to sign the Pacification of Ghent. By this pact they bound themselves to cooperate in driving out the Spanish troops and in resolving their religious differences. In September 1577, William of Orange made a triumphant entry into Brussels. Yet the Pacification did not succeed, perhaps because the Calvinists were too unbending. Certainly the conservative nobility of the south distrusted them, and moreover feared Orange's amicable relations with the French Huguenots. Above all, the diplomatic talent of Spain's new governor-general in the Netherlands, Alexander Farnese, duke of Parma, began in 1578 to win back increasing support for Philip II. A definitive split developed between the north and the south.

On January 6, 1579, the ten southern provinces allied themselves in the Union of Atrecht; on January 23 a group of the seven northern provinces (later joined by the rest) concluded its own Union of Utrecht. History would bear out that this latter event signified the birth of the Northern Netherlands as a nation, but the prince of Orange was not present at the ceremony, nor is there a single depiction of it. Apparently the occasion did not seem so important at the time.

The ideal for which William of Orange had striven so hard—the free union of the north and the south—had now become unrealizable. In 1580 Philip II put Orange under the ban and set a price on his head of twenty-five thousand golden ducats. The States-General of the new United Netherlands renounced Philip II in 1581, but could not give up the idea of sovereignty. At Orange's behest, they chose as their new overlord François, duke of Anjou, brother and heir presumptive of Henry III of France. From his headquarters in Delft, William of Orange as stadholder and captain-general continued his efforts to win the war or to negotiate peace. Though badly wounded he survived one assassination attempt in 1582, but on July 10, 1584, in Delft, as he left a noon meal at which his guest had been Rombertus van Uylenburgh, burgomaster of Leeuwarden and future father of Rembrandt's wife, he was struck and killed by bullets fired by a young Catholic zealot. The assassin was seized, tried, and tortured to death; his family collected the reward for his deed from the grateful Philip of Spain.

Alexander Farnese's military as well as political talent had meanwhile brought about a virtual reconquest of the Southern Netherlands. The French duke of Anjou, however, proved more a hindrance than a help to the north, and after several ineffectual campaigns he withdrew to France, where he died one month before William of Orange was killed. In 1585 Antwerp, the last remaining bastion of revolt in the south, fell into Spanish hands, an event of great importance, not least economically. The non-Catholics in the city were given two years in which to order their affairs and depart; thousands did so, to gain freedom of religion and to salvage their fortunes, for the Dutch had resumed their blockade of the mouth of the Schelde River, crippling all commerce.

Anjou's death left the United Netherlands without a sovereign, and the States-General began at once to seek a new one. They had been on the verge of elevating their stadholder William of Orange, and he of accepting the honor, when he was killed. Now they offered the sovereignty first to Henry III of France, who refused for a number of reasons, and then to Elizabeth I of England. She agreed to a temporary protectorate with Robert Dudley, earl of Leicester, as governor-general. Leicester and a large retinue arrived in the Netherlands with much fanfare in late December 1585. From the beginning, however, his governorship was a fiasco. The earl did not know or wish to know the language and customs, and did not understand and therefore tried to undermine the political situation. The queen twice recalled him to England, first to consult about the execution of Mary Stuart and second about the threat of the armada Philip II was assembling in Spain. In his absence, two of his English commanders turned traitor and handed the towns of Deventer and Zutphen over to the Spaniards. Leicester resigned in disgrace. For the Dutch, the motto became "Serve God by helping yourself."

These developments threw the municipal governments, especially in Amsterdam, increasingly upon their own, and as their self-confidence grew, they felt less enthusiasm for a new sovereign. To be ruled by a prince of Orange was perhaps the least of evils, but even

15 Adriaen van Cronenburg
Woman and Child
Signed and dated 15(8?)7. Panel, 105 × 78 cm.
Museo del Prado, Madrid

that they rejected. Far better to stand on their own feet as citizens of a republic. They therefore decided to vest political power in the States-General and the Council of State. To retain some hold on the past, the States of Holland and Zeeland in 1585 (and in 1589 those of Utrecht, Gelderland, and Overijssel as well) appointed as their stadholder the seventeen-year-old Maurits of Nassau, second son of William of Orange (the first son, Philip William, was held hostage in Spain from 1567 to 1598, and had only a minor role in Netherlands history). Prince Maurits was permitted to exercise the limited powers of his office as a servant of the States and as commander in chief of the army and navy, under strict tutelage during the first years. As military adviser he had his cousin Willem Lodewijk, stadholder of Friesland; his political mentor was his father's counselor and friend, Johan van Oldenbarnevelt, a former Sea Beggar but now legal advocate for the States of Holland, and rapidly proving himself to be a statesman of international stature.

By about 1590 Amsterdam had emerged as the most important Dutch port, benefiting from Antwerp's downfall as a shipping and financial center. The Calvinists were firmly in control, having unseated the Catholic magistracy in 1578. For years before, there had been a flight of Protestants from the city. Amsterdam's population, which can be conservatively estimated at about thirty thousand in 1550, declined sharply and only began to regain that level about 1585, after the resumption of normal trade. The quite steady influx, from 1530 on, of new *poorters* from outside—*poorterschap* or municipal citizenship was attained by birthright or purchase, and conferred certain rights—diminished at the beginning of the revolt and sank to a low point during the years from 1572 to 1577, then began to rise rapidly. Only relatively few of the immigrants could afford citizenship, however; the total number of newcomers was much larger than those registered as *poorters*. Among them, in any event, were people skilled in arts that found a ready reception in the Republic.

It is difficult to measure the impact of the war and the restriction of trade on the world of art. In rare instances, such as the Amsterdam civic-guard paintings, a numbing effect is clearly evident. Whereas twenty or more commissions for such group portraits were given between 1550 and 1566, not a single one is known between 1566 and 1578; two dated paintings remain from 1579. Dirck Barendsz, who had returned from Venice in 1562, and the sons of Pieter Aertsen (who had died in 1575) were the only painters of note at the time in Amsterdam. Until he died in 1574, aged seventy-six, Maerten van Heemskerck kept working in Haarlem in a style already old-fashioned, and there was hardly any question of succession by a younger generation. Neither in Leiden, once artistically blooming, nor in Delft were there any masters left to speak of. In Utrecht, Jan van Scorel had died; his talented pupil Anthonis Mor van Dashorst (often referred to by his Italianized name, Antonio Moro) worked primarily in Antwerp. Anthonie Blocklandt was still there and remained important mainly as a link between Jan van Scorel and the new generation, to which Abraham Bloemaert and Joachim Wttewael would belong. In Zeeland there was no painting activity at any level. In the other provinces outside of Holland and Utrecht, only local painters were active; of these, Adriaen van Cronenburg, one of the fairly numerous Frisian portrait painters, is the only artist of individuality. Signed portraits by him, such as his *Woman and Child* (fig. 15), now in the Prado, are known from the middle of the century. His style is closer to that of the Westphalian portrait painters than to the Dutch.

Literature did not share the retarded development of painting, partly because it was less bound by economic circumstances. None of the writers of this period was financially

dependent on the proceeds of his work, and literature became the preeminent medium for recording direct reactions to events. It goes perhaps too far to designate as literature the "resistance poetry" of the time, but the verses (the first dating from 1564) collected and published in the Sea Beggars' songbooks nevertheless had a special role. The earliest extant collection is *Een Nieu Geuzen Lieden Boexken* of 1581. The songs, originally circulated as broadsheets, were written to well-known tunes, easily sung by everyone. Their great popularity made them part and parcel of the revolt, especially at the outset.

This was the origin of the "Wilhelmus," which survived to become the Dutch national anthem. With the initial letters of its fifteen stanzas forming the acrostic "Willem van Nassau," the poem reflected the new patriotism and the old loyalties: while declaring for freedom, it vows continued allegiance to the king of Spain (as do all who solemnly sing it today). The author is unknown.[2] Among the possibilities are Dirck Volkertsz Coornhert and Filips van Marnix, lord of St. Aldegonde.

Marnix's poems are superior to most of those by his contemporaries, and they reveal their author's combative nature. His most important prose work is *Bienkorf der H. Roomscher Kercke* (Beehive of the Holy Roman Church) of 1569, an extremely barbed satire against Catholicism that gained fame at home and abroad. A fervent Protestant, Marnix had studied under Calvin in Geneva; he was a friend of and ambassador for William of Orange, and was closely involved in the fight for freedom. Eloquent and erudite, he wrote with ease in Latin, Greek, Dutch, French, Spanish, and Italian.

Coornhert (fig. 16) was a different personality. Educated in the sciences and arts in his native Amsterdam, he settled in Haarlem in 1546 as an engraver, later becoming a notary and advancing to secretary and pensionary (or chief legal officer) of that city. He remained a Catholic, but sharply criticized the Church; his attitude in matters of religion was highly independent: he insisted upon true freedom of thought and worship. The number of treatises he wrote is virtually endless. Because of his idiosyncratic ideas, he was persecuted by both Catholics and Protestants: Alva imprisoned him briefly in 1567, and upon his release he fled to Cleves; returning in 1572, he was appointed, with the recommendation of William of Orange, secretary to the States of Holland. But one of the Sea Beggar captains stirred up so much trouble about him that he had to flee abroad once more. In 1577, after the Pacification of Ghent, he took up residence again in Haarlem.

In his writings Coornhert was a staunch advocate of the pure Dutch language. In this, as in many other things, he found a supporter in the younger Hendrick Laurensz Spieghel, a wealthy merchant and magistrate in Amsterdam, and an important man of letters as well. Spieghel's ethical ideas, for which he was largely indebted to Coornhert, are recorded in *Hertspieghel* (Heart Mirror), posthumously published in 1614. In his predilection for the Dutch language Spieghel went so far as to request the "Heads of the High Schools of Leyden"—schools where the teaching was exclusively in Latin—"to make our Mother-tongue the Mother-tongue of all the fine arts." This desire to write in one's native language was a noteworthy step, undoubtedly associated with the war for independence and the dawning awareness of nationality. The writers of the last quarter of the sixteenth century were the first to set out the new course.

We have reached a point where it seems necessary and feasible to interrupt a narrative account with a long digression. Economically and politically, as the historian Robert Fruin has ably demonstrated,[3] the ten years from 1588 to 1598 were the true growing time of the young Dutch nation, a decade that confirmed its existence and set the pattern for the future. In the development of painting, the boundaries are more difficult to define, but in these same years a number of artists, already active, were clearly laying the groundwork for the specific evolution in the Golden Age that soon emerged. Before resuming the chronological story, therefore, let us take a look at the artists of the time, at their place in society, the commissions they received, and the subjects in which they began to specialize.

THEODORVS COORNHERTIVS AMSTELREDAMVS.
Quid valeant Bataui linguâ, ingenioq̃ Batauo,
Rara inter Batauos lux, Theodore, doces.
Quis posthàc craßam Batauis affinxerit aurem?
Dijperam, ſi quis tale quid auſus erit.

16 Jan Muller after Cornelis Cornelisz van Haarlem
Portrait of Dirck Volckertsz Coornhert
1590. Engraving

The Artist's Social Position

The term "artist" as understood today did not exist in the Middle Ages, when the person who painted or sculpted was considered an ordinary craftsman. During the Renaissance in Italy this attitude changed, and the artist as an individual gradually began to win a place above—sometimes far above—that of the craftsman, a place that entitled him to enter the world of poets and scholars.

The patrons acknowledged this elevation of the painter from craftsman to artist. Clear evidence of this appears in a letter from Federigo Gonzaga of Mantua to his agent, instructing him to obtain a work by Michelangelo: "And should he perchance ask what subject we prefer, tell him that we merely wish and hope for a work of his genius, that this alone is our most particular and important intention, and that we are thinking not of any special choice of material or any special subject if only we can possess an example of his unique art."[1]

This altered attitude implied higher fees, and the artist began to live more luxuriously. It also implied higher standards for him to meet, necessitating knowledge in many fields, especially literature. Great art, it was deemed, must engage the viewer's intellect rather than his senses. Art must display "invention," thus leading to higher thoughts.

During the sixteenth century the new kind of artist spread from Italy throughout all of Europe. The royal and ducal courts, in particular those of Francis I at Fontainebleau, Philip II at Madrid, Rudolf II at Prague, and Duke Albert V at Munich, acted like magnets in attracting artists from many regions. The Northern Netherlands made a modest contribution to this court art. A few painters worked at one court or another and brought some of the new ideas back to their own country, as did those who went to the source itself—Italy—and returned home.

Because of his sojourns in Italy and at various courts abroad, the Fleming Jan Gossaert (see p. 17) was the first to bring back to the north not only a new style of painting but also a new style of life. Utrecht-born Anthonis Mor van Dashorst became so at home in the courts that, although he sometimes visited his birthplace, he worked chiefly in the Southern Netherlands, at the courts of Philip II and Alva, and in England, where he painted portraits of the nobility.

It was the younger Dirck Barendsz, a native of Amsterdam, who was in large degree responsible for the acceptance of the new type of artist in the Northern Netherlands. In his early twenties he went to Venice and stayed with Titian, in whose studio he received training in art and the social graces. Van Mander relates that Barendsz met the poet Filips van Marnix there and formed a friendship that lasted after the artist returned to Amsterdam. According to van Mander, Barendsz possessed "a noble spirit of surpassing intelligence" and had "all his association with honorable people of power and education, like himself, for he was also a man of letters, a Latinist, and very learned." He corresponded in Latin with Domenicus Lampsonius, the art-loving secretary of the bishop of Liège, and was also a good musician.[2]

Similar "Renaissance" qualities can be found in other artists. Hans Vredeman de Vries of Leeuwarden visited many German cities and was active not only as a painter but also as an architect and fortifications expert. Cornelis Ketel worked at Fountainebleau and Paris, and was one of the celebrated portrait painters of the royal court and the nobility in London, before settling in Amsterdam. His versatility led van Mander to call him "a good master, experienced in all kinds of art as well as masonry, geometry, symmetry, and perspective, and also in the intellectual art of poetry."[3] The renowned Haarlem engraver Hendrick Goltzius, too, who in 1590 went to Italy with a servant and traveled about incognito, attained a style of life in which the intellectual element of being an artist overshadowed the purely manual. And Karel van Mander himself, a wellborn, displaced southerner of wide-ranging capabilities and erudition, constantly urged young artists to improve their minds and look to their social position.

Nevertheless, in the Northern Netherlands there were no artists who lived in the flamboyant luxury enjoyed by some of their counterparts in Flanders, where Willem Key and Frans Floris, for instance, comported themselves like *grands seigneurs*. The latter regularly entertained such high noblemen as the prince of Orange and the counts of Egmont and Hoorne at dinner. And whereas Rubens, van Dyck, and Teniers were to continue this

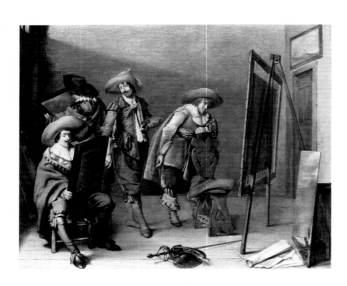

17 Pieter Codde
Art Lovers in a Painter's Studio
Panel, 38.3 × 49.3 cm. Staatsgalerie, Stuttgart

new way of life in Flanders, in the north it seldom if ever occurred, even in the best of times. Part of the explanation no doubt lies in the differences in temperament and culture, for in the south the royal and ecclesiastical courts set an elegant tone, while in the north the inclination was more sober, even puritanical.

The typological change that can be observed taking place among painters in the Northern Netherlands—from versatile, all-round, and often well-to-do artists to artists of considerably narrower scope both artistically and in their life style—is linked also with the continuance of the medieval guild system and the increase of specialization. Certain artists limited themselves more and more to portrait painting, or to still lifes or landscapes. In Flanders, too, there was specialization in the sixteenth century; Joachim Patenier, for example, painted only landscapes and was hired to paint the landscape background in the biblical compositions of other artists. In the seventeenth century, however, the trend went even further—some painters concentrated exclusively on, say, still lifes of fish.

The social and economic circumstances likewise worked for change. When the Netherlands split in two, it was along a border determined by external not natural factors, but the breach was nonetheless wide and deep. The south, where Calvinism first took root but was soon eradicated, stayed in the Catholic fold; the north became increasingly Protestant. The south remained under Spanish rule, which became tighter rather than looser as the church and the nobility regained and intensified their dominance.

A specialization in art similar to that in the north did take place in Antwerp, brought on by economic necessity. The painters remaining in that now destitute city had to find a market for their work and began to export paintings abroad, to Italy and elsewhere.[4] As the demand grew, so did the commercialism of their art, compelling them to rapid and efficient production. Yet only a few of the most talented could maintain their old luxurious life style, and only a handful of artists outside of Antwerp contributed to the development of painting in the south.

In the north, power came into the hands of the bourgeois municipal governments, made up primarily of merchants prospering in the new atmosphere of freedom. The Calvinist Church, averse to ornamentation, fell away almost completely as patron of the arts. The stadholder's court began a modest patronage in Holland and Zeeland, where the nobility had never been of much significance, but only after 1625, during the stadholdership of Frederik Hendrik. Neither the landed gentry in the other provinces nor the Orange residence of the Frisian stadholders was of more than local importance to artistic life.

The burghers, therefore, became the patrons—the burghers as private citizens and as officials. They wanted paintings for their homes, which at first were rather small and unpretentious, and for public buildings and charitable institutions: town halls, assembly rooms of the militia companies, regents' chambers in the hospitals and poorhouses. The public commissions had to meet certain standards, but those for private quarters were quite unrestricted, except for the conventions of portraiture. A free market could develop for paintings of widely divergent subject matter: biblical and mythological compositions, landscapes, seascapes, still lifes, and scenes of daily activity. The painter no longer worked solely on commission but produced, according to his own insight, a supply which he must then attempt to sell in his own studio, through art dealers, or at annual fairs. Pieter Codde painted a scene that must often have occurred when prospective clients called on an artist (fig. 17), and an art shop with paintings prominently on display, including a Vroom-like seascape hanging on the side wall, appears in the right background of the street scene called *The Quack* (fig. 18), painted by an unknown artist early in the seventeenth century. Thus

18 Artist Unknown, Dutch School, 17th Century
 The Quack
 Panel, 69 × 91 cm. Rijksmuseum, Amsterdam

evolved a market ruled by supply and demand: a painter had to pay attention to the wishes and means of the buyers, but he could also produce work to his own taste and offer it as he pleased.

Under these circumstances, it is no wonder that the painters sought insurance of some kind. They found it in the old-fashioned, long-standing guild regulations, which took care of the most urgent need: the protection of their product against outside competition. At the same time, specialization within the profession, the artists' concentration on one subject, formed a natural protection against inside competition except perhaps for the most gifted and versatile artists.

Specialization was not the only trend nor economic conditions the only factor in the development of painting in the Northern Netherlands. There, more than elsewhere in Europe, new and independent subject matter kept cropping up, offering fresh opportunities for painters of particularized talent. And changes in public opinion and taste led to preferences for certain subjects, such as landscape.

The training of painters likewise changed. In the second half of the sixteenth century a journey abroad, preferably to Italy, was a prime requisite. Such a trip broadened the professional horizon of young painters and fostered their general development. This tradition persisted until about 1620, but after that the training was carried out almost entirely in the Netherlands itself. Utrecht alone followed a different pattern; nearly all of its figure painters visited Italy, and their art has a different character from that in other Dutch centers. The Italianate landscape painters who continued to journey south went to paint and to seek inspiration from the Italian landscape, not to serve an apprenticeship.

A growing national consciousness may have displaced the previous interest in Italian art. In literature, this new awareness is expressed in the attempt to write in Dutch, the mother tongue. Or perhaps the shift in subject matter now obviated the need for going abroad; the Italian models were useful only for the history painters. Probably these two factors are closely related. But did intellectual limitation, linked with specialization, also lessen the interest in Italian art? It is difficult to determine the importance of a painter's economic and social background; artists continued to travel extensively, and those who managed to get to Italy, such as the Italianates, were not obviously wealthier than the others. The number of Dutch painters who received part of their training abroad fell off during the seventeenth century, but the number of students in general—not just art students—who either studied or completed their education abroad increased demonstrably. After having studied at the new university in Leiden, many sons of merchants rounded off their education with a Grand Tour.

The war with Spain did not hinder traveling to any great extent, for borders were not closed. In 1604 the Amsterdam city fathers even sent the composer-organist Jan Pietersz Sweelinck to buy a new harpsichord in Antwerp, famed for the production of these musical instruments, though Antwerp was then enemy territory.

Painting was termed "free" and "noble" in the Netherlands toward the middle of the sixteenth century, and van Mander, a paramount representative of late sixteenth-century ideas, entitled the first section of his *Schilder-Boeck* "Foundation of the Noble Free Art of Painting." He was opposed to including painters in craftsmen's guilds because art was too free to be so confined: "Oh, all too ungrateful contemporary centuries, which have bowed to the pressure of meddlesome bunglers and permitted such scandalous laws and similar illiberal regulations a place in the cities, so that almost everywhere (with the exception of Rome) a Guild is made of the noble art of Painting, just as is done with all the rude handicrafts and trades, such as weaving, fur-sewing, carpentry, smithing, and so on."[5]

Van Mander's distress found virtually no echo during the first half of the seventeenth century. Artists in all of the cities were joined with artisans in the local St. Luke's Guild. Only in Middelburg was there one protest: in 1616 the artists—for the first time called "fine painters"—presented a petition "to be separated and to have a separate chamber from the other guild brothers and the rough painters."[6] The petition was refused by the municipal authorities. The word "painter" was rarely defined; "fine painter" or artist was not distinguished from "rough" or house painter until much later, toward the middle of the century. "Fine painters" also sometimes painted signboards, evidence that an artist's business still had a craft aspect.

By 1642 Leiden was the only important Dutch city that had no St. Luke's Guild. After much effort, the Leiden painters were then granted an ordinance, which led to the founding of their own guild in 1648, but with no distinction between house painters and art painters. The charter specifically includes "painters who lay on paint with *penseel* [artist's brush] or *quast* [house-painter's brush]." The house painters were referred to as "common daubers," and they protested vigorously because their entrance fee was the same as that of the "fine" painters, "for not only can a fine painter earn just as much in a day or two as [a house painter] in a whole month, but a fine painter can keep working the whole year long and enjoy the profits," while the house painter was dependent on wind and weather.[7]

Houbraken complained that in Dordrecht "because of the bad times, ordinary art painters also fell into the daub-pot and helped to increase the numbers of rough painters," another indication that no clear distinction was being made between artist and house painter.[8] Even when it was made, the manual work, the application of paint by means of a brush, seems to have been the determining factor in the division into guilds. In Haarlem the fine painters attempted in 1631 to obtain greater authority in the guild, suggesting that an "upper section" of artists and a "lower section" of craftsmen should be established "to give renewed luster to the art of painting." Again, the city fathers vetoed their proposal.[9]

There is every reason to believe that seventeenth-century Dutch painters, whether or not they really were concerned about their status vis-à-vis manual laborers, greatly needed the advantages afforded by guild membership. The craft guilds in the Netherlands had reached their prime in the sixteenth century and were of far greater social importance in the south than in the north, but they continued to function in the seventeenth century. Their aim was to assure good professional training, guaranteed product, and protection against outside competition. By limiting the number of apprentices, they could maintain control of production. Internally, far-reaching provisions were made for guild members, comparable with modern socialized medical care and pensions for widows and orphans.[10]

With the Reformation the guilds in the north had become wholly secular, but they retained a vestige of their religious affiliations by keeping the names of their patron saints. The St. Luke's guilds, to which the painters in nearly every instance belonged, were regular craft guilds.[11] Although regulations differed from place to place and from craft to craft, the governing fundamentals were the same: the relationship between master and pupil, the number of pupils admitted, the length of apprenticeship, the requirements for proof of mastery, and so on. Only *poorters*—officially registered citizens—were allowed to be members of guilds, and only guild members could sell their products locally. Exception was made for annual markets and fairs; out-of-town wares could also be vended there. If a craftsman moved to another town, he had to purchase citizenship in his new place of residence and join the guild before he could begin to sell his products.

All of these regulations applied in principle also to artists, but theirs was a special case. The rules forbidding the importation of paintings from other localities were particularly hard on them. Control of these imports was extremely difficult, however, and there were

all sorts of cunning ways to slip past it. Dutch cities had a great deal of trouble trying to police art works smuggled in from the south, especially from Antwerp, where, as noted above, artists were largely dependent on export after the blockade of the Schelde had paralyzed the city's economy and brought local sales almost to a halt.[12]

Supervision of guild regulations became even harder as municipal populations increased. In fast-growing Amsterdam, for instance, the regulations were more or less ignored. Ferdinand Bol, Govert Flinck, and several other painters worked for years in the city and even received important commissions from semi-official institutions before they were registered as citizens in 1652. Nor was much attention paid, apparently, to the number of pupils a master took in.

19 Abram van der Plancke
 The Judgment of Willem the Good
 Signed and dated N. van Galen 1657. Canvas,
 190 × 213 cm. Town Hall, Hasselt, Netherlands

An exceptional instance of dodging guild regulations occurred in the town of Hasselt, in the eastern province of Overijssel, in 1657. A painter by the name of Abram van der Plancke, of whom nothing else is known, made a highly theatrical painting of *The Judgment of Willem the Good* for the Hasselt town hall (fig. 19). Since he was not a citizen, he should not have been given the commission, and in accepting it he broke guild law. A remarkable solution was found for the problem: the painting was signed by Nicolaes van Galen, a local guild member, and the town fathers took it upon themselves to pay the fine due the guild.[13]

After about 1640, artists in various cities began to push for their own organization separate from the too-restrictive guild. They did so most probably in order to promote their own interests. A splinter group of this sort succeeded in Dordrecht in 1642, when local painters founded a "Brotherhood or Confrerie of St. Luke"; a "Painters' College" was established in Utrecht in 1644, a "Brotherhood of St. Luke" in Hoorn in 1651, and a "Confrerie" in The Hague in 1656. In the other towns and cities the old guild system was maintained, and the artists seem to have had less desire for change. In Amsterdam, where, to judge from all sorts of indications, the guild's hold was very slack, a "Brotherhood of Painting" was founded in 1653, but this organization existed alongside the St. Luke's Guild and painters could be members of both. The annual banquets held by the brotherhood on St. Luke's Day were convivial events, with poets and art-loving burghers welcomed as guests.

Artists thus remained united in guilds or similar organizations, which is not to say that

they lacked a higher opinion of themselves. But what did the other citizens think of them? According to van Mander, people in general were not much impressed by artists, and he quotes the old saying "Hoe schilder hoe wilder" (The more the painter, the wilder).[14] The moralist-poet Jacob Cats, in his *Trou-ringh* (Wedding Ring) of 1637, more or less ridicules the artist by having him make quasi-learned pronouncements. Constantijn Huygens, secretary to three successive princes of Orange, writes quite lyrically about artists in his journal, however, and states his belief that the ancient Greeks gave high rank to the art of painting. He asks himself whether painting will ever be so greatly appreciated in Holland: "For honor's sake it is enough that it has the favor of the most powerful lords on earth, either through being practiced by men of note or by making famour all those who apply themselves to it with success. It has always produced immeasurable benefit (at least if by that word is understood the profit from material gain)."[15]

In his youth, Huygens had had drawing lessons, as was customary for boys of good family, and later he made a few paintings himself, but from his remarks it is clear that a career in art was not even considered by the wealthy class to which he belonged. Moreover, his ideal was undoubtedly that of the Italian Renaissance master, whom he wished more Dutch artists would emulate. Van Mander's story about a "young nobleman" who was making good progress in his artistic studies under Anthonie Blocklandt yet "did not wish to be named among the painters, thinking apparently that that would diminish his honor or family glory,"[16] at least casts doubt on the "nobility" of painting as a profession. Willem van Oldenbarnevelt wrote, in a letter of 1633 complaining about the attitude of Rubens, who had come to Holland on a diplomatic mission, "He is too haughty for a painter";[17] and when Rembrandt had disagreements with his wife's family, those wealthy Frisian in-laws called him "a mere painter."[18]

It is not easy to understand the ranks and stations of seventeenth-century society. There was a distinct top layer of patricians or regents, who held the most important offices. These incumbents always chose new members of governing bodies from among their own ranks, so that the regents formed a closed group. Nevertheless, other citizens could get in, if, for example, the aspirant acquired wealth through trade, or—even better—married a regent's daughter. The young republic offered unprecedented chances for upward mobility. A man whose father had come in through the town gates as a simple workman could advance to the highest offices. One example out of many is the history of Jan Poppen. Arriving in Amsterdam from Germany, he began his career in 1568 as clerk in a business office and worked his way up to become, in 1602, a director of the newly founded Dutch East India Company. His son, Jacob Poppen, was one of Amsterdam's richest residents and served the city as a burgomaster.[19]

But we rarely find painters among the sons of the regents or of the wealthy merchants. The exceptions are Isaac Nicolai van Swanenburgh, burgomaster of Leiden, and his sons; Hendrick Verschuring, who rounded off his activities as a painter by becoming burgomaster of Gorcum; and Dirck van Delen, Jacobus Mancadan, and Dirck van Lisse, burgomasters of Arnemuiden, Franeker, and The Hague, respectively. As a scion of the landed gentry, Michiel Sweerts could call himself *ridder* (knight); Jacob van Campen, son of a distinguished family, received training as a painter but was later primarily active as an architect. Jan van de Cappelle inherited a dye-works from his father and can therefore be counted among the well-to-do. Jacob van Ruisdael studied medicine in Caen and was registered as a physician in Amsterdam. With these latter examples, however, we have moved out of the regent class into the prosperous middle class.

Just below this were the tradesmen, artisans, and lesser merchants, among whom there was no clear difference of rank. As a rule, seventeenth-century Dutch painters were born into this level of the middle class, from tradesmen to craftsmen. Their incomes were usually insufficient to enable them to break loose from their own milieu. Despite Huygens' remark and the Leiden house painters' jealousy of the more fortunate "fine" painters, there was little chance that an artist could live in the grand style. Rembrandt's deliberate attempts to do so ultimately failed, and his very successful townsfellow Bartholomeus van der Helst died impoverished. Gerrit Dou is an exception: he received high prices for his paintings, and he was a good investor. Gerrit van Honthorst, official court painter to Frederik Hendrik and teacher of other members of the court, earned a great deal and could even afford a carriage, symbol of exceptional prosperity. But these success stories are few. Many artists could not live on the proceeds of their paintings and had to take on other jobs to make ends meet.

When these general impressions can be tested against concrete data, they are corroborated. A comparison of the tax registers from the years 1585 and 1631—the only such records available—provides insight into the prosperity of Amsterdam painters. In 1585 money had to be raised to recruit infantry and cavalry for Prince Maurits' army, and each municipality was assigned an amount, requiring an assessment based upon the individual wealth of its citizens. Those assessed all belonged to the propertied class, and the levies varied from one guilder for the least well-to-do burghers to 210 guilders for the wealthiest. Known painters who appear in the register are Dirck Barendsz, Adriaen van Conflans, Cornelis Ketel, and Pieter Pietersz, each of whom was taxed three guilders, and Aert Pietersz, who was assessed one guilder. They belonged within the broad category of minor tradesmen and intellectuals. The well-known municipal stonecutter, Joost Jansz Bilhamer, had to pay a good deal more: twelve guilders.[20]

In 1631 the levy was a two percent tax on property worth above 1,000 guilders, and the assessments show a picture similar to 1585, though the amounts cannot be compared. The painters this time identifiable in the register invariably belong among those least assessed. Gillis d'Hondecoeter and Govert Jansz each paid five guilders and thus possessed property worth 1,250 guilders; David Vinckboons paid ten guilders; Jan Jansz den Uyl and Nicolaes Eliasz, each fifteen; Arent Arentsz, twenty; and Adriaen van Nieulandt, twenty-five. The other painters then living in Amsterdam were not subject to the tax, although several, including Pieter Lastman, were assessed but cannot be traced in the register's sketchy notations.[21]

The prices that painters asked for their work also eliminate the chances for any great prosperity in most cases. It is extremely difficult to interpret seventeenth-century monetary values accurately. There is little sense in trying to compare them with today's prices, and caution must be exerted even in comparing them with each other. Documentary data are derived from the quite rare commissions in which a price is mentioned, and from appraisals, auctions and other sales, and lotteries. As noted earlier, exact information about a painting, such as its measurements and a more or less detailed description, is rarely present in these documents, so that only seldom can we identify a painting listed in them. Thus we gain no impression of the quality or the size, and the latter was an important factor in the price. This is made abundantly clear from the fact that the Antwerp sea painter Andries van Eertveld asked fourteen guilders for "double-sized" canvases, seven for "single-sized," and four for "quarter-sized," including the frame.[22] When Simon de Vlieger bought a house in 1637, paying for it partly with paintings, he was credited with thirty-one, eighteen, or thirteen guilders per panel, according to size.[23] Measurements in both of these instances seem to

have determined the price, reflecting a tradesman's rather than an artist's system of values. Rubens once refused to accept payment reckoned by size; he argued that the price be set instead by the quality of the work—and by the number of figures included in the composition.[24]

One example of comparative price ratios may be usefully examined. In 1649 the painter Jan de Bont organized a lottery to be held at the castle in Wijk bij Duurstede, and relatively detailed descriptions of the art works to be offered were drawn up prior to the event.[25] Such lotteries or raffles, as they were called, were closely supervised by the town council. Usually the profits went to some charity—a hospital or an old people's home—but sometimes the sales were organized for the benefit of the artists themselves or art dealers. The prizes consisted mainly of silver objects, furniture, and paintings, always appraised beforehand by experts. On this occasion the experts were Willem de Heusch, Cornelis van Poelenburgh, Jan Both, and Jan Weenix, all board members of the Utrecht painters' society. Although the appraisal list contains no measurements, in some instances it can otherwise be determined whether the painting was large or small.

Of the 158 objects raffled, 150 were paintings, primarily by Utrecht artists. The painters of 77 of the works were known, and the appraisers considered these pieces to be originals. They did not know the name of the painters of 21 pictures, deemed 49 to be copies, and in three cases could not decide whether the pieces were copies or originals. The copies were mostly after well-known masters, such as Cornelis van Haarlem, Paulus Moreelse, Jan de Heem, Abraham van Beyeren, David Teniers, Peter Paul Rubens, and Jan van Bijlert, and some were rated at remarkably high prices. A copy after a still life by de Heem, for instance, was valued at 50 guilders, whereas original works—also still lifes—by van Beyeren were only 12. Among the highest valued pieces was a *Roemer* (presumably a still life centered around a tall drinking glass known as a *roemer* or rummer) by de Heem at 200 guilders, a biblical scene by Nicolaus Knupfer at 100 guilders, and a painting of dogs by Jan Weenix at 136. Jan van Goyen, on the other hand, was among the cheaper masters, with a landscape appraised at 18 guilders and a winter scene and a summer scene each marked 25. The still lifes by organizer de Bont himself, a painter hardly known today—he specialized in fish still lifes (fig. 20) and everyday scenes—varied between 15 and 70 guilders. Benjamin Cuyp, at 50 guilders for his biblical scenes and cavalry battles, was just about average. Notations on several paintings indicate cooperating artists: a landscape by Jan van Heus with figures by Jan Miense Molenaer, a landscape by Herman Saftleven with fish by de Bont (this was probably a beach scene). One painting is said to be a copy after Poelenburgh, retouched by himself.

When the appraisal of de Bont's lottery is compared with data from other sources, the results do not vary in essence. There were no masterpieces in this lottery, of course, and none of the valuations approached the prices commanded by renowned painters. The Leiden fine painters were among the best paid. Gerrit Dou, for instance, received between 600 and 1,000 guilders per painting,[26] and Frans van Mieris and Pieter van Slingeland got

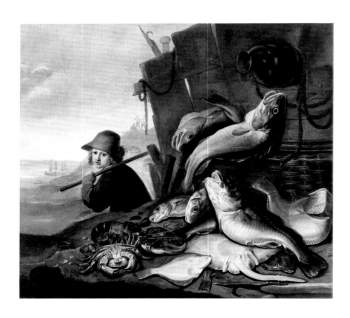

20 Jan de Bont
Fish Still Life on the Beach
Signed and dated 1653. Canvas, 135 × 150.3 cm.
Centraal Museum, Utrecht

21 Jan van Goyen
View of The Hague
Signed. c. 1651. Canvas, 170 × 456 cm.
Gemeentemuseum, The Hague

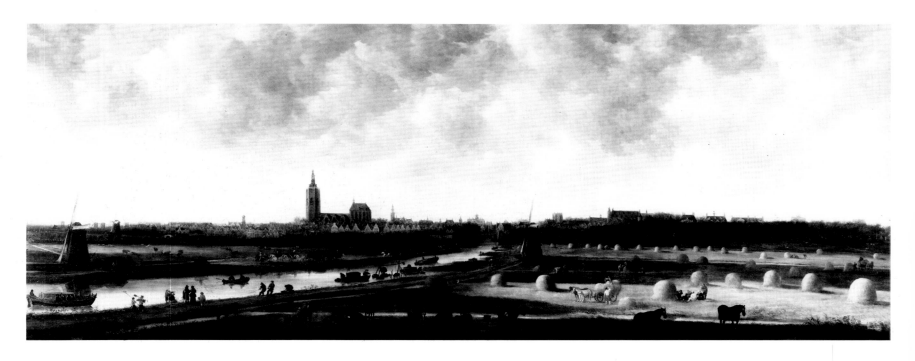

almost that much, especially when they worked for foreign patrons. Gerard Ter Borch of Deventer,with his exquisitely wrought little portraits and figure paintings, was also in this price class, while the Utrecht master Gerrit van Honthorst received prices far above average from his patrons, the stadholders.

Commissions from the stadholder's court and from municipal authorities were more remunerative than those from private patrons. Van Goyen, whose landscapes, as far as is known, always brought less than 50 guilders, was paid 650 guilders by the town council for his *View of The Hague* (fig. 21). Even considering the large size of this painting, the difference in price is striking. Presumably the payment for governmental commissions, which sometimes ran much higher, included a sort of honorarium that was completely separate from the actual market value.

Exceptions aside, we can confidently say that living masters in the seventeenth century did not receive very high prices for their paintings, and that only a few artists became wealthy on their own proceeds. Considered in this light, Constantijn Huygens' remark that painting "has always produced immeasurable benefit" can only be interpreted as a reference to classical ideas, derived from Seneca's *De Beneficiis* and widely proclaimed during the Renaissance, regarding the goals of painting: *Gloriae causa*—for the sake of glory or fame; *Lucri causa*—for the sake of wealth; and *Amoris causa*—for the sake of the love of art.[27] Whereas fame formerly took precedence over wealth, we see van Mander equalizing the two and sometimes even moving wealth up front. This is in contrast with the goals of poetry, where only glory is mentioned, never money. That these ideas continued to live on undiminished in the seventeenth century can be discovered by reading Samuel van Hoogstraeten's *Inleyding* and by looking at his work as well, for he expressed them pictorially. On his perspective box, now in the National Gallery in London (see fig. 339a), he painted the three ideas. *Gloriae causa* is represented by a young painter at his easel, being crowned with a laurel wreath by a putto (fig. 22a); *Amoris causa,* by a youth drawing the figure of the Muse Urania (fig. 22b); and *Lucri causa,* by a young painter accompanied by a putto carrying a cornucopia from which coins are falling (fig. 22c). What or whether the struggling seventeenth-century artists thought about these notions are questions that none of them chose to answer in documentary form, but they were undoubtedly aware of them.

22 Samuel van Hoogstraeten
 Exterior of a Peepshow
 a. *Gloriae causa*
 b. *Amoris causa*
 c. *Lucri causa*
 Signed. Exterior: 58 × 88 × 63.5 cm; interior:
 54.5 × 80 × 53 cm. The National Gallery, London

The Patrons

The Church

Whatever other causes underlay the Netherlands revolt against Spanish rule, the first explosion, the storm of iconoclasm in 1566, was aimed at the Catholic Church. The fierce attack upon "idolatry and superstition" found a tangible target in the statues and paintings that ornamented the churches. Apart from causing irreparable damage, one logical consequence of iconoclasm was that many years passed before Dutch Calvinism permitted any form of decoration. Pieter Saenredam's view of the choir of St. Bavo's in Haarlem (see fig. 2), dated 1628, clearly shows how the Calvinists "purified" the churches they took over from the Catholics: the interiors were whitewashed, and neither statues nor paintings graced the walls; the starkness of the architecture was enlivened only by heraldic devices, hung in memory of deceased worshipers. When a distinguished parishioner merited a monumental tomb, a sculptor was allowed to enter the church, but in the early days only through the back door. Even as late as 1673, when Gerrit Berckheyde painted the interior of St. Bavo's with a service in progress (fig. 23), the soberness of decoration remained, as it does to this day.

The decoration of the organ, which again came to be played during services despite protests by the orthodox, did present opportunities for commissioning artists. Once a church decided to have a new organ built, the elders usually hired a painter to decorate the folding shutters. The organ in the Nieuwe Kerk in Amsterdam provides an example. This church was restored and newly furnished after a fire in 1645 destroyed the interior and much of the fabric. Jacob van Campen designed the organ front, and Jan van Bronckhorst painted the shutters with scenes from the biblical account of David as a musician soothing the madness of King Saul (1 Samuel 16:14–23) (fig. 24). The beautiful, richly carved wood pulpit was executed between 1649 and 1664 by the sculptor Albert Vinckebrinck. This pulpit is another instance of the Church's functioning as patron, or at least of eliciting commissions for the benefit of the Church; the burgomasters, who kept a strict eye on expenditures and piety, made the final decision on every aspect of commissions. The ornateness of the pulpit also provides clear evidence that the early stern principles of sobriety and simplicity began to weaken after about the middle of the seventeenth century.

For the organ doors painted by Caesar van Everdingen for the Grote Kerk in Alkmaar, the themes chosen were again from the life of David (fig. 25). The commission has been preserved,[1] and it contains several details that deserve attention. The contract was signed in August 1643 by the burgomasters of Alkmaar, not by the church council, and presumably some months after van Everdingen had begun work on the project: he seems first to have made a model and submitted it for approval. The stipulations were then made that the artist would work "continually" and would supply his own paint and brushes; the paint must be of good quality, and the finished product as well painted as the model. Van Everdingen was to receive a total sum of 2,000 guilders: 250 paid in advance, 750 when the contract was let, and the remaining 1,000 due upon completion of the project. In March 1644 he received a bonus of 150 guilders, a not unusual gesture when a commission was executed satisfactorily.

The specification of his work which van Everdingen submitted at the end of the job is interesting. According to this document, he worked 547 days, billed at three guilders per day. Apparently he had his studio in Amersfoort, perhaps along with Jacob van Campen, who designed the organ case there. In any event, van Everdingen had to pay seven guilders to the Amersfoort St. Luke's Guild. He charged 20 guilders for supplying and grinding the paint, and nearly 35 guilders for fees paid to models. This statement of account shows to what extent the painters themselves saw their work as a business, with the hours of labor and cost of material determining the price they asked for.

Unlike the Church of England, the Dutch Reformed Church was never officially recognized as the state church, but it exercised great power in religious matters, among other things demanding and getting municipal ordinances that forbade any other denomination or sect to hold public services in buildings externally recognizable as places of worship. The result was that the banned congregations met in small groups for services, often in private homes. The Catholics in particular had many "hidden" chapels (everyone knew about them), which in the course of the seventeenth century often grew into quite

23 Gerrit Berckheyde
Interior of the St. Bavo Church, Haarlem
Signed and dated 1673. Panel, 60.8 × 84.9 cm.
The National Gallery, London.

24 Jan van Bronckhorst
David Playing the Harp before Saul
Signed and dated 1655. Organ shutters. Nieuwe
Kerk, Amsterdam

25 Caesar van Everdingen
The Triumph of David
Organ shutters. Grote Kerk, Alkmaar

23

24

25

extensive buildings with richly decorated interiors.[2] There were plenty of Catholic painters to call on for new decorations. Abraham Bloemaert, for example, executed his *Adoration of the Shepherds* altarpiece in 1623 for the hidden chapel in the Oude Molstraat in The Hague.

The Dutch Reformed Church, for its part, remained exceedingly chary of giving painting commissions, organ fronts notwithstanding. It was less stringent about sculpture, although the commissions for the monumental tombs of William of Orange in Delft and later those of the Dutch naval heroes in Amsterdam and elsewhere were extended not by the church but by the town councils or the families. In commissioning sacramental silver, however, the church had the major say. The extent to which the Calvinist faith influenced painting in general or the choice of subject matter in particular will be discussed later.

26 Willem Buytewech
 The Lake and Buildings of the Binnenhof, The Hague
 Signed. Pen and bister, traces of black chalk,
 30.7 × 54.7 cm. Municipal Archives, The Hague

The Court and the Nobility

During the sixteenth century, the court and the nobility had much less importance in the provinces of Holland and Zeeland than elsewhere in Europe. In the eastern and northern Netherlands provinces, however, the nobility played a substantial role. A century later, in 1675, the nobility in Overijssel, which comprised only a little over one percent of the province's population, possessed forty-one percent of the total wealth. Yet there is no evidence that this small, rich elite contributed in any significant way to cultural life in the Republic.

When William of Orange took up residence in Delft in 1572, he lived quite simply, in a former convent, and brought with him a presumably rather small collection of paintings, which he had little time or opportunity to enlarge. His successor, Prince Maurits, held his court at The Hague (fig. 26) and had no great interest in art. Apart from portraits, he probably ordered very little on his own initiative. He was, however, regularly honored with paintings. The States-General gave him a life-size portrait by Jacob de Gheyn II of the white stallion captured from Archduke Albert of Austria during the Battle of Nieuwpoort in 1600 and awarded to Maurits (fig. 27), and the Amsterdam Admiralty presented him with Cornelis van Wieringen's painting of the 1607 Battle of Gibraltar (see fig. 43). The prince's major talent and interest was in military science and the technological inventions connected with it; when he built, it was forts, not palaces. But toward the end of his life he displayed some enthusiasm for the restoration of the stadholder's quarters, the Binnenhof (Inner Court), in The Hague. He also made plans for a garden to be laid out, complete with a pavilion, grottoes, and an aviary, at the adjacent Buitenhof (Outer Court).[3] The commission for the design went to Jacob de Gheyn II, but both the stadholder and he died—Maurits in 1625, de Gheyn in 1629—before the project could be fully carried out, and his son, Jacob de Gheyn III, completed the work.

Maurits was succeeded as stadholder by his half brother Frederik Hendrik, the son of William I and his fourth wife, Louise de Coligny, daughter of the French admiral and Huguenot leader Gaspard de Coligny who perished in the massacre on St. Bartholomew's Day 1572. When Frederik Hendrik was fourteen, in 1598, he was invited to visit the French court of Henry IV, himself a former Huguenot, and ten years later he went there again. On both occasions the young prince got a taste of true regal splendor, especially during the second visit, when he saw the new additions to the Louvre and the nearly completed palace at Fontainebleau.

In 1613 Frederik Hendrik journeyed to London to attend the wedding of his nephew Frederick V, elector palatine of the Rhine, to King James I's eldest daughter, Elizabeth Stuart, a couple whose ties to the house of Orange-Nassau held firm in an approaching crisis. A fervent Protestant, Frederick became king of Bohemia in the autumn of 1619, but within months was attacked and deposed by the Holy Roman Emperor. His downfall marked the beginning of the Thirty Years' War in Germany against the Hapsburgs. Forced into exile, Frederick and Elizabeth (derisively nicknamed the Winter King and Queen) settled in 1621 in The Hague and became the leaders of fashion at the stadholder's court (fig. 28). Amalia van Solms, whom Frederik Hendrik married in 1625 at the urging of Prince Maurits, had been lady-in-waiting to the Winter Queen and remained her friend.

27 Jacob de Gheyn II
 The White Spanish War Horse Captured from
 Archduke Albert of Austria in the Battle of
 Nieuwpoort and Presented to Prince Maurits
 Signed and dated 1603. Canvas, 228 × 269 cm.
 Rijksmuseum, Amsterdam

28 Adriaen van de Venne
 Frederick V, King of Bohemia, and His Wife
 Elizabeth Stuart on Horseback
 Signed and dated 1628. Canvas, grisaille,
 154.5 × 191 cm. Rijksmuseum, Amsterdam

Frederik Hendrik's upbringing enabled him to establish especially amicable relations with the French and English courts, and his aspirations were distinctly different from those of Maurits. Moreover, after the latter's death in 1625, William I's entire fortune devolved upon Frederik Hendrik, and his wealth was increased by his allotted share, as the Republic's military commander in chief, of the booty from war and privateering. From the outset he attempted to introduce greater elegance in the stadholder's court, including building new palaces and collecting paintings and other art objects.[4]

Constantijn Huygens, the prince's secretary, without doubt exerted a favorable influence upon his employer's development as art lover. Born in 1595, Huygens had received a superior education, had traveled widely, and was master of languages ancient and modern. He wrote poetry in Dutch, French, and Latin, translated John Donne's poems into Dutch, composed and played music, and had a more than superficial knowledge of theology, natural science, astronomy, philosophy, literature, architecture, and painting. His younger son, Christiaan, born in 1629, was to become one of the most renowned scientists of the seventeenth century.

Between 1632 and 1634 an inventory was made of the stadholder's properties,[5] and this list contains nearly one hundred paintings, the majority purchased by Frederik Hendrik. The favorite painters seem to have been Cornelis van Poelenburgh (12 pictures), Gerrit van Honthorst (9), Anthony van Dyck (6), Hendrick van Balen (5), Paulus Moreelse (5), Peter Paul Rubens (4), and Roelant Savery (4). In addition, one work each is listed for a number of Flemish and Dutch painters, among whom are Paulus Bril, Jan Bruegel, Jan van Bijlert, Alexander Keirincx, Jan Lievens, Rembrandt van Rijn, Moyses van Uyttenbroeck, and Hendrick Vroom. The Flemish artists are in the majority, followed by those of the Utrecht school.

To what extent the collection reflected Constantijn Huygens' taste can only be surmised. The presence of works by Rembrandt and Lievens, both then very young, certainly indicates Huygens' advocacy, for we know from his journal how much he admired the work of these two youthful painters. Too much emphasis, however, is sometimes placed on this admiration and on the fact that Huygens also praised Esaias van de Velde. His first choice was obviously the Flemish painters. He considered Rubens "one of the wonders of this world ... a painter experienced in all the sciences.... I have always been convinced that no one exists outside the Netherlands, nor shall soon appear, who merits comparison with him, whether in richness of invention, in daring and grace of form, or in complete versatility in all genres of painting."[6] Influenced or not by Huygens, Frederik Hendrik turned to Flemish artists and to the Utrecht and Haarlem history painters when it came to commissioning decorations for his palaces.

The prince's building activities resulted in a completely restored hunting castle at Honselaersdijk, finished in 1638; in the "Huis ter Nieuburch" near Rijswijk, built between 1634 and 1638 (fig. 29); in the rebuilding of the castle at Buren and the refurbishing of the castle at Breda; in a new palace on the Noordeinde in The Hague; and finally in the "Huis ten Bosch," a country villa for Amalia van Solms just outside The Hague (fig. 30). The Winter Queen laid the first stone for this "house in the woods" in 1645, but construction was still going on at the time of Frederik Hendrik's death in 1647, and the decorations took several years more.[7]

The participation of the architect-painter Jacob van Campen was of great importance in all these projects. The van Campens were a distinguished and wealthy family. Jacob came into a fortune at an early age, and from his mother's side he inherited a large estate near

29 Jan de Bisschop
The "Huis ter Nieuburch" near Rijswijk
Pen and brush in bister. Collection J.Q. van
Regteren Altena, Amsterdam

30 Jan van der Heyden
The "Huis ten Bosch" near The Hague
Signed. Panel, 21.6 × 28.6 cm. The National
Gallery, London

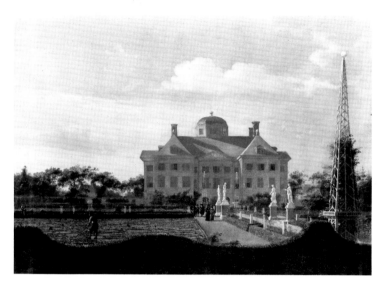

Amersfoort, carrying with it the title of Lord of Randenbroek. Several family members held high office in Amsterdam and were active in the city's cultural life. They helped to procure important commissions there for Jacob, the foremost being his work on the major alteration of the Burgher Orphanage in 1634–35 and his design for the Municipal Theater in 1637.

Jacob first trained as a painter under Frans de Grebber in Haarlem. Afterward, presumably between 1615 and 1621, he is thought to have spent several years in Italy. His first work as an architect came in 1625, when he designed the façade of the Balthasar Coymans house on the Keizersgracht in Amsterdam (fig. 31), the first façade in the city to show the clear influence of the Italian architect Palladio and of French style. If this classifical front is compared with the work of the older architect Hendrick de Keyser (fig. 32), the enormous stylistic leap which van Campen had made is at once evident.

He refined and strengthened his style in two mansions built in The Hague in the mid-1630s: the Mauritshuis for Count Johan Maurits of Nassau-Siegen (see p. 45), and Constantijn Huygens' new town house nearby, for which van Campen served at least as adviser, Huygens himself apparently having conceived most of the plans.[8] Huygens was however so pleased with van Campen's suggestions that he presumably recommended him to the stadholder, and thus van Campen became actively involved in Frederik Hendrik's building projects. It is clear from the extant correspondence that Huygens always retained the upper hand in these works, as it were orchestrating the overall plans, and that van Campen was responsible for seeing that the best possible architectural and decorative designs were made and the work carried out. Some of the designing he did himself, and some was done by his colleague-pupils Pieter Post, Arent Arentsz van 's-Gravesande, and Bartholomeus van Bassen; their individual contributions cannot be distinguished.

The artists commissioned to execute the painted decorations, which were closely keyed with the architecture, came, as mentioned above, from the circle of Utrecht and Haarlem history painters, artists whose work acknowledged Rubens' style to greater or lesser degree. Paulus Bor, Pieter de Grebber, Moyses van Uyttenbroeck, Cornelis Vroom, and Theodoor

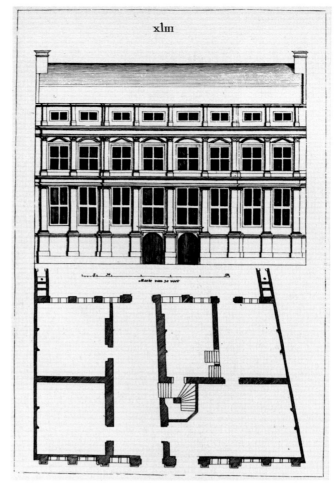

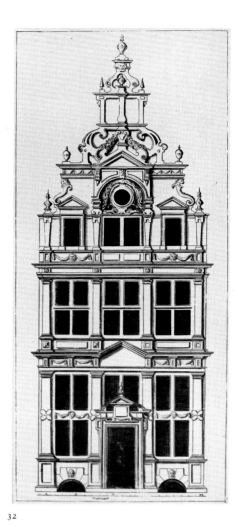

31 Jacob van Campen
Design for a House at Amsterdam
1625. From Salomon de Bray, *Architectura Moderna*, 1631

32 Hendrick de Keyser
Design for a House at Amsterdam
From Salomon de Bray, *Architectura Moderna*, 1631

33 Cornelis Holsteyn
Design drawing for a Gallery, Honselaersdijk Palace
Four drawings from a series of ten, 20.9 × 580 cm (entire series). Print Room, Rijksmuseum, Amsterdam

31 32

Matham were active at Honselaersdijk.[9] Vroom probably concentrated on the landscape elements in the paintings. Unhappily, the Honselaersdijk palace was razed in 1816, and nothing remains but a few drawings and one painting to give some idea of the style of decoration. The extant architectural drawings are strongly illusionistic (fig. 33), giving an impression of the spatial continuity achieved by fusing the decorations with the architecture. Honthorst brought this form of decorative painting to Holland from Italy, and a ceiling piece by him in this style, intended for a house in Utrecht, is dated 1622, the year of his return (fig. 34). It is the earliest extant ceiling painting in the Northern Netherlands, but unfortunately only partially preserved; it was originally over twice as large, and symmetrical in composition.[10] *The Concert* of 1624 provides an example of "vertical illusionism," in which the continuation of space is suggested (fig. 35).

All of the decorations for the Huis ter Nieuburch have also been lost, but Joachim von Sandrart provided a good description of its architectural plan. Pieter Soutman, a Haarlemmer strongly influenced by Rubens, worked there, as did Honthorst, who painted a very large ceiling.

33

34

35

34 Gerrit van Honthorst
 Ceiling with Balcony and Musicians
 Signed and dated 1622. Panel, 308 × 216.5 cm.
 The J. Paul Getty Museum, Malibu, California

35 Gerrit van Honthorst
 The Concert
 Signed and dated 1624. Canvas, 168 × 178 cm.
 Musée du Louvre, Paris

At Buren, Jan Breucker and Gerrit van Santen, two painters of little further importance, executed a series of paintings celebrating Frederik Hendrik's military victories. Jacob Backer also painted a *Freedom* for this palace (fig. 36).

The castle at Breda had earlier belonged to Hendrik III of Nassau, an uncle of William of Orange. Along with his wealthy wife, the Spanish countess of Mencia de Mendoza, he had made it a cultural center in the sixteenth century. New decorations were painted by Jan Gossaert, Barend van Orley, Jan Vermeyen, Maerten van Heemskerck, and Simon Benning, and an important collection of paintings was on display. In addition, there were numerous tapestries, including a series depicting the genealogy of the House of Nassau, after designs by Orley.[11] These tapestries were passed on to another branch of the family, but Orley's cartoons were still at the castle in the seventeenth century, and Prince Maurits had painted copies made from them. In 1632 Frederik Hendrik, with more funds at his disposal, ordered another series to be woven from the old cartoons. He also commissioned Gerrit van Honthorst to design four new tapestries portraying his father, his brothers, and himself. Honthorst's cartoons were ready in 1638, and in 1639 the Delft tapestry weaver Maximilaen van der Gucht delivered the hangings. Sad to say, none of these has survived.

The decoration of the Huis ten Bosch[12] has by far the most importance for us today. This project was carried out in entirety after Frederik Hendrik's death, and Constantijn Huygens probably deserves most of the credit for conceiving the overall artistic scheme, working in close collaboration with Jacob van Campen. The artists they selected received detailed instructions regarding how their paintings should be composed and executed to fit in with the master plan. In the great central hall, the Oranjezaal, which has been preserved intact and unspoiled, there is a brilliant unity of architecture and decoration. This hall is in the shape of a Greek cross with truncated arms, and it is topped by an octagonal cupola that rises 19 meters (about 62 feet) from the floor and has a diameter of 7.50 meters (about 24$\frac{1}{2}$ feet). The decorations extend to the very top of the dome. On the lower levels, up to 8.25 meters (about 27 feet), the paintings are on canvas; on the vault of the dome, the paintings are directly on the wood. Light falls into the room from three doors on the south side and from windows in the drum of the cupola.

As Amalia van Solms's memorial to her husband, the Oranjezaal gives a perfect impression of the Baroque taste then current in European courts. The subject matter of the paintings—Frederik Hendrik triumphant—accords with the late stadholder's aspirations. The pictures mounted at the middle level, with scenes depicting the prince's life and virtues, are comparable in theme but definitely not in composition with Rubens' series of Maria de' Medici in the Luxembourg Palace in Paris. Below are eight paintings showing a "classical" triumphal parade, which culminates with Jacob Jordaens' huge *Triumph of Prince Frederik Hendrik* (fig. 37); this canvas measures 7.30 by 7.50 meters, or about 24 by 24$\frac{1}{2}$ feet. The other paintings in the hall are allegorical and mythological variations on the main theme. There seems little doubt that the visualization of this theme was worked out according to the rules of rhetoric governing the composition of a funeral oration, and that the whole should be considered a heroic elegy interpreted in painting.[13]

The artists who worked on the Oranjezaal were Theodoor van Thulden of 's-Hertogenbosch in Brabant; Thomas Willeboirts Bosschaert, Gonzales Coques, and Jacob Jordaens, all from Antwerp; and the Hollanders Caesar van Everdingen (fig. 38), Salomon de Bray, Jan Lievens, Christiaen van Couwenbergh, Pieter Soutman, Pieter de Grebber, Gerrit van Honthorst, and Jacob van Campen himself.

A visitor to the Oranjezaal today cannot help being impressed. Some of the paintings are not the best produced by their respective artists, because the Dutch painters, at least, were unaccustomed to working on such a monumental scale; they were also bound by Huygens' and van Campen's instructions and by the necessity of adapting their work to one another's (which they observed to only a limited extent). Yet the effect of the whole is harmonious and indeed quite regal by Dutch standards. The other rooms of the Huis ten Bosch were less elaborately decorated, but contained a number of exceptionally large portraits by Honthorst as well as works by Rubens, van Dyck, Willeboirts, Gerard Seghers, and Govert Flinck, among others.

This summary makes clear that the court of Frederik Hendrik and Amalia van Solms exercised a stimulating influence on painting, especially when we remember that they were also assembling a considerable art collection. Major purchases continued to be made after

36 Jacob Backer
Freedom
c. 1645. Canvas, 162.5 × 115.8 cm. Staatliche
Schlösser und Gärten, West Berlin

the inventory of 1632–34, among them the Passion series which Frederik Hendrik, at Huygens' instigation, commissioned from Rembrandt (see p. 277). Given the international character of the stadholder's court, it was scarcely remarkable that the taste of the patrons and their advisers should lean toward Rubens, van Dyck, and their followers, whether Flemish or Dutch. Even Huygens, who gives evidence of appreciating other trends in Dutch art, could hardly have chosen otherwise when it came to establishing a court style. And Jacob van Campen, whose architecture was derived so knowledgeably from Italian and French models, of course concurred.

Among critics of Dutch seventeenth-century art, it has become more or less customary to belittle this international trend as un-Dutch. We should not forget, however, that people of

37 Wall of Oranjezaal with Jacob Jordaens'
The Triumph of Prince Frederik Hendrik
Huis ten Bosch, The Hague

38 Wall of Oranjezaal with Caesar van Everdingen's
Allegory on the Birth of Prince Frederik Hendrik
Huis ten Bosch, The Hague

the period themselves considered this to approach the highest ideal, and that Frederik Hendrik's building program exerted a strong influence on the design of other official buildings throughout the country. If the stadholder's son and successor, Prince William II, had lived longer (he died in 1650 at the age of twenty-four), and if a stadholderless period had not then lasted until 1672, this international court style with its strong historical and allegorical character might have had more chance to develop. Since this did not happen, the Oranjezaal with its monumental unity of decoration has remained unique in Dutch art. The only thing comparable is the Amsterdam town hall (now the Royal Palace), also designed by Jacob van Campen, although the paintings commissioned for its great Burghers Hall were far from successful. Internationally oriented taste, however, began a new advance in the second half of the seventeenth century, following the direction set by the Oranjezaal but on a less elaborate scale.

Among the other members of the Orange-Nassau family who functioned as patrons of art, Johan Maurits of Nassau-Siegen, a second cousin of the stadholders, is of primary interest.[14] His town house in The Hague, now the Mauritshuis Museum, was one of Jacob van Campen's most successful architectural achievements, and a proving ground for young Pieter Post. In 1636 Johan Maurits was appointed governor of Brazil by the Gentlemen XIX

39 Frans Post
View of Olinda, Brazil
Signed and dated 1662. Canvas, 107.5 × 172.5 cm.
Rijksmuseum, Amsterdam

40 Albert Eckhout
Negro Woman and Child
Signed and dated 1641. Canvas, 273 × 178 cm.
The National Museum of Denmark, Department
of Ethnography, Copenhagen

(as the board of directors was known) of the Dutch West India Company. Remarkably, when he went to Brazil to assume his duties, he insisted upon taking along in his entourage not only the usual military and commercial staffs, but also the scholar-physician Willem Piso, the cartographer-naturalist Georg Marcgraf, and the painters Frans Post (brother of the architect Pieter Post) and Albert Eckhout. The painters remained in Brazil from 1637 to 1644, each recording what he saw in his own way: Post concentrated on landscapes (fig. 39), and Eckhout on portraying people (fig. 40). Johan Maurits presented twenty-four of Eckhout's Brazilian paintings to the king of Denmark in 1654, and they are now in the National Museum in Copenhagen; many of his remaining works were destroyed when fire gutted the Mauritshuis in 1704. An extensive collection of Post's work has survived, however, partly because he devoted the rest of his life after his return from South America to painting Brazilian landscapes.

The stadholdership of the province of Friesland was held from 1584 onward by Willem Lodewijk, son of William of Orange's eldest brother, and other members of this branch of the Nassau family, from which the present house of Orange directly descends. The Frisian stadholder's court at Leeuwarden was never as important as the court in The Hague. The painters' commissions there were virtually all for portraits. Wybrand de Geest, who will be discussed on page 221, was long the leading painter in Leeuwarden. The country nobility living in the eastern provinces of the United Netherlands were more interested in agriculture than in cultural pursuits, and had no significance as patrons of the arts.

The Government

The Republic of the United Netherlands consisted of seven provinces: Holland, Zeeland, Utrecht, Gelderland, Overijssel, Friesland, and the city of Groningen and surroundings. Each had its own assembly, called the States (of Holland, Zeeland, and so on), a title in use since the fifteenth century, when the Burgundian overlords called together delegates of the provincial estates in an effort to establish a centralized government. During the Republic the composition of these assemblies differed from province to province. In Holland and Zeeland, the two richest and westernmost provinces (Holland then comprised both the North and South Holland of today), one vote was reserved for the knighthood or first noble (Orange) and one for each city. Municipal power was wholly in the hands of the burgomasters and town councils, which were self-perpetuating and by and large closed groups. The States-General or national assembly was made up of representatives from the seven provinces. It was these bodies—the States-General, the Provincial States, and the burgomasters and town councils—that had a major share in distributing commissions to artists.

No systematic investigation to ascertain the nature and number of commissions given by the various governmental groups has yet been undertaken, and therefore no survey can be

presented here. The commissions however belong in two categories: those for the decoration of buildings, and those for works of art intended as gifts. Both kinds were of great importance to artists—tapestry weavers, silversmiths, furniture makers, glaziers, and brass founders, and certainly painters. Tapestry weavers get first mention because an unusually large part of their work was produced on governmental commission in both categories, for decorating buildings and for presentations. They also ran a thriving rental trade: important guests visiting a city could be received in simple spaces made dignified and warm by the hanging of tapestries.

Gifts were always given to such visitors and were taken for presentation when a Dutch delegation or ambassador traveled abroad. A couple of examples can suffice to indicate the munificence of the gifts to royal personages.[15] When, after their marriage in England in 1613, the elector palatine and his wife, Elizabeth Stuart, traveled through the Netherlands on their way to Heidelberg, Elizabeth received from the States-General, among other things, a case decorated with 36 diamonds, a pearl necklace valued at 32,000 guilders, 16 tapestries, damask woven in Haarlem, and "Indian" cloth manufactured in Amsterdam. Amsterdam itself presented her with a golden ewer worth 150,000 guilders, and Haarlem gave her a cradle with accessories.

Valuable objects rather than paintings seem to have been the customary gifts. The famous "Dutch Gift" which the States-General lavished upon Charles II of England in 1660 to win his favor was an exception. In addition to a yacht presented by the city of Amsterdam, a costly bedstead, purchased for 100,000 guilders from Mary Stuart (the widow of William II of Orange, and Charles II's sister), and a complete set of furniture, statuary, and jewelry, the gift consisted of a large number of paintings. Most of these were works by Italian masters from the collection of the recently deceased Amsterdam merchant Gerrit Reynst, with several canvases by Dutch painters—including Gerrit Dou's *The Young Mother* (fig. 41)—for good measure. In any event, the gesture of amity and hoped-for reciprocation did not work, for the restored monarch did not repeal the anti-Dutch Navigation Act of 1651 or otherwise promote bilateral relations.

In Paris, Hugues de Lionne, the French foreign minister, had a collection of paintings depicting famous cities. On a visit to him, Coenraad van Beuningen, the ambassador of the States-General to the court of Louis XIV, noticed that "Amsterdam" was missing from the collection, and at his urging the burgomasters of Amsterdam commissioned Ludolf Bakhuysen in 1665 to paint a view of the city (fig. 42) for presentation to the minister.[16] The Amsterdam treasurer's accounts show that the artist received the sum of 1,275 guilders for his work, which he delivered in 1666; this is one of the very few gift entries that pertain to a painting.

Paintings were sometimes presented to the stadholders, and the prices paid were much higher than those on the open market. In 1621, as mentioned earlier, the Amsterdam Admiralty wished to honor Prince Maurits with a painting depicting the Battle of Gibraltar, a naval victory in 1607 over a Spanish fleet by a squadron of Dutch warships convoying

41 Gerrit Dou
The Young Mother
Signed and dated 1658. Panel, rounded at the top,
73.5 × 55.5 cm. Mauritshuis, The Hague

42 Ludolf Bakhuysen
The Harbor of Amsterdam, with the City in the Background
Signed and dated 1666. Canvas, 128 × 222 cm.
Musée du Louvre, Paris

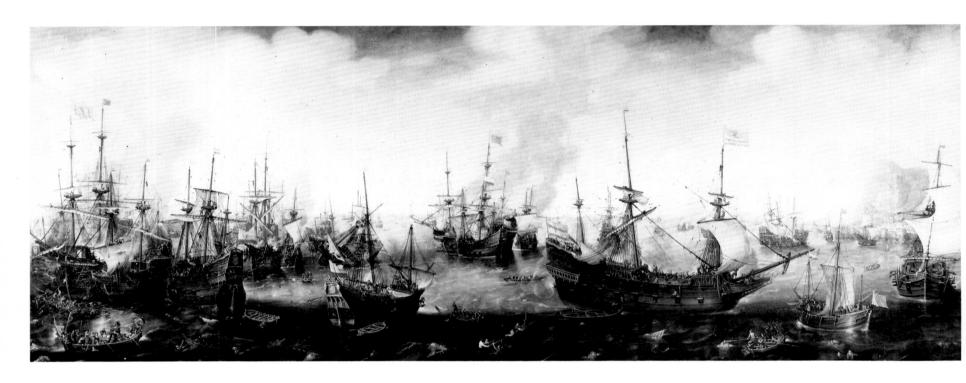

43 Cornelis van Wieringen
The Battle of Gibraltar
Signed and dated 1622. Canvas, 180 × 490 cm.
Nederlandsch Historisch Scheepvaartmuseum,
Amsterdam

merchant vessels. The Admiralty board first approached the most renowned painter of ships, Cornelis Vroom, but he asked 6,000 guilders, so they turned to Abraham de Verwer and Cornelis van Wieringen. How matters developed is not clear, but both artists appear to have each executed the commission. Van Wieringen received 2,450 guilders for his picture (fig. 43), and de Verwer got the same for the painting listed in the inventory of the stadholder's collection, but now untraceable.[17] Two paintings for less than the price of one was apparently an irresistible bargain.

The States-General ordered tapestries and furniture to decorate their building in The Hague, and a series of twelve paintings by Otto van Veen as well. Van Veen, or Vaenius, had learned the Mannerist style during a sojourn in Italy about 1575–80, and is noted today mainly for having been the young Rubens' last teacher. In 1613 Pieter van Veen (see fig. 456), legal counsel to the Court of Holland, received 2,200 pounds for his brother Otto (then living in Antwerp) as payment for "the war and the deeds of Civilis against the Romans as an adornment of their High Eminences' Chamber of Assemblies."[18] One of the episodes that van Veen depicted was *Brinio Raised upon the Shield* (fig. 44), which shows the man chosen leader by a neighboring tribe pledging his allegiance to Claudius Civilis, chief of the Batavi.

The town hall in every seventeenth-century Dutch community displayed one or more paintings. Usually these pictures referred directly or indirectly to the particular city or town or to the function of government. They could be townscapes, group portraits, or historical or allegorical scenes. Local artists for the most part received the commissions. Jan van Goyen's large *View of The Hague* (see fig. 21) is one such painting.

Historical and allegorical works customarily dealt with the administration of justice or with the characteristics a good municipal government ought to possess. The glorification of William I of Orange was a favored allegorical subject, seen in both paintings and prints. Hendrick Pot's rendition of this theme (fig. 45) was purchased by the city of Haarlem in 1620 for 450 guilders; the handsome frame for this painting was made by Domenicus Jansz Bagijn for 175 guilders. The large canvas depicts a long procession made up of three

44 Otto van Veen
 Brinio Raised upon the Shield
 1613 or shortly before. Panel, 38 × 52 cm.
 Rijksmuseum, Amsterdam

45 Hendrick Pot
 The Glorification of William I
 c. 1620. Canvas, 136 × 342.5 cm. Frans Hals
 Museum, Haarlem

elephants pulling a victory float with William the Silent marching alongside, accompanied
by the Netherlands lion; ahead are many figures holding banners portraying the Christian,
governmental, and military virtues of the Oranges and memorializing the deaths of Count
Adolf of Nassau in 1568, Count Lodewijk of Nassau in 1574, and William I of Orange
himself in 1584.

 Other paintings hung in the Haarlem town hall. Vroom had painted *The Capture of
Damietta* for it in 1611, *The Arrival of Leicester in Vlissingen* in 1623, and *The Battle of
Haarlem Lake* in 1630. The building was further adorned with pictures by other artists; *The
Seven Capital Sins Punished by Justice, and the Blessings of Virtue and Peace* hung above the
fireplace in the courtroom, and *Wisdom and Caution* was the chimneypiece in the
burgomasters' chamber.[19]

 In contrast with these varied pictures in Haarlem, a carefully worked-out scheme of

46 Jan Lievens
Brinio Promoted to General
1661. Canvas, rounded at the top, c. 600 × 600
cm. Former Town Hall, now Royal Palace,
Amsterdan

paintings was prepared for the new town hall (now the Royal Palace) in Amsterdam, on which construction was begun in 1648, the year in which the Treaty of Münster ended the Eighty Years' War. Jacob van Campen was again the architect, and here, too, he probably had great influence in planning the decorations, for a consistency of design is evident.[20] The two main themes were the new-won peace and the independence of the mightiest city in the Republic. The entire building was considered a symbol of municipal freedom, and the paintings must also express this self-reliance.[21] Each one had its symbolic meaning, and stories from the Bible and from classical antiquity were used to draw parallels between past and present. For the burgomasters' chamber, Ferdinand Bol painted *The Intrepidity of Gaius Fabricius Luscinus in Pyrrhus' Army Camp* (see fig. 760) and Govert Flinck did *Marcus Curius Dentatus, Who Scorned His Enemy's Gold and Chose a Meal of Turnips Instead* (see fig. 761). Both of these subjects exemplify the resolution and integrity of the Roman consuls—traits which the Amsterdam burgomasters should also possess.

The galleries of the great Burgerzaal or Hall of the Citizens were to be decorated with the same theme as that of the assembly hall of the States-General: the revolt against the Romans by the Batavi, the legendary Germanic tribe claimed as ancestor by the Dutch. This struggle was considered a parallel of the just-ended war with Spain. The commission for a series of twelve enormous paintings on the theme went to Govert Flinck. He had scarcely begun when he suddenly died, at the age of forty-five, and the commission was passed on to Jacob Jordaens, Jan Lievens, who painted another version of the Brinio episode (fig. 46), and Rembrandt (see fig. 763). Their paintings were not altogether successful, however. Even discounting Rembrandt's piece, which was removed and replaced by another, the patrons' dissatisfaction can be assumed from the fact that only part of the series was ever completed. The paintings were placed in lunettes high above the floor, with very poor lighting, an unfavorable arrangement that made the pictures appear from (far) below as little more than dark spots. Inexperience in designing the pictorial decoration of monumental architecture was partly to blame for this fiasco. For our more extended discussion of the town hall paintings, see page 358.

It is noteworthy that burgomasters (in larger towns there were usually several in office at one time) seldom commissioned group portraits of themselves, as was customary with

officers of many other municipal institutions. Among the few exceptions are portraits of the Hague burgomasters together with the civic guard, painted by Jan van Ravesteyn and Cornelis Jonson van Ceulen, respectively, and of the Dordrecht burgomasters by Cornelis Bisschop. The most remarkable painting in this respect, one in which the composition deviates completely from traditional group portraiture, is the large canvas painted by Gerard Ter Borch in 1667 of the Deventer magistracy (fig. 47). The two burgomasters sit enthroned in the middle, with a long row of councilmen on either side; the four municipal secretaries are centrally placed in the foreground. The group, known as a college, is assembled in the council chamber, which remains unchanged to this day. The weapons on the wall in the background are executioners' swords, and they, too, still ornament the room.

47 Gerard Ter Borch
The Magistracy of Deventer
Signed and dated 1667. Canvas, 186.2 × 248 cm.
Town Hall, Deventer

48 Ferdinand Bol
Portrait of Michiel Adriaensz de Ruyter,
Vice-Admiral of Zeeland, Holland, and West
Friesland
Signed and dated 1667. Canvas, 157 × 138 cm.
Rijksmuseum, Amsterdam

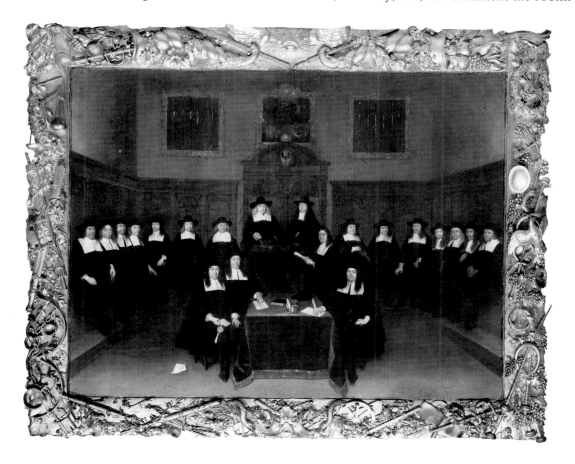

The beautifully sculptured frame displays symbols of government, justice, trade, and art.

Governmental commissions given to painters were not necessarily limited to the above-mentioned subject matter. Local events were also favored. To cite two examples among many: when a huge porpoise was caught in the Black Water near Zwolle, the burgomasters of that town commissioned Dirk Hardenstein to render the event in paint.[22] And when a ship from Lübeck was chased onto the Scheveningen beach by Dunkirk pirates, the stranded vessel was floated free with the help of the Hague militia, whereupon the city fathers asked the sea painter Willem van Diest to immortalize this "heroic" deed.[23]

The Admiralties were also important in awarding commissions. Originating from the Sea Beggars' little hodgepodge fleet, the Republic's navy grew into a complicated organization. There were five Admiralties, each with a large degree of independence: that of Zeeland, based in Middelburg; of the Maas, based in Rotterdam; of Amsterdam; of West Friesland, also known as the Northern Quarter, based sometimes at Hoorn, sometimes at Enkhuizen; and of Friesland, based first at Dokkum and later at Harlingen. The Admiralties had responsibility for the construction, furnishing and provisioning, and maintenance of the navy, and the recruitment of personnel. Their financial resources were drawn mainly from customs duties on imports and exports.

Quite naturally, the Admiralties gave artistic commissions first and foremost to sea painters. Yet their chambers also contained portraits. In 1666, after the four-day battle (June 11–14) in which Michiel de Ruyter, just promoted to vice-admiral, defeated the English fleet under Admiral George Monck, all five Admiralties voted to hang portraits of the hero in their council chambers. De Ruyter presented his portrait painted by Ferdinand Bol (fig. 48) to his home Admiralty of Zeeland.[24]

Allegory also appealed to the Admiralties. Ferdinand Bol created two paintings, *Imperia*

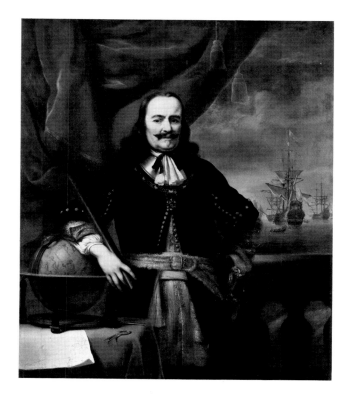

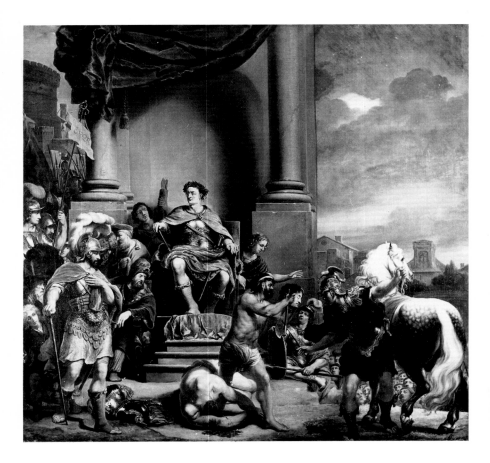 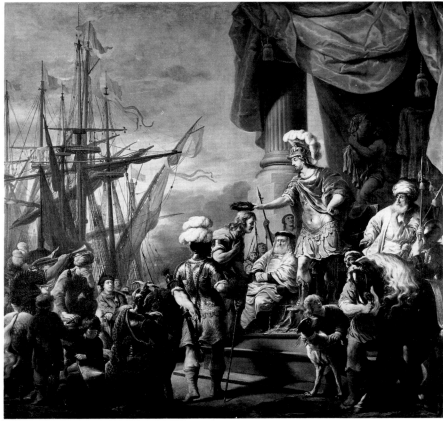

49 Ferdinand Bol
Imperia Manliana
Signed. c. 1662–63. Canvas, 218 × 232 cm. State
University, Utrecht. On loan from the
State-owned Art Collections Department

50 Ferdinand Bol
Aeneas Distributes the Prizes
c. 1662–63. Canvas, 218 × 232 cm. State
University, Utrecht. On loan from the
State-owned Art Collections Department

Manliana (fig. 49) and *Aeneas Distributes the Prizes* (fig. 50), for the Amsterdam Admiralty. In the story shown in the former, the consul Titus Manlius Torquatus beheads his son for disobeying his father's orders not to fight the enemy; the son's victory did not save his life. In the latter, Aeneas crowns with laurel the captain of a ship that had won a race.[25] The two paintings symbolize the Admiralty's right to punish disobedience strongly and reward valor graciously.

The Regents

Extremely important as patrons were the regents or governors of charitable institutions— the old people's homes, hospitals, orphanages, and poorhouses—and such centers of correction as the rasp houses for men and the spinning houses for women. The attitudes and insights in the Netherlands regarding the care of the poor and the treatment of malefactors had altered drastically during the sixteenth century.[26] The medieval concept that poverty must be accepted as God's will and was thus an inevitable social phenomenon was abandoned. Charitable assistance traditionally provided by the church and the monasteries, as well as by private individuals, came to be looked upon as less than sufficient. No longer were only the most urgent needs to be alleviated; the causes of poverty and the accompanying beggary and crime must be sought and an attempt made to destroy the root of the trouble. The origin of the changing attitudes lay both in the new ideas introduced by humanism and in purely practical necessity.

Alongside the new concepts, the medieval idea of merciful benevolence continued to advocate charity as a means of fulfilling Christian duty, saving souls, and furthering one's own salvation. The verse accompanying the illustration of charity (fig. 51) in Johan de Brune's emblem book of 1624 reads:

So, young lady, go ahead! Let the fishes' food, your bread,
Float on the water, not thinly spread.
The cost is little, and it will take root
When you reap the harvest of this rich fruit.
But neither is it enough: you must be sure
Never to forget the needs of the poor;
Then shall your soul do no ill, nor your wealth offend,
For it is bestowed, with God's pledge, to the gain of Heaven.

The changing attitudes nevertheless had great influence upon the measures taken by the

government to deal with social ills, and the government's share in the alleviation of need was vastly increased with the overthrow of the Catholic Church in the Northern Netherlands. Much official thought was devoted to all forms of relief. New buildings were erected that attracted attention at home and abroad, not only because they exemplified the new ideas, but also because nothing was stinted in carrying out these ideas throughout the entire Republic. As the sixteenth century advanced into the seventeenth, orphanages and homes for the poor or the elderly were constructed that belonged among the best examples of civic architecture in Europe. The still extant orphanage at Buren, founded by Maria von Hohenlohe, William of Orange's eldest daughter, and built in 1613, is a beautiful example of Dutch Renaissance architecture. Such outstanding architects as Hendrick de Keyser, his son Pieter, and Jacob van Campen worked on various buildings of the Burgher Orphanage in Amsterdam (now the Amsterdam Historical Museum). In Haarlem, the Old Men's Home (now the Frans Hals Museum) was designed in 1608 by the city's best architect, Lieven de Key, on commission from the municipality. In every city and many towns of the Netherlands, the *hofjes* or courtyards surrounded by residences for the elderly, usually named for the private individual who founded them, still form oases of peace within modern traffic.

These buildings, so munificently conceived, offered unprecedented work for painters and sculptors. Entryways and gables were almost always ornamented with sculpture (fig. 52), and a statue was frequently placed in the courtyard (fig. 53). The commissions for the paintings in these social institutions are of two categories: pictures which in one way or another symbolized the purpose of the institution, such as biblical or allegorical scenes of charity; and group portraits of the governing board, ordered and paid for by the members themselves and always hung in the regents' assembly chamber.[27]

The first category was clearly the terrain of the history painters. Many hospitals commissioned "The Seven Works of Charity." The subject had a long history in the Northern Netherlands. The oldest known example is the 1504 series of seven panels by the

51 Emblem from Johan de Brune, *Emblemata of Zinne-werck*, Amsterdam, 1624, p. 300

52 Lieven de Key
Old Man with Alms Box
Sandstone, height 125 cm. Originally crown of gable, Old People's Home, Haarlem. Frans Hals Museum, Haarlem

53 Artus Quellinus (?)
Frenzy
Sandstone, height 162 cm. Originally in the inner courtyard of the Insane Asylum, Amsterdam. Rijksmuseum, Amsterdam

Master of Alkmaar, depicting one act of charity in each panel, with Christ always among the onlookers (fig. 54). An interesting later example, with all seven acts united on one canvas, is the painting which Joost Droochsloot made in 1618 for the St. Barbara and St. Laurens Hospital in Utrecht (fig. 55).[28] In the crowd are a number of figures wearing high hats who presumably represent the governors of the hospital. Their faces look like portraits, and it was quite in the spirit of the times that officials should want to see their own likenesses in such a painting. Strictly speaking, this was a continuation of the old tradition of portraying the patrons in the side wings of altarpieces.

A variation on this theme is found in the panels attributed to Werner van den Valckert depicting the Amsterdam almoners going about their charitable tasks, which included

54 Master of Alkmaar
 The Seven Works of Charity
 Dated 1504. Seven panels, each c. 101 × 55 cm.
 Rijksmuseum, Amsterdam

55 Joost Droochsloot
 The Seven Works of Charity
 Signed and dated 1618. Canvas, 189 × 295 cm.
 Centraal Museum, Utrecht

registering orphans and the needy (fig. 56). Jan de Bray's painting for the Children's Charity Home in Haarlem (fig. 57) shows the admission of children into the orphanage and at the same time several relevant works of mercy: clothing the naked, giving water to the thirsty, and feeding the hungry. It is not known whether any of the figures portray the regents or regentesses of the home, or the housefather or housemother.

Two exceptional canvases directly related to the theme of the seven acts of charity were made by Jan Victors for the Reformed Parish Orphanage in Amsterdam. The commission must have been given by the regents and regentesses listed by name in the lower right corner of each painting. One picture (fig. 58) depicts realistically the mealtime of the orphan girls in their dining hall. Porridge is being dipped from a large copper pot into pewter bowls, with one bowl for every three or four girls. Their beverage is beer (water was unsafe to drink), tapped into pewter pitchers and passed from mouth to mouth. The housefather and housemother supervise these activities, the former holding a switch handy just in case, and in the background an older girl reads from the Bible. The second canvas shows the children being dressed, with a doctor visiting a patient in the background.

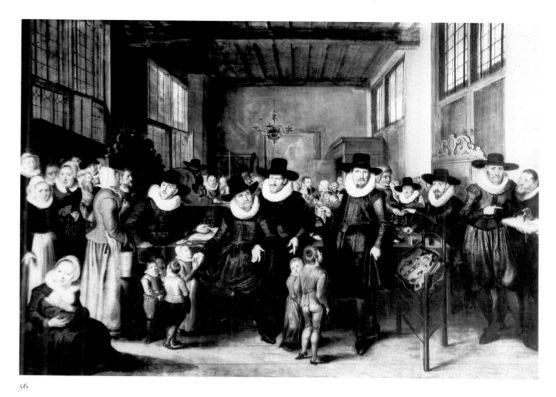

56

56 Werner van den Valckert (attributed)
Registration of the Poor and Orphans by the College of Almoners, Amsterdam
Dated 1626. Panel, 155 × 216 cm. Amsterdams Historisch Museum, Amsterdam

57 Jan de Bray
Receiving Children in the Children's Charity Home, Haarlem
Signed and dated 1663. Canvas, 134.5 × 154 cm. Frans Hals Museum, Haarlem

58 Jan Victors
The Girls' Dining Hall in the Reformed Parish Orphanage, Amsterdam
Signed. Canvas, 146 × 221 cm. Amsterdams Historisch Museum, Amsterdam. On loan from the Reformed Parish

59 Jan van Bronckhorst
Allegory on the Distribution of Food
Canvas, 262 × 157 cm. Amsterdams Historisch Museum, Amsterdam

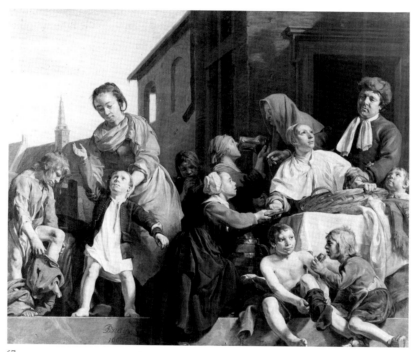

57

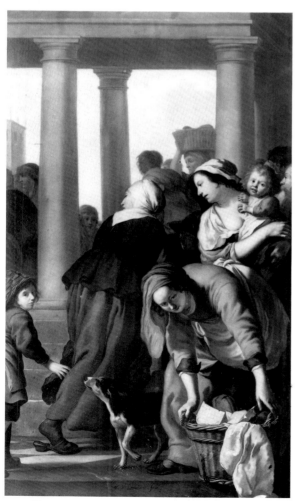

59

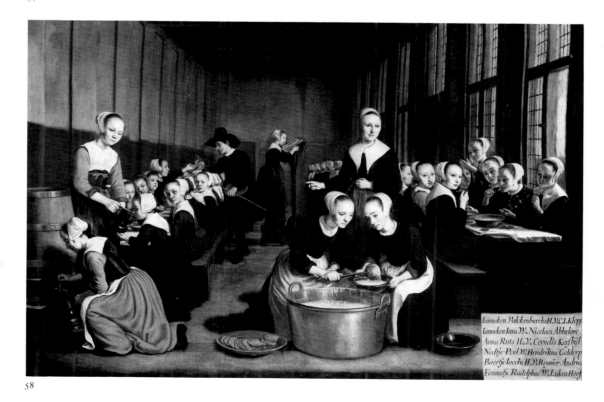

58

The theme is rendered more allegorically in the series of canvases—one of which is *The Distribution of Food* (fig. 59)—painted by Jan van Bronckhorst for the Amsterdam "Huiszittenhuis," an institution which supplied food and fuel to needy shut-ins. For the leper asylums, the parable of Lazarus and the rich man (Luke 16:19–31) was considered fitting, although less well-known stories were sometimes chosen. For instance, for the Amsterdam Leper Asylum, Ferdinand Bol painted *Elisha and Naaman the Syrian* (see fig. 71), an account related in II Kings 5:1–27 of the healing of the Syrian military captain Naaman, a leper, by Elisha, who refused any reward. The same subject was painted by Pieter de Grebber in 1637 for the Leper, Pestilence, and Insane Asylum at Haarlem.

Most of the commissions given by or for the charitable institutions, however, went to the

60 Hendrick Bloemaert
 Distribution to the Poor by Maria van Pallaes
 Signed and dated 1657. Canvas, 90 × 176 cm.
 Centraal Museum, Utrecht

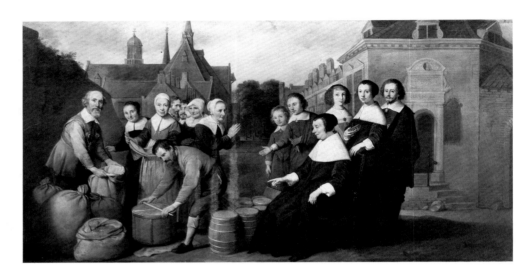

portrait painters. The regents and regentesses who governed these establishments, and other board members fulfilling various functions in public life, often decided to have themselves portrayed together. These group portraits, now called regents paintings, form a special chapter in Dutch portrait art and will thus be discussed in more detail below, in the chapter "Something to Paint."

The privately sponsored institutions, such as the *hofjes*, also commissioned portraits, and these sometimes differed markedly from the more or less standarized paintings for religious or municipal institutions. In 1657 Hendrick Bloemaert made a curious painting (fig. 60) on commission from Maria van Pallaes for the Pallaes Foundation in Utrecht, which she had established six years earlier. Seated in an armchair and surrounded by her five children— some of whom were dead before the picture was painted—she gazes at her two menservants doling out grain to the indigent elderly who are housed and fed by her charity. In the right background appears the hall of the foundation with its twelve *Godskameren* (chambers of God, as the rooms for the residents were called); at the left is the former St. Agnes Convent, headquarters in the 1650s for the Utrecht painters' fraternity, of which Bloemaert was deacon in 1655–56.[29]

The Guilds

The marksmen's guilds, which functioned as a sort of local militia in every Dutch city, were also important patrons of the portrait painters. Before the Reformation the guilds had been strongly religious, usually with their own chapel or altar in the church, dedicated to their patron saint, George or Sebastian. After the Protestant take-over and during the dangerous years at the beginning of the war with Spain, the guilds' religious aspect dwindled and military preparedness came to be emphasized. In the seventeenth century, as the threat of hostilities receded, the guilds, now more accurately civic-guard companies, turned more and more into social clubs for well-to-do gentlemen. They continued to do guard duty, and served as escort for important visitors. One of the few pictures of the militia in action on such an occasion is by Sybrand van Beest and depicts the departure (in the left background) of Queen Henrietta Maria, wife of Charles I of England and mother-in-law of the stadholder William II, from the beach at Scheveningen in 1643 (fig. 61). The Hague guardsmen who commissioned this work are portrayed in full regalia, the officers foremost, the men with pikes and muskets at parade rest.

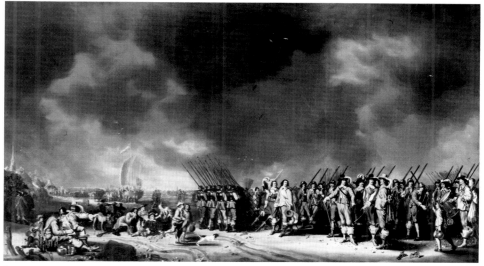
61

61 Sybrand van Beest
*Queen Henrietta Maria of England Departing from
the Beach at Scheveningen*
Signed and dated 1643. Canvas, 109 × 186.5 cm.
Gemeentemuseum, The Hague

62 Claes Lastman and Adriaen van Nieulandt
*Captain Abraham Boom, His Lieutenant Anthony
Oetgens, and Seven Members of the Amsterdam
Detachment Sent Off in 1622 to Defend the City of
Zwolle*
1623. Canvas, 245 × 572 cm. Amsterdams
Historisch Museum, Amsterdam

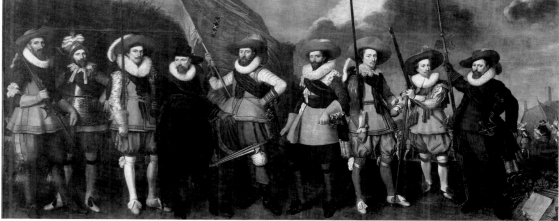
62

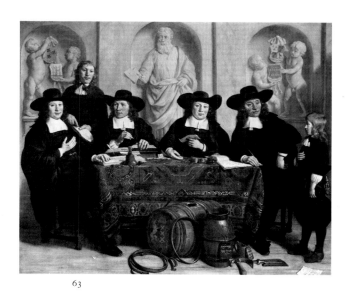
63

63 Gerbrand van den Eeckhout
*The Four Governors of the Coopers' and Wine
Rackers' Guild, Amsterdam*
Signed and dated 1673. Canvas, 211.5 × 253 cm.
Amsterdams Historisch Museum, Amsterdam.
On loan from the State-owned Art Collections
Department

The civic-guard halls, called *doelens* (targets) after the shooting range that always lay next door, were decorated with group portraits. The earliest of these paintings date from about 1530 (see fig. 10). After the middle of the seventeenth century no new ones were commissioned in Amsterdam and only a few elsewhere.

The specific occasion for commissioning a civic-guard painting is usually not known. Sometimes the promotion of an officer to captain or colonel seems to have provided the impetus, sometimes the completion of a new *doelen*. In 1636 a large new hall, the Kloveniersdoelen, was opened in Amsterdam, and in the next seven years seven paintings were ordered to ornament the walls. Sometimes, again, the commission was to celebrate actual combat duty. Thus, nine members of an Amsterdam company that had helped in the defense of Zwolle in 1622 had themselves portrayed together by Claes Lastman (Pieter Lastman's brother) and Adriaen van Nieulandt (fig. 62). The number of guardsmen appearing in a group portrait seldom reflects the true strength of the unit to which they belonged. The paintings were paid for by the men themselves, each financing his own likeness, and only those who could afford it were immortalized.

To a slightly lesser degree, the craft guilds also gave commissions for group portraits, the guild officials regularly taking the initiative in ordering a painting and standing guarantee for the payment. In a contract of 1626 the "ruling delegates of the Wine Merchants' Fraternity" of Amsterdam declare that they, together with the guild servant, "were painted by Mr. Niclaes Elias and portrayed from life, with the intention that the same piece shall remain in the aforesaid chamber [the guild hall] as a memorial," and that "the costs of painting and appurtenances shall be paid by the six aforementioned first delegates out of their own pockets, without in any way bringing or causing burden to the aforementioned guild."[30] The painting here referred to is unfortunately lost, but a later one, also portraying officers of the same fraternity, survives; it was painted by Gerbrand van den Eeckhout in 1673 (fig. 63). In composition this type of group portrait, in which six or seven individuals at the most are portrayed, corresponds exactly to the regents painting.

The production of so many group portraits of regents, guild officials, and militia is unique in European art. In the Netherlands, these paintings occurred primarily in the provinces of Holland and Zeeland.

The Burghers

The commissions awarded by the court, the government, and the regents produced many notable works of art, and they were of great importance to artists financially and as marks of official recognition. Yet quantitatively, these orders were as nothing compared with the total number of paintings purchased by individuals. It is unfeasible systematically to categorize the various kinds of private patrons. Little precise information has been preserved to indicate the relationship between patron and painter, and these patrons ranged from casual buyers at fairs to specialist collectors. Except for portraits or for pictures of someone's house or country place, there were probably few instances of specific commissions.

64 Jacob Matham
Jan Claesz Loo's Town House, the Brewery "Het Schip," at Haarlem and His Country Villa "Velser-end" near Brederode
Signed and dated 1627. Pen painting on panel, 71 × 116 cm. Frans Hals Museum, Haarlem

65 Allart van Everdingen
The Trip Cannon Foundry at Julitabroeck, Södermanland, Sweden
Canvas, 192 × 254.5 cm. Rijksmuseum, Amsterdam

In the absence of documentation it is well-nigh impossible to determine the role of the private patron in the origin of a painting, or how his specific wishes influenced the end product. That he had such wishes in a number of cases may be assumed. The curious pen painting that Jacob Matham made in 1627 for the Haarlem burgomaster and brewer Jan Claesz Loo can hardly be explained except as a following of the patron's rather eccentric desire to unite in one painting his town house and brewery on the Spaarne River in Haarlem and his country villa miles away in the dunes (fig. 64). The wordy inscription at the bottom of this piece reads along these lines.

It may also be assumed, though there is no documentary evidence, that the extremely wealthy Trip and de Geer families instigated or commissioned the journey of the landscape painter Allart van Everdingen through Sweden and Norway between 1640 and 1641. These families, interrelated by marriage, owned many enterprises in Sweden, including iron mines; van Everdingen made a large painting of the Julitabroeck cannon foundry near Nyköping in Södermanland (fig. 65). This and other Swedish landscape paintings adorned

58

66 Dirck Valkenburg
Negro Merrymaking in Surinam
Signed. Canvas, 58 × 46.5 cm. Statens Museum
for Kunst, Copenhagen

the Trip family's magnificent canalside mansion, the Trippenhuis, in Amsterdam. It may be said that a private commission here influenced landscape art, because van Everdingen continued to paint Scandinavian landscapes, and Jacob van Ruisdael later added this subject to his repertoire.

A contract that has been preserved was drawn between the planter Jonas Witsen and Dirck Valkenburg in 1706. In it Valkenburg pledged himself to spend four years in Surinam working for Witsen as bookkeeper and painter, "in order to paint the plantations...from life as well as...rare birds and plants."[31] One of his paintings shows a crowd of blacks, brought in as slaves to work the plantations, holding a jamboree (fig. 66).

A great deal of traveling was done in the seventeenth century, and painters did their share of it. Sometimes their goal was Italy, in order to become acquainted with the famous art there, but just as often they seem to have been motivated merely by an urge to see more of the world. The diary that Vincent Laurensz van der Vinne kept during a long trip abroad provides a superb picture of the pleasures and dangers encountered along the way at mid-century.[32] He left Haarlem on Wednesday, August 21, 1652, together with two other young painters, Guillam Dubois and Dirck Helmbreker. After a few days, the latter had had enough and went home; Dubois held out for several months. But in Cologne van der Vinne was joined by a cobbler friend from Haarlem, Joost Boelen, a Mennonite like himself, and in Frankfurt by the painter Cornelis Bega. They then set out to travel by boats of various sorts, wagon, coach (seldom), donkey, and mostly on foot through Switzerland and France, observing everything with interest and sometimes getting involved in local troubles, such as a peasant uprising in Switzerland, during which they were arrested as spies and jailed for three days. There were highwaymen to watch out for, bad inns, dangerous dogs, and at one time even a wolf. Throughout their journey they tried to earn their keep by painting or drawing portraits and landscapes, usually with success. When Vincent liked a place—as he did Geneva—and quickly made money there, he stayed a while, sometimes for months. Finally, after visiting Paris, he set out for home, arriving back in Haarlem on September 1, 1655, "having been away in total three years and eleven days."

Whether people were travelers or not, one of their favorite hobbies at this time was collecting pictures of foreign cities and landscapes. Most were content with engravings or maps and atlases, made widely available by printing, but the wealthier collectors could afford drawn or painted landscapes and maps colored by hand. Among the most beautiful of such collections was that of Laurens van der Hem, a rich, art-loving Amsterdam merchant, which, unlike all the other collections, was not broken up after his death but survived intact and is now in the National Library at Vienna. It consists of over two thousand maps, drawings, watercolors, and prints. Among the drawings are works by Lambert Doomer, Jan Hackaert, Adriaen Matham, Roelant Savery, Willem Schellinks, and Reinier Nooms. Van der Hem presumably paid for at least some of the trips abroad made by these artists. His collection also hints at a bit of intrigue: the collector had managed to get hold of a number of strictly secret Dutch East India Company maps, which he would show to no one.[33]

The true collector of paintings no doubt sometimes gave artists specific commissions. Rembrandt's *Juno* (fig. 67), which he painted near the end of his life, was most likely made at the behest of the collector Herman Becker,[34] for there is documentary evidence that Becker ordered a painting from Rembrandt on a theme of this sort. An emigrant from Riga to Amsterdam, he dealt in jewels, marble floor tiles, and textiles, earning profits that permitted him to build up an admirable collection of paintings.

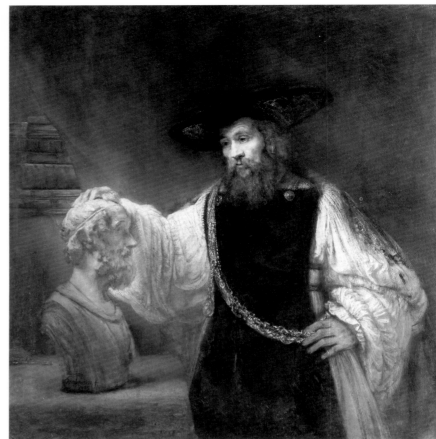

67 Rembrandt van Rijn
 Juno
 c. 1665. Canvas, 127 × 107.5 cm. The Armand
 Hammer Foundation, Los Angeles

68 Rembrandt van Rijn
 Aristotle Contemplating the Bust of Homer
 Signed and dated 1653. Canvas, 138.5 × 133.4 cm.
 The Metropolitan Museum of Art, New York.
 Purchase, Friends of the Museum, 1961

Likewise the commissions given by Don Antonio Ruffo, a Sicilian nobleman, to Rembrandt indicate that patrons at times described the subjects they wanted quite precisely, as well as specifying the size of the paintings.[35] Following his patron's written instructions, Rembrandt made for Ruffo *Aristotle Contemplating the Bust of Homer* (fig. 68), *Alexander the Great,* and *Homer.*

We can usually answer without trouble the questions of what the "official" patrons wished to have as adornment of their buildings and why they gave the commissions they did, but the same is not at all true when it comes to private citizens and their homes. In the inventories of seventeenth-century collectors or occasional private buyers, we find a great variety of subject matter. It is therefore useful to frame another double question: what subjects did an artist have in his repertory, and why did he choose these in the first place? But before we tackle this question, we can postpone no longer a brief consideration of seventeenth-century art theory in the Netherlands.

Theories of Art *by Beatrijs Brenninkmeyer-de Rooij*

On St. Luke's Day in 1641—it fell on the eighteenth of October—the painter Philips Angel gave a speech in Leiden in praise of painting. The following February his eulogy appeared in print, in a booklet of fifty-eight pages. To support his argument that painting outshines all other arts, even poetry, he inserted a list of authors who had written about painting, mostly classical writers now virtually unknown except to scholars.[1] Only three Netherlanders appear in the list: Carel van Mander, Jan Orlers, and "Ter Brug" (Gerard Ter Brugghen or Brugge). Orlers was a distinguished citizen of Leiden, a member of the town council, a former burgomaster, and a historian of note. His *Beschrijvinge der Stadt Leyden* (Description of the City of Leiden), with commentaries on local painters, first appeared in 1614 and had just been reissued in 1641 in an expanded, up-to-date version; it contains the first "biography" of Rembrandt and contemporary information about other artists. Not much is known about Ter Brugghen, but Angel presumably had in mind his *Verlichtery Kunst-Boeck* (Book of Illumination in Art), first published in Amsterdam in 1616.

About van Mander there could be no mistake: his *Schilder-Boeck* was the first book about painting written in the Dutch language. Its appearance, in 1604, as we have noted in the Introduction, did not cause a flood of other writings about art and artists. On the contrary: the paucity of seventeenth-century literature on the subject stands in remarkable contrast to

the vast number of paintings produced during that period in the Netherlands, but elsewhere in Europe the dearth of published theoretical literature on art was almost as great. In the writings of Netherlanders that do exist, the subject is for the most part modeled, via van Mander, on Giorgio Vasari's famous *Lives of the Most Excellent Painters, Sculptors, and Architects* of 1568, and the texts in general give summaries of the painters' lives.

Van Mander's *Schilder-Boeck* is the most extensive and the best known of these texts. In 1618 a new edition of it was printed in Amsterdam (fig. 69), with an anonymous biography of the author appended. The volume is divided into six sections: The Foundations of the Noble Free Art of Painting, The Lives of the Ancient Illustrious Painters, The Lives of the Modern or Contemporary Illustrious Italian Painters, The Lives of the Illustrious Netherlandish and High German Painters, Explanation of the *Metamorphoses* of Publius Ovidius Naso, and The Rendering of Figures. The work of the ancients was of course unknown to van Mander, as it is very largely to us today; information about the Italians, from Cimabue (born in 1240, according to van Mander) to such contemporaries as Antonio Tempesta, he drew as much as possible from Vasari; but he collected all the material about the Netherlandish and German painters himself, beginning with the van Eyck brothers, by interviewing and writing letters to people who had known them or at least lived in the same town, by seeking out their works in private and public collections, and by recalling personal anecdotes of those he knew himself.

These biographies were later expanded somewhat and brought up to date, and other artists added, by several writers, of whom I mention only those of firm Dutch connection. First there was Cornelis de Bie, with his *Gulden Cabinet* of 1661–62. Then came Joachim von Sandrart, a painter from Frankfurt who lived and worked in Amsterdam from about 1637 to 1645 and included Dutch artists in his *Teutsche Academie* of 1675–79. Finally, well into the eighteenth century, Arnold Houbraken published his *Groote Schouburgh* in 1718–21.

Besides the biographies, a few works on art theory also appeared in the Netherlands. In chronological order, the most important of these are as follows:

1604. Van Mander's *Grondt* or "Foundation," a long didactic poem in ottava rima, written as preface to the *Schilder-Boeck.* In it the author addresses young people who want to learn to paint and—over their heads—practicing artists and art lovers in the Netherlands.

1637–1641. Franciscus Junius, *De pictura veterum,* first published in Amsterdam in Latin in 1637; in English, by the author, *The Painting of the Ancients in Three Books,* in 1638; and in Dutch in 1641. Junius, son of an émigré Huguenot professor at Leiden University, was employed from 1620 on as librarian by Thomas Howard, earl of Arundel, one of the great English collectors of paintings, gems, books, ancient statuary, and coins.[2] As a scholar, Junius had little knowledge of or interest in "modern" art. Basing his discussion therefore on classical texts, he wrote about painting and the demands made on artists and their work according to the rules of rhetoric.[3]

1642. Philips Angel's *Lof der Schilder-Konst* (Praise of Painting), in fact an extended plea for the founding of a St. Luke's guild in Leiden.[4] As a printed speech, this booklet did not encompass as much material or have as wide dissemination as the other works listed here.

1670. Willem Goeree, *Inleydingh tot de pracktijck der al-gemeene Schilderkonst* (Introduction to the Practice of Painting in General), a melange of passages borrowed mostly from Italian Renaissance writers.

1678. Samuel van Hoogstraeten, *Inleyding tot de Hooge Schoole der Schilderkonst: anders de Zichtbaere Werelt* (Introduction to the Advanced School of Painting: or, The Visible World). A new and greatly expanded version of van Mander's "Foundation," written three

69 Title page of *Het Schilder-Boeck* by Karel van Mander. Second edition, Amsterdam, 1618

generations later. Hoogstraeten subscribes to Angel's view that most people consider painting a craft and that this is one of the reasons for the small number of books written about art. For lack of these, "thousands attack or object to art, without even weighing the difficulties involved, yes, more or less as if they had a shoemaker's craft in hand."

1682. Willem Goeree, *Natuurlyk en Schilderkonstig Ontwerp der Menschkunde* (Natural and Pictorial Design of Human Physiognomy), a very free version of Leonardo da Vinci's *Trattato della Pittura*.[5]

1707. Gerard de Lairesse, *Het Groot Schilderboek* (The Great Book of Painting). The origin of this work is rather unusual. About 1690 Lairesse, a popular painter, went blind, and to support himself he gave talks about painting and drawing, which he later collected and published in this and another volume, *Grondlegginge der Teeken-Konst* (Fundamentals of Drawing). The *Groot Schilderboek* became one of the most read, most used manuals of art, far outdistancing in popularity all of its predecessors.

Van Mander was an erudite humanist first and a painter second, and Junius was a scholar, but it is noteworthy that all the other books were written by artists. This is not to say that they give any impression of the activities in a seventeenth-century studio; they devote as much discussion, for instance, to the origin and meaning of the various colors as they do to the use of paint itself.[6] The authors, thoroughly schooled in Latin, approach their subject and handle the terms and concepts in the same way: when seeking a theoretical basis for art, they turn to ancient writings and borrow the requisite fundamentals from established and recognized authors. But there were no theoretical works on ancient painting, though such classical writers as Pliny[7] had written about art and artists. The modern writers therefore often borrowed the ideas and terminology of the arts considered to be related to painting, mainly rhetoric and poetics among the "free" or "liberal" arts.[8] The result was a sort of terminological and theoretical corset which inevitably did not fit the art of painting, as is abundantly evident in the literature listed above. Not until the writing of Gerard de Lairesse at the beginning of the eighteenth century do the ideas seem to be wholly digested and integrated.

Besides the theoretical literature, there were other writings in which artists and works of art are mentioned. First among these are the travel accounts, useful because travelers in the Netherlands sometimes described in their journals what they had seen and where, including visits to artists' studios.[9] Paintings were rarely displayed in public; museums had not yet been invented; some pictures could be seen in town halls, other public buildings, or, infrequently, churches. Most paintings were in private collections.

An early example of such reporting is contained in the notes of the Utrecht humanist Arnoldus Buchelius, who journeyed throughout the Netherlands from the early 1580s to the late 1630s. He made notes on paintings and painters alike in his diary and especially in his little notebook, unpublished until the twentieth century, called *Res Pictoriae*. He never intended this notebook to be an independent publication, but used it as a source for his other writings, among them a detailed description of the city of Utrecht.[10]

The comments of the English travelers Peter Mundy and John Evelyn, who visited Amsterdam and Rotterdam in 1640 and 1641, respectively,[11] reflect the astonishing ubiquity of art in the Republic during this period. Mundy notes the abundance of paintings for sale on the streets of these cities and hanging in every house and shop, even at the blacksmith's and cobbler's. Evelyn was especially impressed by the many "Landscips and Drolleries, as they call those clownish representations."

In 1667–68 and 1669 Cosimo III de' Medici, soon to succeed as grand duke of Tuscany, paid extended visits to the Netherlands. He was in Amsterdam on December 29, 1667, and called at the studios of several artists, including Rembrandt and Willem van de Velde. Neither of these painters could show him good examples of their work, but steered him to private collectors who owned some of their paintings. Cosimo took the trouble to go look, and was received "with the greatest courtesy and friendliness";[12] unfortunately, he says nothing about what he saw.

The material found in such accounts is mainly factual. The range of subjects is much smaller than in the theoretical studies. The same is true of the descriptions of towns and cities, although these may contain a number of everyday facts about painters—when an artist entered the guild, for instance, or traveled to Italy.

A few extant writings concern painters and the making of paintings but do not belong in any of the above categories. The *Regulen* by Pieter Fransz de Grebber of Haarlem is a set of eleven rules of thumb which the history painter should know before he starts to work. Among the rules are: 1) determine the proper perspective, placement of the horizon, and fall of light in relation to where the painting is to be hung (this rule interestingly enough presupposes a patron); 3) place the most important figures and action in the foreground—the "most beautiful" part of the painting (a rule contrary to the Mannerists, who liked to place their main scene in the middle-ground); 4) avoid heads all in a row; and 11) make sure that as figures diminish in size with distance, their colors also dim. These rules take up only one page; they were published in Haarlem in 1649, but it is not known upon what occasion.[13]

Constantijn Huygens' remarks about art were set down from 1629 to 1631, when he was in his early thirties. As a humanist and man of letters, Huygens possessed a remarkable insight that becomes apparent as soon as he writes about art and artists. His contemporaries, however, cannot have known what he wrote: his "autobiography," in Latin, was not published until 1897.

What of this literature, especially the theoretical writing, was known to seventeenth-century artists? Buchelius and Huygens were not published in the seventeenth century, Hoogstraeten and Lairesse not until 1678 and 1707, respectively; they therefore fall outside the scope of this discussion. Nevertheless, they will be considered here, for otherwise the theoretical literature would be extremely scant, and especially because a strong continuity can be traced through all the works.

This continuity exists on two levels. First and most clearly perceptible are the repeated borrowings by one author from another. A good example is Hoogstraeten, whose work in many places reveals that he had studied van Mander intensively, even taking over and freely paraphrasing some sections and passages. On the second level is a more general continuity, the humanism that was the prevailing culture in the seventeenth century. No major changes in thought occurred until the eighteenth;[14] all of the writers under discussion, whether they were learned (Junius) or probably otherwise (Angel), developed from this humanist background. All of them, moreover, placed the greatest stress on renderings of the human figure and human activities. They pay substantially less attention to landscape painting[15] and make only the merest mention of other subject matter—still lifes, portraits, interiors. Probably the many painters who specialized in these fields had little or no interest in the theoretical books.

There is also evidence that these books were not widely disseminated. The inventories of artists' possessions, usually drawn up posthumously, often list the books owned.[16] About 280 inventories from the sixteenth, seventeenth, and eighteenth centuries have been published, and in them van Mander is listed twelve times, Junius four times, Lairesse twice, Hoogstraeten once, and Angel not at all. Very thin numbers, even taking into account the fact that many of these inventories date from before 1678 and thus antecede Hoogstraeten and Lairesse.

Approaching the problem from the other side, it was natural that seventeenth-century Dutch writings about art should reflect ideas prevailing in the highly civilized, art-loving society of that time. When, in addition, many of the theoretical subjects in one book are similarly treated in others, these writings should be acknowledged to give a view, however small, of how people thought about art in the seventeenth century.

Much remains to be investigated. Only van Mander's "Foundation" has been thoroughly analyzed, by Miedema,[17] who has shown that this didactic poem can be read on various levels: the artistic, the philosophic, and the technical, all liberally sprinkled with moralistic advice. The work was clearly intended for a much larger public than youthful painters alone. Junius is discussed at length by Ellenius in his book on Swedish art theory in the second half of the seventeenth century. But for the others, very little recent literature exists.[18] We cannot at this time answer such questions as how much the writers were influenced by foreign publications. We know only the sources used by van Mander for his "Foundation" and his lives of ancient painters. French literature in particular must have been of importance in the last quarter of the seventeenth century.

Our major concern, however, is to gain insight into how paintings were viewed and judged in the seventeenth century. The (artist) authors of the theoretical works apparently

considered themselves uniquely qualified to answer this question: all of them agree that the judging of paintings should be left to artists and experienced connoisseurs. Even Junius joins in this, supported by Pliny the Younger, no less, whom he quotes as saying, "He must of necessity be an artist...to rightly judge [the work] of a painter, a carver, or a caster of statues."[19] Constantijn Huygens adduces his father, the statesman Christiaan Huygens, who "had realized...and at the same time, he said, had learned through his own lack of experience, that no one was in the least qualified to judge painting, which is nowadays everywhere to be found, who had not in one way or another familiarized himself at first hand with the basic principles of this art. He had seen how distinguished men, famous for their learning in every field of knowledge, had made themselves ridiculous to connoisseurs by pontificating about the art of painting."[20]

Hoogstraeten[21] illustrated this conviction with an anecdote about an ancient artist, Dion, who had made a painting of Leda at the moment when her twins, Castor and Pollux, were emerging from their eggshells at her side. Dion displayed this picture in his shop and made various changes as a result of the remarks it aroused: "Now he shortened Leda's nose or Castor's arm, then he thinned down Pollux's neck or the mother's knee, until the goddess resembled neither a goddess nor a hen with her chicks, but rather a female bear with two unlicked cubs. Having done this, he displayed it once more in his shop, with a sign reading:

The judgment of the people, silly and dumb,
Has messed up this piece, by gum!"

Apart from establishing the artist as the best critic, the writers all agree that before any painting can be begun, the subject matter must be selected. In seventeenth-century texts, the term used with reference to this is *inventio* (invention), a word borrowed from rhetoric[22] and having the broader significance of not only the choice itself but also the search, the bringing together of parts. Given the large free market for which the Dutch artist painted, the choice of subject indeed lay largely with himself.

In principle, it would seem that the texts advise the artist to paint the subjects he does best: "It is better to do one thing excellently than many things only passably." But no, this is immediately followed by: "He who cannot become a lutist can learn to play the pipes, says Cicero."[23] Since lute playing in the seventeenth century was considered a higher form of musical activity than pipe playing, there definitely seems to be a distinction here, determined by the choice of subject matter.

In any event, the classifying of paintings by subject matter began with van Mander, who in his Introduction listed all manner of subjects for young people wishing to learn to paint: "If it is not perfection in figures and History, then it may be Animals, Kitchens, Fruits, Flowers, Landscapes, Masonry, Prospects, Compartments [cartouches], Grotesques, Nights, Fires, Counterfeits [portraits] from life, Seas and Ships, or [finding] something else to paint."[24] Clearly, by mentioning them first, he ranks highest in the hierarchy of subject matter "figures and History" pieces—and by "figures" he means those in a story, not portraits—but the rest of his listing seems to be arbitrary. Not until 1678, three quarters of a century later, did Samuel van Hoogstraeten classify the ranking. In a long passage he vividly describes three groups of subject matter and rates them in ascending order of importance:

The first guild appears with...grotesques, or with gay festoons...a bright wine-rummer on a brimful table....Or they arrange kitchens with all sorts of food, of meat and fish...and everything that is understood under the name of still life....But these artists must know that they are only common soldiers in the army of art....

The second gang arrives with thousands of decorations, and plays with cabinet pieces of every sort. Some introduce satyrs, forest gods, and Thessalonian shepherds...or build a luxurious Paradise, where all kinds of animals graze along the hills in the sunshine. Others come with night scenes, and fires, carnivals, and mumming....Nevertheless, I deem all these choices high enough to make the most virtuous spirits sweat....

Some are then...transported and driven to the highest and most distinguished rung of painting...which is the rendering of the most memorable histories....The paintings, then, that belong to the third and highest grade are those which display the most noble actions and...the wisest creatures to mankind.[25]

In other words: not only do the most respected paintings show an important event, but at the same time and especially they display what we would now call exemplary (literally, in the sense of good or bad) behavior. People are still viewed as the acme of God's creations, as microcosms in which the macrocosm permits itself to be recognized,[26] and as such of manifest importance to the artist. For this reason, Hoogstraeten could place the portraitists in both the first and least significant group—calling them "counterfeiters, who…prettily imitate eyes, noses, and mouths"—and in the third and highest group: "…so that in their works people become aware of the above-mentioned wisdom or the human soul."[27]

It is clear that for Lairesse, at the very end of the century, history painting (which he also calls "Scenes") stands on a lonesome height above other subject matter. He begins his fifteenth chapter, entitled "What must be understood as a Scene, and how many there are," with the modest disclaimer: "I have long questioned whether I could, without the appearance of conceit, openly publish these remarks about Scenes."[28] He then laments the many available scenes that are not taken advantage of by contemporary artists.

This much is certain: in seventeenth-century art theory, the still lifes and landscapes, so expensive and coveted today, got short shrift, although landscapes were definitely admired, and both genres commanded respectable prices at sales from time to time. Indeed, as early as 1630, Huygens was lyrical about landscapes: "The harvest of landscape painters in our Netherlands…is so immeasurably large and so famous that anyone who wished to mention them one by one would fill a book.…It can even be said that, as far as naturalness is concerned, the works of these clever men lack nothing except the warmth of the sun and the movement caused by a cool breeze."[29]

There was little inducement, however, for artists to think up a totally new subject for every painting, to make their "own discoveries." If such stimulus did exist, it was not because the artist's originality was of any great moment, but rather because the development of painting might thereby be furthered and earlier painters surpassed, especially those of antiquity and the Italian Renaissance. "Try with all your might, O zealous young painters," Hoogstraeten advised, "to train yourselves for your own discoveries. Apelles and Protogenes diverged from the paths of…their predecessors. So also did Paulo Kalliary [Veronese] and Tyntoret [Tintoretto], and struck down new roads. Who knows whether art can be brought still higher?"[30]

It was nonetheless expected that every artist planning to make a history painting should first read and digest the whole account, as recorded by the best writers.[31] His position differed from that of the poet or historian, for he could depict but one moment of the history, not the whole. He must therefore choose this moment well: it must represent a crisis or turning point.[32] Hoogstraeten calls it an "immediate action" or "instantaneous deed"[33] and counsels the artist to think deeply about the content and intent of the story before he decides which moment to render. To Lairesse, it followed logically that the artist must have a good memory "in order to keep well in mind and to ponder upon that which he wishes to depict," and van Mander had said, "Memory is the Mother of the Muses."[34] The intention, it seems, was also that the viewer of a painting should become personally and directly involved with what he sees: he must be shocked or delighted or filled with sympathy.[35]

When the subjects chosen for paintings in the seventeenth century are analyzed, it is evident that this advice was widely followed. In his *Resurrection of Christ* (fig. 70), one of the Passion series commissioned by Frederik Hendrik, Rembrandt carried out the "immediate action" so fully that the viewer sees a sword falling from the hand of one of the guards. Of extraordinary interest in this case is the firsthand information that we possess from the artist himself: Rembrandt makes his intention clear in a letter to the stadholder's secretary, Constantijn Huygens: "…in the two pictures which His Highness commissioned me to make—the one being where Christ's dead body is being laid in the tomb and the other where Christ arises from the dead to the great consternation of the guards…the greatest and most natural movement has been expressed."[36] And by "movement," motion, he meant "emotion" as well.

After the preparatory reading, the artist's next step was drawing, upon which all good painting then depended.[37] The painter was expected to have, as Angel put it, "a steady and sure hand"[38] with which to render the *dispositio*—the "ordering" or composition of the painting. The most prominent place should be reserved for the main character (or

70 Rembrandt van Rijn
The Resurrection of Christ
Signed and dated 163(.). Canvas on panel, rounded at the top, 91.9 × 67 cm. Alte Pinakothek, Munich

71 Ferdinand Bol
 Elisha and Naaman the Syrian
 Signed and dated 1661. Canvas, 151 × 248.5 cm.
 Amsterdams Historisch Museum, Amsterdam

72 Melchior d'Hondecoeter
 The Fable of the Crow
 Signed and dated 1671. Canvas, 176 × 189 cm.
 Mauritshuis, The Hague

characters); others who, according to the story, played less important parts were to be recognizably portrayed but downstaged; and the figures that the artist introduced merely for ornamentation or "enlargement" of the painting were to be kept furthest out of the way.[39] This method of composition was often used and is well illustrated by Ferdinand Bol's *Elisha and Naaman the Syrian* (fig. 71). The viewer's attention is first drawn to the turbaned old man on the right, the prophet Elisha, who is refusing the gifts brought him by the Syrian army captain Naaman, whom he has just cured of leprosy. The artist uses successively more subdued colors, making the viewer aware of Naaman only secondarily, and thereafter of the gifts themselves and of the boy spreading them out. Elisha's untrustworthy servant, Gehazi, is posed in the archway at far right, with his hand on his chin. Naaman's retinue, which takes up the whole left third of the painting and most certainly was intended as "ornamentation," is so much in shadow that it does not interfere with the incident depicted. The whole composition therefore is focused upon the individual figures in their roles of descending importance.

On the whole, no one seems to have minded if one painter took over another's composition so long as the subject matter was different. Hoogstraeten makes this clear in a passage in which he draws analogies with poetry writing:

Nevertheless you will be permitted, when you sometimes encounter a well-ordered piece, to borrow from it the vois or way of rendering, that is, the flourish of joining and leap. Just so [does] a poet, who makes a new little song to an old tune. It is then no disgrace to compose a few verses on a known tune which already pleases the world. But here one must take care to use a different stuff: and so that painter has been deemed praiseworthy who brings to bear the same power of art in his painting of Achilles that once was perceived in Apelles' Alexander. Thus Virgil is honored as a Prince of Latin Poets, because in his wanderings of Aeneas, following the wanderings of Homer's Ulysses, he never deviated from his predecessor. And just as it can truly be said that he sometimes imitated him, it cannot be said that he anywhere steals from him. But he seems to be kindled by the same spirit as he races for the prize in the course of honor.[40]

Another subject of discussion is the borrowing of compositional details. This, too, is permitted, in Angel's phrase, "in order to bring imperfection closer to perfection," but Hoogstraeten insists that it must be done with care and not too often; pertinent here is also the latter's catchy "Well-cooked turnips make good soup," by which he means that an artist must be modest in what he takes over and must adapt and integrate it into his own painting.[41] To clarify his meaning, Angel relates Aesop's fable of the crow which dressed itself up in other birds' feathers and went strutting around, but did not fool the other birds: they came to reclaim their plumage, leaving the crow battered and bare.[42] Melchior d'Hondecoeter used this fable as the subject for a painting in 1671 (fig. 72).

The fable also had a seventeenth-century parallel. The Flemish artist Gonzales Coques was commissioned to paint the legend of Psyche in a series of ten pictures for the stadholder Frederik Hendrik. He asked another Fleming, Abraham van Diepenbeek, to help him with

73 Carel Du Jardin
The Conversion of St. Paul
Signed and dated 1662. Canvas, 186.5 × 134.5 cm.
The National Gallery, London

74 Antonio Tempesta
The Conversion of St. Paul
c. 1630. Etching, 36 × 47.8 cm. Graphische
Sammlung Albertina, Vienna

some "new inventions" for this project. When Coques arrived in The Hague with the
sketches, Constantijn Huygens confronted him with a series of prints, attributed to Raphael,
which had clearly served as van Diepenbeek's models: "So when the lord of Zuylichem
[Huygens] brought out the...prints and had them compared with the sketches, there was
such scoffing and snickering that the defendant [Coques] surely wished himself far away
from there."[43]

Neither the sketches nor Coques's paintings have survived, but other borrowings,
including more honorable ones, can often be recognized in seventeenth-century paintings.
One example is Carel Du Jardin's *The Conversion of St. Paul* (fig. 73), in which the painter
incorporated motifs from a print by Antonio Tempesta (fig. 74).[44] Yet the advice not to
borrow too much or imitate too slavishly still held. As with the invention of subject matter,
however, it was again a question not so much of the artist's originality as of upholding the
principle of *aemulatio* (rivalry): "Those who always follow will never lead."[45]

For the pictorial rendering, the artist was ever encouraged to follow nature—and, at the
same time, the great masters. All the writers recommend the "imitation of nature" and tell
wondrous anecdotes, usually borrowed from antiquity, about perfect imitation. Thus the
story of the painter Zeuxis, who could render fruit so perfectly that birds came to peck at
his paintings. Even stronger—the tale of the painter Parrhasius, who succeeded in fooling
Zeuxis himself by painting such a convincing sheet over his picture that Zeuxis tried to pull
it off. Illusionism of this sort can be found now and then in seventeenth-century paintings:
Hoogstraeten reports that his own father painted a goat so realistically that when the
original saw its portrait, it became furious and butted the canvas to pieces.[46]

Yet nature should not be followed too slavishly, for it is full of imperfections. The painter
should imitate nature, but only at its best—nature as it ought to be (another idea borrowed
from rhetoric). He is therefore indeed compelled to look about him with a critical eye
whenever he wishes to follow nature. It is up to him to make a "correct choice." To do so
he is well advised to study and imitate the "great masters" of antiquity and the Italian
Renaissance, who had already—and always—made the "correct choice." That the work of
ancient painters was lost and could be known (at least in the seventeenth century) solely
from written descriptions and through other forms of ancient art seems to have bothered no
one. The only artist who apparently found this annoying was Peter Paul Rubens: he wrote
a letter to Junius (who published it as a preface in the Dutch edition of *De pictura veterum*)

asking why a treatise like Junius' on ancient painting could not also be written about Italian paintings, "models and prototypes of which still exist that can be pointed at with a finger, and of which it can be said: There they are."[47]

To follow the great masters is of prime importance, as Lairesse states: "The correct, yes the essential practice consists in this, that, after...the sketch has been made, one looks to see what the great masters have thought and done about this matter, how they have chosen their objects, and with what additions they have enriched [their work]—this will give you new, firm, and good thoughts; after this, notice the grace of their actions, faces, light and shading."[48] The work of the great masters assuredly shows that a "correct choice" has been made. The advantage for the painter is that, by studying this work, he learns how to look at nature with his own eyes so that he, in his turn, will make the same "correct choice."

This choice finds expression in the execution of a painting. As already noted, one finds little explanation or instruction on the technical or craftsman level. Light and shade and even the reflection of light must be correctly rendered, and this matter does receive attention in the writings,[49] but the treatment is so discursive that the twentieth-century reader gains no impression of simple applicability. Concerning the use of color, as mentioned above, as much or more attention was paid to the meaning of the various colors as to the use of them. Moreover, the moral lesson was not skipped here, as Hoogstraeten illustrates: he states that the human nude must not be too gray, too green, too chalky white, too woodenly yellow, or too stony red, and he inserts the following example:

Saint Peter looks too red, said one of the cardinals
To Raphael of Urbino, and that does not please us.
He was ashamed, said the latter, when I painted him,
Because of the life he saw his followers leading.[50]

Very little is said about the use of perspective. Van Mander and Hoogstraeten refer to other literature, with Hoogstraeten remarking, "Others have gone into this subject so thoroughly and wisely that it bores me here either to add or subtract anything."[51]

The depiction of the human figure and human activities receives by far the greatest attention, and leads to fairly extensive discussion of the rendering of cloth and draperies.[52] The sparse remarks about "beauty," especially in the sense of beauty's being a harmony between the parts and the whole, do not usually appear here, but preface the discussion of proportion.[53] This is not illogical. In the tenth book of his De architectura, the ancient Roman writer Vitruvius—the most important source for the seventeenth-century study of proportion—had demonstrated that the human figure with outstretched arms and legs fits into both a circle and a square, and that the body is so put together that every part bears a relationship to the whole. His principal law of proportion is that the head comprises one eighth of the body. This rule, with variants, was adhered to throughout the entire century, with credit usually given to Vitruvius himself.

But in addition to the proportions of the human body, its "decorum" had to be respected. To van Mander, this meant that the painter, in rendering his figures, must pay attention to their characters and the circumstances in which they are placed: a fighter exerts himself differently from a philosopher; virgins must look demure. Character and circumstance should also be apparent in the color of the clothing: purple for kings, white for virgins.[54]

Hoogstraeten and Lairesse have a broader interpretation of decorum. According to them,

75 After Michelangelo
Leda and the Swan
Canvas, 105 × 135 cm. The National Gallery,
London

unseemly events, especially those that do not occur in public (Potiphar's wife trying to seduce Joseph, for instance), simply should not be painted.[55] Lairesse attacks Michelangelo for having painted Leda nude, on the ground with the swan (fig. 75): "Why did he not place her on a couch, as befits such a Princess, and especially without a head-covering?"[56] The presence of her headdress, which the writer apparently felt was out of place here, and the absence of a couch (though she does seem to be lying on a large cushion of some sort) are criticized to the same degree as the "immodesty" of the scene itself.

In applying the concept of decorum and also of the "instantaneous deed," and in seeking a correct rendering of nature, the artist was expected to represent movements or actions accurately. This meant, first, that a body must not be cut off by the position of an arm, for example; and second, that the "action" must make clear the role of a figure at the moment depicted.[57] That this occasionally led to difficulties is illustrated by van Mander's story about a painter in Greek antiquity who wished to portray the Judgment of Paris. By command of the gods, Paris had to present a golden apple to the most beautiful of three goddesses: Juno, Minerva, or Venus. The painter began with Juno and Minerva, then encountered a problem: he was quite unable to portray beauty greater than that which he had just achieved, yet Venus was destined to win the contest. He rescued himself from this dilemma by painting her from the back, so that the viewer would imagine that when she turned around, she would be the most beautiful.[58]

If it was important to render movement correctly, facial expressions required even greater skill. Enormous value was attached to the accurate depiction of the "affections" or "passions."[59] The emphasis on both actions and passions derived from the commonly held notion that specific human emotions led to specific movements of the body and face. When an artist succeeded in rendering these correctly, the viewer would be able to recognize the situation in which the figure was depicted—he could, so to say, "read" the picture. Moreover, people were convinced that the viewer, seeing the emotions so displayed, would experience them himself. By way of illustration, Hoogstraeten draws another parallel with poetry:

A beautiful poem will not lightly stir me,
But friendliness can transport heart and soul.
People laugh, or grieve, the viewer gets the clue:
So if you want me to cry, cry for me.[60]

And Angel: "See there the power that lies hidden in this art, which knows how to heal the outbursting feelings of tigers and lions, changing them into a sheep's gentleness, and a dove's innocence."[61]

76 Claes Berchem
Allegory on Amsterdam
Signed. Canvas, 175 × 148 cm. Amsterdams
Historisch Museum, Amsterdam

Thus it appears that in the seventeenth century there existed norms different from ours for viewing and judging paintings. The present-day demand for originality had little or no meaning; the word "imitation" was used freely and with no distaste. By the opposite token, great admiration was felt for history painting, which has since fallen entirely out of favor.

Hoogstraeten summed up the qualifications which the seventeenth-century art lover should demand of a painting. First, the subject matter should be examined, to see whether the picture is a history piece having "admirable virtues" and "worthy content." Then the viewer must observe whether the proportions are well executed, whether the coloring is good, whether the light and shade have been correctly rendered. Next, it must be asked whether the actions and passions play their proper roles and whether the scene is placed in correct surroundings—what Hoogstraeten calls their "own circumstances." By this he means that a story taking place in summer, for example, should not be set in a winter landscape. And finally, the viewer must ask himself whether the composition has been put together intelligently, and whether he can find "grace" in the painting. For (and this should be taken to heart) "if you become infatuated with other trifles, you are not worthy of the name of art lover."[62]

The importance of these theories in the practice of art is in question. There remain many fewer history paintings than landscapes, and seventeenth-century appraisals do not always indicate that the marketplace valued histories more highly than the still lifes created by the "soldiers" in the army of art.

Realism and Symbolism

History paintings and portraits belong among traditional subject matter, but a number of themes developed in seventeenth-century Holland that can be classified as more or less new and independent. More or less, because such subjects as landscape had already appeared in sixteenth-century Flemish art, and the Netherlands was certainly not the only region in which this innovation took place. Yet we can observe that an individualistic approach and mode of expression arose in Holland with some regularity, and to a large degree helped to determine the character of Dutch art.

The usual explanation for the evolution of specific themes into independent categories of painting is that they detached themselves from the traditional history painting. Reference is always made to fifteenth-century Flemish religious paintings, in which extraordinary attention was devoted to details; the perfect execution of still lifes, landscapes, and domestic interiors permits the assumption that these subjects were loved in and of themselves, however unimportant they were to the main theme. And out of this arose, as a matter of course, the interest of the seventeenth-century Dutch artist in such things.

This train of thought is not invalid, but it needs to be amplified. Recent research has made clear that there are many elements—more in some subjects than in others—which run counter to the much-praised "realism" of seventeenth-century Dutch painting, making it less realistic than once was thought. Apart from their apparently true-to-nature reflection of reality, many paintings have a symbolic or moralistic meaning. Symbolic or allegorical representation had its own role in the seventeenth century. There are countless prints and paintings depicting peace and war, wealth and the vanity of riches, love and charity, the growth of cities. One example is Claes Berchem's *Allegory on Amsterdam* (fig. 76). The symbolism here is so diffuse and recondite that it has not yet been wholly deciphered; a

77

78

77–80 Jacob Matham after Hendrick Goltzius
 The Four Elements: Earth, Air, Fire, Water

81–84 Anonymous after Hendrick Goltzius
 The Four Elements: Earth, Air, Fire, Water

79

80

81

82

83

84

pantheon of classical deities is present, including Jupiter, Neptune, Venus, and Minerva, and they are apparently paying homage to a beautiful woman (the Maid of Amsterdam?), who holds a map showing the 1612 expansion plan of the city.

Alongside all this, the tradition continued of portraying the elements, the virtues, the senses, and the seasons. Characteristically, certain mutations took place: in the traditional rendering of these series, an attribute changes an ordinary figure into a personification, usually in a religious or mythological context; now there arose a parallel tendency toward profane figures or everyday scenes. Haverkamp Begemann calls this phenomenon "the trend toward a realistic camouflage of allegories," and he demonstrates the development by referring to, among other things, the depiction of the elements.[1] In the sixteenth century, the four elements—earth, air, fire, and water—were customarily represented by idealized persons accoutred with the relevant attributes. For instance, in 1588 Jacob Matham made engravings of the four elements, after examples by Goltzius, as nude figures (figs. 77–80). In 1606 the next development became clear. An anonymous engraver, again after Goltzius, depicted the four elements as persons derived from reality: "earth" is symbolized by a hunter with the spoils of the chase, "air" by a falconer, "water" by a fisherman, and "fire" by a cook (figs. 81–84). Buytewech, finally, as engravings after him by Jan van de Velde

85

86

85–88 Jan van de Velde after Willem Buytewech
The Four Elements: Earth, Air, Fire, Water

89–93 Jan Miense Molenaer
The Five Senses: Touch, Sight, Sound, Smell, Taste
Signed (all except *Sound*) and dated 1637 (*Touch*
only). Panels, each 19.5 × 24 cm. Mauritshuis,
The Hague

87

88

show, eliminated the personification entirely and was content with scenes from daily life: "earth" is a marketplace; "air," a *vinkenbaan* or shooting and trapping range for small birds, and hunters out on the hills; "fire," peat being unloaded, with a roof ablaze at the left and men setting a fire at the right; and "water," a quayside fish market, with anchored boats, and fishermen talking to villagers (figs. 85–88).

The representation of the five senses in the seventeenth century also shows a trend toward scenes of daily life. If five little panels by Jan Miense Molenaer had not been kept together, they probably would not now be recognized as one series of the senses (figs. 89–93). The same artist also transformed the senses into a family group (fig. 94). This was not just Molenaer's joke; quite the contrary, it was seventeenth-century thinking that prompted him to give this prim and proper family an extra meaning. Today these *double entendres* can often no longer be interpreted. Prints, drawings, and paintings sometimes have captions or headings that give a clue. Droochsloot's drawing of an inn scene (fig. 95) is clearly labeled "De vijf sinnen" (The Five Senses).

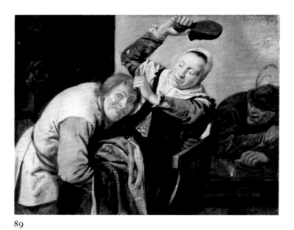

89

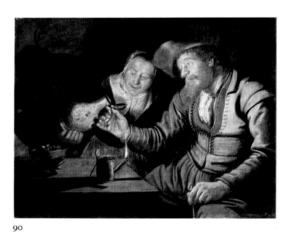

90

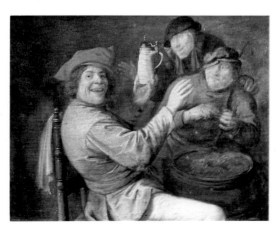

91

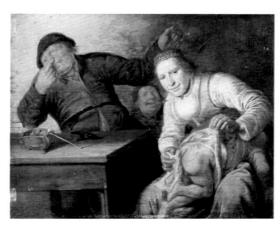

92

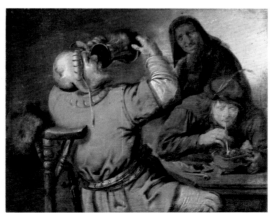

93

94

94 Jan Miense Molenaer
The van Loon-Ruychaver Family
Signed. Canvas, 57×94 cm. Van Loon
Foundation, Amsterdam

95 Joost Droochsloot
The Five Senses
Signed. Pen and bister, red chalk, 18.5×30 cm.
Museum der Bildenden Künste, Leipzig

96 Title page of *Sinnepoppen* by Roemer Visscher,
Amsterdam, 1614

97 *"Happy Slavery"* from Jacob Cats, *Sinne- en
Minnebeelden*

95

96

97

Motifs from daily life had been used much earlier, of course, to reflect certain ideas. Hieronymus Bosch's renowned tabletop, with its seven sins painted in little scenes (see fig. 129), is a mine of information about the situations and attributes he chose to employ. Inn scenes, brothels, and similar subjects were already being painted in the sixteenth century to expose the evils of dissolute living and the dire consequences of drinking. More will be said about this later.

Other clues to the seventeenth century's way of thinking and the manner of expressing this in art can be found in the emblem books of the time, volumes containing pictures accompanied by strongly moralistic texts explaining the picture in one or more ways. There was usually a threefold arrangement: a motto, a picture, and a commentary, sometimes in verse, sometimes in prose. Roemer Visscher, Amsterdam merchant, poet, and advocate of the Dutch language, coined the word *Sinnepoppen* to use as the title of his emblem book, published in 1614 (fig. 96). In his introduction he defines a *sinnepop* as "a short, pithy utterance which at first sight cannot be understood by every Tom, Dick, and Harry, yet is not so obscure that, by guessing, one may not hit yea or nay; nevertheless, some reflection and deliberation are required in order to savor the sweetness of the kernel or pill."[2] In his biographical sketch of Otto van Veen, Houbraken says, "To show that his intellect was capable of everything, he made a long series of emblems or symbolical pictures, a work only for geniuses."[3]

It is evident that the emblems were not immediately understandable even to contemporaries and that a certain amount of training and skill was necessary to catch and enjoy their full meaning. Yet emblem books were extremely popular and often went into many editions. Some were written in Latin—games for the erudite. Others, such as the

98 Adriaen van de Venne
"Miserable Legs Carry the Poor"
Panel, grisaille, 62 × 50 cm. Museum Boymans-
van Beuningen, Rotterdam

statesman-poet Jacob Cats's *Sinne- en Minnebeelden* (Sense and Love Emblems) of 1627, appeared in the vernacular and became almost household items. Cats usually chose quite simple little pictures of everyday objects, animals, or situations, as with his caged parrot labeled "Happy Slavery" (fig. 97). He then provided a commentary which explained each picture in three ways: amorous, social, and religious. The whole is moralistic, the amorous explanation serving as a magnet to draw out the Christian interpretation.

The tendency to give simple objects or situations a second, symbolic meaning was deeply rooted in seventeenth-century thought. Roemer Visscher's first *sinnepop* was, "Nothing is empty or meaningless," which he illustrated with a flask submerged upside down yet taking in no water because it is filled with air: just so does God fill everything. The painters of the time made grateful use of the possibilities suggested by aphorisms like this, and it is even probable that many subjects would never have been painted at all if their double meaning, whether erotic or moralistic, had not been so commonly understood.

The lapse of centuries makes it difficult for us today to play the exciting seventeenth-century game of searching out the double meanings that lie behind many paintings. A thorough knowledge of contemporary literature in general and of emblem books in particular is required, as well as a sensitivity to verbal nuances and values. I shall therefore limit myself mainly to examples that are least obscure, have been published by other writers, and seem to me trustworthy.

The search for the symbolism, the double meaning, of many seventeenth-century pictures sometimes arouses resistance in people who have been taught to view this art as generically realistic. They feel that "typical Dutch realism" is being attacked. But they are wrong, for this matter-of-fact realism combined with a profound desire for moralization was precisely typical for that day and age. It regularly appears in Dutch literature. The poet-playwright Gerbrand Adriaensz Bredero, always considered the most realistic writer of his time, says of himself in the preface to his *Geestigh Liedt-Boecxken* (Witty Songbook) of 1621: "Some nose-wise and narrow folks, being prejudiced, will accuse these my little songs of frivolity, even before they take the trouble to find out why, wherefor, and how [the songs] were made. They will scarcely believe that I am describing the follies of some people humorously, gently reproving, and showing up their mistakes before the eyes, admonishing and giving other warnings, so that they may cleverly avoid these paths of error."[4] Many a painter could have used the same words to defend his "jolly company" or brothel scene from the criticism of his contemporaries, and he indeed often did defend himself, not in words, but in his own way: by adding details to make it very clear that his picture contained a warning.

An artist could of course most easily ensure that his purposes were understood by appending a text to his painting. This was done by many painters of *vanitas* still lifes, which by definition were expressions of the inevitable perishing of human beings and earthly possessions—in other words, intrinsically moralistic works. Favorite inscriptions were *Vanitas vanitatum, Memento mori, Sic transit gloria mundi,* and the like. On an emblematic still life by Torrentius (Jan van der Beeck) appears, "That which exists out of measure perishes in evil immeasurably" (see fig. 421), which may be considered a sort of painted *sinnepop.* Adriaen van de Venne, who illustrated many emblem books, also supplied a number of his paintings with texts; his grisaille of a blind beggar with his wife and child on his shoulders has the legend "Miserable legs carry the poor" (fig. 98). In Jan Steen's work, too, inscriptions frequently provide the key to the intended meaning of the picture (see cpl. 101).

A second method by which an artist could clarify his intentions concerning an interior scene was to include a painting on the back wall to explain the whole situation. Two

101

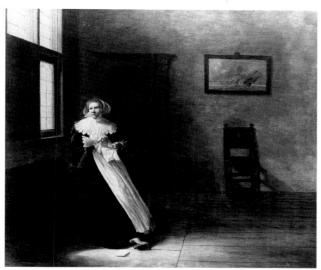

99

100

99 Dirck Hals
 Young Woman Tearing Up a Letter (Love Rejected)
 Signed and dated 1631. Panel, 45.5 × 56 cm.
 Mittelrheinisches Landesmuseum, Mainz

100 Dirck Hals
 Young Woman Holding a Letter (Love Requited)
 Signed and dated 1633 (?) Panel, 34.3 × 28.3 cm.
 John G. Johnson Collection, Philadelphia

101 Jan Steen
 Easy Come, Easy Go
 Signed and dated 1661. Canvas, 79 × 104 cm.
 Museum Boymans-van Beuningen, Rotterdam

paintings by Dirck Hals exemplify these pictures within a picture.[5] Both show a room in which a woman is sitting with a letter in her hand; a painting hangs on the wall behind her. In one of them (fig. 99), the woman is tearing up the letter, and the background painting depicts a small ship on a rough sea. In the other (fig. 100), the woman is smiling, and her painting shows a small ship on a smooth, calm sea. For the seventeenth-century viewer these representations indicated, respectively, love rejected and love requited. Since we today are less accustomed to the symbolism of rough and smooth seas, we must consult literature for corroborative evidence. And, in Jan Harmensz Krul's *Minne-beelden: Toegepast, de Lievende Ionckheyt* (Love Emblems: Adapted for Young Lovers), published in Amsterdam in 1634, we find the following: "Love may rightly be compared to the sea, considering its changeableness, which brings in one hour hope and in another hour fear: just so does it go with a lover as with a skipper embarking on the sea, one day good weather, another day storm and howling wind."

A third way for a painter to transmit his meaning to a viewer was to include one or more objects, or a scene in the background, to serve as clues to the veiled symbolism of the main theme. In his Introduction,[6] Samuel van Hoogstraeten put it succinctly:

To ornament a single piece most dearly,
'Tis best by sundry means to improvise
Accessories that its deck'd gist revealeth:
An artful play on art it doth comprise.

Some of the seventeenth-century meanings of these "accessories" are relatively easy for us to fathom today because the symbolism of the objects has changed little over the years. In other cases, however, where the *double entendre* of an object or situation has been lost, it is harder to dig out the original intention. A good example is Jan Steen's painting *Easy Come, Easy Go* (cpl. 101). The main scene is of a prosperous-looking man eating and drinking at a table, attended by a servant on either side. Without going into detail, let me point out, as an "accessory" that the "deck'd gist revealeth," the painting above the mantel portraying the goddess Fortuna, with a view of sinking ships behind her. To left and right are putti symbolizing poverty and wealth. In the left background a doorway permits a glimpse of two men playing trictrac, an old form of backgammon.

Fortuna has never lost her identity as a personification of luck's ups and downs, and the game of trictrac, like all games of chance, has long had a disreputable connotation. A sixteenth-century print by Heinrich Aldegrever shows Socordia or Improvidence holding cards in one hand and a trictrac board—sometimes called a "traffic" board—in the other

VERKEERDEN YVER

102 Heinrich Aldegrever
 Socordia or Improvidence
 1549. Etching

103 Cornelis Anthonisz
 Wealth and Idleness
 Woodcut

104 Jan van de Velde
 "Verkeerden Yver"
 Engraving

105 Dirck Hals (attributed)
 Brothel Scene
 Pen and bister, brush in gray, and pencil,
 19.9 × 32.2 cm. Teylers Museum, Haarlem

(fig. 102). Cornelis Anthonisz took over this example almost literally for his woodcut *Wealth and Idleness* (fig. 103). In the seventeenth century, as it became more customary to transfer symbolism to scenes from daily life, a print by Jan van de Velde (fig. 104) was given the punning title *Verkeerden Yver*, which can mean either Misplaced Zeal or something like Traffic Jam (in itself suggestive of further nuances), as well as a four-line rhyme below:

How lightly one traffics one's hard-earned cash,
And proceeds idly to the host and his hostess;
Though the children and wife are starving at home,
Still, day or night, one hies to the pothouse.

Jan Steen gave his viewers the clues of Fortuna, the sinking ships, and the trictrac players, making it abundantly clear that he was painting a picture not merely of a rich man at home, but also of the fickleness of human fate and the perils of luxurious living. To cap it all, he added to the mantelpiece the motto "Easy come, easy go."

 Card playing, dice throwing, trictrac playing, smoking, drinking—all signs of profligacy and often introduced into depictions of brothel scenes—are shown in a drawing attributed to Dirck Hals (fig. 105). Civil authorities time and again banned gambling with dice, cards, and trictrac, and preachers fulminated from their pulpits against this kind of gaming, and sometimes against ball playing as well. Balls and a ring lie at Improvidence's feet in Aldegrever's print; they were used in an outdoor game called ball-shooting.

 Jan Steen's *Easy Come, Easy Go* presents few difficulties of interpretation for us today—the symbolism is still familiar and lightly veiled. When what is veiled is erotic, however, things can become more difficult. Countless innocent-looking little scenes turn out, on closer examination, to be considerably less than that. One notable example is Gabriel Metsu's small masterpiece, still listed in the Amsterdam Rijksmuseum's catalog as *The Hunter's Present* (fig. 106). Most of us are accustomed to viewing seventeenth-century art aesthetically, and it may seem farfetched to discover the eroticism in Metsu's charming scene. Yet de Jongh's acute analysis of this painting,[7] supported by many examples from literature and art, cannot be gainsaid. As he points out, the word *vogelen* or *veugelen*—fowling—is the key to this painting. A dictionary of Middle Dutch defines it first as bird-catching, especially of waterfowl, and second as the copulation of animals or human beings. That the visual arts also used both these meanings is borne out by this dialogue accompanying an engraving of a man selling poultry (fig. 107): "How much for this bird, fowler? It's already sold. To whom? To a landlady where I go fowling all year." The man's unmistakable fumbling in his breeches and the abundant carrots (a standard phallic symbol) reinforce these innuendos. Dutch literature affords innumerable examples of the presentation of gamebirds as an invitation to "fowling." "Going hunting" had the same double meaning, with the gun symbolizing the male sex organ; the verb *naaien* (to sew) was a

106 Gabriel Metsu
The Hunter's Present
Signed. Canvas, 51 × 48 cm. Rijksmuseum,
Amsterdam. On loan from the City of
Amsterdam

107 Gillis van Breen after Claes Jansz Clock
The Poultryman
Engraving

synonym then as now for sexual intercourse; the dog symbolized both loyalty and sensuality (notice the dogs in Dirck Hals's brothel scene); and a shoe could be an erotically charged object, indicating a woman's power over a man (under her heel), the woman herself ("old shoe" meant a woman who had had a string of lovers), or the female genitalia. The piquant nuances of Metsu's painting cannot escape us, especially when the artist crowns the armoire with a statuette of Cupid.

One must be careful about interpreting seventeenth-century paintings in this way; it is easy to start digging everywhere for hidden meanings. During the course of the century, the moralistic or symbolic aspect of paintings became diluted. Increasingly, buyers were uninterested in such things, or perhaps not sufficiently schooled to be able to puzzle out a meaning. For this reason, unless there are ample clues pointing in the same direction, one cannot begin to unveil the "deck'd gist" with any certainty. It is important, however, to have it established that the seventeenth century's fascination with emblems carried over into painting. The century was saturated not only with symbolism but with a profound impulse to moralize as well, yet this enhanced rather than limited the free expression of things erotic. In our discussion of various subjects, all this will continue to play a role.

Something to Paint

History Painting and the Depiction of Contemporary Events

In the hierarchy of subject matter, we have seen that the rendering of "history" ranked highest. Yet no Dutch writer in the seventeenth century defined precisely what the term meant; perhaps it was considered self-explanatory. Van Mander described history painting as "figures and histories," and when Constantijn Huygens discussed the subject, he began with an apology: "The Netherlands in my time has brought forth no fewer history painters [than landscape painters], as I am wont to call them, perhaps not wholly correctly, and certainly no less talented."[1] To our amazement, besides such well-known history painters as Lastman, Pynas, and the Utrecht Caravaggists, he then proceeds to list Frans Snijders, a painter of animals and kitchen scenes.

Among the writers on art, van Mander describes the compositional and structural requirements of history painting in his chapter "On the Ordering and the Invention of Histories,"[2] and from his examples it can be determined that under history he included stories from the Old and New Testaments, mythology, classical history, and literature. Allegory belonged here also; he cites an allegory of the Nile River and of the personification of cities, among others. In his turn, Hoogstraeten added the painting of "whole land and sea battles" and introduced contemporary history as well.[3] Whether he was also thinking of paintings in which the human figure plays a subordinate part—as in the sea battles by Willem van de Velde—is not entirely clear. In any event, a bit further on in this passage he says definitely that he means paintings "that display the noblest actions and... the wisest creatures to mankind." And if the subject meets the requirements of a history painting but does not make the viewer sufficiently aware of "wisdom or the human soul," the painter does not belong in the third or highest grade. Hoogstraeten then draws a direct parallel between the history painter and the tragic poet. Lairesse does not commit himself; he mentions more or less all the subjects not worthy of being painted,[4] but provides no clear definition of the history painting.

To arrive at a conception that does not differ too greatly from the seventeenth-century view, we might offer the following definition: a history piece is any painting in which the human figure plays the main role and the subject matter is derived from the Bible, history, mythology, or literature, including allegory.[5]

Lairesse remarked, interestingly enough, that seventeenth-century painters had actually made very limited use of these inexhaustible sources: "Nothing surprises me more than that, where so many histories have been written in the Holy Scriptures, one sees so few depictions and varied renderings of them."[6] Pointing out that the subjects chosen were always the same as those already painted, he accused his contemporaries of ignorance and negligence for apparently thinking that earlier artists had claimed the best subjects. Lairesse's

108 Cornelis van Wieringen
The Capture of Damietta
Painted for the St. Andries Doelen, Haarlem.
1628. Canvas, 101 × 230 cm. Frans Hals Museum, Haarlem

comment is largely true: a fairly rigid tradition seems to have governed the choice of history subjects, and even Rembrandt did not venture far from it.[7]

This phenomenon may be related to a desire, in certain situations and for certain purposes, to have history paintings of a moralistic tenor easily understood by everyone. People sought parallels for contemporary events in ancient history and the Old Testament; side by side was their clear wish to discover in their own past any and all events attesting to the heroic deeds of their forefathers.[8] The subject of Otto van Veen's series of twelve paintings for the States-General was the revolt of the Batavi against the Romans (see fig. 44), an example of a brave and successful ancestral struggle against foreign rule. The same subject was later chosen as main theme for the decoration of the Amsterdam town hall. Pseudohistorical events, too, were sometimes used in a similar way. The capture of Damietta, a port on the Nile, by a small Haarlem boat is one example: this military adventure took place in 1188, according to the natives of Haarlem. While historically doubtful, it was not entirely impossible, since Damietta was a frequent target of the Crusaders, and these included many a Netherlander. The story kept cropping up as a popular theme after the beginning of the sixteenth century, and both Vroom and van Wieringen used it in the early seventeenth century in paintings commissioned by the Haarlem town council (fig. 108).

In many town halls throughout the Republic, the courtroom was decorated with a picture whose purpose was to remind the judges of the great responsibility pertaining to their office. Bible stories such as the Last Judgment and the Judgment of Solomon were thought fitting, as were certain subjects from classical writers. But local legends were also used. One of the most popular was "The Judgment of Count Willem III" (or Willem the Good), an event that supposedly took place in 1336. The story went as follows: The bailiff of South Holland forced a farmer to give him his good cow in return for a poor one. Since the cow was the farmer's entire means of livelihood, he complained to the count. Although the count was sick in bed, he thoroughly examined the case, judged in favor of the farmer,

109

110

109 Claes van der Heck
The Judgment of Count Willem III of Holland
Signed and dated 1618. Panel, 130 × 210 cm.
Stedelijk Museum, Alkmaar

110 Caesar van Everdingen and Pieter Post
Count Willem II of Holland Granting Privileges
1654. Canvas, 218 × 212 cm. Collection
Hoogheemraadschap van Rijnland, Leiden

and, in his own bedroom, had the bailiff beheaded by an executioner. This tale was thought to be ideal adornment for a courtroom; Claes van der Heck painted it for the town of Alkmaar in 1618 (fig. 109), and in 1657 the town of Hasselt took unusual measures to acquire a picture on the same theme (see p. 31 and fig. 19). It was also reproduced many times in print form, as a sort of early comic strip.

Themes also became linked to particular settings. Organ shutters, for example, were usually ornamented with episodes from the life of David as harpist and psalmist (see fig. 24).

The desire to add a new dimension to national history produced a fairly large number of pictures based on such themes as the granting of privileges to a municipality or polder, the awarding of a coat of arms, or the gaining of other distinctions. A fine example of this is Caesar van Everdingen's 1654 painting representing Count Willem II of Holland granting privileges to the Rhineland district water-control board in 1255 (fig. 110). The count is seated on a throne and holds the parchment charter in his hand as he receives the dike reeves. At lower right appears a relief showing Mercury and Pallas Athena holding the Spaarndam sluice gates shut against the sea, symbolized by Neptune on his sea horse: the duties of the water-control board were to defend the land against the sea by might, money, and ingenuity. The façade in the background faithfully links up with the original architecture and was painted by Pieter Post, the architect of the board's new building in Halfweg (between Amsterdam and Haarlem), for which the painting was commissioned to celebrate the fourhundredth anniversary of the event depicted.

Among the requirements set for history paintings, historical "accuracy" was loosely construed. A painting had to include certain recognition factors, but otherwise the artist had considerable liberty. Lastman without qualm placed contemporary silver objects, for example the ewer made in 1614 by Adam van Vianen (fig. 111),[9] in the foreground of both mythological and biblical compositions, such as his 1618 painting *Tobit and Tobias with the Angel* (fig. 112). The buildings in his paintings are reminiscent mainly of Roman palaces or ruins, whether or not these suited the time and place of the story.

The same thing happened in literature. In 1637 Joost van den Vondel, his conscience clear, used the just completed Amsterdam Bourse as a setting in his drama *Gijsbrecht van Aemstel*, although the action in the play—Lord Gijsbrecht's defense of beleaguered Amsterdam—takes place a few years after the murder of Count Floris V of Holland in 1296; in other respects the playwright attempted to portray the thirteenth-century town accurately. Both Lastman and Vondel were well aware of the anachronisms they committed, but presumably considered them within the bounds of artistic license.

In his "Praise of Painting," Philips Angel gives a true glimpse of the relativity of any need for sticking to facts: "It is most praiseworthy... to rummage about industriously in musty old books and to gain knowledge of histories... then, if we want to express this in drawings, plates [prints], or paintings, [we] must add our own high reflections, in order the better to blend in our permissible freedom without injuring the sense of the histories but to

111

112

111 Adam van Vianen
 Gilded Silver Ewer
 1614. Height 25.2 cm. Rijksmuseum, Amsterdam

112 Pieter Lastman
 Tobit and Tobias with the Angel
 Signed and dated 1618. Panel, 62 × 93 cm. Statens
 Museum for Kunst, Copenhagen

113 Caesar van Everdingen
 Diogenes Searching for an Honest Man
 Signed and dated 1652. Canvas on panel,
 76 × 103.5 cm. Mauritshuis, The Hague

114 Hendrick Goltzius
 Susanna and the Elders
 Signed and dated 1607. Panel, 67 × 94 cm. Musée
 de Douai, France

further adorn our work, as the Ancients have done, and many of the currently celebrated intellects still do."[10] The message is clear: one must study and know history, but one has the complete liberty or even the responsibility to add one's own inventions, as long as they do not damage the basic core of the history. It is important to keep this precept in mind, for it was the fundamental seventeenth-century approach not only to history painting but to other subject matter as well.

This conscious anachronism appears now and then in portraiture, leading to most curious results. In 1652 Caesar van Everdingen depicted Diogenes with his lantern in hand seeking an "honest man" in a seventeenth-century Dutch public square (fig. 113). The people around him are apparently portraits (formerly identified as members of the Steyn family of Haarlem).[11] It is as if, in this painting, a late medieval tradition has reemerged, and biblical or classical episodes have become contemporary scenes, their main historical characters now also portraits of living people.

Although van Everdingen's painting is an extreme example, it was not unusual to put portraits into biblical or mythological pictures. Goltzius included his friend Jan Govertsz (at the right) in *Susanna and the Elders* (fig. 114), and Rembrandt added his own portrait at various times to biblical paintings, including some in the Passion series (see fig. 585). Worth noting is that both Goltzius and Rembrandt cast the person portrayed as a sinner.

Besides the deliberate liberties that a painter permitted himself, real mistakes of course also crept in, often occasioned by a lack of knowledge. This is seen especially in the costumes and objects used. But this phenomenon is of lesser interest in our attempt to fathom the mentality of the painter.

The artist's own imagination sometimes played a larger role in history paintings, and the historical accuracy of the accessories was deemed of less importance. It is interesting to examine the way seventeenth-century artists depicted their own contemporary history. We find, remarkably, that faithfulness to facts was a relative matter even there. The rendering of actual events, however, is not strictly within the limits of the history painting. The

113

114

115 Jan van Goyen
River Landscape with the Hooglandse Kerk, Leiden
Signed and dated 1643. Panel, 39.8 × 59.5 cm.
Alte Pinakothek, Munich

116 Willem van de Velde the Elder
The Battle of Terheide
Signed and dated 1657. Pen painting on canvas,
170 × 289 cm. Rijksmuseum, Amsterdam

116a Detail: Willem van de Velde in his galliot

invention of photography has accustomed us to seeing "real" pictures of what is going on, however subjective these photographs may in fact be. This has greatly influenced our way of looking at things, including how we see the art of the past. The realistic tendencies of seventeenth-century art were very strong, but they should never be judged by the standards of photographic realism. They offered much greater possibilities and were therefore actually much richer.

Even topographical painting took advantage of these possibilities. Jan van Goyen placed Leiden's Hooglandse Kerk in an imaginary landscape (fig. 115); Jan van der Heyden gathered elements from various cities together in a sort of idealized townscape; and Jacob Matham combined the town house and the country estate of his patron in one painting (see fig. 64).

Among representations of seventeenth-century history, a distinction can be made between firsthand reporting and the depiction of events that had occurred some time previously. The painter or draftsman was seldom present at the event, especially when it involved military action. Not until the second half of the century did the marine painter Willem van de Velde the Elder accompany the fleet and make drawings of battles from his galliot, sketches he later turned into his famous "pen paintings" (figs. 116 and 116a), which will be discussed on pages 306–7. But in most cases the artist used information provided by others, whether the event had taken place recently or long before.

Firsthand reporting came almost exclusively through prints, the only medium for a rapid dissemination of news on a fairly wide scale. The prints were always supplied with an explanation or even an extended account, and these "flysheets" and "newsletters" were the forerunners of newspapers. War reporting was published this way, but news was not limited to battles and sieges. Ceremonial processions; the births, marriages, and funerals of royal or distinguished personages; festivities to welcome important guests (fig. 117); and unusual phenomena of nature—all these were covered. From the verse printed at the bottom of

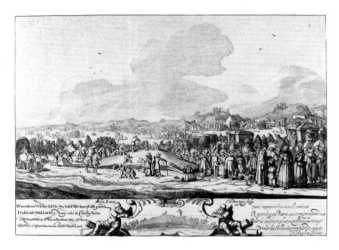

117 Salomon Savery after Simon de Vlieger
*Festivities on the Amstel River in Honor of Maria de'
Medici's Visit to Amsterdam, 1638*
Engraving

118 Cornelis van Kittensteyn
A Sperm Whale Stranded near Noordwijk, 1629
Etching

Cornelis van Kittensteyn's etching of a stranded sperm whale (fig. 118), it appears that strange natural events were sometimes considered ill omens, for the last line reads: "God, please turn evil away from us and our dear Fatherland." Prints were used for political purposes as well: the public was inundated with political broadsheets and cartoons, in which the opponents in the Eighty Years' War fought paper battles to gain sympathizers.

A number of publishers specialized in these newsletters, and they of course needed to obtain pictures of, say, a sea battle as soon as possible. This need occasionally led to what now seem curious practices. Old plates were sometimes reissued, slightly changed and with revised texts. To scoop the Battle of the Downs (Goodwin Sands) in 1639, for instance, Claes Jansz Visscher used an old copperplate of a sea battle off the coast of Bantam, near Java in the East Indies, that had taken place in 1601. Portrait penny-pinching was also not unknown: a print by Crispijn de Passe showing Prince Maurits at the Battle of Nieuwpoort in 1600 was later published again with a new head resembling later portraits of the stadholder. The second print was perhaps issued to enhance the prince's popularity during his quarrels with Johan van Oldenbarnevelt in 1618–19 (see p. 177). Later the same print reappeared, this time as a likeness of King Gustavus Adolphus II of Sweden.[12]

It goes without saying that a painting was not a useful means of spreading news. With rare exceptions, a painting of an important military action was executed exclusively on commission and usually a considerable time after the event. In 1621 the Amsterdam Admiralty commissioned Abraham de Verwer and Cornelis van Wieringen to paint the Battle of Gibraltar (see fig. 43), which had taken place in 1607. The Battle of Haarlemmermeer, fought in 1573, was depicted in 1629 by Hendrick Vroom on commission of the Haarlem magistracy (fig. 119); and the Battle of the Zuider Zee, also fought in 1573, was rendered in a large painting by Jan Blanckerhoff for the Hoorn town hall some three quarters of a century later.

In the Northern Netherlands the paintings of the war at sea exceed those of the land war both in quantity and quality; the opposite is true in the Southern Netherlands. Given the northerners' seafaring nature, this is not surprising, but another reason was probably that the top naval officers were all Hollanders, whereas the army command was made up of noblemen, most of them foreigners, in the stadholder's entourage. Most of the pictures of land warfare were of the stadholder's spectacular victories, at the Battle of Nieuwpoort (fig. 120) or the siege of 's-Hertogenbosch. A few events, although unimportant to the outcome of the war, had enormous popularity. One such was Gerard Abrahamsz Leckerbeetje's skirmish on Vucht Heath in 1600, its insignificance recorded in an extraordinary number of prints and paintings, one of them by Joost Droochsloot (fig. 121).

As a form of history painting, the allegorical picture occupied a prominent place. Having been launched successfully in sixteenth-century prints, it continued to be popular for decades to come. Allegorical paintings were almost exclusively official commissions. All important events, from the birth or death of a member of the House of Orange to public fortunes and misfortunes, were recorded in allegorical pictures and poems, and nothing was overlooked in heralding the similarities between these and like events in mythology and biblical history. Hendrick Pot's *Glorification of William of Orange* in the Haarlem town hall has already been mentioned (see p. 48). In the Oranjezaal of the Huis ten Bosch, Caesar van Everdingen's picture celebrating Frederik Hendrik's birth shows Minerva and Mars in attendance, with the infant prince and the Netherlands lion in the forefront (fig. 122); on a side panel Frederik Hendrik is symbolically portrayed as the young Hercules overpowering the snakes. The same occurs in state portraits: Amalia van Solms had herself painted as

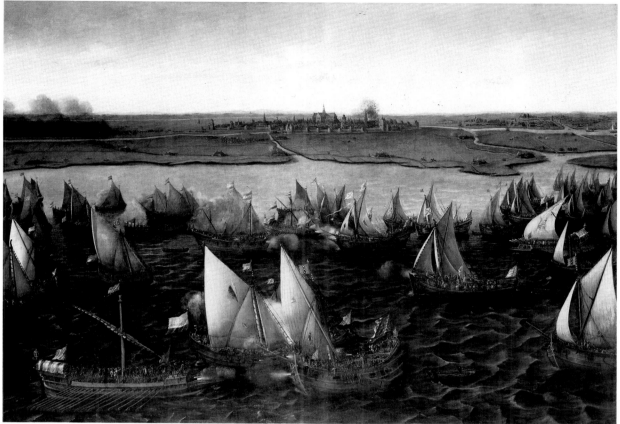

119

119 Hendrick Vroom
The Battle of Haarlemmermeer
Signed. 1629. Canvas, 190 × 268 cm.
Rijksmuseum, Amsterdam

120 Pauwels van Hillegaert
The Battle of Nieuwpoort
Signed. Panel, 82.5 × 117.5 cm. Rijksmuseum,
Amsterdam

121 Joost Droochsloot
The Battle on Vucht Heath
Signed and dated 1620. Canvas, 65 × 94.5 cm.
Private collection

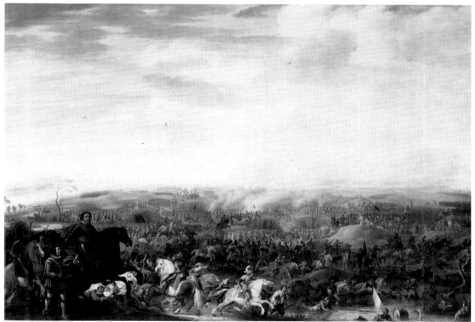

120

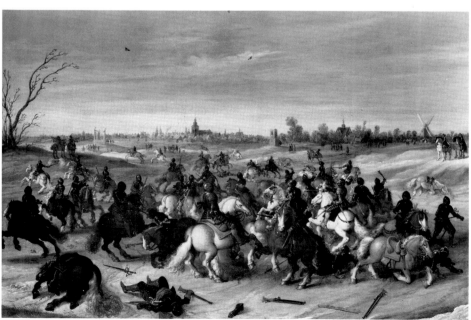

121

Diana, and the Winter Queen as a shepherdess. After the glorious raid on Chatham in 1667, during the Second Anglo-Dutch Naval War, the city fathers of Dordrecht commissioned Jan de Baen to paint an allegory of their fellow townsman Cornelis de Witt, who had sailed along with the fleet as delegate of the States-General (fig. 123).

History and allegory were closely intertwined in seventeenth-century minds. Prints had spread the allegorical language of form and content, and it may be safely assumed that a large part of the educated population had little trouble understanding the message.

Except for pictures of sea battles, which we will discuss later, official commissions were limited to allegories and to various themes from biblical and ancient history. In addition, throughout the century there was a continuing demand on the open market for pictures

122 Caesar van Everdingen
Allegory on the Birth of Prince Frederik Hendrik
Signed. c. 1650. Canvas, 373 × 243 cm.
Oranjezaal, Huis ten Bosch, The Hague

123 Jan de Baen (copy after a lost painting)
The Apotheosis of Cornelis de Witt, with the Raid on Chatham in the Background
Canvas, 75.5 × 102 cm. Rijksmuseum, Amsterdam

based on biblical and mythological subjects. Inventories reveal that, besides landscapes and seascapes, still lifes, and domestic paintings, nearly all art collectors possessed biblical and mythological paintings as well.

In regard to biblical pictures, the question immediately arises whether or not Calvinism influenced the choice of subject, and the answer seems so simple that it is given almost automatically: of course the religion shared by nearly all strata of the population must have affected this choice. Upon closer examination, the issue becomes more complicated. In the first place, the opposition between the Protestant and Catholic faiths was apparently less acute than used to be thought. When the revolt against Spain broke out, most of the people in the Northern Netherlands were Catholic. The Calvinists who succeeded in winning power in the cities were a minority, it seems, and the resistance that this small group increasingly aroused was not directed wholly against Catholicism but had political overtones. Dutch history books state that "the Victory" began at Alkmaar in 1573, and the reader tends to assume that the entire population of this town was so united in its religion that it rose as one man against the Spanish foe. Nothing could be less true. Although statistical data are in short supply, we do know that in 1576—three years after the victory—the Dutch Reformed congregation in Alkmaar was only two and a half percent of the total population; eleven years later, in 1587, this percentage had risen to eleven. Smaller Protestant sects, such as the Mennonites, are not included in this count, but they would have increased it only slightly. By the middle of the seventeenth century, to be sure, the majority of the populations of Holland, Zeeland, Friesland, and Groningen was Protestant. Yet it is clear that, in the Northern Netherlands, Catholicism survived the eighty years' struggle between the faiths more successfully than has been realized.[13] This was in part because the pervasive tolerance, stemming from the moderate Calvinists, permitted freedom of religious conviction, although freedom of public worship was banned. Apart from a hard core of Calvinist fanatics, the great majority of the Protestants no doubt lived amicably enough alongside the Catholics. Another ameliorating factor was formed by the Christian humanists. Drawn mostly from intellectual and academic circles, this group had arisen

during the sixteenth century under the influence of the great Erasmus of Rotterdam—scholar, theologian, and Renaissance humanist. Throughout the seventeenth century humanism continued to thrive in the Netherlands.

Against this multifaceted background, the question can be examined of the religious, especially Calvinist, influence on Dutch painting. It seems clear that an artist's depiction of biblical subjects need not be construed as his membership in any particular sect or creed. Since the Reformed Church did not give commissions, it did not tell painters what to paint. In the marketplace the demand persisted for biblical pictures, and to meet it artists continued to rely on tradition, although slight shifts took place here and there. Certain subjects—the Fall of Man and the Last Judgment—are rarely encountered in seventeenth-century Dutch art. But whoever supposes that the lives of the saints or the adoration of Mary disappeared from the repertory of Protestant painters need only look at such subjects as Saint Jerome and the Death of the Virgin by Rembrandt and his pupils to see that the opposite is true.

The prints and illustrated books published during the sixteenth century provided artists of subsequent generations with an inexhaustible source of examples based on stories from the Old and New Testaments and the Apocrypha. Prints by and after Dürer, Lucas van Leyden, Maerten van Heemskerck, Tobias Stimmer, Maerten de Vos, and Stradanus, to name only a few, were well known in the Netherlands and were collected by Dutch artists. Illustrated Bibles were in nearly every household. Artists not only mined this treasury of examples, they carried on the same tradition; and this characterizes the rendering of biblical subjects in Dutch art, particularly those by Rembrandt and his pupils. In addition, the work of the Italians and of Rubens and van Dyck served as models for the figure painters in the Utrecht and Haarlem schools. The art of the Northern Netherlands was not affected by the edicts of the Council of Trent, which in 1563 had banned many motifs and established new guidelines for art in the service of the Counter-Reformation in southern Europe.

Figure Paintings

Paintings that depict highly varied scenes of daily life are commonly called genre paintings. The first use of the word "genre" in this context presumably occurred in some as yet untraced eighteenth-century French source. The word was not used in the seventeenth century; it originated at a time when such pictures were thought to be purely realistic renderings of daily life, although an occasional painting was recognized as being related to the Prodigal Son theme, say, or to representations of the five senses. Friedländer defines this group of paintings by elimination: "Genre is a vague term with uncertain limits, easier of negative than of positive definition. Whatever is *not* of historical, religious, or mythological significance in a picture dealing with man and his activities, whatever is *not* characterized, exalted, or consecrated by knowledge, thought, or faith, falls in the category of genre."[14] And Martin declares these paintings to be "no more than the depiction of daily life" in which events of little or no purport are usually portrayed.[15] All of these views fall short in not recognizing that a large proportion of "genre" paintings have a moralistic or symbolic meaning.[16]

In the seventeenth century many different words were used to designate the themes found in these paintings. A picture of a merry group was called a "company" or a "pleasantry"; a guardroom scene was known by the Dutch as a *kortegaard*, a corruption of *corps-de-garde*; a peasant scene was a "peasant company" or simply "peasants"; and so on. Hoogstraeten uses, among other terms, "painters of small trifles," "drolleries," "millers' taphouses."[17] It is noteworthy that such a picture was often rather specifically described in seventeenth-century listings. Vermeer's painting known variously as *The Kitchenmaid*, *The Cook*, *The Milkmaid*, and *Woman Pouring Milk* (see fig. 981) was listed in an Amsterdam auction of 1696 as "A maid pouring out milk."

The group of seventeenth-century paintings now designated as genre can therefore not be assigned any name based on contemporary usage. The term "figure painting," however, seems preferable to "genre" and will be used here.[18] A figure painting is characterized by the presence of one or more human figures, otherwise anonymous—thus in principle neither portraits nor historical or biblical personages. These figures play an important if not dominant role in the composition. Borderline cases, of course, constantly crop up. It is difficult to decide whether scenes of recreation on the ice should be classified as figure

124

125

126

paintings or landscapes,[19] or whether some of the people depicted were meant to be portraits.

Various themes had already led to the showing of figures in everyday surroundings in fifteenth- and sixteenth-century art. Representations of the vices and virtues were popular; merry-making groups are found in renditions of the Prodigal Son,[20] the Garden of Love (fig. 124), the wedding of Amor and Psyche or of Peleus and Thetis, and banquet scenes, such as *Mankind Awaiting the Last Judgment* (fig. 125). There are depictions of goldweighers (fig. 126) and notaries, card- and chessplayers (see fig. 5), quacks ("stonecutters," removing "rocks" from the head) and other charlatans (fig. 127)—motifs that appear again and again, yet remain only partly decipherable to us today. What meaning did the peasant scenes, for instance, have for contemporary viewers? That they liked them is certain, as evidenced by the peasant fairs and dances by Pieter Bruegel the Elder (fig. 128), by pictures of rich and poor kitchens, and by many similar subjects.

A systematic examination leading to a meaningful analysis of fifteenth-century sources is not possible here.[21] Let a few examples therefore suffice.

Mention was made earlier of the tabletop (*tabla*), now in the Prado in Madrid, painted by Hieronymus Bosch (fig. 129). The composition is circular, with the figure of Christ in the center; around it, in wedge-shaped segments, are the seven deadly sins; in the four corners of the table are medallions with allegorical depictions of Death, the Last Judgment, Hell, and Heaven. Scenes from daily life illustrate the seven sins, three of which are *Superbia* (pride,

124 Louis de Caullery
Venus, Bacchus, and Ceres with Mortals in a Garden of Love
Panel, 54.5 × 74 cm. Rijksmuseum, Amsterdam

125 Jan Sadeler after Dirck Barendsz
Mankind Awaiting the Last Judgment
Engraving

126 Quinten Metsijs
The Goldweigher and His Wife
Signed and dated 1514. Panel, 71 × 68 cm. Musée du Louvre, Paris

127 Jan Sanders van Hemessen
Removing the Rocks in the Head
Panel, 100 × 141 cm. Museo del Prado, Madrid

127

128 Pieter Bruegel the Elder
Peasant Dance
Signed and dated 1568. Panel, 114 × 164 cm.
Kunsthistorisches Museum, Vienna

129 Hieronymus Bosch
Tabla with the Seven Deadly Sins
Signed. Panel, 120 × 150 cm. Museo del Prado,
Madrid

vanity), *Gula* (gluttony), and *Ira* (anger), each named by the painter in Gothic script. *Superbia* (fig. 130) is represented by a woman facing a richly laden cabinet, around a corner of which a demon holds up a mirror to catch her reflection; a small table at the left holds a vase of flowers, and on the floor is a jewel chest. Through the door at the right another room is visible, with a burning hearth, a man also looking in a mirror, and a cat sitting on the floor. Except for the demon, it is a very homey scene, but one in which every detail emphasizes that the true theme is vanity. *Gula* (fig. 131) gives an equally realistic view of a room in which two men are eating and drinking voraciously, while *Ira* (fig. 132) shows an outdoor scene with two men, one restrained by a woman, in a murderous drunken brawl. In each case the details, too numerous to mention, point up the meaning.

130–132 Hieronymus Bosch
Tabla with the Seven Deadly Sins: Superbia, Gula, Ira

There is little difficulty in discovering a connection between these scenes, thought to have been painted about 1475–80, and seventeenth-century Dutch figure paintings. Not that these pictures by Bosch served as examples (the tabletop belonged to Philip II), but Bosch was one of the first to use metaphors from daily life to illustrate abstractions, and the tradition continued. This metaphorical language is closely related to the parables of Jesus in the New Testament, and it is therefore not surprising that parable themes such as the Prodigal Son had lasting popularity among artists. The graphic artists usually produced a succession of scenes depicting the whole story; the painters mainly chose episodes of the Prodigal Son on his downward path of dissipation, which functioned also as a warning against the dissolute life. Often one episode was selected as the main theme, with other scenes rendered in the

133 Jan Sanders van Hemessen
The Prodigal Son
Signed and dated 1536. Panel, 140 × 198 cm.
Musées Royaux des Beaux-Arts de Belgique,
Brussels

134 Frans Pourbus
The Prodigal Son
Panel, 61.5 × 98.2 cm. Museum Mayer van den
Bergh, Antwerp

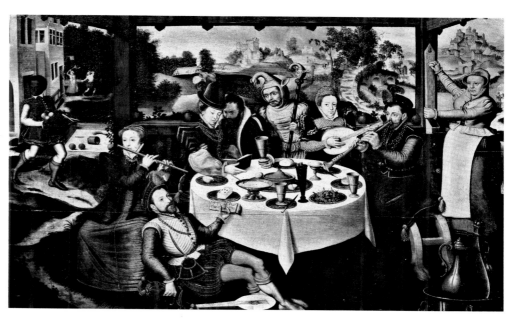

background. The wantonness was represented in rough company, with music provided by peasant bagpipes, as in Jan Sanders van Hemessen's 1536 painting (fig. 133), or in the elegant society portrayed by Frans Pourbus, with more refined instruments (fig. 134).

The Prodigal Son theme continued to thrive in the seventeenth century, but is not always identifiable as such in "merry company" pictures. It can be recognized with a large degree of certainty in one of David Vinckboons' paintings entitled *The Garden Party* (fig. 135), especially if this work is compared with an etching after it by Claes Jansz Visscher, one of a series of four on the Prodigal Son (fig. 136). That the painting, in motif and composition, also harks back to representations of the Garden of Love, another popular theme in the fifteenth and sixteenth centuries, seems unmistakable.

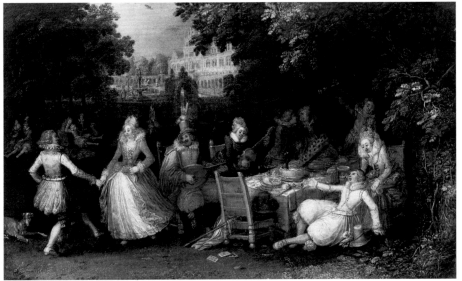

135

Ille iugo excuffo vernans florente iuventa.
Deficere haud fperans unquam fibi poffe crumenam.
Fornix confumit grave olenti: fcortaq; probris
Affectum pellunto domo. lotioq; zerundant.

136

135 David Vinckboons
The Garden Party (The Prodigal Son)
Panel, 28.5 × 44 cm. Rijksmuseum, Amsterdam

136 Claes Jansz Visscher after David Vinckboons
The Prodigal Son
Etching

137 Gabriel Metsu
*Merry Couple in the Inn (The Painter and His
Wife?)*
Signed and dated 1661. Panel, 35.5 × 30.5 cm.
Gemäldegalerie Alte Meister, Staatliche
Kunstsammlungen, Dresden

In general, all the festive companies, whether or not they are clearly Prodigal Son pieces, may be construed as warnings against immoderation and loose living; this is certainly true of such prints as *Mankind Awaiting the Last Judgment* (see fig. 125). Evidence for this interpretation appears in countless reiterated elements, such as dancing, smoking, music-making, gaming with cards or trictrac board, excessive eating, drinking, and lovemaking. In Pourbus' *The Prodigal Son* (see fig. 134), a woman with a tally stick for recording the drinkers' consumption defines the environment as an inn or brothel. Identification of the locale often helps us to understand the true meaning of a scene in a seventeenth-century painting. Thus, Metsu's merry couple (fig. 137), with a woman again marking up the tally, can immediately be seen as conveying a situation to be avoided, probably the Prodigal Son theme once more. Moreover, this painting has traditionally been called *The Painter and His Wife*, a hypothesis within the bounds of possibility. Compare, for instance, the self-portrait of Rembrandt with Saskia on his lap (cpl. 138), which can also be interpreted as having

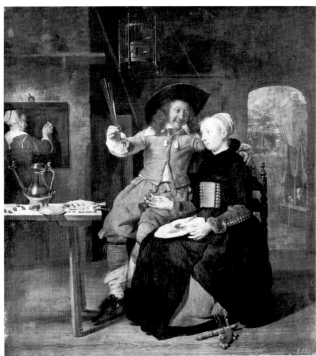

137

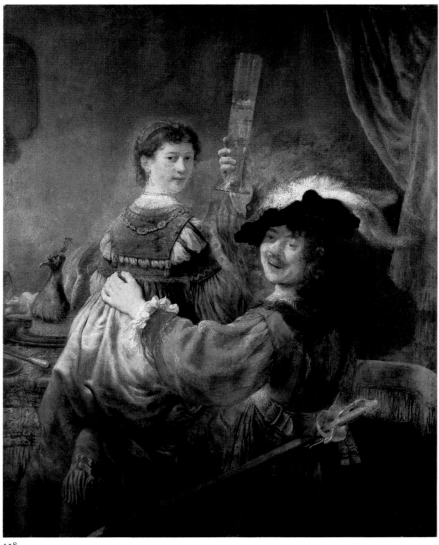

138

140

141

139

Prodigal Son overtones.[22] Whether, in the merry company pictures, the often appearing youth pouring drinks from a pitcher represents an admonition for moderation is open to question. In any event, the gesture of pouring had long been part of the symbolism of moderation or *temperantia*, as seen in the engraving by Lucas van Leyden (fig. 139).

Although the virtues also had a place in sixteenth-century iconography, there are few figure paintings in this category that serve as predecessors of seventeenth-century compositions. Now and then we encounter a woman at a spinning wheel representing domestic fidelity and industry (fig. 140). This motif continued to exist and to expand in the seventeenth century, which produced innumerable pictures of women spinning, tatting, or sewing (fig. 141); women at work around the house or caring for children probably also should be classed as portayals of domestic virtue.

The figure paintings by the Utrecht Caravaggists and their followers make up another category. They hark back not, of course, to Flemish or Dutch examples but to Italian paintings, and therefore have a different form and composition. Noteworthy, however, is that the subjects and presumably also the meaning are usually the same: card or trictrac players (fig. 142) and feasting or merry-making groups of all sorts, sometimes unmistakably inspired by the Prodigal Son theme. Yet it is not always clear whether the paintings of a single half-length figure holding a musical instrument or a drinking vessel represent an admonition or one of the five senses. More research is needed into the origin of the "realistic" paintings of Caravaggio and his followers.

139 Lucas van Leyden
Temperancia
Engraving

140 Maerten van Heemskerck
Portrait of a Woman Spinning
Dated on the frame 1529. Panel, rounded at the top, 84.5 × 65 cm. Rijksmuseum, Amsterdam

141 Nicolaes Maes
Girl Sewing
Signed. Panel, 41 × 32 cm. Duke of Sutherland Collection

142 Wouter Crabeth
Cheating
Signed. Canvas, 134.7 × 169 cm. Muzeum Narodowe, Warsaw

◁
138 Rembrandt van Rijn
The Prodigal Son in the Inn (Self-Portrait with Saskia)
Signed. Canvas, 161 × 131 cm. Gemäldegalerie Alte Meister, Staatliche Kunstsammlungen, Dresden

142

144

143

143 Anonymous after Pieter Bruegel the Elder
St. George's Day Fair
Etching

144 David Vinckboons
Flemish Kermis
Signed and dated 1610. Panel, 110 × 167 cm.
Musées Royaux des Beaux-Arts de Belgique,
Brussels

145–148 Jacob Matham
The Effects of Drunkenness
Engravings

Scenes in which peasants play the major roles were mainly exploited by Pieter Bruegel the Elder in the sixteenth century. He drew and painted fairs, peasant weddings, dancing peasants, and his paintings were widely known by the prints made after them (fig. 143). There is still uncertainty about the meaning of some of these pictures, but none about their popularity, particularly among court circles. Bruegel's peasant paintings hung in palaces in Brussels and Mechelen.

What did the nobility see in these unusual pictures? Did the upper crust find the diversions of the lower classes merely farcical?[23] Did they interpret the peasants' fairs and feasts as an essential escape valve for unfortunates balanced on the thin edge of existence, perhaps thinking "There but for the grace of God go I?" Or did they simply like the paintings in their own right? In his biographical sketch of Bruegel, van Mander says, "Indeed, there are very few works from his hand that the beholder can look at seriously,

145

146

147

148

149

149 Claes Jansz Visscher
Saying Grace
Dated 1609. Etching

150 Crispijn de Passe (?) after Adriaen van de Venne
A Zeeland Mussel Seller
Etching, from *De Zeeuwsche Nachtegaal*,
Middelburg, 1623

151 Jan Both
The Sense of Touch
Etching, from a series of five

without laughing. However stiff, serious, and morose one may be, one cannot help laughing or smiling."[24]

It is striking that in many of the kermis and other recreational folk scenes, such as David Vinckboons' *Flemish Kermis* of 1610 (fig. 144), various official-looking figures are holding themselves apart from the festivities—and from the fistfights and other mischief that seem to be a part of the fun. The artists may have put them there to establish the difference between the upper and lower classes, or they may have been taking a shot at standoffish officialdom. People did look at the profligates and condemn their carryings-on. These pictures without doubt shook a minatory finger.

In the graphic art of the early seventeenth century, the strongly moralistic aspect of many subjects was stressed yet again. Jacob Matham's series of four sheets revealing the effects of drunkenness is an excellent example (figs. 145–48). The series depicting the four elements, the times of day, and so forth, and the pictures in the emblem books all followed the same trend, cast increasingly in apparently realistic, everyday scenes laden with allegorical, symbolical, or moralistic content. There are also early prints illustrating pious family life (fig. 149).

Figure paintings before the 1630s can nearly always be traced back thematically to earlier Flemish and Dutch examples or to the emblematic and allegorical prints of the preceding decades. An added meaning must probably always be ascribed to the "pleasantries," "socials," and "brothels," as well as to the peasant fairs and fights, the quack "stonecutters," and the "foot doctors." The morals which people in the seventeenth century read into little scenes from daily life frequently seem farfetched to us today. If a small print, possibly by Crispijn de Passe after a drawing by Adriaen van de Venne, of a Zeeland mussel seller (fig. 150) were not accompanied on the next page by a verse, we should never dream of the explanation given therein:

Do as the mussels do and stay in your shell,
Be happy indoors, but don't go beyond yourself;
For if you keep to your house long and well,
You remain inviolable, and always fresh, and white.

That smoking, drinking, card and trictrac playing, and lovemaking continued to have negative implications is clear not only from inscriptions on graphic art, but also, as noted above, from the ceaseless warnings launched by seventeenth-century preachers from their pulpits. No great effort was required to include the five senses in the list of things to be indulged in at one's peril. Indispensable though the senses might be, they were considered dangerous: through them the evils of the world could easily influence the soul.[25] The senses were depicted in all sorts of ways in the print series, and in paintings they appear in series (see figs. 89–93) or combined within one picture. An etching on the sense of touch (fig. 151) by Jan Both, one sheet from a series of five, shows the continuation of such sixteenth-

152 Pieter Codde
Merry Company
Signed and dated 1633. Panel, 49 × 76.6 cm.
Akademie der Bildenden Künste, Vienna

153 Hendrick Pot
Vanity
Signed. Panel, 58 × 73 cm. Frans Hals Museum,
Haarlem. On loan from the State-owned Art
Collections Department

154 Willem Duyster
Lady and Gentleman with Musical Instruments
Signed. Panel, 43.4 × 35.9 cm. Staatliche Schlösser
und Gärten, West Berlin

155 *Love Works Miracles* from Jacob Cats, *Sinne- en
Minnebeelden*

152

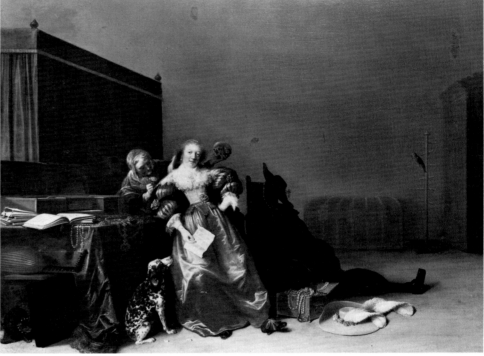

153

154

155

century themes of quackery as foot operations, tooth pulling, and boring holes in the head
to let out folly, which may themselves in some way be representations of the five senses.

As the seventeenth century advanced, an increasingly broad range of themes developed
within the bourgeois figure painting, so that it becomes ever more difficult to classify all
these pictures in one category or another. A thorough study of the varying nature and
meaning of this complicated subject remains to be done. We can here take only a cursory
look at the development of some of the outstanding themes.

The "company" painting originated in Haarlem as an outgrowth of the Prodigal Son and
similar themes, then evolved in Amsterdam and elsewhere into pictures, always interior
scenes, that are usually more intimate than the Haarlem examples and often have no
moralizing factor. They can occur in combination with family portraits, as in Pieter
Codde's *Merry Company* (fig. 152). Sometimes, as in Hendrick Pot's *Vanity* (fig. 153), they
contain a distinct *vanitas* element. A painting by Willem Duyster (fig. 154) that portrays a
lady and a gentleman with various stringed instruments suggests a relationship with an
emblematic verse by Jacob Cats (fig. 155), in which instruments attuned to each other are
compared with souls in harmony.

It is easy to relate such scenes, which were painted in many variations, to the
compositions introduced somewhat later, after about 1650, by Gerard Ter Borch: interiors
with a few figures linked by a glance or a gesture, presumably often indicating an amatory
bond (cpl. 156). The interior architecture and furnishings were relatively unimportant to
Ter Borch and his predecessors, but of major interest to the Delft painters. In the work of

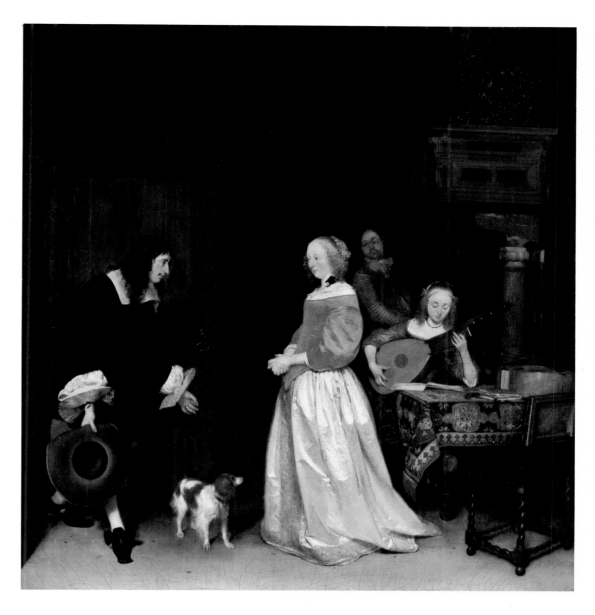

156 Gerard Ter Borch
 The Suitor's Visit
 c. 1658. Canvas, 80 × 75 cm. National Gallery of
 Art, Washington, D.C. Andrew W. Mellon
 Collection, 1937

157 Esaias Boursse
 Interior with a Woman Sewing and a Child
 Canvas, 52 × 59 cm. Gemäldegalerie, Staatliche
 Museen, West Berlin

Pieter de Hooch and his disciples, the space in which the action occurs seems to have a greater role than the people portrayed. There is little or no tension among the figures: the women are busy with household tasks or caring for children, as in Esaias Boursse's *Interior with a Woman Sewing and a Child* (fig. 157). Were such pictures still considered symbolical of domestic virtue, or had the double significance disappeared?

In addition to the sober and quiet company paintings, the general trend of which is quite clear, "merrier" paintings continued, filled with noisy feasters. We need think only of Jan Steen and his dozens of variations in this field: family parties, proverbs, inn scenes, brothels.

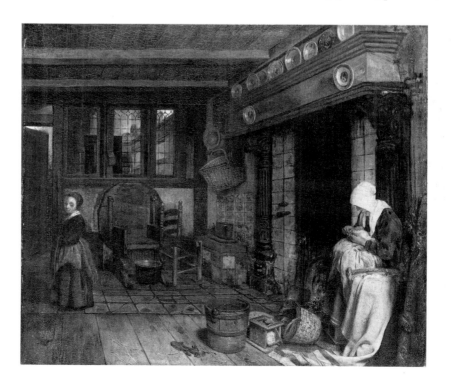

158

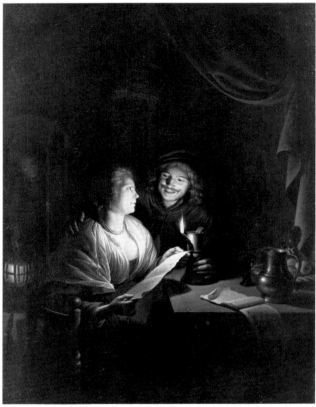

159

158 Pieter Quast
*"The Triumph of Folly," a Scene from the Play
"Tarquinius and Brutus," in the Amsterdam
Municipal Theater*
Signed and dated 1643. Canvas, 69.5 × 99 cm.
Theater Museum, Amsterdam. On loan from the
State-owned Art Collections Department

159 Gerrit Dou
A Couple by Candlelight
Panel, 25.7 × 19.3 cm. English Royal Collections.
Copyright reserved

160 Adriaen van Ostade
Peasant Interior with Men and Women
Signed. Panel, 29.1 × 36.3 cm. Alte Pinakothek,
Munich

The influence of the theater on his work will be discussed later (see p. 426). The theater had indeed already made an impact on painters, and they on it. In early years, more artists than perhaps we realize had helped with the settings and decorations for productions by the chambers of rhetoric, as the literary clubs were called, and during the 1630s and 1640s Pieter Quast and Jan Miense Molenaer, among others, made paintings of scenes from dramas presented in Amsterdam (fig. 158).

Gerrit Dou was important in the development of the bourgeois figure painting. He was the first to tackle many subjects, or at least to popularize them—pictures of schools, the rendering of a figure or two enclosed by a window frame, and scenes by candlelight (fig. 159). Later, Dou often depicted girls and women at work in the house. Despite a first impression of innocence, these paintings, too, may well have a double meaning, usually amorous. Emmens has convincingly shown that Dou's lying-in rooms, school scenes, and quill sharpeners possess a distinct *double entendre*.[26] In the domestic scenes of other figure paintings, however, the presence of a veiled meaning is less certain.

The peasant figure painting underwent a development that in some respects is comparable with that of the company painting. Originally, in works by Adriaen Brouwer and Adriaen van Ostade, the scenes depicted were quite coarse (fig. 160), with plenty of smoking, drinking, and lovemaking, if not fighting: bad habits on display. The pictures of poor people and peasants by Adriaen van de Venne seem different in character. Van de Venne was greatly interested in literature and became Jacob Cats's most important illustrator. He usually gave titles to his paintings, such as *Arme Weelde* (Poor Luxury; fig. 161), that indicate the intended interpretation; unfortunately the words themselves have a double meaning that is often difficult if not impossible to decipher today. In general, however, it

160

161 Adriaen van de Venne
"Arme Weelde" (Poor Luxury)
Signed and dated 1635. Panel, 33 × 60 cm.
Museum Boymans–van Beuningen, Rotterdam

162 Jacob Duck
Soldiers and Prostitutes in a Guardroom
Panel, 55 × 85.5 cm. Musée du Louvre, Paris

163 Adriaen van Ostade
Village Inn
Signed and dated 1660. Panel, 45.5 × 39 cm.
Gemäldegalerie Alte Meister, Staatliche
Kunstsammlungen, Dresden

161

162

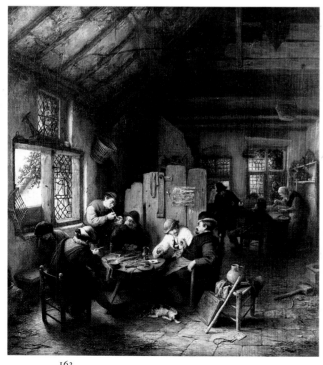

163

can be said that the ragged indigents, beggars, and peasants were not depicted from feelings of pity, but to convey a symbolic or moralizing message. The same is true of the scenes with soldiers, the *kortegaardjes*. These pictures seem to be somewhat akin to the peasant scenes: the guardsmen are usually shown smoking, drinking, and gaming, and the few women present should probably also be interpreted as up to no good (fig. 162).

After 1650 the peasant figure painting underwent a change. Although the feasting and dancing continue, the scenes become less rowdy (fig. 163). It is striking that peasants are rarely shown at work, except for slaughtering (fig. 164) or tending cattle; there are no scenes of farmers plowing or sowing. In the pictures of artisans, too, only a few trades are shown: weaving (fig. 165), shoemaking, tailoring, and once or twice silversmithing (fig. 166). Other manual laborers were apparently unable to arouse the artists' interest. Not until Jan and Caspar Luyken published one hundred of their engravings under the title *Het*

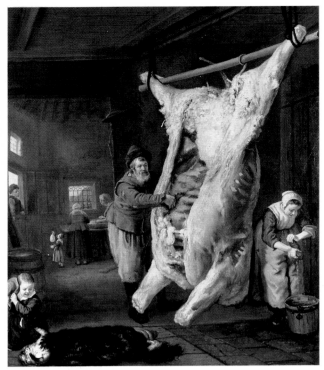
164

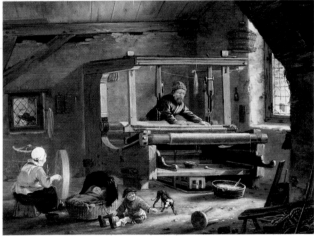
165

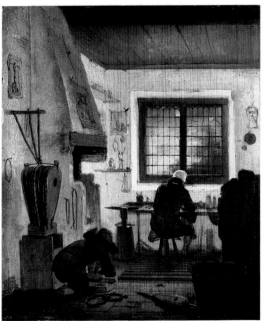
166

166 Egbert van der Poel
A Silversmith's Workplace
Signed. Panel, 28.8 × 22.8 cm. Städelsches
Kunstinstitut, Frankfurt am Main

164 Jan Victors
The Slaughtered Ox
Signed and dated 1647. Panel, 85 × 71 cm. Private
collection

165 Gillis Rombouts
A Weaver's Workplace
Signed and dated 1656. Panel, 32 × 38.5 cm. Frans
Hals Museum, Haarlem

Menselyk Bedryf (Human Industry) in 1694 was this subject treated systematically, with a title, motto, and moralizing verse accompanying each print.

Thorough research will some day clarify the background of the subject matter of figure paintings. The themes that were used were many and varied, yet large areas of daily life remained untouched by seventeenth-century artists.

Portraiture

Once when Nicolaes Maes was in Antwerp, he called on Jacob Jordaens and introduced himself as a portrait painter; Jordaens is said to have exclaimed, "Brother, I pity you! Are you one of those martyrs?"[27] From this remark we might assume that van Mander's old classification of portrait painting as inferior to history painting remained valid throughout the seventeenth century. And indeed, Samuel van Hoogstraeten, whose hierarchy of subject matter was drawn up in 1678, continued to rank portraiture low.[28] Later, in 1707, Gerard de Lairesse voiced an opinion similar to Jordaens': "As far as this matter [portraiture] is concerned, it has often seemed strange to me that someone can abandon his freedom to make himself a slave."[29]

Van Mander's explanation of why so many painters devote themselves to portraiture occurs in his biographical sketch of Michiel van Miereveld:

But in our Netherlands, and especially at this present time, we have this lack, and this calamity, that there is little work to be done in figure composition that could provide our young people and our painters with the opportunity for such practice, through which they might achieve distinction in historical scenes, figures, and nudes. For what they are commissioned to do is mostly portraits from life; and so most of them, lured by profit or simply in order to make a living, start and continue on that bypath of the arts (that is, portraiture from life), without having the time or the desire to look and search for the road of historical or figure painting which leads to the highest perfection.

Two sentences later, van Mander admits that the term "bypath" may be too harsh and need softening with "a brush or a feather," for "one can certainly do a good job of a portrait and ... a face, being the noblest part of the human body, provides a fine opportunity to make manifest and prove the virtue and powers of Art."[30]

It is difficult today to sense the meaning of such notions to the seventeenth-century painters and to the patrons and connoisseurs. The ideas quoted above may have been abundantly outweighed for the artists by the "lure of profit." There is no evidence that portrait painters were not appreciated or that masters like Honthorst and Rembrandt had any objection to painting portraits. Bartholomeus van der Helst, who specialized almost exclusively in portraiture, enjoyed great fame, and Anthony van Dyck without doubt received his English title and honors for his court portraits, not for his biblical paintings.

The number of portraits painted in the Netherlands in the seventeenth century was enormous. They ranged from life-size to miniature, from full-length to faces, and in between from knee-length to half-length to busts (with or without hands). Besides individual portraits, there were portraits of couples; of whole families, indoors or out; and there were group portraits of the regents of institutions and of civic-guard companies. It is thrilling to watch the seventeenth-century portrait painters embroidering upon sixteenth-century models, grasping the possibilities for introducing and adapting variations on a theme limited by the patron's appearance and desires. In these changes, the line between portrait and company painting cannot always be defined, certainly not when an extra

meaning is added to the picture, as for instance in the family group by Jan Miense Molenaer which portrays not only four generations of the van Loon-Ruychaver family—the eldest generation as a painting on the wall—but at the same time depicts the five senses (see fig. 94). I have already mentioned (p. 80) the patrons who had themselves portrayed in biblical or mythological roles or in rustic costume, another example of which is Jan Baptist Weenix's *Portrait of a Girl Dressed as a Shepherdess* (fig. 167). This led to strange mixtures of portraits and history painting.[31] Sofia Hedwig, duchess of Braunschweig Wolfenbüttel, for example, commissioned Paulus Moreelse to portray her, with her children, as Caritas (fig. 168). It is interesting to compare this allegorical portrait with the court portrait Moreelse made of her (see fig. 172).

167 Jan Baptist Weenix
Portrait of a Girl Dressed as a Shepherdess
Signed. Canvas, 125 × 100 cm. Musée de Picardie, Amiens

168 Paulus Moreelse
Portrait of Sofia Hedwig, Duchess of Braunschweig Wolfenbüttel, with Her Children as Caritas
Signed and dated 1621. Canvas, 140 × 122 cm. State Museum Het Loo Palace, Apeldoorn

The majority of portraits, however, was done according to fixed schemes that hardly changed throughout the century. When a married couple had themselves portrayed, it was on two identical canvases or panels that were hung as pendants, the man nearly always to the left and the woman to the right. Both individuals look toward the center, and the light on both usually falls from the left (figs. 169 and 170). This means that the man's face is partly in shadow, creating an attractive play of light and giving full opportunity for plasticity in the modeling, whereas the woman's face receives the light directly so that both sides of her face are lighted equally. As a result, the pendant portraits of women may have less pictorial interest than those of men.

Bust-length portraits permit little variation in pose. If the hands are included, gestures of some liveliness can be introduced, and these gestures may have significance.[32] It should not be imagined, however, that each portrait commission received individual treatment. The patron had certain formulas to choose from in the larger studios, such as Michiel van Miereveld's. The master painted only the face and hands, and his pupils did the rest. In the inventory of Miereveld's estate, paintings are listed "of which the visage was fulfilled [by the master] and the clothing painted by Jacob Delff."[33] Various portraitists also offered "standard poses," stock paintings in which the head alone was painted individually. Such was the case with Ketel and Goltzius and, much later in the century, with Ter Borch and Netscher as well.[34]

Profile portraits were rare, full-face portraits somewhat more frequent. Three-quarter poses predominated. With knee-length and full-length portraits a painter had greater opportunity to deviate from the fixed pattern, although only a few, like Rembrandt,

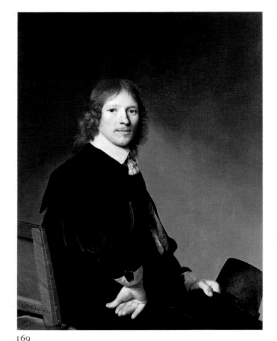

169

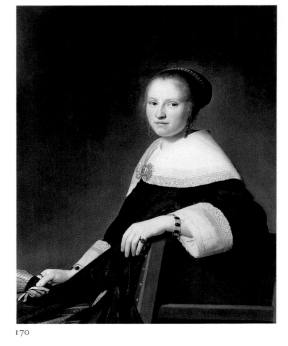

170

171

availed themselves of this (fig. 171). The life-size, full-length portrait was actually seldom commissioned in Holland in the seventeenth century. It took up too much room in the house, and it was expensive. The type had originated in the court circles and among the landed gentry, whose residences in The Hague, Utrecht, and Leeuwarden were more palatial than those of the urban burghers. The earliest large portraits, such as that of Sofia Hedwig (fig. 172), must have been painted by Paulus Moreelse before 1604, because van Mander, in his brief biography of this artist, then in his early thirties, mentions "the Count and Countess of Culemborgh, full-length, and so large as life."[35] Moreelse, who perhaps knew this sort of portrait from the work of the Antwerp painter Frans Pourbus, probably provided the starting point for the state portraits that Miereveld and Ravesteyn painted at the Hague court and de Geest at the Frisian court. In Amsterdam, a few of the very wealthy had themselves portrayed full-length: Laurens Reael and his wife, by Cornelis van der Voort; Burgomaster Cornelis de Graeff and his wife, by Nicolaes Eliasz (see figs. 405 and 406).

Full-length portraits, whether life-size or small-scale, offered splendid opportunities for embellishment. Folio volumes could be placed on a table to suggest erudition and globes in the background to enhance the breadth of outlook; in the portraits of magistrates a clock or a watch could symbolize the sitter's moderation as a wise governor—or his mortality. The accessories, whether meant as symbolic or not, fulfilled a definite function especially in the group portraits. In one of Nicolaes Maes's family groups (fig. 173), the church of Dordrecht is pictured in the background, clearly locating the family's place of residence. Botanical

172

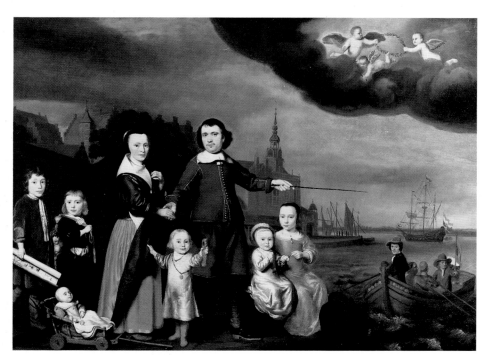

173

169 Johannes Verspronck
Portrait of Eduard Wallis
Signed and dated 1652. Panel, 97 × 75 cm.
Rijksmuseum, Amsterdam

170 Johannes Verspronck
Portrait of Maria Strijp
Signed and dated 1652. Panel, 97 × 75 cm.
Rijksmuseum, Amsterdam

171 Rembrandt van Rijn
Portrait of a Fashionably Dressed Man
Signed and dated 1633. Canvas, 125 × 100 cm.
The Taft Museum, Cincinnati, Ohio

172 Paulus Moreelse
*Portrait of Sofia Hedwig, Duchess of Braunschweig
Wolfenbüttel*
Canvas, 202 × 126.5 cm. English Royal
Collections. Copyright reserved

173 Nicolaes Maes
A Merchant of Dordrecht with His Wife and Children
Signed and dated 1659. Canvas, 112 × 154.5 cm.
North Carolina Museum of Art, Raleigh, N.C.

symbolism was a favorite device for referring to matrimony. In van der Helst's portrait of the Amsterdam cloth merchant Abraham del Court and his wife (cpl. 174), the plucking of a sweet but thorny rose symbolizes the joy and pain of love. The fountain spouting in the background has obvious sexual overtones.

The desire for liveliness and action in group portraits, so evident in the civic-guard and regents paintings, is present in the family groups as well. In the portrait of the Beresteyn family (fig. 175), painted about 1630 or 1631 and attributed to Pieter Soutman, the artist went out of his way to give every member of the family something to do. The same desire is already apparent in even simpler compositions, such as Ravesteyn's portrait of the lawyer

174 Bartholomeus van der Helst
*Portrait of Abraham del Court and His Wife, Maria
de Keerssegieter*
Signed and dated 1654. Canvas, 172 × 146.5 cm.
Museum Boymans-van Beuningen, Rotterdam

175 Pieter Soutman (attributed)
The Beresteyn Family
c. 1630–31. Canvas, 167 × 241 cm. Musée du
Louvre, Paris

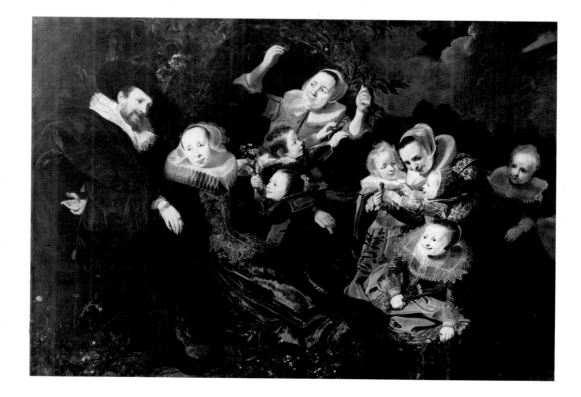

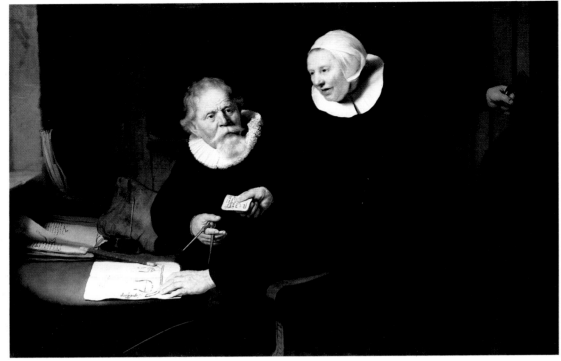

176

177

Pieter van Veen (see fig. 456). Thomas de Keyser (see cpl. 582), Rembrandt (fig. 176), and many other painters used the motif of a letter being handed to the main figure.

The backgrounds in most seventeenth-century portraits of single individuals were initially dark and rather flat. Architecture was suggested occasionally, but was seldom an important element. About 1650 one sees, albeit exceptionally, a landscape in the background, as in Pieter Nason's presumed self-portrait (fig. 177), and thereafter greater variation was introduced. Curtains are draped aside to reveal a park or an interior. The background colors become lighter, together with the whole tonality of the portrait. Current fashions, of course, determined the total effect to a large extent: when predominantly dark clothing went out of style and was replaced by velvets, silks, and embroidered stuffs, the whole aspect of portraiture altered drastically (fig. 178). The decorations and furnishings of the interiors with family groups also reflect changing taste and fashion. About the middle of the century these family groups, usually rather small in format (fig. 179), began to gain in popularity.

The equestrian portrait never found much favor in the Northern Netherlands.[36] Van der Venne painted members of the Hague court nearly life-size on their horses (see fig. 28), but soon much smaller pictures became the mode (fig. 180). This type, also originating in court circles, seems to have appealed to various well-to-do burghers as well; Thomas de Keyser, in particular, painted a number of handsome portraits of them on horseback (fig. 181). Rembrandt's large painting (fig. 182), dating from the 1660s, is exceptional in his oeuvre

178

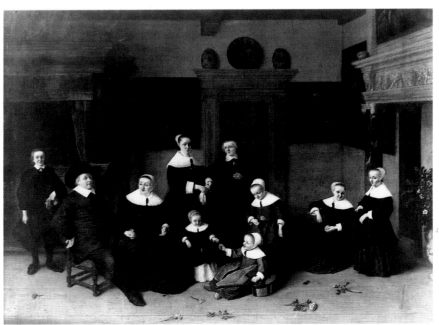

179

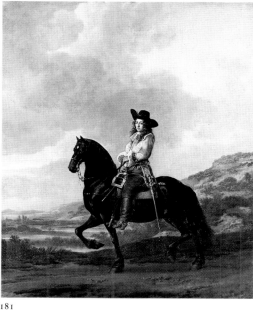

180　Pauwels van Hillegaert
*Prince Frederik Hendrik on Horseback with
Maastricht in the Background*
Signed. Panel, 37 × 33 cm. Amsterdams
Historisch Museum, Amsterdam

181　Thomas de Keyser
Portrait of Pieter Schout on Horseback
Signed and dated 1660. Copper, 86 × 69.5 cm.
Rijksmuseum, Amsterdam

182　Rembrandt van Rijn
Portrait of Frederik Rihel (?) on Horseback
Signed and dated 1663. Canvas, 282 × 248 cm.
The National Gallery, London

◁

176　Rembrandt van Rijn
The Shipbuilder and His Wife
Signed and dated 1633. Canvas, 115 × 165 cm.
English Royal Collections. Copyright reserved

177　Pieter Nason
Self-Portrait (?)
Signed and dated 1648. Canvas, 94 × 77.5 cm.
Muzeum Narodowe, Warsaw

178　Nicolaes Maes
Portrait of a Young Man
Signed and dated 1676. Canvas, 127 × 102 cm.
Kunsthalle, Hamburg

179　Adriaen van Ostade
Family Group in an Interior
Signed and dated 1654. Panel, 70 × 80 cm. Musée
du Louvre, Paris

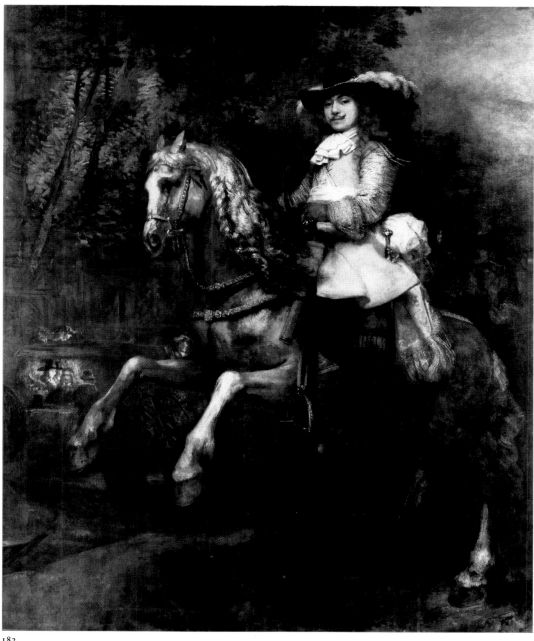

182

and hardly one of his successes. The Dutch did not take the same pleasure in horseback
riding as the Italians, Spaniards, and Flemings, and Dutch painters had less experience with
or demand for equestrian portraiture.

The highest demands that faced the portrait painter were the formal group portraits of
the civic guards, the regents, and the anatomy lessons.[37] Portraying a large number of
persons on one canvas presented extreme difficulties, for the composition easily could
become dull and wooden. Although certain variant patterns were possible, the success of the

183 Dirck Jacobsz
 *A Group of Seventeen Members of the Amsterdam
 Civic Guard*
 Signed and dated 1529. Panel, 122 × 184 cm.
 Rijksmuseum, Amsterdam. On loan from the
 City of Amsterdam

184 Jan van Scorel
 *Twelve Members of the Jerusalem Brotherhood of
 Utrecht*
 Shortly after 1525. Panel, 48 × 276.5 cm. Centraal
 Museum, Utrecht

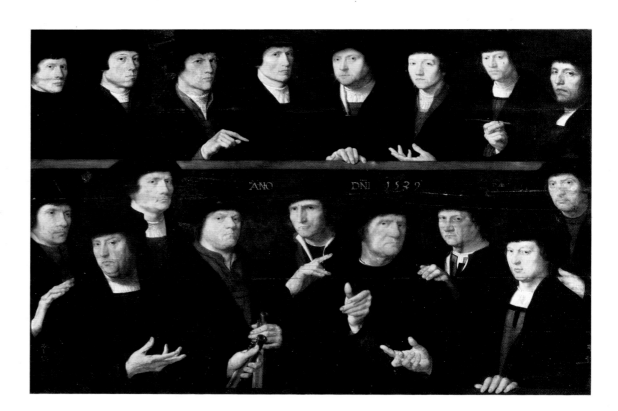

painting depended on many factors; no one fixed scheme was sufficient, nor was the artist's ability to paint acceptable individual portraits. For, quite apart from good likenesses (we must assume they were good, for there is no way to tell today), the most subtle nuances of pose, gesture, and glance were required to bind the figures and faces into a natural whole, creating contacts among those portrayed and with the viewer as well. Each type of group portrait had its own specific problems. By far the largest number of official commissions were painted in Amsterdam, with Haarlem as the next most important center. We shall therefore limit ourselves mainly to those two cities.

Civic-Guard Paintings

The earliest known civic-guard painting is a work by Dirck Jacobsz dating from 1529 (fig. 183). The guardsmen are ranged in two rows, one above the other, in a compositional scheme related to that used by Jan van Scorel a few years earlier in portraying the Utrecht and Haarlem pilgrims to Jerusalem (fig. 184). Jacobsz's painting consists of seventeen individual portraits: the men respond to each other hardly at all, but stare straight at the viewer; the only relief is in their gestures. This was the pattern until well into the seventeenth century, although some artists occasionally achieved greater liveliness by introducing weapons or other attributes, subdividing the groups, or adding a landscape as background.

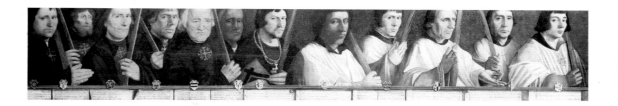

185 Cornelis Anthonisz
Banquet of the Amsterdam Civic Guard, known as
The Brass Penny Banquet
Signed and dated 1533. Panel, 130 × 206.5 cm.
Amsterdams Historisch Museum, Amsterdam

186 Cornelis Ketel
The Company of Captain Dirck Jacobsz Rosecrans
Signed and dated (.)588. Canvas, 208 × 410 cm.
Rijksmuseum, Amsterdam. On loan from the
City of Amsterdam

As early as 1533, Cornelis Anthonisz had discovered another solution: he painted the guardsmen around a table laid with food and drink, some of the men seated and others standing in a row behind (fig. 185). The great advantage of this arrangement is the introduction of a central motif. The picture should not be considered a true-to-life reflection of the civic-guard banquets, which were the high point of each company's year, but the idea was certainly borrowed from such feasts. Dirck Barendsz continued with this theme and, having been trained in Italy, was able to unify the group in space and light, creating a composition which transforms the "sardine" look into a more natural gathering (see fig. 10). When Cornelis Cornelisz, in 1583 and 1599, painted the first militia portraits in Haarlem, he, too, chose the banquet scene as motif (see figs. 350 and 375).

Meanwhile in 1588 in Amsterdam, Cornelis Ketel accomplished a true innovation by portraying the company of Dirck Jacobsz Rosecrans all standing at full length (fig. 186). A sketch has been preserved of an even earlier work in this style. Ketel's troop is built up quite symmetrically, with a group of three men in the middle and two groups of five on either side. The pose and treatment of the guardsmen give the composition greater vivacity, emphasized by their weapons and banner. The painting was an immediate success; van Mander proclaimed it "very beautifully painted, and elegant to look at."[38]

The civic-guard paintings of the seventeenth century thus had three compositional options, or combinations thereof: half-length, aligned figures; banquet scenes with seated figures; and standing figures. It is worth noting that in Haarlem the militiamen were never rendered full-length, as they were in Amsterdam, Hoorn (fig. 187), and other places. Frans Hals painted his only full-length guardsmen on commission from an Amsterdam company. The patrons apparently got whatever they wanted and could pay for, their choice in part determined by the size and shape of the available wall space. As Slive has pointed out, in the *doelen* of St. Adrian in Haarlem there was no room for full-length civic-guard paintings.[39]

Ketel's full-length composition seems to have set a difficult example to follow. The Amsterdam guardsmen who had themselves portrayed by Lastman and van Nieulandt after

187

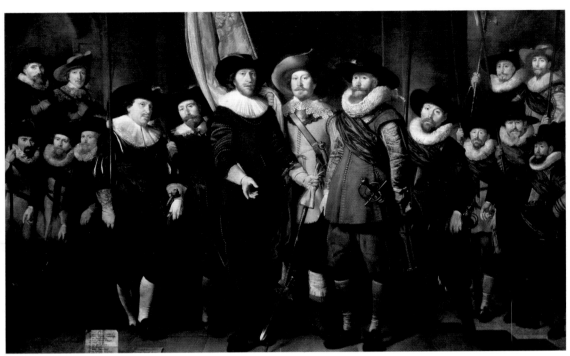

188

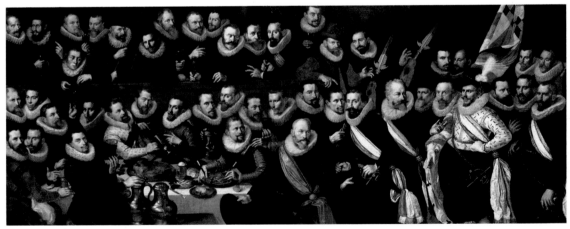

189

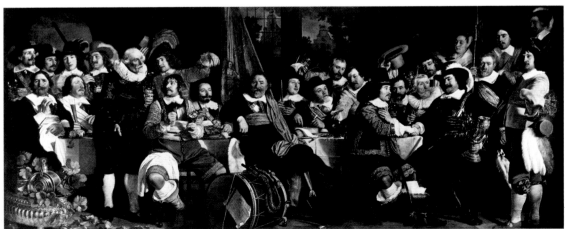

190

187 Jan Albertsz Rotius
 The Company of Captain Jan Vrericks Abbekerk
 Signed and dated 1651. Canvas, 338 × 343.5 cm.
 Westfries Museum, Hoorn

188 Thomas de Keyser
 The Company of Captain Allaert Cloeck
 Signed and dated 1632. Canvas, 220 × 351 cm.
 Rijksmuseum, Amsterdam. On loan from the
 City of Amsterdam

189 Frans de Grebber
 *Banquet of the Officers and Sergeants of the Haarlem
 Civic Guard*
 Signed and dated 1619. Canvas, 206.5 × 500 cm.
 Frans Hals Museum, Haarlem

190 Bartholomeus van der Helst
 *The Celebration of the Peace of Münster, 1648, at the
 Crossbowmen's Headquarters, Amsterdam*
 Signed and dated 1648. Canvas, 232 × 547 cm.
 Rijksmuseum, Amsterdam. On loan from the
 City of Amsterdam

191 Rembrandt van Rijn
The Company of Captain Frans Banning Cocq,
known as *The Night Watch*
Signed and dated 1642. Canvas, 363 × 437 cm.
Rijksmuseum, Amsterdam. On loan from the
City of Amsterdam

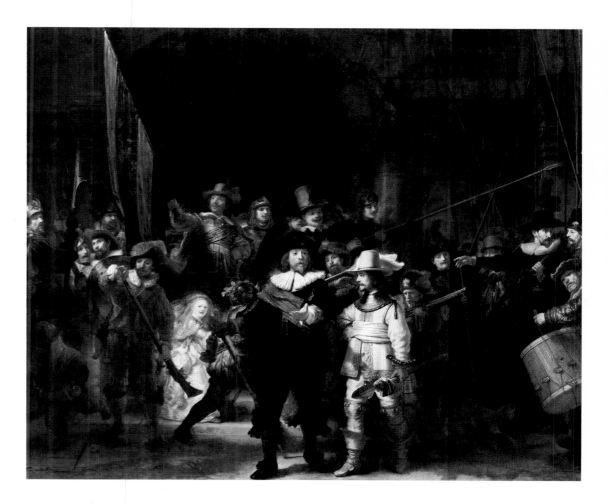

their expedition to Zwolle in 1622 stand like so many wooden puppets (see fig. 62). Thomas de Keyser attempted to get more life into his compositions by positioning the heads at different levels, but failed to find a satisfactory solution: spatial fluency and harmonious relationships are lacking (fig. 188).

Although the militia patrons in Haarlem spared their painters this problem, they made things difficult by wanting to have a large number of persons in their paintings. Frans de Grebber, for instance, was asked to portray first twenty-nine, then thirty-three, and in 1618–19 forty-six guardsmen on one canvas (fig. 189). He can hardly be blamed for the fact that his solution—a combination of all three basic forms—was less than successful.

Frans Hals painted his first civic-guard banquet in 1616 (see fig. 374). He turned back to Cornelis Cornelisz's 1599 composition, but his inimitable technique and his uncanny ability to capture the natural liveliness of pose, gesture, and facial expression enabled him to overcome all difficulties. In this respect, he was moving along the trail blazed by Dirck Barendsz, not by Cornelis Cornelisz. Hals's later, sublime civic-guard paintings were logical advances upon this work of 1616.

Among the dozens of civic-guard paintings made in Amsterdam and other cities, two works merit special attention: Bartholomeus van der Helst's civic-guard banquet (fig. 190) and Rembrandt's so-called *Night Watch* (fig. 191). The first was painted to memorialize the banquet held at the Voetboogsdoelen or crossbowmen's hall in Amsterdam on June 18, 1648, in celebration of the Treaty of Münster, which ended the Eighty Years' War and officially recognized the independence of the United Dutch Republic. With this painting van der Helst, who was technically one of the most capable artists of the seventeenth century, created a sort of apotheosis of all civic-guard banquet scenes. Outdoing even his own monumental civic-guard painting of 1639–43, *The Company of Captain Roelof Bicker* (see fig. 624), he here achieved what no one in Amsterdam had yet managed to bring off: the portrayal of no fewer than twenty-five people in such a way that each individual portrait was given its full due, enhancing but not compromising the harmony of the whole, which is suffused with an atmosphere of unconstrained relief and happiness. For dramatic effect, the ensign Jacob Banning occupies center stage, with the company banner over his shoulder and the drum at his side; seated near the far right is the captain, Cornelis Jansz Witsen, in his hand the silver drinking horn of the Guild of St. George—the horn is now in the Amsterdam Historical Museum—receiving the congratulations of his lieutenant, Johan Oetgens van Waveren.

Rembrandt's painting is of the militia company commanded by Frans Banning Cocq, and it was one of the six civic-guard portraits (plus a seventh of the governors) commissioned about 1638 for the assembly and banqueting hall of the new Kloveniersdoelen (arquebusiers' or musketeers' hall) in Amsterdam; for our further discussion of these paintings, see page 291. The *Night Watch* is more heavily burdened by history than any other Dutch seventeenth-century painting, but let us here consider it as it was regarded in its own time: one more in the long series of civic-guard paintings. Rembrandt's commission was probably no different from the others: to portray Captain Banning Cocq and Lieutenant van Ruytenburch in the midst of those members of their company who wished to pay for the honor. Presumably it was the patrons' choice whether the painting would be a banquet or a "stand-up" piece with full-length or half-length figures, although we have no information about this. Rembrandt was evidently asked to paint two officers and sixteen men, all at full length, and his working out of this commission bears witness to great originality. He painted the guardsmen standing about as they no doubt often stood, waiting for the moment when "the Young Lord of Purmerlandt as Captain gave the command to his Lieutenant... for his Burgher Company to march" (to quote a note accompanying a drawing of the painting in Banning Cocq's own album[40]). The random activity preceding the "fall in" is what Rembrandt chose to portray. But he used this motif, his own "invention," to create order in an apparently orderless swirl, to achieve a satisfactory composition in accordance with his own insight. And Rembrandt would not be Rembrandt if he had not also striven for strong contrasts of light and shade and for a maximum of lively motion. His painting became in many respects less a civic-guard portrait than a history piece, and, hierarchies of painting notwithstanding, some of his contemporaries seem to have indicated that he had overstepped the bounds of his commission.

People have justifiably wondered where the large civic-guard paintings—and those for the new *doelens* were larger than ever before—were painted. Few of the painters' studios can have accommodated such canvases, and it has been suggested that the pictures were painted *in situ*. This possibility seems negated by a deposition made by Nicolaes Eliasz in connection with a wager between Bartholomeus van der Helst and an apothecary about Eliasz's finishing his civic-guard painting for the Kloveniersdoelen on time; he declared that he had delivered his picture on the tenth day of July 1642, "into the New Arquebusiers' Hall."[41] Obviously he had painted it elsewhere, but the deposition unfortunately does not say where Eliasz worked or how he transported his huge painting. It is known that the sculptor Artus Quellinus was given working space in the chapel of a former cloister for his decorations for Amsterdam's new town hall. A drawing, attributed to Isaac van Nickelen, shows that disused Catholic churches in Amsterdam also sometimes served as artists' studios (fig. 192).

After 1650, civic-guard paintings ceased to be commissioned in Amsterdam. The reasons were probably the diminishing interest in and need for the militia companies, and the fact that the *doelens* were already full of paintings and had room for no more.

Regents Paintings

Regents paintings include group portraits of the governing officials of charitable institutions, guilds, and similar organizations.[42] Such a commission confronted the artist with fewer problems than did civic-guard paintings because the number of figures to be portrayed was much smaller. Most of the boards that commissioned a picture consisted of from three to seven persons; sometimes a servant—or the matron of the orphanage, say—was also included. Yet these paintings remained a real challenge.

Anticipating the regents paintings in Holland is an interesting group portrait of the Master of the Mint of Nijmegen and Maastricht and his assistants, dating from 1581 (fig. 193). The unknown artist has portrayed the men standing behind a sort of counter, on which coins are lying and a text is written identifying the officials and stating their honorable function; at the right is a mysterious figure in cap and bells. The painter probably came from somewhere in Germany, and his work found no known followers in the western Dutch provinces.

The earliest known regents painting in Amsterdam, attributed to Pieter Pietersz, is dated 1599 (fig. 194). It shows the six inspectors of the drapers' guild, called cloth wardens,

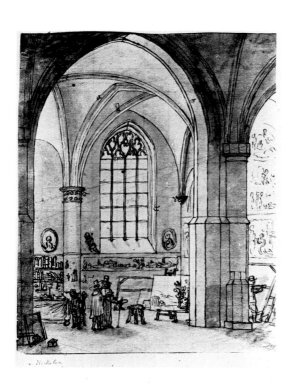

192 Isaac van Nickelen (attributed)
Artist's Studio in a Church
Pen and brush in brown and gray, 23.1 × 17.6 cm.
Herzog Anton Ulrich Museum, Brunswick, West Germany

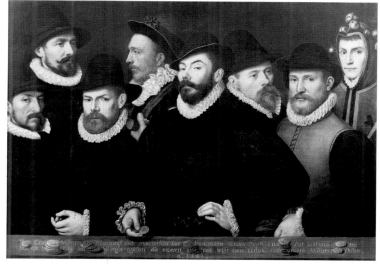

193

194

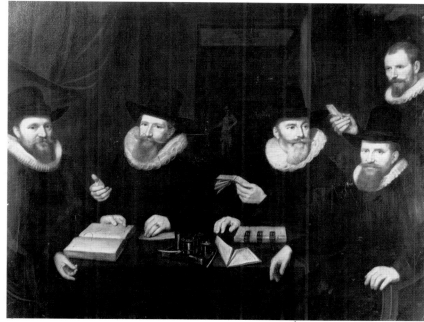

195

193 Artist Unknown
The Master of the Mint of Nijmegen and Maastricht and His Assistants
Dated 1581. Panel, 93 × 133 cm. Huis Bergh,
's-Heerenberg

194 Pieter Pietersz (attributed)
Six Wardens of the Drapers' Guild, Amsterdam
Dated 1599. Panel, 108 × 143 cm. Rijksmuseum,
Amsterdam

195 Cornelis van der Voort
Regents of the Rasp House, Amsterdam
c. 1618. Canvas, 153 × 192 cm. Amsterdams
Historisch Museum, Amsterdam

196 Jacob Backer
Regentesses of the Burgher Orphanage, Amsterdam
Signed. c. 1633–34. Canvas, 238 × 274 cm.
Amsterdams Historisch Museum, Amsterdam

196

painted as half-length portraits. There is no table, no setting, except for the suggestion of chair backs in the foreground corners.

A new compositional formula that would serve for several centuries as the basis for regents paintings was first used by Cornelis van der Voort in several of his paintings dating from 1617 and 1618. The regents, either sitting or standing, are grouped around a cloth-covered table; a servant stands at one side, usually on the right. The men in the painting here reproduced (fig. 195) were the regents of the Rasp House in Amsterdam, a correctional institution for men, where the inmates were put to work rasping campeche wood (logwood) into a powder used in making paint. Whether the regents customarily wore hats indoors or thought the effect enhanced their dignity in a painting, they are all portrayed hatted, the servant hatless—thus introducing a tradition that persisted in the regents paintings until the end of the seventeenth century, when wigs began to be worn. The functions of the board members are more or less indicated by the attributes, mostly lying on the table, and by a few particularized gestures, such as recording minutes or counting money, details that enliven the composition.

Throughout the seventeenth century, painters alternated between using the seated and the standing arrangements, with half-length figures centered around a cloth-covered table. The only real amplification was full-length treatment, as seen in Jacob Backer's portrayal of the women governors of the Burgher Orphanage in 1633 or 1634 (cpl. 196). This solution brought pictorial spaciousness and increased the distance between the viewer and the figures portrayed. Backer was also one of the first to introduce a child, almost as an attribute; here it is a little orphan girl, clad in the distinctive red and black garments of her orphanage, being presented to the regentesses by the housemother.

The motif of the child was taken over by other artists. Ferdinand Bol used it with great success in his 1649 picture of the four regents of the Amsterdam Leper Asylum (fig. 197). By giving prominence to the housefather and the little boy, evidently a sufferer from the disease, the artist has reinforced the narrative element and broken up a dull symmetry. An even more asymmetrical arrangement occurs in van der Helst's portrait of the governors of the St. Sebastian or archers' guild (fig. 198). The militia leaders are here portrayed seated at a table, apparently taking inventory of the guild's treasures, one of their official duties, so that the picture is a regents rather than a civic-guard painting. The narrative element is strongly stressed by the two youths holding bows and arrows in the right background.

It had become customary very early in the development of the civic-guard banquet paintings to place one or more of the company officers in front of the table. This plan was adopted for the regents paintings, especially in Haarlem, in order to break the monotonous expanse of tablecloth and to achieve an interesting grouping. Van der Helst posed the St. Sebastian governors this way, and chose a low vanishing point, so that the viewer looks up, as it were, at the group portrayed. This no doubt had something to do with the hanging of the painting—fairly high on the wall, perhaps above a fireplace. The same applies to Rembrandt's *The Sampling Officials of the Drapers' Guild* (fig. 199), where the vanishing point is below the surface of the table.

After about 1660, there was a clear tendency among Amsterdam artists to lighten the backgrounds of their regents paintings and to enliven them with architectural elements. A similar trend in ordinary portraiture was mentioned earlier (see p. 102). One example is a 1673 work by Gerbrand van den Eeckhout portraying the four governors of the Amsterdam Coopers' and Wine Rackers' Guild (see fig. 63). The leaders of the trade guilds did not often commission group portraits, although a few other such paintings are known,

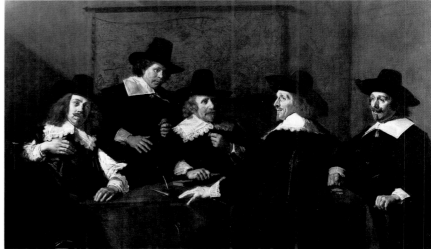

197

198

199

200

197 Ferdinand Bol
Regents of the Leper Asylum, Amsterdam
Signed and dated 1649. Canvas, 224 × 310 cm.
Amsterdams Historisch Museum, Amsterdam

198 Bartholomeus van der Helst
*Governors of the St. Sebastian or Archers' Guild,
Amsterdam*
Signed and dated 1657. Canvas, 183 × 268 cm.
Rijksmuseum, Amsterdam. On loan from the
City of Amsterdam

199 Rembrandt van Rijn
*The Sampling Officials of the Drapers' Guild,
Amsterdam*
Signed and dated 1662. Canvas, 191.5 × 279 cm.
Rijksmuseum, Amsterdam. On loan from the
City of Amsterdam

200 Frans Hals
Regents of the St. Elizabeth Hospital, Haarlem
1641. Canvas, 153 × 252 cm. Frans Hals Museum,
Haarlem. On loan from the Elisabeth van
Thüringen Fund

some from other cities. In van den Eeckhout's work the attributes of the guild appear
prominently in the foreground, and a statue of St. Matthew, patron saint of the coopers, is
centered in the background. In the niches at either side putti hold up the coats of arms of the
officials portrayed. In that period, no well-to-do citizen holding an important office failed
to provide himself with heraldic appurtenances.

In Haarlem the light background had appeared two decades earlier. Regents were not
portrayed there until 1641, when Frans Hals painted the regents of the St. Elizabeth Hospital
(fig. 200), and Johannes Verspronck the regentesses of the same institution (see fig. 488).
Both artists chose the scheme of half-length figures grouped around a table. And both used
light backgrounds, making these Haarlem pictures seem much lighter, even though the
figures wear the same traditional dark clothing as those in contemporary Amsterdam
paintings. Later in the century it was mainly Jan de Bray who, besides Frans Hals, received
commissions for regents paintings in Haarlem; he contributed little to the well-established
pattern. Frans Hals's two late masterpieces in this field are discussed on page 377.

In contrast with the civic-guard paintings, the regents paintings remained exceedingly
popular. In Amsterdam, the series has continued unbroken into the twentieth century.

Anatomy Lessons

The third type of official group portrait was the so-called anatomy lesson. This differed
from the civic-guard and regents paintings by having a central motif, in which one person,
the docent or professor, played the leading role. This motif developed from the annual
lecture in anatomy given by the praelector of anatomy of the Surgeons' Guild, always held
in winter because the corpse (often an executed criminal) being dissected could be better

preserved at that time of year. The lessons, which were open to the public, were held in the Theatrum Anatonicum, in Leiden, Delft, and Amsterdam. A print by Bartholomeus Dolendo (fig. 201) of an anatomy lesson held in Leiden gives a good idea of the actual surroundings and set-up on such an occasion, and also makes it immediately clear that in most cases the painted anatomy lessons (as far as is known always commissioned on the initiative of the praelector) hardly·reflect the real scene. An exception to this is a more realistic painting made in Delft. In this work by Michiel and Pieter van Miereveld, the onlookers are standing at various levels around the operating table, presumably on raised platforms, with those at the left peering through the leg bones of mounted skeletons (fig. 202).

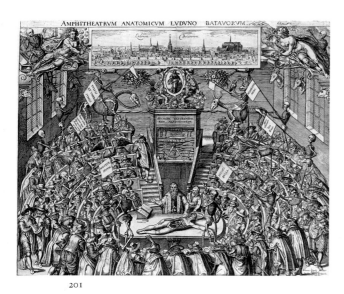

201

201 Bartholomeus Dolendo after Johannes Woudanus
 Theatrum Anatomicum, Leiden
 Engraving

202 Michiel and Pieter van Miereveld
 *The Anatomy Lesson of Dr. Willem van der Meer,
 Delft*
 Signed and dated 1617. Canvas, 144 × 198 cm.
 Oude en Nieuwe Gasthuis, Delft

203 Aert Pietersz
 *The Anatomy Lesson of Dr. Sebastiaen Egbertsz de
 Vrij, Amsterdam*
 Signed and dated 1603. Canvas, 147 × 392 cm.
 Amsterdams Historisch Museum, Amsterdam

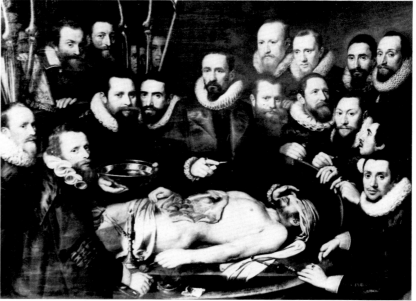

202

It was again in Amsterdam, however, that the tradition of the anatomy-lesson painting was strongest,[43] although there were fewer commissions for them than for civic-guard portraits. The praelector enjoyed a long tenure and at most commissioned an anatomy-lesson painting only twice during his years of service, usually near the beginning and the end. The earliest known anatomy lesson is by Aert Pietersz in 1603 (fig. 203). The famous physician Sebastiaen Egbertsz de Vrij is portrayed (standing behind, with surgical scissors in his hand) with twenty-eight colleagues gathered around the cadaver on the table. The large number of participants made it impossible for the painter to include spectators, and the picture is a conventional group portrait, differing in essence not at all from civic-guard paintings of the period. It took nearly two years to complete; the commission was given in 1601, but in 1602, soon after the artist began to work, the plague broke out in Amsterdam, and eleven thousand people died. The painting was hung in the guild chamber in December 1603, by which time five of the doctors portrayed were dead.

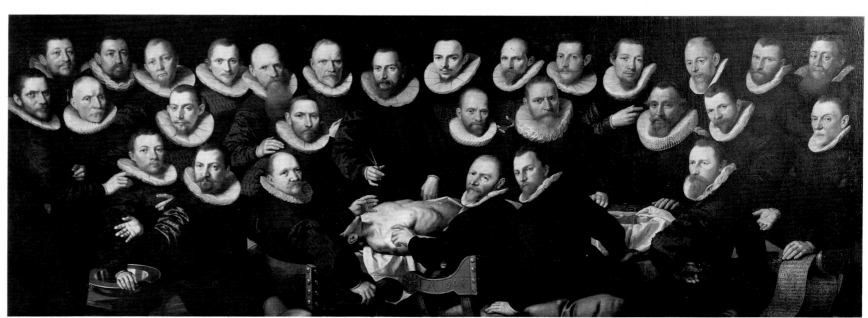

203

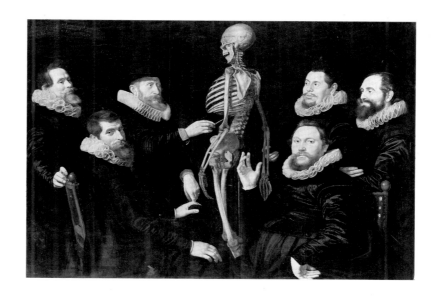

204 Thomas de Keyser
The Anatomy Lesson of Dr. Sebastiaen Egbertsz de Vrij, Amsterdam
1619. Canvas, 135 × 186 cm. Amsterdams Historisch Museum, Amsterdam

205 Rembrandt van Rijn
The Anatomy Lesson of Dr. Nicolaes Tulp
Signed and dated 1632 (painted over). Canvas, 169.5 × 216.5 cm. Mauritshuis, The Hague

When the same Dr. Sebastiaen Egbertsz gave his second commission, in 1619, this time to Thomas de Keyser, he made things considerably easier: only five officials attended the lesson (fig. 204). It was of course impossible to include the increasing number of surgeons who joined the guild. De Keyser's composition is symmetrical, with three men to the right and three to the left of the mounted skeleton. (A corpse may not have been available, or perhaps the doctors wished to study bone structure.) And the master surgeon, in accordance with a new convention, is wearing a large hat.

It is one of the marvels of seventeenth-century Dutch art that Rembrandt, just moved from Leiden at the age of twenty-six and barely launched on his career in Amsterdam, was able to create a painting of such great originality as his *Anatomy Lesson of Dr. Nicolaes Tulp* (cpl. 205). He brought a new form and content to the subject with an ingenuity never before displayed in the history of the group portrait. Rembrandt painted a group that deviated in every respect from standard practice. By placing the corpse on the diagonal, he could efficiently and asymmetrically build up the group of "students" at the head of the table, while the lecturer, Dr. Tulp, stands in his full dignity and importance, facing them

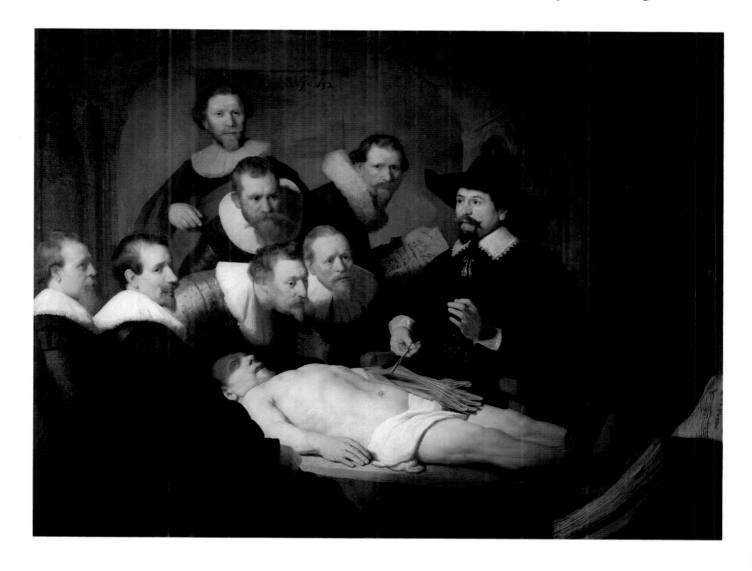

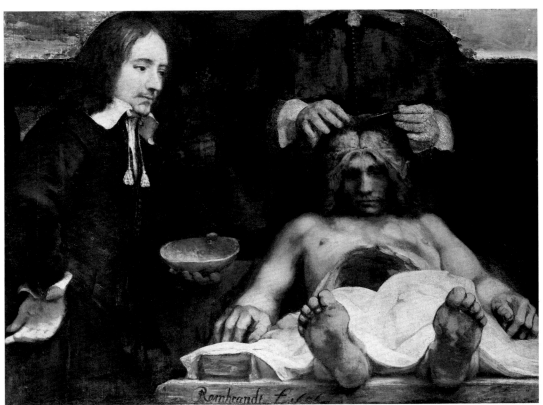
206

207

206 Rembrandt van Rijn
The Anatomy Lesson of Dr. Joan Deyman
(fragment)
Signed and dated 1656. Canvas, 100 × 134 cm.
Rijksmuseum, Amsterdam. On loan from the
City of Amsterdam

207 Rembrandt van Rijn
The Anatomy Lesson of Dr. Joan Deyman
c. 1656. Pen and bister, 11 × 13.3 cm. Print
Room, Rijksmuseum, Amsterdam. On loan
from the City of Amsterdam

naturally. By their intent expressions, the members of his audience reveal their deep absorption in the lesson. Rembrandt fulfilled the demand to treat all those depicted as individual portraits; he also brought to the central theme, the anatomy lesson itself, its first real significance.

It is sad that Rembrandt's second anatomy-lesson painting, of 1656, survives only as a fragment (fig. 206); the work hung in the anatomical theater of the Amsterdam Surgeons' Guild, where it was severely damaged by fire in 1723. In its undamaged state, it must have been an impressive composition. The corpse is on the axis of the painting, the soles of the feet thrust foremost. This very stringent foreshortening was a traditional perspective stunt. Rembrandt made a compositional sketch (fig. 207) which shows that the men were grouped symmetrically, with Dr. Joan Deyman, the praelector, in the middle just behind the body (for further discussion, see p. 355).

Apart from Rembrandt's, the anatomy-lesson pictures made after the middle of the century are more or less predictable. Adriaen Backer arranged his group in 1670 against a much lighter background (fig. 208); like Gerbrand van den Eeckhout in his painting of the governors of the wine merchants' guild (see fig. 63), he adds statues of subjects related to the theme, in this case Apollo and Asklepios, the patrons of surgeons. Backer reveals himself here and in several other group portraits to be an excellent portraitist. He has laid down the corpse with a gracefulness that is in decided contrast with Rembrandt's second anatomy lesson—a demonstration of the change in taste which had meanwhile occurred.

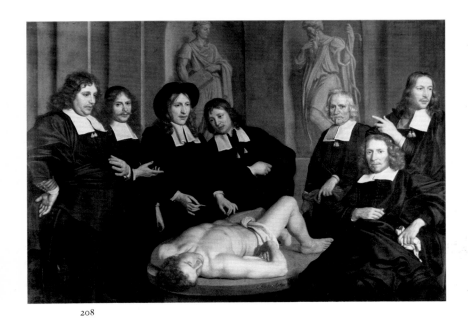
208

209

And yet, the old pattern could be adapted anew. Backer's anatomy lesson had been commissioned by Professor Frederik Ruysch, who thirteen years later gave his second commission to the little-known artist Johan van Neck. Van Neck evidently studied Rembrandt's first anatomy lesson, but he modified his composition in his own way (fig. 209): this time the corpse being dissected is that of a newborn baby (the placenta lies at its side), and at the right, with the skeleton of an infant in his hand, stands Dr. Ruysch's young son, who later became a physician himself.

Still Lifes

The term *stilleven* first appears in the Northern Netherlands about 1650.[44] It is of Dutch coinage and means "things lying still." In the seventeenth century the word *leven* (life) was also sometimes used to mean "model," and the compound *stilleven* could signify "inanimate model," or by extension "soulless model."

Still lifes had been painted for a long time before 1650, but we find them listed in inventories as a "little banquet," "little breakfast," "little tobacco painting" or merely "little tobacco," "death's head" or "vanitas," "little kitchen," "flower pot," "fruit" or "fruitage," and so on. The various kinds of still lifes were differentiated by the objects depicted. Most painters also kept to a combination of certain objects which they apparently thought were logically associated and appropriate to their purpose—a didactic purpose rather than an aesthetic one, except as beauty or good example elevated the mind. Each artist had an aesthetic sensibility, but the idea of art for art's sake had not yet been born, and a still life assembled exclusively for pleasure in the objects and in the play of light over them was unthinkable in the seventeenth century.

Floral Painting

When we examine the various forms in which the still life appeared, the question arises whether the flower painting belongs among them or not. Under the strict definition of the term still life, it does not; in the seventeenth century a considerable distinction seems to have been made in favor of the painter of flower pieces over the painter of still lifes. Whereas the flower painters were among the best-paid artists—de Gheyn received 600 guilders in 1606 for a flower painting, and Bosschaert was able to command 1,000 for his last work—the still-life painters usually got meager fees. As noted above, Samuel van Hoogstraeten speaks disdainfully of the painters of still lifes and flower paintings alike, declaring them to be "only common soldiers in the army of art," and Gerard de Lairesse goes so far as to call the subject one for "weak Spirits."[45]

Flowers had long been included in religious subjects, always with a symbolic meaning.[46] The white lily and, in the north, the white iris were symbols of the Virgin's purity, as the rose was of her love. The daisy stood for charity, the carnation for resurrection and the hope for eternal life. Graphic artists seem to have been especially fond of carnation symbolism. More worldly symbolism was also assigned to flowers: the rose could indicate earthly love as well as heavenly love; the buttercup signified the unmarried state; the cinquefoil meant affection or inclination. Flowers in general symbolized spring (fig. 210) or sweet smells, and withering blossoms were a frequent motif in *vanitas* paintings. Paintings and emblem books are evidence that the seventeenth-century Dutch still recognized and used flowers as traditional symbols. The sunflower, like the rose, is often encountered as a

◁

208 Adriaen Backer
 The Anatomy Lesson of Professor Frederik Ruysch
 Signed and dated 1670. Canvas, 168 × 244 cm.
 Amsterdams Historisch Museum, Amsterdam

209 Johan van Neck
 The Anatomy Lesson of Professor Frederik Ruysch
 Signed and dated 1683. Canvas, 142 × 203 cm.
 Amsterdams Historisch Museum, Amsterdam

sign of love for God (fig. 211) and of earthly love, as in the self-portrait of Ferdinand Bol with his wife (fig. 212).[47]

In the late fifteenth and the sixteenth century, a few flower paintings might be considered independent works, in that flowers dominate the pictorial surface. One such is by Hans Memling (fig. 213), but his flower still life, as in virtually all cases of this sort, is part of a larger whole—here it belongs with the portrait of a man in an attitude of adoration on the other side of the panel. This panel was probably once one wing of a diptych, with the Madonna depicted on the other wing.[48] When the diptych was shut, only the flower painting could be seen, symbolizing the purity and love of Mary. Neither iconographically nor generically is this painting a precursor of the independent flower piece, nor are the

211

210

210 Lucas van Valckenborgh
 Spring. One of a series of the Four Seasons
 Signed and dated 1595. Canvas. Dimensions and
 whereabouts unknown

211 The sunflower as emblem of the love of God,
 from Zacharias Heyns, *Emblemata*, 1625

212 Ferdinand Bol
 Self-Portrait of the Painter and His Wife
 Signed and dated 1654. Canvas, 205 × 180 cm.
 Musée du Louvre, Paris

212

214

213

215

216

213 Hans Memling
Vase of Flowers
Reverse of a portrait. c. 1490. Panel, 28.7 × 21.5
cm. Collection Thyssen-Bornemisza, Castagnola,
Switzerland

214 Ludger Tom Ring the Younger
Vase of Flowers
Signed and dated 1565. Canvas, 98.5 × 158 cm.
Westfälisches Landesmuseum, Münster

215 *Vase of Flowers* from Adriaen Collaert,
Florilegium, Antwerp, end of 16th century
Engraving

216 *Crocus* from Crispijn de Passe II, *Den Blom-hof*,
Utrecht, 1614

"flower pots" of 1562 and 1565 by the Westphalian painter Ludger Tom Ring the Younger
(fig. 214), little panels that presumably served originally as cabinet doors.[49]

During the sixteenth century, as part of the humanist revival of learning and
advancement of science, an intense interest in botany arose, leading to the publication of
books about plants and to the laying out of botanical gardens. The gardens may be
considered outdoor extensions of the *kunstkamers*, the collectors' cabinet of marvels in which
the rarest and most curious objects and flowers were assembled. Painting, too, was associated
with this interest: Joris Hoefnagel, having early depicted flowers and insects for such patrons
as Emperor Rudolf II, later accompanied the Flemish cartographer Abraham Ortelius on
journeys through Germany and Italy, making on-the-spot drawings of plants and flowers.

In the second half of the sixteenth century, Christophe Plantin, the well-known Antwerp
printer, published a number of botanical books illustrated by the engraver Pieter van den
Borcht; these were important to the further development of floral painting. At the end of
the century the Antwerp engraver Adriaen Collaert issued a *Florilegium* especially for artists
(fig. 215), evidence that the painting of flowers had by then become nothing unusual.
Antwerp's importance as a center of botanical illustrations is attested by a letter written by
the Southern Netherlander Carolus Clusius (Charles de l'Escluse or Lécluse), who had
become professor of botany and head of the *Hortus Botanicus* or horticultural garden at
Leiden University in 1593. In it he requests Antwerp engravers to make woodcuts of
various herbs, since there was no one in Leiden or nearby competent to do so.[50] Illustrated
botanical books began to be published a little later in Holland; one was Crispijn de Passe II's
Den Blom-hof (The Flower Court) of 1614 (fig. 216).

217

218

219

217 Dirck van Delen
Tulip in a Chinese Vase
Signed and dated 1637. Panel, 38.5 × 29 cm.
Museum Boymans-van Beuningen, Rotterdam

218 Jacob de Gheyn II
Vanitas
Signed and dated 1603. Panel, 82.5 × 54 cm. The
Metropolitan Museum of Art, New York.
Charles B. Curtis, Marquand, Victor Wilbour
Memorial, and Alfred N. Punnett Endowment
Funds, 1974

219 Jan Bruegel the Elder (attributed)
Vase of Flowers
Copper, 30.5 × 20.3 cm. Private collection

The early development of the flower painting went hand in hand with the interest in botany and may also be assumed to have taken place in Antwerp. Again there is evidence in another letter, this time by Jan Bruegel, who wrote to Cardinal Federigo Borromeo in Milan in April 1606: "I have begun on a bouquet of flowers for Your Eminence. The result will be a success and very lovely because of both the naturalness and the exceptional beauty of the various flowers, many of which are here unknown or extremely rare; for this reason I went to Brussels to draw from life some of the flowers not to be found in Antwerp."[51] The painting he refers to cannot be traced.

Ambrosius Bosschaert, one of the first flower painters in the Northern Netherlands, was born in Antwerp in 1573 but fled with his parents to Middelburg when he was in his early teens. From the beginning he specialized in painting flowers, and he kept in close touch with flower enthusiasts. The demand for floral paintings was probably mainly stimulated by these botanical connoisseurs.[52] Many a flower piece no doubt originated in their desire to see their expensive specimens rendered in color.

Of all flowers, the tulip aroused the greatest interest in the Netherlands. It was presumably Clusius who was chiefly instrumental in introducing this exotic. He had been in charge of the imperial medicinal herb garden in Vienna, where tulips were cultivated earlier than in Holland, and when he came to Leiden in 1593 he brought some bulbs with him.[53] Between 1610 and 1620, the tulip became an expensive, fashionable, and highly coveted flower. A veritable tulip mania began about 1633, reaching its peak some four years later. New varieties were constantly being developed and marketed for unbelievable amounts of money. When the market crashed in 1637, thousands of speculators went down with it. The flower paintings of the time reflect the new rage; increasing numbers of tulips in large arrays of colors and varieties appear in the painted bouquets, and there are even a few instances of a single tulip in a vase (fig. 217).

Along with the new botanical interest, the older tradition of attributing symbolic meaning to flowers continued. The tulip became a favorite emblem of human mortality (fig. 218). The inscription on a painting attributed to Jan Bruegel the Elder (fig. 219) indicates that a mixed bouquet could impart the same message:

How you stare at this flower, which seems to you so fair,
Yet is already fading in the sun's mighty glare.
Take heed, the one eternal bloom is the word of God;
What does the rest of the world amount to?—nothing.

Many *vanitas* still lifes have scattered blossoms or a whole bouquet (see figs. 248 and 252). The presence of insects on the flowers or near the vase reinforced the symbolism of the passing of time.

220 Roelant Savery
Vase of Flowers
Signed and dated 1601 or 1604. Copper, 29 × 19
cm. Centraal Museum, Utrecht

The flower painting was included in the curriculum of the painters' apprentices. According to van Mander, while Cornelis Cornelisz van Haarlem was a pupil of Gillis Coignet in Antwerp, he "made a pot with all sorts of flowers after life, but (as his master wished) with scarcely any greenery."[54] Van Mander further relates that when Jacob de Gheyn II first started to paint, he practiced the use of colors by making a small flower painting. Indeed, van Mander recommends in his "Foundation" the painting of flowers as a useful exercise in learning "how to sort paints."

The date of the first flower paintings in the Northern Netherlands is uncertain. Van Mander mentions one Lodewyck Jansz van den Bos, whose flower paintings he had seen among other works in collections in Middelburg and Amsterdam; the painter was born in 1525 in 's-Hertogenbosch, so his flower paintings presumably date after 1550. Cornelis van Haarlem's flower painting cited by van Mander must have been painted about 1580, and de Gheyn's about 1600. Ambrosius Bosschaert is listed in 1593, when he was twenty years old, as an official of the Middelburg St. Luke's Guild, and he was probably active as a flower painter shortly before that date. Letters between Clusius and Middelburg flower collectors in 1596 and 1597 reveal that flower painters were already working in the Zeeland capital at that time.

Unfortunately, out of all these early paintings, not one has been preserved, but after 1600 we have something to go by. A small flower painting by Roelant Savery is dated 1601 or 1604 (fig. 220), and most likely originated in Amsterdam. The many insects in this painting, including the death's-head moth, the sexton beetle, the dayfly, and the bluebottle, are, like the flowers, common symbols of transience, yet uncommon at this early date in their variety. They moreover reflect another new scientific interest: entomology.

Ambrosius Bosschaert is of greater importance to the development of the flower painting, because his work attracted more followers. One of his earliest dated works,[55] a panel bearing the monogram *A.B.* and the date 1609 (cpl. 221), is of a bouquet composed quite symmetrically, with little depth; all the flowers seem to occupy one plane. This piece shows a clear relationship to Collaert's engravings in his *Florilegium*. The flowers are in perfect condition and readily identifiable; the background is a nearly even dark gray; the decorative vase stands on a tabletop, where various insects are crawling. The Middelburg group of painters continued to use this compositional scheme for some time, as did their followers in Utrecht, Amsterdam, and Delft.

The question arises of how true to nature are the representations in the flower paintings. The answer can be outlined as follows: the flowers themselves were always studied from nature and depicted as accurately as possible, but the painting as a whole, in the vast majority of cases, was a work of imagination—"of the spirit," to use the contemporary phrase. The painted bouquet often contains flowers that do not bloom at the same time of year; the blossoms are also nearly always at their height of perfection; and the arrangement is usually unnatural, if not uncomfortable. The flowers are sometimes out of proportion as to size, and often so many are bunched together that their stems could not possibly be crammed into the vase in the picture. In making their compositions, as many sources inform us, the flower painters worked from drawings or other models, and it is known that some artists used the same drawing over and over, so that paintings that date years apart show the same flower in exactly the same position.

Closely related to the flower painting are the fruit painting and the still life with shells. A good many artists specialized in flowers and fruit, often combined in one composition (fig. 222). Still lifes of shells alone are fairly rare (see fig. 425). In the seventeenth century, shells

221 Ambrosius Bosschaert
Vase of Flowers
Signed and dated 1609. Panel, 50.2 × 35.3 cm.
Kunsthistorisches Museum, Vienna

222 Balthasar van der Ast
Fruit, Flowers, and Shells
Signed. c. 1620–25. Panel, 55.2 × 89.2 cm. The
Toledo Museum of Art, Ohio. Gift of Edward
Drummond Libbey

223 Willem van Aelst
Vase of Flowers
Signed and dated 1663. Canvas, 67 × 55 cm.
Ashmolean Museum, Oxford

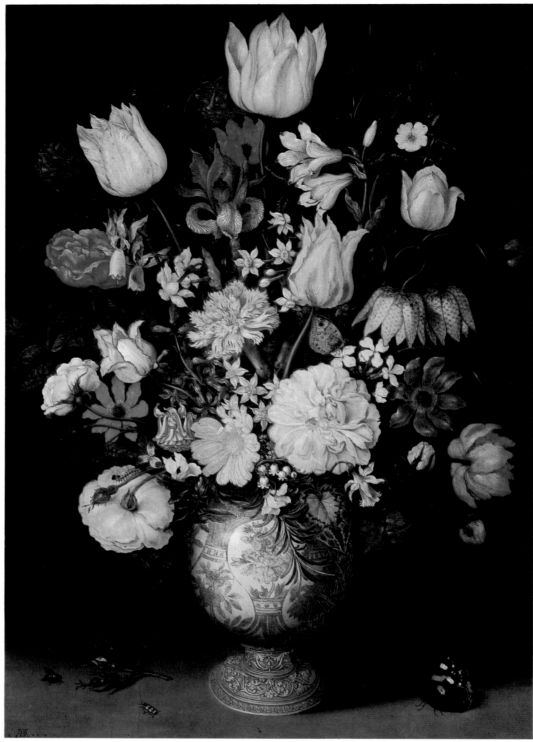

221

223

222

were highly prized collectors' items, and those portrayed in still lifes were exotic specimens from distant shores.

In the further development of the flower painting, it is seldom clear whether the painter's or the patron's interest was chiefly botanical, symbolic, or both. Flower paintings may well have become so popular in themselves that the original motives for painting them disappeared.

As the flower painting evolved during the course of the century, its creators aimed at a looser and more natural composition, with greater depth in the bouquet. The symmetrical construction yielded to the asymmetrical arrangements worked out by artists after 1650. The artists' rapidly developing technical skills led to extremely subtle and beautiful paintings, of which Willem van Aelst's *Vase of Flowers* of 1663 is a fine example (fig. 223).

Kitchen Paintings and Market Scenes

The kitchen painting enjoyed great popularity in the sixteenth century. In the Northern Netherlands, Pieter Aertsen was the pioneer in this type: a kitchen scene, with an abundance of food on display, and a number of figures either standing around or busy with the preparation of a meal. In the background there is nearly always a Bible scene. Aertsen's paintings, in which he was probably assisted by his pupil Joachim Beuckelaer, were usually of large size, as were Beuckelaer's own works in his turn (fig. 224).

It has sometimes been assumed that the Bible story was tucked into the background as an excuse for the artist to exceed himself in the sumptuous still lifes in the foreground, which were what he really wanted to paint. The art theories of the period, however, do not admit of an explanation like this. The purpose of such a painting was moralistic, as everyone knew, and no one had any difficulty in grasping the message conveyed by the still life in relation to the biblical scene.[56]

In a few cases the painter brought out the moral by adding an inscription. One of Aertsen's relatively small paintings, dated 1552 (fig. 225), devotes the entire right side to a beautifully painted still life. By contrast, the scene at the left, showing Christ in the house of Martha and Mary, is unobtrusive, but on the fireplace appear the words "Mary hath chosen the better part." These give the clue to the meaning of the painting: this is an illustration of the antithesis between the *vita activa* and the *vita contemplativa*, with special reference to Martha's concern for worldly things and Mary's preference for the word of God. The dominant still life displays food, beverages, money (a moneybag is hanging over the open cabinet door), sealed documents, flowers, crockery, and folded linens; it takes some effort to discover the spiritual message behind this worldly accumulation.

The paintings by Aertsen and Beuckelaer seem nearly always to contain such contrasts. The background scenes are usually Christ and the woman taken in adultery, Christ with Martha and Mary, Christ at Emmaus, or the parable of Lazarus and the rich man. When figures and a kitchen still life fill the foreground, the message is presumably a warning against the pleasures of the flesh. The women are often depicted with a fowl in their hands;

224

225

224 Joachim Beuckelaer
Kitchen Piece with Christ in the House of Martha and Mary
Signed and dated 1566. Panel, 171 × 250 cm.
Rijksmuseum, Amsterdam

225 Pieter Aertsen
Still Life with Christ in the House of Martha and Mary
Signed and dated 1552. Panel, 60 × 101.5 cm.
Kunsthistorisches Museum, Vienna

226 Pieter Aertsen
Christ and the Woman Taken in Adultery
Panel, 122 × 180 cm. Nationalmuseum, Stockholm

226

as noted on page 76, "fowling" had clear sexual connotations. In Aertsen's painting now in Stockholm (fig. 226), the background scene is of Christ and the adulteress; in the foreground two men, one on each side, challengingly thrust a string of onions and a bird at a woman seated amidst a still life of vegetables and fruit. As is clear from one of Cats's emblems (fig. 227), the "disrobing" of an onion leads to tears, a play upon fleshly lust and the resultant remorse; the connection between this image and the adulterous woman is self-explanatory.

In general it can be taken for granted that the kitchen still lifes with a biblical scene illustrated the opposition between worldly and spiritual values, the mundane being the more obvious but the more superficial. In pictures that lack a biblical scene—Aertsen's *The*

164

NVDA MOVET LACHRIMAS.
XXVIII.

HEROD. LIB. 1. *Mulier exutâ tunicâ verecundiam pariter exuit.*
ANNÆN. ROBERT. RER. IVD. LIB. 4. CAP. 10.
Nuditas in viro indecens, in muliere probrosa: unde Herodotus apud Lydas & plerasque gentes, etiam barbaras, viris indecorum fuisse tradit se nudos ostendere, nam (ut ait Cicero) hoc solum animal natum est, pudoris & verecundia particeps.
ADDE,
Flagitii principium esse, nudare inter cives corpora.
Wee

227

229

227 Emblem from Jacob Cats, *Sinne- en Minnebeelden*

228 Pieter Cornelisz van Ryck
Kitchen Piece
Signed and dated 1604. Canvas, 189 × 288 cm.
Herzog Anton Ulrich Museum, Brunswick, West Germany

229 Jan Victors
Market Scene
Canvas, 118 × 146 cm. Private collection

228

Egg Dance, for instance (see fig. 12)—the intention was perhaps solely to portray abundance and sensuality, but hardly without moral stigma.

The kitchen painting underwent a revival about 1600. In Delft it was taken up by Michiel van Miereveld, in Utrecht by Joachim Wttewael, in Leiden by David Bailly, in Amsterdam by Adriaen and Jacob van Nieulandt, among others, and in Haarlem by Pieter Cornelisz van Ryck (fig. 228) and Cornelis Cornelisz van Haarlem.

Closely related to the kitchen paintings are the market scenes, another specialty of Aertsen and Beuckelaer (see fig. 255). This type of painting continued to be produced, by Jan Victors (fig. 229) and others, in many variations throughout the seventeenth century.

Little Banquets, Breakfasts, and Tobaccos

When seventeenth-century writers spoke of *banketjes, ontbijtjes,* and *tabakjes,* they were referring to simple still lifes depicting objects connected with eating, drinking, and smoking. The painting of these subjects was not confined to the Netherlands, but such still lifes flourished remarkably there, especially in Haarlem.

The earliest examples of relatively simple still lifes are found, albeit sporadically, in the sixteenth century. Several variants of one particular composition are known, and its origin can with considerable certainty be placed in Antwerp: the style of the painting is Flemish, and a hand—the emblem of the Antwerp painters' guild—appears on the earthenware mug (fig. 230). The words on the border of the wooden plate in the right foreground are only partly legible and do not make much sense, but there is an interesting piece of paper, a little print, tacked to the back wall. It shows an owl reflected in a mirror, flanked left and right by a candlestick and a pair of spectacles—an obvious representation of the proverb, "What good are candle and glasses if the owl doesn't want to see?" On the paper is also written *goeindach bruer* (good-day, brother) and *Uuilen.spieghel,* undoubtedly a reference to Tyl Uilenspiegel, the clownish embodiment, popular since the fourteenth century, of mankind's sad folly and silliness. Through a window at the right is a landscape with a gallows. This still life has a meaning, but today we can decipher it only dimly.

The origin of another sixteenth-century still life (fig. 231) presumably must be sought in

Amsterdam, for in its style this painting seems related to the still lifes in early civic-guard pieces; moreover, the pewter jug is of Amsterdam model. The unknown painter of this still life also had a moral message in mind, borne out by the small scene in the background, the Temptation of Christ, with the relevant biblical citation of Luke 4 painted onto the wall alongside. The purport cannot be mistaken, and it is analogous to the deeper meaning of a number of kitchen paintings: the temptations of worldly goods countered by faith in Jesus Christ. Somewhat later is a still life by Osias Beert, again from the Flemish school (fig. 232); in the background appears the story of the rich man and Lazarus the outcast.

The still lifes painted shortly after 1600 in Haarlem show no overtly symbolic or moralizing intent. The possibility should not be overlooked, however, that to

230

232

230 Antwerp Master
Still Life
Panel, 37 × 48 cm. Museum Boymans-van
Beuningen, Rotterdam. On loan from the
State-owned Art Collections Department

231 Artist Unknown
Still Life with the Temptation of Christ
c. 1580. Panel, 63 × 115 cm. State-owned Art
Collections Department, The Hague

232 Osias Beert
Still Life with the Rich Man and Lazarus the Outcast
Panel, 51.5 × 76 cm. Private collection

233 Nicolaes Gillis
Still Life
Signed and dated 1614. Panel, 65 × 100 cm.
Národní Galerie, Prague

231

233

contemporaries it was self-evident that the very theme pointed a warning finger at the superfluity of earthly goods.

The early Haarlem still lifes, such as that by Nicolaes Gillis (fig. 233), correspond in composition to the Amsterdam painting with the Temptation of Christ just discussed. The vanishing point is located so high that the objects on the table do not overlap one another; works of this type are sometimes called "spread-out" or "additive" still lifes. The colors are fresh and clear. One regular feature is a damask cloth that partially covers the table. There is almost always a glass or two among the objects, and usually a plate with various kinds of cheese; remarkably enough, Haarlem still lifes seldom contain meat or fish.

The spread-out still life was fully developed in Haarlem by 1610 and thrived until about 1625 (fig. 234). Changes then occurred: the number of objects was reduced, and the arrangements became more natural, the artist no longer striving to render every object in its entirety. The palette became very restrained. This development is demonstrated clearly in the work of Pieter Claesz and Willem Claesz Heda. In Claesz's brilliantly painted *Still Life*

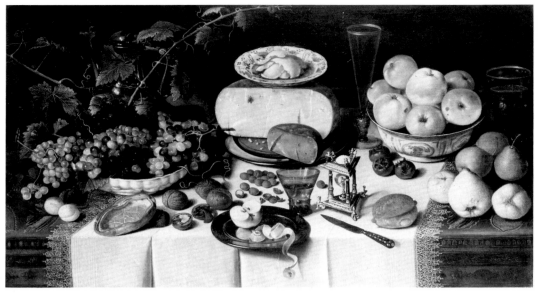

234

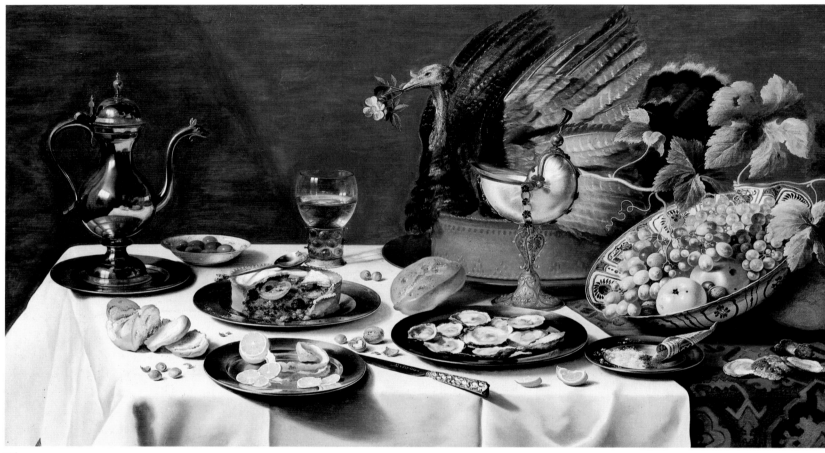

235

234 Roelof Koets
 Still Life
 Signed and dated 1625. Panel, 80 × 135 cm.
 Museum Mayer van den Bergh, Antwerp

235 Pieter Claesz
 Still Life with a Turkey Pie
 Signed and dated 1627. Panel, 75 × 132 cm.
 Rijksmuseum, Amsterdam

236 Willem Claesz Heda
 Still Life
 Signed and dated 1633. Panel, 59 × 79 cm. Frans
 Hals Museum, Haarlem

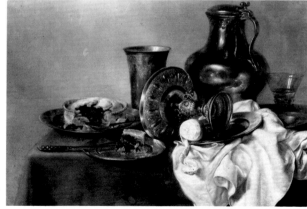

236

with a Turkey Pie of 1627 (cpl. 235), the pattern of the earlier works is still evident, although the vanishing point is a bit lower and the color slightly less exuberant. In Heda's still life of 1633 (fig. 236), the change-over is complete: the composition is unlabored yet carefully thought out, the treatment of materials extremely refined, and the color scheme limited mainly to grays and browns.

237 Jan Jansz van de Velde
 Still Life with a Pipe Lighter
 Signed and dated 1653. Canvas, 43 × 40 cm.
 Ashmolean Museum, Oxford

238 Barthel Bruyn the Elder
 Vanitas Still Life
 Reverse of *Portrait of Jane-Loyse Tissier, 1524.*
 Panel, 61 × 51 cm. State Museum Kröller-Müller,
 Otterlo

The simple type of still life with a limited number of uncomplicated objects was particularly popular in the second quarter of the seventeenth century. The subsequent trend was toward a much richer type.

Besides the little breakfasts, still lifes with the paraphernalia of smoking were also popular (fig. 237). In these, the bond with the *vanitas* still life is often more pronounced than in the breakfast paintings: smoking was counted an indecent if not dangerous new habit (the Spanish brought the first tobacco seeds to Europe from the New World about 1562, and the plant was soon cultivated widely for snuff; smoking tobacco was not introduced until the 1590s, but the Dutch took to it immediately), and the playing cards that often appear had long symbolized the evils of gambling.

Vanitas Still Lifes

In his study of realism and pseudorealism, the art historian de Jongh characterizes the mentality of the seventeenth-century Dutch by saying, "Dominating everything is the tendency to moralization, as a rule resulting in the encouragement of virtue and in reminders of transitoriness and death."[57] The strongly prevailing thought that each individual must be prepared to die at any moment was of course in accord with this outlook. The joy of life shines forth from Dutch paintings of this period, but we are constantly confronted also with direct or veiled allusions to human mortality.[58] Its most explicit form is in the type of still life called *vanitas*, in which the biblical symbolism of inevitable mortality, most clearly set out in the Book of Ecclesiastes, is about as easy for us to decipher as it was for contemporaries.

In sixteenth-century portraits, it was customary to introduce some symbol of mortality—a skull perhaps or, more optimistically, a carnation, emblem of the hope for eternal life. Pompeius Occo holds both in Dirck Jacobsz's portrait of him (see fig. 9). The artist could express the same thought by painting a still life with a skull on the back of a portrait, or he could include an explanatory text, as in the still life by Barthel Bruyn the Elder (fig. 238). The candle here symbolizes the shortness of life, and the inscription reads *Omnia morte cadut, mors ultima linia rerum* (Everything is conquered by death, death is the end of things). Another way to indicate the fragility of human existence is found on the back of a circular portrait by Cornelis Ketel dated 1574 (figs. 239 and 240): above a bubble-blowing putto is an inscription in Greek that reads "Man is a soap bubble." On the portrait side, a pocket-watch lies on the table next to the man; watches and hourglasses were other favorite sixteenth-century symbols of the passage of time or the brevity of life.

Vanitas symbolism carried over into the next century, the customary objects often amplified with others bearing a similar message. A still life of a skull festooned with grain, by the otherwise virtually unknown painter G. van Deynum, also includes an hourglass, a crucifix, a smoldering match, a pipe, an oil lamp, and cherries (fig. 241); to leave nothing to doubt, the painter added the words *Hodie mihi cras tibi* (Today me, tomorrow you). A glowing match instead of a candle often appears in seventeenth-century still lifes, or a pipe with the smoke from burning tobacco (which hints at "Ashes to ashes"). Cherries had long been a symbol of eternal life, among other things, a meaning they, along with the crucifix, are no doubt meant to convey in this painting. Roses and documents affixed with large red seals augment the skulls and other traditional *vanitas* objects in a painting by Abraham van der Schoor (fig. 242). That roses were connected with thoughts of mortality is attested by Cesare Ripa, who wrote in his *Iconologia* of 1593 under Vita Breve: "The rose is a

239 240

241

242

239, 240 Cornelis Ketel
 Portrait of a Man. Verso: *Putto Blowing Bubbles*
 Signed and dated 1574. Panel, round, diameter
 43 cm. Rijksmuseum, Amsterdam

 241 G. van Deynum
 Vanitas Still Life
 Signed. Dimensions and whereabouts unknown

 242 Abraham van der Schoor
 Vanitas Still Life
 Signed. c. 1660–70. Canvas, 63.5 × 73 cm.
 Rijksmuseum, Amsterdam

symbol... of our fragile nature.... And very correctly is our life compared to a rose, which is truly beautiful and pleasant, yet withers and fades in the same day."[59] The Bible is the source of a similar metaphor: "Man... is of few days, and full of trouble. He cometh forth like a flower, and is cut down: he fleeth also as a shadow, and continueth not" (Job 14:1–2).

But all flowers can serve as emblems of transiency. This is made explicit in a still life by Pieter de Ring (fig. 243): flowers are depicted along with a skull, coins, an hourglass, a watch, a pipe and tobacco, and the inscription on the piece of paper at lower right: *Vanitas vanitatum et omnia vanitas* (Vanity of vanities, all is vanity: Ecclesiastes 1:2). The glassware in this painting obviously has the same symbolism, as is once again borne out by Ripa's dictum: "Truly are mankind's hopes a fragile glass, and life is therefore also short." Musical instruments, whose tones die quickly, and the products of art likewise belong in the *vanitas* painter's repertoire.

A somewhat divergent idea on art and life appears in an engraving of 1626 by Hendrik Hondius (fig. 244). A *vanitas* still life, with the traditional objects, is arranged on a table in a room, but in the foreground are various attributes pertaining to art. The title is *The End Crowns the Work*, conveying the thought that though the artist may die, his work lives on.

Van der Schoor and other artists included sealed documents in their still lifes. The symbolism of ephemerality was evidently thought applicable to business affairs, to which "eternal" values were often attached; kingship, which was in a precarious state in the seventeenth century; and science: all led to pride yet were powerless against death. Vincent van der Vinne made this explicit in his still life with a whole range of *vanitas* objects, a tag reading "Think about the end," and in the foreground a crown and a drawn portrait of Charles I of England, with another inscription: "Things can change" (fig. 245).

Clearly, objects of quite different sorts can be involved in *vanitas* symbolism. The combination of objects usually leaves no doubt that the picture is a moralizing still life on the theme of human mortality, yet borderline cases remain open to question about whether or not a particular object belongs within a certain meaning. There is a pocket-watch in nearly all of Abraham van Beyeren's opulent still lifes, often in combination with a rose (see fig. 271): did van Beyeren intend these objects as a warning—that the viewer must realize that this splendor and abundance were but vain and transitory? I am inclined to answer in the affirmative, but the same is not necessarily true of all ornate still lifes.

The still lifes of the Frisian painter Petrus Schotanus contain documents, globes, and books (all common *vanitas* symbols), and often dead fish and birds as well (fig. 246). These paintings also have elaborate texts; the writing in the picture here reproduced is a paraphrase of Ecclesiastes 9:12: "Like the fish, the net, and the bird, the snare: so Death overcomes Man, at an unseasonable time; and all things pass away, with time." Must we therefore interpret all the fish and bird still lifes by other artists in this sense? I think not, unless there are other *vanitas* symbols in them.

The first independent *vanitas* still lifes—those not combined with a portrait—were presumably painted about 1600. Van Mander mentions that the Amsterdam collectors Jaques Rozet and Reynier Antonissen each had a "death's head" among the items they owned, one painted by Abraham Bloemaert, the other by Jacob de Gheyn II. We know what Bloemaert's looked like, because Jan Saenredam made an engraving of it (fig. 247). De

243

244

243 Pieter de Ring
Vanitas Still Life
Signed and dated 1643. Canvas, 64.5 × 84 cm.
Private collection

244 Hendrik Hondius I
The End Crowns the Work
1626. Engraving

245 Vincent van der Vinne
*Vanitas Still Life with Crown and Portrait of
Charles I*
Signed. Canvas, 94.5 × 69 cm. Musée du Louvre,
Paris

246 Petrus Schotanus
Vanitas Still Life
Signed. Panel, 63.2 × 47.4 cm. Private collection

247 Jan Saenredam after Abraham Bloemaert
Death's Head
Engraving

248 Adriaen van Nieulandt
Vanitas Still Life
Signed and dated 1636. Panel, 39.5 × 36 cm. Frans
Hals Museum, Haarlem

245

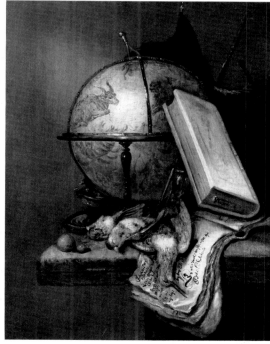
246

Gheyn's may be the same as the *vanitas* still life, dated 1603, with the inscription *Humana Vana* (see fig. 218).[60] In it the skull, placed on a few sheaves of grain in a niche, is flanked by images of Democritus laughing at human folly and Heraclitus bemoaning it. Above the skull floats a transparent ball that reflects many objects relating to transience and vanity, among them playing cards and a trictrac board. Coins lie on the stone sill; at the left is a vase of flowers, displaying most prominently the expensive tulip; at the right stands a smoking urn. De Gheyn's painting—he also made a drawing on the theme—harks back to

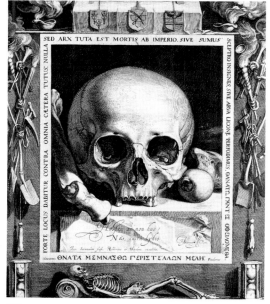
247

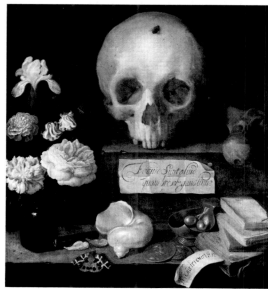
248

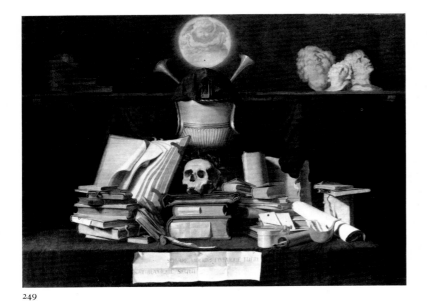

249

250

251

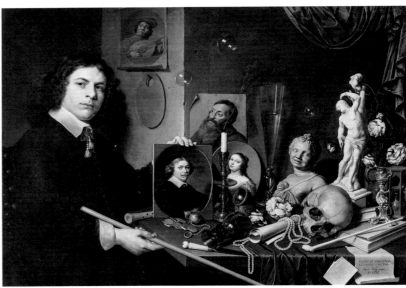

252

249 Jacob de Gheyn II
Vanitas Still Life with Books
1621. Panel, 117 × 165.5 cm. Yale University Art
Gallery, New Haven, Connecticut. Gift of the
Associates in Fine Arts

250 Leiden School (?)
Still Life of Books
Panel, 61.3 × 97.4 cm. Alte Pinakothek, Munich

251 Jan Davidsz de Heem
*Interior of a Room with a Young Man Seated at a
Table (Studium?)*
Signed and dated 1628. Panel, 60 × 82 cm.
Ashmolean Museum, Oxford

252 David Bailly
Vanitas Still Life with a Portrait of a Young Painter
Signed and dated 1651. Panel, 89.5 × 122 cm.
Municipal Museum De Lakenhal, Leiden

sixteenth-century allegory, as expressed primarily in prints. What is new is his treatment of the subject independently in a painting.

No other *vanitas* still lifes have survived from the early decades of the seventeenth century, but it is certain that the type, as made by de Gheyn, continued to exist. Adriaen van Nieulandt's still life of 1636 (fig. 248) is in the same spirit. Like de Gheyn's, it must have originated in Amsterdam.

In 1621, during his Hague period, de Gheyn painted a still life which contains the same basic elements as his 1603 piece, augmented by an elaborate still life of books (fig. 249). Pinned to the tablecloth in the foreground of this painting is a quotation from the *Pharsalia* (2:381) of the Roman poet Marcus Annaeus Lucanus: "Keep within bounds, hold fast to your goal, follow nature." De Gheyn's work may well have influenced the painters Jan Davidsz de Heem, Jacob de Gheyn III, and Jacob Westerbaen: between 1625 and 1630, in Leiden and The Hague, these artists created a number of still lifes featuring books (see fig. 567). Although a book still life often contains a skull or an hourglass, its theme is not necessarily transience alone; there is good reason to think that some book still lifes, with or without pens and inkpots, may symbolize *studium* (fig. 250). When *vanitas* elements are also present, the subject may be a dialogue between *studium* and *vanitas* with the former victorious, in analogy with Hondius' print mentioned above, where the artist's name is shown to survive in his work. De Heem's *Interior of a Room with a Young Man Seated at a Table* (fig. 251), with its still life of books, may be interpreted as representing *studium*.

In 1651 David Bailly painted a portrait of a young artist standing beside a still-life display that is a virtual inventory of the objects available to the *vanitas* painter: skull, hourglass, a candle just snuffed out, precious jewels, smoking equipment, flowers, coins, books, and glassware (fig. 252). Many categories of art—painting, sculpture, music, silversmithing—are represented, while soap bubbles float in the air. On a slip of paper appears the classical *vanitas* admonition. During the second half of the seventeenth century, *vanitas* motifs and still lifes continued to be regularly produced by such artists as Edwaert Collier (see fig. 958).

253

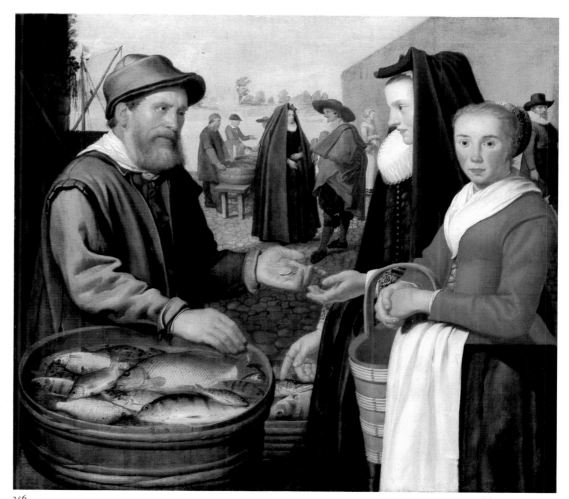

256

253 Crispijn de Passe after Maerten de Vos
Water. One of a series of four on the Four
Elements. Engraving

254 Pieter van Noort
A Fisherman with His Catch
Signed and dated 1631. Canvas, 142 × 187 cm.
Muzeum Narodowe, Warsaw

255 Joachim Beuckelaer
Fish Market
Signed and dated 1570. Panel, 151 × 202 cm.
Nationalmuseum, Stockholm

256 Jacob Gerritsz Cuyp
Fish Market
Signed and dated 1627. Canvas, 110.5 × 121.5 cm.
Dordrechts Museum, Dordrecht

Fish and Bird Still Lifes

Despite the birds and fish in Petrus Schotanus' *vanitas* roster, the transiency theme probably
had no great significance in the development of the independent still life of fish or birds. If
any tradition was involved, it was more likely that of the four elements. The representation
of the elements, as we have seen, underwent a change at the beginning of the seventeenth
century, when idealized figures with attributes gave way to scenes from daily life.
Buytewech used the shooting and trapping of songbirds to represent the element air, and
fishermen on a beach to represent water (see figs. 85–88). In a series of the four elements by
Crispijn de Passe after Maerten de Vos, water is symbolized by a fisherman and a woman at
a fish stall (fig. 253). A painting by Pieter van Noort showing a fisherman with his catch
(fig. 254) may well illustrate the element water, but we must be cautious in our conclusions
where there is no other evidence of a series portraying the elements.

The sixteenth-century fish-market scenes by Pieter Aertsen and Joachim Beuckelaer (fig.
255) may be the predecessors of these fish still lifes. The fish market itself remained a popular
subject with artists like Jacob Gerritsz Cuyp (cpl. 256) and Emanuel de Witte (see fig. 1080).

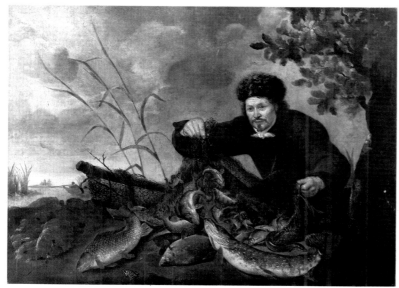

254

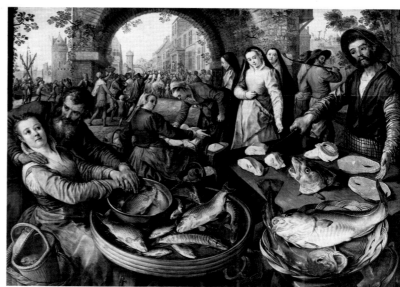

255

257 Clara Peeters
 Still Life with Fish, Oysters, and Shrimps
 Signed. Panel, 25 × 35 cm. Rijksmuseum,
 Amsterdam

258 Pieter van Schayenborch
 Still Life with River Fish
 Signed and dated 1657. Canvas, 73 × 111 cm.
 Private collection, Netherlands

Independent fish still lifes were painted quite early by, among others, the Flemish artist Clara Peeters (fig. 257). Among the Northern Netherlanders, Pieter de Putter, Pieter van Noort, and Pieter van Schayenborch explored this subject after about 1630. Schayenborch's *Still Life with River Fish* (fig. 258) is a good example of their paintings, in which the fish are displayed on a table, with or without nets, fishing rods, or creels. Freshwater fish are not usually found together in the same painting with saltwater fish.

After 1650 Abraham van Beyeren became the ablest painter in this category. His brilliant style and masterful feeling for composition brought fish still lifes to new heights. The backgrounds of his paintings often include a little view of a beach with fishermen and their boats (fig. 259). Artists sometimes combined their talents in making such pictures: Adam

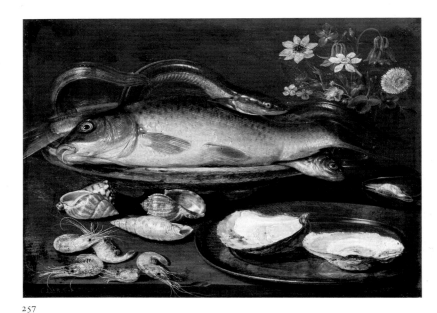

257

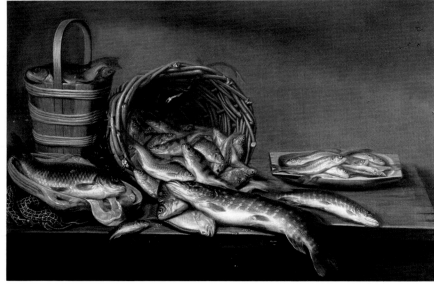

258

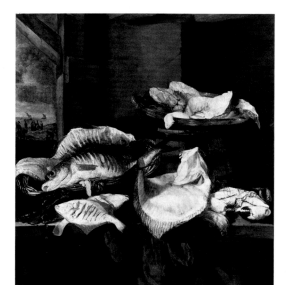

259

Willaerts painted the sea, for instance, and Willem Ormea the fish in the *Beach Scene with the Miracle of the Fishes* (fig. 260), from the account in Luke 5:1–11.

Although van Beyeren had a certain following, only a few artists persisted as independent fish still-life painters. Interest in the subject lasted longest in Utrecht, where Jacob Gillig specialized in it until late in the century (see fig. 879).

The still life with birds was another category that developed from the kitchen paintings and market scenes by Aertsen and Beuckelaer. In a work by Adriaen van Nieulandt of 1616 (fig. 261), an elaborate bird still life becomes part of a kitchen piece. Depicted in the background is the story (from II Samuel 13) of the slaying of Amnon at Absalom's feast, and in the left foreground appears once again the silver ewer made by Adam van Vianen in 1614 (see fig. 111).

About 1640 Rembrandt painted his study of dead peacocks (more properly, peahens), with a girl leaning on a sill in the background (fig. 262), and only after that year did the first still lifes of dead songbirds alone begin to be produced by such artists as Cornelis Lelienberg (fig. 263). More ample hunting still lifes set in the open air followed, displaying large game

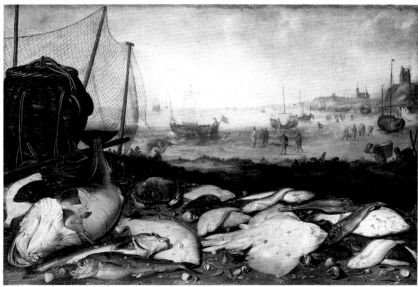

260

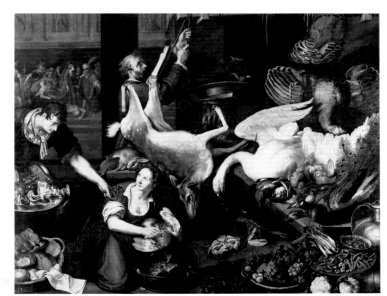

261

262

263

262 Rembrandt van Rijn
Still Life with Peacocks
Signed. c. 1639. Canvas, 145 × 135.5 cm.
Rijksmuseum, Amsterdam

263 Cornelis Lelienberg
Dead Birds
Signed and dated 1654. Panel, 56 × 45.5 cm.
Formerly Staatliche Kunstsammlungen, Dresden.
Destroyed during World War II

264 Jan Baptist Weenix
Still Life with a Dead Swan
Canvas, 152.5 × 154 cm. The Detroit Institute of
Arts. Gift of Ralph H. Booth

◁

259 Abraham van Beyeren
Still Life with Sea Fish
Signed. Canvas, 114 × 103 cm. Hannema-
de Stuers Foundation, Het Nijenhuis, Heino,
Netherlands

260 Adam Willaerts and Willem Ormea
Beach Scene with the Miracle of the Fishes
Canvas, 115 × 146 cm. Public Center for Social
Welfare, Bruges

261 Adriaen van Nieulandt
Kitchen Piece
Signed and dated 1616. Canvas, 194 × 247 cm.
Herzog Anton Ulrich Museum, Brunswick, West
Germany

birds and smaller species. Probably important here was the example of the Flemish artists Frans Snijders, Adriaen van Utrecht, Jan Fijt, and Pieter Boel, masters in the rendering of wild game, whether animal or bird. As wealthy Dutch merchants took to hunting with increasing enthusiasm, they began to seek decorations for their country houses. Hunting still lifes developed into highly decorative pieces, often of large format; one of the finest of these is Jan Baptist Weenix's *Still Life with a Dead Swan* (fig. 264).

Compositions in which birds or hares are shown hanging from a peg or nail (cpl. 265) are one variation on the theme of hunting trophies. By using this device and by refining the play of light and shade on the wooden or plastered back wall, painters attempted to create an effect that would momentarily fool the observer into taking the picture for reality. Paintings of this sort, known as "deceivers" or *trompe-l'oeils*, became extremely popular.

264

265 Melchior d'Hondecoeter
Dead Rooster
Signed. Canvas, 111.5 × 83 cm. Musées Royaux
des Beaux-Arts de Belgique, Brussels

266 Philips Angel
Trompe-l'oeil with Hunting Gear
Signed. Panel, 95 × 58.5 cm. Akademie der
Bildenden Künste, Vienna

267 Cornelis Norbertus Gijsbrechts
Painter's Easel with Fruit Still Life
Signed. Panel, 226 × 123 cm. Statens Museum for
Kunst, Copenhagen

265

266

267

268

268 Pieter Claesz
 Still Life
 Signed and dated 1650. Panel, 92.5 × 139.5 cm.
 Private collection

269 Adriaen van Utrecht
 Still Life
 Signed and dated 1642. Canvas, 221 × 307 cm.
 Museo del Prado, Madrid

270 Jan Davidsz de Heem
 Still Life
 Signed and dated 1640. Canvas, 149 × 203 cm.
 Musée du Louvre, Paris

Artists vied in inventing new ways of showing their skill at this kind of illusionism. Besides compositions with birds, they made pictures of hunting accoutrements hanging on a wall (fig. 266) or of other equipment and objects (see fig. 1012), all to please and tease their viewers. Cornelis Norbertus Gijsbrechts outdid everyone when he sawed a large panel into the shape of an easel, painted a still life on it, added painters' equipment, a miniature portrait, and a note, and leaned another "frame" and stretcher face backward against the easel's foot (fig. 267). So successful was his little deception that he did it again and again.

Ornate Still Lifes

After about 1640 still lifes of relatively simple composition and restrained palette began to yield to more complex compositions and a more elaborate palette. Moreover, in many cases the earlier practice of bringing objects together according to a predetermined scheme was abandoned. Various types of still lifes were now combined. Such older masters as Pieter Claesz joined in this development, as may be seen by his *Still Life* of 1650 (fig. 268).

The source of the new trend was Antwerp, where artists like Frans Snijders and Adriaen van Utrecht were painting still lifes which produced an impression of overwhelming abundance in their diversity of objects, fruits, flowers, and dead game, often amplified by living human and animal figures (fig. 269). When the human figures in these compositions are active participants, this type of painting is a continuation of the more traditional kitchen painting. A direct link between Antwerp still-life painters and those in the Republic was provided by Jan Davidsz de Heem, who began his career in Holland and Utrecht, then moved to Antwerp in 1636 and settled there more or less permanently, while maintaining close ties with his homeland. The paintings he made in Antwerp (fig. 270) clearly show the pervasive influence of his Flemish colleagues, and his work influenced painters in Holland, although the huge, opulent Flemish type of still life never became popular in the north.

Other painters also gave new impulse to the subject. Shortly after 1650, Abraham van Beyeren began to paint *pronk* or ornate still lifes, usually vertical in format, of fruit together with embossed silver bowls, expensive glass, and Chinese porcelain (fig. 271). Willem Kalf,

269

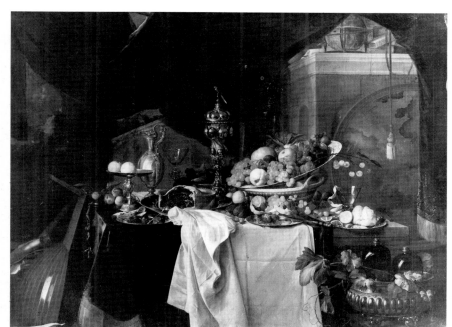

270

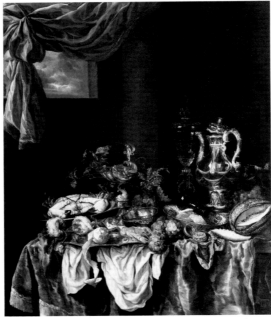
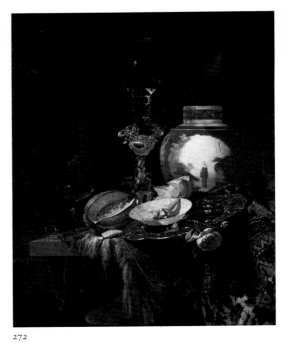

271 Abraham van Beyeren
Still Life
Signed and dated 1654. Canvas, 126 × 106 cm.
Museum Boymans–van Beuningen, Rotterdam

272 Willem Kalf
Still Life with Chinese Vase
Canvas, 102 × 83 cm. Musée de Picardie, Amiens

273 Joachim Patenier
Landscape with the Rest on the Flight to Egypt
Signed. Panel, 74 × 91 cm. Museo del Prado,
Madrid

271 272

less exuberant in his compositions, concentrated on the gleam of silver and crystal against a
dark background (fig. 272). Simpler compositions were painted by Pieter van Roestraten,
among others (see fig. 840), but the still life of the third quarter of the seventeenth century
took its form in the work of de Heem, van Beyeren, and Kalf.

Landscapes

The surge of Dutch landscape painting in the seventeenth century is a truly remarkable
phenomenon. There is ample evidence of the great and diversified public demand for
landscapes: topographically recognizable landscapes, seemingly realistic local landscapes,
fantastic mountain views, Scandinavian landscapes, Rhine River views, Italianate
landscapes—all could and did sell. It is tempting to treat these separately, as "categories" of
landscape. But again, as far as we know, nobody at the time made any particular
differentiation among these types, so it is better to proceed by examining Dutch landscape
art as a whole before turning to its most important branches.

The question that immediately arises is, when was landscape painting first accepted as an
independent genre?[61] To find the answer, we must look once again to Flanders. Certain
artists were specializing in landscape there by the beginning of the sixteenth century, and
were already known as landscape painters. Joachim Patenier, who became a member of the
Antwerp guild in 1515, was probably the first landscape specialist. He painted fantastic
mountain landscapes, always including a Bible story, to be sure, but with the landscape
definitely predominating (fig. 273). Patenier and other Flemish landscape artists enjoyed
great fame, at home and also abroad: in Spain, Patenier was deemed the greatest Flemish

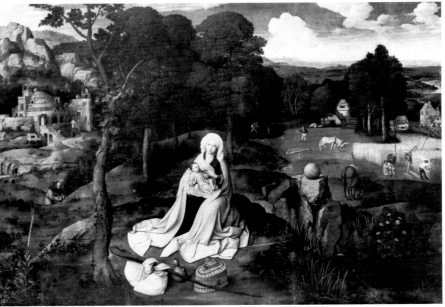

273

artist next to van Eyck and Rogier van der Weyden,[62] and the Flemish were renowned in Italy for their beautiful landscapes. This admiration had an edge to it, for the Italians rated landscape painting low on their scale of values and were therefore quite willing to cede honors in it to the northerners.[63]

In Italy an attitude existed that the painter should create what he wished, which made it possible to accept landscapes as independent works of art. Whether in the north a similar acceptance was a deciding factor in the development of landscape painting remains uncertain. When Karel van Mander wrote about landscape in his *Schilder-Boeck*, he continued to treat it as subsidiary to larger composition, but nevertheless devoted a whole chapter to it. This fact should in no way be considered an acknowledgment of landscape as

274

275

276

277

274–277 Jacob Grimmer
The Four Seasons
Signed and dated 1575 (*Winter* only). Panels, each
c. 36×60 cm. Szépmüvészeti Múzeum, Budapest

an independent entity—for then the same recognition would have to be attributed to "animals" and "draperies," subjects which he also handled in separate chapters.[64] From his own experience van Mander knew and admired the work of Flemish landscape painters such as Patenier, Herri met de Bles, Jacob Grimmer, and Pieter Bruegel, and he extravagantly praised as a "landscape maker" his contemporary Gilles van Coninxloo, then already working in Amsterdam. One wonders how he reconciled the work of these painters with his theory of landscape.

To us, the landscapes by these early painters seem close to "pure," despite the narrative element they always contain, however subordinate. Often they are part of a series portraying the months or seasons; an excellent example is Jacob Grimmer's series of the four seasons (figs. 274–77), in which the winter scene is dated 1575. The observation of nature seems more straightforward and exact in the seasons series than in the landscapes with a Flight into Egypt or a Saint Jerome, which stem from the tradition in miniature paintings often found in books of hours.

Whether or not sixteenth-century Flemish landscapes are landscapes *sui generis*, there can be no doubt that they inaugurated the explosive development in landscape painting that took place in the Northern Netherlands in the seventeenth century. The powerful impulse emanating from Flanders was decisive for Dutch landscape painting: the first artists to paint landscapes in Holland were émigré Flemings, led by Coninxloo. And in the graphic arts,

essential to the subject of landscape, countless series of prints published in Flanders or engraved after Flemish examples can be shown to have irrefutably influenced the development in the north.

When we examine the theoretical matrix within which this surprisingly rapid development took place, a new problem arises. Unlike the Italians, the Dutch seem to have had no pronounced aesthetic theory on the subject, or at least nothing beyond that expressed by van Mander. And if everyone agreed with him that landscape was a subsidiary matter, whence this sudden fascination with it? Probably, as so often happens, the interest came from no single source, but from the action of many different factors.

Successive generations in the Northern Netherlands, beginning with Geertgen tot Sint Jans and a little later Jan van Scorel and Maerten van Heemskerck, had displayed their interest in landscape. Reinforced by the potent Flemish influence at the turn of the seventeenth century, Dutch traditions formed the basis for further development. But increasing national pride, combined with a growing awareness of nature as a reflection of God's power, and a general desire to observe and comprehend the surrounding world, surely affected realistic Dutch landscape painting. Nor should the tendency to moralization be forgotten: many landscapes, like still lifes and company paintings, may have had an extra didactic or moral meaning.

The same elements pertain to literature, too.[65] Nearly always the beauty of nature as God's visible creation is observed and praised. As the poet Vondel wrote:

Just as we at twilight, in the growing dusk,
See the glory of the low-sunk evening sun
Shining on the sea, and the foaming brine
Shaded with rays and purple glow and gold,
Witnesses of the light which, just disappearing,
Has quicksilvered, caressed, and illumined the world:
So shall we now see God and the highest majesty,
Reflected in the work of His providence.

Huygens, whose attitude toward landscape was level-headed, also often joined his observations of nature with musings about God and man. In addition he has something of the national pride, as well as something of the urbanite who enjoys the countryside yet has especial praise for nature touched by human hand. Of particular interest is Huygens' protest, as a strong Calvinist, against calling a landscape "picturesque." He considers that term a distortion of truth, as if God were copying the work of painters. In fact, he even rejects painted landscapes:

God's work, which I can undergo, see, possess,
I need no copy of by human hand...
The best painting, I know no name to give:
'Tis but a deluded shadowing of life.
Do you wish to understand virtue? Walk then in sunshine
And see what are the shadows of the purest life.

Huygens' longing for nature—or to escape from court life in The Hague and his daily responsibilities—is evident in the name he gave to his country estate, "Hofwijck" (Refuge from Court), and the long poem he composed about this refuge.

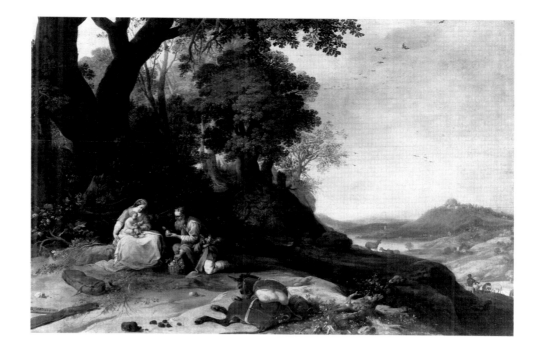

278 Bartholomeus Breenbergh
Landscape with the Rest on the Flight to Egypt
Signed and dated 1634. Panel, 54.8 × 78.4 cm.
Alte Pinakothek, Munich

Jacob Cats also had a country place, called "Sorghvliet" (Flight from Care), and in his "Shepherd" poems of 1618 he expressed his yearning for an unspoiled life on the land, away from the artificialities of city dwelling. Adopting the form of the classical pastoral, he managed to be patriotic, despite the Arcadian names of his shepherds and shepherdesses, by choosing as his locale the island of Walcheren in Zeeland. In his other works, too, Cats always voiced his admiration of nature as God's creation. Moreover, as an archmoralist, he tied a lesson to his descriptions of nature:

When I walk through the woods
And see the young and growing trees,
And I find one a poplar,
One a tall oak, one a low elder,
A linden, an elm, a beech, an ash,
At once I am taught a lesson:
For while I stand alone and try
To feed my spirit through my eye,
Just so I always find
Something useful for my mind.

In general, the early seventeenth-century poets had a rather lively interest in nature and were well aware of the landscape around them. Yet their descriptions occur almost invariably as parts of a larger whole; few poems are devoted solely to nature. Unless the poem is a pastoral, there is usually a moral attached to the observations of nature, and nature is continually praised as the creation of the Lord.

When we look at the landscape paintings of this period we must bear in mind that the same sort of mentality lay behind them. There are undisguised pastorals among them, set either in an idealized landscape or in an "adapted" Dutch landscape, like Cats's; there are also landscapes which may bear a message or a double meaning, and others that are landscapes pure and simple.

Without drawing the limits too sharply, we can group the outstanding types of landscape art into several categories. The more or less traditional imaginary landscape continued to thrive. More fantastic landscapes, modeled on Flemish examples, were also composed; in them existing elements—mountains, distant valleys with winding rivers, groves of trees, and villages—were assembled to form a "cosmic" landscape. Works by Segers and Rembrandt (see fig. 642) are examples of this trend. Alongside these there evolved the idyllic or arcadian fantasy landscape, often the setting for biblical or mythological stories, as in Bartholomeus Breenbergh's *Landscape with the Rest on the Flight to Egypt* (fig. 278); this type was usually related to the contemporary Italianate landscape. The painters who knew the Italian landscape through personal experience and used it in their work form an extremely important group, as do the painters who found their motifs in their own country; we will treat these groups separately. Other types of landscape, such as the Tyrolean views painted

by Roelant Savery and the Scandinavian scenes introduced by Allart van Everdingen, will be included in the discussion of these artists.

The Dutch Landscape

The naturalistic depiction of the Dutch landscape is correctly considered one of the most characteristic expressions of Northern Netherlandish art in the seventeenth century, and to us it is fascinating to trace the origin and the development of this landscape type. Contemporaries, of course, showed no favoritism for it; they liked exotic fantasy landscapes or the work of the Italianates just as well as "national" landscapes. The borderline between Dutch and non-Dutch landscapes is indeed less sharp than might be expected, for by far the largest proportion of all painted landscapes are studio pieces rather than realistic renderings of any particular spot. To be sure, all landscape artists used motifs sketched from nature. The differences of approach lay in the choice and application of these motifs and in the ideal toward which the artist was striving.

The Flemings provided an important source for Dutch national landscapes. Besides his many fantasy landscapes and drawings made on his trips through the Alps and Italy, Pieter Bruegel drew a number of views of Brabant direct from nature. In his immediate circle, too, there originated series of topographical drawings, distributed in engraved editions, that had great influence on developments farther north. The first publication, by Hieronymus Cock, dated from 1559 and bore the significant title (in translation) "Many and Very Beautiful Scenes of Diverse Villages, Farms, Fields, Streets, and the like, ornamented with all sorts of Animals. Altogether portrayed from life, mostly in the surroundings of Antwerp." In 1612 in Amsterdam Claes Jansz Visscher made etched copies of twenty-three prints from this series (fig. 279) and republished them, albeit ascribing them incorrectly to Pieter Bruegel as "inventor."[66] The publication of these old landscapes was characteristic of Visscher's interests, and his familiarity with them had earlier stimulated him in the same direction. He sketched landscapes in his own neighborhood (see fig. 363), made prints of his drawings, and published them in series. Before long, similar print series by other artists, among them Jan van de Velde, Cornelis van Wieringen, and Willem Buytewech, began to

279 Claes Jansz Visscher after Cornelis Cort
 Landscape in the Vicinity of Antwerp
 Etching

281

280

Aensien doet gedencken
Opt'schoonste voor--gedaen en kan niet krencke Oock eer verkoop waut aensien doet gedencken
Hoe meer vertoont hoe beter men verciert D'ervarentheyt hier van de waerheyt liert 1

282

appear, usually published by Visscher. Through these publications, which established close contacts between Amsterdam and Haarlem, Visscher played a central role in the development of the national landscape painting.

The work of the German (but Rome-based) painter Adam Elsheimer, about whom more will be said later (see p. 191), was also influential. Engraved reproductions of Elsheimer's paintings by the Utrecht amateur Hendrick Goudt (fig. 280) became widely known in the Netherlands after about 1610. His influence is unmistakable in the work of such Haarlem artists as Jan van de Velde and Buytewech (fig. 281), especially in the composition and the representation of masses of trees.

Goltzius' beautiful drawings of the Haarlem dune area about 1600 (see fig. 352) had relatively little influence, for landscape drawings were not considered independent works of art, nor were they intended for sale. Many earlier realistic landscapes, drawn from nature—those by Dürer, for example—no doubt were unknown to contemporaries.

In addition to the topographical print series—one of 1612 was entitled "For the Lovers of Pleasanter Places Who Have No Time to Journey Afar"—there were landscape series accompanied by moralistic verses, such as Mattheus Merian's "Various Pleasant Landscapes Adorned with Emblems" (fig. 282), and series of landscape-like "elements," such as those by Buytewech (see figs. 85–88), which, if they had not included inscriptions, would not have been easily recognized as representations of earth, air, fire, and water. Occasional prints sometimes strikingly anticipate developments in painting: a lottery print circulated in 1615 on behalf of the hospital in Egmond aan Zee (fig. 283) became the ancestor of a painting by Jacob van Ruisdael forty years later (cpl. 284).

280 Hendrick Goudt after Adam Elsheimer
Tobias and the Angel
Signed and dated 1613. Engraving

281 Willem Buytewech
Forest Landscape with a Lake
Pen and brush in brown and gray ink, 18.9 × 30 cm. British Museum, London

282 Mattheus Merian
Various Pleasant Landscapes Adorned with Emblems
Published by Claes Jansz Visscher, Amsterdam, 1615

283 Lottery print on behalf of the hospital in Egmond aan Zee
Published by Claes Jansz Visscher, 1615

283

284

284 Jacob van Ruisdael
A View of Egmond aan Zee
Signed. Panel, 49.8 × 68.3 cm. Glasgow Art
Gallery and Museum

285 Artist Unknown
Polder Landscape near Enkhuizen
c. 1600. Panel, 60 × 138 cm. Town Hall,
Enkhuizen

286 Arent Arentsz, called Cabel
Polder Landscape with Fishermen and Farmers
Panel, 27 × 52 cm. Rijksmuseum, Amsterdam

The rendering of the national landscape in painting began early in the 1620s, with
Haarlem the most important center. But there seem to have been precursors, who worked
virtually in isolation. For example, in the Enkhuizen town hall hang two panels which, very
naively but realistically, depict the surrounding North Holland polderland (fig. 285).
Among other evidence, the clothing of the people in these pictures indicates that they must
have been painted shortly after 1600. Nothing is known about the origin of these panels;
perhaps they were commissioned by the polder administration or the dike reeve.

In Amsterdam, Hendrick Avercamp had begun to paint his winter scenes about 1608 (see
figs. 407–9), and probably shortly afterward Arent Arentsz, called Cabel, worked on polder

285

286

views (fig. 286). Avercamp's early works are Flemish-oriented, more or less linked with the renderings of winter scenes in the old "seasons" series. Cabel was much more original, but his place in the development of this genre cannot be exactly determined because his works are not dated.[67] In any event, his early paintings of purely Dutch landscapes had no followers, presumably because the Flemish trend in Amsterdam, led by Coninxloo, Vinckboons, and Bol, was too strong. The earliest known "Holland" landscape by Esaias van de Velde, then working in Haarlem, is dated 1614 (fig. 287). Remarkably enough, van de Velde kept right on painting fantastic mountain landscapes (fig. 288) alongside his works showing the Dutch countryside.

Although the art of Avercamp and Cabel, except for their winter landscapes, attracted no

287

288

followers, the early work of the Haarlem painters Esaias van de Velde, Pieter de Molijn, Jan van Goyen, and Salomon van Ruysdael became seminal for the subsequent development. Their landscapes were initially rather static, with human figures as elements both of narrative and color (fig. 289); they evolved into monochromatic, atmospheric compositions, in which the figures steadily diminish in importance. An essential contribution to this development was made by the marine painter Jan Porcellis, a Flemish emigrant, who was renowed for his atmospheric seascapes. Beginning shortly after 1625 and continuing into the 1640s, the tonal landscape created and dominated by Jan van Goyen and Salomon van Ruysdael (fig. 290) and their followers set the trend for much of Dutch landscape art. Decidedly more color later crept into these artists' palettes. At the same time, clouded skies began to have an ever greater part in the composition, especially in the work of Jacob van Ruisdael (fig. 291).[68]

We cannot here follow all the byways of Dutch landscape art, yet the great variety within this genre must be pointed out. The variations range from the composition and subject matter to the lighting and weather conditions depicted. There seems to have been interest in every feature of the landscape. Specialists concentrated on one aspect or another: winter views, moonlight scenes, dune landscapes, distant prospects (fig. 292). And given the

287 Esaias van de Velde
Horsemen in a Landscape
Signed and dated 1614. Panel, 25 × 22.5 cm. State Museum Twenthe, Enschede

288 Esaias van de Velde
Mountain Landscape
Signed and dated 1624. Panel, 36.7 × 59.7 cm. Národní Galerie, Prague

289 Jan van Goyen
Village Scene in De Bilt, near Utrecht
Signed and dated 1623. Panel, 39.5 × 69.6 cm. Herzog Anton Ulrich Museum, Brunswick, West Germany

290 Salomon van Ruysdael
River Landscape with Fishermen
Signed and dated 1631. Panel, 36.6 × 65.5 cm. The National Gallery, London

289

290

291

292

291 Jacob van Ruisdael
 Landscape with a View of Ootmarsum
 Signed. Shortly after 1660. Canvas, 59.1 × 73.2
 cm. Alte Pinakothek, Munich

292 Philips Koninck
 Landscape with the Waal River near Beek
 Signed and dated 1654. Canvas, 150 × 203 cm.
 Statens Museum for Kunst, Copenhagen

293 Jan van Kessel (attributed)
 Landscape with Windmill
 Canvas, 88 × 108 cm. Private collection

294 Aert van der Neer
 View of a Village
 Signed. Panel, 31.5 × 36 cm. Gemäldegalerie Alte
 Meister, Staatliche Kunstsammlungen, Dresden

outlook of the Dutch as expressed in their literature, one asks whether there might not be symbolic content in these paintings—whether the painter was creating an ode to the glory of God or merely rendering his love of nature and of his own countryside. A "portrait" of a windmill such as that attributed to the little-known Jan van Kessel (fig. 293) makes us ponder a symbolic intent: windmills were such a common sight in the seventeenth century that one would hardly have been painted for its "picturesqueness."[69] A clue can be found in a verse on the title page of *Het Haerlemmer-meer-boeck*, published in 1640 by the great hydraulic engineer Jan Leeghwater to promote his project of using windmills to pump Haarlem Lake dry:

The mill stands still as long as the wind does not blow,
But when the wind rises, the sails begin to go,
And the mill grinds everything high and low.
So is it between God and the man who knows Him not:
God's wrath tarries a while, as if He hath forgot;
Then He punishes by crushing sin, as sinners very well know.

But was Jacob van Ruisdael thinking of the mills of the gods (or the mill of God) when he painted his magnificent *Mill at Wijk bij Duurstede* about 1665?

 And what induced an artist like Aert van der Neer to paint, alongside his moonlight and winter scenes, a view of a village so modest and unobstructive (fig. 294)? Did sheer sensitivity to nature lead an unknown painter, perhaps Hendrick ten Oever, to paint a very realistic meadow, with grazing cattle, a row of trees darkly silhouetted against the horizon, and a low light skimming over the grassland (fig. 295)? In color, composition,

293

294

295 Hendrick ten Oever (attributed)
Meadow Scene with Cattle
Canvas, 74.5 × 105.5 cm. Private collection

and treatment of light, this painting is so unusual that one would prefer to believe it grew from spontaneous impulse. Perhaps it did, for a change, but most painters seem to have been bound to particular schemes of composition. Salomon van Ruysdael stuck to a certain few, nevertheless managing endless variations; van der Neer repeated himself with seemingly tireless zeal, the wonder being that his work remained on such a high level of quality; and most of Hobbema's paintings are variations on one theme. But each of these artists, no matter what his purpose or vision, responded to the Dutch landscape and recorded its subtleties and beauties in ways never seen before.

The Italianate Landscape

There was also a relatively large group of painters who chose the southern, Italian landscape as their main theme. They have come to be called the Italianates. The core of this group had visited Italy for longer or shorter periods; others never went there, but took over Italian motifs. And then there were many artists who were not true Italianates, but freely wove together the elements of both Dutch and Italian landscapes.

The Italianates were an important part of the artistic life in the Netherlands. In the early 1630s the inventory of the stadholder Frederik Hendrik indicates that he owned twelve works by Cornelis van Poelenburgh, one of the best representatives of this group. No other painter was so honored. Moreover, some of the most talented landscape painters—Paulus Potter, Aelbert Cuyp, Philips Wouwerman, Adriaen van de Velde—clearly were aware of the Italianates, whose influence accounted for the lighter, brighter palette of Dutch landscape painters after 1650.[70] There is every reason to pay attention to this group, since art historians used to dismiss its members as "not really Dutch" and thus more or less second rate. Because most of the Italianates painted in a meticulous style, their work fell out of favor with the rise of Impressionism. Now, they attract new interest, and a number of excellent recent studies permit us to know them better.[71]

We shall here devote a little extra space to the Italianates because some of the factors that unified them had to do with Rome, a center we will not otherwise discuss. Artists from the

296

297

296 Paulus Bril
 Roman Landscape with Ruins of the Forum
 Signed and dated 16(..). Canvas, 84 × 112 cm.
 Herzog Anton Ulrich Museum, Brunswick, West
 Germany

297 Cornelis van Poelenburgh
 Landscape with the Rest on the Flight to Egypt
 Signed. Panel, 26 × 34.5 cm. Formerly Staatliche
 Kunstsammlungen, Dresden. Destroyed during
 World War II

298 Bartholomeus Breenbergh
 The Preaching of John the Baptist
 Signed and dated 1634. Panel, 54.5 × 75 cm.
 Whereabouts unknown

298

Netherlands had been active in Rome for many years, but the first generation of Dutch
Italianate painters, who worked there between 1620 and 1630, had the most in common.
They formed a closed group; during their relatively long sojourns in Italy they developed
their own style, quite different from anything learned at home. When they returned to the
Netherlands, their style did not develop demonstrably further. This was less the case with
the second generation, whose members visited Rome mainly between 1640 and 1650 but
usually stayed only for a year or so. Although their work was strongly influenced by what
they learned in the south, they continued to develop once they were back in their own
country. The leading painters of the first generation were Cornelis van Poelenburgh and
Bartholomeus Breenbergh; of the second, Jan Both, Jan Asselijn, Claes Berchem, and Jan
Baptist Weenix.

The history of the Dutch Italianates actually begins with the sojourn of the Flemish artist
Paulus Bril in Rome. Born in Antwerp in 1554, Bril went to Italy about 1580 and devoted
himself to landscape painting, at first in a decidedly Mannerist style, but after the turn of the
century in a simpler style based directly on nature. He provided his landscapes, in which a
clear southern light prevails and Roman ruins predominate, with little figures, usually
shepherds with their flocks (fig. 296). During his lifetime in Rome, where he died in 1626 at
the age of seventy-two, Bril kept in touch with the northern painters in the city, some of
whom became his pupils. His work was certainly known by those interested in landscape
painting. They also knew the work of Elsheimer, the German artist, who had died in Rome
in 1610, but his influence on the Dutch landscape painters working in Rome was
considerably less than it was on the Dutch history painters—Lastman, Moeyaert, and the
Pynas brothers.

Cornelis van Poelenburgh probably arrived in Rome about 1617 and stayed there until
1625. After an interlude in Florence, where he was employed by Ferrante II, grand duke of
Tuscany, he returned to his birthplace, Utrecht, and worked mainly there for the rest of his
life. Inspired by Bril's work, Poelenburgh initiated in the Netherlands the Arcadian
landscape as practiced by the Italianates, with clear, bright colors and a limpid light. In his
scrupulously painted landscapes, ruins and small figures are essential elements of the
composition (fig. 297).

Bartholomeus Breenbergh, born in Deventer in 1598,[72] got to Rome in 1619; working at
Poelenburgh's side, he developed into an important Italianate landscape painter. His work
resembles Poelenburgh's, though his compositions are perhaps less evenly balanced (fig.
298). The paintings of these two artists cannot always be told apart. Breenbergh, too,
remained approximately ten years in Rome. In 1633 he is mentioned as being in
Amsterdam.

Shortly after 1620 both Poelenburgh and Breenbergh took part in establishing a northern
painters' fraternity in Rome, the so-called *Bentveughels* (Birds of a Feather, more or less),
commonly known as the Bent.[73] The club brought the Dutch and Flemish painters
together, to help each other and to form a united front against the stringent rules and
demands of the church authorities and of the Accademia di San Luca, the Roman painters'

guild. Foreigners had to pay annual dues whether or not they belonged to the guild. The northerners refused, even when Pope Urban VIII expressly ordered them to do so in 1633. Eventually the controversy between the Accademia and the *Bentveughels* died down, and some painters became members of both societies.

The Bent did not have rules and regulations, but developed their own traditions, with wine as energizer. One tradition was the "baptism" of each new bird arrived from the north. In the presence of Bacchus himself, the initiate ceremoniously received his brotherhood name, usually an unflattering epithet based on his looks or personality. Poelenburgh was baptised "Satyr" and Breenbergh "The Ferret."

In the nearly one hundred years of the Bent's existence—Pope Clement XI finally banned

299 300

it in 1720 for heretical inclinations—there were scores of members; of many we know only the names, and the work of others is unimpressive. We can catch a glimpse of the life they led from extant drawings, such as the anonymous sketch showing a group of members at an inn (fig. 299). A sheet by Jan Asselijn shows some of the brothers more seriously engaged, drawing and painting in the open air (fig. 300). They must have been accustomed to painting outdoors, at least occasionally, though the landscapes by the Italianates are characterized by composed views put together of parts observed in nature. Countless loose sheets of drawings have been preserved, upon which the artists carefully recorded the date and place.

Drawings are an important and often very attractive part of the Italianates' work. Some of these artists kept repeating themselves in their paintings and ultimately lost spontaneity, but in drawing from nature they display considerably more artistic personality and power. One example is the work of Herman van Swanevelt, nicknamed "The Hermit," who was in Rome from 1629 to 1641. His drawings are sometimes surprisingly fresh and lively (fig. 301). His paintings, of which *The Departure of Jacob* (fig. 302) is typical, form a link between the first and second generations of Italianates. After his stay in Rome, Swanevelt moved back and forth between that city and Paris, but he is thought to have died about 1655 in the Netherlands, at his birthplace, Woerden.

301

302

303

304

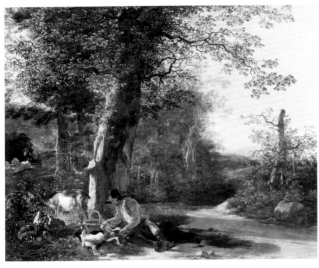

305

Yet another *Bentveughel*, Pieter van Laer,[74] whose name was actually Bodding, had great influence on the Dutch colony in Rome and even attracted some Italian followers. His brotherhood name was "Bamboccio" (Clumsy Doll), given him because he was a cripple, and he and his followers became known as the Bamboccianti. After training as a painter in Holland, van Laer went to Rome in 1625 and stayed there until 1639. He created a new type of painting: Roman street scenes with market vendors, hawkers, craftsmen, and beggars. The depiction of lower-class people had become popular. Van Laer used strong contrasts of light and dark, making his scenes lively and interesting (fig. 303). He also painted landscapes. His oeuvre must have been created chiefly while he was in Rome. After his return to his birthplace, Haarlem, in 1639, he is listed there for several years, but seems to have left again about 1642. Perhaps he died soon afterward, for there are no further traces of him.

Although the second generation of Dutch Italianates may have established their style and manner of working while in Italy, most of them continued to build on what they had learned and painted their best works long after they were back home. This is true of Jan Both, who went to Rome sometime between 1635 and 1637 and returned to Utrecht in 1641, and of Jan Asselijn; he, like most travelers to Italy, journeyed down through France, and after several years in Rome, spent five years in France on the way home. He settled in Amsterdam in 1647, where he worked fruitfully and vigorously in the five years before his death in 1652. Jan Baptist Weenix, Adam Pynacker, and Carel Du Jardin also remained in Rome for only a few years.

Each of these painters of the second generation had a distinct personal style and palette. What they shared was subject matter and, to a certain extent, composition: high-rising ruins or rocks or stands of trees often form a strong vertical element, as in Claes Berchem's *Landscape near Tivoli* (fig. 304). There was also a general interest in specific detail. In particular, they tried to render plants and trees as naturally as possible, so that the various species are recognizable from their manner of growing and the shapes of their leaves. Figures of people and animals are indispensable to the composition. The Italianate landscape painters were able to attain an extremely poetic approach to nature, as evidenced by Pynacker's *Forest Landscape* (fig. 305).

The third generation, which went to Rome in the third quarter of the seventeenth century, produced work completely different in character. These painters—Jacob de Heusch and Johannes Glauber of Utrecht, and Jan Frans van Bloemen and Hendrick van Lint of Antwerp—associated themselves wholeheartedly with the more international, classically oriented landscape paintings of the French master Nicolas Poussin, who spent most of his career in Rome and died in 1665. They lost their links with their national traditions and indeed deserted their homelands for long periods or entirely, settling in Italy. Their work falls outside the scope of this book.

303 Pieter van Laer
Street Scene in an Italian Town
Signed and dated 16(..). Whereabouts unknown

304 Claes Berchem
Landscape near Tivoli
Signed. Canvas, 105.5 × 94 cm. Fondation
Custodia (Collection F. Lugt), Institut
Néerlandais, Paris

305 Adam Pynacker
Forest Landscape
Signed. Canvas, 60 × 75.5 cm. Private collection

306

306 Roelant Savery
Orpheus Enchanting the Animals
Signed and dated 1610. Panel, 51 × 66 cm.
Städelsches Kunstinstitut, Frankfurt am Main

307 Paulus Potter
The Young Bull
Signed and dated 1647. Canvas, 235.5 × 339 cm.
Mauritshuis, The Hague

308 Claes Berchem
Portrait of a Cow
Signed and dated 16(..). Canvas, 99 × 81.5 cm.
Private collection

Animal Paintings

The Fleming Roelant Savery introduced the animal painting into the Northern Netherlands in the second decade of the seventeenth century. During his previous stay in Prague and Vienna at the courts of Emperors Rudolf II and Matthias, from 1604 to 1615, he had no doubt begun to depict all sorts of animals, inspired by those he saw in the imperial zoo; but no known works of his contain animals before about 1610. After that date, and certainly after Savery began to work in Amsterdam in 1616 and after 1619 in Utrecht, the animal painting became increasingly important in his oeuvre. To combine many kinds of animals in one painting, he chose such subjects as the Garden of Eden, Noah's Ark, or Orpheus enchanting animals with his lyre playing (fig. 306). The compositions are often overfull, the landscapes incidental to the many animals they contain, usually exotic species. This type of painting was continued by the Utrecht painter Gillis d'Hondecoeter, a pupil of Savery.

For the portrayal of the domestic animals of the Dutch countryside—cows, sheep, pigs, horses—it is not possible to point to any one source. Seventeenth-century landscape paintings nearly always contain human and animal figures, and animals of one kind or another belong in many biblical scenes. Both the landscape and the history painter were familiar with the representation of animals.

Not until nearly 1650, however, is there real evidence of a separate genre, of compositions in which livestock are predominant or of paintings that might be considered animal portraits. Paulus Potter's short career began then, and some of the Italianate landscape painters began to "star" animals in their pictures. Besides Potter's famous bull (fig. 307) and his portraits of horses, many other compositions were created in which the animals receive equal treatment with the landscape. Innumerable painters seized the opportunities these "animal landscapes" afforded. The most talented were Adriaen van de Velde, Aelbert Cuyp, and Claes Berchem. A fair number of independent animal studies by Berchem have been preserved (fig. 308).

308

307

309 Gijsbert d'Hondecoeter
Birds of Varied Plumage
Signed. Panel, 25 × 39 cm. Museum
Boymans-van Beuningen, Rotterdam

310 Melchior d'Hondecoeter
Poultry
Signed. Canvas. Private collection

Hunting scenes, such as those by Philips Wouwerman (see fig. 828), formed one variation. The hunting piece in which a wild boar or a deer is being savaged by a pack of hounds, usually rendered life-size or larger, was a specialty of such Flemish painters as Frans Snijders and Paulus de Vos; paintings of this sort found little favor in the north.

Another development was the depiction of small waterfowl and poultry. The genre probably originated with Roelant Savery and progressed through his pupil Gillis d'Hondecoeter to Hondecoeter's son and pupil, Gijsbert, who began to concentrate on the portrayal of ducks, geese, and chickens in a landscape (fig. 309). During the second half of the century Melchior d'Hondecoeter, Gijsbert's son, developed into a true specialist (fig. 310): he created a type of bird painting, with chickens, ducks, peacocks, turkeys, and sometimes such exotic birds as pelicans, that became popular and survived well into the eighteenth century, primarily as decorative murals for country estates.

Finally, among the animal paintings may be included the fights on horseback. Sometimes these paintings depicted actual historical battles, such as Leckerbeetje's skirmish on Vucht Heath (see fig. 121), but usually they are imaginary scenes, varying from attacks by highwaymen to pitched cavalry encounters. In the seventeenth century, these paintings were known as *batailles*.

Marine Paintings

In principle, there is a substantial difference between the depicting of events at sea, such as naval battles or an assembled fleet, in which the ships are the real subject matter, and the portrayal of the sea, the coast, rivers, lakes, and other inland waters, in which the natural element dominates. Some artists limited themselves to the one or the other: Willem van de Velde the Elder concentrated almost exclusively on naval events and portraits of ships, whereas his contemporary Jan Porcellis was concerned solely with depicting the sea itself and bodies of water. Other painters combined the subjects, and their works belong in both categories.

Karel van Mander relates how Hendrick Vroom, in his constant roving about, came to be shipwrecked off the coast of Portugal and, after being rescued, "painted his own adventure and shipwreck, selling it in Lisbon to a great Gentleman for a lot of money"; and how later, in Haarlem, "on the advice of the Painters there, [he] proceeded to make pieces with Ships. … And [since] the people in Holland are similarly seafaring, [he] also began to have great success with these little Ships."[75] Van Mander is giving an explanation of the origin of marine painting in the Northern Netherlands, but this explanation hardly satisfies the art historians; they point to previous sea paintings by Pieter Bruegel the Elder, and to sixteenth-century pictures of ships. Unfortunately, van Mander failed to mention any dates; it would be interesting to know when Vroom, who was born in Haarlem in 1566, painted his first sea picture. We do know that in 1592, having been recommended by van Mander, he designed cartoons for the weaver François Spiering to use in making a series of ten tapestries for Charles Howard, lord admiral of England, depicting the defeat of the Spanish armada in 1588. To receive such a commission, Vroom must have had a reputation as an experienced painter of ships, although no dated painting of his is known before 1607. In any event, the

311 Hendrick Vroom
The Arrival of Frederick V, Elector Palatine, at
Vlissingen, May 1613
Signed and dated 1623. Canvas, 203 × 409 cm.
Frans Hals Museum, Haarlem

312 Jan Porcellis
Seascape
Signed and dated 1629. Panel, 27 × 35.5 cm.
Municipal Museum De Lakenhal, Leiden

favorable market mentioned by van Mander surely helped Vroom to make a name for himself.

Vroom's importance is sometimes underestimated, because certain writers discovered *ex post facto* that his rendering of the atmosphere of Dutch waters was not wholly successful, and that he was too anecdotal and too colorful.[76] This judgment overlooks the very early date when Vroom began to paint, long before atmospheric effects were an element in landscape art. Indeed, the painters who busied themselves with depicting the fleet and naval battles were, with few exceptions, more interested in the events than in nature's moods. A case in point is Vroom's painting of the arrival in Vlissingen, in May 1613, of Frederick V, Elector Palatine, on his way home with his new bride (fig. 311). This very large canvas gives a lively view of the roads off Vlissingen harbor, filled with a great variety of vessels, some of which are firing salutes. The painting was commissioned in 1623 by the Haarlem burgomasters and councilmen for their town hall.

Jan Porcellis was Vroom's opposite in approach. His great interest lay in portraying not the Dutch fleet but the inland waters. In this he was one of the first to record the cloudy gray skies that dissolve into and become one with the water (cpl. 312). The boundary

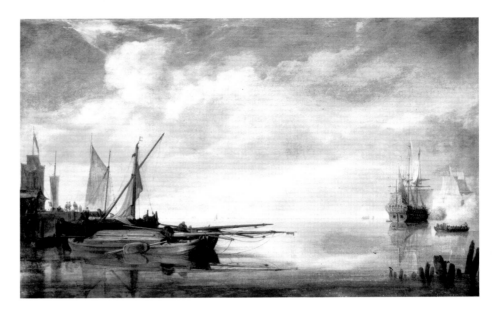

313 Simon de Vlieger
Calm Water
Signed. Canvas, 64.5 × 100 cm. Museum
Boymans-van Beuningen, Rotterdam

314 Heerman Witmont
The Battle of the Gabbard, 1653
Signed. Pen painting on panel, 113 × 155 cm.
National Maritime Museum, Greenwich, London

between sea and land blurs away with him, and in his late works often cannot be defined at all. Another borderline area in which marine painters and landscape painters alike tested their powers was the shore view; originally this belonged to the shipwreck theme, which Porcellis also explored.

Both approaches—that of Vroom and of Porcellis—attracted followers. A synthesis of the two was found by Simon de Vlieger. This gifted artist began by painting more or less in Vroom's manner, but quickly developed a quieter, more atmospheric Porcellian way. At the end of his life, about 1650, de Vlieger was able to combine both trends, creating paintings in which ships and the fleet have stellar roles yet are enveloped in a wholly accurate rendering of the Dutch atmosphere (fig. 313). In his own right and as teacher of Jan van de Cappelle and Willem van de Velde the Younger, de Vlieger was a major figure in the history of marine painting.

Meanwhile, Willem van de Velde the Elder had also begun his career. His works can hardly be called paintings, for the technique in his large pen drawings was very similar to that of Goltzius (see figs. 116 and 116a); he drew with a pen and India ink on a canvas or panel coated with white oil paint. In the seventeenth century such works were called "pen paintings"; this term is better than "grisaille," for a grisaille is a painting done with a brush in tones of one color, usually brown or gray. Heerman Witmont of Delft may have used this technique before van de Velde did (Witmont's *Battle of the Gabbard, 1653* [fig. 314] is a good example of his work), but van de Velde's phenomenal talent stimulated the development and popularity of the pen painting, which lasted until late in the eighteenth century. Ludolf Bakhuysen employed the technique several times, and other artists—Cornelis Bouwmeester, Cornelis Mooy, Adriaen van der Salm, Experiens Sillemans, and Pieter Vogelaer—became specialists in it. Caspar van den Bos of Hoorn occupies a separate place among the pen painters. He may have developed concurrently with van de Velde,

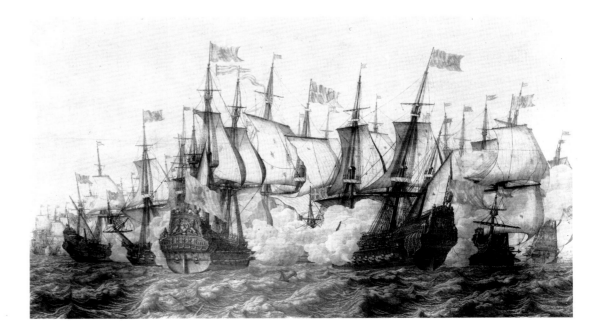

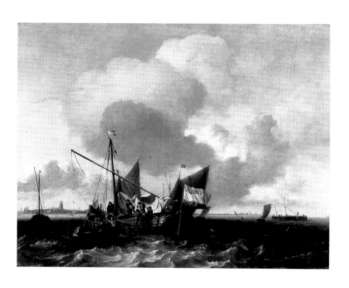

315 Ludolf Bakhuysen
Ships in the Zuider Zee off Naarden Fortress
Signed. Panel, 37.5 × 48.4 cm. Wallraf-Richartz
Museum, Cologne

316 Simon de Vlieger
Shipwreck
Dated 1640. Canvas, 111 × 182 cm. Amsterdams
Historisch Museum, Amsterdam

yet independently; he worked more often with a brush than did the others (see fig. 669).

Willem van de Velde the Elder is the first artist known to have sailed with the fleet in order to make sketches of a battle in progress, later using these for his definitive painting (see fig. 116). Before his time, painters of naval encounters had had to rely on eyewitness accounts or written records. Nearly all the scenes of naval battles that were painted before 1650 were commissioned years after the event.

The demand for naval-action paintings remained strong while the Dutch ruled the seas. But when the tide turned in the third quarter of the seventeenth century and England's supremacy could not be gainsaid, the Dutch public began to lose interest in naval pictures. Having read the signs correctly, the van de Veldes, father and son, moved to England, there to pursue their successful careers.

The last generation of marine painters in Holland, with Ludolf Bakhuysen as its chief representative (fig. 315), continued to depict all aspects of ships and seafaring. During the first half of the century Amsterdam had replaced Haarlem as the center for these artists, but other Dutch ports, such as Hoorn, Enkhuizen, and Middelburg, produced capable painters of sea pictures. Besides naval battles and portraits of ships, the subject matter of these artists was varied. Storms and shipwrecks were undoubtedly among the oldest themes,[77] subjects which had special meaning for the Dutch, so deeply concerned with the dangers and blessings of seafaring. These pictures, along with naval battles, were apparently favorites for hanging above the mantel, where they provided both decoration and object lessons: notice, for example, the painting-within-the-painting in Thomas de Keyser's portrait of Huygens (see cpl. 582) and in Jan Steen's *Easy Come, Easy Go* (see cpl. 101). A *Shipwreck* by Simon de Vlieger (fig. 316), now in the Amsterdam Historical Museum, once hung above the fireplace in the Oudezijds Huiszittenhuis in Amsterdam, an institution devoted to distributing food and fuel to the housebound poor, many of whom were disabled sailors or the families of men lost at sea. In an eighteenth-century list this painting is described as "Portraying a Shipwreck and thus as the origin of the poverty encountered in this house."[78] But, as we have said, the sea was also compared to love, and calm waters were an almost prayerful symbol of safe homecoming.

In 1628, in Gouda, a writer signing himself I. de Ville published a little book entitled *T'samen-spreekinghe Betreffende de Architecture ende Schilderkonst* (Dialogue Regarding Architecture and Painting). The author's purpose was to urge Dutch artists to master perspective in the painting of architecture. From that same year dates the earliest known church interior by Pieter Jansz Saenredam (see fig. 2), whose work signaled a new phase in architectural painting in the Netherlands. Saenredam based all his paintings upon measurements and carefully executed drawings, so that the perspective in the finished work was exact, although he sometimes "manipulated" the architectonic elements.[79] He also tried

317 Pieter Saenredam
Interior of the St. Bavo Church, Haarlem
Signed and dated 1660. Panel, 70.5 × 54.8 cm.
Worcester Art Museum, Massachusetts

to record the colors and the play of light that he had observed, and, to punctuate the space, he placed a few, but only a few, figures in his interiors (cpl. 317). Earlier painters had been fond of embellishing their churches with biblical scenes, such as Christ driving the money-changers from the temple; at most Saenredam included, as rightfully present, a minister preaching to his congregation. This thoughtful realism, its art based on observation and geometrical exactitude, was a new phenomenon in Dutch painting. Nothing like it had been seen before.

In looking back at what had preceded Saenredam, we must begin with Hans Vredeman de Vries, the first Dutch painter to choose architecture as an independent subject. Born, as his name indicates, in Friesland, in 1527, de Vries worked in various German and Flemish cities as an architect and builder of fortifications, designer of triumphal arches, painter of fantastic architectural scenes, and architectural theorist.[80] About 1600 he was in Amsterdam and The Hague, and in Leiden in 1604, two years before his death, he published a book in Latin, German, French, and Dutch; its short title is *Perspective dat is de hoogh-geroemde Conste* (Perspective, that is, the Highly Renowned Art); a supplementary volume appeared the next year. This work, lavishly illustrated with engravings of de Vries's perspective inventions, was of great importance to Dutch painters in mastering perspective.

318 Hans Vredeman de Vries
Fantasy Interior
Signed and dated 1558. Pen, 20.8 × 26 cm.
Graphische Sammlung Albertina, Vienna

319 Hans Vredeman de Vries
Fantasy Architecture
Signed. Canvas, 137 × 164 cm. Kunsthistorisches
Museum, Vienna

320 Frans Francken and Paul Vredeman de Vries
Interior with Figures
Panel, 76 × 88.5 cm. Kunsthistorisches Museum,
Vienna

A decade later, in 1614, another study of perspective was published in The Hague.
Written in French by the Dutch mathematician and fortifications expert Samuel Marolois, it
was a summary of all the works on the subject that had appeared up to that time in
Germany, Italy, and France. This book was translated into other languages, including
Dutch,[81] and went through many reprintings. The painters undoubtedly used it, too.

A drawing dating from 1558 (fig. 318) gives an impression of Hans Vredeman de Vries's
early work, as does a later painting that he presumably made for Rudolf II during a stay in
Prague at the end of the century (fig. 319). The drawing is of an interior that may have
existed, yet is constructed here to demonstrate the rules of perspective—indeed, the drawing
was made for an engraving included in a series of examples of perspective. The painting
carries the perspective devices much further, presenting an artfully imagined, palatial
Renaissance structure with arcades, galleries, courtyards, and fountains, in all of which the
most difficult problems of perspective are addressed.

These two types of architectural paintings—the observed interior and the architectural
fantasy—found followers in Antwerp as well as Amsterdam. Until late in the seventeenth
century they remained favorite subjects, allowing painters to display their facility with
perspective.

Paul Vredeman de Vries, son of Hans, had an important share in the development of
interior paintings. His paintings show spaces based upon reality but with the recession so

arranged that the perspective magnifies the size of the original (fig. 320). The figures in these paintings were often done by other artists; Frans Francken painted them in the picture here reproduced.

In Antwerp Hendrick van Steenwijck the Elder, a pupil of Hans Vredeman de Vries, had also begun to paint church interiors, mostly imaginary but occasionally documentary. As early at 1573, when he was twenty-three, he painted the interior of the cathedral at Aachen (fig. 321), and afterward those of Antwerp and Louvain. His fantasy interiors are always of Late Gothic architecture and usually contain a great many figures. Van Steenwijck's type of church interior was imitated mainly in Antwerp, but also found some following in the north. Many architectural fantasies were painted by such Northern Netherlands artists as

321

322

321 Hendrick van Steenwijck the Elder
 Interior of Aachen Cathedral
 Signed and dated 1573. Panel, 52 × 73 cm. Alte
 Pinakothek, Munich

322 Hendrick Aertsz
 Fantasy Interior
 Signed and dated 1600. Panel, 63 × 85 cm. Private
 collection

323 Dirck van Delen
 An Architectural Fantasy
 Panel, 46.7 × 60.5 cm. The National Gallery,
 London

323

Hendrick Aertsz (fig. 322), Bartholomeus van Bassen, and Dirck van Delen (fig. 323). In fundamentals, their compositions went back to the examples of the elder de Vries.

After 1650 the painting of true-to-life church interiors displaced the imaginary interiors almost entirely. Seemingly independent of Saenredam, other artists began to paint realistic interiors at that time, especially in Delft.[82] It is interesting that Emanuel de Witte's earliest known work in this genre, a 1651 interior view of the Oude Kerk in Delft (see fig. 965), was originally mounted in a special frame with little doors that opened to reveal the picture, presumably to strengthen the illusionistic effect. Attempts to create other effects of this sort, such as framing an interior by painting a door or an archway around it, may be seen in the *Interior of a Church* (fig. 324) by Louys Aernouts Elsevier, a Delft painter of whom few other works are known. In addition to those in Delft, there were painters in Amsterdam (where de Witte took up residence), Rotterdam, Middelburg, and Haarlem who made pictures of the interiors of local churches.

In their church interiors, the Delft painters in particular used figures which, because they keep reappearing in more or less the same combinations, raise the old question of a double

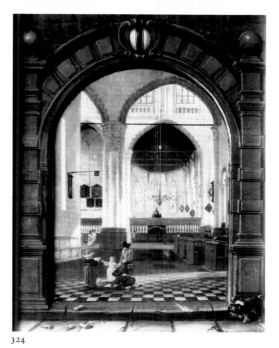

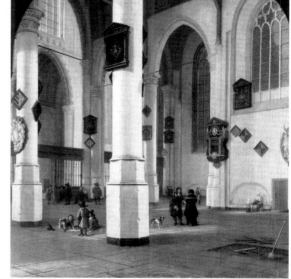

324 325

324 Louys Aernouts Elsevier
Interior of a Church
Signed and dated 1653. Panel, 54.5 × 44.5 cm.
Museu Nacional de Arte Antiga, Lisbon

325 Hendrick van Vliet
View in the Oude Kerk, Delft
Signed. Canvas, 77.5 × 68.2 cm. Mauritshuis, The
Hague

326 Master of Bellaert
*Christ before Pilate, with the Town Hall and
Pandpoort, Haarlem*
c. 1460. Panel, 38.5 × 26.5 cm. Private collection,
Oegstgeest

327 Hendrick Pacx
*The Orange-Nassau Family Rides Out from the
Buitenhof, The Hague*
Canvas, 145 × 214 cm. Mauritshuis, The Hague

meaning: were these paintings meant to give a little sermon as well as an interior view? In Hendrick van Vliet's *View in the Oude Kerk, Delft* (fig. 325) the figures are a mother with a baby and a little child, children playing, a couple with a dog, and what appear to be elderly people in the background; in the right foreground a grave has just been dug (other paintings of this type may include the gravedigger or a stonemason). Brought together in this painting, they perhaps symbolize the ages of mankind and the inevitability of death.[83]

 The townscape was another important branch of Dutch architectural painting. In the fifteenth and sixteenth centuries, views of towns and villages appear regularly in the backgrounds, particularly of religious pictures (fig. 326). In the seventeenth century, accurate townscapes first occur in historical paintings. A reliable rendition of the old square called the Neude in Utrecht is the scene for Pauwels van Hillegaert's *Prince Maurits Dismisses the Militia* of 1622 (see fig. 366), and the tree-lined Vijverberg in The Hague was depicted with topographical exactitude in many portrayals of the princes of Orange (fig. 327) or of local festivities. Hans Bol's little painting of the water tourney held in The Hague on January 6, 1586, in honor of the earl of Leicester is a fine early example of this genre (fig. 328), and, exceptionally, is contemporaneous with the event.

 Nonetheless, the evolution of the painted townscape did not get under way until the second half of the seventeenth century, and the graphic arts and cartography rather than painting were probably its true precursors.[84] In the graphic arts, a distinct progression can be traced in rendering topographical town views and important buildings. The rise of

326

327

328 Hans Bol
Water Tourney in Honor of the Earl of Leicester, The Hague, 1586
Signed and dated 1586. Panel, 12.5 × 58 cm.
Gemäldegalerie Alte Meister, Staatliche Kunstsammlungen, Dresden

329 Willem Jansz Blaeu
Map of Holland.
1608. Copper engraving

cartography and of illustrated descriptions of cities was decisive to this development. Regional maps were ornamented with skylines of cities (fig. 329), and city maps with local views. The back wall in *The Art of Painting* (see fig. 986) by Johannes Vermeer, an artist who was very fond of maps, is dominated by a large map of the Seventeen Provinces of the Netherlands bordered by twenty small townscapes on the right and left sides. It has been established that the original of this map was available in print between 1631 and 1655.[85]

In 1612 the Amsterdam cartographer and printer Willem Jansz Blaeu brought out a new edition, in Dutch translation, of Lodovico Guicciardini's *Descrittione di tutti i Paesi Bassi*. This work, by an Italian merchant and writer long resident in Antwerp, had first been published by Plantin in 1567; it contained maps of cities and towns and other illustrative material. Blaeu retained part of this in his edition, but he replaced some of the old maps with new ones and added new engravings, especially of such Dutch landmarks as the Bourse in Amsterdam, by Claes Jansz Visscher, and the Middelburg town hall, by Pieter Bast. In the

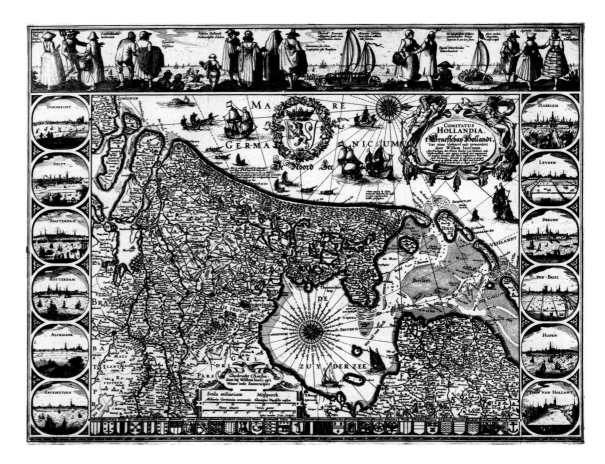

330 Hendrick Vroom
View of Delft
Signed and dated 1615. Canvas, 71 × 163 cm.
Municipal Museum Het Prinsenhof, Delft

following decades many descriptive books and atlases appeared, increasingly illustrated with pictures of major public and ecclesiastical buildings, sometimes with interior views. Strong local patriotism and the growing awareness of national bonds no doubt help account for the popularity of these publications. In 1628 Samuel Ampsing began his "Description and Praise of the City of Haarlem" with these lines:

I know not how a love so strong can in us dwell
For our Father-Town, and show such zeal
And endeavor in our soul, that it ne'er departs
From our thought or our hearts.

It is striking that the painted town skyline, in which the view is from outside the walls of a city, more or less followed the progress in the graphic arts, while the painted townscape proper—a glimpse of the streets, squares, and canals inside the walls—with a few exceptions did not become popular until much later, about 1660. Hendrick Vroom, who began early to introduce town profiles into his harbor scenes, apparently in consequence received commissions to paint cities in this way. Among the first of these are his two views of Delft, dating from 1615 (fig. 330). The demand for this sort of town view and the artists' interest in it continued throughout the century. Sometimes profile views were commissioned by municipal authorities as independent pictures; sometimes they were parts of larger landscapes.

About 1655, after several Dutch painters had immortalized foreign cities with topographically correct town views—Abraham de Verwer, for instance, painted a number of views of Paris between 1637 and 1640 (see fig. 652)—a lively interest arose in Dutch town views. Artists in most of the large cities began to make exact renderings of their urban surroundings, with understandable preference for the most imposing buildings. Earlier town views, such as Jan Beerstraaten's 1652 painting of Amsterdam's fire-ravaged old town hall (see fig. 1070), are records of historical events rather than topographical townscapes. Beerstraaten went outside Amsterdam for his views after 1660, painting castles (fig. 331), little towns, and villages as far away as Friesland, always in winter, with a fall of snow and frozen waters tempting to skaters. About the same time Jan van der Heyden began to paint townscapes in Amsterdam such as his *View of the Herengracht* (fig. 332). He made topographically accurate pictures and fantasy views that used existing elements, freely combining these as he chose. Together with van der Heyden, the Berckheyde brothers of Haarlem, Job and Gerrit, belong among the most talented specialists in this field; they extended their activities to Amsterdam, where, among other things, Gerrit painted the flower market (fig. 333), and The Hague. Their earliest works date from shortly after 1660.

Besides the painters who specialized in townscapes and concentrated mainly on interesting topographical elements, a number of seascapes and landscape artists also produced excellent

331 Jan Beerstraaten
The Castle of Muiden in Winter
Signed and dated 1658. Canvas, 96.5 × 129.5 cm.
The National Gallery, London

332 Jan van der Heyden
View of the Herengracht, Amsterdam
Panel, 36.5 × 44 cm. Musée du Louvre, Paris

333 Gerrit Berckheyde
The Flower Market, Amsterdam
Signed. Canvas, 45 × 61 cm. Amsterdams
Historisch Museum, Amsterdam

331

332

333

town views. Often they had an original, picturesque way of looking at a city. Among the most attractive examples are works by Reinier Nooms (fig. 334), Jan Wijnants (see fig. 1072), Johannes Lingelbach (see fig. 750), Jacob van Ruisdael (fig. 335), and Meindert Hobbema (see fig. 1025). The painting by Lingelbach, dating from 1656, is of early date.

The city of Delft and the work of Pieter de Hooch are sometimes mentioned as van der Heyden's source of inspiration, a suggestion that seems debatable or at least difficult of proof. Van der Heyden's working method was extremely detailed, as can be seen from his *View of the Herengracht*. De Hooch on the other hand, although he chose little streets and courtyards (along with domestic interiors) as his subjects (see fig. 973), clearly painted for the sake of working out the play of light and perspective, not to describe the architecture.

334 Reinier Nooms, called Zeeman
 View of the Prinsengracht, Amsterdam
 c. 1666. Canvas, 52 × 67 cm. Amsterdams
 Historisch Museum, Amsterdam

335 Jacob van Ruisdael
 *View of the Dam, with the Old Weighhouse, and the
 Damrak, Amsterdam*
 Signed. Canvas, 52 × 65 cm. Gemäldegalerie,
 Staatliche Museen, West Berlin

Carel Fabritius' few scenes of Delft (see fig. 966) are also only tangential to the present discussion; beautiful though these paintings are, the distortion of the view makes them studies in perspective rather than townscapes proper.

Johannes Vermeer contributed inimitably to the painting of townscapes with his *The Little Street* and *View of Delft* (see fig. 982 and cpl. 983). Both canvases were and have remained unique. The charming work of Jacobus Vrel also stands alone. Unlike nearly all the other townscape painters, Vrel preferred to paint not monumental buildings but simple streets and alleyways with little shops (almost always including a bakery) and craftsmen at work (cpl. 336).

City guides and topographical works, which contributed so greatly to the development of the Dutch townscape in the seventeenth century, were published in ever greater numbers in the eighteenth. Patriotism kept up the demand for ropographical paintings as well. The treatment of the subject matter underwent little change until the end of the eighteenth century, however, and van der Heyden's work was usually the model followed.

336 Jacobus Vrel
Townscape
Panel, 50 × 38.5 cm. Kunsthalle, Hamburg

337 Artist Unknown
The St. Maartenskerk, Zaltbommel, before the Fire of 1538
Panel, 174.5 × 117.8 cm. Reformed Parish, Zaltbommel

338 Bartholomeus van Bassen
Design for the Nieuwe Kerk, The Hague
Signed and dated 1650. Panel, 82.5 × 112 cm. Gemeentemuseum, The Hague

336

To round off this discussion, let me mention two offshoots of architectural art. The first is the painted maquette.[86] In addition to the three-dimensional models used as working aids in the construction of important buildings, "design" paintings were also sometimes commissioned. Usually representing churches or church towers, they presumably served to give an idea of the original architecture before damage (most often by fire), of necessary or desirable structural changes, or of plans for a new structure. Sometimes they were reproduced as prints and used to advertise fund-raising lotteries for new building projects. Painted maquettes exist of churches in Haarlem, Amsterdam, Alkmaar, and Zaltbommel (fig. 337), among other places. There is also what might be called a perfected design painting made by Bartholomeus van Bassen for a proposed new church in The Hague. Various architects were invited to submit their designs, and van Bassen turned his into a townscape (fig. 338). He did not win the competition; the church was built according to another plan.

337

338

339 Samuel van Hoogstraeten
A Peepshow with Views of the Interior of a Dutch House
a. Exterior
b. View inside
c. Exterior, top: *Venus and Cupid*
Signed. Exterior: 58 × 88 × 63.5 cm; interior: 54.5 × 80 × 53 cm. The National Gallery, London

The second offshoot is the perspective box, a delightful form of art that flourished between about 1650 and 1660 as a manifestation of the surge of interest in perspective and illusionistic effects at that time.[87] Built of wood on a triangular or rectangular base, such a box ordinarily measured about two feet high, three feet wide, and two feet deep. Its inner walls were painted in such a way that a view inside through a peephole yielded a surprisingly spacious and almost tactile experience of a church, or a gateway, or the room of a house.

The peepshow painters, presumably most active in Haarlem and Delft, of course needed a thorough understanding of perspective. The greatly distorted scenes on the walls of a box had to be extraordinarily well constructed in order to produce the desired effect. Samuel van Hoogstraeten, who included this ingenious sort of painting among his many activities, wrote of "the amazing perspective box, which, if it is correctly and knowledgeably painted, shows a figure no larger than a finger appear to be as large as life."[88] And indeed, anyone lucky enough to get a look inside a peepshow loses all sense of the box's true dimensions.

A few perspective boxes have been well preserved, one of the most beautiful being by Hoogstraeten himself, now in the National Gallery, London (fig. 339). Five of the six inner walls are painted; the sixth is of ground glass (modern), to permit the entry of light. There are two peepholes, one at each end, giving different views of completely furnished interiors of a Dutch house, which is further decorated with many paintings and a stained-glass window. The front and both ends of the exterior (the back is unpainted) bear allegorical scenes, as discussed above (see p. 35); on the top are Venus and Cupid, painted in anamorphic foreshortening (fig. 339c): the picture must be viewed from a certain angle to be recognizable. Pictorial jokes of this sort were popular in other countries, too, especially in the sixteenth century.[89]

The peepshow represents a remarkable form of the interest in perspective and illusion and is in some ways related to *trompe l'oeil* still lifes. Carel Fabritius' *View in Delft, with a Musical Instrument Seller's Stall* (see fig. 966), a particularly interesting perspective townscape, shows that artist's fascination with the problems of perspective, the phenomenon of wide-angle vision, and the use of optical instruments.[90]

With a wonderful clarity of vision and sureness of hand, Dutch painters of the seventeenth century explored and recorded the world around them. Their country embraced a morality that could have been stultifying, and in their own way the artists joined in it, too, yet always with a joy in their ability to render visible the things of the spirit and the flesh. They taught their contemporaries new ways of seeing themselves and their surroundings, gave them new aesthetic experiences, and, while catering to a ready market, expanded that market by their versatility and "invention." Some of them—at the very least, those who signed their works, let us say—presumably felt an obligation to the future, and there is no doubt that we, the future, remain in their debt.

PART II

The Turning Century: Economic Growth and Military Gains

It is time to pick up once again the threads of Dutch history and economic growth, and then to begin the trips around the Republic's art centers which I have chosen as the framework for exploring the diversities and similarities that characterize the artists of the succeeding generations. The small geographical area within which they lived permitted easy communication. Towns and cities were linked by an ancient network of waterways, which carried the nation's shipping, both freight and passenger. From Amsterdam there was, later in the seventeenth century, regularly scheduled service by the *trekvaart* (the towing canal, with horse-drawn boats) to Haarlem and Leiden, and from there on down to The Hague, Delft, and Rotterdam. Utrecht was reached by traveling along the canal to Weesp and then up the Vecht River. The IJssel River towns—Deventer, Zwolle, Kampen—lay just across the Zuider Zee, the route to the Frisian towns as well. A road system also existed, permitting faster but more expensive travel by coach; along some routes, especially across the forested Veluwe moor to the east, there was danger of highwaymen. So the waterways remained the arteries of transport, commerce, and defense, and came to be a salient feature of the landscape art just emerging.

For centuries agriculture had been a mainstay of this region's economy. Among the crops cultivated were flax, hops, rape seed for oil, madder roots for dyes, and garden produce. Some grains, chiefly rye, oats, and buckwheat, were grown but in insufficient quantities to feed the population, necessitating imports from abroad, in particular from the Baltic area. The Frisians and North Hollanders had long been noted for the excellence of their beef and dairy cattle, and there was a thriving export of meat, butter, and cheese.

Exploitation of peat, another product of the land, provided much-needed fuel, but changed the topography. About 1530, techniques had been developed for digging below water level, and within a few decades share companies for the production and sale of peat sprang up all over the Northern Netherlands. As the diggings grew deeper and filled with water, bogs became lakes. At the same time, with the introduction of windmills for pumping, efforts were made to reclaim as much land as possible, by the diking in and drainage of other areas. Although some of the new land thus gained proved too sandy for cultivation, much of it was fertile. In the century from 1540 to 1640, roughly 12,500 acres were reclaimed.

Second to agriculture in the Republic's early economy was the fishing industry, and by far the most important branch of this was the herring or "big" fishery, so called because it had the largest fleet, estimated at about four hundred and fifty boats in 1600. Approximately eighty percent of the catch was destined for export, mainly to northern Germany. Since the fishing fleets were particularly vulnerable to attacks by English and Dunkirk privateers— and by the Sea Beggers as well—warships had to be delegated to convoy them (fig. 340).

The cod or "small" fishery required larger, more expensive boats capable of sailing as far as Iceland; it was of less economic importance than the herring industry. The Dutch did not engage in whaling until 1612, but the profits from this dangerous enterprise were so great that two years later the States-General granted the monopoly in whaling and the sale of whale oil to the newly chartered Northern Company, which maintained a summer base on Spitsbergen. It took nearly fifty years for outside competition to break the monopoly.

The Dutch merchant marine evolved out of the seasonally limited fishing fleets to become the bulk carrier of Europe. Not least of the reasons for its success was the

340 Pieter Vogelaer
Dutch Herring Fleet
Signed. Pen painting on panel, 84 × 114 cm.
Rijksmuseum, Amsterdam. On loan from the
Koninklijk Oudheidkundig Genootschap

341 Hendrick Vroom
*The Return to Amsterdam of the Second Expedition to
the East Indies, July 19, 1599*
Canvas, 110 × 220 cm. Amsterdams Historisch
Museum, Amsterdam. On loan from the
Rijksmuseum

introduction, in 1595, of a newly designed cargo ship called the *fluit* or flute, a sturdy, efficient, capacious vessel well adapted to the all-important Baltic trade in grain and timber. By the turn of the century, Dutch shippers were extending their activities from the White Sea in the far north to Italian and Levantine ports on the Mediterranean and to African ports along the Atlantic seaboard.

In 1595 also, after attempts to find a northeastern route to the Orient had failed, the first Dutch expedition set sail from Amsterdam via Africa's Cape of Good Hope to seek the fabled Spice Islands of the East Indies. Only one of the four ships returned, two years later, but it brought back enough goods and even more information; the Amsterdam merchants immediately chartered a second fleet of eight ships. All of these got back within a year, their return recorded sometime later in a painting by Hendrick Vroom (fig. 341), and their cargoes guaranteed enormous profits to the shareholders. Public excitement was so great that "companies of the distant seas" sprang up everywhere throughout the Republic. Those of Holland and Zeeland, especially, engaged in cutthroat rivalry, imperiling the whole trade. Therefore, to quell this competition, regulate and protect the trade, and strike blows at Spanish and Portuguese interests in the South Seas, the States-General in 1602 granted charter to the Verenigde Oostindische Compagnie (United East India Company), sometimes called the Dutch East India Company, often referred to by its initials, VOC. One of the earliest joint-stock companies on record, it sold shares on the open market. Thousands of ordinary Dutchmen subscribed, including, one may surmise, those artists who could afford it. That painters did invest, not always successfully, in maritime ventures is evident from the unspecified "damages and losses at sea" mentioned in Rembrandt's petition for insolvency in 1656.[1]

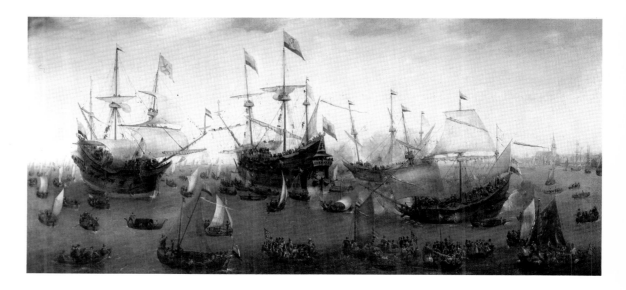

342 Job Berckheyde
The Courtyard of the Amsterdam Bourse after the Renovation in 1668
Signed. Canvas, 89 × 116 cm. Amsterdams Historisch Museum, Amsterdam

Before the war, industry had been concentrated in the Southern Netherlands, although Haarlem and Leiden had made modest beginnings at textile manufacture. All the industries suffered badly from the hostilities and from the blockade of shipping, for they were dependent upon imported raw material. Antwerp's definitive fall to the Spanish in 1585 marked the end of that city's long dominance as port and industrial center. In the ensuing exodus, many of the richest and most active merchants and manufacturers fled, often to the north, taking along their capital, their know-how, and sometimes part of their equipment. There were even more displaced craftsmen, workers essential to all branches of industry, and unskilled laborers able to man ships and work on the docks. The influx into the major towns of Holland and Zeeland came not only from Flanders and from Germany, where the Hansa towns were in decline and where, in 1618, the Thirty Years' War broke out, but also from the impoverished countryside.

While the impact of the newcomers is difficult if not impossible to measure, it was admittedly very great. Yet it must not be overestimated at the cost of playing down the energy, ingenuity, and business acumen of the native population. When the refugees came, the Dutch were for the most part willing to welcome and assimilate them—and to use their knowledge and skills. But if the Flemish textile workers brought new methods for cultivating flax and new techniques of weaving, the Dutch perfected windmills for fulling and calendering cloth and for producing threads in great quantity and variety. The windmill was indeed constantly being adapted to new uses: sawing wood, crushing seeds for oil and grain for flour, and keeping the water level under control. It is justly credited with being the greatest technological boon to industry of the period.

And so the United Provinces began to prosper as never before, with Holland and Zeeland in the forefront. Tapestry weaving was pursued with great success in Amsterdam and elsewhere, especially Delft, where the Flemish weaver François Spiering settled. Leiden was reestablished as a textile center, and Haarlem became noted for its bleaching plants and the excellence of its beer. But of all the cities, Amsterdam made the greatest progress, partly because it had its own merchant fleet; Antwerp had always depended on vessels chartered from outside, including the Amsterdam carriers of Baltic grain.

The growth of the Amsterdam fleet at the turn of the seventeenth century brought with it the need for more shipyards, rope factories, sailmakers, and suppliers of every sort of marine equipment. Also required were warehouses for storing the cargoes brought in and held for sale and transshipment. Financial activity attracted merchants from far and wide, and Amsterdam began to replace Antwerp as a money market. A bank for exchanging and regulating the many currencies then in circulation was established in 1609, and in 1612 the commodity and stock brokers took possession of their new Bourse on the Dam, designed by Hendrick de Keyser (fig. 342). A contemporary described the activities there as "confusion of confusions," but the profits could not be denied. Dreams of sharing in them lured new immigrants and perhaps gave hope even to the indigenous poor.

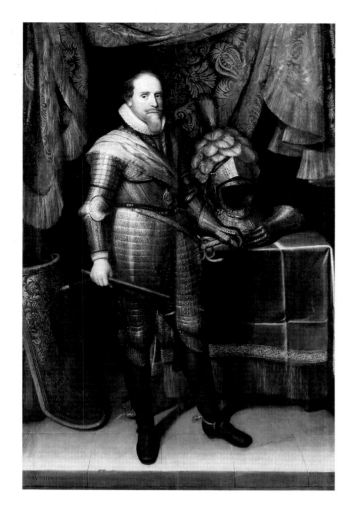

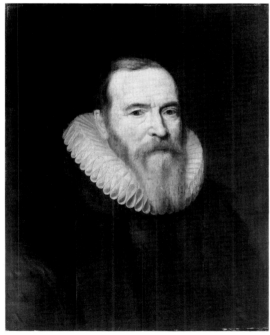

The Republic's military situation slowly improved. For a time, after the earl of Leicester departed in 1587, the outlook had been bleak: the English troops mutinied and were soon withdrawn, and the Spanish army under the duke of Parma seriously threatened to move again into the heartland of Holland. Then, in the summer of 1588, Philip II launched his "invincible Armada" against England. The plan was for the Spanish warships to rendezvous off the Flemish coast, where Parma and an army of 26,000 men would be ready to join the invasion. But he was kept bottled up at Dunkirk by English and Dutch fleets on constant patrol, the great, clumsy Spanish galleons were harried and doughtily attacked by the lighter, swifter English ships, and the people of Zeeland soon had a saying about what happened to the armada: "God blew, and scattered the Spaniards."

Philip II continued to play into the Republic's hands, for he next decided to take advantage of the political and religious strife in France over the succession to the throne of the Protestant Henry of Navarre. By allying himself with the Catholic League there, Philip could increase Hapsburg power and restore the Church in France. He therefore ordered Parma to aim his strategy and the bulk of his troops against France, which greatly relieved Spanish pressure on the United Provinces; it also caused the death of Parma, who succumbed to exhaustion and old wounds in 1592.

Prince Maurits (fig. 343) had meanwhile been developing into a first-class military tactician. He studied the ancient Romans' organization and deployment of armies as his model for reorganizing the Republic's army. At the same time he kept up with the newest weaponry and methods of warfare, inventing some himself, and he insisted that his troops be paid on time. In this he was aided by Johan van Oldenbarnevelt (fig. 344), whose position as advocate (spokesman) of the States of Holland was the most powerful legal office in the Republic. Equally skilled in domestic and foreign politics, Oldenbarnevelt performed so competently and indefatigably that he was given the honorary title of Advocate of the Land.

During the 1590s Prince Maurits regained most of the Spanish-held territory and towns in the east and northeast of the country, and restored the lines of defense by water. In 1600, at the insistence of Oldenbarnevelt and the States-General, who wished to destroy the pirate strongholds at Dunkirk and Nieuwpoort, Maurits agreed to lead a campaign down the Flemish coast. His army assembled on the beach at Nieuwpoort. The expected assistance from the Flemings did not materialize, however, and veteran Spanish troops suddenly arrived under the command of Archduke Albert of Austria, governor-general of the Southern Netherlands. The Dutch won the ensuing assault, but were unable to follow it up. They withdrew, taking considerable booty, including the archduke's white warhorse that later became the subject of several paintings (see fig. 27); otherwise they gained virtually nothing, and certainly put no stop to the Dunkirk pirates. The encounter was nevertheless called a victory.

Philip II had died in 1598, two years before this indecisive battle, and Philip III inherited his father's debts along with his throne. The divided Netherlands was a particularly expensive possession, for the south produced little income, and fighting the north required huge military expenditures. The Republic was also in debt: it owed England eight million guilders, and France fourteen million, with interest running as high as fourteen percent. So feelers began to go out: perhaps peace could be negotiated.

The early attempts to reach a settlement proved abortive, partly because Ambrogio Spinola, a man of unusual competence and wealth, took over the military command in the south and began to regain losses. More important, however, were the demands made by

343 Michiel van Miereveld
Portrait of Maurits, Prince of Orange
Signed. Panel, 221.5 × 146 cm. Rijksmuseum, Amsterdam

344 Studio of Michiel van Miereveld
Portrait of Johan van Oldenbarnevelt
Panel, 63 × 49 cm. Rijksmuseum, Amsterdam

both sides and the split in the Republic about the desirability of peace: Prince Maurits would not give up his army; the Calvinists refused to accept the reinstitution of public Catholic worship; and the merchants vetoed the limiting of Dutch trade to continental Europe. Yet Spain grudgingly agreed to acknowledge the independence of the United Provinces, and on that basis the negotiators drew up a plan for a long-term cessation of hostilities so that the political, religious, and commercial questions could be worked out. On April 9, 1609, a formal truce was signed: for the next twelve years there would be no fighting.

The Turning Century: The Development of Painting

Haarlem: Karel van Mander and His Friends

Haarlem (fig. 345) had much to endure in the 1570s: the seven-month siege of 1572–73, which ended with the capture of the city and the reprisal killing of magistrates and garrison; the Spanish occupation until 1576; and a fire in that year that destroyed much of the town, including important buildings. Even before the siege, Haarlem's economic condition had been declining, and to build it up again took real effort.

Textiles had long been an important local industry, Flemish weavers having come to Haarlem in the fourteenth century after dissension in the southern guilds. Dating also from medieval times were the many breweries on the Spaarne River, which flows through Haarlem; when seepage of sea water made the river become slightly brackish, excellent water for brewing was found in the nearby lakes behind the dunes lining the North Sea. The purity of this water made it particularly valuable, too, for bleaching fine linen and cotton cloth. Displaced craftsmen from the south, arriving in the 1580s, again provided manpower and know-how for reviving the weaving and bleaching industries. And so Haarlem began to flourish anew. Its population in 1580 was about 18,000; by 1622 it had grown to 40,000. Nevertheless, despite some expansion to the north, Haarlem could not rival Amsterdam's spectacular growth, for its commercial activities remained too limited.

As a center of art at the end of the sixteenth century, however, Haarlem clearly held first place. The cultural tide had turned in 1577, when Dirck Volkertsz Coornhert returned to the city from one of his several exiles abroad. He had spent four years in Germany, mainly

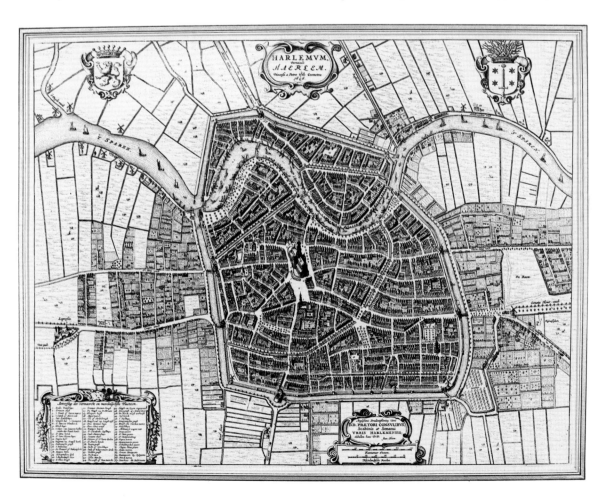

345 Pieter Wils
 Map of Haarlem
 1646

in Xanten, a haven for Protestant refugees, helping to raise money for William of Orange's army, and working at his old trade as an engraver. He brought a pupil, the seventeen-year-old Hendrick Goltzius of Mühlbracht back with him to Haarlem. Coornhert was a competent but not overly original engraver, confining himself to prints after the work of others (fig. 346); his true talent lay rather in his writings (see p. 26). Goltzius, however, was to become the most accomplished draftsman and engraver of his time. Coornhert no doubt introduced him to Philip Galle, the master's first pupil and now established as an engraver and printer in Antwerp. Goltzius worked for Galle for five years and seems to have gone regularly to Antwerp, where he made a number of portrait drawings. With this experience, he opened his own printshop and publishing house in Haarlem in 1582.

The year 1583 brought two new arrivals to Haarlem: Cornelis Cornelisz returned to his birthplace after an apprenticeship in painting in Antwerp and further study and travel in France; and Karel van Mander, poet and painter, came from war-torn Flanders, seeking safety and work. They soon made contact with each other and with Goltzius, forming a triumvirate of the utmost importance to the development of Dutch art.

Van Mander's life story is related in some detail in the biography appended to the second edition of *Het Schilder-Boeck*, published in 1618, twelve years after his death. The many personal anecdotes in this "Life," and the precise descriptions of his early paintings, indicate that the anonymous writer must have been acquainted with van Mander and perhaps had access to his papers. Karel was born in 1548 in Meulebeke, a village in the middle of Flanders, to parents from well-to-do, aristocratic families, who sent their son to the Latin and then the French schools. Karel began drawing as a boy, and he then became a poet, combining his talents in elaborate productions for the local chamber of rhetoric. His father consented to lessons in painting, and in 1573 underwrote Karel's trip to Italy.

Karel spent more than three years in Rome, meeting and working with other young artists and receiving commissions on his own. His most talented new acquaintance was Bartholomeus Spranger of Antwerp, only two years his senior; Spranger had mastered large-scale history painting and had as his patrons Pope Pius V and high churchmen. Emperor Maximilian II took him into his employ in 1575, and he spent the rest of his life working at the imperial courts in Vienna and Prague, ruled from 1576 to 1612 by the art-loving Rudolf II.

Spranger painted in the style now known as Mannerism, which developed from the elegant *maniera* style dominant in Rome during much of the sixteenth century. With Vasari as their chief spokesman (using the language of rhetoric), the Mannerist painters advocated the study but not the slavish imitation of nature. They transformed nature according to their ideas of art as the supreme expression of truth and beauty, selected and organized by the artist's "invention," and demanding the portrayal of the utmost grace of facial and bodily movement. The tension in their figures extends to the tips of the fingers and toes, and a decorative play of lines animates their landscapes.

In 1577 Spranger invited van Mander to join him in Vienna, where preparations for the investiture of Rudolf II required many artists to help with the festive decoration of the city. It was probably in thanks for his assistance that Spranger gave van Mander the drawings he later brought to Haarlem in 1583. When Karel returned home to Flanders he found it in a state of precarious peace that soon turned to anarchy, the countryside pillaged by "malcontents" (as he called the unpaid mercenary deserters from Alva's army). In 1581 they attacked his village and burned down his parental home; with great difficulty Karel rescued his family (now including his wife and infant son) and set out on the perilous trail that led him to the "old and honorable city of Haarlem." His first work there was painting signboards.

Cornelis Cornelisz, fourteen years younger than van Mander, escaped these harrowing experiences and first studied under Pieter Pietersz in Amsterdam, then under Gillis Coignet in Antwerp. In 1579 he went to France and for four years absorbed the court style of the Mannerist painters working in Paris and at Fontainebleau. Returning home, at the age of twenty-one, he had mastered this style and was eager to learn more. And Karel van Mander was ready to share with him and Goltzius the knowledge of art he had garnered in Flanders, Italy, and Austria.

In his biography of Goltzius in *Het Schilder-Boeck*, van Mander writes: "When anno 1583 I came to live in Haarlem, I became acquainted with him and showed him some of

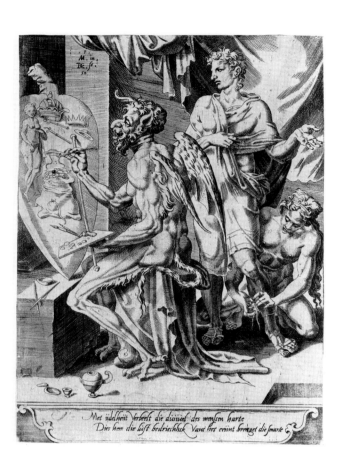

346 Dirck Coornhert after Maerten van Heemskerck
Allegory on the Hope of Profit
1550. Engraving, from a series of four

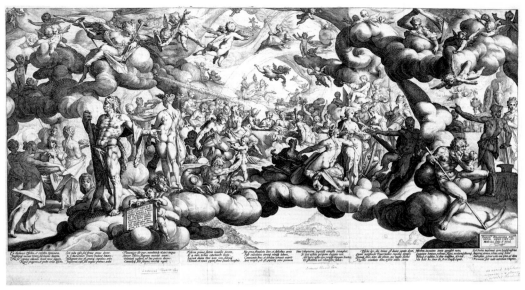

347

347 Hendrick Goltzius after Bartholomeus Spranger
The Wedding of Cupid and Psyche
Engraving

348 Cornelis Cornelisz van Haarlem
The Massacre of the Innocents
Signed and dated 1591. Canvas, 270 × 255 cm.
Frans Hals Museum, Haarlem. On loan from the
State-owned Art Collections Department

349 Karel van Mander
Before the Flood
Signed and dated 1600. Copper, 31 × 25.5 cm.
Städelsches Kunstinstitut, Frankfurt am Main

Spranger's drawings, which he liked very much."[1] This appears to have indeed been the case: Goltzius' work of about 1585 includes engravings after Spranger and several drawings that were clearly borrowed from him (fig. 347). The Mannerist tradition also shows up in Cornelis Cornelisz's work, mainly in his paintings with many figures, mostly nudes. In such overfull compositions as his *Massacre of the Innocents* of 1591 (fig. 348), the bodies seem entwined in inextricable knots. Van Mander himself continued to paint in this style, though less tortuously, as shown by his *Before the Flood* of 1600 (fig. 349), one of his few paintings that have survived (his work is known mainly from engravings made after his drawings).

Further evidence of these artists' friendship with each other comes from van Mander's anonymous biographer, who says: "Shortly after becoming acquainted with Goltzius and Master Kornelis, he made with the three of them an Academy, in order to study from life."[2] This passage has aroused much controversy, the principal question being what kind of academy it might have been. One scholar believes there could not have been any academy before 1588 in which the artists drew from living models, since among Goltzius' innumerable drawings there is not one before that date of a live nude model.[3] Another points out that the term "from life" must be interpreted with caution; at that period it was also used to designate drawing after statuary and plaster casts.[4] The emphasis could perhaps

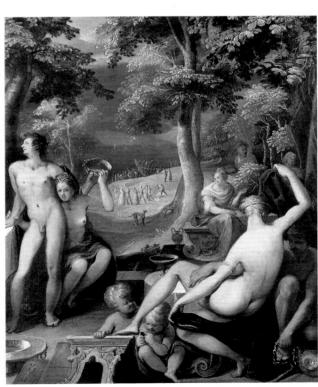

348

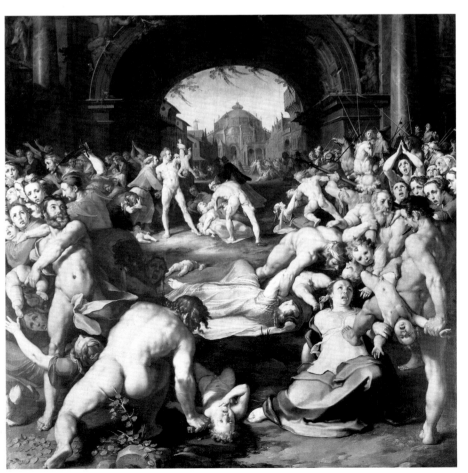

349

350 Cornelis Cornelisz van Haarlem
Banquet of the Haarlem Civic Guard
Signed and dated 1583. Panel, 135 × 233 cm.
Frans Hals Museum, Haarlem

better be placed on the words "the three of them," meaning that this trio simply worked together, and thus eliminating any question of a true academy with pupils and a curriculum. Surely van Mander would have mentioned it in his *Schilder-Boeck*, where he had every opportunity to do so but says not one word. Whatever form the academy took, it is reasonable to assume that he tested his theories very thoroughly in Haarlem. Not for nothing did he choose as his anagram "*Van* elck *Man* rader" (Every man's adviser).

He had a chance to demonstrate his ideas and talents publicly in 1586, when Haarlem welcomed the earl of Leicester, the new governor-general, with pomp and ceremony. Van Mander was called upon to help with the decorations, and with his Viennese experience in making triumphal arches he won general acclaim.[5] He continued to work in Haarlem, painting and gathering material for his book, and he apparently also kept in touch with Spranger, exchanging letters and drawings or prints. Spranger returned to the Netherlands in 1602 for the first time in thirty-seven years, and all the artists in Haarlem turned out to greet him with banquets, theatrical performances, and speeches praising him and the art of painting, about which he had taught them so much. Sustained by this joyous reunion, van Mander retired in the same year to his country estate near Alkmaar to finish writing *Het Schilder-Boeck*, and then moved to Amsterdam, presumably partly to watch the book through publication. His death there in 1606 was greatly mourned.

Cornelis Cornelisz was a more gifted painter than van Mander and did not limit himself to Mannerist history paintings, but produced individual and group portraits as well. He painted a civic-guard banquet (fig. 350) in 1583, the year of his return to Haarlem, and again in 1599 (see fig. 375), the latter particularly praised and praiseworthy for its liveliness of composition and portraiture. Cornelis was one of the few painters of his time with sufficient technical skill and knowledge to create large works, and the younger generation of artists in Haarlem learned from him. His most direct followers were Gerrit Pietersz Sweelinck, who continued his career in Amsterdam, and Cornelis Enghelsz Verspronck.

Hendrick Goltzius is a perfect example of a transitional figure in whose work old and new forms alternate and seem even to vie with each other. His production of drawings and engravings was enormous, and his complete technical mastery brought him wealth and

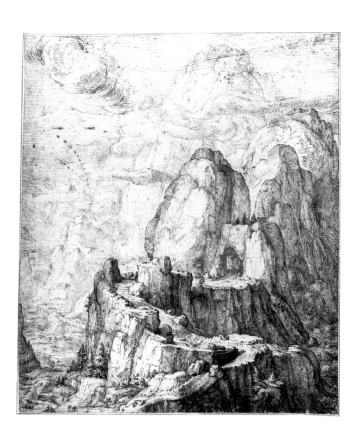

351 Hendrick Goltzius
Mountain Landscape
Signed and dated 1594. Pen and bister, 43.9 × 35.6
cm. Teylers Museum, Haarlem

352 Hendrick Goltzius
Landscape near Haarlem
Signed and dated 1603. Pen and bister, 8.7 × 15.3
cm. Museum Boymans-van Beuningen,
Rotterdam

widespread fame. In 1590, perhaps at van Mander's urging, he undertook a trip to Italy, accompanied by a servant. They sailed from Amsterdam to Hamburg, and then set out by foot through Germany and over the Alps, seeking the company of painters and engravers at inns along the way; it was Goltzius' whim to trade places with his servant and to ask leading questions about himself and his famous prints. The answers he got delighted him. Goltzius would not have been Goltzius if he had not also worked industriously wherever he went. The mountains impressed him greatly, and, like Dürer and Bruegel, he made many sketches of mountain landscapes which he worked into finished drawings and engravings after his return (fig. 351). Arriving in Italy, he went first to Venice, then to Bologna and Florence, and reached Rome in January 1591. He spent the next six months very profitably, becoming acquainted with outstanding artists, drawing from antique statuary, and copying works by Raphael, Michelangelo, and especially Polidoro da Caravaggio.

Goltzius returned by way of Munich to Haarlem at the end of 1591, and immediately set his printshop to work at top capacity. He himself engraved three hundred of his drawings; his pupils Jacob Matham, Jacob de Gheyn II, and Jan Saenredam, five hundred more. Matham and de Gheyn soon left the studio, but Saenredam remained. Goltzius' prints were sold in Amsterdam, Frankfurt, Venice, Rome, Paris, and London. Through them, artists who did not have a chance to travel became acquainted with his new style, which largely abandoned Mannerism in favor of the broader outlook he had gained in Rome and elsewhere on his travels. Goltzius became ever more famous, especially after he began to produce his so-called *Meisterstiche*, a series of engravings in the style of Dürer and Lucas van Leyden, and his pen paintings: goose-quill drawings on prepared linen or parchment in which he imitated engraving.

Our admiration today is aroused less by these works than by Goltzius' beautiful portrait drawings, his animal and plant studies, and his landscapes, which include both fantastic rocky scenes and true-to-nature views of the Dutch dunes (fig. 352). What we most like now is what van Mander chose to ignore in his otherwise extensive discussion of Goltzius' work; van Mander, a prime exponent of late-sixteenth-century taste and theories of art, was more interested in "works of the imagination" than in "studies from life" or portraiture. Goltzius took up painting about 1600, but his paintings do not equal his drawings and engravings.[6]

Hendrick Cornelisz Vroom, a neighbor of Goltzius, was one of the first to find a new specialty in painting naval battles and ship portraits. Just how early he began this work is difficult to determine, though van Mander's biography of him is so detailed that it presumably came directly from Vroom himself. It tells us that Vroom drifted about at a young age as a painter of pottery, working in Poland, Spain, and Italy as well as Holland. In Danzig he was taught by an uncle employed there as municipal architect, and in Rome he had lessons from Paulus Bril. About 1590 he returned to Haarlem and settled down.

Vroom's earliest known dated painting is from 1607, but his reputation as a marine painter was certainly established much earlier. The 1594 "Memorandum Book" of the burgomasters of Haarlem records that he had been excused from militia duty because of

"his singular Art in the portraying and painting of various naval [works], in which he excels over others."[7] We have already mentioned (p. 148) the tapestry series on the defeat of the Spanish Armada which he designed for Lord Charles Howard in 1592. This series, which hung in the old House of Lords in London, was destroyed when that building burned down in 1834, but another series of five tapestries dating from the mid-1590s is still preserved at Middelburg. These hangings were designed by Vroom for the Middelburg tapestry workshop De Maecht on commission from the States of Zeeland, and depict the Battle of Rammekens, a fort just east of Vlissingen taken from the Spaniards in 1573 (fig. 353). It is known from bills of account and letters of Vroom to De Maecht that the artist visited the site to make preliminary studies.[8] He chose a very high horizon for his composition, thus

353 Jan de Maecht after Hendrick Vroom
The Battle of Rammekens, 1573
1598. Tapestry, 380 × 740 cm. Zeeuws Museum, Middelburg. On loan from the Province of Zeeland

354 Hendrick Vroom
Naval Battle
Signed and dated 160(.). Canvas, 91.4 × 152.8 cm. Tiroler Landesmuseum Ferdinandeum, Innsbruck

permitting himself as it were to look down on the battle and render a clear view of the individual ships engaged in it. A similar high horizon and bird's-eye view appear in a painting of a naval battle that cannot be positively identified (fig. 354). The date on this canvas is 160–, the last digit obliterated; this is probably Vroom's earliest known work. His career extended almost to his death in 1640, at the age of seventy-four, so that he will reappear in our discussion (see p. 179).

Vroom was not the only painter who worked for the tapestry weavers. Cornelis van Wieringen and Pieter de Grebber of Haarlem, Gerrit van Honthorst of Utrecht, and Simon de Vlieger, who worked in many places, all created tapestry designs, but their work in this field has not been preserved.

Utrecht: Late Mannerism

Next to Haarlem, Mannerism took its strongest hold in Utrecht, where it was presumably introduced by Anthonie van Montfoort, called Blocklandt. Born in 1534 in Montfoort near Utrecht, Blocklandt studied for a time under Frans Floris in Antwerp and then journeyed in 1572 to Rome, where he came under influences stemming from Parmigianino's personal version of Mannerism. He was back in Utrecht by 1577, bringing this new style with him and teaching it to his pupils. Most of his paintings were altarpieces that were destroyed during the iconoclastic outbreak: *Joseph before Pharaoh* (fig. 355) is one of the best of those saved.

Joachim Wttewael of Utrecht was early influenced by Blocklandt, though he was not his pupil. He, too, traveled and became acquainted with the work of Italian and French Mannerists. The Utrecht Saddlers' Guild lists him in its records in 1592 (Utrecht painters had belonged to this guild since the Middle Ages, having originally been taken into it because they painted shields). He remained active in Utrecht until his death in 1638, faithful always to the Mannerist style. For the most part he painted biblical and mythological compositions with many figures, often nude; the skin tones tend to be metallic or enamel-like. A small painting of his on copper, *The Wedding of Peleus and Thetis* (fig. 356), was inspired by Spranger's *Wedding of Amor and Psyche*, of which Goltzius made an engraving (see fig. 347). Wttewael undoubtedly knew the print, for he took over many compositional details literally. He also painted portraits and a few kitchen pieces. In 1611 he was one of the founders of the St. Luke's Guild in Utrecht.

Abraham Bloemaert, too, was reared in Mannerism, but unlike Wttewael he later abandoned this style. In 1580, when he was sixteen and had finished his schooling in Utrecht, he went to Paris and Fontainebleau for three years. Upon his return to Holland he worked for a short time in Amsterdam, where his father, Cornelis Bloemaert, was municipal architect. He settled in Utrecht in 1583, but spent the years 1591–93 in Amsterdam; while there he painted in a Mannerist style, and continued in this affinity after his return to Utrecht, as shown by his small panel *Judith Displaying the Head of Holofernes* of 1593 (fig. 357). Soon, however, he developed his own quieter style. Bloemaert showed time after time that he was open to fresh ideas and trends. He explored portraiture and new ways of rendering biblical, mythological, and allegorical subjects; he designed tapestries and stained-glass windows. His skillful and original drawings form an attractive part of his oeuvre. More will be said later about Bloemaert's work after 1600, and about his pupils.

355

356

357

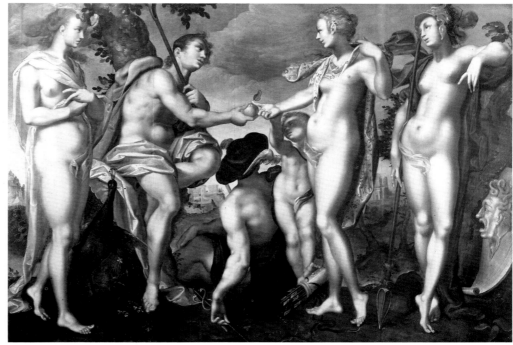

358

An important Utrecht-trained painter was Michiel van Miereveld of Delft. Son of a goldsmith, he was only twelve years old when he became Blocklandt's pupil in 1579. He first concentrated on engraving and on painting history pieces, such as his *Judgment of Paris* of 1588 (fig. 358), but turned wholly to portraiture when he later settled in Delft. In his biography of Miereveld, van Mander deplores this specialization, writing: "It seems to me that, if he had applied himself to historical subjects... he would have made some excellent pictures."[9]

Amsterdam: Magnet for Artists

One of the most interesting artists in Amsterdam at the end of the sixteenth century was undoubtedly Cornelis Ketel, a true man of his time. He was born in Gouda in 1548, and became Blocklandt's pupil at the age of eighteen. In 1566 he went to Paris and Fontainebleau, where he found an international circle of artists. Then he returned to Gouda, but, writes van Mander, "Since there was no painting for him to do there, he left anno 1573 for England and went to London."[10] In London Ketel concentrated entirely on portraiture and achieved great success. After eight years there, he went back to Holland.

By 1581 the atmosphere in Amsterdam, where Ketel settled, was most favorable to an artist of his talents. In the three years since the Calvinists had seized municipal control from the Catholics, the economy had been restored, and there was increasing interest in cultural things. The civic-guard companies were once more giving out commissions for group portraits. They hired Pieter Pietersz, Aert Pietersz, Dirck Barendsz—and Cornelis Ketel. As early as 1581 he painted a militia portrait, of which only the preliminary sketch has survived (fig. 359). In 1584 he painted the company of Captain Rosecrans and Lieutenant Ruysch, and four years later he portrayed the same captain with Lieutenant Pauw and thirteen guardsmen (see fig. 186). The first painting was completely traditional, but in the second Ketel made an important step forward: he painted the figures full length, and succeeded in achieving unprecedented liveliness. He had clearly profited from his stay in England, where full-length portraits were in vogue. The Mannerist style, sometimes overelegant, is here soberly limited by the subject matter.

Ketel was a cultivated man, accepted into intellectual circles. His good friend van Mander relates that the artist composed verses and epigrams (which he called *zinnekens*) to accompany his allegorical paintings, practically none of which are still extant. Fortunately, many of his forceful portraits survive. Ketel possessed great inventiveness, which found an outlet in experimentation: disdaining brushes, he painted portraits with only his fingers, and then went on to use only his toes. Van Mander describes a number of these paintings, saying that they were exceptionally good and in great demand.[11] Ketel was the last important sixteenth-century painter in Amsterdam, in spirit as well as in time. Yet without doubt his work held the potential for development toward new forms.

Also active in Amsterdam at the turn of the century was Gerrit Pietersz Sweelinck,

355 Anthonie van Montfoort, called Blocklandt
Joseph before Pharaoh
c. 1575. Canvas, 122 × 139 cm. Centraal Museum, Utrecht

356 Joachim Wttewael
The Wedding of Peleus and Thetis
Signed and dated 1602. Copper, 31 × 42 cm.
Herzog Anton Ulrich Museum, Brunswick, West Germany

357 Abraham Bloemaert
Judith Displaying the Head of Holofernes
Signed and dated 1593. Panel, 34.5 × 44.5 cm.
Kunsthistorisches Museum, Vienna

358 Michiel van Miereveld
The Judgment of Paris
1588. Panel, 167 × 245 cm. Nationalmuseum, Stockholm

359 Cornelis Ketel
Sketch for a Civic-Guard Painting
1581. Pen and wash, 29 × 39 cm. Print Room, Rijksmuseum, Amsterdam

360 Gerrit Pietersz Sweelinck
Triptych with *The Adoration of the Shepherds*; on
the wings, the portraits of the den Otter Family
Signed and dated 1601. Center panel: 90 × 58 cm;
side panels: 90 × 22 cm. Amsterdams Historisch
Museum, Amsterdam

361 Hans Bol
Winter Scene
Etching

brother of the organist-composer Jan Pietersz Sweelinck. Born in Amsterdam, Gerrit
studied mainly in Haarlem under Cornelis Cornelisz, and must have been there about
1588–90, when Cornelis joined van Mander and Goltzius in the enigmatic "academy."[12]
After working independently in Haarlem for several years, Sweelinck went to Antwerp and
Rome; he returned to Amsterdam about 1600. His triptych painted in 1601 for the den
Otter family of Amsterdam (fig. 360) shows the influences he had undergone in Haarlem
and abroad. Sweelinck was decidedly less talented than Ketel, but he formed a link between
the Haarlem tradition, augmented by Flemish and Italian elements, and the development in
Amsterdam, particularly as seen in the work of his pupil, Pieter Lastman.

Many painters of Flemish extraction and training chose to settle in Amsterdam rather
than Haarlem.[13] Among the first to arrive was Hans Bol. Born in Mechelen (Malines) in
1534, he left after the sack of the town in 1572, worked for a time in Antwerp, moved on to
Bergen op Zoom, Dordrecht, and Delft, and reached Amsterdam only in 1586. By then he
was in his fifties, and his style was long since formed. He painted and etched landscapes,
mostly distant views with many small figures (fig. 361). His work is pervaded by the
influence of Pieter Bruegel the Elder, and his arrival in Amsterdam may have precipitated
the renewed interest in Bruegel and his circle that was later given further stimulus by Claes
Jansz Visscher's publications (see fig. 279).

The list of immigrants connected with painting goes on and on. In 1591 Jacob Savery
from Kortrijk and David Vinckboons' father from Mechelen obtained their Amsterdam
citizenship, and a year later Cornelis van der Voort's father from Antwerp got his.
Newcomers often delayed purchasing citizenship until forced to, usually by needing official
status to pursue their careers. Membership in a guild, for instance, was denied to non-
citizens, so some of these people may already have been in the city for several years. Gillis
van Coninxloo arrived in 1595. Roelant Savery (brother of Jacob) worked in Amsterdam
from about 1595 to 1604; at some time during those years Willem van Nieulandt arrived
with his parents from Antwerp and became Savery's pupil. Adriaen van Nieulandt, also
from Antwerp and probably related to Willem but not his brother, began studying with
Pieter Isaacsz in 1607.

Up to about 1590, painting in Amsterdam had been limited principally to portraiture.
The arrival of Flemish landscape painters, especially Gillis van Coninxloo, altered the
situation drastically. Coninxloo, born in 1544, fled in 1585 from Antwerp to Frankenthal, in
Germany, a haven for many other Flemish refugees; from there, as a fully mature painter,
he brought new ideas to Amsterdam.[14] His *Forest View with Hunters* of 1605 (fig. 362) is a
beautiful example of his work; he has captured the eerie quality of the ponderous trees with
the light sifting through them, brightening the foliage and path, and reflected in the
waterfall at the right and the stream at the left. These elements, observed in nature, have

been harmoniously composed into a fantasy landscape. Had the strong element of fantasy, or imaginative invention, not been present, Karel van Mander would probably never have written his laudatory appraisal of Coninxloo: "So I know at this time no better Landscape-maker; in Holland his treatment is beginning greatly to be followed: and the trees that here stood rather bare are beginning to grow like his."[15]

Van Mander's prediction to the contrary, only a handful of painters remained faithful to the fantasy landscape. Among them was perhaps the mysterious Govert Jansz, who was active in Haarlem and Amsterdam and whose work is listed in many inventories without a single painting of his being now traceable. Among them, too, were Hercules Segers, Coninxloo's pupil, who left his master's path, and the less interesting Alexander Keirincx.

362 Gillis van Coninxloo
Forest View with Hunters
Signed and dated 1605. Panel, 58.5 × 83.5 cm.
Historisches Museum der Pfalz, Speyer

363 Claes Jansz Visscher
The Inn "De Bergevaerders Camer" on the River Amstel
Dated 1608. Pen and bister, 13.2 × 18.9 cm.
Municipal Archives, Amsterdam

The Flemish influence in Amsterdam was strengthened and modified by the work of David Vinckboons. Like Hans Bol, he too was a native of Mechelen, born there in 1576. His father was a "cloth" painter: after the decline of tapestry weaving in Mechelen about the middle of the century, a local industry grew up for the production of imitation tapestries, painted on cloth with watercolor or tempera. In 1586 the Vinckboons family fled to Antwerp and then, via Middelburg, to Amsterdam, where they were settled by 1591. David's earliest known works, chiefly peasant feasts (see fig. 144) or landscapes with hunting parties, date from the first years of the seventeenth century and show clear traces of Flemish influence—the effects of his father's having taught him to paint, and also perhaps indicating contact with Hans Bol. The peasant scenes stem directly from the two Pieter Bruegels, the Elder and the Younger. Vinckboons' paintings sold very well and were engraved by Claes Jansz Visscher, among others (see fig. 136).

Although born in Antwerp, in 1567, Paul Vredeman de Vries can hardly be classified as a Flemish artist, for his father, Hans Vredeman de Vries, was constantly on the move as an architect. Father and son are known to have been in Amsterdam about 1600, and Paul presumably worked there for several years: his marriage is recorded in the municipal archives for 1601, and in 1604 he acquired Amsterdam citizenship. Like his father, he painted fantasized pictures of churches, palaces, and interiors (see fig. 320). He had no noticeable influence on Amsterdam artists, and soon departed for Prague, where he worked at the court of Rudolf II.

Among all these newcomers, one native Amsterdammer stands out: Claes Jansz Visscher. Son of a ship's carpenter, he was born in 1587, and built up a career as engraver and publisher. He was a draftsman as well, and his drawings and prints made a substantial contribution to the rapidly evolving landscape art. His first independent drawings date from about 1605; soon his work began to reveal his interest in the landscape around Amsterdam, which he drew directly from nature (fig. 363). Visscher's landscape studies predate similar drawings by Jan van de Velde and Willem Buytewech of Haarlem; although later than the

studies Goltzius made in the 1590s, they are ahead of Goltzius in opening up a new trend in landscape art. Had they served as preliminary studies for composed landscape paintings, one would have to be cautious in making such a statement, but they led to a new form: series of topographical landscape etchings.

As a maker and publisher of prints, Visscher turned both to earlier examples, such as engravings after Pieter Bruegel (or what he thought were Bruegels—see p. 138), and to new works by his contemporaries—Gillis van Coninxloo, Abraham Bloemaert, David Vinckboons, and Cornelis van Wieringen. Buytewech and Esaias and Jan van de Velde made their own plates, and Visscher published them. In this way he forged a link between the Amsterdam and Haarlem artists.

Other Centers

When we look at the cities of Holland and Zeeland other than Haarlem, Utrecht, and Amsterdam, we are struck by the scarcity of their painters. One of the few truly active artists outside of these main centers was Jacob de Gheyn II. He was born in 1565 in Antwerp, where his father, a painter and designer of stained-glass windows, was temporarily employed. The younger Jacob studied under Goltzius in Haarlem, then worked in Amsterdam from 1591 to 1595, and in Leiden until 1598. Thereafter he settled in The Hague, presumably in connection with his many projects for Prince Maurits. He fitted easily into the court circles, for he was wealthy and came of good family; moreover, he was enterprising: he drew, engraved, designed stained-glass windows, and about 1600 began to paint. He took his subject matter initially from traditional sixteenth-century sources, but soon struck out on his own, becoming one of the first to produce *vanitas* still lifes (see fig. 218) and floral paintings (fig. 364). His bouquets are symmetrical, with the tulip always the dominant flower. In 1603 he made a life-size painting of the famous white stallion captured from Archduke Albert at the Battle of Nieuwpoort three years before and presented as a war trophy to Prince Maurits (see fig. 27)

The portrait painter Daniel van Queecborne was also attracted to The Hague by commissions from the stadholder. He had fled from Antwerp in 1585 and sought refuge in Middelburg, where he became deacon of the St. Luke's Guild in 1590. His portraits are rather dry but not without merit (fig. 365). Michiel van Miereveld, another portraitist active in Delft and The Hague, will be discussed in the chapter on painting from 1609 to 1625, as will the flower painter Ambrosius Bosschaert, who was a guild official in Middelburg in 1593 but has no known paintings dated earlier than 1606. We know too little about the activities of these artists at the turn of the century.

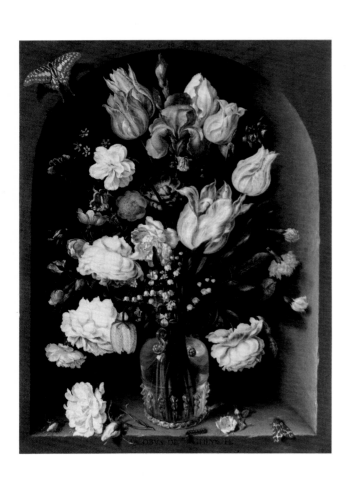

364 Jacob de Gheyn II
Flowers in a Glass Vase
Signed and dated 1612. Copper, 58 × 44 cm.
Gemeentemuseum, The Hague

The Twelve Years' Truce

The Twelve Years' Truce proclaimed in April 1609 ushered in a remarkable period in Dutch history. Because religion was not mentioned in the official documents, the Calvinists could continue to consolidate their power and ban all other denominations and sects from public worship. Nor was mention made of Spain's demand that the Dutch cease trading in the Far East and privateering in Atlantic waters, and so the Dutch stepped up their mercantile activities in the East Indies and delighted in hunting down Spanish ships bearing treasure from the New World.

Yet the truce did not bring the expected peace and tranquillity to the United Provinces, and in fact gave rise to one of the most tragic episodes of the Eighty Years' War. As early as 1607 the Parisian Huguenot pastor Pierre du Moulin had written to Professor Sibrandus Lubbertus in the Frisian university town of Franeker: "We know that hatred of the Spaniards has up to now been the bond of your union: up to now fear has restrained the internal hatreds and unrecognized signs of disunity."[1] Du Moulin was referring to long-standing quarrels within the Calvinist Church that now flared up with special intensity between liberals and orthodox. In 1603, despite fierce opposition from the fundamentalists, the liberal preacher Jacobus Arminius was appointed professor of theology at Leiden University, the preeminent training ground for Calvinist ministers, where his senior on the faculty was Franciscus Gomarus, champion of the ultra-orthodox. Many unavailing efforts

to reconcile the difficulty were made by the university regents and the States of Holland through their advocate, Johan van Oldenbarnevelt, and the dispute broke wide open in 1608.

The main point at issue was the doctrine of predestination: in Calvinist dogma, God's power is sovereign; since Adam's fall the sinful man can be saved only by the grace and mercy of God, not by free will or in reward for good deeds. Arminius, a believer in free will, confronted Gomarus in 1609 in a ten-day debate that settled nothing but shattered his frail health; he died shortly afterward. His followers, known as the Arminians, thereupon drew up a "Remonstration," signed by forty-four clergymen, and presented it to the States of Holland, gaining for themselves the new name of Remonstrants. This petition was composed by Johannes Uyttenbogaert, whose portrait Jacob Backer painted in 1638 (see fig. 604), after Rembrandt had already twice portrayed him; it repudiated predestination and argued for the supremacy of God's love, which reaches out to all mankind; it also asked for governmental protection against persecution. Gomarus' adherents attacked this "heterodoxy" in 1611 with a "Contra-Remonstration" propounding the seven articles of their "true" faith, and advising the state to keep out of church affairs.

The two men who had set off this doctrinal controversy were as different in character as in their opinions. Gomarus was intolerant, surly, and difficult to get along with, even for his supporters; Arminius seems to have been level-headed, friendly, tolerant, ever searching for and testing new ideas, trying to see every side and therefore sometimes wavering. These characteristics were precisely what most irritated Gomarus, who had unbounded confidence in himself and in the rightness of his cause; he considered Arminius' quest for enlightenment to be indecision.

The conflict would probably have remained a pulpit and pamphlet war had not the relationship between church and state become a burning question, ultimately involving the whole country. The influential merchants who governed the cities wished to keep clear of the problem because it interfered with commerce, and also because they did not want the clergy to gain too much political power. Drawn in despite themselves, many of these regents, especially in Holland, sided with the Remonstrants. One powerful exception was Reinier Pauw, burgomaster of Amsterdam and a fierce Contra-Remonstrant. Flemish immigrants in the Netherlands, oddly enough, also made up a strong Contra-Remonstrant group. Calvinism had initially taken much firmer hold in Flanders than in the north, and it was naturally the most convinced Flemish Protestants who had fled to escape Catholic oppression, but these believers in freedom of religion now became rigid and intolerant. Burgomaster Pauw and his supporters pressed for a national synod to resolve the doctrinal differences, knowing that they had a voting majority and could dominate the proceedings. The Remonstrants, knowing this, too, refused to consider a synod.

Politics played an increasing role in the choosing of sides. Provincial and municipal leaders in the areas outside of Holland decided to challenge the might of this wealthiest and most ambitious province and its predominantly Remonstrant government under the leadership of Oldenbarnevelt. They did this to achieve a balance of power, not out of religious conviction, but they failed to reckon with Amsterdam and soon found themselves in the same camp: Reinier Pauw, a declared enemy of Oldenbarnevelt, had enlisted the city on the side of the Contra-Remonstrants. The liberal mercantile regents in other cities of Holland could do little to counteract this move, and the smaller municipalities—Edam and Purmerend, later Enkhuizen and Dordrecht—went along with Amsterdam. Thus the conflict became nationwide, with the Contra-Remonstrants in the most powerful position.

Street fighting and riots broke out in many places. Government authorities at all levels attempted without success to quell the disquiet by issuing severe ordinances. Finally, in 1616, Oldenbarnevelt asked Prince Maurits to use national troops to restore order in the cities of Holland, and when Maurits refused, Oldenbarnevelt decided to give the cities the right to maintain public peace by hiring soldiers from the stadholder's army to serve as local militia. This was an affront to Maurits, a direct assault on his military power, and certainly responsible in part for his joining the Contra-Remonstrants in opposition to Oldenbarnevelt, his former teacher and friend. Relations between them had been strained since the Battle of Nieuwpoort, and especially since Oldenbarnevelt's success in promoting the Twelve Years' Truce against Maurits' wishes. For strictly political reasons the stadholder now became the leader of the orthodox Calvinists (he is said to have remarked that he

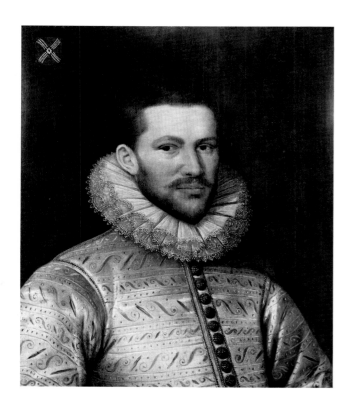

365 Daniel van Queecborne
Portrait of Andreas van der Meulen
c. 1585. Panel, 61 × 51 cm. Centraal Museum, Utrecht

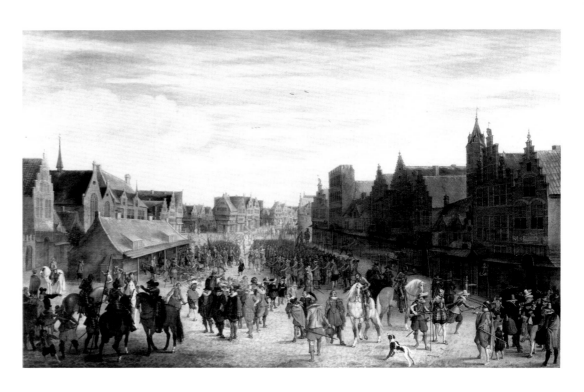

366 Pauwels van Hillegaert
Prince Maurits Dismisses the Utrecht Militia
Signed and dated 1622. Panel, 96 × 147 cm.
Municipal Museum Het Prinsenhof, Delft

didn't know whether predestination was blue or green). With the support of his orthodox cousin, Willem Lodewijk of Nassau, stadholder of Friesland, Maurits immediately played his strongest trump, calling for the assembly of a national synod to debate the religious issues. He also took military steps, pressing the States-General to allow him to disband the local militias, and carried out this mission by going first to Utrecht, in early August 1618—an event memorialized in a 1622 painting by Pauwels van Hillegaert (fig. 366). The States of Holland and the Remonstrants failed to thwart this action, and thereby brought on the final crisis. On August 29, 1618, Oldenbarnevelt and his colleagues were arrested and imprisoned in The Hague, and in November of that year the national synod was convened at Dordrecht.

There followed two trials, each with a predictable outcome. Ecclesiastically, the synod, at its fifty-seventh difficult session, expelled the Remonstrants as "liars and deceivers" and banned their ideas and writings. Politically, a prejudiced court in The Hague (one of whose members was Reinier Pauw) accused Oldenbarnevelt, the Republic's best statesman, of high treason (with no valid evidence) and condemned him to death. On May 13, 1619, Johan van Oldenbarnevelt was beheaded in the courtyard of the Binnenhof, on a high platform erected to give the hundreds of spectators a good view. He was seventy-two years old and had served his country for forty-three years.

The Remonstrants were now exposed to undisguised religious persecution. Many were arrested, many fled. Municipal governments were "purified" of Remonstrant elements, and the hard-line Calvinists seemed wholly triumphant. A man of no ambition was appointed advocate of Holland, and the proud title Advocate of the Land disallowed. With no strong statesman to defend its policies, the Republic's foreign relations deteriorated.

In April 1621 the Twelve Years' Truce ran out, and Spain and the United Netherlands resumed their war. Prince Maurits was eager to meet his old foe, General Spinola, still in command in the south, but could hold off a Spanish attack on Bergen op Zoom only with difficulty. Bad weather foiled the stadholder's long-cherished plan to retake Antwerp. An assassination plot against him in 1623, involving two of Oldenbarnevelt's sons, was discovered in the nick of time. And in 1625, the year of Maurits' death, the town of Breda, site of his first victory and thought to be impregnable, fell to the Spaniards.

Painting and the Graphic Arts during the Truce

The period of Dutch art that coincides roughly with the Twelve Years' Truce was extremely exciting. The break with sixteenth-century traditions, begun hesitantly in the first decade of the new century, became stronger as fresh ideas and approaches replaced the old. One is tempted to ascribe this development to the "peaceful" years following the cessation of the war, but, as just pointed out, those years were far from peaceful. The artists,

however, kept on working amid the swirl of political, economic, and religious crises; there was no renaissance in 1609 nor any decline when the truce expired in 1621. The resumption of war did not threaten the Republic's flourishing art centers; for the military action was in the south and along the borders; the army, mostly foreign mercenaries, did not call up local men; and there was little fear of a renewal of the sieges that had so devastated the Northern Netherlands in the early days of the war.

The world of art was somewhat affected by outside events, of course. The fierce religious quarrels precipitated a large number of political prints. Claes Jansz Visscher, a staunch Contra-Remonstrant, took an active part in the dispute by publishing prints in support of that side. But there are virtually no indications that the religious strife exerted any influence on the development of art in general.

The rising economy, however, had a positive impact on art. The steadily growing number of painters bears witness to the increased demand for paintings, a demand not interrupted by the resumption of hostilities. On the contrary, the profits that could be made precisely because of the war were larger than ever. The two important centers of progress in art during this period were Haarlem and Amsterdam, long-time rivals, lying only ten miles apart, yet differing greatly in character. Economically, Amsterdam's development was much stronger and more diversified than Haarlem's, and its attractions held greater appeal to refugee artists. But Haarlem had a longer and firmer tradition as an art center, and some of the most interesting new trends started there.

Haarlem: Cradle of the New Art

Of the older generation of Haarlem artists, only Hendrick Goltzius and Cornelis Cornelisz were still active in the first decades of the new century. Goltzius died in 1617; his work in engraving was continued by Jacob Matham and Pieter Soutman, who also painted portraits Cornelis Cornelisz was in his prime, but made no further contributions to the artistic revival. Frans de Grebber ranked with him in portraiture and history painting.

The first among the innovative artists, not unexpectedly, was Hendrick Vroom. He had already introduced a new, realistic approach to the painting of ships and naval encounters, and he continued to improve upon it. Ship portraits demand great accuracy, and Vroom took fastidious care in rendering the details of a ship, its crew, and the setting (see fig. 354). This exactitude came from his thorough knowledge of the subject and his ability to look at it closely—traits possessed by many painters of this period and by the scientists as well. The seventeenth century has rightly been called the age of observation.

Vroom was also an important forerunner of the landscape painters. Although his skies show little subtlety and his seas tend to be too green and stereotyped, he succeeded in capturing weather conditions, from peaceful rippling waves to gale-whipped seas, sometimes with well-observed nuances of color. He painted a number of beach scenes, too, but more important are his views of harbor towns, such as that of Hoorn (cpl. 367), in the backgrounds of some of his marine paintings. These skylines are closely related to the drawings and engravings of "town profiles" that became popular about 1600. Vroom's palette here is often amazingly sensitive, and the details are exact and well executed. His success with these views probably led to commissions for townscapes without water and boats, such as his two 1615 views of Delft (see fig. 330).

In his few known sea pictures, Vroom's pupil Cornelis van Wieringen displays similar characteristics, and contemporaries rated him nearly as high as his master—compare his

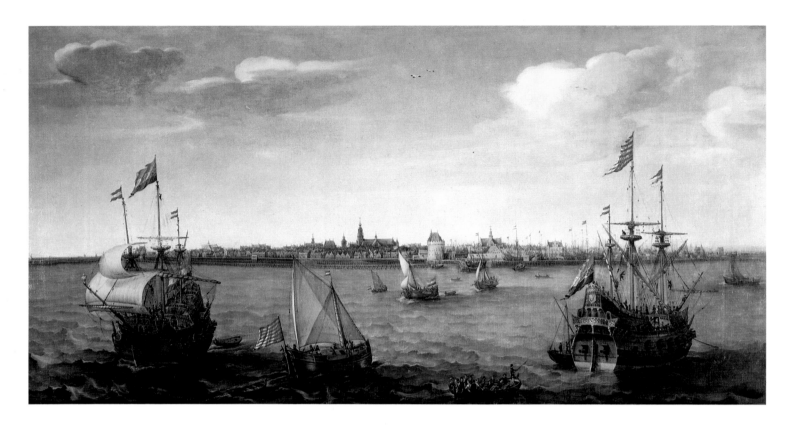

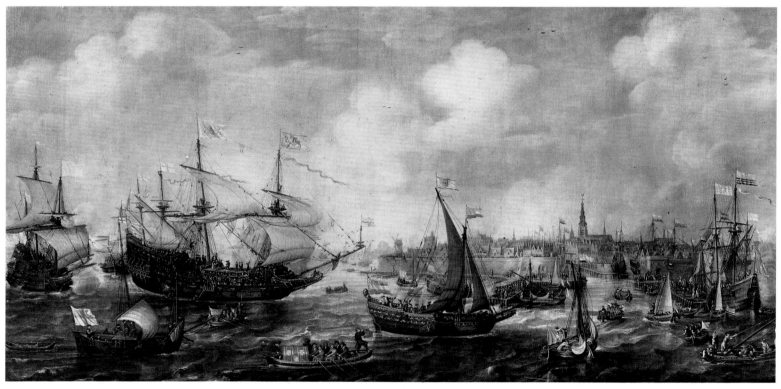

367 Hendrick Vroom
 View of Hoorn
 Signed and dated 1622. Canvas, 105 × 202.5 cm.
 Westfries Museum, Hoorn

368 Cornelis van Wieringen
 *The Arrival of Frederick V, Elector Palatine, at
 Vlissingen, May 1613*
 Signed. Canvas, 110 × 215 cm. Frans Hals
 Museum, Haarlem

painting of the arrival of Elector Frederick V in Vlissingen (fig. 368) with Vroom's (see fig. 311). Many of van Wieringen's drawings have luckily survived; they include seascapes, landscapes, and views of coastlines and towns, all closely resembling the work of Hendrick Goltzius. Claes Jansz Visscher, Jan van de Velde II, and other engravers made prints of some of them.

Haarlem was also the center for innovations in still-life painting during the first decades of the seventeenth century. Three Haarlem artists, Nicolaes Gillis, Floris van Dijck, and Floris van Schooten, began almost simultaneously to devote themselves to this genre. Exact dates are known only for van Dijck: he was born in Haarlem in 1575, and, after a visit to Italy, entered the Haarlem St. Luke's Guild in 1610, becoming head of it in 1637. The still life dated 1613 (fig. 369) is typical of his work: a pewter dish holding two half rounds of cheese is placed in the middle of a table on a lace-edged damask napkin atop a red cloth; round about lie fruit and nuts, a green "berkemeier" drinking glass, bread, and a bowl of apples, while another pewter dish containing a roll juts out over the edge. This "spread-out" still life shows remarkable similarity to a painting by Nicolaes Gillis dated two years earlier (cpl.

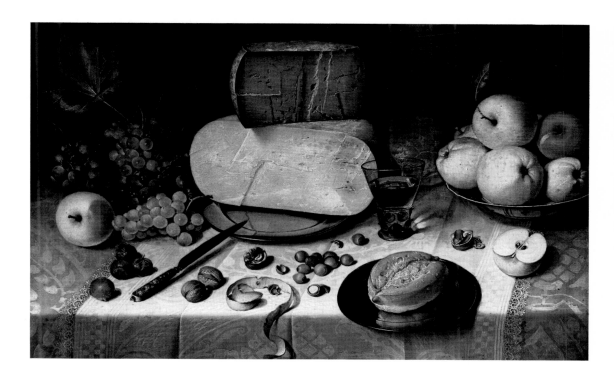

369 Floris van Dijck
 Still Life
 Signed and dated 1613. Panel, 49.5 × 77.5 cm.
 Frans Hals Museum, Haarlem

370 Nicolaes Gillis
 Still Life
 Signed and dated 1611. Panel, 59 × 79 cm. Private
 collection

370): a plate of cheese also in the center; a green glass—this time a *roemer* or rummer—with light playing through it to illuminate the white napkin; half an apple, partly shelled nuts, and a roll on a dish projecting over the front edge of the table. The viewpoint in both paintings is rather high, so that one looks down on the array. The objects do not overlap, each one existing in its own right. Gillis' work seems a bit harder than van Dijck's, the highlights brighter. Both painters repeated this motif several times. There is an uncommon restraint in these Haarlem still lifes, perhaps implying a moral: beware of worldly things.

 Nicolaes Gillis presumably came from Antwerp, but we know neither the date of his birth nor the year of his arrival in Haarlem. His name appears in the Haarlem records between 1622 and 1632; in view of the similarities between the two still lifes just mentioned, however, he must already have been working there about 1610, and may have brought the motif of the laid table with him from Antwerp, its assumed source. Several Antwerp still-life painters, such as Osias Beert, Clara Peeters, and Hans van Essen, were specializing in this theme at that time. Van Essen is recorded in Amsterdam in 1611, and Clara Peeters is frequently referred to as working there the next year, but I have been unable to find any documentary verification of this.

 Nothing is known of Floris van Schooten's origins; he was active in Haarlem by 1605, although no dated works survive from this period. He went beyond Gillis and van Dijck in

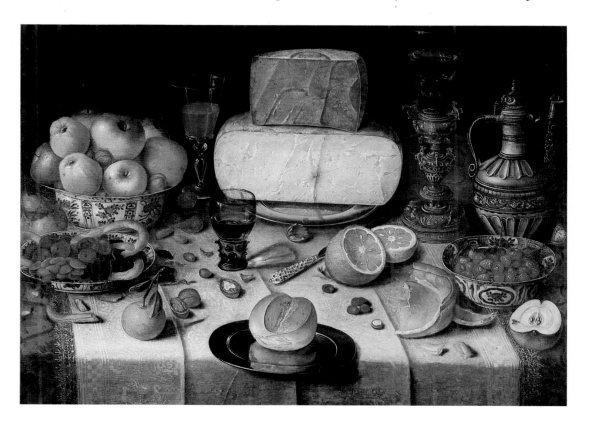

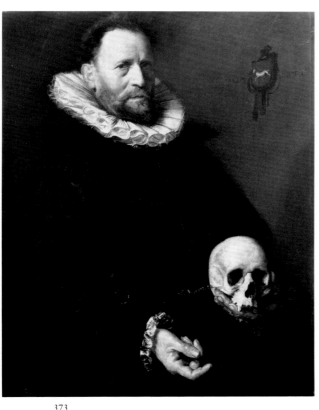

371

371 Floris van Schooten
Allegory on the Brevity of Life
Signed. Panel, 35.5 × 48 cm. Private collection,
Schiedam

372 Floris van Schooten
Little Breakfast
Signed. Panel, 52 × 89 cm. Frans Hals Museum,
Haarlem

373 Frans Hals
Portrait of a Man Holding a Skull
c. 1611. Panel, 94 × 72.5 cm. The Barber Institute
of Fine Arts, University of Birmingham, England

372

his choice of subject matter, painting kitchen pieces and market scenes—themes also used by
Pieter van Ryck and Cornelis Cornelisz (see fig. 228)—and an allegory on the brevity of life
(fig. 371), as well as still lifes (fig. 372). The allegorical picture, recently rediscovered,[1]
reveals Cornelisz's clear influence. Van Schooten's still lifes were initially much like those of
Gillis and van Dijck, but his style distinctly changed, and he joined his younger colleagues
Pieter Claesz and Willem Claesz Heda in painting monochromatic "banquets."

During this period, portrait painting in Haarlem was dominated by Frans Hals. His father, a
cloth-shearer and cloth-dresser, was a native of Mechelen (Malines) but lived for some years
in Antwerp before moving his family to Haarlem, probably in the late 1580s. The reasons
for the move were no doubt both economic and religious: the textile industry was shifting
to the north; and the elder Hals, though carried on the Catholic rolls in Antwerp,
presumably had Protestant leanings, for when his son Dirck was born in Haarlem in 1591,
he had the baby baptized in the Reformed Church, the registry of this event providing the
first definite evidence that the family had settled in Haarlem.

Frans Hals presumably became a pupil of Karel van Mander about 1600, but no stylistic
traces of his master can be found in his work. He entered the St. Luke's Guild in 1610, and
his earliest known dated painting stems from 1611. Despite his training under van Mander,
an advocate of history painting, Hals developed exclusively into a portraitist. A strong
quality of portraiture pervades even his single-figure compositions, which are most likely
allegorical or symbolic representations. These early figure paintings also show to full
advantage his inimitable brushstroke, flowing and sure; his early portraits, which were no
doubt commissions, lack this free handling of paint. Later, about 1640, he was able to
employ his virtuoso technique with complete mastery in his portraiture. In composition,
Hals at first followed tradition: in a painting probably from about 1611, the man holding
the skull is placed high and slightly to the left in the pictorial space (fig. 373). The
brushwork is smooth but not particularly free.

In 1616 Hals painted the officers of the St. George militia company at a banquet (fig.
374), the first of his imposing series of group portraits, all now in the Frans Hals Museum in
Haarlem. As in Amsterdam, the civic guard in Haarlem had originally comprised two
guilds: the crossbowmen, with St. George as their patron, and the archers, whose patron
was St. Sebastian. A reorganization took place in 1519, when firearms replaced bows as
military weapons. In 1560 the St. Sebastian guild was discontinued and a new guild
founded, the arquebusiers, armed with muskets and choosing St. Adrian as patron. At the
end of the siege of Haarlem in 1573, Spanish troops took reprisal by executing almost the
entire civic guard. When the companies were reestablished, under municipal aegis, they lost
most of their old guild character, and with the waning hostilities they were seldom called
upon to perform military duties. In the seventeenth century, as we have mentioned, the
former guilds resembled social clubs for well-to-do young men.

The annual civic-guard banquet stemmed directly from the days of the old guilds. That
these occasions tended to get out of hand is evident from a Haarlem ordinance of 1633, in
which complaint is made that "in all the meetings of the Companies, lasting a whole week,

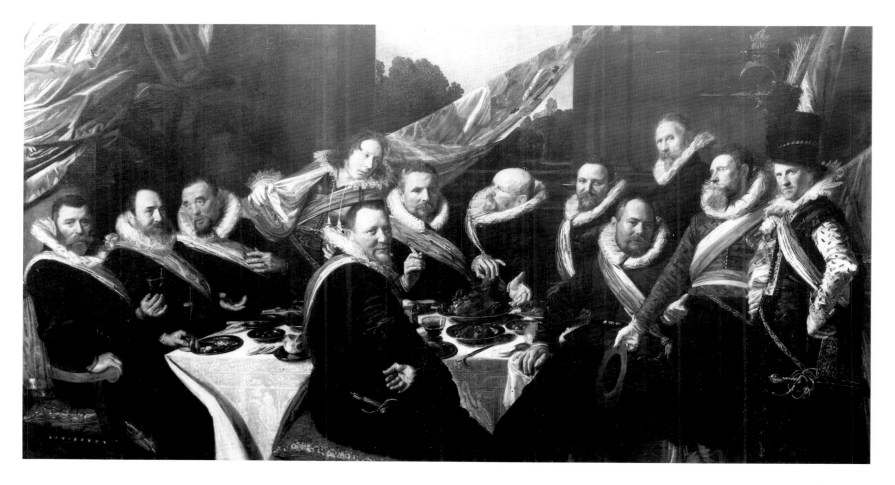

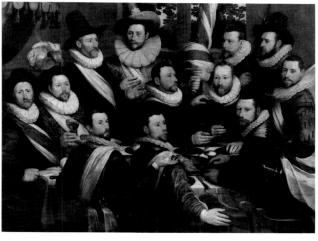

374 Frans Hals
Banquet of the Officers of the St. George Civic-Guard Company, Haarlem
Dated 1616. Canvas, 175 × 324 cm. Frans Hals Museum, Haarlem

375 Cornelis Cornelisz van Haarlem
Banquet of the Officers of the Haarlem Civic Guard
Signed and dated 1599. Panel, 156.5 × 222 cm. Frans Hals Museum, Haarlem

a very great deal of money is used up, to the great cost of the municipality"; it is also noted that the guardsmen brought along their wives and children to enjoy the feast, leading "to a highly excessive devouring of Food and Drink."[2]

When we look at a seventeenth-century civic-guard painting, we must realize that this group of men belonged to the elite class of society and had virtually nothing to do with the pursuit of the war. We must be aware that the painted situation rests on fantasy: the banquet used as its theme was hardly a true rendering of reality. The number of diners depicted was limited to the commissioned and noncommissioned officers who wished to be portrayed, and who could and would pay for the privilege. Efforts to include a whole company usually ended up in such hopelessly overcrowded pictures as those by Frans de Grebber (see fig. 189).

Slive has correctly pointed out that, in his civic-guard banquet of 1616, Frans Hals followed the composition initiated by Cornelis Cornelisz in 1599 (fig. 375).[3] By slightly modifying the arrangement of the officers, however, he achieved much greater naturalness: the poses and gestures of the figures flow together into one lively whole; earlier civic-guard painters, in both Amsterdam and Haarlem, had never carried their desire for animation much beyond a studied gesture. The guardsmen in Hals's painting are almost all clad in black, emphasizing the bold red and white of the banners and the officers' sashes and the orange of the colonel's sash; a good deal of red also appears in the flesh tones. Subdued colors are used for the dining equipment and the food on the exquisitely painted damask tablecloth, seeming to anticipate the tonal still lifes that Pieter Claesz and Willem Claesz Heda would later paint in Haarlem. The loose, vigorous style of painting is most pronounced in the clothing of the ensign-bearer at far right.

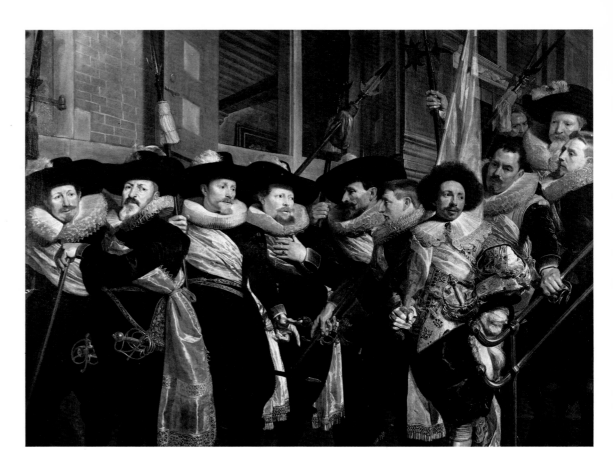

376 Hendrick Pot
Officers of the St. Adrian Civic-Guard Company, Haarlem
c. 1630. Canvas, 214 × 276 cm. Frans Hals Museum, Haarlem

Frans Hals was himself a member of the crossbowmen's guild from 1612 to 1615. With this first civic-guard painting he demonstrated his genius as a portraitist and in particular as a painter of the difficult group portrait, leaving far behind his rivals in this field: Cornelis Cornelisz, Frans de Grebber, Cornelis Verspronck, Pieter Soutman, and Hendrick Pot. Of all these painters of group portraits, only Pot, the youngest and another of Karel van Mander's pupils, attempted to imitate Hals's style in a few of his works (fig. 376).

About 1612 a number of artists who would prove highly important to the development of Dutch landscape art arrived almost simultaneously in Haarlem. Most of them did not stay long, but what they learned there decisively affected their later careers. These artists were Hercules Segers, Willem Buytewech, Esaias van de Velde, Jan van de Velde, Pieter de Molijn, and Jan van Goyen.

Hercules Segers, though a native of Haarlem, studied under Gillis van Coninxloo in Amsterdam and then presumably returned to Haarlem, joining the guild in 1612; two years later, however, he is again recorded in Amsterdam. Certain of his etchings were clearly made near Haarlem and show some relationship with the work of the Haarlem avant-garde, but Segers had little further connection with his birthplace, and his work will therefore be discussed in the section on Amsterdam.

Willem Buytewech is also first mentioned in the Haarlem St. Luke's registry in 1612, but he may have arrived a year or two before. He was born in Rotterdam in 1591 or 1592; where he studied is not known. His religious etchings show the influence of Annibale Carracci and Rubens.[4]

As far as we know, Buytewech's paintings made up only a relatively small part of his oeuvre. All of them depict elegant social gatherings, either indoors or out, and are painted crisply and smoothly in fairly bright colors. The garden-party theme was also used repeatedly by Buytewech's contemporaries David Vinckboons and Esaias van de Velde; there is little variety of composition in any of these *fête champêtre* paintings. Buytewech's indoor gatherings, however, have a more personal note. The scenes look somewhat theatrical (fig. 377), which has led to the justified inference that they were connected with the stage. Buytewech was acquainted with the poet-playwright Gerbrand Adriaensz Bredero; he designed the title page for Bredero's book of poems *Alle de Spelen* (All the Games; fig. 378) and made an etching of a scene from his drama *Lucelle*. The atmosphere of the paintings accords with Bredero's moralistic literary portrayal of the well-to-do at play.

Buytewech's drawings and etchings, with or without allegorical or symbolic meaning, are more important than his paintings. In motif and composition, his landscape drawings

377

378

377 Willem Buytewech
Merry Company
c. 1617–20. Canvas, 49.3 × 68 cm. Museum
Boymans-van Beuningen, Rotterdam

378 After Willem Buytewech
Title page of *Alle de Spelen* by Bredero.
Rotterdam, 1622

379 Willem Buytewech
Landscape with a Row of Trees
Pen and bister on gray paper, 17.4 × 28 cm.
Kupferstichkabinett und Sammlung der
Zeichnungen, Staatliche Museen, East Berlin

(fig. 379) made a definite contribution to Dutch landscape art. Sober and directly observed from nature, they are independent works of art, not, as is so often the case, simple notations to be later, perhaps, worked into a painted composition. That the artist so intended them is supported by the etchings that Buytewech sometimes made from the drawings, a practice also followed by Esaias and Jan van de Velde. There must have been a close relationship among these three artists, with exchanges of ideas and themes, but it is not clear which of them took the lead.

One wonders why the production of landscapes was concentrated in Haarlem, and why these young Amsterdam artists went there. Van Gelder suggests that they may have felt unable to compete with Vinckboons and Visscher in Amsterdam.[5] But Haarlem had long been the city of engravers, ranging from Coornhert and Goltzius to Saenredam, Matham, and Soutman, and this tradition surely also proved a lure. It definitely was responsible for the arrival of Jan van de Velde II. His father, Jan van de Velde I, calligrapher and French teacher in Rotterdam, had already employed the Haarlem engravers in 1605 for the title page of his *Spieghel der Schrijf-Konste* (Mirror of Penmanship), designed by Karel van Mander and engraved by Jacob Matham; Goltzius engraved the author's portrait. It is not surprising that Jan van de Velde sent his son to learn the art of engraving from Matham.

In 1614 Jan van de Velde II entered the Haarlem guild with the rank of master, thus beginning his fruitful career as draftsman and engraver. He made prints after the work of other artists and carried out his own ideas; in his original works he was influenced by Claes Jansz Visscher, but even more by his cousin Esaias van de Velde and his friend Willem Buytewech (see figs. 85–88). Very few paintings by him are known.

379

380

380 Esaias van de Velde
 The Garden Party
 Signed and dated 1615. Panel, 35 × 61 cm.
 Rijksmuseum, Amsterdam

381 Esaias van de Velde
 The Cattle Ferry
 Signed and dated 1622. Panel, 75.5 × 113 cm.
 Rijksmuseum, Amsterdam

382 Esaias van de Velde
 Winter Landscape
 Signed and dated 1629. Panel, 38.5 × 59.5 cm.
 Staatliche Kunstsammlungen, Kassel

While Jan van de Velde concentrated on prints, Esaias van de Velde devoted himself more and more to painting. He presumably studied under Vinckboons or Coninxloo in Amsterdam and went to Haarlem about 1610, joining the guild two years later. His *Garden Party* of 1615 (fig. 380) still clearly shows Vinckboons' influence. Esaias left Haarlem in 1618 to settle in The Hague, where he made an essential contribution to the development of Dutch landscape art. Perhaps the finest example of his talent is *The Cattle Ferry* of 1622 (fig. 381): a flat-bottomed ferry is being poled across a river that flows through a village; among its passengers are a horse-drawn cart and two cows. The picture is a striking image of an

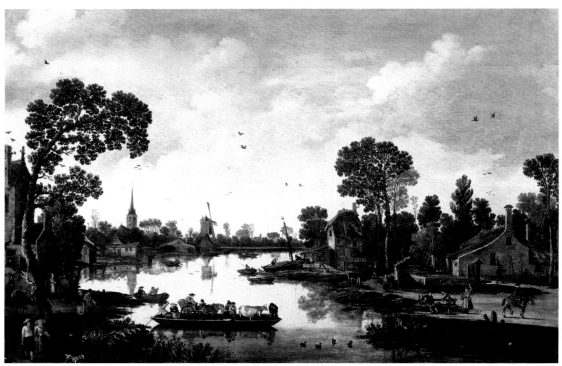

381

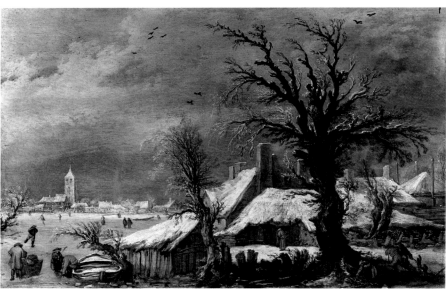

382

everyday village scene, purely rendered; full attention is paid to the narrative element and to nature. The shapes of the trees and the way they are painted betray Elsheimer's influence. There is little effect of depth, however, since the tonal values and colors in the foreground and background are nearly equal. Landscape paintings like this, based compositionally on motifs borrowed from nature, were commonly done in the studio; they nevertheless belong among the pioneering efforts. The artist's vision was focused upon portraying his native landscape as naturally as possible, and Esaias' *Winter Landscape* of 1629 (fig. 382) again shows how ably he caught the essence of the Dutch countryside. Some of his other works lean toward a more traditional Flemish model; still others are imaginary mountain landscapes (see fig. 288).

Flemish influences were not the only ones to reach Amsterdam (directly, via Claes Jansz Visscher and Esaias van de Velde) and Haarlem (indirectly, via the graphic arts). The work of the younger Haarlem artists also bears unmistakable traces of the German painter Adam Elsheimer, who painted mostly small, lyrical landscapes lit by rarefied sunlight or moonlight, with heavy groups of trees reflected in water. There could have been no personal contact between him and the Haarlem artists, for he died in Rome in 1610; his influence reached them in another way. The Utrecht nobleman and amateur engraver Hendrick Goudt met Elsheimer in Rome about 1605, and he was so impressed that he purchased a number of Elsheimer's paintings. Back in Holland, Goudt in 1610–14 made engravings of seven of these works, one of them a *Flight to Egypt* (fig. 383; see also fig. 280). The Haarlem artists most likely had access to these prints; it is known that Jan van de Velde and Goudt were acquaintances.

All things considered, Esaias van de Velde was the most progressive of the Haarlem group. Like his landscape paintings, his topographical drawings and etchings are strongly realistic and reveal his great interest in his own surroundings. Did Constantijn Huygens and other contemporaries recognize this new direction in art? There is no clear answer. Huygens praised Esaias highly, but included him in the same sentence with Jan Wildens, a Flemish painter of fantastic landscapes, and placed him on about the same level as Paulus Bril, a much older artist who never ventured near true-to-nature landscapes. In any event, just as the new realism was taking hold in Haarlem, a different formula for the Dutch landscape began to unfold in Amsterdam.

Amsterdam: The Young Metropolis

What do I see, coming now from tired, flat Haarlem,
So close to Amsterdam, which like a new city
Lifts its head in the sky? What gates, walls, houses,
What canals broad and deep, what bridges and sluices
Appear ever clearer before my eye?

These lines, written by the poet Reinier Telle in 1615, reflect the surprising rapidity with which Amsterdam revived and grew at the beginning of the seventeenth century. In 1580 William of Orange had predicted to the city fathers that "Amsterdam will come to prosper and advance above all other cities," and he was right. Expansions in 1585 and 1593 had proved insufficient to house the ever-increasing population, the streams of people flowing in from rural areas and from other towns and countries. In 1609 a new expansion project was initiated. Hendrick Jacobsz Staets, the *stadstimmerman* (an old title, roughly equivalent to municipal architect), conceived the brilliant plan of encircling the old inner city with three concentric belts of canals linked by radial streets and smaller canals. Many buildings had to be condemned and razed before dredging and new construction could begin in 1612. The driving force behind the project was Frans Hendricksz Oetgens, a former burgomaster but since 1607 *fabrieksmeester*, a post corresponding to director of public works. Oetgens was a seventeenth-century entrepreneur. With his inside knowledge of the future plans, he bought up large parcels of land within the project's limits, planning to resell them to the city. The scandal that ensued when this became known cost him his job but not his reputation; he had made other very real contributions to the work in progress.

Amsterdam was to be renovated and beautified as well as expanded. The architect-sculptor Hendrick de Keyser lent his talents unstintingly to this end. Born and trained in

383 Hendrick Goudt after Adam Elsheimer
The Flight to Egypt
Signed and dated 1613. Engraving

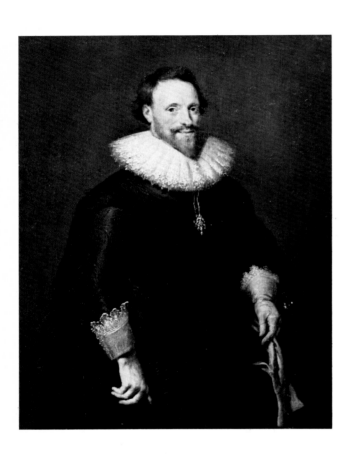

384 Michiel van Miereveld
Portrait of Pieter Cornelisz Hooft
Signed and dated 1629. Panel, 112.5 × 85 cm.
Portrait Gallery of the University of Amsterdam

Utrecht, he came to Amsterdam in 1591, perhaps along with his teacher, Cornelis Bloemaert, father of the painter Abraham Bloemaert. In 1595 de Keyser was appointed master carver and stonemason, and in 1612 municipal architect. The appearance of Amsterdam's seventeenth-century core owes much to his work; his Zuiderkerk, Westerkerk (see fig. 1076), and the ornamental spires he designed for the Mint Tower and the Montelbaans Tower still dominate the inner-city scene.

The largest and most prestigious commission de Keyser received as a sculptor was for the tomb of William the Silent in the Nieuwe Kerk in Delft (see fig. 735). He began working on it in 1614, but had not finished at the time of his death seventeen years later. This monument harks back to the sixteenth century in design and choice of materials: bronze and various marbles. The recumbent figure of the great stadholder, carved in white marble, is a serene masterpiece. The prince seems to be sleeping, with his little dog at his feet.

Hendrick de Keyser was a highly respected citizen of the Republic. Among his many friends were the artists Hendrick Goltzius and Cornelis Ketel.

A striving for new modes of expression, for trying things yet undone, marked Amsterdam's cultural life during the years of the Truce, and it found perhaps its greatest outlet in literature. Some of the Republic's best prose writers and poets lived and worked in the city—Roemer Visscher, Pieter Cornelisz Hooft, Gerbrand Adriaensz Bredero, and Joost van den Vondel.[6]

Roemer Visscher was an amateur of literature and a cultural leader. He had become wealthy in the thriving business of insuring ships and cargoes. When several of the vessels he had insured sank near the North Holland island of Tessel (Texel) on March 25, 1594, he whimsically commemorated the event by naming his newborn daughter Maria Tesselschade (Tessel loss). He hired the best teachers to educate Maria and her elder sister Anna in languages, literature, painting, engraving, embroidering, and music. Meanwhile he was indulging his own interest in writing and began to publish his literary efforts in 1611; his *Sinnepoppen* of 1614 (see p. 73) is his best-known work. He was also an enthusiastic member of the *Eglentier* (Eglantine) chamber of rhetoric. But most of all he was a convivial host; the poet Vondel wrote of "Roemer's house,"

Whose floor is trod upon, whose threshold worn away
By painters and artists, by singers and poets.

After Visscher's death in 1620, his daughters continued this hospitality until they married.

Pieter Cornelisz Hooft (fig. 384), son of a wealthy merchant and burgomaster of Amsterdam, was born in 1581. He enjoyed an excellent education, including the traditional three-year grand tour of France and Italy, and afterward studied law at Leiden University. In 1609 Prince Maurits appointed him bailiff of Gooiland, steward of Muiden, and lord of Weesp and Weesperkarspel, a joint office of considerable prestige and emolument. He restored the medieval castle at Muiden, a few miles east of Amsterdam on the Zuider Zee, and made it his residence and—in Roemer Visscher's tradition—a cultural center. He began to write poetry in his youth; his sonnets are models of the Dutch language used purely and beautifully. The *Eglentier* chamber of rhetoric produced his plays successfully—a pastoral, two historical dramas, and a comedy. But he earned his most secure fame as a historian. In 1628 he started his *Nederlandsche Historien,* a history of the revolt against Spain from Charles V's abdication in 1555 up to 1587. The work comprises twenty-seven books; the first

385 Title page of *Lijck-dichten* with the portrait of
Bredero. Amsterdam, 1619

386 Jan Lievens
Portrait of Joost van den Vondel
Etching

twenty were published in 1642, and the rest after Hooft's death in 1647. His prose style,
patterned on Tacitus, is exemplary, and he consulted many contemporary documents and
interviewed survivors of the early days of the war. Had he lived, he would have carried the
project further.

Gerbrand Adriaensz (fig. 385), called "Bredero" after the house in which he was born,
was four years younger than Hooft and came from a totally different milieu. His father was
a shoemaker, a fairly prosperous one to judge from his activities in the money market and as
a tax collector. Gerbrand first trained as a painter, studying under Frans Badens, but this
effort cannot have lasted long. He began to publish his poems and plays in 1610.

Hooft employed the Dutch language in a courtly way; Bredero used the vernacular. He
was a master of Amsterdam and Waterland dialects, of street talk and slang, and often
portrayed lusty scenes. All of this has caused him to be branded unjustly as lower-class, but
his work shows a wide knowledge of literature; he translated Louis Le Jars's 1563 play
Lucelle from the French, and his Dutch version was another of the *Eglentier*'s successes in
1613–15. In 1613 he became ensign of an Amsterdam militia company, which indicates that
his social position and financial capacity were above average. Bredero was keenly alert to
the life around him and could transmute it into dramatic form. His characters range from
the down-to-earth yet hardly downtrodden poor to the dashing rich, almost always
sketched against a moralistic background. Bredero's brilliant career as a comic playwright
was cut short by his untimely death in 1618, at the age of thirty-three.

Joost van den Vondel (fig. 386) was born in 1587 in Cologne, where his Mennonite
parents had fled from Antwerp a few years before; in 1597 the family settled in Amsterdam,
finding their place among the community of Brabant emigrants. Vondel joined the Brabant
chamber of rhetoric called *'t Wit Lavendel* (White Lavender), and in 1610 he composed his
first play. He went on to become the most productive Dutch poet-playwright of the
seventeenth century. Besides his plays and lyrical poems, he published a great deal of
satirical poetry, in which he expressed sharp reactions to political events, sometimes at his
own cost. His conversion to Catholicism in 1641 also brought him into disfavor with the
stricter Calvinists. His literary career reached full maturity after 1625, and its high point was
his drama *Lucifer* of 1654. Vondel continued to write almost to the end of his long life; he
died, aged ninety-two, in 1679.

The literary societies or chambers of rhetoric to which these writers belonged were an
important part of Dutch cultural life, not least for establishing contacts among cities and
towns through annual festivals and dramatic competitions known as *landjuwelen*, a term
compounded from *land* (district) and the Old French *joiel* (feast), netherlandized to *juweel*
(jewel), partly because of the often costly prizes awarded at these events. The chambers had
flourished during the sixteenth century, particularly in Flanders but increasingly in the
north, and they continued to fill a real cultural function at the beginning of the seventeenth
century. Keenly critical of both government and church, they made positive contributions

387 Frans de Grebber (?) after Hendrick Goltzius
Blazon of the Haarlem chamber of rhetoric
De Pelikanisten
1606. Panel, 123 × 98 cm. Sociëteit Trou moet
Blycken, Haarlem

to public opinion by reacting to current events. Artists were often members, and the
relationship is clear between the allegorical, symbolical, and moralistic ideas expressed in
paintings and prints and the morality plays and allegorical pageants put on by the societies.
A large wooden blazon or escutcheon (fig. 387) bearing the emblems of the Haarlem
chamber *De Pelikanisten* (the Pelicanists) survives from a *landjuweel* held in Haarlem in 1606;
it was presumably painted by Frans de Grebber after a design by Goltzius. Each chamber
had a blazon, and it was customary at a *landjuweel* to award a prize for the most beautiful
blazon, which was then presented to the host society. Good artists were therefore happy to
engage in the preparation of these large emblems.

After Amsterdam joined the revolt against Spain in 1578, the *Eglentier* thrived as never
before. At the beginning of the seventeenth century the leading members of this chamber
were Hooft, Bredero, and the physician-playwright Samuel Coster. All sorts of difficulties
in the society, however, led these three and other members to resign in 1617 and to found
the Nederduytsche Academie. This new institution was modeled after the academies in
Italian cities, and its name indicated that it aimed at being more than a dramatic club.
Courses were offered in mathematics, Hebrew, history, and Greek philosophy; the lectures
were given in Dutch rather than Latin, and great stress was placed on the need for pure
Dutch to be used in speech and literature. In the winter of 1622–23 Hooft, Vondel, and
others of those concerned held a series of meetings to discuss the rules of their native
language.

Amsterdam was a hive of cultural activities during this period, and here we mention only
a few that are significant to the art of painting. Literature was the most important because
there is ample evidence of links between writers and painters; this applies also to other cities,
such as Haarlem, where Frans Hals was a member of the *Wijngaertranken* chamber. Among
the Amsterdam artists, Ketel wrote poetry, Moeyaert was a member of the *Eglentier*, and
Werner van den Valckert now and then tried his hand at versifying.[7]

A considerable group of history painters were working in Amsterdam at this time. They
included Frans Badens, Pieter Lastman, Jan and Jacob Pynas, Jan Tengnagel, Werner van
den Valckert, and Claes Moeyaert, and all of them except possibly Moeyaert had visited
Italy. Since no signed work by Badens is known today, he cannot be considered here. Of
the others, Pieter Lastman is by far the most important. His father was an Amsterdam
goldsmith, and through him Lastman no doubt had access to the gold and silver vessels that
feature so prominently in his paintings. According to van Mander, Lastman was a pupil of
Gerrit Pietersz Sweelinck. He traveled to Italy in 1603 or 1604, but by 1607 he was back in
Amsterdam, where he remained for the rest of his life.

Lastman must have encountered Mannerist ideas during his training period, for Sweelinck
was strongly influenced by Cornelis Cornelisz van Haarlem, but he arrived in Rome at a
time of strong reaction against Mannerism, and no doubt he turned to the work of the new
young artists: Caravaggio, the Carracci, and Elsheimer. Caravaggio was born in Milan in
1573, went to Rome in 1588 or 1589, and worked there until 1606, making it possible for
Lastman to have met him personally. Caravaggio broke sharply with the academic and
Mannerist traditions and created an art so realistic that it shocked his contemporaries. He
placed his figures at the front of the pictorial surface, literally under the viewer's nose, and
portrayed them with uncompromising honesty (fig. 388). Annibale Carracci, born in
Bologna in 1560, also went to Rome and worked there from 1600 until his death in 1609.
His break with tradition was different from Caravaggio's, for he reached back to the art of

388

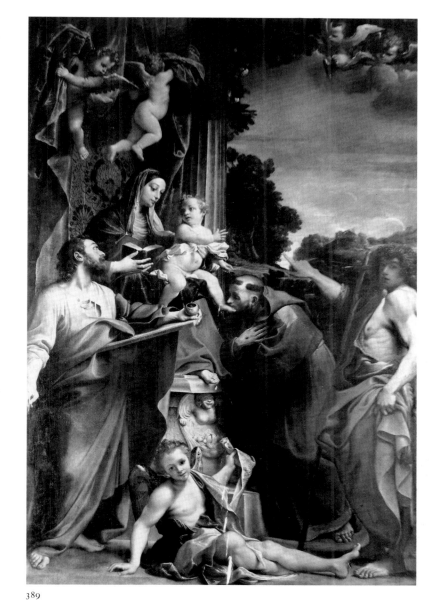

389

388 Caravaggio
The Madonna of the Rosary
Canvas, 364 × 249 cm. Kunsthistorisches
Museum, Vienna

389 Annibale Carracci
The Virgin with St. Matthew
Signed and dated 1588. Canvas, 348 × 255 cm.
Gemäldegalerie Alte Meister, Staatliche
Kunstsammlungen, Dresden

390 Adam Elsheimer
The Flight to Egypt
Signed (on the reverse) and dated 1609. Copper,
31 × 41 cm. Alte Pinakothek, Munich

Raphael and the harmonious aspects of the High Renaissance, bringing new freshness to his subjects (fig. 389). The third important painter at work in Rome during Lastman's stay was Adam Elsheimer, mentioned above as arriving there in 1600 from Frankfurt on the Main. Elsheimer attracted a circle of artists around him in Rome, including the Flemings Paulus Brill and the young Peter Paul Rubens. There is no direct evidence that Lastman was one of this group, but he can hardly have avoided knowing about it, if not joining it.

Caravaggio was a major influence on Elsheimer, particularly in the use of light, yet it is difficult to imagine two artists of greater contrast. Caravaggio used large canvases, and human figures dominate his compositions; Elsheimer painted exclusively on small copper panels, and his main theme is landscape, lyrically treated (fig. 390), though he did make a few figure paintings. The scope of his oeuvre is still uncertain because he signed so few

390

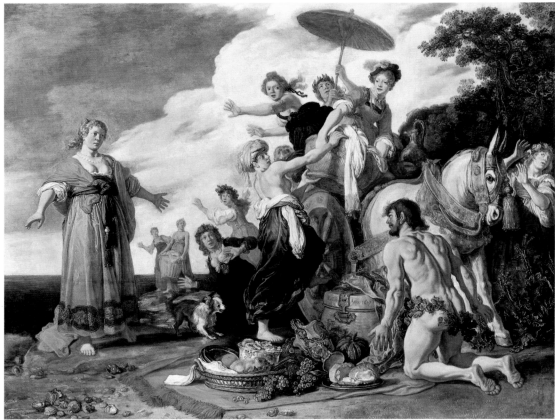

392

391

391 Pieter Lastman
The Flight to Egypt
Signed and dated 1608. Panel, 29 × 25.5 cm.
Museum Boymans-van Beuningen, Rotterdam

392 Pieter Lastman
Odysseus and Nausicaa
Signed and dated 1619. Panel, 90 × 115 cm. Alte
Pinakothek, Munich

393 Pieter Lastman
Paul and Barnabas at Lystra
Signed and dated 1617. Panel, 76 × 116 cm.
Amsterdams Historisch Museum, Amsterdam

works, but we can get some idea of his output from the many copies made even during his lifetime, including the engravings by Hendrick Goudt of Utrecht, which introduced Elsheimer's work in the Netherlands (see fig. 383).

It is difficult to say which of these three artists exerted the greatest influence on Lastman. One of his earliest works, *The Flight to Egypt* of 1608 (fig. 391), is reminiscent of Elsheimer, but Lastman's diminishing interest in landscape even as background probably indicates that the two Italian masters had a more lasting effect on him. Caravaggio's *Madonna of the Rosary* was in the gallery of the Amsterdam art dealer Abraham Vinck in 1617, and it aroused great interest in Dutch artists. Lastman's *Odysseus and Nausicaa* (cpl. 392), painted in 1619, shows Caravaggio's influence in the pyramidal grouping and the strong contrasts of light and dark; Odysseus' upturned feet, moreover, seem directly borrowed from the footsoles of a kneeling figure in the *Madonna of the Rosary*.

Lastman himself presumably considered his stay in Italy as decisive for his art: he often signed his paintings "Pietro Lastman." From the beginning he devoted himself exclusively to history painting. Such works as *Paul and Barnabas at Lystra* of 1617 (fig. 393) bring to mind a stage crowded with broadly gesturing actors. The whole scene is evenly illuminated, but the

393

figures in the foreground receive the most light. Lastman painted the human body correctly and paid great attention to details of architecture, plants, weapons, utensils, and especially the gold and silver objects of which he was so fond. In the *Paul and Barnabas*, Adam van Vianen's silver ewer of 1614 once again appears (see fig. 111), held by the garlanded youth kneeling with his back turned in the right foreground. Lastman's details sometimes clutter his already full paintings. His work was strongest between 1615 and 1625; his compositions later became less striking, the figures less tensile.

The work of Jan and Jacob Pynas is stylistically related to Lastman's. These brothers were probably born in Haarlem and made a trip to Italy about 1605, but did not return to their birthplace: the elder, Jan, worked for a short time in Leiden and then settled in Amsterdam

394

395

394 Jacob Pynas
Hermes and Argus
Signed and dated 1618. Panel, 38.7 × 52.8 cm.
Private collection

395 Jacob Pynas
Paul and Barnabas at Lystra
Signed. Panel, 48.7 × 67.7 cm. The Metropolitan
Museum of Art, New York. Gift of Emile Wolf

396 Jan Pynas
The Departure of Hagar
Signed and dated 1614. Panel, 78 × 106 cm.
Collection Daan Cevat, Guernsey

397 Jan Pynas
Joseph's Cloak Being Shown to Jacob
Signed and dated 1618. Panel, 90 × 119 cm.
Hermitage, Leningrad

after a second journey to Rome in 1615; Jacob worked in Amsterdam, then moved permanently to Delft.

It is difficult to differentiate the work of the two brothers, because they both signed their works with a monogram or simply "J. Pynas"; only a few paintings bear a full first name. As a rule, Jacob is credited with the landscapes, which are always accompanied by a biblical or mythological scene (fig. 394); these paintings are reminiscent of Elsheimer, having the master's typical cauliflower-shaped trees and often highly stylized piles of rocks; the fall of light is fairly hard. Besides landscapes, Jacob also made history paintings that show an affinity to Lastman's in composition and subject matter, such as his *Paul and Barnabas at Lystra* (fig. 395).

In a fully signed and dated work by Jan Pynas, *The Departure of Hagar* of 1614 (fig. 396), the figures are wooden and the colors rather harsh, but this painting may not be typical of his work. In *Joseph's Cloak Being Shown to Jacob* (fig. 397), dated 1618, the figures are rendered with much greater freedom. The attribution of this picture is certain, because the playwright Joost van den Vondel remarks in the preface to his drama *Joseph in Dothan*, first performed in 1640, that Pynas' painting had inspired him to write a play on the same theme.

396

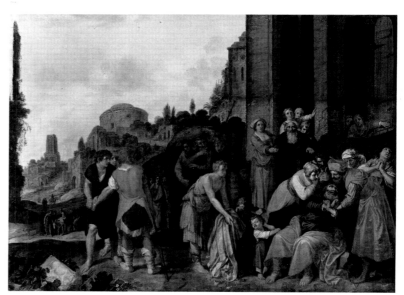

397

398 Jan Tengnagel
The Race between Atalanta and Hippomenes
Signed and dated 1610. Canvas, 56.5 × 91.5 cm.
Amsterdams Historisch Museum, Amsterdam

399 Claes Moeyaert
Mercury and Herse
Signed and dated 1624. Panel, 53.8 × 84 cm.
Mauritshuis, The Hague

400 Werner van den Valckert
*Christ Blessing the Children (Portraits of Michiel
Poppen and His Family)*
Signed and dated 1620. Panel, 200 × 157 cm. State
Museum Het Catharijneconvent, Utrecht

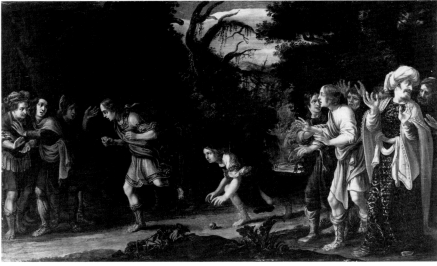

398

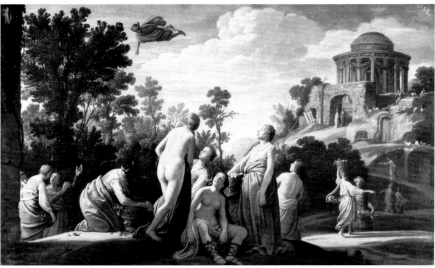

399

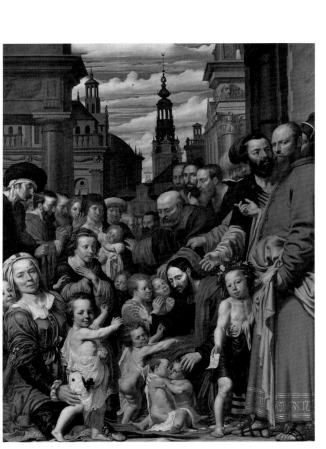

400

A sister of the Pynas brothers married the painter Jan Tengnagel, who, according to his own account, was in Rome in 1608. Tengnagel was a prominent citizen of Amsterdam. In 1613 he painted a large civic-guard piece; he was an officer of the St. Luke's Guild, served as municipal provost, and after 1625 occupied the post of deputy sheriff. It can be assumed that by then he had given up painting. One of his sons became a poet and playwright. Tengnagel's rather charming history paintings, of which *The Race Between Atalanta and Hippomenes* is representative (fig. 398), are similar to Lastman's, although definitely not as strong.

Claes Moeyaert's early work is also akin to that of the Lastman group. It is not certain whether he visited Italy. In 1618 he is mentioned as a famous Amsterdam artist,[8] and dated paintings by him are known from 1624. *Mercury and Herse* (fig. 399), an early work, justifies his good name as a painter. Moeyaert was an excellent draftsman, and the fall of light in his paintings is often interesting. Yet he can hardly be counted among the innovators, either in the 1620s or later, when his style changed drastically but still followed where others had led.

This group of Amsterdam history painters, to which Pieter Lastman's brother-in-law François Venant also belongs, are sometimes called the pre-Rembrandtists. They advanced history painting beyond Mannerism, seeking out strongly narrative subject matter in which the physical and mental state of the figures depicted offered a challenge to their powers of representation, and in this they indeed paved the way for Rembrandt. They also played an undeniable and important role in the cultural life of their time, enjoying close contact with the writers and the theater. Moeyaert designed stage scenery and was regent of the municipal theater in 1640 and 1641.[9]

Werner van den Valckert, a native of Amsterdam, was a contemporary of the pre-Rembrandtists, and like most of them he also visited Italy. His earliest known works are etchings that show his dependence on Annibale Carracci. Italian influence is also quite strong in his history paintings. Van den Valckert's strengths and weaknesses are clearly evident in the large panel *Christ Blessing the Children* (fig. 400): the faces are animated and full of character but the poses are studied and stiff, and the composition is overfull. The

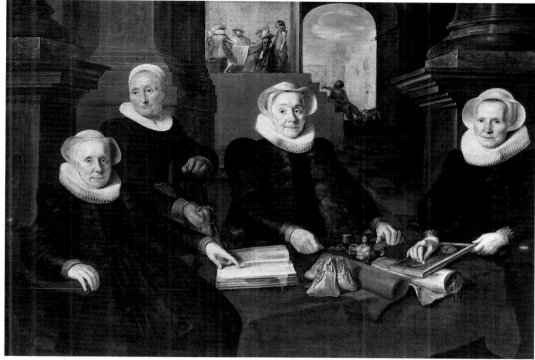

401

401 Werner van den Valckert
Three Regentesses and the Housemistress of the Amsterdam Leper Asylum
Signed and dated 1624. Panel, 134 × 192 cm.
Rijksmuseum, Amsterdam. On loan from the
City of Amsterdam

402 Cornelis van der Voort
Portrait of Cornelis Pietersz Hooft
Dated 1622. Panel, 124 × 90.5 cm. Amsterdams
Historisch Museum, Amsterdam. On loan from
the Rijksmuseum

403 Cornelis van der Voort
Portrait of Anna Jacobsdr Blauw, Wife of Cornelis Pietersz Hooft
Dated 1622. Panel, 122 × 90 cm. Amsterdams
Historisch Museum, Amsterdam

scene is set amid imaginary classical architecture, so that one is amazed to see, rising in the center background, the tower and spire of Hendrick de Keyser's Zuiderkerk in Amsterdam, completed in 1614.

Van den Valckert also painted portraits of individuals and groups, of which his *Three Regentesses and the Housemistress of the Amsterdam Leper Asylum* (fig. 401), dated 1624, is a good example. The women are gathered around a table, as usual in such pictures. The purpose of the institution is related to the scene in the background: Dives the rich man confronting the pauper Lazarus. Van den Valckert presumably worked mainly in Amsterdam; his name appears in the registers there in 1619.

In Amsterdam the art of portraiture developed greater variety and spontaneity than elsewhere (always excepting the unique work of Frans Hals in Haarlem), and it is tempting to link this florescence with the city's lively, international atmosphere. Before Rembrandt arrived there were three leading portraitists, all of them better artists than van den Valckert. Cornelis van der Voort devoted himself primarily to portraits, although it is known from the inventory of his estate that he also painted other subjects. His clients were wealthy Amsterdam merchants and regents, such as the burgomaster Cornelis Pietersz Hooft and his wife, Anna Jacobsdr Blauw (figs. 402 and 403), parents of the poet-historian P.C. Hooft. A number of excellent group portraits by van der Voort have been preserved. He achieved unusual vivacity in his 1618 painting, *Regents of the Old People's Hospital, Amsterdam* (cpl.

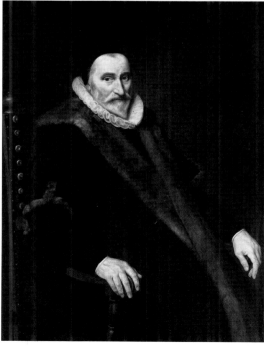

402

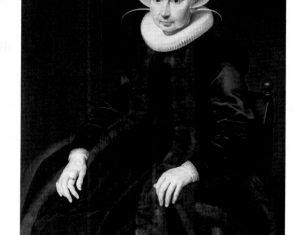

403

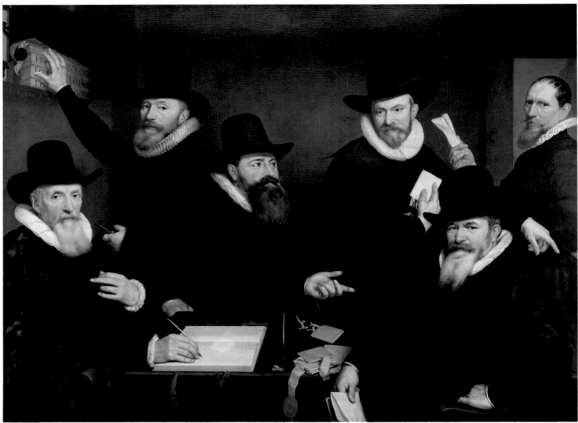

404

404 Cornelis van der Voort
Regents of the Old People's Hospital, Amsterdam
Signed and dated 1618. Canvas, 152 × 200 cm.
Amsterdams Historisch Museum, Amsterdam

405 Nicolaes Eliasz, called Pickenoy
Portrait of Cornelis de Graeff
Canvas, 184 × 104 cm. Gemäldegalerie, Staatliche
Museen, East Berlin

406 Nicolaes Eliasz, called Pickenoy
*Portrait of Catherina Hooft, Wife of Cornelis de
Graeff*
Canvas, 184 × 104 cm. Gemäldegalerie, Staatliche
Museen, East Berlin

404). Animation had formerly been suggested by gesture alone; here there is real activity that elucidates the official functions of the various regents. This was an important step forward in the development of the group portrait. Van der Voort's work, to be sure, does not begin to approach the liveliness of Frans Hals's militia banquet of 1616; the different temperaments of the two artists is discernible in their style of composition, pose of figures, and brushwork. Van der Voort lacked Hals's genius, but was nevertheless an expert: his portraits are excellently drawn, the facial color is natural, and he handled the fall of light more competently than such predecessors as Ketel had done; he was also good at rendering the textures of cloth and skin.

These qualities were also possessed by the younger Nicolaes Eliasz, called Pickenoy, as can

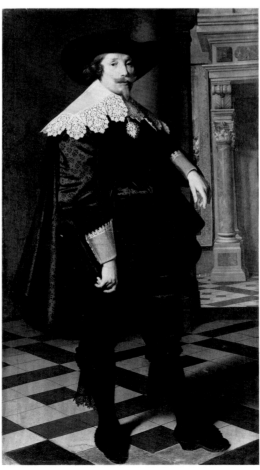

405

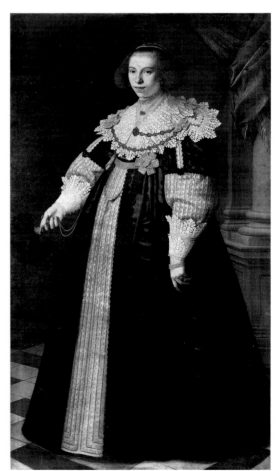

406

be seen in his full-length pendant portraits of the wealthy Amsterdam merchant Cornelis de Graeff and his wife, Catherina Hooft (figs. 405 and 406), who appear in almost regal finery. But many of Eliasz's portraits seem no more than studio poses. Eliasz was born in Amsterdam in 1590 or 1591. Together with Thomas de Keyser, son of the architect Hendrick de Keyser, he took over the lead among the Amsterdam portrait painters after van der Voort's death in 1624. De Keyser had been established as a portraitist for some time, and in 1619 had received an important commission for a group portrait, *The Anatomy Lesson of Dr. Sebastiaen Egbertsz de Vrij* (see fig. 204). Both he and Eliasz did their best work in the second quarter of the century, however, and will therefore be discussed below (see p. 274).

Landscape painting had received strong stimulus in Amsterdam at the beginning of the seventeenth century through the art of the émigré Flemings Coninxloo, Vinckboons, and Hans Bol, and the interest in it developed in several directions. The painters Hendrick Avercamp and Arent Arentsz, called Cabel, devoted themselves exclusively to two Dutch motifs: the winter landscape with skaters and the polder landscape. It is difficult to determine the personal relationship between these contemporary artists and the extent to which they influenced each other or exchanged ideas and themes, for their dated works are scarce and the biographical details insufficient to establish the years in which they may have been in touch.

Avercamp was born in 1585 in Amsterdam; his father was a schoolteacher, but gave up that work in 1586 to settle as an apothecary in Kampen, an old Hansa town on the Zuider Zee. Hendrick was a deaf-mute, and some of his contemporaries called him the "mute of Kampen." He must have shown artistic talent, for his family sent him to study in Amsterdam under the Danish painter Pieter Isaacsz. Just when Hendrick arrived is unknown, but it was presumably before 1607: an annotation in the catalog of the sale in that year of Coninxloo's estate, which Avercamp attended, records him as residing with Pieter Isaacsz, who returned to Denmark some months later. The next bit of evidence is a note on the back of a drawing indicating that Avercamp was in Kampen in 1613; relatives of his still lived in Amsterdam, though, so that he was probably able to keep up contacts there. Although his name does not appear in the surviving municipal archives, he presumably spent the rest of his life in Kampen, where he died in 1634.

Avercamp's earliest known work is a winter scene, signed and dated 1608 (fig. 407), now

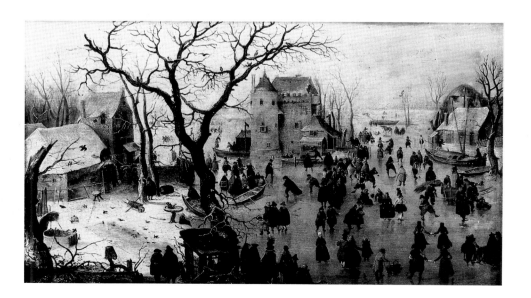

407 Hendrick Avercamp
Winter Scene
Signed and dated 1608. Panel, 33 × 55.5 cm.
Billedgalleri, Bergen, Norway

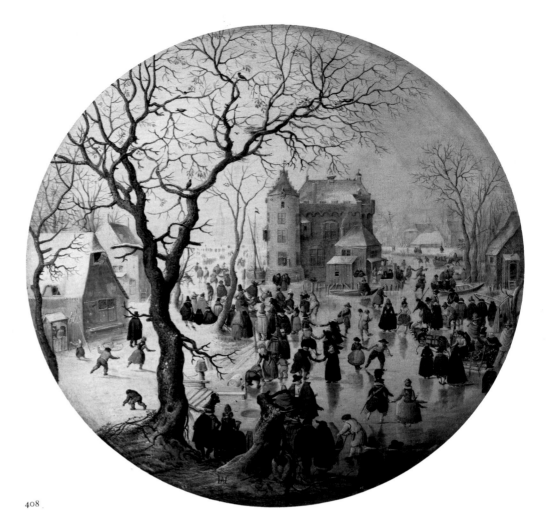

408

408 Hendrick Avercamp
Winter Scene
Signed. Panel, round, diameter 40.7 cm. The
National Gallery, London

409 Hendrick Avercamp
Scene on the Ice
Signed. Panel, 37 × 64.5 cm. Private collection

410 Hendrick Avercamp
Men Sawing
Black chalk, c. 14.5 × 11.5 cm. Private collection

in Bergen, Norway. The high point of view in which the artist placed himself, as if he were looking down from a church tower, enabled him to spread his small figures evenly over the ice and to tell as much as possible about the activities engaging them. Flemish influence is apparent in this choice of a high horizon, the way the trees and buildings are painted, and the round format that Avercamp used in many of his early paintings (fig. 408). He had no doubt seen some of Bruegel's prints in Amsterdam, and come under the influence of Vinckboons and Bol; Coninxloo died in January 1607, making it unlikely that Avercamp was his pupil, as is often stated.

Avercamp concentrated almost entirely on winter scenes peopled with innumerable finely painted little figures. In his later work, presumably after he returned to Kampen, the horizon is lower and the grouping of figures more natural (fig. 409). Avercamp's many drawings often give a striking view of daily life (fig. 410); some, elaborately colored, can be considered independent works of art.

As with Avercamp, relatively little is known about the life of Arent Arentsz,[10] who was called Cabel after the house bearing the sign "In de Kabel" on the Zeedijk in Amsterdam, where he was born in 1585. Later he gave the same name to his own house on the Prinsengracht across from the Noordermarkt; he died there in 1631.

410

409

Topographically recognizable details in his paintings make it apparent that Cabel found his motifs in and around Amsterdam. His works are never dated, but almost always bear the monogram *AA*. Although he painted a number of beautiful winter scenes (cpl. 411), he concentrated mainly on polder landscapes in summer. The horizon is always low, and there is no evidence of Flemish influence. His figures are less graceful than Avercamp's—rather clumsy and squat, but real nevertheless, and directly observed; they are always doing something: the hunter aims at his prey, gypsies predict the future, fishermen are busy with their nets and boats (fig. 412). Cabel's work has an immediate, appealing simplicity; the Dutch polder landscape had never been rendered so poignantly before.

The paintings of Avercamp and Cabel had few followers. Anthonie Verstralen, who was

411 Arent Arentsz, called Cabel
 Winter Scene on the Y in Amsterdam
 Signed. Panel, 52.5 × 99 cm. Amsterdams
 Historisch Museum, Amsterdam

412 Arent Arentsz, called Cabel
 Polder Landscape with Fishermen
 Panel, 46.5 × 95.5 cm. Private collection

probably born in Gorinchem but perhaps worked in Amsterdam, had an affinity for their style, and Adam van Breen's winter scenes show Avercamp's influence. Yet Avercamp's only true successor was his nephew, Barent Avercamp, who also worked in Kampen. As for Arent Arentsz, he appears to have been virtually isolated from the artistic life in Amsterdam.

Landscape was important in the work of Roelant Savery, who came to Amsterdam from Flanders; he stayed only a short time, but may have met and perhaps collaborated with Hercules Segers. Their paintings, in any event, show some relationship of spirit and method.

Hercules Segers, painter and etcher, is an intriguing artist. His etchings are entirely innovative in technique, for he experimented with unprecedented methods; his choice of subject matter, however, was largely traditional. Several contemporary sources designate Segers as "van Haerlem," and it has been established that he was born in that city in 1589 or 1590; his father was a Mennonite emigrant from Flanders. He signed his early prints and drawings in various ways and spellings, but consistently used the signature "Hercules Segers" on his paintings from 1621 onward.

Segers served his apprenticeship under Coninxloo, becoming acquainted with the Flemish landscape traditions through the master's work and through Coninxloo's collection of works by Paulus Bril, the elder and younger Bruegels, Gillis Mostaert, and Joachim

413 Hercules Segers
Landscape
Etching and drypoint, printed in blue ink on prepared blue-colored paper, 22.5 × 48.9 cm.
Print Room, Rijksmuseum, Amsterdam

Patenier. In 1612 Segers became a member of the Haarlem St. Luke's Guild; two years later he married a fairly well-to-do woman, and in 1619 bought a house on the Lindengracht in Amsterdam, which indicates a certain prosperity. In 1631, however, under the pressure of debts, he had to sell the house, and during that year he moved to Utrecht, working there as an art dealer. At the end of 1632 he settled in The Hague, where in 1638 his (presumed) second wife was registered as a widow.

It is interesting to compare these data with Samuel van Hoogstraeten's account, in 1678, of Segers' life and career.[11] In the chapter dealing with "How an artist should defend himself against the violence of Fortune," Hoogstraeten uses Segers as an example of an artist misunderstood by his contemporaries, and the disastrous consequences. No one, he says, wanted to buy the work of "the unesteemed and yet, in art, great Herkules Zegers"; Segers' prints were used as packing material by grocers; the artist was so poor he had to use his shirts and his sheets to print "paintings" on; and at last Segers unwontedly got drunk, fell down the stairs of his house, and died.

As usual with anecdotes chosen to serve as examples, there is a grain of truth in this account, as long as we do not take the embellishments too literally. The remark about the artist's poverty certainly does not apply to the period between 1614 and 1625, but may well be true of later years, when Segers seems to have been in financial difficulty. The implication that there was no interest in his work during his lifetime is inaccurate: one of his paintings was presented to King Christian II of Denmark in 1621, and two others were in Frederik Hendrik's collection, according to the 1632 inventory. The making of prints on linen, moreover, had nothing to do with Segers' poverty, but was one of the many experiments he carried out.

In his earliest etchings, created in Haarlem, Segers' working method can be detected rather easily: he built up his compositions with short, constantly overlapping lines. But in later works his method remains enigmatic. He began to use color more and more, printing with colored ink on white or tinted paper, brushing color on the plate, or coloring the etching itself. By combining these methods, he achieved extremely varied results from one plate, and most of the impressions of his etchings are therefore unique specimens (fig. 413).

Segers' imaginative approach to technical experimentation carried over into his choice of subject, especially as regards his mountain views; it cannot be ascertained whether he had

415

414 Hercules Segers
River Valley
Canvas, 70 × 86.6 cm. Museum Boymans-
van Beuningen, Rotterdam

415 Hercules Segers
View of the Noorderkerk, Amsterdam
Etching and drypoint, printed in black ink on
prepared green-colored linen, 14.1 × 17.7 cm.
Print Room, Rijksmuseum, Amsterdam

416 Hercules Segers
Landscape near Rhenen
Signed. Panel, 42 × 66 cm. Gemäldegalerie,
Staatliche Museen, West Berlin

414

seen these foreign landscapes himself or took his motifs from the work of others. The scenes
are mostly of desolate, inhospitable, rocky masses girding a level area, which is usually
crossed by a meandering stream; in this valley, life seems to go on lyrically amid houses,
churches, trees, and fields surrounded by hedges or fences. Besides these imagined mountain
landscapes, Segers also used other themes in his etchings: the Dutch landscape, ruins, a horse,
a still life of books, a skull.

Only a handful of his paintings are known today; they include a few mountain landscapes
and a couple of Dutch landscapes greatly different in atmosphere and technique. One of the
most beautiful of the mountain views is a river valley with houses (cpl. 414)—a clear
example of fantasy combined with reality. The artist could see the buildings in the
foreground from his house on the Lindengracht; in an etching with a view of the
Noorderkerk (fig. 415) he pictured the same houses through a window, but in the painting
he placed this bit of Amsterdam in the foreground of an imagined river landscape. The
etching and the painting date from his years in Amsterdam, between 1623 and 1631; the
Dutch landscapes were presumably painted later. The palette of the *Landscape near Rhenen*
(fig. 416) is limited mostly to browns and muted greens, which links it to the work of the
tonal landscape painters. About 1640, it is thought, a strip of wood was added to the top
edge to make the painting conform in shape to the taste of the time; its original oblong
format, characteristic of the period in which it was painted, had gone out of style.[12]

416

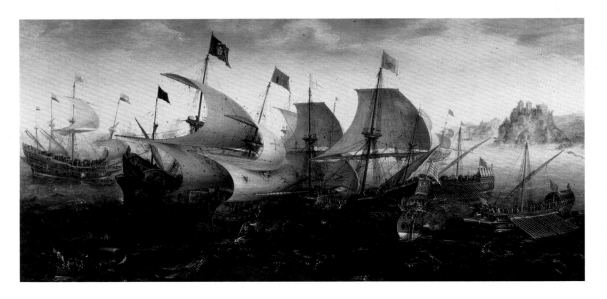

417 Aert Anthonisz
Incident from the Battle of the Spanish Armada,
August 8, 1588
Signed and dated 1608. Panel, 41 × 82.5 cm.
Rijksmuseum, Amsterdam

418 Abraham de Verwer
The Battle of the Zuider Zee
Signed and dated 1621. Canvas, 153 × 340 cm.
Rijksmuseum, Amsterdam

Hercules Segers was a comparative loner among the landscape painters, though some of
his works are at least superficially similar to paintings by others. We know that Rembrandt
owned several of Segers' works, and his few painted landscapes owe much to the older
artist. The two could have met in Amsterdam when Rembrandt was studying under
Lastman in 1624, but when he moved there permanently, in 1631, Segers had just left.
Whether they had any later contact is unknown.

Two landscape painters, Willem van den Bundel and Govert Jansz, were working in
Amsterdam during this period, but practically none of their work has survived. As concerns
Govert Jansz, this is surprising, since a number of seventeenth-century connoisseurs and
artists collected his paintings.

Sea views were painted by Aert Anthonisz, who until recently was called Aert van
Antum by art historians.[13] This painter was born in Antwerp in 1580, came to Amsterdam
as a boy, and married there in 1603. His earliest known painting, dated 1604, was a rather
awkward piece; it was lost during World War II. By 1608 he had become an accomplished
painter of ships and a daring colorist; in the *Incident from the Battle of the Spanish Armada* of
that year (fig. 417), he used a bold orange-red for the galley oars and red for the cannon
fire. His work has an obvious relationship with that of Vroom and van Wieringen. His
career was cut short by his death in 1620, and few of his works survive.

Abraham de Verwer at first lived in Haarlem and often worked as a joiner, not being
registered as a painter until 1614; by 1617 he was living in Amsterdam. He, too, followed
Vroom in certain respects in his early work, and like him chose a fairly high point of view
for such paintings as *The Battle of the Zuider Zee* (fig. 418). Contrary to Vroom and van

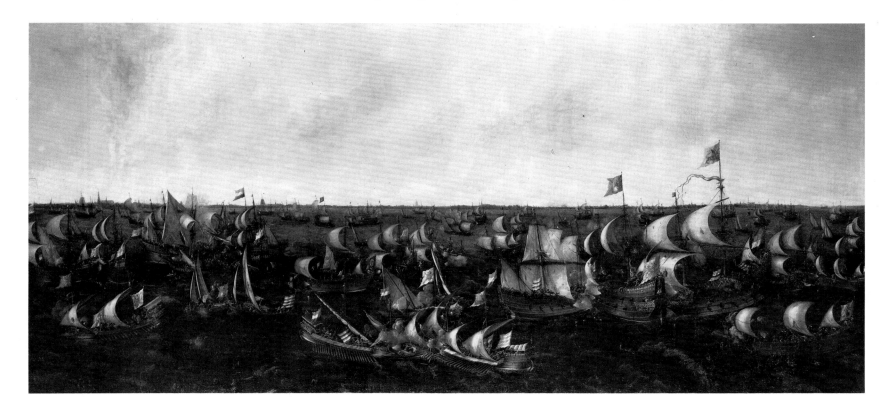

419

419 Clara Peeters
 Still Life
 Signed and dated 1611. Panel, 51 × 71 cm. Museo
 del Prado, Madrid

420 Hans van Essen
 Still Life
 Signed. Panel, 51 × 112 cm. Private collection,
 Sweden

421 Jan van der Beeck, called Torrentius
 Still Life, Allegory on Moderation
 Signed and dated 1614. Panel, nearly round,
 52 × 50.5 cm. Rijksmuseum, Amsterdam

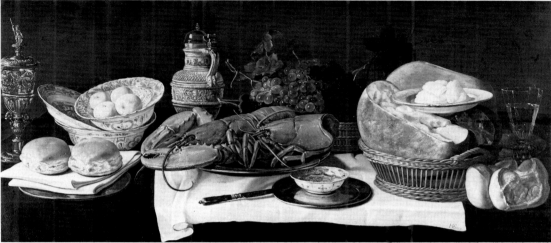

420

Wieringen, however, he later joined the new tonal generation; his palette became far less colorful, and he was able to evoke a sensitive atmosphere in primarily grayish tints. He died in Amsterdam in 1650.

The still-life painters in Amsterdam did not form a group during the first quarter of the seventeenth century, and there is some uncertainty about their activities and relationships. Clara Peeters, the talented painter of still lifes and flowers, was born in Antwerp in 1594, but the place and date of her death are unknown.[14] Some art historians state that she lived in Amsterdam in 1612 and in The Hague in 1617; as I mentioned before, I have been unable to confirm this in the archives,[15] and her work in any event does not indicate a long sojourn in Holland. Her career was in Antwerp, where she painted in a style closely related to that of other Antwerp still-life painters (fig. 419).

The presence in Amsterdam of another Antwerp artist, Hans van Essen, is well documented: he was living there when he married, in 1619, but few signed and dated works by him are known. Bergström reproduces a signed and unmistakably early work[16] that is directly akin to the early type of Antwerp still lifes. The *Still Life* here reproduced (fig. 420) was clearly painted much later, as can be seen from the composition. The lack of dated material makes it impossible to determine van Essen's contribution to the development of still-life painting in Amsterdam.

Jan van der Beeck, called Torrentius, worked primarily in Amsterdam but also spent some time in Leiden and Haarlem. He was a remarkable man, a Rosicrucian of broad religious and moral views, which brought him in 1627 into conflict with the law, resulting in a twenty-year prison sentence; through the intercession of King Charles I of England and the stadholder Frederik Hendrik, he was released two years later and spent the ensuing decade in England. Very few of his paintings survive. There is a nearly round panel of 1614, a still life with a long-spouted pewter pitcher known as a Jan Steen flagon, an earthenware jug, a half-full glass, a bridle, a sheet of music, and two small clay pipes (fig. 421); according to the inscription on the music, this painting is an allegory on moderation, and it is closely related to the illustration on the title page of Roemer Visscher's *Sinnepoppen* (see fig. 96). Torrentius' manner of painting in 1614 is as exceptional as he was himself: his brushwork is invisible, and he has created a surreal effect by placing the objects at eye level against the dark background. Torrentius was acquainted with the camera obscura and possibly used one in painting his pictures.

421

After Holland, Zeeland was one of the richest provinces in the Republic, and Walcheren was its most important island (fig. 422). There are few statistics, but the relative financial worth of the Dutch provinces can be estimated from their assessments for the national military budget. In 1616 these assessments were established in the following percentages, which remained virtually unchanged throughout the seventeenth century: Holland, 58; Friesland, 11.5; Zeeland, 9; Groningen and Utrecht, each 5.75; Gelderland, 5.5; Overijssel, 3.5; and Drente, 1.[17]

Zeeland's prosperity depended on trade and shipping probably even more than Holland's did. The Admiralty records of "convoys and licenses," comparable to present-day import duties, show that at the end of the sixteenth century Zeeland rivaled Amsterdam in the amounts taken in, but dropped off consistently during the seventeenth century. The Zeeland capital, Middelburg, was favorably placed as a haven for the many Flemings who fled to the north, especially after the fall of Antwerp in 1585, yet it had little else to offer.

As a center of painting, Middelburg seems simply to have lacked vitality. Practically none of its painters who rose above the provincial level remained there. The flower painter Ambrosius Bosschaert left in 1613, followed by his talented young brother-in-law, Balthasar van der Ast; the landscape painter Jacob van Geel moved away in 1626; and the versatile Adriaen van de Venne, after working in Middelburg for twelve years, went to The Hague in 1625. The same thing occurred with the tapestry weavers: despite subsidies from the city fathers, who were extremely anxious to keep the labor-intensive industries, not a single weaving mill was able to continue in business.[18]

It is probable that the landscape painter Gillis van Coninxloo, coming from Flanders, stayed in Middelburg before going on to Frankenthal in Germany, where he is mentioned in 1587. At about the same time Ambrosius Bosschaert's parents, Protestants from Antwerp, must have settled in Middelburg. Ambrosius, born in 1573, apparently showed his skill as a painter very early, for he became an official of the local St. Luke's Guild at the age of twenty. Unfortunately, we do not know what or how he was painting then, or under whom he had studied. His earliest known work is dated 1606,[19] and his career after that is easy to follow: he limited himself exclusively to painting flowers and fruit.

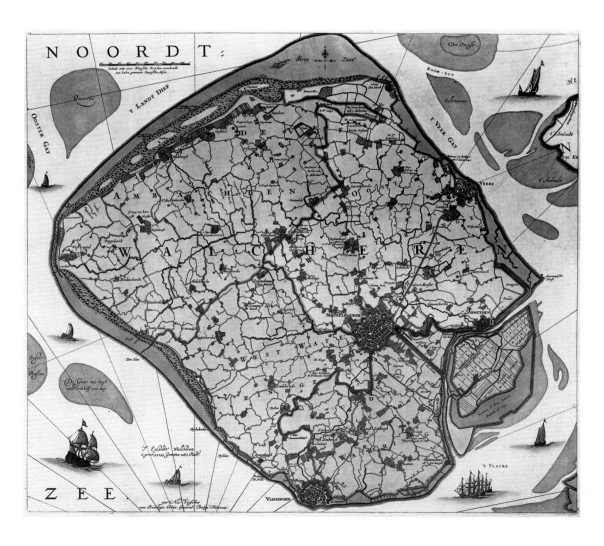

422 Map of the Island of Walcheren

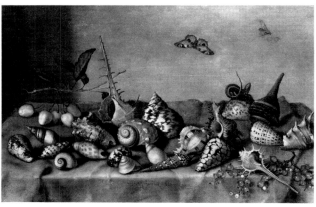

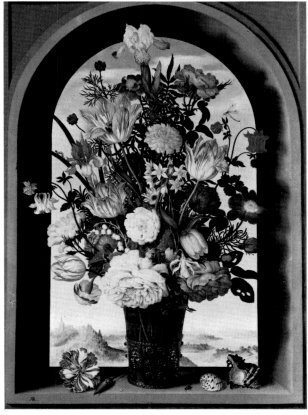

423

423 Ambrosius Bosschaert
Vase of Flowers
Signed. c. 1620. Panel, rounded at the top,
64 × 46 cm. Mauritshuis, The Hague

424 Balthasar van der Ast
Still Life with Flowers, Fruit, and Shells
Signed. Panel, 38 × 71 cm. Staatliche Galerie,
Dessau

425 Balthasar van der Ast
Still Life with Shells
Signed. Panel, 30 × 47 cm. Museum
Boymans-van Beuningen, Rotterdam

425

424

We have already pointed out (p. 116) the connection between the great interest in botany that arose toward the end of the sixteenth century and the popularity of floral paintings. In Middelburg, as elsewhere, the collectors of herbs and plants were as wildly enthusiastic about adding to their gardens as the collectors of shells and other rarities were in filling their "cabinets." The Middelburg collectors wrote to Carolus Clusius, head of the Leiden botanical garden, begging him for rare specimens of tulips, and they sent him in exchange painted portraits of their most prized possessions.[20]

The flower paintings by Bosschaert and his followers attest to those artists' own strong interest in botany, whether or not they wished also to convey the symbolism of flowers. Bosschaert did much to establish the schematic formula they all used, as outlined on page 119: a symmetrical, rather flat and stiff arrangement of cultivated flowers in a vase or a glass, with each individual flower recognizable and showing to advantage; insects and sometimes shells enliven the composition (fig. 423). The smaller, less ambitious works are more intimate and natural than the larger pieces. Later, when Bosschaert had left Middelburg and worked in Bergen op Zoom, Utrecht, and Breda, he varied his otherwise fairly fixed scheme by placing the bouquet in a niche against a landscape background (see cpl. 221). Besides flower paintings, he also produced still lifes with fruit.

Bosschaert was an art dealer as well as a painter, and kept up lively relations with the Amsterdam dealers. He sold a painting by Veronese to a Middelburg collector, Melchior Wijntgis, and in 1612 a picture of a naval battle to the States of Zeeland. In 1613 he delivered to a Middelburg collector "a dish of peaches" by the German painter Georg Flegel. This mention is important, for it indicates Dutch interest in, and perhaps personal contact with, that Frankfurt artist, whose flower paintings and still lifes of simple objects ran parallel with or even preceded the work of the Dutch still-life painters.[21] Bosschaert's sale of the Flegel painting is evidence, moreover, that the European art centers maintained contacts not only through traveling artists and the distribution of prints, but also through the active trading of art dealers. Communications back and forth often went much faster and extended further than we today imagine.

About 1604 Bosschaert married Maria van der Ast, who had a promising young brother, Balthasar. When their father died in 1609, it was quite natural for Balthasar, then fifteen, to move in with the Bosschaerts, and for his brother-in-law to train him in floral painting. There is in any event such a close resemblance between their work that Balthasar's dependence on Ambrosius can be taken for granted. Dated paintings by van der Ast are known from as early as 1610. His work shows greater compositional variety than Bosschaert's, and his initial drawinglike style of painting soon developed into a more tonal approach, with suppler brushwork (fig. 424). In his later work, especially, he attempted to achieve depth in his bouquets. Butterflies and other insects, snails, and salamanders seem to have fascinated him and always appear in his paintings, enhancing the *vanitas* effect. Besides flower and fruit paintings, or combinations of the two, he did a few still lifes of shells, always exotic specimens (fig. 425); these were no doubt commissioned by shell collectors.[22]

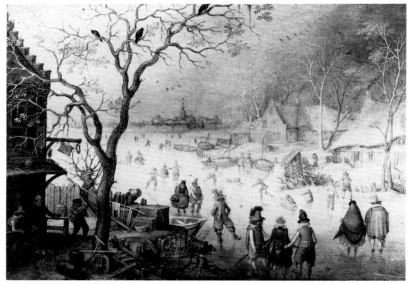

427

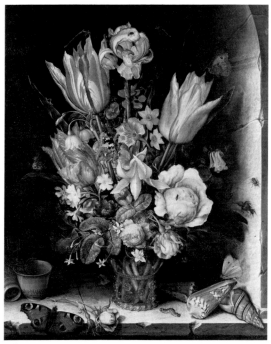

426

426 Christoffel van den Berghe
Still Life with a Bouquet of Flowers, Shells, and Insects
Signed and dated 1617. Copper, 37.8 × 29.2 cm.
John G. Johnson Collection, Philadelphia

427 Christoffel van den Berghe
Winter Landscape
Signed. Copper, 11.5 × 16.5 cm. Mauritshuis,
The Hague

428 Adriaen van de Venne
Winter Scene
Signed and dated 1615. Panel, 16.6 × 23.3 cm.
Worcester Art Museum, Massachusetts

Van der Ast followed his brother-in-law to Bergen op Zoom in 1613 and to Utrecht in 1619. Bosschaert became ill and died in 1621 in The Hague, where he had gone to deliver an outsize flower painting ordered by Prince Maurits' steward, for which he was charging no less than 1,000 guilders. This price was remarkably high, even for Bosschaert, who usually got from 200 to 240 guilders for his pictures. Van der Ast stayed in Utrecht until 1632, then moved to Delft, where he died in 1657.

Ambrosius Bosschaert's three sons, Ambrosius the Younger, Johannes, and Abraham, all followed in their father's footsteps and became painters of flowers and fruit. Their work is capable but conventional, and only Ambrosius seemed open to new ideas.

In Middelburg the Bosschaert tradition was continued by Christoffel van den Berghe, a painter of limited talent whose work nonetheless has a certain charm (fig. 426). In addition to flower pieces, he painted landscapes which show definite Flemish influences (fig. 427). To judge from their work, he and the landscape painter Mattheus Molanus, an émigré Fleming, led a fairly isolated existence in Middelburg.

Apart from the floral painters, Adriaen van de Venne was by far the most important artist active in Middelburg. Born in Delft in 1589 to Flemish parents, he apparently had his schooling in Leiden and The Hague; there is no documentary evidence that he studied in Antwerp, as is sometimes stated. He went to Middelburg about 1614 and stayed there until 1625; this period is one of the most interesting in his long life (he lived to be seventy-three), during which he painted, made illustrations, and composed poetry.

His early work has a strong Flemish flavor, clearly evident in the charming little winter scene of 1615 (fig. 428). The high horizon, the bare trees, the castle, and the many small figures moving on the ice are closely allied to the Bruegel tradition, but van de Venne's

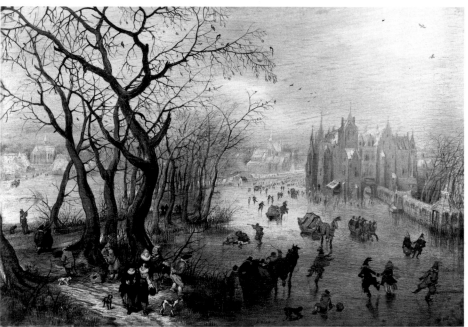

428

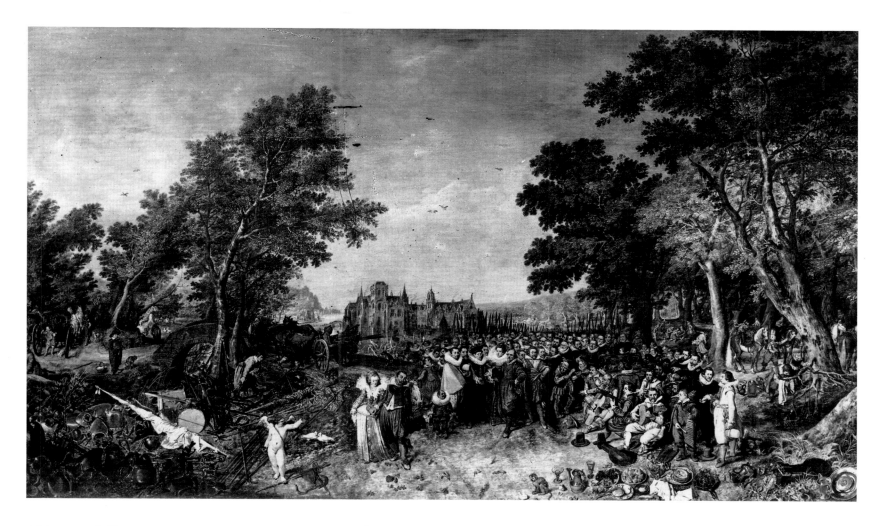

429 Adriaen van de Venne
Allegory on the Signing of the Twelve Years' Truce, 1609
Signed and dated 1616. Panel, 62 × 112 cm.
Musée du Louvre, Paris

430 Adriaen van de Venne
The Harbor of Middelburg
Formerly signed and dated 1625. Panel,
64 × 134 cm. Rijksmuseum, Amsterdam

own talent is unmistakable. He has painted the figures with grace and wit, and has captured the freezing atmosphere and the hazy horizon.

Flemish influence is also discernible in his large panel with an allegorical representation of the signing, in 1609, of the Twelve Years' Truce (fig. 429), painted in 1616. The composition is related to Jan Bruegel's allegories on war and peace. The many people in this painting—the dignitaries, the dwarf and the jester, the musicians, and the figures at the edge of the wood—are painted inimitably. Some of them are recognizable despite the small size of the heads: in the center foreground, standing apart, are Archduke Albert of Austria and his wife, Isabella (daughter of Philip II), co-governors of the Southern Netherlands since 1598; farthest right in the group of nobles behind them are Prince Maurits and Prince Frederik Hendrik of the Republic. In other paintings, such as the well-known *Fishing for Souls*, van de Venne created allegories on the religious quarrels that split the Northern and Southern Netherlands, showing his political interest and involvement. It is not known who commissioned these paintings.

Van de Venne apparently painted a group portrait of the Middelburg civic guard, but it has not survived. His lively *Harbor of Middelburg* (fig. 430) probably depicts the departure of Elector Frederick V and his wife, Elisabeth Stuart, after their visit to Zeeland in 1613.

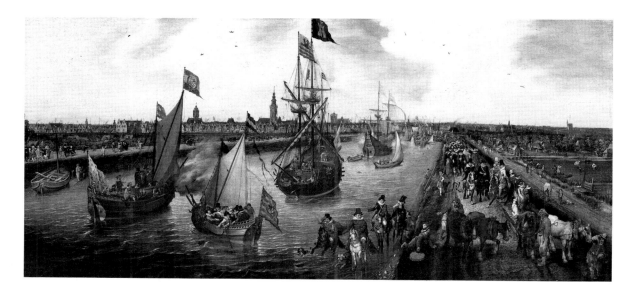

431 Salomon Mesdach
Portrait of Anna Boudaen Courten
Dated 1619. Panel, 96 × 70 cm. Rijksmuseum,
Amsterdam

The only important portrait painter who worked in Middelburg during the first quarter of the seventeenth century was Salomon Mesdach. Little more is known of his life than that he was dean of the local guild in 1628. Compared with portraits of the same time in Holland, his look stiff and old-fashioned, yet they exhibit expert craftsmanship and are now and then remarkably sensitive. One example of his talent is the charming portrait of Anna Boudaen Courten in her bridal finery (cpl. 431); Anna was a member of a distinguished Zeeland family.

Utrecht: Liege of Rome

There was a strong bond between Utrecht, ancient see of bishops, and Rome. In no other Dutch city was the cultural and artistic influence of Italy so pervasive, though one of the outstanding representatives of the Utrecht school, Abraham Bloemaert, never went to Rome. It is difficult to do justice to his art in a short survey: in his early period he followed Mannerist ideals (see p. 172), but he then worked a full half century, from about 1600 until his death, constantly open to new trends and styles, adapting them all in his own way. After his pupil Gerrit van Honthorst returned from Italy in 1620, Bloemaert assimilated Caravaggesque ideas from him and produced such paintings as *The Supper at Emmaus* (fig. 432). Yet despite the many influences, Bloemaert's work remained strongly decorative and elegant, competently drawn, and well balanced in composition. He painted history pieces, single figures, and landscapes (see fig. 357).

Bloemaert's pupils Hendrick Ter Brugghen, Gerrit van Honthorst, and Jan van Bijlert, and Paulus Moreelse's pupil Dirck van Baburen, all made the journey over the Alps and even spent an important part of their lives in Rome. They returned to Utrecht full of new

432 Abraham Bloemaert
The Supper at Emmaus
Signed and dated 1622. Panel, 145 × 215.5 cm.
Musées Royaux des Beaux-Arts de Belgique,
Brussels

433 Hendrick Ter Brugghen
The Mocking of Christ
Signed and dated 1620. Canvas, 207 × 240 cm.
Statens Museum for Kunst, Copenhagen

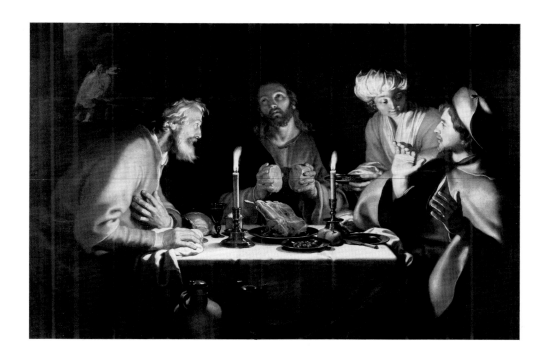

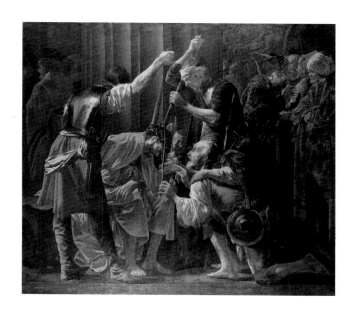

ideas about color, composition, and subject matter, ideas in the main inspired by the work
of Caravaggio, so that they came to be known as the Caravaggists. This appellation was
justified, even though these artists also reflected other Italian influences. Only Ter
Brugghen, who went to Rome about 1604, several years before the others, may have met
Caravaggio, who in 1606 stabbed a man to death in a quarrel and had to flee the city. But
all the Utrecht artists certainly became acquainted with his work when they reached Rome,
and it must have impressed them tremendously as a daring new art. Caravaggio's color
scheme in soft tints of olive green, red, blue, ocher, and lemon yellow, the vitality of his
figures, and their nearness, and especially the strong contrasts between light and dark created
by an invisible light source—all this was quite different from what the northerners had
known.

But besides the work of Caravaggio and his followers, such as Orazio Gentileschi and
Bartolomeo Manfredi, there were endless things to see and do in the Rome of those days.
The new pope, Paul V, who served from 1605 to 1621, had launched a great program of
church building and decoration; his cousin, Cardinal Scipione Borghese, was a patron of
artists, as was the wealthy Marchese Vincenzo Giustiniani, who drew the young Hollanders
into his circle.

It is a pity that of the Utrecht painters in Rome so little is known about Hendrick Ter
Brugghen. He did not exert as much influence as the others did after they returned home,
nor was his work the most admired in Rome or Utrecht, but by present-day standards he
was the most talented of the lot. There is a story that when Rubens was in Holland in 1627,
he said he had met only one artist—Ter Brugghen; few contemporaries seem to have
agreed.

Ter Brugghen was born in 1588 in the province of Overijssel, in the east of the
Netherlands; his family was well-to-do and remained Roman Catholic. After having
studied a while with Bloemaert in Utrecht, Hendrick set out for Rome when he was about
fifteen. He ended his ten-year stay there in the early autumn of 1614 and returned to
Utrecht. Yet not one painting can be ascribed to him with full certainty from either his
Roman period or the five years following. An *Adoration of the Magi*[23] dates from 1619, and

434 Hendrick Ter Brugghen
The Crucifixion with Mary and St. John
Signed and dated 162(.). Canvas,
154.9 × 102.2 cm. The Metropolitan Museum of
Art, New York

435 Hendrick Ter Brugghen
St. Sebastian Tended by Irene and Her Maid
Signed and dated 1625. Canvas, 150 × 121 cm.
Allen Memorial Art Museum, Oberlin College,
Ohio. R.T. Miller, Jr. Fund

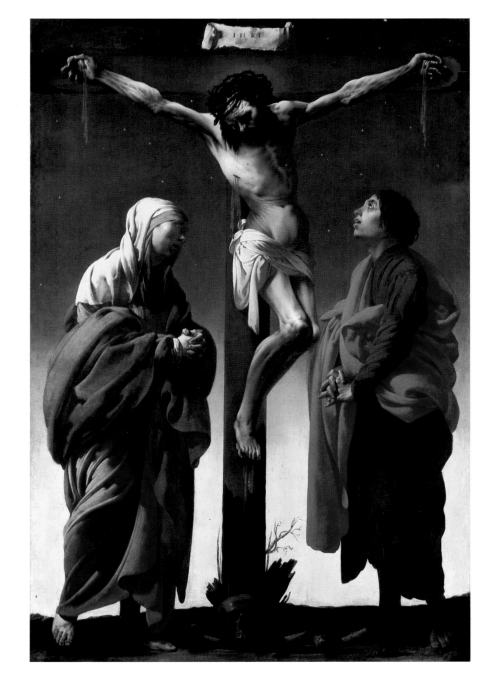

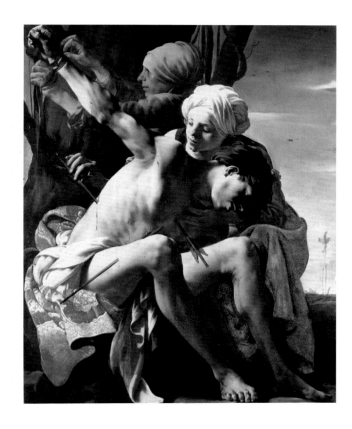

a *Mocking of Christ* (fig. 433) from 1620. Neither of these paintings can be called truly Caravaggesque, although there is a hint of Caravaggio's influence, especially in the treatment of light in the 1620 canvas. But there are also traces of the work of much older painters—Lucas van Leyden and Albrecht Dürer, for instance. The impressive *Crucifixion with Mary and St. John* of about 1625 (cpl. 434), in which the figures are silhouetted against a remarkable starry sky, has elements reminiscent even of Grünewald.

The Caravaggesque elements in Ter Brugghen's work are strongest about 1620–22, when Honthorst and Baburen had just come back from Rome. The pictures these young artists began to paint at that time seem to have had great success, to judge from the many copies made almost immediately, and they most likely provided a new stimulus for Ter Brugghen. He may also have gone to Amsterdam to take a look at Caravaggio's *Madonna of the Rosary* (see fig. 388). In a moderately sized painting of 1625, *St. Sebastian Tended by Irene and Her Maid* (fig. 435), Ter Brugghen achieved a monumentality that is most unusual for a Dutch artist. He died in 1629, aged forty-one, in Utrecht.

Gerrit van Honthorst was born in Utrecht in 1590 and studied under Bloemaert before he went to Rome sometime between 1610 and 1612. Apparently he came under the influence not only of Caravaggio and his followers, but also of Ludovico and Annibale Carracci and, indirectly, of Jacopo da Ponte Bassano (who died in 1592). The eagerness of the young Dutch artist in studying the work of others is evident from his 1616 drawing (fig. 436) after Caravaggio's *Martyrdom of St. Peter*.

Honthorst lived for a considerable time in Rome in the palace of the Marchese Giustiniani, for whom he painted a large canvas, *Christ before the High Priest* (fig. 437). During his last years in Rome he also received commissions to make paintings for churches,

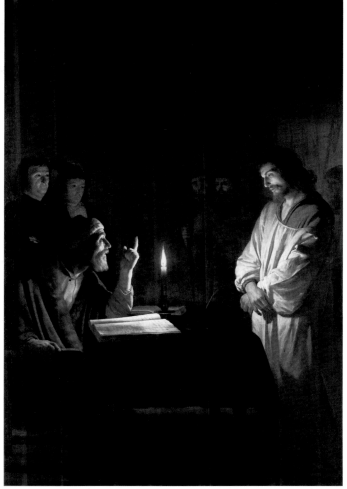

437

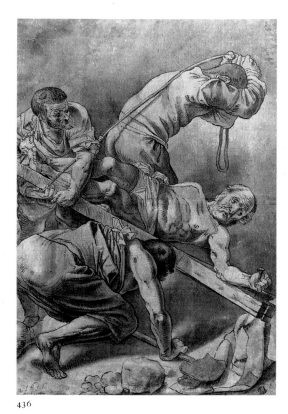

436

436 Gerrit van Honthorst after Caravaggio
The Martyrdom of St. Peter
Signed and dated 1616. Pen and wash, 37.8 × 26.6
cm. Nasjonalgalleriet, Oslo

437 Gerrit van Honthorst
Christ before the High Priest
Canvas, 106 × 72 cm. The National Gallery,
London

438 Gerrit van Honthorst
The Prodigal Son in Merry Company
Signed and dated 1622. Canvas, 130 × 196.5 cm.
Alte Pinakothek, Munich

good evidence that his work was esteemed. He reworked Caravaggio's strong chiaroscuro into night scenes by candlelight, which occasioned his nickname, Gherardo della Notte.

By 1620 Honthorst was back in Utrecht and enthusiastically at work. There was little call for the religious pictures that had largely occupied him in Rome; the spiritual climate in Holland was at its most severe, with the orthodox Calvinists holding sway, and Catholics and other religious communities deprived of much of their freedom. Since Honthorst could expect no commissions from the Reformed Church, he began to paint portraits and merry-company scenes, concentrating on pictures of revelry, music-making groups, and card or trictrac players. The figures are almost always portrayed half-length, and the scenes are often erotic though ostensibly biblical, as in *The Prodigal Son in Merry Company* (fig. 438).

Dirck van Baburen went to Rome in 1612, and, like Honthorst, was given commissions there; he returned to Utrecht at about the same time as Honthorst. One subject that both painters introduced into Utrecht with great success was the single half-length figure, often

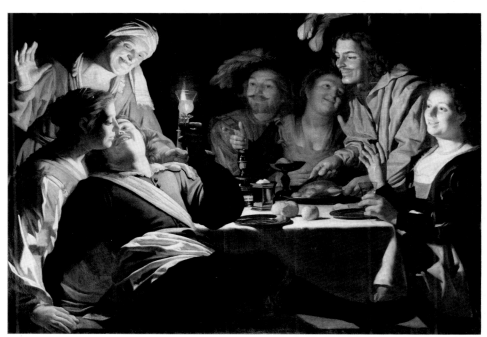

438

439

440

439 Gerrit van Honthorst
The Merry Fiddler
Signed and dated 1623. Canvas, 108 × 89 cm.
Rijksmuseum, Amsterdam

440 Hendrick Ter Brugghen
The Flute Player
Signed and dated 1621. Canvas, 71.5 × 56 cm.
Staatliche Kunstsammlungen, Kassel

441 Dirck van Baburen
The Procuress
Signed and dated 1622. Canvas, 101 × 107.3 cm.
Museum of Fine Arts, Boston. Maria
T.B. Hopkins Fund

442 Dirck van Baburen
Christ Crowned with Thorns
1623. Canvas, 106 × 136 cm. State Museum Het
Catharijneconvent, Utrecht

with a musical instrument (fig. 439). They had borrowed this idea from Bartolomeo Manfredi, whom they may have met personally in Rome. Such compositions are also found in Ter Brugghen's work after 1620, but his more refined color sense and better drawing ability led to paintings of exceptional quality, such as his *Flute Player* (fig. 440), while the works by Baburen and ultimately also Honthorst degenerated into banality and unpleasantness. The laughing faces of Baburen's figures stiffen into grinning masks, the colors harden, and the style becomes insensitive (fig. 441). This applies more or less to his entire later oeuvre, with such occasional exceptions as the *Christ Crowned with Thorns* of 1623 (fig. 442).

Baburen died in 1624, only a few years after his return to Utrecht. Honthorst still had a long life before him (he died in 1656) and, as we shall see later, achieved international recognition and fame. Jan van Bijlert and a few others continued to work in Utrecht in the style of Honthorst and Baburen, but the time of Caravaggism was past. Its significance, however, was acknowledged and its lessons learned by other painters, including Rembrandt, and in nearby Amersfoort a blending of Caravaggism with classical formalism took place in the work of Caesar van Everdingen and Paulus Bor (see p. 318).

441

442

443

444

Artistic life in Utrecht must have been very lively during the first quarter of the seventeenth century, and it was not wholly dominated by the Caravaggists. Wttewael continued to work in his Mannerist style, and Paulus Moreelse was in his prime, though in style and versatility he belonged to the older generation. Both of these artists died in 1638.

Moreelse was an architect and a poet as well as a painter. His history paintings, of which *The Beheading of John the Baptist* (fig. 443) is a good example, clearly reveal the influence of his stay in Italy at the turn of the century. In his portraits (fig. 444) he often imitated Anthony van Dyck's dashing line, but could not escape his own northern stiffness; his contours are more rigid and angular, and his painting style lacks van Dyck's suppleness. He patterned the composition after van Dyck, however, as well as the poses of the figures and their hands.

443 Paulus Moreelse
The Beheading of John the Baptist
Signed and dated 1618. Canvas, 132 × 172 cm.
Museu Nacional de Arte Antiga, Lisbon

444 Paulus Moreelse
Portrait of a Lady
Signed and dated 1627. Canvas, 117.5 × 95 cm.
Mauritshuis, The Hague

445 Roelant Savery
Vase of Flowers, Birds, and Reptiles
Signed and dated 1624. Panel, 130 × 80 cm.
Centraal Museum, Utrecht

445

446

446 Roelant Savery
Forest Scene with a Hermit
Signed and dated 1608. Copper, 20 × 16 cm.
Niedersächsische Landesgalerie, Hannover

447 Roelant Savery
Landscape with Many Kinds of Birds
Signed and dated 1622. Panel, 54 × 108 cm.
Národní Galerie, Prague

448 Gillis d'Hondecoeter
Orpheus Charming the Animals
Signed. Panel, 37 × 68 cm. Nationalmuseum,
Stockholm

Ambrosius Bosschaert and Balthasar van der Ast arrived in Utrecht in 1619 and continued their careers of painting still lifes of flowers, fruit, and shells. The landscape painter Roelant Savery took up the same subject matter and executed it more forcefully in his few known floral paintings (fig. 445). He too reached Utrecht in 1619, after much wandering, and remained until his death in 1639. A native of Flanders, Savery had gone to Amsterdam in his youth and trained there under his older brother, Jacob, and Hans Bol; perhaps he also became acquainted at that time with Coninxloo's landscapes. About 1604 he went to Prague, where Rudolf II commissioned him to make drawings of the Tyrolean landscape (fig. 446). Together with the animal studies he made in the emperor's famous zoo, these landscape sketches provided material for his later paintings, in which he combined his interest in birds and in landscapes (fig. 447). After the death of Rudolf II in 1612, Savery returned to Amsterdam, but was recalled to Vienna two years later by the new Holy Roman emperor, Matthias. He seems also to have worked in Munich and Salzburg, and perhaps other places. He came back to Holland in 1618. His later work is relatively coarse and offers few new ideas.

447

448

449

449 Adam Willaerts
 Dutch East Indiamen off the West African Coast
 Signed and dated 1608. Canvas, 94.5 × 214.5 cm.
 Amsterdams Historisch Museum, Amsterdam

450 Adam Willaerts
 Departure of English East Indiamen
 Signed and dated 1620. Panel, 64.3 × 105.5 cm.
 National Maritime Museum, Greenwich, London

451 Adam Willaerts
 View of Dordrecht
 Signed and dated 1629. Canvas, 181 × 670 cm.
 Dordrechts Museum, Dordrecht

The Flemish element, already fairly strong in Utrecht, was augmented by the arrival of Gillis d'Hondecoeter in the first years of the century and by Adam Willaerts somewhat later. Hondecoeter usually painted rocky landscapes abounding with animals; these works are graphic in treatment and always refined in color (fig. 448). His rendering of birds and animals, in particular, shows a clear affinity with Savery's work.

Adam Willaerts, like Hondecoeter a native of Antwerp, is recorded in 1611 as one of the founders of the Utrecht St. Luke's Guild. He painted seascapes and coastlines with fanciful rocky beaches. His earliest known work, depicting a Dutch East India fleet off the West African coast (fig. 449), dates from 1608 and is compositionally reminiscent of Vroom; it lacks that artist's perfect portrayal of ships, however, and is more variegated in color. Willaerts devoted himself more and more to beach and coastal views; the beach scenes are always filled with crowds of people, lending a strong narrative touch (fig. 450); the coastal views contain fantastic rocks and buildings. The narrative element also appears in more true-to-nature works, such as the huge *View of Dordrecht* of 1629 (fig. 451): all sorts of water-craft, including mussel boats, ferries, and timber rafts, ply about in the river that flows past the city; excitement is provided by the flaming naval vessel from which the crew leap overboard. Willaerts portrayed himself in a boat in the middle foreground.

During his long life—he died in 1664, aged eighty-seven—Willaerts altered his style very little, and the tremendous developments occurring in marine and landscape painting seem to have passed him by. His sons, Abraham and Isaac, also followed placidly in their father's footsteps.

Joost Cornelisz Droochsloot was probably born in Utrecht in 1586, but his work reveals unmistakable Flemish influence. He may have studied in Antwerp[24] or come in contact with David Vinckboons; his figures, at least, are strongly reminiscent of those in works by Vinckboons and Sebastiaen Vrancx. Droochsloot painted village scenes crowded with people; the action may include plundering (fig. 452) or a Bible story (see fig. 55). With only

450

451

452 Joost Droochsloot
The Plunder of a Village
Signed and dated 1626. Canvas, 65.5 × 148 cm.
Centraal Museum, Utrecht

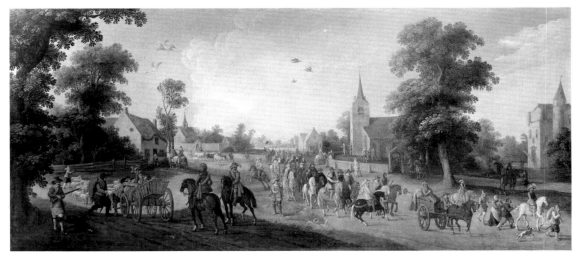

452

453

454

453 Jacob Willemsz Delff I
Self-Portrait of the Painter and His Family
c. 1594. Panel, 109 × 83.5 cm. Rijksmuseum,
Amsterdam

454 Michiel van Miereveld
Portrait of Jacob Cats, Grand Pensionary and Poet
(in the original frame)
Signed and dated 1639. Panel, 67.5 × 57.5 cm.
Rijksmuseum, Amsterdam. On loan from the
City of Amsterdam

a few exceptions, he worked according to a fixed plan that allowed but little variation. In 1623 he became dean of the Utrecht St. Luke's Guild, an office he again held in 1641 and 1642. From 1638 until his death in 1666, he was a regent of the Hiob (Job) Hospital.

Delft and The Hague: Seats of Court and Government

Portrait painters were in particular demand in The Hague and Delft, probably owing to the presence of the stadholder's court, the headquarters of the States-General, and foreign diplomats. The Hague had been the residence of the counts of Holland since the thirteenth century; after the revolt against Spain, it became the new Republic's administrative center. Its existence was threatened for a short time early in the war: still little more than an unwalled medieval village, it was extremely vulnerable and suffered badly in the critical years 1572–76 from onslaughts by both the Spaniards and the Sea Beggars. The government bureaus were moved to Delft, Amsterdam, and Utrecht; the sessions of the States-General and the States of Holland were held in the Prinsenhof in Delft, where William of Orange took up residence in 1572 (and was assassinated in 1584). Delft attempted to capitalize on this situation by proposing that The Hague, being indefensible, should be razed to the ground; the proposal was rejected. When the Spanish troops withdrew from Dutch soil, The Hague was honorably restored as the center of government. The judicial Court of Holland returned there in the spring of 1577, followed by the Exchequer and the States of Holland. In 1585 the States-General assembled once again in The Hague, and Prince Maurits took up residence in the stadholder's old quarters, the Binnenhof. And when things had settled down, people began to want their portraits painted.

Jacob Willemsz Delff I, who was born in Gouda about 1550, worked as a portrait painter in Delft from 1582 until his death in 1601. Some excellent portraits by him have been preserved, among them a portrait of his family (fig. 453), in which he included himself busy painting his wife, with his three sons standing beside him. Two of these sons—Cornelis and Rochus—became painters; the third, Willem, developed into one of the most talented engravers of his time.

Delff also painted civic-guard pieces, one of which, dating from 1592, still hangs in the Delft town hall. Unfortunately, its original quality cannot be determined from its present condition: it was damaged in 1654 when the Delft arsenal exploded and destroyed a large part of the town. The painter's grandson, Jacob Willemsz Delff II, undertook a restoration of the painting, without complete success.

The most productive portraitist around the turn of the century was undoubtedly Michiel van Miereveld. He was widely known and esteemed in his time; Constantijn Huygens praised him extravagantly: "Who he is, and how great he is, is wholly known not only in Delft, the Netherlands, Belgium, and Europe, but, I believe, in the whole world... for he renders the softness of flesh, which few can do, with a skill that can hardly be imitated."[25] Miereveld's portraits indeed possess great naturalness and simplicity; his handling of cloth textures and the metal of armor is very competent. His patrons were members of the Orange-Nassau court and the wealthy burghers of Delft and The Hague, such as Jacob Cats (fig. 454), but he also received commissions from notables of other cities in Holland. The demand for his portraits was so large that he soon established a workshop where his

456

455 Willem van der Vliet
Portrait of Suitbertus Purmerent
Signed and dated 1631. Panel, 113.5 × 85.4 cm.
The National Gallery, London

456 Jan van Ravesteyn
*Portrait of the Attorney Pieter van Veen with His Son
Cornelis and His Clerk, Hendrick Bosman*
Signed. Panel, 126 × 114.5 cm. Musée d'Art et
d'Histoire, Geneva

457 Jan van Ravesteyn
Portrait of a Botanist
Panel, 114 × 84 cm. Národní Galerie, Prague

458 Jan van Ravesteyn
Portrait of a Woman
Signed and dated 1641. Panel, 113 × 84 cm.
Národní Galerie, Prague

sons and pupils painted the accessories, after the master had painted the head and possibly the hands; they also made copies of his works. Prints were made of Miereveld's portraits, mainly by the engraver Willem Delff, son of the painter Jacob Delff I and Miereveld's son-in-law.

Despite its excellence, Miereveld's work had limitations. When he ventured beyond busts or three-quarter-length portraits, he was less secure, and his compositional talent appears weak in his extant group portraits. His strongest point was his ability to portray the closely observed, individual human face, without frills or affectation.

Willem van Vliet worked alongside Miereveld as a portrait painter in Delft; one of his best works is his portrait of Suitbertus Pumerent, rector of the Catholic church in the Begijnhof at Delft (fig. 455). He was surpassed in talent by two of Miereveld's pupils, Paulus Moreelse and Jan van Ravesteyn. We have already encountered Moreelse in Utrecht, where he made his career. Ravesteyn was a native of The Hague, and his work is livelier and more graceful than his master's. A particularly fine example is the triple portrait of the attorney Pieter van Veen with his son Cornelis and his clerk, Hendrick Bosman (fig. 456). Pieter van Veen, brother of the painter Otto van Veen, Rubens' teacher, was attached to the Court of Holland and also held the office of pensionary of Leiden and The Hague. His son

457

458

was born about 1595 and looks to be about twenty in the painting, so that it must date from before 1620. This type of portrait, in which the principal person is shown as instructor, was new in the Northern Netherlands. The theme had been used much earlier in Italy, by Sebastiano del Piombo among others.[26] Pieter van Veen, a man of erudition, may well have suggested the idea for the composition and content of this painting. Ravesteyn usually clung to more traditional compositions (figs. 457 and 458) and never again attained the originality of this portrait group. He continued to work in his birthplace until his death in 1657.

Two other portrait painters, Evert Crijnsz van der Maes and Joachim Houckgeest, were active in The Hague. Each of them painted a full-length portrait of a civic-guard ensign, and these pictures now hang in The Hague's Gemeentemuseum. Van der Maes's portrayal

459 Evert Crijnsz van der Maes
The Standard-Bearer of the Hague Civic Guard
Signed and dated 1617. Canvas, 200 × 103 cm.
Gemeentemuseum, The Hague

of the flag-bearer is remarkably strong (cpl. 459); it is a shame that so little of his work survives. His name, with the designation "painter," appears repeatedly in the municipal financial records. He was a pupil of Karel van Mander, traveled in Italy, and is listed from 1604 on as a member of the Hague St. Luke's Guild.

Daniel Mijtens, son of Antwerp emigrants, worked as a portraitist in The Hague from about 1610, when he was registered with the guild, to 1618, when he became court painter to James I of England. None of his works from his years in The Hague is known today. In

460 Daniel Mijtens
Portrait of Elizabeth Stuart, Queen of Bohemia
Canvas, 196.2 × 114.3 cm. English Royal
Collections. Copyright reserved

England he devoted himself to full-length court portraits of rather rigid formality. He kept up his contacts in Holland, returning for several months in 1626 and again in 1630. It is possible that during one of these visits he painted the portrait of Elizabeth, the Winter Queen, one of his best works of this period (fig. 460). His position at the English court was undermined by the arrival, in 1632, of the more gifted Anthony van Dyck, and he returned permanently to The Hague two years later. Mijtens assuredly played a role in the development of the court portrait in England, and in a sense he may be called the forerunner of van Dyck, but his contribution to Dutch art was small.

Only a few painters who worked on subjects other than portraits were of any significance in The Hague and Delft during the early 1620s. Cornelis Jacobsz Delff, son of the portrait

461

461 Cornelis Jacobsz Delff
Still Life with Food and Copper Vessels
Signed. Panel, 79 × 127 cm. Musée des
Beaux-Arts, Strasbourg

462 Bartholomeus van Bassen
Fantasy Interior
Signed and dated 1622. Panel, 64.7 × 97.7 cm.
Private collection

463 Bartholomeus van Bassen
*Fantasy Interior of the Nieuwe Kerk, Delft, with the
Tomb of William of Orange*
Signed and dated 1620. Canvas, 112 × 151 cm.
Szépmüvészeti Múzeum, Budapest

painter, produced kitchen paintings in the manner of Pieter Aertsen. Delff had an original
way of looking at things, and this shows up best in the paintings that feature the subtle glow
of copper vessels (fig. 461). Jacob de Gheyn II, a more exciting artist than Delff, continued
to work at his many projects. He painted relatively little, but produced many drawings that
rank among the best of the seventeenth century.

The Flemish painter and architect Bartholomeus van Bassen was active in Delft from
1613 to 1622. He then moved to The Hague, where between 1639 and 1650 he was a
member of the magistracy and held the position of municipal architect. He died in 1652. His
architectural work included designs for the Nieuwe Kerk on the Spui (see fig. 338) and for
the tower of the Hague town hall. He painted architectural fantasies that correspond to the
work of Paul Vredeman de Vries and the Antwerp painters Hendrick van Steenwijck the
Elder and the Younger. Van Bassen's interior views of imaginary palaces and rooms (fig.
462) were provided with figures by Esaias van de Velde, who had been living in The Hague
since 1618, and by Frans Francken of Antwerp, with whom he apparently kept in touch.
While parts of the architecture and the furnishings in these paintings are based on reality, the
surroundings are fantasized: van Bassen's rendition of the tomb of William of Orange in the
Nieuwe Kerk in Delft is quite accurate, but he places this monument in an architectural
space that is largely imaginary (fig. 463).

Esaias van de Velde, whose work has already been discussed (p. 185), was the only
important landscape painter in The Hague, although Adam van Breen also worked there for
some time. Van Breen's style is related to van de Velde's, but he seems to have followed
Avercamp in subject matter, especially in his ice scenes; his work is somewhat coarser and

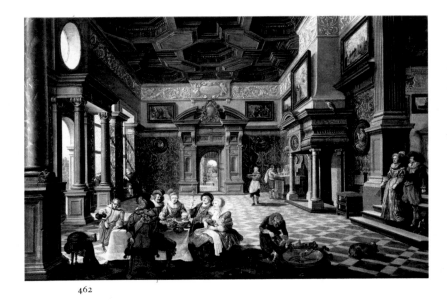

462

463

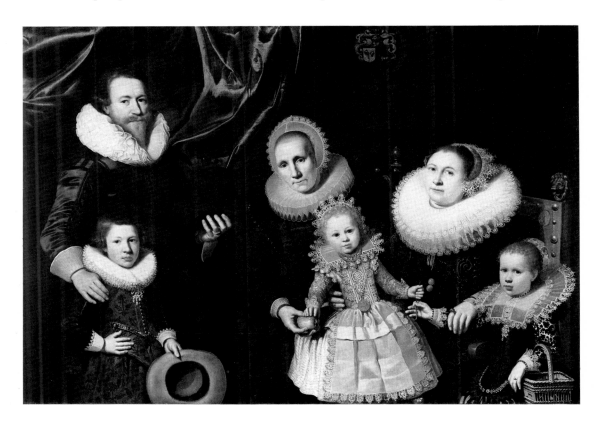

464 Adam van Breen
The Vijverberg, The Hague, in Winter, with Princes Maurits and Frederik Hendrik and Their Retinues in the Foreground
Signed and dated 1618. Panel, 71.5 × 133.5 cm.
Rijksmuseum, Amsterdam

465 Wybrand de Geest
Portrait of the Verspeeck Family of Leeuwarden
Signed and dated 1621. Canvas, 127.8 × 186.8 cm.
Staatsgalerie, Stuttgart

less subtle than Avercamp's. Figures are important in van Breen's paintings, and the view of the Vijverberg in The Hague, with Princes Maurits and Frederik Hendrik and their retinues taking a winter stroll, is an interesting example of a town view combined with potraiture (fig. 464). Van Breen's work is still insufficiently known for valid evaluation, and the information about his life is extremely scarce. He presumably left Holland for Christiania (Oslo) in Norway in the 1640s.

Leeuwarden: Capital of the North

Just as the stadholder's court contributed to the flowering of portraiture in The Hague and Delft, so the court of the Frisian branch of the Nassaus in Leeuwarden—which supplied the stadholder for Friesland, Groningen, and Drenthe—and the relative importance of the Frisian nobility proved a stimulus to portrait painters in the north.

Wybrand de Geest, who was born in Leeuwarden in 1592, was without doubt the most accomplished Frisian artist of his time. After studying with Abraham Bloemaert in Utrecht about 1614, he traveled to Paris, Aix-en-Provence, and Rome, where he was still living in 1618 and had been given the nickname "the Frisian eagle." Sometime later he returned to his birthplace, and in 1622 married Hendrickje Uylenburch, a distant cousin of Rembrandt's wife, Saskia; he was therefore not Rembrandt's brother-in-law, as is sometimes stated. De Geest had a prosperous and fruitful career as court painter for the Nassaus and as portraitist

466 Wybrand de Geest
Portrait of Wytze van Cammingha
Signed and dated 1634. Canvas, 200 × 126 cm.
Harinxma State, Beetsterzwaag, Netherlands

467 Wybrand de Geest
*Portrait of Sophia Vervou, Wife of Wytze van
Cammingha*
Signed and dated 1632. Canvas, 200 × 126 cm.
Harinxma State, Beetsterzwaag, Netherlands

of the Frisian nobility. His position was remunerative enough to allow him to make a collection of paintings, coins, and curiosa. He remained a Catholic, but that was apparently no drawback in his work for the Protestant Nassaus.

De Geest was a capable painter, by any standard. His 1621 portrait of the Verspeeck family (fig. 465) shows that, thanks to his training and traveling, he had freed himself from the stiff, rather impersonal style current in Friesland up to that time. The individual heads in this group portrait are vigorously painted, and the artist shows mastery of the compositional problems of arranging three adults and three children in a natural way. There is a trace of Flemish influence in the composition and painting style that suggests the work of Cornelis de Vos; de Geest may have stopped in Antwerp on his way home from Rome. He was able to achieve satisfactory results with full-length portraits of large and small format (figs. 466 and 467), a type of portrait seldom attempted in the Netherlands at that time. De Geest also painted very appealing children's portraits. He remained active until well past the middle of the century—he died in 1667—but in the long run his portraits lost much of the spontaneity and force so admirable in his earlier works.

In addition to de Geest, a number of other painters of lesser importance worked in Friesland, among them the Fleming Adriaen van der Linde, who was active in Leeuwarden before 1595 and died there in 1609, and Pieter Feddes, who had a prolific career as both painter and engraver.

Leiden: A Slow Beginning

It is remarkable that the city of Leiden took such a modest part in the development of Dutch painting during the first quarter of the seventeenth century and for some time to come. After its fruitful sixteenth century, when such artists as Lucas van Leyden, Aertgen van Leyden, and Cornelis Engebrechts and his sons worked there, one would expect the artistic activity to continue and perhaps to intensify, especially because Leiden was again prospering. The cloth industry, the most important means of livelihood since the fourteenth century, went into a decline about 1550, but after the siege of Leiden in 1574 it revived strongly. So many new workers poured in that the city had to expand in 1610 and, during the Twelve Years' Truce, became one of the most important textile centers of northern Europe. Economically, therefore, a favorable climate existed for the growth of painting.

The founding of the University of Leiden in 1575 might also be expected to have advanced a general interest in art. Scholars were attracted from near and far to positions on the faculty, and in the seventeenth century the university was one of the most popular in all

Europe for Dutch and foreign students. But the university emphasized the academic disciplines and had little apparent effect on art; the same is true of the other universities established in the Netherlands—at Franeker in 1585, Groningen in 1614, Utrecht in 1636, and Harderwijk in 1647. Most of the artists themselves seem to have shied away from university training.

The painter-burgomaster of Leiden, Isaac Nicolai van Swanenburgh, was born in 1538 and died in 1614; his last works fall just within the limits of the period here under discussion, but he belongs wholly to the older generation. He produced history paintings, portraits, and designs for stained-glass windows. The Leiden museum "De Lakenhal" (Cloth Hall) exhibits his series of six panels entitled. "The Old and the New Trade,"

468 Isaac Nicolai van Swanenburgh
Spinning, Shearing from the Warp, and Weaving
Between 1594 and 1606. Panel, 137.5 × 196 cm.
Municipal Museum De Lakenhal, Leiden

469 Jacob Isaacsz van Swanenburgh
Charon's Boat
Panel, 93.5 × 124 cm. Municipal Museum De Lakenhal, Leiden

depicting the change-over from the old to the new methods of manufacturing cloth; one panel is *Spinning, Shearing from the Warp, and Weaving* (fig. 468). Between 1582 and 1606, Swanenburgh filled many municipal posts, including that of burgomaster. His son, Jacob Isaacsz, is remembered today primarily for having been Rembrandt's first teacher. Jacob was trained by his father, then made an extended visit to Italy, returning to Leiden in 1617. Little of his work is still extant—only a few old-fashioned scenes of hell (fig. 469).

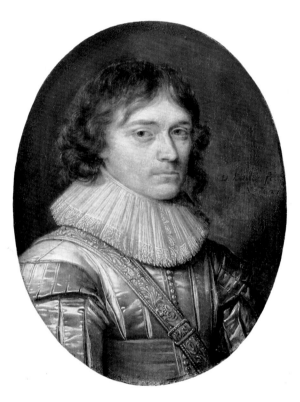

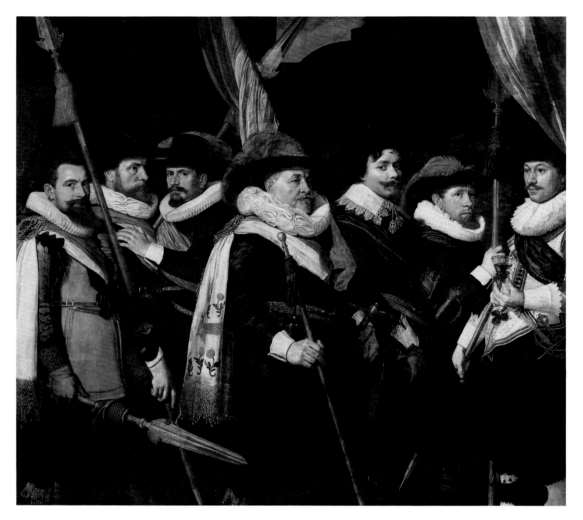

470 Joris van Schooten
The Civic-Guard Company of Captain Harman van Brosterhuyzen
Signed and dated 1626. Panel, 174 × 192 cm.
Municipal Museum De Lakenhal, Leiden

471 David Bailly
Portrait of Count Ulrik, Bishop of Schwerin
Signed and dated 1627. Panel, 15 × 11 cm. Det Nationalhistoriske Museum på Frederiksborg, Hillerød, Denmark

Leiden's best portrait painter was Joris van Schooten. His seven group portraits of the local militia can be seen today in the Lakenhal. In 1626 he agreed to portray, on panels supplied to him free of cost, the civic-guard officers and governors at the rate of twelve guilders per person. His results were competent enough (fig. 470), but he could not vie in composition or liveliness with what other painters of civic-guard portraits were producing at the same time in Haarlem and Amsterdam.

David Bailly, like van Schooten born in Leiden, was highly praised in his time as a portrait painter. He was a pupil of his father, Pieter Bailly, and perhaps also of Jacob de Gheyn II before going to Amsterdam about 1602 to study under Cornelis van der Voort. He then traveled through Germany and Italy, and settled down in his birthplace, where he died in 1657. What is now known of his work does not justify his great reputation in any way. He belonged to the generation from which innovation might be expected, but the portraits he painted and drew between 1620 and 1625 echo the style of his predecessors (fig. 471). His conservatism apparently appealed to his contemporaries.

Jan van Goyen, born in Leiden in 1596, was of major importance to the development of landscape painting. He received his first training from various Leiden painters, including Isaac van Swanenburgh. Thereafter he studied for some time under Willem Gerritsz in Hoorn, a Zuider Zee town north of Amsterdam. In 1615 or 1616 he traveled in France. Decisive for his development, however, was his stay, about 1617, in Haarlem, where his teacher was Esaias van de Velde, his elder by only five or six years. When van Goyen returned to Leiden about 1618, his work was clearly under Esaias' influence. He painted landscapes inspired by his own surroundings—ice scenes, village scenes, country roads—and used a lively, colorful palette (cpls. 472 and 473). The figures in these works are always doing something, and add a strong narrative element. Van Goyen became more original after 1625, and his further career (see p. 336) helped to shape the course of Dutch landscape art. He left Leiden about 1632 and settled in The Hague, where he spent the rest of his life.

The influence of Esaias van de Velde is also clear in the work of another of his Leiden pupils, Pieter de Neijn. The *Landscape with a Sandy Path* (fig. 474) shows de Neijn's interest in the Dutch landscape. He was also a sculptor of moderate talent and held the post of municipal stonemason in Leiden.

Between 1609 and 1625, Haarlem, Amsterdam, and Utrecht were the most important

472

473

472 Jan van Goyen
Summer
Signed and dated 1625. Panel, round, diameter
33.5 cm. Rijksmuseum, Amsterdam

473 Jan van Goyen
Winter
Signed and dated 1625. Panel, round, diameter
33.5 cm. Rijksmuseum, Amsterdam

474 Pieter de Neijn
Landscape with a Sandy Path
Signed and dated 1626. Panel, 28.3 × 44.8 cm.
Municipal Museum De Lakenhal, Leiden

474

centers of painting in the United Republic. Utrecht, strongly oriented toward Italy,
introduced Caravaggism into the Netherlands, yet the revival of art took place most clearly
in Haarlem, where pioneer work was done, especially in painting. So much happened in
Amsterdam, and so many painters of differing origins and ideas were at work there, that it
is virtually impossible to define cohesive units. Amsterdam was in the process of becoming
an international center, and its charms worked on painters like a magnet. As a result, new
directions and unexpected avenues opened up; artists of the next generation had much to
explore.

PART III

475 Bartholomeus van der Helst
Portrait of Andries Bicker
Signed and dated 1642. Panel, 93.5 × 70.5 cm.
Rijksmuseum, Amsterdam

The Republic of the United Netherlands: 1625–1650

When Prince Maurits died in 1625, aged fifty-eight and unmarried, the States of Holland, Zeeland, Utrecht, Gelderland, and Overijssel wasted no time in choosing his half brother Frederik Hendrik, seventeen years his junior, to succeed him as stadholder, captain-general, and admiral of the fleet. The change of stadholder marked the end of the most precarious and unsavory period of the young Republic. Civil war had been narrowly averted. Frederik Hendrik wished, like his father William the Silent, to hold himself above controversial issues and therefore, to the regret of the Remonstrants, never expressed himself unequivocally on the religious question. Yet his attitude was so much less antagonistic than Maurits' had been that the Remonstrants could come out of the hiding into which they had been forced after the Synod of Dordrecht in 1619 and begin to regain their former position in society. Up to 1626 they were still forbidden to hold services in Amsterdam, but the situation soon improved. Reinier Pauw had lost his power in municipal (and national) affairs, and the strong new voice in Amsterdam was that of the wealthy merchant Andries Bicker (fig. 475), elected burgomaster in 1627. Bicker was considerably more flexible in his religious views than his predecessor had been, and other men of liberal stripe won seats on municipal councils in Amsterdam and elsewhere. In 1630 the Remonstrant Church was officially reinstated.

The situation on the military front also improved. After the unfortunate years following the end of the Twelve Years' Truce, when Spanish forces were on the offensive and captured the important fortress of Breda, the Dutch army again began to book victories. Frederik Hendrik had been well trained in warfare by Maurits, and together with his cousin Ernst Casimir, stadholder of Friesland, he campaigned successfully along the eastern border in 1626. In 1629 he retook 's-Hertogenbosch in the south, winning for himself the sobriquet *Stedendwinger* (Conqueror of Cities); before he could disengage there, imperial troops from Germany joined with Spanish forces to raid deep into the Republic, but the Dutch captured the enemy supply depot, and local militias and citizens were able to hold out until help came. In 1632 Frederik Hendrik marched triumphantly through the Maas River valley, liberating Venlo, Roermond, and Maastricht.

Military action and foreign policy were more to the stadholder's liking than domestic affairs. Since the overthrow and execution of Johan van Oldenbarnevelt in 1618, first Maurits and now Frederik Hendrik had had enough power to ensure that the advocate of Holland was little more than a mouthpiece for the stadholder's policies. In 1631, however, a powerful personality gained this post: Adriaen Pauw, son of the redoubtable Reinier, but better educated and less biased, and unlike his father determined not to cater to Orange dreams of glory. His tenure as advocate of Holland was short; after three years he was shunted off to Paris as envoy extraordinary, and in 1636 the nationally beloved, wholeheartedly Orangist poet-moralizer Jacob Cats, who was actually trained in the law, succeeded to this high position and tractably held it until 1651.

The shift of Adriaen Pauw to Paris was not entirely unreasonable, for Frederik Hendrik and the States-General needed a good negotiator to confront Cardinal Richelieu, Louis XIII's canny adviser, with whom the Dutch were working out a special "offensive-defensive" pact: France was to declare war on Spain, with the conditions that the Southern Netherlands would be attacked simultaneously from north and south by Dutch and French armies respectively, and that the territories taken would be divided between them according to the prevailing language. That France at last agreed to fight openly against Spain was a

diplomatic and political victory for the Dutch, although Richelieu's motivation was less to help the Republic than to break the Hapsburgs and gain land and power for France. The alliance nevertheless changed the nature of the Dutch struggle for independence, for the war now broadened into an international conflict.

At first the combined Dutch-French actions seemed to be working, but the Spanish soon rallied, and no breakthrough could be made. In 1637 Frederik Hendrik retook Breda, but lost Venlo and Roermond. Then, in 1639, Philip IV of Spain, in disastrous emulation of his great-grandfather, Philip II, mounted a second armada to "tame" the north. The Dutch admiral Maarten Harpertsz Tromp forced the Spanish fleet to hole up in the Downs roadstead on the English coast opposite Calais; he then attacked and demolished it, despite English protests about his infringement of their territorial waters. This naval victory signaled the end of Spanish sea power, and another blow was delivered when the French, aided by Tromp, seized Dunkirk in 1646.

Financially, the pursuit of the war on land and sea was made possible by the vigorous growth of the Dutch economy, especially in the provinces of Holland and Zeeland. Granted that the merchant-regents were reluctant to share their profits; they had little choice, and they could afford it. In 1628 alone the Dutch West India Company provided enough to prop up the entire national budget and enrich its shareholders as well: operating under the war-endorsed license of *eerlycke kaepvaert* or "honest privateering," its fleet commanded by Admiral Piet Hein captured a Spanish treasure fleet carrying one year's production of silver from the Mexican mines, a prize worth approximately fifteen million guilders. This feat was never repeated, but lesser amounts of loot and booty offset to some extent the losses to Dutch shipping inflicted by "dishonest" buccaneers, such as the Dunkirk and Barbary pirates. The profits of the East India Company increased steadily, as did those of the basic Baltic trade and the local industries. The rise of the economy can be charted by the amounts the government spent on the war during its eighty-year course.

As the Republic became stronger, the Spanish empire weakened. In 1640 revolt broke out in Catalonia, and Portugal seceded from its sixty-year union with Spain and declared its independence. Harassed on all sides, Philip IV began to listen to his advisers, who recommended coming to terms with the Republic, and in 1641 preliminary peace talks were held in Cologne.

Frederik Hendrik's military and political successes and his affable personality gained him renown and popularity, and as his power in the Republic grew, so did his ambition. Using the pretext that the States-General was too large a body to guarantee secrecy in affairs of state, he began to deal with matters of great national importance in closed meetings with representatives carefully chosen by himself. His dynastic aspirations sometimes made him forget his father's model of impartiality. He persuaded the States-General in 1630 to name his three-year-old son, William II, general of the cavalry, and two years later to promise the boy the stadholdership, although this post was not hereditary. Then, with the help of that experienced schemer Maria de' Medici, who went to England after her triumphant visit to the Republic in 1638, he succeeded in arranging the marriage of William II to Mary Stuart, daughter of Charles I of England; the bridegroom was fifteen, the bride ten, when they were wed in 1641. Civil war would soon break out in England, and Frederik Hendrik felt natural sympathy for the members of the royal house. He also had four daughters, one of whom, he thought, would be just right for Charles, the prince of Wales. With this in mind, he gave more support than his position justified to the king's struggle with Parliament.

The Dutch merchants, sensing great danger to their commercial interests, vigorously opposed Frederik Hendrik's English policy. Yet it was not this policy alone that slowly but surely brought about a change in the attitude toward the stadholder. The treaty with France and the course of the war against Spain also displeased the powerful merchants. Military expenditures were enormous, and Holland, which had to provide more than half of the budget, began to clamp down. Frederik Hendrik, like all the Oranges, aspired to retake Antwerp, but the Amsterdammers feared that if he succeeded they would again be faced with a mighty rival. Things came to a head in the winter of 1643–44, when war broke out between the Danes and the Swedes over the Danish king's exorbitant tolls for passage through "his" Sound. Frederik Hendrik had no wish to take sides, needing money to finance his campaign in the south, in compliance with the pact with France. The cities

dependent on the Baltic trade, Amsterdam in particular, refused to vote him funds, insisting instead upon equipping a fleet to protect their interests in free passage of the Danish Sound. A compromise finally allowed the stadholder to meet his obligations, and the cities to send fifty ships to patrol the Sound and keep it open for trade.

Quite apart from his own ambitions, the stadholder could hardly please everyone, certainly not in matters of peace and war. Negotiations to end the war with Spain had so far failed, sometimes for rather curious reasons. The West India Company, for instance, did not want to give up its "right" to privateering, and its pious, profit-hungry shareholders agreed, the majority of them strict Calvinists from the lower middle classes who resisted every concession to the Catholics. Provincial rivalries were also involved, for Zeeland was the

476 Cornelis Beelt
The Proclamation of the Treaty of Münster on the Grote Markt, Haarlem
Signed. Canvas, 103 × 147 cm. Rijksmuseum, Amsterdam

chief promoter of the West India Company, whereas Holland merchants controlled the United East India Company. Then there were matters of protocol: the Dutch, as a sovereign state, demanded that its delegates be accorded the rank of ambassador during any negotiations, but the king of Spain still considered them his subjects, heretic rebels though they were, and refused to consent to this insubordination.

In 1643 new negotiations were opened in Münster among representatives of the king of Spain, the pope, the Holy Roman emperor, the king of France, and the States-General of the United Dutch Republic with the full accreditization they had demanded. Amsterdam was largely instrumental in getting the Dutch to the peace talks, for its regents yearned to get the war over and return to business. After five years of bickering and intrigue, terms were worked out, and on June 5, 1648, the Treaty of Münster was signed; Gerard Ter Borch made a painting of the ratification ceremony (see cpl. 857). The Eighty Years' War was over. The province of Zeeland and the city of Leiden, bulwarks of extreme Calvinist orthodoxy, ostentatiously did not participate in the general rejoicing. Yet the occasion was also solemn, as Cornelis Beelt's painting of the treaty's proclamation on the Grote Markt in Haarlem shows (fig. 476). Frederik Hendrik was not there to participate: he had died on March 14, 1647.

The seventy-nine articles of the peace treaty were advantageous for the Republic. The king of Spain swore to recognize the United Netherlands as a free and sovereign state. Borders were to be drawn along territories presently held. Spain was excluded from all shipping to and from areas captured by the Dutch in the East and West Indies. The Schelde was to remain closed to shipping. Religious matters were to be regulated by the Dutch government "in all morality, without giving any scandal." These articles and the self-confidence of the Dutch throughout the successful negotiations assured that the Republic now belonged among the great European powers.

Painting in Haarlem: 1625–1650

Frans Hals and Other Portrait and Figure Painters

During the first quarter of the seventeenth century Haarlem held its lead in the development of painting and the graphic arts in Holland, but about 1625 this situation began to change. Haarlem was overshadowed by Amsterdam, which increasingly attracted artists from elsewhere and soon drew important artists away from the older center. Haarlem nevertheless maintained its high rank in certain fields: portraiture, landscape painting, and still lifes. Its history painters developed an international style based on the work of the older generation, especially Goltzius and Cornelis Cornelisz, and they were praised by their contemporaries and invited to decorate important buildings throughout the Republic. But any discussion of painting in Haarlem in the second quarter of the seventeenth century must begin with the work of Frans Hals.

In 1624 Hals painted a portrait of a young man, aged twenty-six, now known as *The Laughing Cavalier* (cpl. 477), although he is faintly, provocatively smiling rather than laughing. Brilliant in color and execution, direct and lively in facial expression and pose, this portrait can hardly fail to impress and delight every viewer. The face is painted quite smoothly, but the flesh tones defining its structure are applied in clearly separate brushstrokes. Eyes, eyebrows, and the jaunty moustache and little goatee are rather precisely detailed. The head is excellently modeled and well worked out, the black hat a jutting dark mass against the background yet wholly plastic in its evocative contour. The layered collar is a small masterpiece of brushwork, with countless little crisscross strokes of white on an

477 Frans Hals
The Laughing Cavalier
Dated 1624. Canvas, 86 × 69 cm. The Wallace Collection, London

ivory ground, set off by the black tie and the broad, slightly diagonal swath of sash, seemingly executed in one swift, faultless rush of painting. The highlights of the lustrous cloth are painted with vigorous strokes. The slashed sleeve, embroidered with all sorts of love emblems,[1] is a riot of color: gold-ocher, yellow, red, white, and a little green. In the turned-back cuff there are several strong touches of red.

The genius of Frans Hals becomes fully clear when we recall what was going on elsewhere in Dutch portraiture at this time. Neither Eliasz nor de Keyser in Amsterdam, Miereveld in Delft, nor Ravesteyn in The Hague could touch his brushwork, vivacity of expression, or composition. Hals's uniqueness lay in his ability to combine his compositional, pictorial, and colorist talents into a functional whole.

478 Frans Hals
Banquet of the Officers of the St. Adrian Civic-Guard Company, Haarlem
Signed. 1627. Canvas, 183 × 266.5 cm. Frans Hals Museum, Haarlem

479 Frans Hals
Banquet of the Officers of the St. George Civic-Guard Company, Haarlem
1627. Canvas, 179 × 257.5 cm. Frans Hals Museum, Haarlem

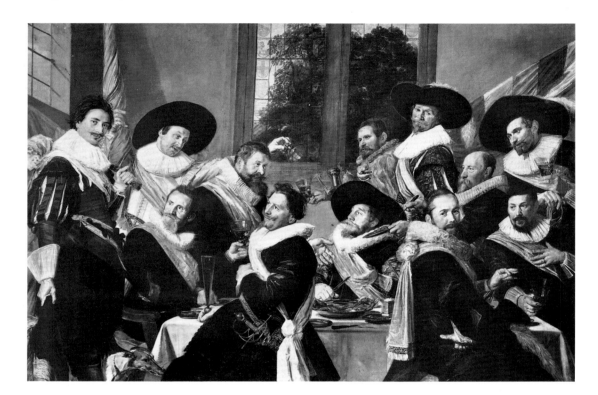

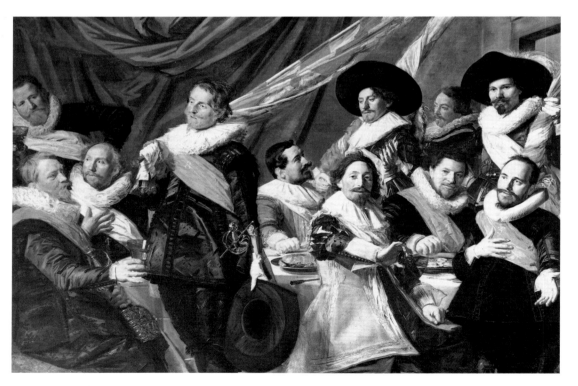

About 1627 he completed two civic-guard paintings: the officers of the arquebusiers' or St. Adrian company (fig. 478) and those of the archers' or St. George company (fig. 479). The first is a little less smooth in brushwork than the second, but more formal in composition, with strongly accentuated diagonals dividing the men into two triangular groups. The officers of St. George, placed compactly in their framework, arouse a stronger feeling of closeness, while their grouping in the less pronounced compositional scheme has great natural animation. There is a striking difference between these two militia paintings of

1627 and Hals's next one (fig. 480), dating from 1633 and again commissioned by the officers of the arquebusiers' company. The strong diagonals here enhance but do not dominate the general horizontality of the composition, and the colors are more subdued. But the painting style and the individualized heads have not changed.

Hals's last civic-guard painting (fig. 481), thought to date from 1639, is something of a disappointment compared with the earlier works. The men are positioned in two rows, much like those in the Amsterdam civic-guard paintings by Nicolaes Eliasz, for example. The figures are excellently painted, yet Hals seems to have lost or abandoned his masterly interrelationships that unified the whole. The landscape and buildings in the background are drab and were perhaps painted by another hand.

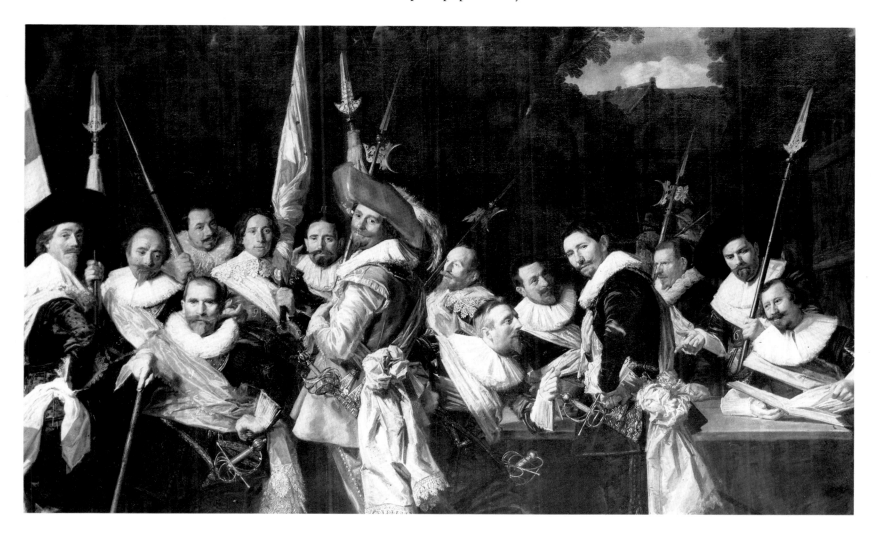

480 Frans Hals
 Officers and Subalterns of the St. Adrian Civic-Guard Company, Haarlem
 1633. Canvas, 207 × 337 cm. Frans Hals Museum, Haarlem

481 Frans Hals
 Officers and Subalterns of the St. George Civic-Guard Company, Haarlem
 c. 1639. Canvas, 218 × 421 cm. Frans Hals Museum, Haarlem

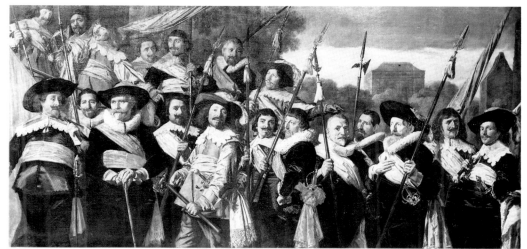

Frans Hals achieved fame with his civic-guard paintings. Not only did artists in other cities take up his example—see for instance the *Civic-Guard Banquet of Captain Jacob Backer* by Nicolaes Eliasz (see fig. 579)—but in 1633 Hals himself was invited to paint a group portrait of an Amsterdam militia company (fig. 482). This was an unusual turn of events, for Amsterdam had ample painters experienced in this field, and local guild regulations placed a virtual ban on outsiders.

482 Frans Hals and Pieter Codde
The Company of Captain Reynier Reael
Dated 1637. Canvas, 209 × 429 cm.
Rijksmuseum, Amsterdam. On loan from the
City of Amsterdam

Hals's Amsterdam patrons had no doubt made the right choice, but later they must have regretted it. The painting was not completed for four years, and then not even by the master himself. This long-dragged-out commission, like a tug of war between patrons and artist, had one great advantage for posterity: both parties hired notaries to press their claims and counterclaims, and the documents have been preserved, giving us invaluable and extremely rare insight into seventeenth-century customs and working methods.[2]

Three years after its commission, the painting was far from finished, and on March 10, 1636, Captain Reynier Reael and Lieutenant Cornelis Michielsz Blaeuw appeared before the Amsterdam notary F. Bruyningh to register their complaint. They demanded that Hals come to Amsterdam within fourteen days to complete the picture, or they would engage another painter in his place. Hals, sick in bed with a sore leg, gave his answer to the Haarlem notary Egbert van Bosvelt on March 20: he had wanted to paint the picture in Haarlem, but had finally agreed to begin it in Amsterdam and finish it in Haarlem, "the same which he had also begun to do, and also would have completed had he been able to get the persons together." But he had failed in this and wasted much time because he could not work at home, and it had also been very expensive because he had to stay at an inn in Amsterdam. If the gentlemen would come to Haarlem, he would finish the painting without further delay "with greater pleasure in Haarlem than in Amsterdam, since he would be at home and with his people and could keep an eye on [them] as well."

On April 29 the Amsterdammers sent an indignant reply: it was true that the original agreement had been for Hals to begin in Amsterdam and finish in Haarlem, for which the fee of sixty guilders per portrait was set, but Hals had later agreed, for an additional six guilders per person, to do the whole work, "both of bodies and faces," in Amsterdam. If he was now prepared to come to Amsterdam within ten days—he need answer only Yes or No—then everyone would at least know where they stood.

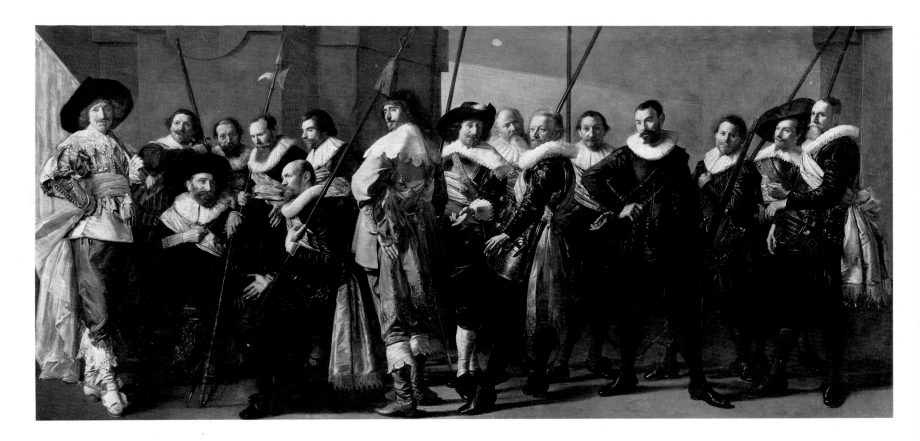

483

484

485

483 Frans Hals
Laughing Boy with Wineglass
Panel, round, diameter 38 cm. Staatliches
Museum, Schwerin

484 Frans Hals
Laughing Boy with Flute
Panel, round, diameter 37.5 cm. Staatliches
Museum, Schwerin

485 Frans Hals
Malle Babbe
Canvas, 75 × 64 cm. Gemäldegalerie, Staatliche
Museen, West Berlin

Hals's answer did not arrive until July 26. He stuck obstinately to his first statement, adding that "he would be pleased to fetch the piece of painting...from Amsterdam and take it to his house, in order first to complete the unpainted clothing; and the same having been done, to paint the faces of the persons willing to come to Haarlem, to his house," because it would take such a short time to do the portraits; and should there be six or seven persons who could not come to Haarlem, he would be willing, because the painting would by then be nearly finished, to complete it in Amsterdam.

Regrettably, here the notarial correspondence ends. What happened next? We know only that Gerard Schaep, who described the paintings in the three Amsterdam *doelens* in 1653, had this to say: "Above the fireplace, Capⁿ Reynier Reael, Lut. Corn. Michielsz Blau aº 1637 painted by François Hals and afterward finished by Codde."[3] The Amsterdam militiamen and Hals presumably never reached an agreement, and the local painter Pieter Codde was found willing to take over Hals's job.

In composition, the picture is wholly the work of Hals, but it is noteworthy that he, presumably in accordance with his patron's wishes, adapted himself to the Amsterdam practice of portraying the figures at full length, in contrast to the usual Haarlem preference for three-quarter length. The result is reminiscent of the militia painting of 1588 by Cornelis Ketel (see fig. 186), who first depicted his models at full length. Apart from the composition, it is difficult to distinguish the portions painted by Hals from those by Codde, who apparently followed Hals's style as closely as possible.

During the 1630s Frans Hals painted a number of single-figure, "character" compositions. Many such paintings are attributed to him, though some should undoubtedly be removed from his oeuvre, for his pupils and later imitators were particularly fond of using these as their models,[4] and they occasionally achieved remarkably Hals-like results. In consequence, there is an unduly large number, for example, of fisher-children and of heads of laughing children. Two small round panels, depicting a boy drinking and a boy with a flute (figs. 483 and 484)—probably representing taste and hearing in a series of the five senses—must in any event be ascribed to Hals. He permitted himself greater technical freedom with such subjects than with his portraits. Perhaps freest of all is his rendition of *Malle Babbe* or Crazy Babbe (fig. 485), a woman apparently known as the witch of Haarlem.[5] The owl perched on her shoulder can be a symbol of demonic powers as well as a play on the folk saying "Drunk as an owl." Hals has inimitably shown this woman in her exuberant wildness; his darting, almost frenzied brushstrokes contribute in large measure to this effect. After 1640 Hals worked exclusively as a portraitist and the "character" pictures disappear from his oeuvre.

Among the portrait painters in Haarlem, Hendrick Pot and Johannes Verspronck were most indebted to Frans Hals. In his large-scale paintings, Pot tried to imitate Hals's technique, an attempt especially noticeable in his militia painting of about 1630 (see fig. 376). Pot was, however, a very changeable painter in the quality of his work and his choice of subject. His small, almost miniature portraits are sometimes surprisingly good. He worked from 1631 to 1633 at the English royal court, and in those years painted the remarkable portrait group in small format of King Charles I, Queen Henrietta Maria, and the infant Charles, prince of Wales (fig. 486), looking rather wee and forlorn in a room richly hung with draperies. Pot

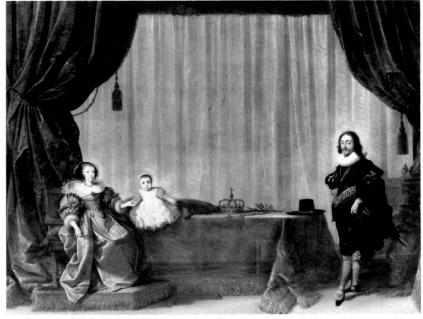
486

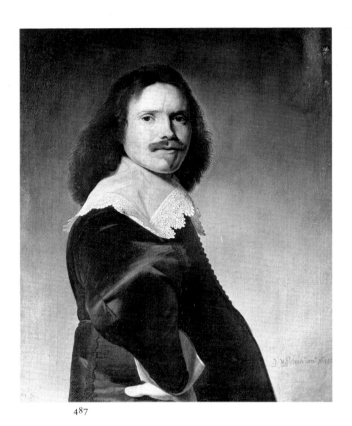
487

486　Hendrick Pot
Charles I, Henrietta Maria, and Charles, Prince of Wales
1632. Panel, 47 × 59 cm. English Royal Collections. Copyright reserved

487　Johannes Verspronck
Portrait of a Man
Signed and dated 1641. Canvas, 84.2 × 67.2 cm. Szépmüvészeti Múzeum, Budapest

488　Johannes Verspronck
Regentesses of the St. Elizabeth Hospital, Haarlem
Signed and dated 1641. Canvas, 152 × 210 cm. Frans Hals Museum, Haarlem. On loan from the Elisabeth van Thüringen Fund

also painted history pieces and biblical scenes. About 1648 he settled in Amsterdam, where he died in 1657.

Johannes Verspronck, a stronger personality and a more talented portraitist than Pot, lacked Hals's spontaneity and technical daring. He painted with some caution, yet his heads are always lively and plastic (fig. 487). Characteristic of his style is the application of a grayish glaze—a thin, almost transparent layer of paint—on the shaded side of the face, with blue-gray touches to highlight the nose and lips. The gleaming black clothing worn by most of his models is always painted with great subtlety, the often playful contour line dark against the usually light-gray background. Verspronck combined refinement with great animation, qualities which justified his high repute among his contemporaries and brought him increasingly better commissions. One of his best portrait groups is the *Regentesses of the St. Elizabeth Hospital* of 1641 (fig. 488). The subtly blended background grays set off the blacks of the dresses, the flesh color of the heads, the white of the "millstone" ruffs, and the green of the tablecloth. Its serene atmosphere, controlled composition, and skilled method of painting make this one of the most attractive group portraits in Dutch art.

Frans Hals undoubtedly influenced the style of his younger brother and pupil, Dirck Hals, but Willem Buytewech contributed more to Dirck's development as a painter. This is apparent in Dirck's choice of subject matter—merry companies in an interior or in parklike

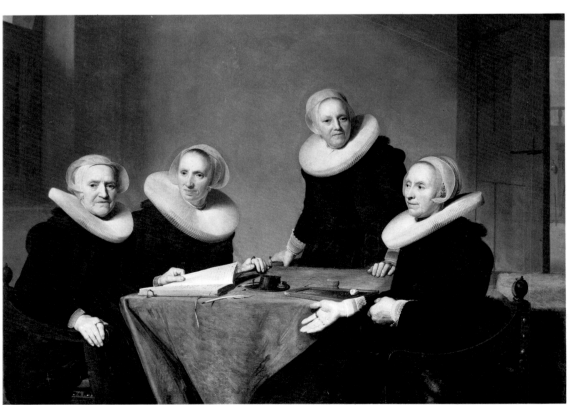
488

234

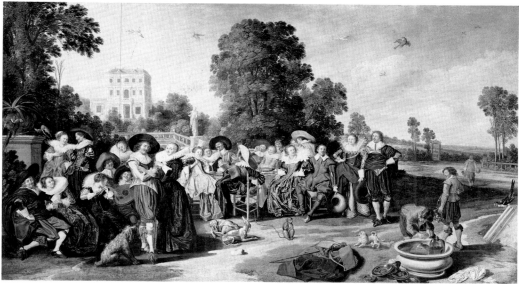

489

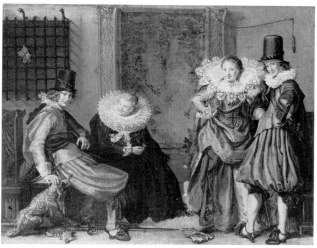

490

489 Dirck Hals
The Garden Party
Signed and dated 1627. Panel, 78 × 137 cm.
Rijksmuseum, Amsterdam

490 Willem Buytewech
Dignified Couples Courting
Canvas, 56 × 70 cm. Rijksmuseum, Amsterdam

surroundings—and in the figures he regularly borrowed from Buytewech's work. The woman standing between the two men at the right in his large *Garden Party* (fig. 489), now in the Rijksmuseum, and the dog in the left foreground are taken almost literally from Buytewech's *Dignified Couples Courting* (fig. 490). In composition, especially in his early work, Dirck Hals is also linked to Buytewech.[6] His painting style, however, is less graphic, his brushwork smoother.

The merry company paintings, whether set indoors or out, were not realistic glimpses of seventeenth-century people amusing themselves. Details in Dirck Hals's work frequently indicate that these paintings conveyed a hidden warning. Thus, the little monkey eating a piece of fruit in the center foreground of *The Garden Party* symbolizes naughtiness and shamelessness. This is not to say that all the elements in this or similar paintings are symbolic or imaginative; many are true to nature, and some of the persons depicted are very likely portraits of real people. Dirck Hals's large *Garden Party*, painted in 1627, is one of the high points of his career; his later work is often weaker and less spirited.

The portrait group blended with a symbolic scene often occurs in the work of another of Frans Hals's pupils, Jan Miense Molenaer, born in Haarlem about 1610. The assumption that he worked in Hals's studio is borne out by a number of early works containing rather large half-length figures. Molenaer ranged widely in subject matter, and the quality of his work fluctuates. His *Allegory of Marital Fidelity* of 1633 (fig. 491) exemplifies the combination of a company scene with a portrait group, the whole comprising a moral. It has been convincingly argued that this picture is a sort of marriage mirror for the young couple at the right.[7] The virtue of moderation or temperance is personified by the man in the center background raising a jug to water his wine, and illustrated by the musicians playing in concordance; and fidelity is symbolized by the dog. There are also vices to be avoided: quarreling, represented by the fighting men in the left background; immoderation, the *kannekijker* or drinker looking into an empty pitcher; and fleshly sin, symbolized by the chained monkey clasping a cat.

The more closely Molenaer's work is examined, the more evident becomes the hidden symbolism that is almost always present. The music-making family group (fig. 492), a magnificent painting showing Molenaer at his best and containing a wealth of information about seventeenth-century musical instruments, is full of double meanings.[8] The allusions to transiency—the bubble-blowing little boy; the clock hanging amid ancestral portraits, in themselves a *memento mori*—are clear, as is the allusion to Justice in the low-relief figure at the base of the column at the right.

In his later work, Molenaer concentrated on paintings of peasants and simple folk, without doubt inspired by Adriaen Brouwer and Adriaen van Ostade. Little scenes that at first glance seem to be everyday incidents again turn out to have specific meanings. One such instance is his series of the five senses (see figs. 89–93): each individual picture might not be recognized as one of the senses, yet all taken together make the intention unmistakable. There has not yet been enough research into how much specific meaning the seventeenth-century viewer normally read into "ordinary" peasant pictures and inn scenes. Molenaer's work would be extremely suitable for such a study.

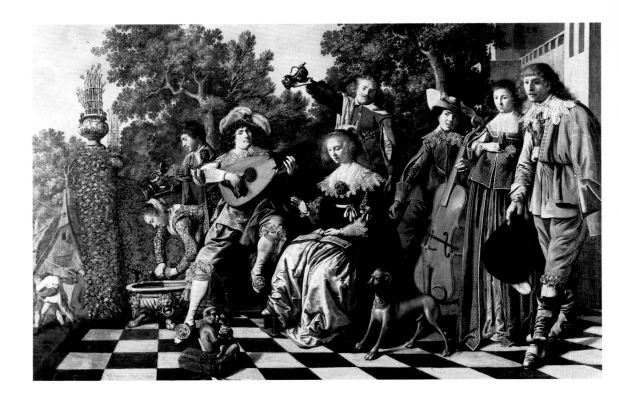

491 Jan Miense Molenaer
Family on a Terrace. Allegory of Marital Fidelity
Signed and dated 1633. Canvas, 98 × 140 cm.
Virginia Museum of Fine Arts, Richmond. Gift
of Mrs. A.D. Williams, 1949

492 Jan Miense Molenaer
Family Making Music
c. 1635–36. Canvas, 62.5 × 81 cm. Frans Hals
Museum, Haarlem. On loan from the
State-owned Art Collections Department

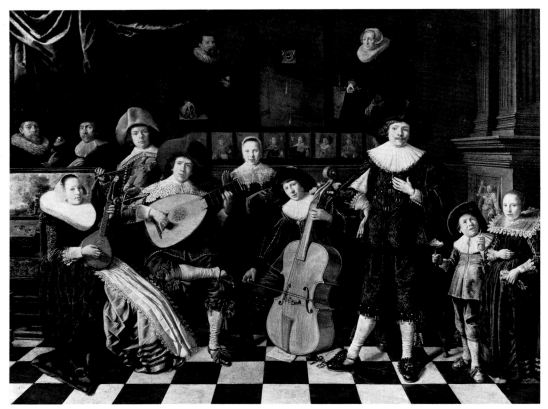

In 1636, when both of them were twenty-five, Jan Miense Molenaer married Judith
Leyster, daughter of a Haarlem brewer who had emigrated from Antwerp and who took
his name from the brewer's mark, the *Ley-ster* or lode-star. Judith herself used this mark in
the monogram with which she usually signed her works. There were few women painters
in the early seventeenth century, yet Judith Leyster merits attention not only as an
exceptional case but for the quality of her work. Her earliest paintings suggest that she may
have studied under one of the Utrecht Caravaggists, perhaps Hendrick Ter Brugghen about
1628, the year she painted a *Democritus and Heraclitus* that is closely related to
contemporaneous paintings on that theme by Ter Brugghen. Such an apprenticeship is
possible, for she is known to have been precocious, and her parents, who were forced to sell
their brewery in 1625, are recorded in Vreeland, a few miles from Utrecht, in 1628.

The next year the family moved again, to Zaandam near Haarlem, and Judith became a
pupil of Frans Hals. Her paintings at that time show his strong stylistic influence. After her
marriage, she and her husband worked closely together, and some of their paintings are
almost indistinguishable. In 1637 the Molenaers bought a house in Amsterdam, where they
presumably lived until 1648, when they moved back to the neighborhood of Haarlem.

493 Judith Leyster
Boy Playing a Flute
Signed. c. 1630–35. Canvas, 73 × 62 cm.
Nationalmuseum, Stockholm

494 Judith Leyster
Tulip
Watercolor, from *Tulip Book*, 1643. Frans Hals
Museum, Haarlem

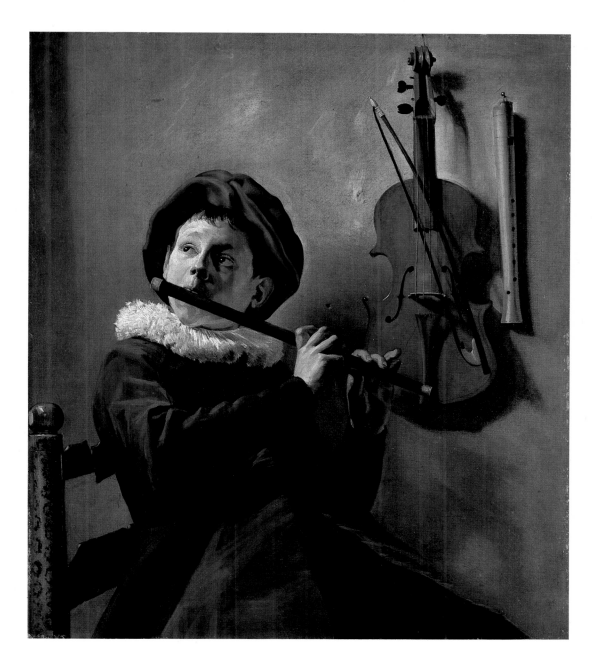

One of the most attractive of Judith Leyster's works is *Boy Playing a Flute* (cpl. 493). Probably painted in the early 1630s, it still clearly shows the Utrecht influence. The artist handles light with great sensitivity, and her brushstroke is assured. Her later work is characterized by small interior scenes, often painted with considerably less brilliance than the earlier works. Judith Leyster's wide interests led her also to paint portraits, still lifes, and floral pieces. Some of her beautifully executed watercolors of flowers have been preserved (fig. 494), and an inventory drawn up at the time of her husband's death, in 1668, indicates that she also made oil paintings of flowers. No dated works by her are known after 1652, and she died eight years later.

Adriaen Brouwer and the Ostades

The depiction of "peasants," an all-inclusive term used to designate the poorer levels of the population, whether peasants or not, was originally a Flemish theme popularized by Pieter Bruegel the Elder, and continued in Amsterdam by the Fleming David Vinckboons. The peasant scenes which his fellow countryman Adriaen Brouwer introduced in Haarlem, however, were distinctly different in character, not simply a continuation of the older Flemish tradition.

Brouwer's role in Haarlem is difficult to estimate accurately, because he never dated his works and little is known about his life. He was born about 1606 in Oudenaarde, an old Flemish weaving town south of Ghent, and received his first instruction from his father, who made cartoons for tapestries. On the basis of Houbraken's biography of Brouwer,[9] which is otherwise not entirely to be trusted, it is thought that he arrived, a trained painter, about 1623 or 1624 in Haarlem, where he presumably worked for some time in Frans Hals's studio. He seems then to have lived in Amsterdam, but he is again mentioned, in 1626, as a

member of the Haarlem chamber of rhetoric *De Wijngaertranken* (The Vine Tendril), to which Frans Hals also belonged. By the winter of 1631–32, Brouwer was back in Antwerp, where he joined the guild. Though his stay in Holland was relatively short, his presence had great significance there. His own way of painting changed drastically, and, with his themes drawn from peasant life (fig. 495), he brought to Dutch art a new element which found many followers, particularly in Haarlem.

The change in his painting style probably resulted less from Hals's direct influence than from Brouwer's response to general tendencies. He exchanged the bright, clear colors of his early work for a more subdued yet vibrant palette, dominated by grays and browns, while his treatment of light developed toward strong contrasts—two stylistic trends that were quite prevalent in that period, above all in Haarlem.

The telling individualization of the figures in Brouwer's pictures of peasants smoking, drinking, and fighting influenced the Haarlem painters, particularly the brothers Adriaen and Isack van Ostade. The two Adriaens may have met at Frans Hals's studio, where—according to Houbraken—they were fellow pupils. In any event, Brouwer's influence on Ostade's early work is so evident that they must have known one another. Yet Brouwer's was not the only influence. The painters of "merry companies" contributed also, and Ostade's choice of theme was perhaps influenced to some extent as well by literary trends toward showing the pugnacity and carousing of country people as at once attractive and repulsive—as Bredero, among others, portrayed them.[10]

Rather wild inn scenes, with a lot of fighting, predominate in Adriaen van Ostade's early work, painted during the 1630s. The color scheme is not yet exciting; besides browns and grays, he used a bit of pale red, purple, and blue. Soon, however, strong contrast of light and dark become important in his compositions. The question of whether Rembrandt's influence[11] may be at work here cannot, in my opinion, be answered forthwith; there were tendencies toward using chiaroscuro outside the immediate Rembrandt sphere. An example of Ostade's strong contrasts is a painting dated 1635 showing reveling peasants in a barnlike interior (fig. 496). The vivid lighting of the main group in the otherwise murky space and the strong *repoussoir* formed by the objects in the left foreground are typical of this period.

After about 1640 Ostade's compositions become calmer, the light warmer. Rembrandt's influence can now be traced with more certainty. One of Ostade's rare biblical pictures, *The Angel Appearing to the Shepherds* (fig. 497), which can be dated about 1640, would be unthinkable without Rembrandt's 1634 etching on the same theme (see fig. 601). During

495

496

495 Adriaen Brouwer
The Village Doctor. The Sense of Touch
Panel, 23 × 20 cm. Alte Pinakothek, Munich

496 Adriaen van Ostade
Peasants Carousing
Signed and dated 1635. Panel, 21 × 24 cm.
Hessisches Landesmuseum, Darmstadt

497 Adriaen van Ostade
The Angel Appearing to the Shepherds
Signed. c. 1640. Panel, 69 × 55 cm. Herzog Anton
Ulrich Museum, Brunswick, West Germany

497

498 Adriaen van Ostade
Landscape with an Old Oak
Signed. Shortly before 1640. Panel, 34 × 46.5 cm.
Rijksmuseum, Amsterdam

499 Isack van Ostade
Interior with a Slaughtered Pig
Signed and dated 1639. Panel, 44 × 67 cm.
Bayerische Staatsgemäldesammlungen, Munich

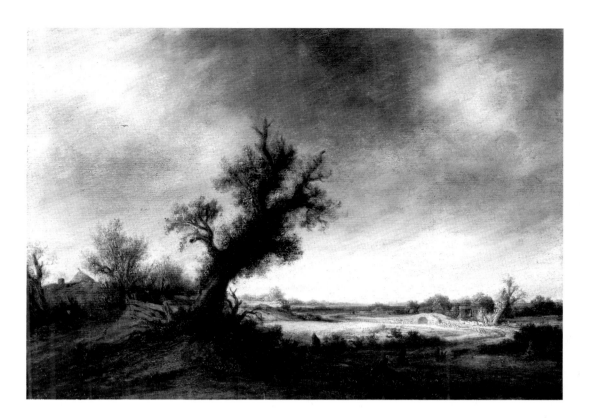

the early 1640s Ostade also painted several landscapes in the monochromatic mode of the Haarlem landscapists;[12] the *Landscape with an Old Oak* (fig. 498) is the most successful of these. His brother Isack had much greater interest in the subject of landscape, however, and this may have contributed to Adriaen's relatively brief attempt at it. Adriaen's later development, which took a definite turn after 1650 and included his major work as an etcher, will be discussed in Part IV (see p. 388).

Isack, ten years Adriaen's junior, initially followed his brother in subject matter, and produced a number of peasant interiors, including one showing a slaughtered pig (fig. 499). Then, striking out on his own, he combined his sensitivity to nature with acute observations of people in his landscape paintings. But we must first look back at the older Haarlem landscapists before examining Isack's work in this field.

Landscape Painters

We have seen that two subjects of utmost importance to Dutch painting—landscape and still life—arose and flourished in Haarlem during the first quarter of the seventeenth century. Nor was there any slackening of interest in landscape painting despite the early departure of three of the ablest landscape painters, Hercules Segers, Esaias van de Velde, and Jan van Goyen.

Even before van Goyen, Pieter de Molijn had heralded a new phase in landscape art. He joined the Haarlem St. Luke's Guild as early as 1616, though no dated paintings by him are known before 1625, while his earliest dated landscape is from 1626 (fig. 500). This painting

has a strong diagonal accent, punctuated by the upward-thrusting trees. A bright light falls on the country road and the sandy hillocks at the right, throwing them into contrast with the slash of brown in the left foreground and the dune sloping up behind the fence. Abraham Bloemaert's landscapes, known in Haarlem at least through prints, may have influenced this composition, but it remains one of the earliest impressions of nature in which the atmosphere plays a role so important that the designation of tone painting is justified. A landscape by Pieter Santvoort dated 1625 (fig. 501) has similar characteristics. Santvoort worked in Amsterdam and died there in 1635; few of his paintings seem to have survived, and he probably made little contribution to subsequent landscape painting. Molijn, on the contrary, did. The rendering of weather conditions was a critical factor in his early work. His palette at first was limited; later he used more green, strengthening the foliage in his landscapes and diminishing the strong light effects; the cloudy skies become friendlier and less dramatic; the human and animal figures are intrinsic to the peaceful scene (fig. 502), though sometimes he livens things up with a sudden highway robbery. Molijn was also important as a draftsman, producing a large number of signed and dated chalk drawings which he evidently considered as independent works of art. In his drawing style he is closely related to Jan van Goyen.

Born a few years before Molijn, Cornelis Vroom, son of the sea painter Hendrick Vroom, is not mentioned in the Haarlem archives as a painter until 1621. Without doubt he studied under his father: his first known works are pictures of sea battles. The earliest of these, now in the National Maritime Museum at Greenwich, London, is dated 1615 (fig. 503). This painting makes clear that Cornelis was no slavish follower of his father. Shortly after 1620 he must have begun to paint landscapes exclusively, and one of his first, with an imaginary Roman ruin standing at the edge of what appears to be a broad river (fig. 504), already shows his sensitive rendering of trees. The influence of both Elsheimer and Esaias van de Velde is evident here. Vroom then began to pay increasing attention to the portrayal of different types of trees, and his poetic, unpretentious

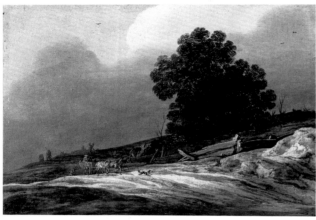

500

501

500 Pieter de Molijn
Dune Landscape with Trees and a Wagon
Signed and dated 1626. Panel, 26 × 36 cm. Herzog Anton Ulrich Museum, Brunswick, West Germany

501 Pieter Santvoort
Landscape with a Sandy Path and a Farm
Signed and dated 1625. Panel, 30 × 37 cm. Gemäldegalerie, Staatliche Museen, West Berlin

502 Pieter de Molijn
Peasants Returning Home
Signed and dated 1647. Canvas, 76 × 93.5 cm. Frans Hals Museum, Haarlem

502

240

503

503 Cornelis Vroom
Spanish Man-of-War Engaging Barbary Corsairs
Signed and dated 1615. Canvas, 51 × 103 cm.
National Maritime Museum, Greenwich, London

504 Cornelis Vroom
Landscape with Imaginary Roman Ruins
Signed. Panel, 29.5 × 60 cm. Frans Hals Museum,
Haarlem

505 Cornelis Vroom
Landscape with a River by a Wood
Signed and dated 1626. Panel, 31.2 × 44.2 cm.
The National Gallery, London

506 Cornelis Vroom
Landscape with Hunters
Signed. Canvas, 86.5 × 125.5 cm. Muzeum
Narodowe, Cracow. Czartoryski Collection

504

compositions (fig. 505) earned him an exceptional place among the Haarlem landscape painters. He was chosen as a participant in the decoration of Frederik Hendrik's palaces, a commission which brought him into close contact with the history painters employed on these jobs; they sometimes worked on paintings together. Vroom probably should also be credited with the landscapes in paintings by Paulus Bor and Jacob van Campen.[13]

In 1627 Vroom received a call to the English court, but none of his work there can be identified, unless it be the landscape now in Cracow (fig. 506), which look immature and differ greatly in color from his other work.[14] He also visited Italy.[15] Vroom's career and travels provide evidence that artists cannot be sharply divided into those who concentrated on the Dutch landscape and those who sought inspiration mainly abroad.

505

506

Pieter de Molijn and Cornelis Vroom both made important contributions to landscape painting, not least by the influence they exerted respectively on Salomon van Ruysdael and Jacob van Ruisdael. Salomon and Jacob—uncle and nephew—belonged to a family highly important to Dutch painting. The name Ruysdael was presumably derived from the small ancestral castle Ruisdael or Ruysschendael in the Gooi, a heath area southeast of Amsterdam.[16] The patriarch of the family was Jacob Jansz de Goyer, a well-to-do cabinet maker and municipal magistrate who had settled in Naarden about 1590. Of his four sons, the two youngest, Izaack and Salomon, turned to art. Both went to Haarlem, where Izaack, who took the name Ruysdael, became a frame maker and art dealer; he also did some painting, but none of his work is known. He married in 1628, and about a year later his son Jacob was born, destined to become the most famous landscape painter in Dutch art. The artist's name is spelled in various ways; he himself employed the signature Jacob van Ruisdael. Since he worked mainly after 1650, he will be discussed in Part IV.

Jacob's uncle Salomon usually called himself "van Ruysdael," although in his early years he was also known as Salomon de Gooyer. He spent his whole life in Haarlem, working as a painter. His son, Jacob Salomonsz van Ruysdael, born in 1630 and therefore a year younger than his namesake cousin, initially worked as a landscapist in Haarlem but later moved to Amsterdam, where he ran a hosiery shop. Things did not go well with him, and he ended up being confined in the Haarlem workhouse for the mentally disturbed. His painting was much like that of his father and his cousin and need not be discussed here.

Salomon van Ruysdael entered the Haarlem St. Luke's Guild in 1623, though his first known dated work is from 1626. His earliest landscapes (fig. 507) are closely related to those of Pieter de Molijn and, like them, are compositionally akin to the landscapes by Abraham Bloemaert. From the chronology of dated works it must be concluded that Molijn was the precursor. Salomon van Ruysdael, however, was distinctly the more talented artist, and he rapidly developed into the leader. Although Molijn had great merits in capturing weather conditions, and in introducing a new dimension into landscape art by using a diagonal path to emphasize the slopes of his dune landscapes, he could not equal Ruysdael, especially in the use of color. Salomon created a far more subtle and natural atmosphere in his landscapes: an excellent example is a 1631 painting known as *After the Rain* (cpl. 508). This title, given at a later date, correctly conveys the artist's success in rendering the rarefied atmosphere that

507 Salomon van Ruysdael
 Landscape with a Cottage and a Thatched Shed
 Signed. c. 1630. Panel, 30.2 × 47 cm. Fitzwilliam
 Museum, Cambridge, England

508 Salomon van Ruysdael
 After the Rain
 Signed and dated 1631. Panel, 56 × 86.5 cm.
 Szépmüvészeti Múzeum, Budapest

often hangs over the Dutch landscape after a rainshower. The color is restrained: subdued greens and a yellowish brown in the land, and a variety of grays and grayish-blue tints in the cloudy sky. The tonal harmony produces an effect of great depth. The little figures are excellently drawn and fit wholly into the color scheme.

Water soon became a major element in Salomon van Ruysdael's work—the water of the lakes, ponds, rivers, canals, and ditches which are the essence of Dutch landscape, certainly in the vicinity of Haarlem. The older landscape painters and draftsmen had not neglected water, as Esaias van de Velde's noted painting of the ferryboat shows (see fig. 381), and another look at it yields insight into Ruysdael's approach. However new and surprising van de Velde's picture seemed in 1622, it lacks atmospheric treatment and is more a narrative

509 Salomon van Ruysdael
 River Landscape with Ferry
 Signed and dated 16(..). c. 1635. Panel, 65.6 × 94.4 cm. Alte Pinakothek, Munich

510 Jan van Goyen
 River View
 Signed and dated 1632. Panel, 34.5 × 53.5 cm. Private collection

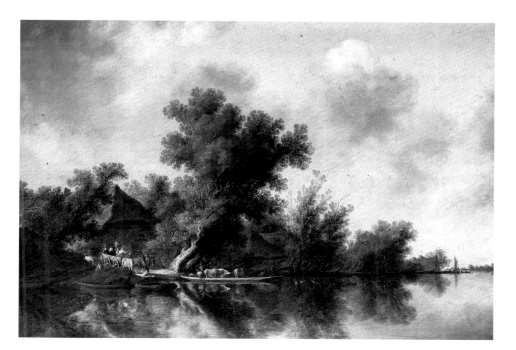

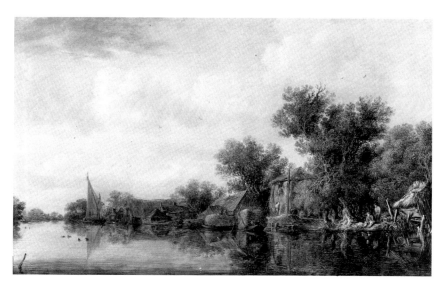

painting than a landscape; the effect of depth comes from draftsmanship, not from use of color. If we compare it with Ruysdael's *River Landscape with Ferry* of about 1635 (fig. 509), we can see the enormous change that has occurred in color and tone, mood and atmosphere.

Any study of Salomon van Ruysdael's work cannot ignore that of Jan van Goyen. At virtually the same time both painters—van Goyen working in Leiden and The Hague—tackled the same subject matter, especially river views, followed the same compositional scheme, and used similar colors and a related style of painting. Van Goyen had earlier made drawings of river scenes, but he did not paint them until after 1630 (fig. 510). The two artists' work in this period is so much alike that the authorship is sometimes confused. This resemblance suggests that van Goyen had not broken his ties with Haarlem, an assumption corroborated by archival sources. In 1634 van Goyen was fined three guilders by the Haarlem guild for painting at Izaack van Ruysdael's house, which was against the rules because van Goyen was not a guild member.[17] From his drawings, it appears that Jan was not homebound but liked to roam about the countryside to make his sketches.

511 Salomon van Ruysdael
River Landscape with Ferry
Signed and dated 1649. Canvas, 99.5 × 133.5 cm.
Rijksmuseum, Amsterdam

512 Salomon van Ruysdael
Estuary with Boats
Signed. Panel, 37 × 55 cm. Staatliche
Kunstsammlungen, Kassel

The compositional scheme of many of Ruysdael's and van Goyen's river scenes is as simple as it is efficient. Water covers the whole foreground and runs off slantingly toward the back. The nearer bank usually has a stand of trees and bushes, with a barn or a farmhouse in between. The farther bank shows only at the horizon, giving depth to the scene by its trees sketched in gray-blue and a taller building, such as a mill or a church tower, rising among them. An important element is always the reflection of the nearer bank in the ruffled water, with fishermen working their nets or a ferry making the crossing loaded with people and livestock (fig. 511). Both painters limited their colors to gray-green, yellow-green, and yellow-brown.

Drastic changes took place in Salomon van Ruysdael's work during the 1640s. He tended to eliminate nearly all trees from his landscapes, leaving only one tall group as the focal point of the composition. The colors become brighter, the clouds stand out more prominently against the clear blue sky. Besides river scenes based on the old pattern, he began also to paint broad bodies of water, the land now in a secondary role and the whole pictorial surface dominated by the play of high clouds above the boat-strewn water (fig. 512). Yet he remained interested in landscapes containing little or no water. Horse-drawn coaches move across these landscapes or come to a halt beside an inn, which is usually half hidden by tall trees. Dutch viewers can recognize the church towers in the distance: those of The Hague, Amersfoort, Beverwijk. In this period Ruysdael and van Goyen grow farther apart in their work. Ruysdael's colors, in particular, seem to become harder and more

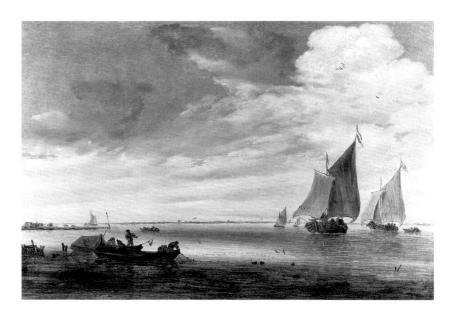

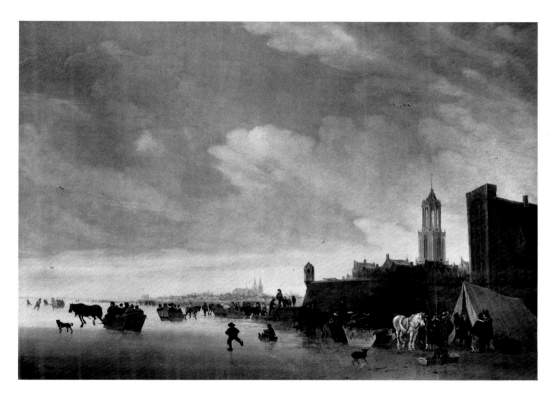

513 Salomon van Ruysdael
Winter Scene near Utrecht
Signed and dated 1658. Panel, 78 × 110.7 cm.
Private collection, Netherlands

514 Isack van Ostade
Travelers outside an Inn
Signed and dated 1646. Panel, 75 × 109.5 cm.
Mauritshuis, The Hague

varied. After 1650, in addition to his river and country landscapes, Ruysdael painted a number of excellent ice scenes (fig. 513) and several smoothly executed still lifes, usually with dead birds (see fig. 837).

Both Jan van Goyen and Salomon van Ruysdael attracted followers. In Haarlem these included Jacob van Moscher, Frans de Hulst, Wouter Knijff, Willem Kool, Cornelis van der Schalcke (sexton of St. Bavo's Church), and somewhat later Cornelis Beelt. In their best works, these painters achieved competent results but made no new contributions requiring discussion here.

Isack van Ostade, born in 1621, began his lamentably short career, as noted above, by painting peasant interiors in the style of his older brother Adriaen. A little later, about 1643, the year in which he joined the Haarlem guild, he began to devote himself primarily to outdoor scenes. Landscape is important in his paintings, but the emphasis is on people; one of Isacks' merits is indeed the degree of unity he managed to achieve between landscape and human figures. He often depicts scenes in front of an inn (fig. 514) or a pleasure garden that are slightly reminiscent of Salomon van Ruysdael's landscapes including similar themes. One striking note is the white horse occurring in many of Isack's compositions. His painting style is fluid and direct, his palette mainly brown but sometimes surprisingly fresh and bright, never hard. In his ice scenes (cpl. 515), his feeling for color and his great talent as a figure painter come to the fore. He died, aged twenty-eight, in 1649.

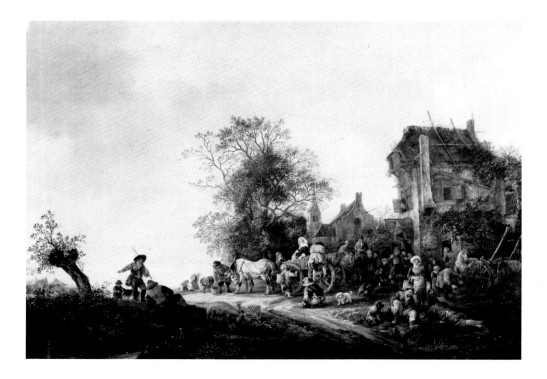

515 Isack van Ostade
 Winter Scene with an Inn by a Frozen Stream
 Signed. Panel, 48.8 × 40 cm. The National
 Gallery, London

516 Pieter Mulier
 Stormy Sea with Fishing Boats
 Signed. Panel, 40 × 60 cm. Private collection

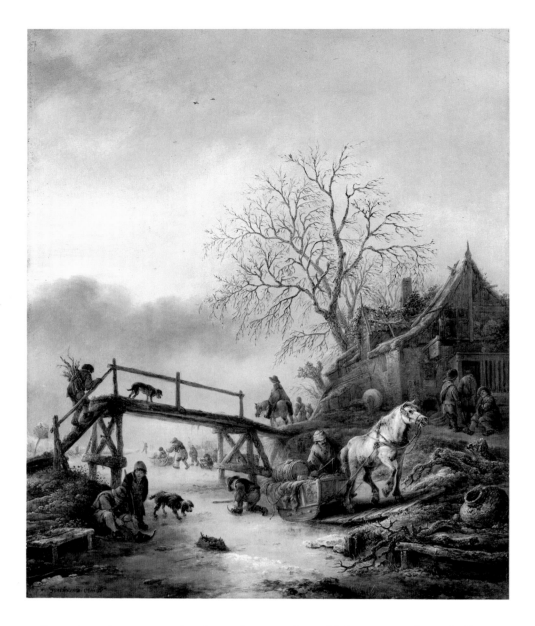

Even though water predominates in a number of Salomon van Ruysdael's paintings, this artist never painted true sea pieces. It is remarkable that in Haarlem, where marine paintings originated, there was no further development of this genre after the first generation, except for Cornelis Vroom's few naval pictures early in his career while still under his father's influence. Only Pieter Mulier, born in Haarlem about 1615, chose to take up the subject anew; he painted not only the inland waters, always in violent motion, but also the open sea. His marine paintings are primarily in shades of gray, with seagulls silhouetted in white against the dark parts of threatening clouds or dark against the light parts (fig. 516). In his work, Mulier is most closely related to Jan Porcellis and Simon de Vlieger.

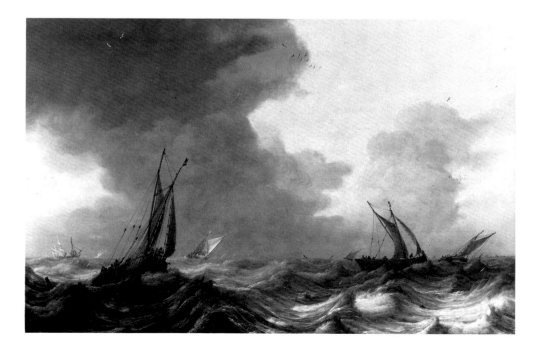

Still-Life Painters

It is neither difficult nor in the least farfetched to see a parallel development between the Haarlem landscape painters and still-life painters both in their use of color and in their progressively simpler compositions. This development can best be observed in the work of Pieter Claesz, one of the outstanding still-life painters. He was born in 1596 or 1597 in Burgsteinfurt, Westphalia, but apparently came to Haarlem while young, married in 1617, and remained there for the rest of his life; he died in 1661. Dated still lifes by him are known from 1621 to 1660, and his development can be followed step by step.

His earliest works accord, in palette and in their spread-out or additive composition, with

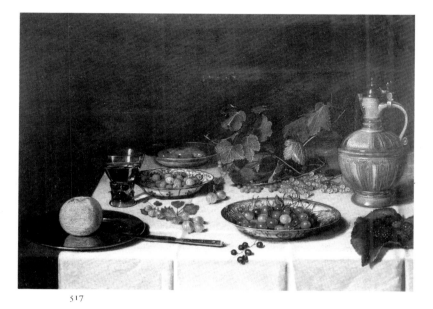

517

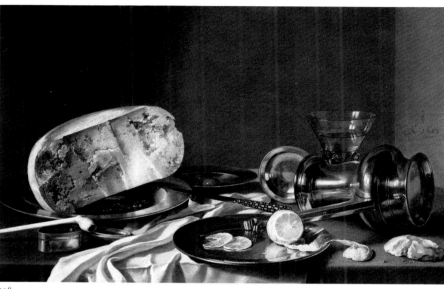

518

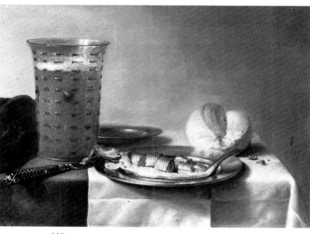

519

517 Pieter Claesz
Still Life
Signed and dated 1621. Panel, 46.3 × 64.3 cm.
Private collection, England

518 Pieter Claesz
Still Life
Signed and dated 1628. Panel, 40.5 × 64.3 cm.
Private collection, England

519 Pieter Claesz
Little Breakfast
Signed and dated 1636. Panel, 36 × 49 cm.
Museum Boymans-van Beuningen, Rotterdam

those of the first generation of Haarlem still-life painters. A new detail, however, is that Claesz includes the left edge of the table, thereby obtaining greater depth (fig. 517). But soon a change appears: he simplifies the number and kind of "props," and abandons the composition of objects that overlap barely or not at all. His motifs now consist of the remains of a meal (fig. 518) or of objects having a more conspicuous *vanitas* aspect, displayed in a balanced composition; color plays a lesser role. Claesz carried this simplification to an ultimate refinement in such paintings as the *Little Breakfast* of 1636 (fig. 519), depicting a "waffle" glass filled with beer, a knife, herring on a pewter plate, a few berries on another, and a roll of bread. The colors are subdued, permitting the delicate gray tints of the pewter and the fish to weigh subtly against the white of the napkin and the muted dark green of the tablecloth. The coloring and the slightly blurred contours create a highly atmospheric effect. Although a small painting like this may have conveyed symbolic meaning to a contemporary viewer, it remains notable that the painter has imposed upon himself the utmost restraint. Today's viewer, unaware of seventeenth-century symbolism, is tempted to recognize here the beginning of art for art's sake.

In the 1640s Pieter Claesz's painting style became broader, more vigorous, and less detailed, and he sometimes turned away from color, painting almost monochromatically in shades of brown. At the same time his compositions became more dashing, with such elements as vine tendrils twining flexibly and playfully around the other objects, which increase in number. And finally, he began to construct richer still lifes on a diagonal axis (see fig. 268). In Claesz's work one sees the still life starting to go its own way more strongly in Holland than elsewhere. If the development of the first generation of Dutch still-life painters—Gillis, van Dijck, and van Schooten—went parallel to a degree with still-life painting in other European cities, such as Antwerp and Frankfurt, the trend which Claesz and Heda led in the second generation grew into a current that remained almost wholly confined to a few Dutch cities. This new current formed the basis for the explosion in the third generation, when de Heem, van Beyeren, and Kalf would create their ornate still lifes.

Willem Claesz Heda underwent a less pronounced stylistic development than did Pieter Claesz. Heda was born in 1594 and is first mentioned in the Haarlem guild records in 1631; he was elected a top official of the guild in 1637 and several times thereafter. Signed and dated works by him are known from 1621 onward, the earliest a *vanitas* still life (fig. 520) in

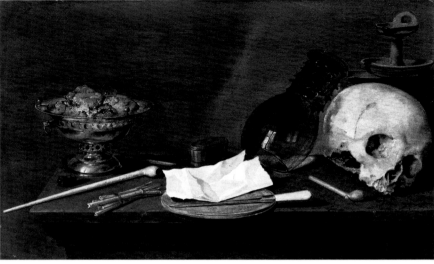

520

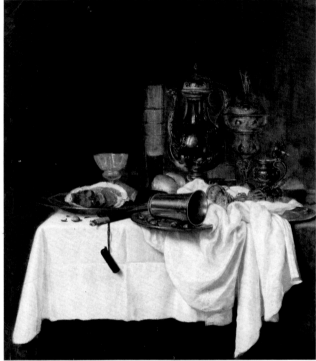

522

which Heda seems ahead of the general development of this form. The objects are spread out as in the usual additive still-life composition, but the viewpoint is lower, so that one does not look down on the array. The composition of this nearly monochromatic painting indeed seems to anticipate by a decade Claesz's arrangements of simple objects. Heda has chosen his objects from the traditional transiency roster: a skull, an oil lamp, a down-turned glass, smoking paraphernalia, and a charcoal-filled brazier. Remarkably, this is the first-known appearance of smoking equipment in a Dutch *vanitas* still life.

Most striking in Heda's work is his refined use of color and thoughtful harmony of color and tone. A beautiful example of these qualities is the 1634 still life in the Boymans-van Beuningen Museum (cpl. 521), built up from cool and warm grays, olive green-gray, and greens, with the yellow accent of the partly peeled lemon. The substance and texture of glass, silver, and pewter is marvelously rendered, as are the oyster shells with their translucent, slithery contents, and the sharp glints of the broken glass. The composition is in equilibrium, and this modest-sized panel gives the effect of a monumental still life.

The horizontal format used here was the most popular at this time for still lifes, but Heda also worked with a vertical format, as in the powerful panel of 1638 (fig. 522), also an example of the richer type of still life. Costly silver objects predominate, and the draped white tablecloth becomes a major element in the composition. The tall objects placed next to each other add statuesqueness to the composition, whose verticality is little disturbed by the overturned silver beaker and, to the right, the *bekerschroef* (a glass mounted on an ornamental silver or gilt base).

520 Willem Claesz Heda
Vanitas Still Life
Signed and dated 1621. Panel, 45.5 × 69.5 cm.
Museum Bredius, The Hague. Collection
Gemeentemuseum

521 Willem Claesz Heda
Still Life with Oysters, Rummer, and Silver Tazza
Signed and dated 1634. Panel, 43 × 57 cm.
Museum Boymans-van Beuningen, Rotterdam

522 Willem Claesz Heda
Still Life with Silver Vessels
Signed and dated 1638. Panel, 102.5 × 84.7 cm.
Kunsthalle, Hamburg

▷

523 Gerrit Heda
Still Life
Signed and dated 1642. Panel, 82 × 60 cm.
Rijksmuseum, Amsterdam

524 Maerten Boelema, called The Mute
Still Life
Signed and dated 1664. Panel, 73 × 96 cm. Musées
Royaux des Beaux-Arts de Belgique, Brussels

525 Hans Bollongier
Vase of Flowers
Signed and dated 1639. Panel, 68 × 54.5 cm.
Rijksmuseum, Amsterdam

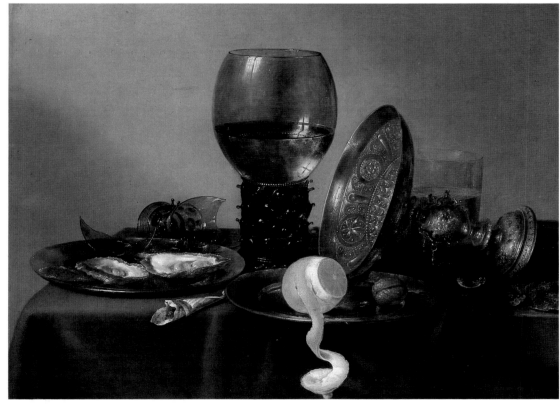

521

Heda continued working in this vein for virtually the rest of his life. The richer still lifes, like that of 1638, in time became more numerous but show no essential change. His last known dated works, from 1664 and 1665, lack the perfection and subtlety of his paintings of the 1630s. Heda died in 1680 in Haarlem. In the meantime his son and pupil, Gerrit Heda, began painting still lifes in a style so similar to his father's that their work is often difficult to distinguish (fig. 523). Both signed themselves simply "Heda" without initials; rarely Gerrit used the signature "Jonge Heda" (Heda Junior).

The work of another of Willem Heda's pupils, the Frisian-born Maerten Boelema, called The Mute, is of lesser quality. His compositions are for the most part slightly off-balance and somewhat restless, but occasionally his achievement was worthy of his master (fig. 524).

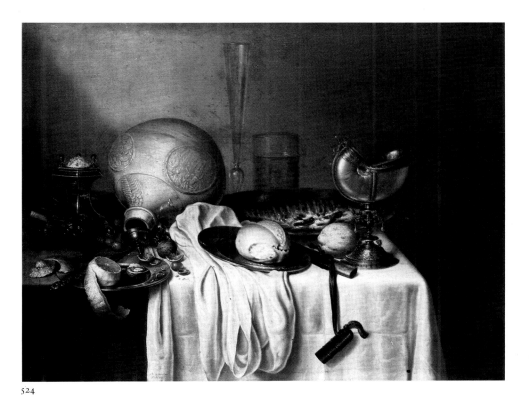

524

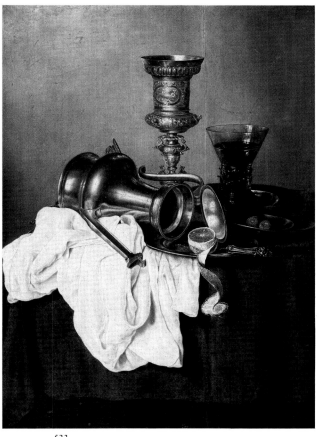

523

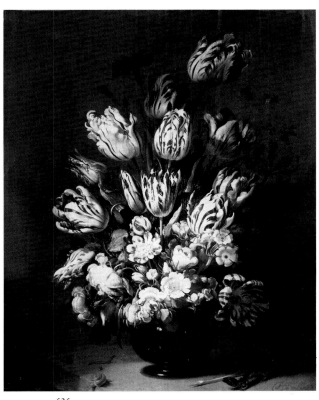

525

Jan Jansz van de Velde, son of the engraver Jan van de Velde II, painted still lifes more or less like those of Claesz and Heda. He is recorded as being in Amsterdam from 1642 onward and will therefore be discussed among the artists of that city.

Strangely enough, among the Haarlem artists there were almost no flower painters, although the city had already become the center of the bulb-growing industry. Judith Leyster, as noted above, made oil paintings of floral pieces, but only her highly individual flower watercolors on paper have been preserved (see fig. 494). The only other known painter of any importance who produced flower pieces in Haarlem was Hans Bollongier, born in that city about 1600. He worked more or less in the Bosschaert tradition, but his bouquets are rendered with strong effects of chiaroscuro and his brushstroke is fuller and more powerful, characteristics that make his paintings extraordinarily attractive (fig. 525).

Pieter Saenredam

One of the most remarkable Haarlem painters, an artist who occupies a unique niche in Dutch art, is Pieter Saenredam. His father was the engraver Jan Saenredam, who lived in Assendelft but whose work entirely devolves on nearby Haarlem, where he had been a pupil of Hendrick Goltzius. An exceptionally able and productive professional, the elder Saenredam made prints of his own invention and after those of others, including the Haarlemmers Karel van Mander, Hendrick Goltzius, and Cornelis Cornelisz, and the Utrecht painters Abraham Bloemaert and Paulus Moreelse. He also made engravings after Italian works.

Two years after Jan Saenredam's death in 1607, his widow moved with her only child, twelve-year-old Pieter, to Haarlem. In 1612 the lad entered the studio of Frans de Grebber, where he remained until 1622. A few drawings by him are known from the following years—flowers and plants, portraits, and a scattering of town and village views. His earliest known painting is dated 1628 (see fig. 2). This interior of St. Bavo's in Haarlem perfectly

reflects the atmosphere of the church at that time: stripped of every vestige of the Catholic worship for which it had been built, and adapted to the requirements of a strict Protestantism. But above all this painting attests to a fundamental understanding of perspective. Pieter can scarcely have gained this knowledge except through Jacob van Campen, who came to Haarlem in 1624 after a six-year stay in Italy, where he had studied architecture in particular. The two men no doubt met in de Grebber's convivial workshop and became lifelong friends; there is regular mention in the archives of their working together. Van Campen drew a portrait of Saenredam, which Pieter himself inscribed: "Monsieur J. van Campen made this after me Pieter Saenredam A° 1628" (fig. 526). In it he appears somewhat misshapen, not because van Campen could not draw, but because Saenredam was a hunchback.

Saenredam lived in Haarlem but made sketches in many places throughout the country. Sometimes he worked at Jacob van Campen's request—among other things, making a drawing of the Grote Kerk in Alkmaar, for which van Campen had been commissioned to design the organ case—and sometimes at the request of his fellow townsman, the painter-architect Salomon de Bray. Thus he spent longer or shorter periods in Assendelft, Alkmaar, Rhenen, 's-Hertogenbosch, Amsterdam, and Utrecht. His travels can be followed almost day by day, for he carefully noted the date on his sketches and often added the purpose and the circumstances of the visit.

Saenredam was a man of the utmost precision, and his working method was meticulous. When he started to paint a church interior, he first made a detailed sketch on the spot, sometimes working out particular problems separately. If necessary, he took measurements and made ground plans to scale. Thereafter, he used the sketches in his studio to make a careful construction drawing in perspective of the same size as the future painting,

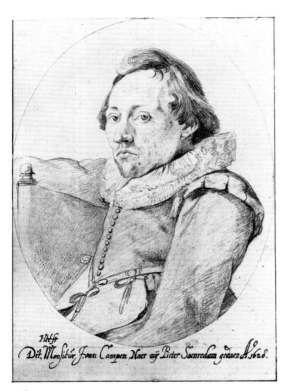

526

526 Jacob van Campen
Portrait of Pieter Saenredam
Dated 1628. Black chalk, 26 × 18.2 cm. British Museum, London

527 Pieter Saenredam
Interior of the St. Odulphus Church, Assendelft
Dated July 31, 1634. Pen and bister, black chalk, heightened with white, on blue paper, 24.4 × 41.8 cm. Amsterdams Historisch Museum, Amsterdam. Fodor Legacy

528 Pieter Saenredam
Interior of the St. Odulphus Church, Assendelft
Signed and dated 1643. Pen, 74.5 × 50.7 cm. Rijksdienst voor de Monumentenzorg, Zeist, Netherlands

527

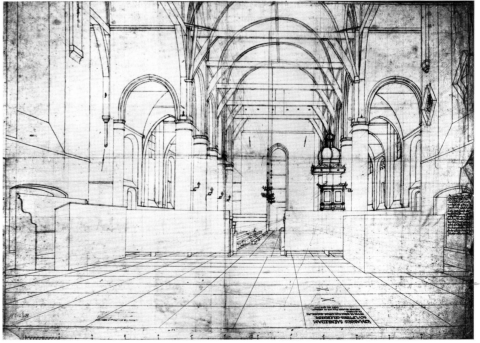

528

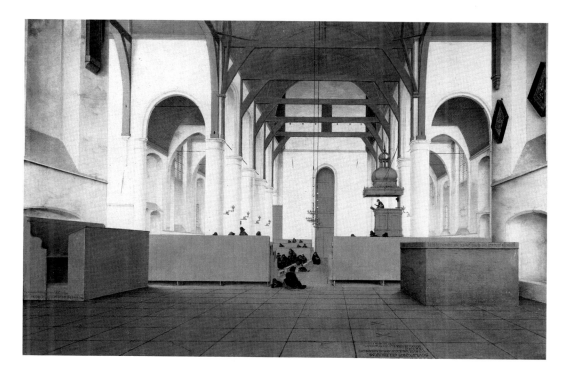

529 Pieter Saenredam
Interior of the St. Odulphus Church, Assendelft
Signed and dated 1649. Panel, 50 × 76 cm.
Rijksmuseum, Amsterdam. On loan from the
City of Amsterdam

530 Pieter Saenredam
The Square of St. Mary and the Mariakerk, Utrecht
Signed and dated 1663. Panel, 110.5 × 139 cm.
Museum Boymans-van Beuningen, Rotterdam

transferred this drawing to a panel, and proceeded with his oil painting. Years sometimes elapsed between the first sketch and the final painting.

His working method is well exemplified in the history of his painting of the church in Assendelft. Two drawings survive, the first a sketch in ink and chalk with the notation, "The 31. July 1634" (fig. 527). On the subsequent construction drawing (fig. 528) he wrote: "This composition is to be seen in the church at Assendelft, a village in Holland. The drawing of this completed on the 9th day [of] December in the Year 1643. This painted the same size as this drawing, on a panel of one piece, and the painting completed the 2nd Day of the month October in the year 1649, by me Pieter Saenredam." On the painting (fig. 529) he noted: "This is the church at Assendelft, a village in Holland, by Pieter Saenredam, painted in the year 1649, the 2 October."[18] The paving stone in the near right foreground marks his father's burial place, and the large boxlike tomb at the right is that of the lords of Assendelft. Saenredam has carefully transcribed the inscriptions in both cases.

Saenredam was also interested in the exteriors of important buildings and churches. In 1663 he painted the Mariakerk in Utrecht (fig. 530), a large panel notable for its refined color scheme and air of serenity. This painting, executed two years before Saenredam's death, is a high point in Dutch townscape art.

Pieter Saenredam's long stay in Frans de Grebber's studio brought him in contact with many other artists. This studio must have been an important center for the Haarlem painters; in 1640 de Grebber had no fewer than sixteen pupils. He and Cornelis van Haarlem remained active for a long time and continued to set their stamp on the artistic life of this relatively small city. Cornelis lived until 1638, and in 1646 de Grebber, then seventy-three years old, completed a commission for the stadholder's court.[19] Few of de Grebber's history paintings have been preserved, so that his rank in this field can no longer be determined. As a portraitist he was overshadowed by Hals's greater talent. But having had Jacob van Campen for some time in his studio led to far-reaching consequences. When van Campen was employed as master architect-painter on Frederik Hendrik's building projects in the 1640s, he exerted great influence on the decorative schemes and on the selection of artists to carry them out. He naturally turned to his old friends in Haarlem, where he had moreover taken refuge in 1629 from Spanish troops advancing on Amersfoort, near to his estate.

History Painters

The Haarlem history painters formed a closely knit group, and it was they whom Jacob van Campen called in for the stadholder's projects. This work brought them in touch with painters from Utrecht and especially Flanders who were also engaged in the decoration of the palaces. It is interesting at this point to try to define the extent of the Flemish influence on the Haarlem painters.

Contact between the Northern and Southern Netherlands was continual during the long course of the Eighty Years' War, and only rarely were objections raised to visits back and forth. By coincidence, one of these exceptions concerned the greatest Flemish painter, Peter Paul Rubens. After the Twelve Years' Truce expired, Rubens was permitted only limited travel in the north because of his political function as "secretary to the king in his secret council." In this position Rubens was active in the diplomatic relations and negotiations between north and south, albeit with remarkably little success. In 1627 and again in 1631 he was Philip IV's emissary to The Hague, but his second mission was a failure and marked the end of his political career.

As a painter, Rubens had an exceptionally high reputation in the north, especially in court circles and among intellectuals and artists. Huygens' praise of him, already cited (see p. 40), can be taken as the general consensus. In 1612, during the truce, Rubens had traveled through the northern provinces; in Haarlem the painters held a banquet for him. And in 1627, on his first diplomatic mission, he looked up artists in various Dutch cities; we are most informed about his stay in Utrecht, where he met Honthorst, Ter Brugghen, Moreelse, Poelenburgh, and Bloemaert.[20]

To gauge Rubens' influence on Dutch art, however, we must look beyond these personal contacts. His major impact came through his works, the paintings as well as the prints made after them.[21] Rubens' paintings in the north were few, and all painted after his return from Italy and before the end of the truce—that is, from 1609 to 1621.[22] His political position thereafter made it difficult for Dutch patrons to give him commissions. Frederik Hendrik owned several of his works, as did the Winter King, and there were some in private collections; Willem Swanenburgh made engravings of a few of these in 1611 and 1612, including *The Supper at Emmaeus* (fig. 531).

In addition, the English ambassador to The Hague, Sir Dudley Carleton, owned an extremely important collection of Rubens' work. In 1618 this sophisticated diplomat had

struck a deal with the artist: Carleton exchanged his collection of antique statuary for paintings by Rubens. It is interesting that Frans de Grebber and his son Pieter were charged with handling the transportation of these works; they must at that time have come to know Rubens and his paintings, as well as Carleton's collection, which even before the exchange contained work by Rubens and Tintoretto, among others. In 1625 the ambassador returned to England, taking his collection with him.

The collection of another famous Englishman, Thomas Howard, earl of Arundel and Surrey, was in the Northern Netherlands for some time after the earl's death in 1646, when his widow broke up their Antwerp household and came north; she lived successively in Alkmaar, Amsterdam, and Amersfoort.[23] The estate was in dispute, and in 1655 a panel of experts, comprising Jacob van Campen, Paulus Bor, and Matthias Withoos, made an inventory of the collection, then in Amersfoort. The extant documents attest to the extraordinary quality of the paintings Arundel had collected: besides about ten works by Holbein, there were paintings by Altdorfer, Cranach, Dürer, Lucas van Leyden, Bruegel, Rubens, van Dyck, and Rembrandt, as well as many by the great Italian masters.

Yet the prints made after Rubens' work were undoubtedly more important than his seldom-seen paintings in making his art known in the Northern Netherlands. Countless artists became acquainted with his oeuvre through the prints; many—including Rembrandt—collected them and used them in various ways.

One of Rubens' purposes in visiting Haarlem in 1612 was presumably to meet the engravers who had made that city famous as a center of the graphic arts. Rubens maintained and supervised his own engravers' workshop in Antwerp and was always looking for talented artists. Whether his 1612 visit bore fruit is unknown, but he increasingly used Dutch engravers in the years that followed. His Leiden engraver, Willem Swanenburg, had died prematurely in 1612, aged thirty-one, but Jacob Matham, Goltzius' stepson and most gifted pupil, made a forceful engraving of Rubens' *Samson and Delilah* of 1609–10 (recently acquired by the National Gallery, London); the two artists had been in Rome at the same time and perhaps met there. Andreas Stock, a pupil of Jacob de Gheyn II in The Hague, and the Haarlem-trained Jan Muller went to work for Rubens. The master's most accomplished engravers were the Haarlemmer Pieter Soutman and Lucas Vorsterman. Vorsterman was born in Bommel in Gelderland but spent most of his career in Antwerp; between 1619 and 1622 he produced more than forty prints after Rubens' work. Later, about 1628, the brothers Boetius and Schelderic van Bolswert from Friesland were employed by Rubens.

Having strong and accurate prints made of his paintings was of major importance to Rubens. He expressed his wishes clearly in a letter to Pieter van Veen in 1619: "I am more interested in having the work carried out under my eyes by a young man, inspired by the wish to do well, than by great artists, who always work according to their own ideas."[24] He was also concerned about the marketing of his prints in the north. In 1619 he petitioned the States-General for a license to publish eighteen prints, designated by title; when his request was refused, he prevailed upon Dudley Carleton for help, and through the ambassador's mediation succeeded in getting the license. This had real financial value, for it included a copyright on publication for a specified length of time, usually seven years. It would be interesting to know how, and in what ways, Dutch art was influenced by those eighteen engravings, most of them the work of Vorsterman. Unfortunately, no systematic research has been done on the question.

The work of the Antwerp masters Anthony van Dyck and Jacob Jordaens also was renowned everywhere in the Northern Netherlands, and these painters, more than Rubens, were regularly given commissions there. Jordaens was awarded the lion's share of the decorations for the Oranjezaal in the Huis ten Bosch in the late 1640s and later received commissions for the new town hall in Amsterdam. The direct contact with him and the other Flemish participants—Theodoor van Thulden (a Brabant disciple of Rubens), Thomas Willeboirts, and Gonzales Coques—was without doubt a stimulating experience for the Haarlem painters chosen to work on the Oranjezaal.

The oldest Haarlem painter engaged in the decoration of this hall was Pieter Soutman, who was born about 1580. An engraver of great repute, he joined Rubens' studio in 1615 or 1616 to make engravings after the master's paintings; he returned to Haarlem in 1628. Soutman's merits as a painter are rather difficult to establish, because relatively few of his paintings are known today. Rubens' work undoubtedly influenced him, but in 1642 and

531 Willem Swanenburgh after Rubens
The Supper at Emmaus
Engraving

532 Pieter Soutman
Part of Frederik Hendrik's Triumphal Procession, with Captured Treasures
Signed and dated 1648. Canvas, 380 × 210 cm.
Oranjezaal, Huis ten Bosch, The Hague

533 Salomon de Bray
Girl in a Straw Hat
Signed and dated 1635. Panel, 75.5 × 60.5 cm.
Formerly Staatliche Kunstsammlungen, Dresden.
Destroyed during World War II

534 Salomon de Bray
Part of Frederik Hendrik's Triumphal Procession, with Musicians
Signed and dated 1649. Canvas, 385 × 205 cm.
Oranjezaal, Huis ten Bosch, The Hague

532

534

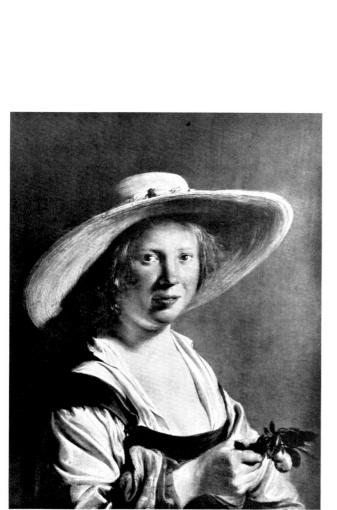

533

1644, when he made group portraits of the Haarlem civic guard, he followed the style of
Frans Hals. Previously he had worked for the stadholder, making portraits in 1639 of
King Philip IV of Spain and his queen for the gallery of royal portraits at the Huis ter
Nieuburch.[25] Soutman's painting for the Oranjezaal, representing captured treasures borne
in Frederik Hendrik's triumphal procession (fig. 532), shows him to be an able draftsman
and painter.

Salomon de Bray was the next in line of these Haarlem painters, and he was given a
considerably bigger Oranjezaal assignment than Soutman. Son of Flemish emigrants, he was
born in Amsterdam in 1597 but went to Haarlem at an early age; by 1615 he was a member
of the St. Adrian civic-guard company and in 1617 joined a chamber of rhetoric. De Bray
was many-sided: painter, draftsman, designer of silver, architect, town planner. He wrote a
book on contemporary Dutch architecture (*Architectura Moderna*), published in 1631, and his
Bedenckingen, over het Uytleggen en Vergrooten der Stadt Haarlem (Reflections on the Layout
and Expansion of the City of Haarlem) of 1661 is of major importance in the history of
town planning in the Netherlands. He wrote poetry, too; his collection *Minnedichjes,
Uytgedruckt in Liedekens* (Love Poems, Expressed in Little Songs) appeared in 1627.

De Bray's versatility is apparent in his painting: he produced history paintings, figure
pieces, landscapes, portraits, and a few architectural paintings. In Haarlem he came more or
less under the influence of his teachers Cornelis Cornelisz and Goltzius, but about 1635 such
paintings as *Girl in a Straw Hat* (fig. 533) show a kinship with the work of the Utrecht
Caravaggists. It is reasonable to suppose that Jacob van Campen had something to do
with this. Yet at about the same time de Bray seems to have experimented with a
Rembrandtesque style, although the dating is difficult to determine because the chronology
of his work is still uncertain. From 1648 to about 1652 he was engaged on the Oranjezaal
decorations; given his wide-ranging interests, it is no wonder that the like-minded van
Campen chose him as a member of the team. De Bray contributed two sections of the
triumphal march—the musicians leading it (fig. 534), and the captured weapons—as well as
a grisaille of putti holding a scroll inscribed with Frederik Hendrik's name and birth date
(fig. 535).

One requirement for the participants in the Oranjezaal project was that they strive for as
much unity as possible—van Campen's instructions are quite specific—and obviously the
lesser talents tried to accommodate themselves to the greater. De Bray found his model in
Jacob Jordaens, whose influence permeates his Oranjezaal works and continues for years in

535 Salomon de Bray
Putti Holding a Cartouche with Frederik Hendrik's Birth Date
Signed and dated 1651. Canvas, 103.5 × 255 cm.
Mauritshuis, The Hague. Formerly Oranjezaal,
Huis ten Bosch

536 Salomon de Bray
Rebecca and Eliezer at the Well
Signed and dated 1660. Canvas, 90 × 165 cm.
Musée de Douai, France

537 Pieter de Grebber
The Raising of Lazarus
Signed and dated 1632. Canvas, 107 × 88 cm.
Galleria Sabauda, Turin

535

536

537

his other history paintings. Oddly enough, de Bray later reached back to the Lastman
tradition, so that such paintings as *Rebecca and Eliezer at the Well* of 1660 (fig. 536) look old-
fashioned. Despite his long and active career (he died in 1664), de Bray is poorly represented
in Dutch museums.

Pieter de Grebber was born in Haarlem about 1600 and studied under his father, Frans,
and Hendrick Goltzius. He also became one of van Campen's favorites. His work parallels
Salomon de Bray's in some respects: a mixture of influences is apparent, again from the
Flemish as well as the Utrecht side, with added traces from the work of Cornelis van
Haarlem (as in the face of Mary in *The Adoration of the Magi* mentioned below). At the
beginning of the 1630s de Grebber's paintings, more strongly than de Bray's, bear the stamp
of Rembrandt's chiaroscuro (fig. 537).

De Grebber's thorough training in painting and drawing is clearest in his history
paintings. These compositions are well balanced, the figures anatomically and plastically
accurate. The refined color scheme is based on clear grays and lilac tints. *The Adoration of the
Magi* of 1638 (fig. 538) shows his painting style and color sense to advantage. The magus at
the left is garbed in dark blue and white, the kneeling king in light green and gold, and
Mary in rose and light blue. De Grebber was also active as a portrait painter, producing
such charming groups as the *Family in a Landscape* (fig. 539). The illumination of his heads
shows him to have remained longer under Rembrandt's influence than his history paintings

538

539

538 Pieter de Grebber
The Adoration of the Magi
Signed and dated 1638. Canvas, 78 × 98 cm.
Musée des Beaux-Arts, Caen. Mancel Collection

539 Pieter de Grebber
Family in a Landscape
Signed. Canvas, 204.5 × 291.5 cm. Museu
Nacional de Arte Antiga, Lisbon

540 Jacob de Wet
The Entombment
Signed and dated 163(7?). Panel, 73 × 56.5 cm.
Collection Daan Cevat, Guernsey

541 Willem de Poorter
Paul and Barnabas at Lystra
Signed and dated 1635. Panel, 55 × 82 cm.
Schilderijenzaal Prins Willem V, The Hague. On
loan from the State-owned Art Collections
Department

indicate. He was assigned two scenes for the triumphal-procession series in the Oranjezaal:
one with war trophies, and the other with the sacrificial bull; both paintings are of high
quality.

Not all of the history painters in Haarlem, to be sure, were invited to participate in the
decoration of Frederik Hendrik's palaces. Among those excluded were Willem de Poorter
(born in 1608) and Jacob de Wet (born about 1610): their work did not measure up to van
Campen's classical standards, nor could they be considered capable of producing large-scale
paintings. De Poorter and de Wet were both profoundly influenced by Rembrandt (also
not asked to contribute to the Oranjezaal), so much so that a master-pupil relationship can
be assumed. Their apprenticeship would have had to take place while Rembrandt was still
in Leiden, for their small biblical and historical scenes are based on Rembrandt's work of
about 1629 to 1631. De Wet's paintings faithfully emulate his master's example, with
compositions full of motion (and emotion) and powerful effects of light and dark (fig. 540),
but they have rightly been called a "somewhat dull and rustic variation on Rembrandt's
art."[26] De Poorter's work is more polished and individual. His *Paul and Barnabas at Lystra*
(fig. 541), formerly entitled *Solomon Worshiping Foreign Gods,* is indebted to Pieter Lastman
for the figure of the high priest, but the chiaroscuro is Rembrandtesque. De Poorter also
painted small portraits and figure pieces that include still lifes (fig. 542).

The last Haarlem history painter needing mention here is Cornelis Holsteyn. His work, of

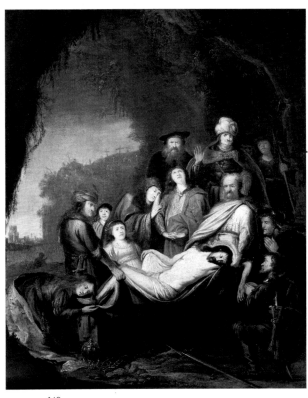

540

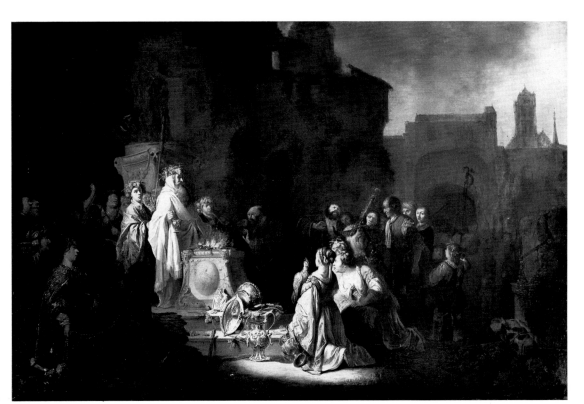

541

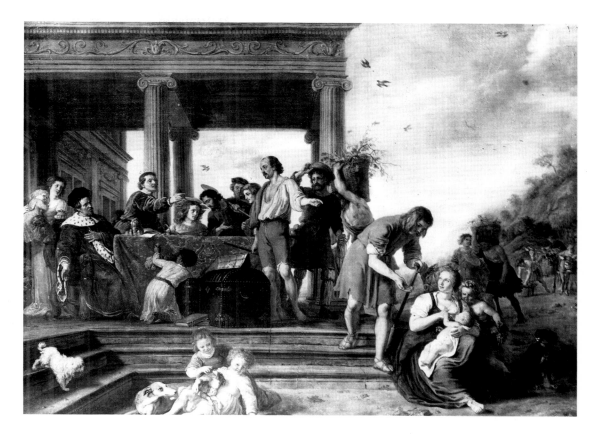

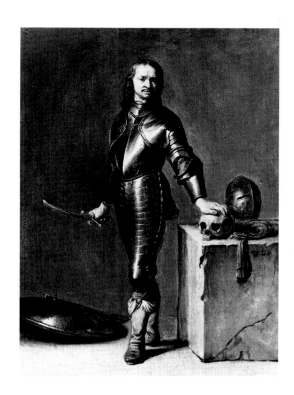

542 Willem de Poorter
Man in Armor
Signed. Panel, 20.2 × 15 cm. Collection Daan
Cevat, Guernsey

543 Cornelis Holsteyn
The Laborers in the Vineyard
Signed and dated 1647. Canvas, 199 × 270 cm.
Frans Hals Museum, Haarlem

which *The Laborers in the Vineyard* of 1647 is representative (fig. 543), shows a relationship with that of Salomon de Bray and Caesar van Everdingen as well as a Flemish influence. At some point Holsteyn left Haarlem for Amsterdam, where he was living in 1652 and possibly earlier. He was given commissions for paintings for the Amsterdam town hall and for such charitable institutions as the Oude Zijds Huiszittenhuis and the Burgher Orphanage.

Caesar van Everdingen

The important painter Caesar Boëtius van Everdingen of Alkmaar cannot be counted a true Haarlemmer, though he lived in that city at one time and was associated with the Haarlem history painters who worked on the Oranjezaal decorations. The elder brother of the landscape painter Allart van Everdingen, Caesar was taught, according to Houbraken, by Jan van Bronckhorst in Utrecht—information impossible to verify yet reasonable enough in view of the unmistakable Utrecht elements in his work. Some principal dates of his life are easy to assemble: he was born about 1616–17 in Alkmaar and joined the guild there in 1632; in 1648 and 1650 he worked for the Oranjezaal; he became a member of the Haarlem St. Luke's Guild in 1651, but returned in 1657 to Alkmaar, where, except for a short stay in Amsterdam in 1661, he lived until his death in 1678.

It was of great importance to Everdingen's future career that he met Jacob van Campen fairly early, presumably about 1643, at the time he received the commission to paint the shutters for the organ of the Grote Kerk in Alkmaar, the same organ for which van Campen designed the case and of which Saenredam made an on-site drawing (see p. 250). According to his statement of account, Everdingen worked on the shutters in Amersfoort; van Campen had a studio there and no doubt urged his younger colleague to join him, for otherwise Everdingen would have worked at home. In Amersfoort he probably met the well-known local painter Paulus Bor, whose work shows many similarities to his. Bor had worked on the decoration of Frederik Hendrik's hunting castle Honselaersdijk, together with Pieter de Grebber, Moyses van Uyttenbroeck, Cornelis Vroom, and Theodoor Matham. It appears that the contacts among these Utrecht, Amersfoort, and Haarlem painters were unusually close, and that Everdingen joined the circle. When one of his works for the Oranjezaal, *Four Muses with Pegasus in the Background* (fig. 544), is compared with van Campen's painting for the triumphal procession (fig. 545), the similarity of style is immediately evident. Except for his works in the Oranjezaal, few paintings by van Campen are known. Apparently he was not a prolific painter, but a large canvas depicting *Argus Lulled to Sleep by Hermes* (fig. 546) has recently been discovered and correctly attributed to him.

257

545

544 Caesar van Everdingen
Four Muses with Pegasus in the Background
Signed. c. 1650. Canvas, 340 × 230 cm.
Oranjezaal, Huis ten Bosch, The Hague

545 Jacob van Campen
Part of Frederik Hendrik's Triumphal Procession,
with Gifts from the East en West Indies
c. 1648–49. Canvas, 380 × 205 cm. Oranjezaal,
Huis ten Bosch, The Hague

546 Jacob van Campen
Argus Lulled to Sleep by Hermes
Canvas, 204 × 194 cm. Mauritshuis, The Hague

Unfortunately, little research has been done to date on Caesar van Everdingen's work, and an accurate chronology cannot yet be given. Most of his dated paintings stem from the 1650s—the period when he was working in Haarlem, and affinity with the Haarlem group is indeed apparent. What is striking about Everdingen's art is his flowing style of painting, his fine draftsmanship and strong plastic orientation, and his tendency to idealize, expressed

547 Caesar van Everdingen
Bacchus with Two Nymphs and Amor
Signed. Canvas, 147 × 161 cm. Gemäldegalerie
Alte Meister, Staatliche Kunstsammlungen,
Dresden

548 Caesar van Everdingen
Socrates, His Wives, and Alcibiades
Canvas, 210 × 198 cm. Musée des Beaux-Arts,
Strasbourg

in the manner of execution and in the frequent sensuality of his subject matter, as in his
Bacchus with Two Nymphs and Amor (cpl. 547). The portrait group of 1652, *Diogenes
Searching for an Honest Man* (see fig. 113), however, shows a side of his work in which
matter-of-fact observation predominates. Most extraordinary is the large canvas portraying
Socrates, both of his wives (Myrtame and Xantippe), and Alcibiades (fig. 548). Everdingen
took the abstruse subject from Diogenes Laertius, the third-century biographer of Greek

549 Jan Martszen the Younger
Gustav Adolf in the Battle of Lützen, 1632
Signed and dated 1636. Panel, 54.2 × 97.7 cm.
Herzog Anton Ulrich Museum, Brunswick, West
Germany

550 Pieter Post
Bleaching Fields in the Dunes
Signed and dated 16(..). Panel, 43.7 × 61.5 cm.
Fondation Custodia (Collection F. Lugt), Institut
Néerlandais, Paris

philosophers, and it is as rare in Dutch art as is the monumental execution. Although the painting is not signed, the attribution, based partly on the signed *Diogenes* of 1652, is convincing. The figures are large, and the colors have been held primarily to warm grays and browns, accented by the central figure's silk skirt shot with shades of orange and a yellow top. In combination with Socrates' nondescript clothing, the color scheme is especially subtle. One wonders who might have ordered so large a painting on such a theme.

Painters of Other Subject Matter

Finally, we turn to the Haarlem artists who undertook other types of subject matter than those already discussed. For example, Esaias van de Velde painted cavalry battles early in his career, while he was still in Haarlem. He seems to have been the first painter in the Northern Netherlands to paint in a small format the subjects of fights between horsemen and attacks upon travelers. The Antwerp artist Sebastiaen Vrancx had preceded him in the south, and Jan Martszen the Younger of Haarlem later specialized in the theme. Martszen was skillful in depicting horses, particularly in vigorous motion (fig. 549). In his choice of colors and manner of drawing as well as in his rendering of landscape, he shows a clear relationship with Esaias van de Velde. A few cavalry skirmishes by Pieter Post, a native of Haarlem, have also been preserved. Post was one of the outstanding Dutch architects of his time, and presumably painted more or less as a hobby. He worked primarily for the Orange-Nassau court, first as overseer and colleague of Jacob van Campen, later as an independent architect. Besides his cavalry pictures, he also painted a few landscapes that are subtle in their execution and palette (fig. 550).

Pieter's younger brother, Frans Post, occupies a special place in Dutch art. In 1637 he and the figure painter Albert Eckhout traveled to northeast Brazil, then a Dutch colony, in the retinue of the newly appointed governor-general, Johan Maurits of Nassau-Siegen (see p. 46). Post remained in Brazil for seven years, painting the landscape around him. A few of his paintings and many drawings from this period have been preserved. The paintings are somewhat naive, yet they splendidly capture the atmosphere of the country (fig. 551) and

550

549

551 Frans Post
Landscape in the Vicinity of Porto Calvo, Brazil
Signed and dated 1639. Canvas, 61 × 88 cm.
Musée du Louvre, Paris

552 Frans Post
Manoah's Sacrifice
Signed and dated 1648. Canvas, 191.5 × 166 cm.
Museum Boymans-van Beuningen, Rotterdam

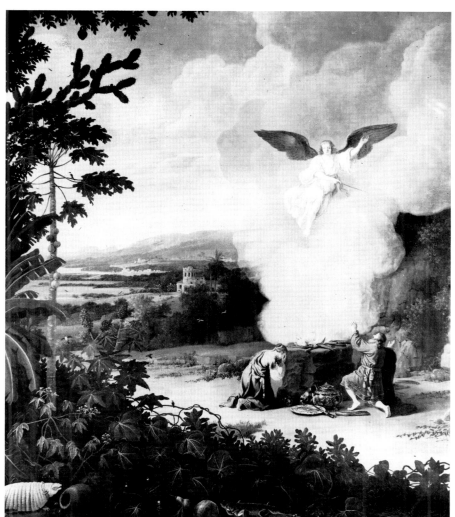

are often of topographical importance. Upon his return to Haarlem, in 1644, he continued
to specialize in Brazilian landscapes, using his large collection of on-the-spot drawings.
Perhaps inspired by the example of the Haarlem landscape painters, he bettered his
technique, so that his early naiveté disappeared, but so also did his originality. The later
landscapes are well-composed broad views, in bright colors under slightly cloudy skies, and
always include human figures. In the foreground, usually forming a strong *repoussoir*, are
Brazilian plants and animals, rendered with great care as to species and characteristics (see
fig. 39). Post must have been quite pleased with this effect, for he used it even in his biblical
composition, *The Sacrifice of Manoah* of 1648 (fig. 552), which also has a Brazilian landscape
as background. In the long run his countless repetitions led to less sensitive color schemes
and painting style. Post died in 1680 in Haarlem.

Painting in Leiden: 1625–1631

Rembrandt and Lievens

Next in our circuit of Dutch cities is Leiden, not because this town had a leading position in art, but because it was briefly, from about 1625 to 1631, the base for a number of young painters of great potential: Rembrandt van Rijn, Jan Lievens, Jan Davidsz de Heem, Jan van Goyen, and an older artist of special importance, Jan Porcellis. Before continuing on to Amsterdam, where Rembrandt settled in 1631, we must examine the development of these artists in Leiden.

Rembrandt Harmensz van Rijn was born on July 15, 1606. His father was a miller and thus belonged to the prospering middle class. Rembrandt served his apprenticeship as painter under Jacob Isaacsz van Swanenburgh, son of a Leiden burgomaster. Then, about 1625, he studied for several months in Amsterdam with Pieter Lastman, at that time one of Holland's most celebrated history painters. Rembrandt learned a great deal from Lastman, even though the paintings most evidently indebted to his master's work give little indication of the pupil's future greatness.

When Rembrandt returned home, probably at the end of 1625, he met another young artist, about a year and a half his junior, named Jan Lievens. Also a native of Leiden, Lievens had become a pupil of the portraitist Joris van Schooten in 1615, at the age of eight, and two years later he entered Lastman's studio, where he remained about the same length of time. He and Rembrandt must have been in close touch and perhaps shared a studio, for they sometimes used the same models. Their exact relationship, however, and their influence on one another are difficult to establish, mainly because we lack sufficient signed and dated works by Lievens from this period. A few passages from Constantijn Huygens' autobiography give us some information.[1] Huygens describes Rembrandt and Lievens as strapping lads who work unbelievably hard, so hard in fact that he is worried about their health. He regrets that they will not take the time to go to Italy to study the great masters, adding that the young painters themselves believe the Italians can be studied just as well in various large collections north of the Alps. Huygens ranks Rembrandt higher than Lievens in "judgment and liveliness of feeling," Lievens higher for his "grandeur of invention" and "daring subject matter and figures." Lievens prefers large canvases with figures life-size or even bigger, whereas Rembrandt achieves a stronger effect in smaller paintings.

By the time Huygens wrote his autobiography, between 1629 and 1631, Lievens must already have produced a considerable oeuvre: history paintings, imaginary figures, heads of old men, and portraits. Various examples of the old men's heads, in particular, are known— heads which, as Huygens said, are as full of wrinkles as a philosopher's—but unfortunately, except for a praying monk of 1629, none is dated. The undated paintings are well worked out (fig. 553), with special care exerted to catch the surface nuances of the wrinkled skin, which is always illuminated by a subtle play of lights and shadows. The color is usually

553

553 Jan Lievens
 Head of an Old Man
 Signed. Panel, oval, 63 × 49.5 cm. Collection
 Daan Cevat, Guernsey

554 Jan Lievens
 Portrait of Rembrandt van Rijn
 Signed. c. 1628. Panel, 57 × 45 cm. Collection
 Daan Cevat, Guernsey

555 Jan Lievens
 Portrait of Constantijn Huygens
 c. 1627–30. Panel, 99 × 84 cm. Rijksmuseum,
 Amsterdam. On loan from the Musée de Douai

554

555

556 Jan Lievens
Job on the Dunghill
Signed and dated 1631. Canvas, 170 × 145 cm.
National Gallery of Canada, Ottawa

grayish, the manner of painting rather dry. Lievens often scratched in the paint with the
butt of his brush to accentuate the texture of the flowingly painted hair and beards. The
clothing falls in heavy, rather conventional folds and is rendered broadly. It is interesting to
compare these heads of old men with two of Lievens' known early portraits: that of
Rembrandt dating from about 1628 (fig. 554), and that of Huygens presumably painted
about 1627–30 (fig. 555).[2] The painting style in the portraits, especially of the heads, is
smooth and fluent, probably because the skin of both models was young and wrinkle-free.

Lievens' history paintings include a large *Raising of Lazarus,* dated 1631, a subject that
Rembrandt was working on at the same time, and another large canvas, *Job on the Dunghill*
(cpl. 556). Both works confirm Huygens' remark that this still young painter was not afraid
of large formats and life-size figures. Huygens reports further that Lievens was as cocky as
he was intelligent, and everything—Lievens was only fourteen when he set up as an
independent painter—indicates that he was a *wunderkind,* who alas did not measure up later
to the high promise of his youth.

Compared with Lievens, Rembrandt was a slow beginner. His earliest known paintings
of 1625 and 1626, when he was already nineteen or twenty years old, are far from
masterpieces. The 1626 history painting, tentatively entitled *The Clemency of the Emperor
Titus* (fig. 557), is not persuasive in spatial effect or the expression of the figures. The colors
are rather gaudy, and the distribution of light is disorderly. The first painting in which
Rembrandt's talent begins to stand out is the small panel *Tobit and Anna* of the same year
(fig. 558), in which he admirably captures the tension of the story from the apocryphal
Book of Tobit: blind old Tobit believes that his wife, Anna, has stolen a goat; she cannot
convince him that she has earned it honestly, and Tobit turns in prayer to the Lord,
declaring he would rather be dead than alive. Both Anna's powerlessness and the despair of
the old man, clad in ragged garments that bespeak his former wealth, are magnificently
rendered. The anatomy of the figures, however, and the perspective of the room make it

clear that Rembrandt was still having difficulties. The composition as a whole goes back to an engraving by Jan van de Velde after Willem Buytewech.

From 1627 onward, Rembrandt developed rapidly. In that year he painted *St. Paul in Prison* (fig. 559), a panel in which he rendered the figure's expression and pose even more impressively than in *Tobit and Anna*; his use of light is also more interesting, and contributes to the unity of the composition. These two elements—the expression of the figures and the handling of light—would from then on play a dominant role in Rembrandt's work.

Huygens saw and appreciated this power of Rembrandt's and he extensively described and praised one painting, *Judas Returning the Thirty Pieces of Silver* (fig. 560), in which these elements stand out. This painting was long known only in copies and was not rediscovered until 1939. Rembrandt's working method as well as his painting style are extraordinarily clear in it.[3] X-ray photographs reveal that Rembrandt must have changed his mind during the course of painting, for he made certain radical alterations to the composition. He painted out a foreground figure standing with his back turned, replacing it with the seated figure seen from the back. He devoted increased attention to the still life of book and scrolls on the table at the left, and, remarkably, refocused the strong concentration of light away from the main group and onto this still life. A drawing (fig. 561) which I once thought to be a

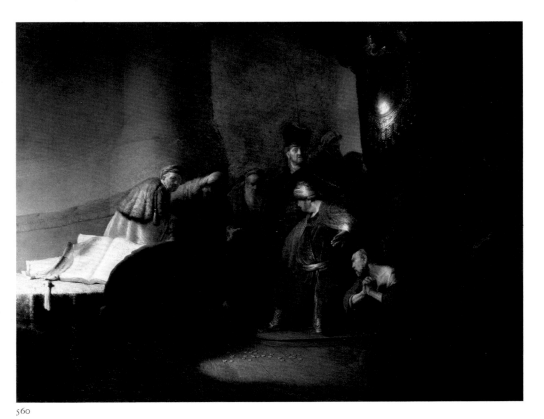

561

557 Rembrandt van Rijn
The Clemency of the Emperor Titus (?)
Signed and dated 1626. Panel, 89.8 × 121 cm.
Municipal Museum De Lakenhal, Leiden. On
loan from the State-owned Art Collections
Department

558 Rembrandt van Rijn
Tobit and Anna
Signed and dated 1626. Panel, 39.5 × 30 cm.
Rijksmuseum, Amsterdam. On loan from
Baroness Bentinck-Thyssen Bornemisza, Paris

559 Rembrandt van Rijn
Paul in Prison
Signed and dated 1627. Panel, 72.8 × 60.3 cm.
Staatsgalerie, Stuttgart

560 Rembrandt van Rijn
Judas Returning the Thirty Pieces of Silver
Signed and dated 1629. Panel, 85.1 × 132 cm.
Private collection, England

preliminary sketch more likely represents an intermediate stage, yet still before he altered the back-turned figure. Rembrandt took pains to typify the figures: pose and gesture are designed to heighten the drama of the scene. The figures are painted carefully, with attention to small details, whereas the background is rather sketchily handled, and the definition of the room—this was to remain characteristic of Rembrandt's work to the last— is extremely vague: it is impossible to reconstruct a ground plan of the temple chamber in which the event is taking place.

As Huygens remarked, Rembrandt must indeed have worked very hard. Each of his paintings bears witness to incessant experimentation. He probed every facet of concern to a history painter: researching the story; rendering it in pictorial form; portraying the states of mind of the figures in pose, gesture, and facial expression; solving compositional problems; and establishing the best color and light effects. Many studies from this period are known, often with himself as model (fig. 562). Rembrandt's Leiden period in the late 1620s may be equated to postgraduate study, a time in which he gained technical control in painting and etching, and at the end of which he produced a few works that fully bore out his mastery, such as the etching presumably portraying his mother (fig. 563).

Little in Rembrandt's work at this time indicates interest in or contact with any Leiden artists other than Jan Lievens. But what little there is provides evidence that he was definitely aware of the *vanitas* painters, whose work was important in Leiden from 1625 onward. Rembrandt included still lifes of books in many of his Leiden paintings, sometimes with clearly symbolical intent—for instance, the still life in the right background of *Two Philosophers* of 1628 (cpl. 564). This panel is almost certainly the one owned by Jacob de Gheyn III and described in his will of 1641 as a painting by Rembrandt "where two old men sit arguing, the one has a large book in his lap, there comes in a [ray of] sunshine."[4]

561 Rembrandt van Rijn
Judas Returning the Thirty Pieces of Silver
c. 1629. Pen and washes in bister and India ink,
11.8 × 14.5 cm. Private collection

562 Rembrandt van Rijn
Self-Portrait
c. 1627–28. Pen and bister, brush and India ink,
12.7 × 9.5 cm. British Museum, London

563 Rembrandt van Rijn
Rembrandt's Mother
c. 1631. Etching

562

563

564 Rembrandt van Rijn
Two Philosophers
Signed and dated 1628. Panel, 72.4 × 59.7 cm.
National Gallery of Victoria, Melbourne. Felton
Bequest 1934

565 David Bailly
Vanitas
Drawing in the *Album Amicorum* of Cornelis de
Montigny de Clarges, 1624. Royal Library, The
Hague

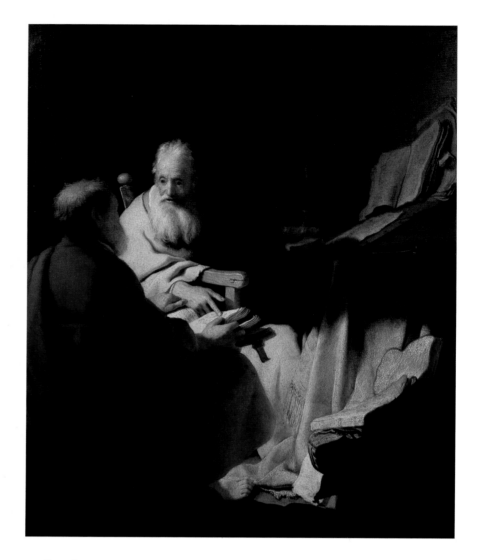

Still-Life Painters

David Bailly is usually called the father of the *vanitas* still life in Leiden. Yet only three works remain today: a small drawing, dated 1624, in an *album amicorum* (fig. 565); a still life that Bailly added to his own portrait painted by Thomas de Keyser;[5] and his 1651 portrait of an artist with an array of *vanitas* objects (see fig. 252). He was certainly interested in *vanitas* paintings, for he had been trained by Jacob de Gheyn II, who, as we have noted, was one of the first Dutch still-life painters. Moreover, three of Bailly's pupils—his nephews Harmen and Pieter van Steenwijck and Pieter Potter—specialized in *vanitas* still lifes. The sparse number of Bailly's works in this genre, however, does not justify the important place assigned him in the literature.

Harmen van Steenwijck was more talented than his younger brother, Pieter. Born in 1612 in Delft, he studied under Bailly in Leiden from 1628 to 1633, and worked there until about 1644. He concentrated on *vanitas* still lifes, but sometimes painted still lifes with fish and game. His palette is colorful but rather pastel in tone. He liked vigorous light effects, and in his backgrounds there are nearly always distinct bands of light and dark (fig. 566). The well-painted objects of the still life are usually displayed on a tabletop or stone slab.

In his Leiden period the still-life painter Jan Davidsz de Heem produced more interesting works than those of Bailly and the Steenwijck brothers. De Heem was born in 1606 in Utrecht and presumably studied under his father, the still-life painter David de Heem, and perhaps under Balthasar van der Ast, who moved to Utrecht in 1619. Jan Davidsz went to Leiden about 1625, was married there the next year, and stayed at least until 1631 or possibly longer.[6] Among his paintings of these years are a number of small-sized book still lifes in gray and brown tints (fig. 567), showing the pains he has taken to render the capricious forms of leather-bound folios and dog-eared pages, and to create an exciting play of light and shade. The books lie on a table in splendid disarray. Usually a few titles can be read, revealing works for the most part by contemporary writers—here, the poets Jacob Westerbaen and Gerbrand Bredero. Sometimes de Heem added a globe and a skull to the composition, sometimes a musical instrument. These paintings belong in the category of *vanitas-studium* still lifes (see p. 128). In the 1630s de Heem's style suggests contact with the

566 Harmen van Steenwijck
Vanitas Still Life
Signed. Panel, 37.7 × 38.2 cm. Municipal
Museum De Lakenhal, Leiden

567 Jan Davidsz de Heem
Still Life of Books
Signed and dated 1626. Panel, 36.1 × 48.5 cm.
Mauritshuis, The Hague

Haarlem still-life painters, and he may have spent time in that city before leaving for Antwerp, where he is recorded in 1636 and remained for the next two decades.

Of these painters active in Leiden, only Bailly and Harmen van Steenwijck worked there for any time. In 1631 Rembrandt left for Amsterdam, and Lievens for London. Sometime in the next year or so de Heem went to Antwerp. Willem de Poorter, who was presumably one of Rembrandt's first pupils, worked but briefly in Leiden. Soon only one painter of strong personality remained: Gerrit Dou, thought to be the first of Rembrandt's long line of pupils. Before turning to him we shall take a look at Jan Porcellis, who lived in the village of Zoeterwoude a few miles south of Leiden.

Porcellis and van Goyen

To discuss Porcellis here in connection with the Leiden painters is challengeable: he was in Zoeterwoude only during the last years of his life. There are several good reasons for doing so, however. The major part of his presently known oeuvre was created during these last years, and the great importance now assigned to him as a pioneer in atmospheric marine painting is based on this late work. It is plausible, for instance, to assume that the change in the work of Jan van Goyen, who returned to his birthplace, Leiden, in 1618 and stayed there until 1632, occurred in part through the influence of Porcellis, whom van Goyen knew personally: in 1629 he sold Porcellis a house.[7]

Porcellis was born in Ghent in or before 1584; lived in Rotterdam presumably from his early youth but is not recorded there until 1605; in Antwerp in 1615, becoming master there in 1617; in London; in Haarlem about 1622–23; in Amsterdam from 1624 to 1626; and thereafter in Voorburg in 1626, The Hague in 1630, and Zoeterwoude, where he died in 1632. If *A Storm at Sea* (fig. 568), and *A Sea Battle at Night*, now in the collection of the Queen of England, are the same as the panels mentioned in 1613 as being in the English royal collection, they are Porcellis' earliest known paintings,[8] typical in all aspects of the work of the older generation of marine painters.

Dated works by Porcellis, however, are otherwise known only from 1624 on, and in these he shows himself to be an innovator in the field of marine painting. Actually, he was not a sea painter, for he sought his subject matter in the Dutch inland waters, though

568

568 Jan Porcellis
A Storm at Sea
1612 or before. Panel, 41.3 × 124.5 cm. English
Royal Collections. Copyright reserved

569 Jan Porcellis
Estuary in Stormy Weather
Signed. Panel, 58 × 80.5 cm. Museum
Boymans-van Beuningen, Rotterdam

570 Jan Pocellis
Shipwreck off the Coast
Signed and dated 1631. Panel, 36.5 × 66.5 cm.
Mauritshuis, The Hague

sometimes along the coasts as well. To Vroom, a ship's portrait was of primary interest, but not to Porcellis, nor did he "portray" the simple fishing boats that appear in his pictures. What apparently thrilled him was the atmosphere of water and sky, the movement of waves, the play of sunlight breaking through the clouds (figs. 569 and 570). In old inventories his paintings are listed as "storms," "quiet waters," "Zuider Zee views," "beaches." Porcellis pursued these effects with silvery gray and brown tones, becoming one of the first Dutch painters to practice a new kind of nature painting, purely inspired by observation. He owned a small yacht in which he sailed about the Dutch waterways.

569

570

Porcellis was highly esteemed during his lifetime: in Samuel Ampzing's description of Haarlem of 1628 he is called "the greatest artist of ships." This laudatory designation makes us wonder whether the admirable small panels we know are representative of the works for which he was famed.

About 1627–29 Jan van Goyen's work entered a new phase: his colorful narrative landscapes yielded to paintings in which nature became more important and the varied colors were modulated into subdued brownish tints (fig. 571). The change may have come in part from Porcellis' example, but not from that alone. Both of these artists were wanderers—Porcellis in his boat, and van Goyen probably on foot, roaming all over the Netherlands, sketching everywhere he went, and keeping up his earlier contacts, especially

571　Jan van Goyen
Landscape with a Cottage and a Haystack
Signed and dated 1628. Panel, 22 × 34 cm. State
Museum Twenthe, Enschede

in Haarlem. Van Goyen learned about tonality not only from Porcellis but also from Salomon van Ruysdael and Pieter de Molijn, and his work, like theirs, became increasingly monochromatic and organized on strong diagonals in a triangular scheme. Van Goyen moved to The Hague about 1631 or 1632, but can hardly be said to have settled down.

Gerrit Dou

Gerrit Dou, born in Leiden in 1613, was about fifteen years old and had already studied under other teachers when he became the pupil of the twenty-two-year-old Rembrandt in 1628. Shortly afterward, other pupils entered the studio. When Rembrandt left Leiden for Amsterdam, Dou established himself as an independent painter and lived and worked in his birthplace until his death in 1675.

Dou absorbed more from Rembrandt than appears at first sight. In the treatment of light, he certainly adopted a great deal from his master, as may be seen in his 1637 *Interior with a Young Violinist* (cpl. 572). The precise, detailed style of painting for which he became so famous is found also in Rembrandt's early work. Yet Dou continued to follow this style, whereas Rembrandt proceeded along a completely different technical path, so different that the artists might be said to represent two opposed ways of painting: the rough, loose manner and the smooth and tidy. Dou's nature and talent led him away from Rembrandt; with his passion for working out meticulous details and his perfected technique, he rightly became the founder of the Leiden school of "fine" painters that thrived until well into the eighteenth century.

As usual whenever technique threatens to supplant content in art, Dou's work has undergone severe criticism by art historians, especially when impressionistic styles are in fashion. But even at such times, his technical skill arouses admiration, begrudging or not. In the seventeenth century his paintings commanded some of the highest prices on the market, and during his lifetime his works hung in major collections in Holland and abroad. The Leiden collector Johan de Bye owned twenty-seven of Dou's paintings, which he exhibited

572 Gerrit Dou
Interior with a Young Violinist
Signed and dated 1637. Panel, rounded at the top,
31.1 × 23.7 cm. National Gallery of Scotland,
Edinburgh. On loan from the Duke of
Sutherland Collection

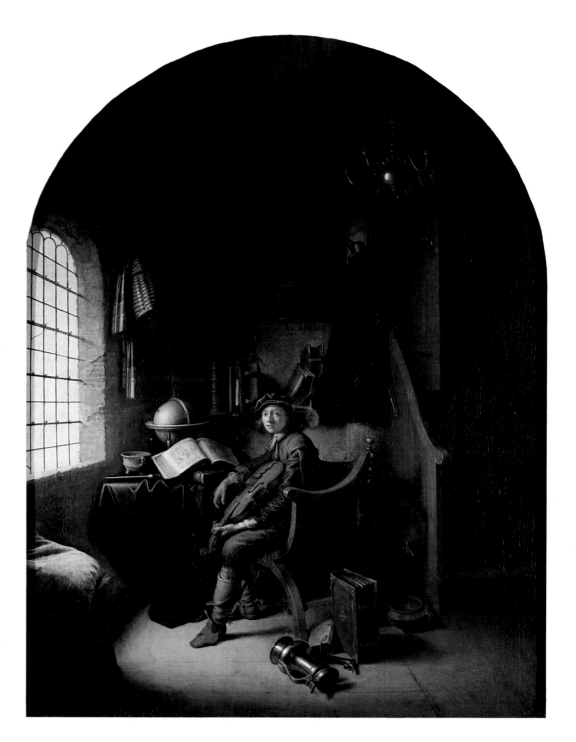

publicly, and Peter Spiering, the Swedish ambassador in The Hague, paid Dou a thousand guilders a year for the privilege of first choice in buying his works.

Interestingly enough, Houbraken was critical of Dou, partly because of his subjects: "It is a pity that this man's genius has not been applied to the greatest contemplations, and his brush to the depiction of more worthy and more costly objects."[9] He is referring to Dou's many paintings of scenes from daily life. It is remarkable that as early as Houbraken's time (the early eighteenth century), the double meanings of these pictures were evidently fathomed no longer. One of Dou's paintings, a triptych which Houbraken describes as his masterpiece, should have struck the biographer as indeed containing worthy "contemplations." This painting was purchased by Catherine the Great, but regrettably lost on the way to St. Petersburg in 1771. It is known only from a copy (fig. 573). The outer panels were painted by Jan Coxie with "pictures of the liberal arts," according to Houbraken.

The deeper meaning of the scenes in the triptych was rediscovered only in 1963 by the late Dutch art historian Jan Emmens, who published his findings in a brilliantly reasoned and persuasive essay.[10] Emmens shows that the triptych, which came to be known as *The Nursery*, symbolizes Nature, Education, and Practice. In the seventeenth century, these three elements were considered to form a unity indispensable to good upbringing, and certainly to success in art. Houbraken himself said: "Three things are necessary to reach knowledge, Nature, Education, and Practice: and unless Practice is joined to Nature and Education, no fruit can be expected."[11] As customary and typical in the seventeenth century, Dou

573 Willem Joseph Laquy after Gerrit Dou
*Nursery (Symbolizing Nature), Night School
(Symbolizing Education), Man Cutting a Quill
(Symbolizing Practice)*
Triptych. Canvas, 83 × 70 cm (middle); panel,
80 × 36 cm (each of the wings). Rijksmuseum,
Amsterdam

depicted these concepts in scenes from daily life. In the middle panel, Nature is symbolized by a mother about to suckle her child; in the left panel, Education by a school; and in the right panel, Practice by a man sharpening his quill pen. That Dou chose to embody these themes in a triptych is unique.

Other paintings by Dou must also have symbolic meaning. The famous trumpeter now in the Louvre (fig. 574), once owned by Johan de Bye, is full of innuendoes: in the foreground relief (after the Flemish sculptor Frans Duquesnoy), masked putti are teasing a billy goat (symbol of lust); the feast in the background provides the usual symbol of deplorable human desires for worldly things. By contrast, the silver ewer standing in a basin is an emblem of the pure life. The trumpeter may personify a cautionary virtue or imply a heavenly warning: the sound which the Book of Revelation assures us will signal the Last Judgment.[12]

This little painting is in every way an excellent example of Dou's talent. Without losing sight of the whole, he has worked out the trumpeter, the drapery, and the rug hung over the sill to the last detail, and has painted the highly significant scene in the background in grayish tints with somewhat broader strokes. The composition with the scene framed by a painted stone arch is one that Dou frequently used. Besides enclosing the scene and thus making it more intimate, this device also creates an illusionistic effect that is sometimes enhanced by a curtain pulled back to reveal the scene only partially. A splendid example of this *trompe-l'oeil* effect occurs in his self-portrait (fig. 575).

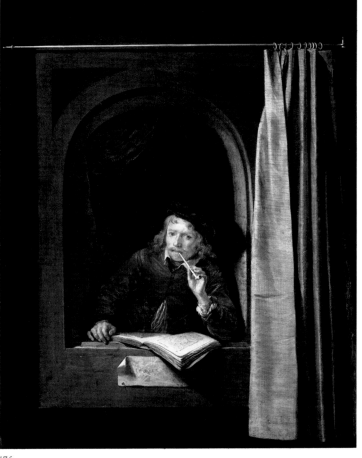

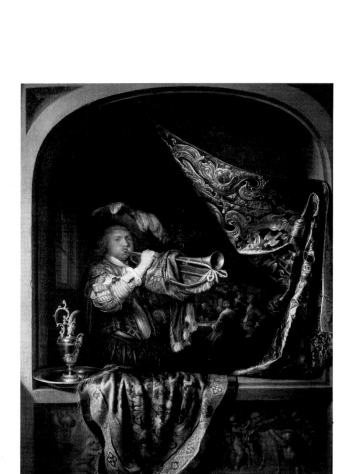

This composition of Dou's was enormously popular and attracted many imitators. He also started two other trends: hermits (fig. 576) and candlelit scenes (fig. 577). Both motifs originated in Rembrandt's studio, the latter through Rembrandt's versions of the Utrecht Caravaggists' theme. Dou's treatment, however, led in another direction: he retained the exciting play of light and dark, but placed his emphasis on the setting and the fastidious finish of its many details. Dou also painted portraits, of high quality, yet presumably did not capture good likenesses, required his models to pose too long, and charged too much; in any event, he abandoned the field.[13] He had many pupils and followers. His most important and

574

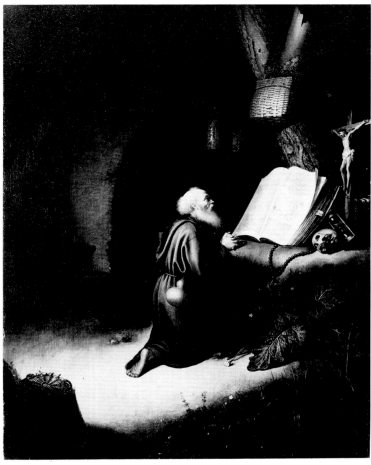
576

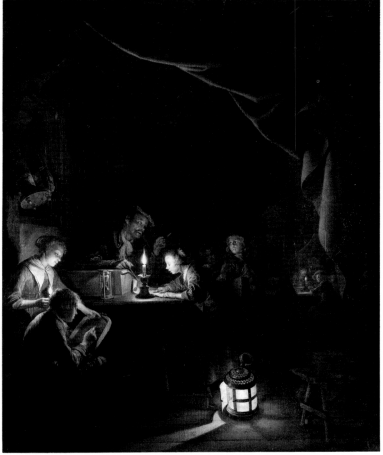
577

faithful pupil was Frans van Mieris, who will be discussed later (see p. 432). Others, including Jacob van Spreeuwen, Domenicus van Tol, and Jacob Toorenvliet, occasionally painted attractive pictures but contributed little to any artistic development. Whether Quiringh Brekelenkam should be counted among Dou's pupils is debatable, for his work reveals a degree of independence and will also be treated later (see p. 431).

Painting in Amsterdam: 1625–1650

Portraiture

Rembrandt's main reason for leaving Leiden in 1631 and heading for Amsterdam was probably the financial rewards he hoped for in that rapidly growing young city. At the turn of the century Amsterdam's population had been about 50,000; it had doubled by 1625, reached 120,000 in 1630, and rose to over 200,000 in the second half of the century. By that time the spectacular voyages of discovery were over, but the seven seas were still firmly in Dutch hands, and Amsterdam was the unrivaled center of trade, the marketplace for the world's staples.

What waters are not shadowed by her sails?
On which marts does she not sell her wares?
What peoples does she not see lit by the moon,
She who herself sets the laws of the whole Ocean?

Thus wrote Vondel in 1631, not without bravado. But the Amsterdammers of that day were not modest. Since shortly after the death of Prince Maurits, the municipal government was again solidly controlled by a relatively small group of regents, led by members of the Bicker and de Graeff families.[1] As merchants, they were determined to create a climate favorable to shipping and trade which would serve their own interests and the economy of Holland as well. The Amsterdammers were a powerful factor in the Republic, and fully conscious of this power, but precisely because they concentrated on commerce, industry, and shipping, their government was in no way fanatic. Amsterdam was far from a paradise—poverty, crime, and disease were endemic and could, when grain prices rose, become critical—yet compared with other cities and countries, it was a lively and pleasant place. The economy moved steadily upward, the war action was only in the country's rather distant border areas; the power over the seas increased. In this exceedingly favorable situation during the second quarter of the century, the cultural aspects of society flourished.

It is striking how many painters continued to arrive in Amsterdam. The stream of Flemish refugees had stopped; the influx now was of artists from other places who came to settle in the city for a while, often permanently. When Rembrandt arrived, the older generation of artists still included not only his former master Pieter Lastman but also David Vinckboons, Willem and Adriaen van Nieulandt, Jan Pynas, Jan Tengnagel, and Claes Moeyaert. The portrait painters Nicolaes Eliasz and Thomas de Keyser were at the peak of their careers, and at least twenty or thirty artists of Rembrandt's age were making a good start.

The Amsterdam art dealer Hendrick Uylenburgh may have encouraged Rembrandt's move, and in any event played an important role in the artist's first years in Amsterdam. In June 1631, while still living in Leiden, Rembrandt loaned Uylenburgh one thousand guilders, presumably to support his art shop, a large sum in those days. Other painters—Claes Moeyaert, Simon de Vlieger, Jacob de Wet, Jan Jansz Treck, and Lambert Jacobsz—also had financial interests in it. Upon his arrival, Rembrandt moved in with Uylenburgh, who lived at the corner of Sint-Anthoniebreestraat and Zwanenburgwal, and it was almost certainly here that Rembrandt met Hendrick's young first cousin, Saskia van Uylenburgh of Leeuwarden; they became engaged in 1633 and were married a year later.

Before the end of 1631 Rembrandt had executed his first Amsterdam commission: a portrait of Nicolaes Ruts, a merchant in the Muscovy trade (cpl. 578). The head is powerfully painted and plastically modeled. The composition, with the figure portrayed full front, one hand holding a note and the other resting on the back of a chair, was a

◁

574 Gerrit Dou
 The Trumpeter
 Signed. Panel, 37 × 29 cm. Musée du Louvre, Paris

575 Gerrit Dou
 Self-Portrait
 Signed. Panel, 48 × 37 cm. Rijksmuseum, Amsterdam

576 Gerrit Dou
 Hermit Praying
 Signed. Panel, 57 × 43 cm. Gemäldegalerie Alte Meister, Staatliche Kunstsammlungen, Dresden

577 Gerrit Dou
 The Night School
 Signed. Panel, 53 × 40.3 cm. Rijksmuseum, Amsterdam

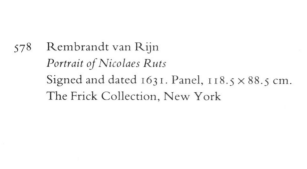

578 Rembrandt van Rijn
Portrait of Nicolaes Ruts
Signed and dated 1631. Panel, 118.5 × 88.5 cm.
The Frick Collection, New York

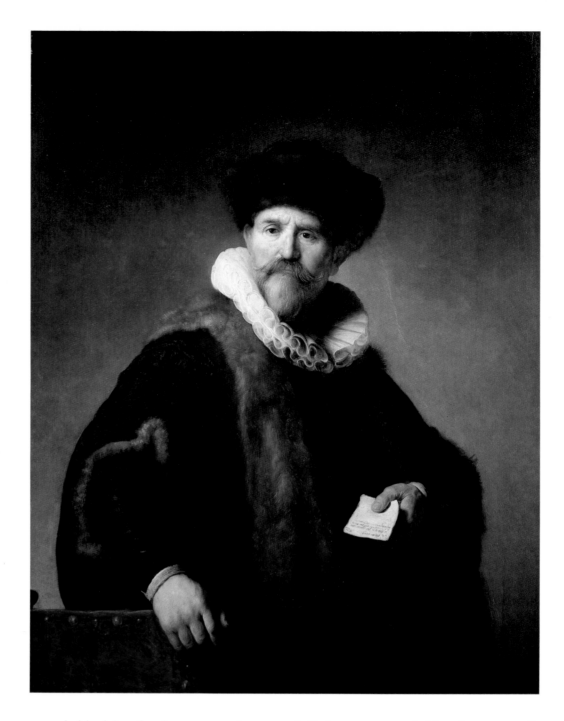

remarkable debut for the young painter—and all the more remarkable when one realizes that no known portrait from his Leiden period even hints at being a commissioned work. The portraitlike heads from that time must presumably be construed as studies. Even more important than the portrait of Ruts, however, was the group portrait on which Rembrandt was busy as early as January 1632: *The Anatomy Lesson of Dr. Nicolaes Tulp*, the great merits of which are discussed elsewhere (see p. 113).

With these two paintings Rembrandt not only joined the ranks of the best Amsterdam portrait painters, but indeed left them behind. Although his training and ambitions had been in history painting, a field he did not desert, portraiture began to take on major importance for him. And no wonder, for there was plenty of money in Amsterdam to pay for portraits: with the booming economy, the burghers could embellish their houses, and portraits became a favorite form of interior decoration. In addition, commissions for group portraits grew to record numbers.

Cornelis van der Voort had earlier profited from this demand: four civic-guard and three regents paintings by him are known, all painted between 1617 and 1624, the year of his death. Werner van den Valckert, another master of the group portrait, died about 1627, so that there now remained only two experienced group portraitists in Amsterdam, Nicolaes Eliasz and Thomas de Keyser. At the beginning of his career, in 1619, de Keyser had painted a group portrait for the surgeons' guild, and Eliasz had made one in 1625. When one wonders why Tulp commissioned a young, untried Leiden artist, Rembrandt van Rijn to paint his anatomy lesson rather than one of these established artists, the answer may be the practical fact that both were engaged on prior commissions. In 1632 de Keyser finished a

large canvas for Captain Allaert Cloeck and his civic-guard company (see fig. 188), and may have already accepted a commission to paint a group portrait of unprecedented size—at least six meters, or some seventeen feet, wide—for the company of Captain Jacob Symonsz de Vries; he completed this painting, which included twenty-one portraits, in 1633. Nicolaes Eliasz likewise delivered in 1632 a monumental militia painting of Captain Jacob Backer with his men, twenty-four figures in all, gathered around a banquet table (fig. 579). Eliasz in particular continued to obtain important commissions for group portraits (in 1639, 1642, 1645) and evidently was not displaced by Rembrandt, despite the latter's remarkable feat in *The Anatomy Lesson of Dr. Tulp*. There was ample room for painters of group portraits.

Eliasz and Thomas de Keyser had set the fashion in portraiture in Amsterdam before

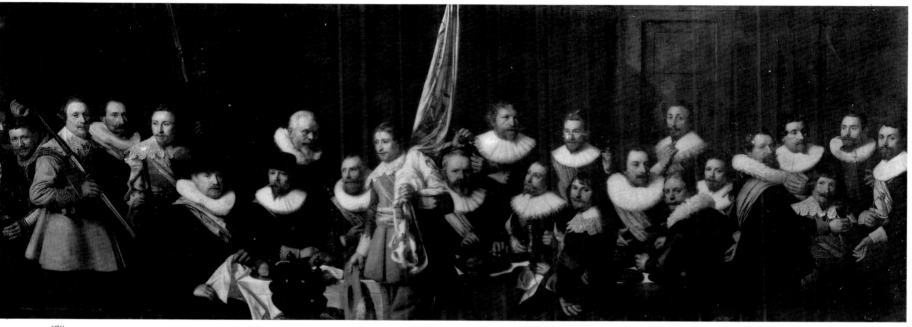

579

579 Nicolaes Eliasz, called Pickenoy
Civic-Guard Banquet of Captain Jacob Backer
1632. Canvas, 198 × 531 cm. Amsterdams
Historisch Museum, Amsterdam

580 Nicolaes Eliasz, called Pickenoy
Portrait of a Gentleman
Dated 1628. Panel, 122 × 91 cm. Private
collection

581 Nicolaes Eliasz, called Pickenoy
Portrait of a Lady
Dated 1628. Panel, 122 × 91 cm. Private
collection

Rembrandt arrived, and both were powerful links in the tradition of portrait painting that made their city world-renowned for this pictorial type.

Nicolaes Eliasz was born in Amsterdam about 1590 or 1591, son of Elias Claesz Pickenoy, an Antwerp emigrant. He may have studied under the portrait painter Cornelis van der Voort, whose work his own most resembles. Eliasz's art is technically excellent, his painting style smooth, and his heads have good plasticity. He painted cloth with thoughtful skill, being a master at rendering the darkly gleaming, richly woven garments with white collars and cuffs that his models usually wore (figs. 580 and 581). Full-length portraiture was well

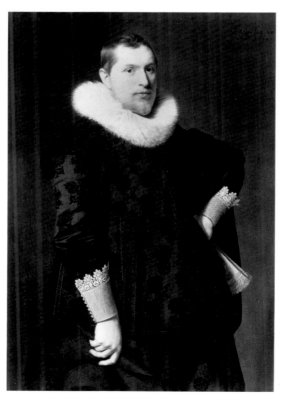

580

581

within his technical ability (see figs. 405 and 406), and he usually found satisfactory solutions in composing his many civic-guard and regents paintings. He was perhaps inspired by Frans Hals's work, an influence apparent in such paintings as *The Civic-Guard Banquet of Captain Jacob Backer*. Eliasz achieved and maintained a consistently high level, and he exemplifies the solid, competent portrait painter. He died in Amsterdam between 1654 and 1656.

Thomas de Keyser's work is not as well balanced, and his civic-guard paintings are inferior to those of Eliasz. He could barely control the composition of large canvases, and a glimpse at his 1632 militia painting (see fig. 188) at once reveals his failure to gain greater depth by placing the men on different levels: the interrelationships among the figures are lost, and his manner of placing the heads on the torsos seems forced. The heads themselves

582 Thomas de Keyser
Portrait of Constantijn Huygens and His Clerk
Signed and dated 1627. Panel, 92.4 × 69.3 cm.
The National Gallery, London

are powerful enough, set down with broad strokes, and they have undeniable character. De Keyser was stronger in pictures of more modest size. He showed his art to best advantage in his individual portraits and small groups, in which the often full-length figures are placed in an interior. His 1627 portrait of Constantijn Huygens (cpl. 582) belongs indisputably among the gems of Dutch portraiture.

Son of the architect Hendrick de Keyser, Thomas was also active in his father's field: he was a stone dealer, and in 1662 he was appointed municipal architect of Amsterdam. Between 1640 and 1654 he apparently produced few paintings, but afterward he took up his brush again; he died in 1667. Among the finest works of his late period is the equestrian portrait of Pieter Schout, with the background landscape presumably painted by Adriaen van de Velde (see fig. 181).

Rembrandt profited in full from the abundance of work for portrait painters in Amsterdam. Many portraits have survived from his first ten years in the city—heads, busts, half lengths, three-quarter lengths, full lengths, and double portraits. Even for a painter as inventive as Rembrandt, to be sure, there was little chance for variation in the composition of bust-length portraits. But as soon as he worked on larger formats, he experimented in various ways at breaking through the traditional pose. In double portraits (see fig. 176), too, he could create livelier compositions and introduce a bit of narrative.

In his handling of paint, Rembrandt also differed from his predecessors. His technique is not simple to describe, because he changed his working method from model to model. This characteristic had already appeared in his Leiden period. Sometimes, when he had to portray

583 Rembrandt van Rijn
Portrait of a Woman
Signed and dated 1634. Panel, oval, 69.5 × 55.4 cm. The J.B. Speed Art Museum, Louisville, Kentucky

584 Rembrandt van Rijn
Portrait of an 83-Year-Old Woman
Signed and dated 1634. Panel, oval, 68.7 × 53.8 cm. The National Gallery, London

a smooth skin, he painted flowingly, the individual brushstrokes hardly visible, and he worked with superimposed transparent layers, as in his *Portrait of a Woman* (fig. 583) of 1634. At other times, when he wanted to capture the wrinkled skin of an old woman, for instance, his strong brushstrokes are perceptible, and he used fewer transparent glazes (fig. 584); this portrait is also from 1634. Rembrandt often applied shadows and half-shadows in a transparent glaze, so that the underpainting shows through. In this way the more opaque paint reflects highlights that are well observed and contribute in large measure to the plasticity of the head and the spatial effect in general. Rembrandt then proceeded to strengthen this effect by creating subtle backgrounds with lively brushstrokes and distribution of light. Although these backgrounds usually do not represent anything specific, they always set off the figures in tangible space. In his rendering of clothing, Rembrandt did not differ greatly from his contemporaries.

Portrait painting kept Rembrandt busy, but it could never supplant his activities as a history painter. Constantijn Huygens had recognized his skill in this field when he visited Rembrandt and Lievens in Leiden, and he did not forget it: about 1632 Rembrandt received a commission to paint a series of Passion scenes for Frederik Hendrik, the order coming through Huygens, the stadholder's secretary. The wording is not known, for no document of the commission has been preserved, but the result was a series eventually comprising *The Elevation of the Cross* (fig. 585), *The Descent from the Cross* (fig. 586), *The Entombment, The Resurrection* (see fig. 70), and *The Ascension*. Added much later were an *Adoration of the Shepherds* and a *Circumcision,* themes outside the Passion series; the plan may have been to enlarge it to the life of Christ.

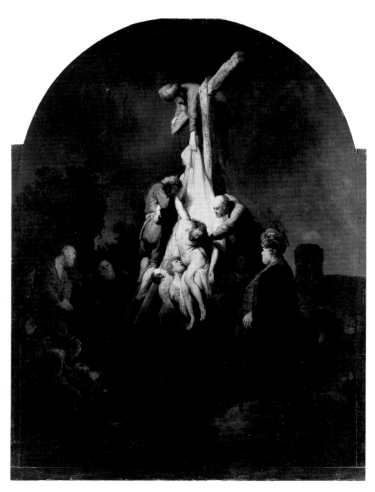

585 Rembrandt van Rijn
The Elevation of the Cross
c. 1632–33. Canvas, rounded at the top,
96.2 × 72.2 cm. Alte Pinakothek, Munich

586 Rembrandt van Rijn
The Descent from the Cross
c. 1633. Panel, rounded at the top, 89.4 × 65.2 cm.
Alte Pinakothek, Munich

Rembrandt seems to have had great difficulty getting the result he wanted in these pictures. While he must have had the *Elevation* and the *Descent* ready for delivery about the end of 1632 or beginning of 1633, it appears from an exchange of letters with Huygens that he did not finish the *Ascension* until 1636 and that he was still working hard on the *Entombment* and the *Resurrection*, though he did not deliver them until 1639.[2] His excuse for the delay was the "studious diligence" he had exerted to attain "the most and the most natural movement" in the paintings, but this argument is weak. More likely he simply had too many other things going on at the same time. In any event, the series, which now hangs in Munich, is something of a disappointment, partly because of the poor condition of several of the paintings, but also because the execution in even the well-preserved sections is less than brilliant.

During this period Rembrandt began to paint pictures in large format, choosing biblical themes that allowed him to depict strong emotions combined with violent movement and pace. Thus, in 1635, he painted Samson angrily threatening his father-in-law for giving his bride to another man (cpl. 587). It is obvious that, in addition to movement and human emotion, Rembrandt was excited by spectacular light effects. Samson's sword and richly brocaded garment gleam with subtle light, and his clenched fist casts a menacingly evocative shadow on the wall, anticipating the shadow of Banning Cocq's hand on van Ruytenburch's tunic in *The Night Watch* (see fig. 191). In 1636 Rembrandt painted a large canvas that carries Baroque movement to the extreme in a scene where Samson, betrayed by Delilah, is blinded by the Philistines (fig. 588). The brutal violence of the soldiers, Samson's face twisted with agony, and his bare foot with the toes curled in powerless anger and pain—all are rendered with alarming naturalness.

These paintings bear witness to enormous daring as well as to complete mastery of the material. There is a strong possibility that Rembrandt, with canvases like these, was setting himself up as a rival to Rubens and wished to prove himself the Flemish master's equal. Yet his dramatic urge seems to have reached its peak with *The Blinding of Samson*. In the same year he also painted *Danaë* (fig. 589), one of the most beautiful nudes in seventeenth-century art. He presumably kept this painting for a long time and at some date made extensive alterations to it, especially to the figure of Danaë.[3] The expression of human feelings continued to fascinate him, but he came to rely less on movement to suggest mood. In a number of somewhat smaller works he used a quieter narrative style, as in the lovely panel depicting the meeting between Mary and Elizabeth (fig. 590).

587 Rembrandt van Rijn
Samson Threatening His Father-in-Law
Signed and dated 163(5?). Canvas, 156 × 129 cm.
Gemäldegalerie, Staatliche Museen, West Berlin

588 Rembrandt van Rijn
The Blinding of Samson
Signed and dated 1636. Canvas, 236 × 302 cm.
Städelsches Kunstinstitut, Frankfurt am Main

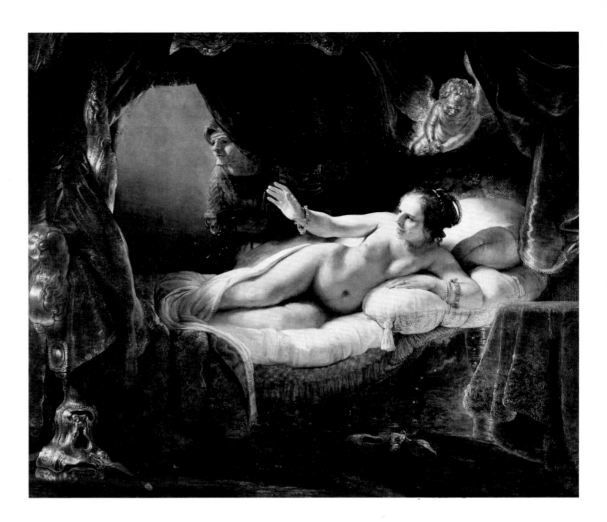

589 Rembrandt van Rijn
 Danaë
 Signed and dated 1636. Canvas, 185 × 203 cm.
 Hermitage, Leningrad

590 Rembrandt van Rijn
 The Visitation
 Signed and dated 1640. Panel, rounded at the top,
 56.5 × 48 cm. The Detroit Institute of Arts

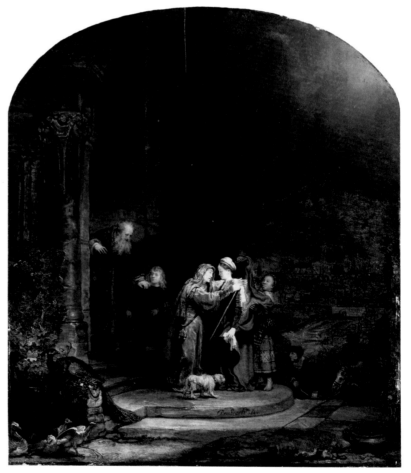

It is tempting to go on and on about Rembrandt's work during this period, and to include his etchings and drawings, but the literature about him is so prolific that the discussion here will best be limited. Suffice it to say that etching remained a major interest and that, in addition to his large and meticulously executed etchings of this time, such as *The Death of the Virgin* (fig. 591), he also made prints that are surprisingly simple and direct (figs. 592 and 593). His drawings bear witness to unceasing study *naer 't leven* (after life) (fig. 594) and *uit de geest* (of the spirit) (fig. 595).

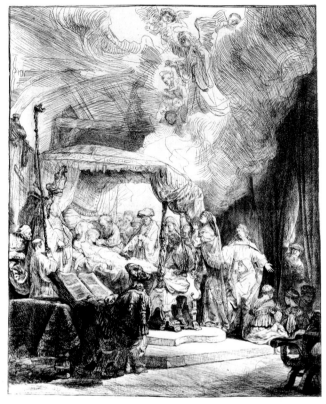

591

592

593

594

591 Rembrandt van Rijn
The Death of the Virgin
Signed and dated 1639. Etching and drypoint

592 Rembrandt van Rijn
Portrait of Menasseh Ben Israel
Signed and dated 1636. Etching

593 Rembrandt van Rijn
Studies of Saskia and Others
Signed and dated 1636. Etching

594 Rembrandt van Rijn
Woman Carrying a Child Downstairs
Pen and bister, wash, 18.7 × 13.3 cm. The
Pierpont Morgan Library, New York

595 Rembrandt van Rijn
Christ as a Gardener Appears to Mary Magdalen
Pen and bister, 15.2 × 19 cm. Print Room,
Rijksmuseum, Amsterdam

595

596 Pupil of Rembrandt (Constant van Renesse?)
Pupils Sketching in Rembrandt's Studio
c. 1650–60. Pen and bister, wash, black chalk,
heightened with white, 18 × 26.6 cm. Hessisches
Landesmuseum, Darmstadt

About 1640 Rembrandt must have received the commission for his first and only civic-guard painting, *The Company of Captain Frans Banning Cocq,* known as *The Night Watch* (see fig. 191). The new wing of the Kloveniersdoelen or arquebusiers' hall had been completed in 1638, and, as we noted in Part I (p. 108), in the following years commissions were given for seven large group portraits to decorate the meeting and banqueting room. The patrons now had many more painters to choose from than in the early 1630s, for a whole new generation had arisen to meet the increased demand for portraits. Besides the nestor, Nicolaes Eliasz, and Rembrandt, the militia officials picked four young painters, each of whom seemed able to meet the high standards of a civic-guard painting. These artists were Jacob Backer, Govert Flinck, Joachim von Sandrart, and Bartholomeus van der Helst. Before looking inside the Kloveniersdoelen, as it were, we must stop to consider the new generation to which they belonged. Some of its members were Rembrandt's pupils; others represented a different trend in painting, led by van der Helst.

Rembrandt as Teacher

Rembrandt's success in Amsterdam can be determined not only by the commissions he received but also by the many pupils who came to him from far and wide. His manner of teaching can scarcely have followed the rules of the St. Luke's guilds in Holland, which would have limited him to only a few pupils and made the relationship between master and apprentice more nearly resemble that in the craft guilds. Deviation from the guild regulations was not exceptional: at about the same time as Rembrandt, Frans de Grebber, as we have seen, had sixteen pupils at once. Information about Rembrandt's many pupils comes in the first place from the German painter and biographer Joachim von Sandrart, who worked in Amsterdam from 1637 to 1642: he reports that the artist's house was filled with "countless highborn children for instruction and training."[4] Since Sandrart had spent some time in Honthorst's studio, which he said contained twenty-five pupils, it may be concluded that Rembrandt had at least that many and probably more. Arnold Houbraken amplifies Sandrart with more specific detail: "Being there [in Amsterdam], work flowed to him from all sides; the same also many Pupils, to which end he leased a Warehouse on the Bloemgraft, where each of his Pupils had his own space (closed off by paper or canvas) in order to be able to paint after life without bothering one another."[5] This information is more or less corroborated by a passage from the deed of sale of Rembrandt's house in 1658: "The owner will... take with him two tile stoves and several partitions in the attic placed there for his apprentices, belonging to Rembrandt van Rijn."[6]

How did Rembrandt go about teaching all these pupils? He seems to have used a system comparable with that in the Italian academies.[7] He had probably learned about such institutions from Hendrick Uylenburgh, who, in addition to his art shop, ran an "academy" of drawing and painting attended by young artists aspiring to be professionals and by dilettantes as well. Some of their work he sold in his shop. Whether Rembrandt taught in this academy is unknown, but his interest in it can be assumed, for he lived in Uylenburgh's house for four years.

Rembrandt's teaching method can be deduced in part from a drawing of his studio made by one of his pupils (fig. 596). He himself (second from the left) was on hand to supervise. His pupils were not all novices, but included older artists who probably welcomed the opportunity to sketch from a live nude model. Plaster casts (on the ledge above the model) were also available as study material. The pupils were taught to hold their sketchbooks

upright while drawing, in order, as Rembrandt's pupil Samuel van Hoogstraeten later wrote, "that you don't need to lift your head or turn your eye too much when looking up."[8] Rembrandt certainly continued the tradition of having his pupils copy paintings by established masters, including himself. Whether he permitted them to paint the less important parts of his own work is not known. Such a suggestion has up to now been indignantly dismissed, less on factual evidence than on the grounds that nineteenth-century opinions of Rembrandt's sacred genius would not admit to such practices. As long as the contrary has not been proved, it is more honest to assume that Rembrandt was probably no different from his contemporaries in this respect, and that he called on his pupils for help in working out his own commissions.

Among Rembrandt's pupils were not only future artists but also youths of good upbringing, for whom learning to draw was part of their general education. We shall limit our consideration here to those who succeeded in setting their mark on Dutch art.

Rembrandt's Circle in the 1630s

In 1632 or 1633 Govert Flinck, born in Cleves in 1615, came to live in Hendrick Uylenburgh's house. A Mennonite, he had been studying for several years in Leeuwarden under Lambert Jacobsz, a Mennonite preacher, painter, and art dealer, before becoming Rembrandt's pupil. Uylenburgh was also a Mennonite and had close business relations with Lambert Jacobsz, so that it was quite natural for the young Flinck to stay with him. And along with Flinck, Rembrandt probably began to attract a separate small group of his own pupils at Uylenburgh's.

About 1636 Flinck established himself as an independent master, quickly developing into a good portrait and history painter. His work up to about 1640 clearly shows his reliance on Rembrandt, as can be seen in a portrait of 1639, presumably a self-portrait (fig. 597).[9] This painting once bore the false signature of Rembrandt, but during a restoration Flinck's original signature came to light. In its technique, composition, and treatment of light, the portrait displays Rembrandt's influence, but it lacks his sure touch. The structure of the eyes, in particular, and the handling of the shadowed areas are weak. Other portraits of the period give better evidence of Flinck's talent—the charming *Portrait of a Boy in a Landscape* (fig. 598), for instance.

597 Govert Flinck
Self-Portrait (?)
Signed and dated 1639. Panel, 65.8 × 54.4 cm.
The National Gallery, London

598 Govert Flinck
Portrait of a Boy in a Landscape
Signed and dated 1640. Panel, 129.5 × 102.5 cm.
The Barber Institute of Fine Arts, University of
Birmingham, England

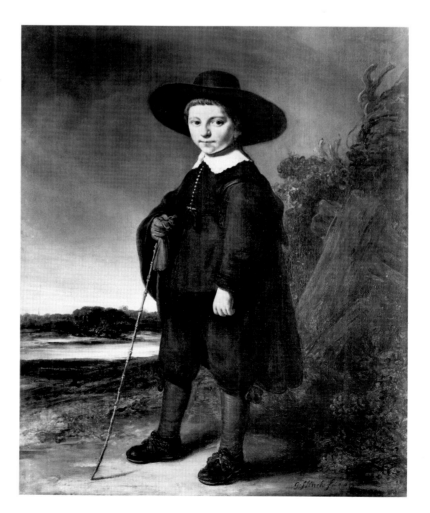

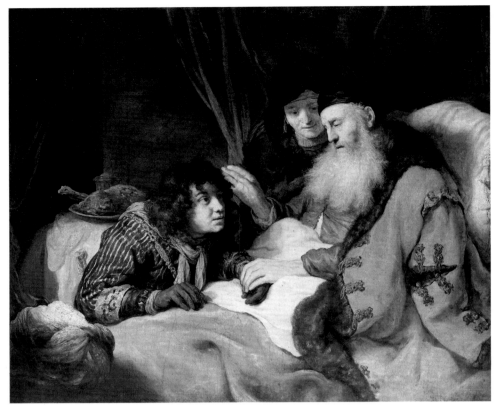

599

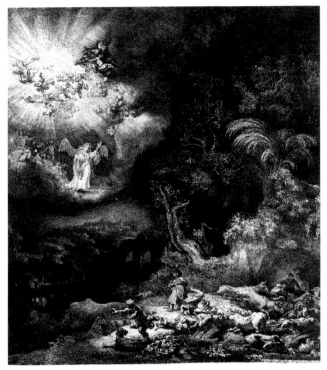

601

599　Govert Flinck
Isaac Blessing Jacob
Signed and dated 1638 (disappeared when the
painting was cleaned). Canvas, 117 × 141 cm.
Rijksmuseum, Amsterdam

600　Govert Flinck
The Angel Appearing to the Shepherds
Signed and dated 1639. Canvas, 160 × 196 cm.
Musée du Louvre, Paris

601　Rembrandt van Rijn
The Angel Appearing to the Shepherds
Signed and dated 1634. Etching and burin

Rembrandt's influence is also apparent in Flinck's early biblical pictures. Without his master's example, Flinck could not have conceived one of his most successful works, *Isaac Blessing Jacob* (fig. 599), whose date of 1638 is now invisible but was recorded by early observers. The large, very ambitious canvas *The Angel Appearing to the Shepherds* of 1639 (fig. 600) was also obviously inspired by Rembrandt's etching of 1634 (fig. 601). Flinck changed the composition and transposed the format from vertical to horizontal, but his direct borrowings cannot be disguised: the angel bringing the glad tidings, the sway-backed cow in the left foreground, and the palm tree. The landscape is painted mainly in brown and olive green, the clothing of the shepherds in brown and yellow tints.

Sometime in the early 1640s Flinck's style underwent a distinct change, its magnitude measurable in the double portrait he painted in 1646 (fig. 602). He has gone over entirely to the elegant style and smooth manner of painting then in fashion in Amsterdam, primarily through the influence of Bartholomeus van der Helst. The magnificently painted civic-

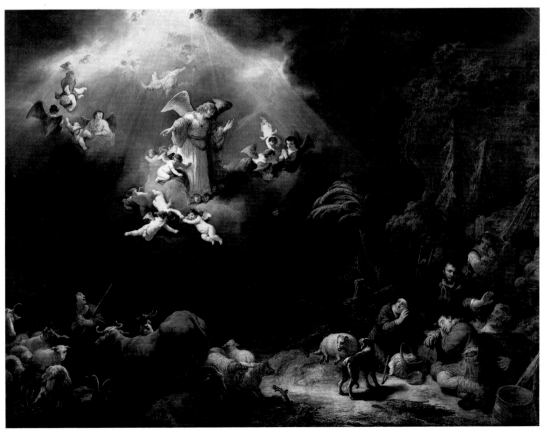

600

602 Govert Flinck
 Double Portrait
 Signed and dated 1646. Canvas, 152 × 168 cm.
 Staatliche Kunsthalle, Karlsruhe

603 Govert Flinck
 *The Civic Guard of Amsterdam Celebrating the
 Treaty of Münster, 1648*
 Signed and dated 1648. Canvas, 265 × 513 cm.
 Amsterdams Historisch Museum, Amsterdam

guard piece celebrating the Treaty of Münster of 1648 (fig. 603), in which light, clear shades of red, blue, and yellow are used, is a good example of Flinck's later work. He made such an impression with this and other works that he was awarded the most prestigious share in the decorations for Amsterdam's new town hall. He was able to complete only part of this commission, for he died in 1660, just when he had begun the most important phase, the decoration of the galleries adjoining the Burghers' Hall.

Jacob Backer, born in the Frisian port town of Harlingen in 1608, studied together with Flinck under Lambert Jacobsz in Leeuwarden, and the two painters went to Amsterdam at the same time. Although Backer is nearly always called a pupil of Rembrandt, no evidence of this has been produced. He was seven years older than Flinck, thus twenty-three or twenty-four when they arrived in Amsterdam, and, considering his age and the maturity of his first works there, he probably set himself up immediately as an independent artist,

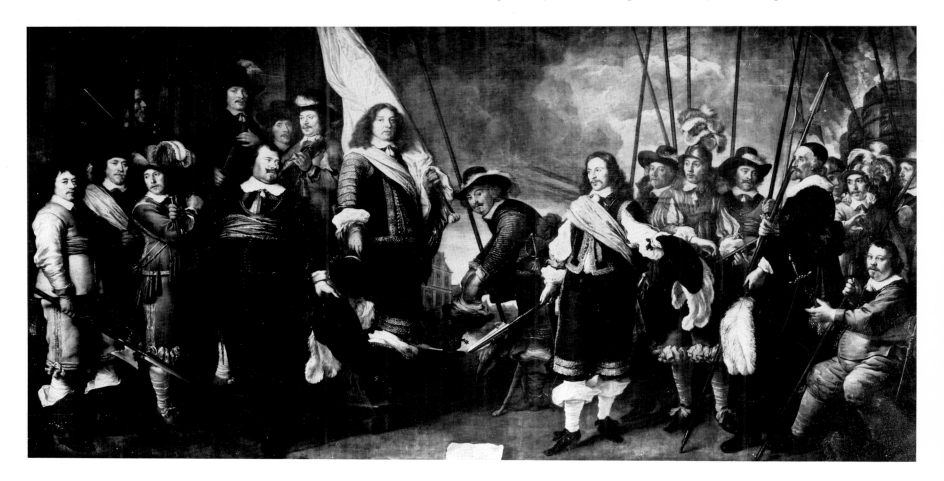

604 Jacob Backer
Portrait of Johannes Uyttenbogaert, Remonstrant
Minister
Signed and dated 1638. Canvas, 122.5 × 98 cm.
Rijksmuseum, Amsterdam. On loan from the
Remonstrant-Reformed Congregation

605 Jacob Backer
Boy in Gray
Signed and dated 1634. Canvas, oval, 94 × 71 cm.
Mauritshuis, The Hague

605

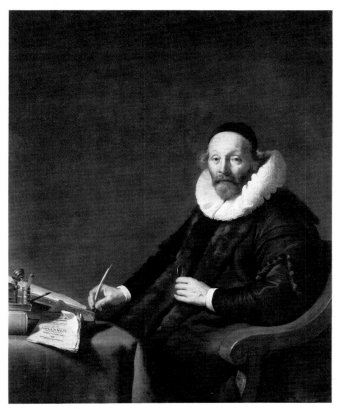

604

though some of his paintings, such as his portrait of the Remonstrant minister Johannes
Uyttenbogaert (fig. 604), bear traces of Rembrandt's influence. Backer's early works show
his talent and originality to be greater than Flinck's.

About 1634, while Jacob van Campen was engaged on a major rebuilding project for the
Amsterdam Burgher Orphanage (his uncle was a regent of this institution), Backer
produced a group portrait for the new Regent's Chamber. This painting (see fig. 196) is one
of the pinnacles of group portraiture in Amsterdam, and it reveals the high technical level
and personal style that Backer had at his command so soon after he reached the city. A
majestic simplicity radiates from the picture, and the subdued coloring and sensitive
handling of light create a powerful atmospheric bond. The portraits themselves are painted
without strong contrasts of light. This painting and the portrait *Boy in Gray,* dated 1634
(cpl. 605), in which similar qualities are present, show that Backer, at least at that time, was
a painter of such independence that he can be linked stylistically neither with Rembrandt
nor with the older Amsterdam portrait painters. Bauch has made the plausible suggestion
that the Frisian artist Wybrand de Geest probably influenced Backer's portrait style.[10]

There are only a few history paintings by Backer from the 1630s to give a clear idea of
his development in this field.[11] Bauch's assumption that he really was Rembrandt's pupil
has resulted in a number of Rembrandtesque paintings being attributed to him upon
insufficient evidence. There is actually nothing to go on until after 1640, and by then
Backer, like Flinck, had chosen to embark on the new classically oriented style. He painted
compositions with large figures, such as *John the Baptist Reproves Herod and Herodias* (fig.

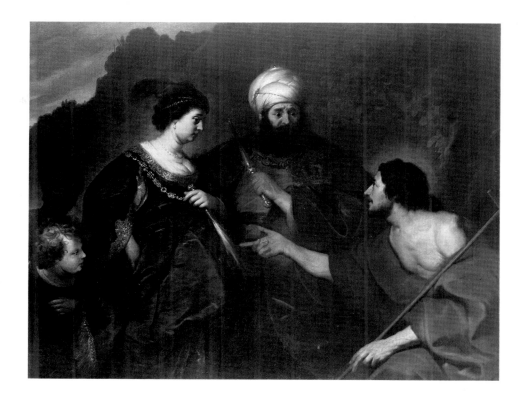

606 Jacob Backer
John the Baptist Reproves Herod and Herodias
Signed and dated 1633. Canvas, 138.8 × 173.3 cm.
Private collection

607 Jacob Backer
Regents of the Nieuwe Zijds Huiszittenhuis,
Amsterdam
Signed. c. 1650. Canvas, 272 × 312 cm.
Rijksmuseum, Amsterdam. On loan from the
City of Amsterdam

606), which are related to the work of de Bray and de Grebber in Haarlem. The large group portrait that Backer made about 1650, one year before his death, of the regents of the Nieuwe Zijds Huiszittenhuis (fig. 607) also shows a relationship with the work of the Haarlemmers, partly in the composition and especially in the light background.

If Jacob Backer probably was not Rembrandt's pupil, Ferdinand Bol certainly was. Born in Dordrecht in 1616, Bol worked in the master's studio for five or six years, presumably from 1635 to 1641;[12] before that he is thought already to have had lessons in painting in Dordrecht, perhaps from Jacob Gerritsz Cuyp. Houbraken records him as a pupil of Rembrandt, and on the back of a drawing Rembrandt himself wrote that he sold work by "fardinandus."[13]

Many borrowings from Rembrandt in Bol's early history paintings attest to the pupil's dependence on his master. One example is the picture which perhaps represents Rachel

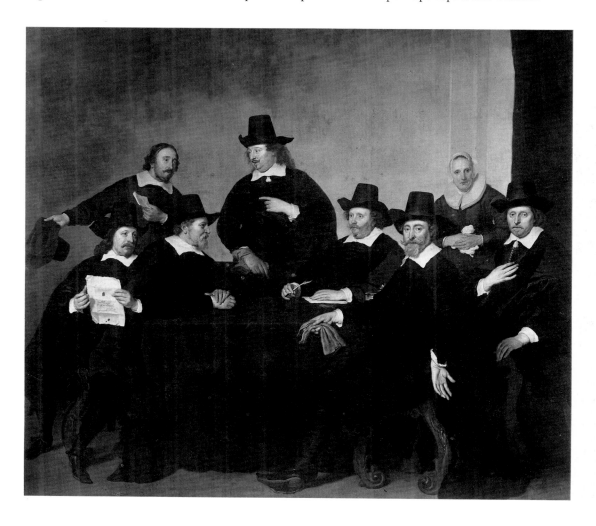

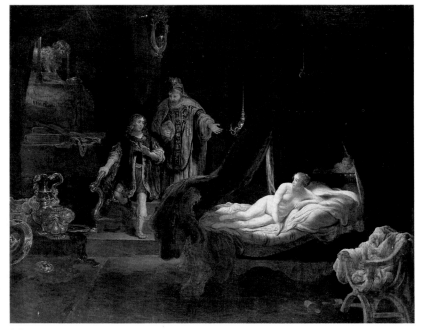

608

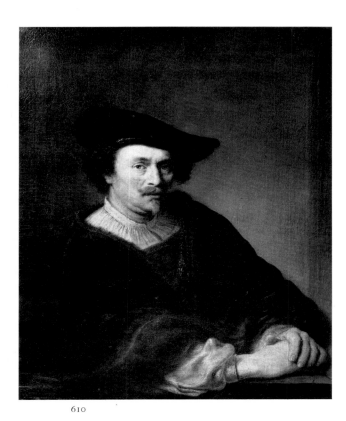

610

608 Ferdinand Bol
Rachel Being Shown to Jacob (?)
Signed. c. 1640. Canvas, 81 × 100 cm. Herzog
Anton Ulrich Museum, Brunswick, West
Germany

609 Ferdinand Bol
The Three Marys at the Tomb of Christ
Signed and dated 1644. Canvas, 280 × 358 cm.
Statens Museum for Kunst, Copenhagen

610 Ferdinand Bol
Self-Portrait
Canvas, 86 × 72 cm. Alte Pinakothek, Munich

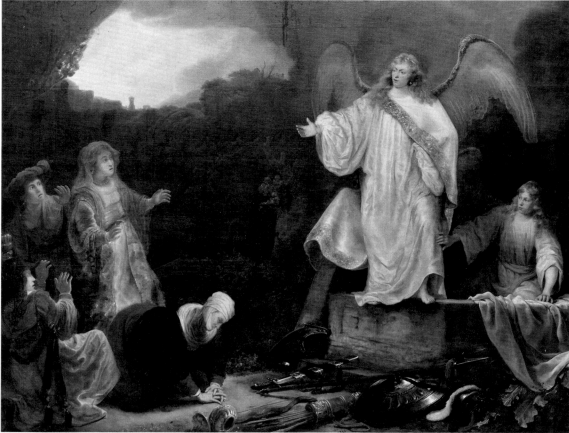

609

being shown to Jacob (fig. 608): it goes back directly to Rembrandt's *Danaë* (see fig. 589). There are also numerous borrowings in the outsize canvas *The Three Marys at the Tomb of Christ* (fig. 609), dated 1644. These two paintings make it clear that Bol's talents as a history painter cannot be compared with Rembrandt's. No matter how well painted some of the details and heads may be, neither picture is convincing as a whole; the figures stand around rather like clumsy actors, for Bol lacked Rembrandt's ability to render the dramatic power of pose and facial expression.

Although Bol makes a much stronger impression with his portraits, and his increasing proficiency leads to excellent results, the facial expressions of his models continue to be somewhat impersonal. His technical skill is revealed in the large group portrait he made in 1649 of the regents of the Amsterdam leper asylum (see fig. 197). He has satisfactorily solved the compositional problems that such a large group portrait naturally presents, and shows his mastery in the rendering of cloth textures. Rembrandt's influence remains pervasive in Bol's portraits—and self-portrait—up to about 1650, especially in the poses and the treatment of light (fig. 610). After 1650 the portraits acquire more and more of the elegance inspired by van der Helst.

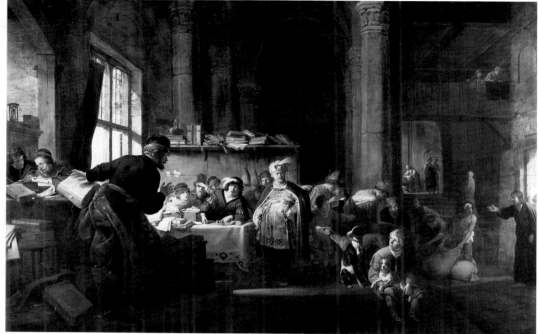

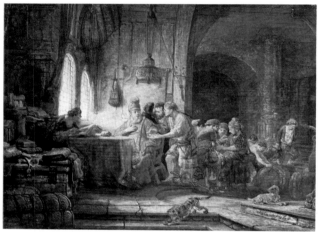

611 Claes Moeyaert
The Calling of Matthew
Signed and dated 1639. Canvas, 153 × 231 cm.
Herzog Anton Ulrich Museum, Brunswick, West
Germany

612 Rembrandt van Rijn
Parable of the Laborers in the Vineyard
Signed and dated 1637. Panel, 31 × 42 cm.
Hermitage, Leningrad

613 Salomon Koninck
Susanna and the Elders
Signed and dated 1649. Panel, 45 × 38.2 cm.
Private collection

Rembrandt also had influence on painters other than those in his circle of pupils. Claes
Moeyaert, for example, who was fifteen or sixteen years older than Rembrandt and had
originally belonged to the Lastman group, appears about 1640 to have appropriated certain
facets of Rembrandt's work: Moeyaert's *The Calling of Matthew* (fig. 611), dated 1639, is in
composition and treatment of light unmistakably inspired by Rembrandt's *Parable of the
Laborers in the Vineyard* of 1637 (fig. 612). Moeyaert's pupil Salomon Koninck also shows
Rembrandt's direct influence in his handling of light. Koninck often painted scholars at
their studies as well as biblical scenes, such as *Susanna and the Elders* of 1649 (fig. 613).

In his biblical pictures, Dirck Santvoort came early under Rembrandt's influence, as can
be seen in his *Supper at Emmaus* of 1633 (fig. 614). But he was mainly a portrait painter,
working during the 1630s in a slightly old-fashioned style reminiscent of Thomas de Keyser,
yet with a charm that is pleasantly exemplified by his portrait of the Bas family of
Amsterdam (fig. 615); his later style was more fashionable. Dirck came from an old
Amsterdam family of painters: he was the great-grandson of Pieter Aertsen, grandson of
Pieter Pietersz, son of the little-known painter Dirck Pietersz Bontepaert, and brother of the

614 Dirck Santvoort
The Supper at Emmaus
Signed and dated 1633. Panel, 66 × 50 cm. Musée
du Louvre, Paris

615 Dirck Santvoort
The Family of Dirck Bas, Burgomaster of Amsterdam
c. 1631. Canvas, 136 × 251 cm. Amsterdams
Historisch Museum, Amsterdam. On loan from
the Rijksmuseum

615

614

landscape painter Pieter Santvoort. A wealthy man, he apparently gave up painting about
1645, for no works are known after that date although he lived until 1680.

The Rotterdammer Abraham de Vries, who worked from 1626 to 1628 in Bordeaux,
Paris, and Antwerp, spent the decade 1630–40 in Amsterdam. Rembrandt's influence is
apparent in some of his portraits (fig. 616). His manner of painting with rather vague
contours creates a spacious aura around his models.

Bartholomeus van der Helst

The name of Bartholomeus van der Helst has appeared repeatedly in these pages, and before
continuing further with Rembrandt's pupils and followers we must consider this artist to
round out our view of the painters in Amsterdam.

Van der Helst was born in Haarlem in 1613, but apparently came to Amsterdam at an
early age. On the basis of his style, it is thought that he probably studied under Nicolaes
Eliasz. He married in 1636, and must therefore have been on his own by that time. His
earliest known dated work is a group portrait painted in 1637 of the regents of the Walloon

616

616 Abraham de Vries
Portrait of a Woman
Signed and dated 16(42). Panel, 68.5 × 58 cm.
Rijksmuseum, Amsterdam

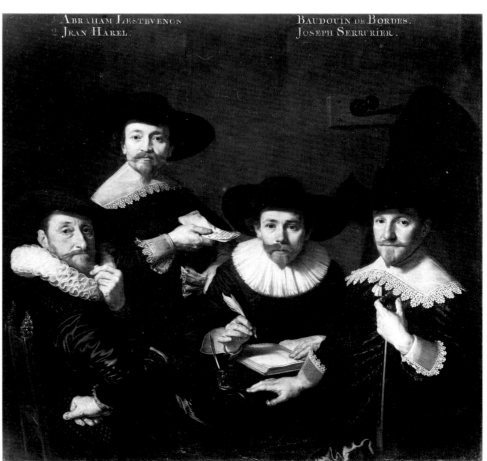
617

Orphanage (fig. 617). There is awkwardness in the rather cramped composition and exaggerated gestures, but the portraits themselves are well painted, with distinct, lucid modeling; this painting lends weight to the assumption that Eliasz was van der Helst's teacher. A 1638 portrait of a minister (fig. 618) is already more natural in pose, and the example of Rembrandt may have exerted an influence here. Yet only in the portraits painted after 1640, such as those of the Amsterdam burgomaster Andries Bicker and his wife of 1642 (fig. 619), does van der Helst appear to have found his form, a form that would soon make him the most famous portrait painter in Amsterdam and at the same time the antithesis of Rembrandt in the two artists' concepts of painting.

Van der Helst's work is characterized by virtually perfect technique and a clarity of

618 Bartholomeus van der Helst
 Portrait of a Protestant Minister
 Signed and dated 1638. Canvas, 74.2 × 63.5 cm.
 Museum Boymans-van Beuningen, Rotterdam

619 Bartholomeus van der Helst
 Portrait of Catharina Gansneb Tengnagel, Wife of
 Burgomaster Andries Bicker of Amsterdam
 Signed and dated 1642. Panel, 92.5 × 70 cm.
 Gemäldegalerie Alte Meister, Staatliche
 Kunstsammlungen, Dresden

◁
617 Bartholomeus van der Helst
 Regents of the Walloon Orphanage
 Signed and dated 1637. Canvas, 135.5 × 139.5 cm.
 Maison Descartes, Amsterdam. On loan from
 the Régence Hospice Wallon

expression that leaves nothing to the imagination. His portraits are well modeled, plastic, and finished with barely perceptible brushstrokes. Although he originally used darkish backgrounds, he came to prefer colors that were light and bright, but never gaudy. The pose and movements of his figures are always aimed at elegance. In his work before 1650, to which we limit ourselves here, the large *Celebration of the Peace of Münster* of 1648 (see fig. 190) is a high point, for in it both his ambition and his ability reached fruition. Technically and compositionally this banquet is an inimitably clever painting, and though the coloring is exuberant, the unity of the whole is not destroyed. These characteristics alone set van der Helst's work apart from Rembrandt's, but the greatest difference between the painters is in their treatment of light. Whereas Rembrandt works with a strong concentration of light which necessarily leaves large areas of the painting in darkness, van der Helst's lighting is even and tensionless. During periods when popular taste has preferred clarity and technical skill, it is no wonder that van der Helst's *Celebration* has been praised inordinately and valued higher than Rembrandt's *Night Watch*.

The Paintings for the Kloveniersdoelen

Considering van der Helst's enormous influence in Amsterdam, it is important to realize that the difference between his art and Rembrandt's became obvious about 1640, just when the prestigious commissions for the decoration of the new banqueting hall of the Kloveniersdoelen were being awarded: six large paintings of the militia companies that were members of this *doelen,* and a portrait group of the board of governors. Never before in the Netherlands had such a major project been launched; it was not surpassed in importance

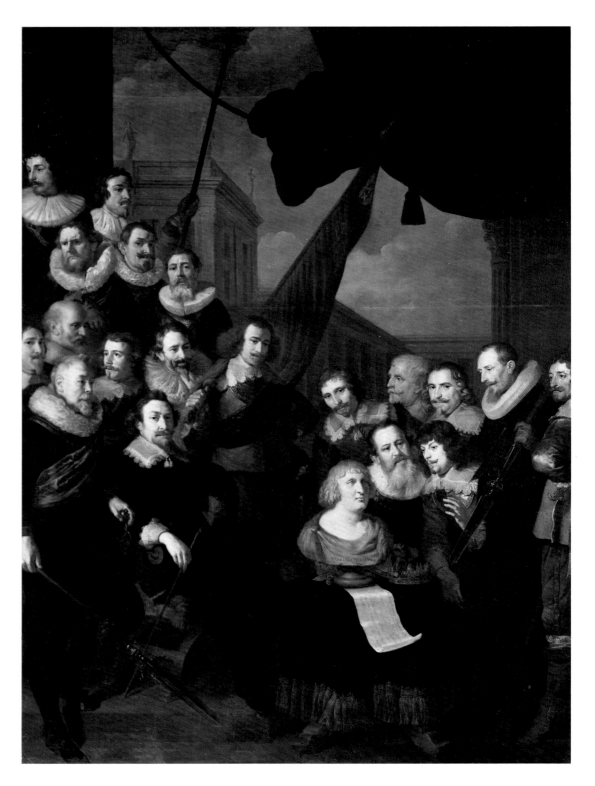

620 Joachim von Sandrart
Portrait of Hendrik Bicker
Signed and dated 1639. Canvas, 139 × 105 cm.
Amsterdams Historisch Museum, Amsterdam

621 Joachim von Sandrart
*The Civic-Guard Company of Captain Cornelis
Bicker*
c. 1642. Canvas, 343 × 258 cm. Rijksmuseum,
Amsterdam. On loan from the City of
Amsterdam

until the decoration of the Oranjezaal in the late 1640s and that of the Amsterdam town hall
in the 1650s and 1660s.

Whether a definite plan for the paintings in the *doelen* was ever drawn up remains a
question, but the arrangement may have been determined by the relative seniority of the
captains of the six companies.[14] Each company was then allocated a section of wall, so that
the size and shape of each painting and the light that would fall on it were known precisely
beforehand. Each company was also presumably free to choose its own painter, but, in view
of the results, it is not likely that the artists were given instructions regarding the
compositions.

The choices fell on the old and very experienced Nicolaes Eliasz; on Rembrandt van Rijn
and Jacob Backer, both of whom had been working in Amsterdam for a considerable time
and had demonstrated their ability to handle group portraits, although neither had yet done
a militia painting; on Govert Flinck and Bartholomeus van der Helst, both considerably
younger than the others and less experienced; and on Joachim von Sandrart, who was a
foreign duck in the Amsterdam canals.

Born in Frankfurt on the Main in 1606, Sandrart had led an active life: a journey to
Prague about 1621 or 1622; apprenticeship under Gerrit van Honthorst in Utrecht, and a
trip in 1627 with the master to the court of Charles I in London; and a stay from 1629 to

Ground plan of the hall of the Arquebusiers'
Civic Guard, Amsterdam (after J.J. de Gelder)

The Doelenstraat with the shooting range on the other side

door

Tower 'Swycht Utrecht'

Large Fireplace

B. van der Helst

Backer

Windows overlooking the Amstel River

N

Eliasz

Rembrandt, *Night Watch*

Missing part of the
Night Watch

Flinck

Flinck Fireplace Sandrart

5 meters

622 Govert Flinck
*Four Governors of the Arquebusiers' Civic Guard,
Amsterdam*
Signed and dated 1642. Canvas, 203 × 278 cm.
Rijksmuseum, Amsterdam. On loan from the
City of Amsterdam

1635 in Rome, where he lived in the palace of the Marchese Giustiniani. After a short visit
to his birthplace, he then settled in Amsterdam in 1637 and quickly made a name for
himself as a portrait painter (fig. 620). Sandrart must have been a man of charm and
sophistication, and he did not fail to impress the wealthy Amsterdammers. When the
pictures for the new hall in the *doelen* were being assigned, he got the commission to
immortalize Captain Cornelis Bicker and a number of men from his company. Sandrart,
who was of a literary turn, chose to gather the men more or less around a bust of Maria de'
Medici (fig. 621), in commemoration of the services of Bicker's company as honor guard
when the exiled dowager queen visited Amsterdam in 1638. Sandrart's choice of theme has
led to attempts to prove that the Medici visit was the inspiration for all the commissions for
the Kloveniersdoelen. It is now known, however, that several of the captains portrayed
either did not, in 1638, have the rank to be included in the celebrations or simply did not
participate in them.[15] The commissions must be regarded as individual orders by the
various companies, and the central theme was self-evident: the pride of the militia, in
themselves and in their splendid new hall.

The assembly and banqueting room was eighteen to nineteen meters long, nine to eleven
meters wide, and about five meters high, or approximately 63 by 33 by 16 feet. There was
only one entrance—a door in the short wall that connected the new wing with the old
tower "Swycht Utrecht" (Utrecht, Be Silent), part of Amsterdam's fifteenth-century
ramparts, which had been occupied by the arquebusiers as their *doelen* since 1522. Light
came into the room through six large windows in the outer long wall overlooking the inner
Amstel River. The short wall opposite the entrance had a fireplace in the center, above
which hung Flinck's rendition of the four militia governors and their servant, who holds the
old guild drinking horn (fig. 622); flanking this center picture were Flinck's and Sandrart's
company paintings (figs. 623 and 621).[16] These two paintings matched each other in neither

293

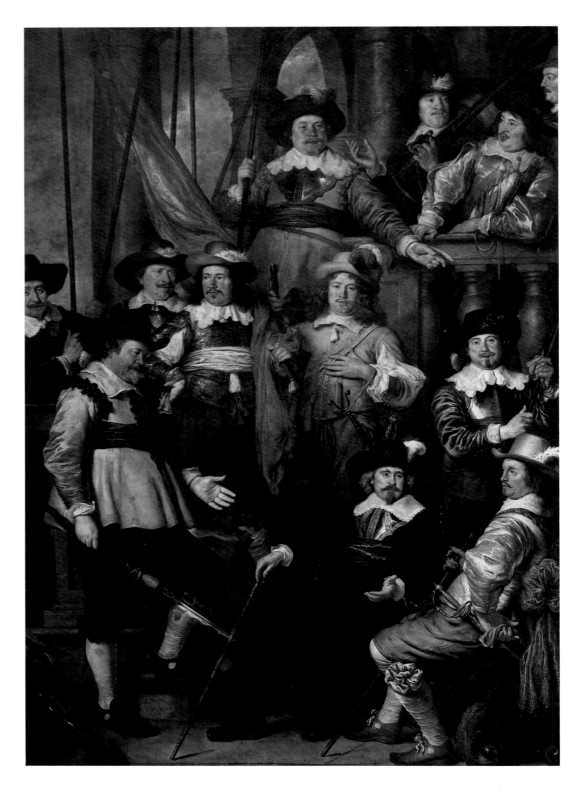

623 Govert Flinck
The Civic-Guard Company of Captain Albert Bas
Signed and dated 1645. Canvas, 347 × 244 cm.
Rijksmuseum, Amsterdam. On loan from the
City of Amsterdam

composition nor scale. The unusual height of the ceiling dictated that both artists group
their figures as high as possible; Flinck's solution was livelier and better balanced than
Sandrart's, and more attractive in color.

Most of the short wall with the entrance door was taken up by a second, huge fireplace,
with van der Helst's painting (fig. 624) mounted above. He had been given the difficult
commission of composing, within a particularly wide, not very high area, a picture
containing no fewer than thirty-two figures. The difficult format gave him the problem of
little space, but he solved it with extraordinary ingenuity by portraying all the men at the
left standing and, after a sort of pictorial comma, building up at the right a varied group of
seated and standing figures. Although this civic-guard picture is not painted as brilliantly as
his banquet scene of 1648 (see fig. 190), it is so full of dashing vitality that it brought van der
Helst to the foremost rank of the portrait painters.

On the long wall across from the windows there hung side by side, from left to right, the
extremely large canvases by Rembrandt, Eliasz, and Backer. Eliasz introduced few
surprising elements in his composition (fig. 625); placing virtually all the guardsmen in one
row, he made no attempt to exploit the possibilities offered him by the broad, tall canvas.
Backer, however, did. He placed a number of guardsmen at the right on a staircase, and
arranged the others in sitting or standing groups (fig. 626). Nevertheless, the demands of the

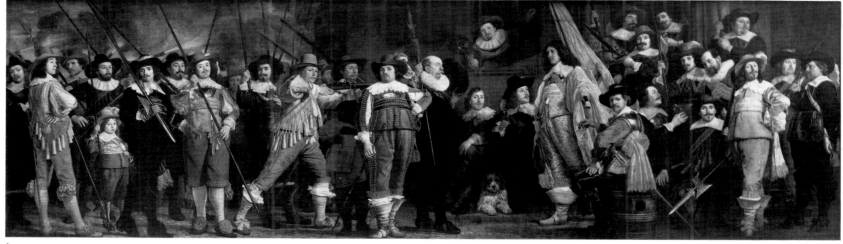

624

625

624 Bartholomeus van der Helst
The Civic-Guard Company of Captain Roelof Bicker
Signed and dated 163(9), presumably completed
1643. Canvas, 235 × 750 cm. Rijksmuseum,
Amsterdam. On loan from the City of
Amsterdam

625 Nicolaes Eliasz, called Pickenoy
*The Civic-Guard Company of Captain Jan van
Vlooswijck*
1642. Canvas, 340 × 527 cm. Rijksmuseum,
Amsterdam. On loan from the City of
Amsterdam

626 Jacob Backer
*The Civic-Guard Company of Captain Cornelis de
Graeff*
Dated 1642. Canvas, 367 × 511 cm.
Rijksmuseum, Amsterdam. On loan from the
City of Amsterdam

626

627 Rembrandt van Rijn
View across the IJ from the Diemer Dike
c. 1650–51. Pen and bister, wash, some white
body color, 7.6 × 24.4 cm. Devonshire Colletion,
Chatsworth, Derbyshire

commission were too heavy for his capacities: his composition has little unity, and the subtle qualities found in his *Regentesses of the Burgher Orphanage* (see fig. 196) are almost wholly absent.

When we look at Rembrandt's contribution, the so-called *Night Watch* (see fig. 191), we immediately see that this painting, with its strong light effects and great animation, is unlike any of the others. Rembrandt's use of light and dark—permitting the guardsmen to emerge from a dark gateway into the full light—and his exceedingly unorthodox way of arranging the officers and men attest to his unparalleled originality and independence. His contemporaries recognized this, and the words of Samuel van Hoogstraeten on the subject are especially telling, since this former pupil of Rembrandt, who had seen the hall with the paintings *in situ* with his own eyes, was no admirer of Rembrandt's style at the time he wrote his commentary in 1678. Van Hoogstraeten said: "In his piece at the Doele[n] in Amsterdam, Rembrandt managed this [unifying of his composition] very well, but in the opinion of many, too well, making more work out of the large picture he wanted to paint than out of the individual portraits contracted by him. This same picture, however, no matter how censurable, will in my opinion outlast all its competitors, being so painterly in concept, so daring in invention, and so powerful that, as some people feel, all the other pieces stand there beside it like playing cards. Yet I still wish that he had lit more lights in it."[17]

Rembrandt's Circle in the 1640s

The Night Watch can be considered to conclude Rembrandt's first Amsterdam period. Up to that point we can easily follow his development in his works. In the decade that followed the completion of *The Night Watch,* Rembrandt's creativity definitely diminishes, especially in his paintings but in his etchings as well. Some compensation may be found in his drawings, although these are extremely difficult to date. In any event, landscape drawings he made primarily in the surroundings of Amsterdam (fig. 627) became an important part of his work about 1645.

To what extent his personal circumstances—Saskia's death in 1642 and his slowly worsening financial situation, among other things—influenced his artistic life is a question that cannot be answered. His production of paintings diminished, yet he kept seeking new

628

628 Rembrandt van Rijn
The Woman Taken in Adultery
Signed and dated 1644. Panel, upper corners
rounded off, 83.8 × 65.4 cm. The National
Gallery, London

629 Rembrandt van Rijn
The Holy Family with the Curtain
Signed and dated 1646. Panel, upper corners
rounded off, 46.5 × 68.8 cm. Staatliche
Kunstsammlungen, Kassel

630 Rembrandt van Rijn
A Girl at a Window
Signed and dated 1645. Canvas, 77.5 × 62.5 cm.
Dulwich Picture Gallery, London

styles and techniques. He began to use small formats more often in his history paintings. His manner of painting is sometimes highly detailed, as in *The Woman Taken in Adultery* of 1644 (fig. 628), sometimes rather sloppy and weak, as in *The Holy Family with the Curtain* painted two years later (fig. 629). In the former painting he seems to reach back to compositions from his Leiden period; the variety, almost gaudiness, of the colors is unprecedented. More familiar is the painting of the young girl looking out of a window, which he made in 1645 (fig. 630); the theme is related to the domestic scenes of some of his earlier drawings (see fig. 594). Technically, this picture is broadly and confidently painted; compositionally, it builds on the style he had been developing in recent years.

The year 1649 marks a nadir in Rembrandt's production. Not one single painting or etching has survived from that year. His domestic troubles became explosive. He had violent quarrels with his housekeeper, Geertge Dirckx, with whom he had been cohabiting for some time, and he ruthlessly rid himself of her by having her confined to a workhouse in Gouda. Hendrickje Stoffels, who had also been part of his household for a couple of years, took Geertge's place.

630

631 Gerbrand van den Eeckhout
Isaac Blessing Jacob
Signed and dated 1642. Canvas, 102 × 130 cm.
The Metropolitan Museum of Art, New York.
Bequest of Collis P. Huntington, 1925

632 Gerbrand van den Eeckhout
Portrait of Jan Pietersz van den Eeckhout
Signed and dated 1644. Panel, 76 × 58 cm. Musée
de Grenoble

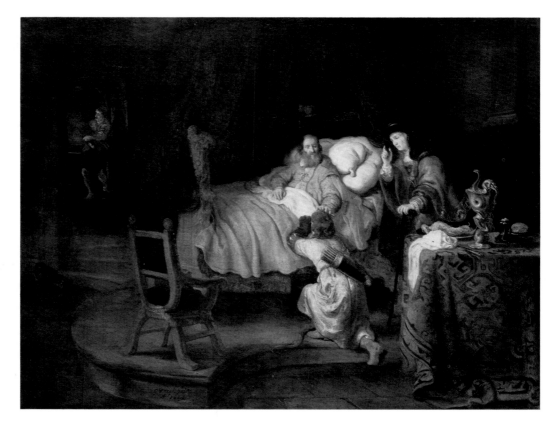

Rembrandt continued to have a good many pupils throughout the 1640s, but though we know their names from documents, little of their work has been preserved. Conversely, numerous paintings of the Rembrandt school that have survived cannot be attributed to any specific artist. In the following brief discussion of Rembrandt's pupils during this period, therefore, we shall concentrate on only a few of the most important.

Gerbrand van den Eeckhout was born in 1621, the son of an Amsterdam goldsmith. He apparently began to study under Rembrandt during the second half of the 1630s, and work by him is known from 1641 onward.[18] Houbraken calls him, along with Roelant Roghman, Rembrandt's friend, and it is quite possible that a bond remained between them after Gerbrand completed his training. Rembrandt's influence is long evident in van den Eeckhout's work, especially in his history paintings. *Isaac Blessing Jacob* (fig. 631), dated 1642, shows how closely he followed his master in composition and treatment of light. On the table at the right, the silver ewer by Adam van Vianen (see fig. 111) turns up once again.

Gerbrand van den Eeckhout, a productive painter, was one of Rembrandt's few pupils able to handle large canvases in a competent if not spectacular manner. He also made a name for himself as a good portraitist, though only a handful of his signed portraits, including a few group portraits (see fig. 63), are known today. One of his earliest portraits, of his father (fig. 632), shows a kinship with Rembrandt's portraits in the treatment of light, but its composition is "modernized" by the introduction of a curtain.

Jan Victors, born in 1620, was presumably another of Rembrandt's pupils before 1640. While still in the master's studio or shortly afterward he made the painting, dated 1640, of a girl leaning out of a window (fig. 633), which shows Rembrandt's direct influence in subject and lighting. In Victors' biblical compositions, such as his 1649 painting, *Jacob Blessing the Sons of Joseph* (fig. 634), he seems to have continued to depend on his master's work, though the execution is harder and less sensitive. Even his very able portraits have an air of Rembrandt about them. After 1650 Victors began to devote himself more to scenes from daily life. He left in 1676 for the East Indies, and nothing more is known of him.

Two young men of outstanding personality—Carel Fabritius and Samuel van Hoogstraeten—entered Rembrandt's studio about 1641. Hoogstraeten, who did his most important work after 1650, will be discussed later (see p. 418). Fabritius, born in 1622 in Midden-Beemster, a village north of Amsterdam, is justly regarded as one of the most gifted painters of the seventeenth century. Rembrandt taught him a fluent brushstroke and how to handle light, and he adapted these techniques in his own original way. His style had great impact on the Delft school, in which connection he will be further discussed (p. 440). The strength of Rembrandt's influence during Fabritius' early years is borne out in his large

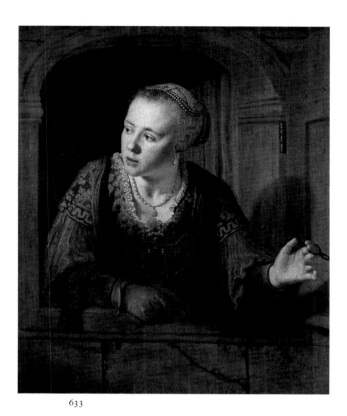

633

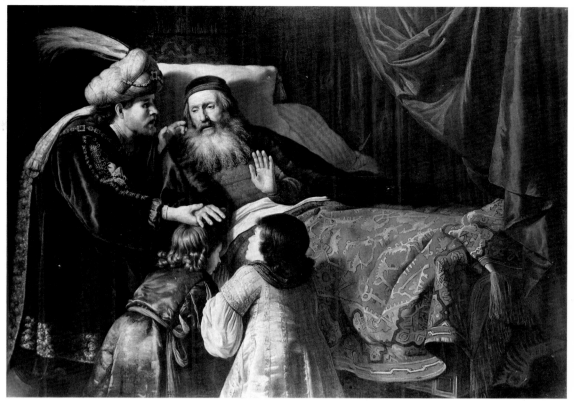

634

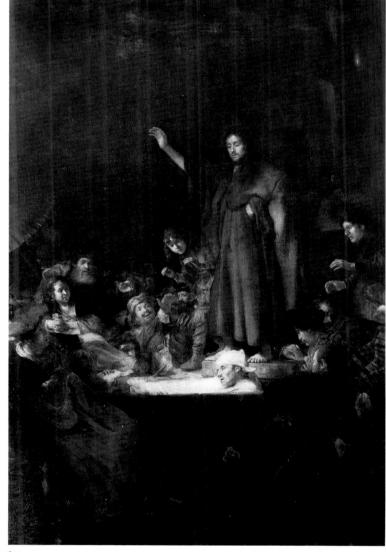

635

633 Jan Victors
Girl Leaning out of a Window
Signed and dated 1640. Canvas, 93 × 78 cm.
Musée du Louvre, Paris

634 Jan Victors
Jacob Blessing the Sons of Joseph
Signed and dated 1649. Canvas, 136 × 190 cm.
Muzeum Narodowe, Warsaw

635 Carel Fabritius
The Raising of Lazarus
Signed. c. 1643. Canvas, 210 × 140 cm. Muzeum
Narodowe, Warsaw

Raising of Lazarus, painted about 1643 (fig. 635): certain elements in it derive not only from the master's work of the 1630s, which Fabritius may have come to know in the studio, but also from *The Night Watch*, whose beginnings he had seen from close by.

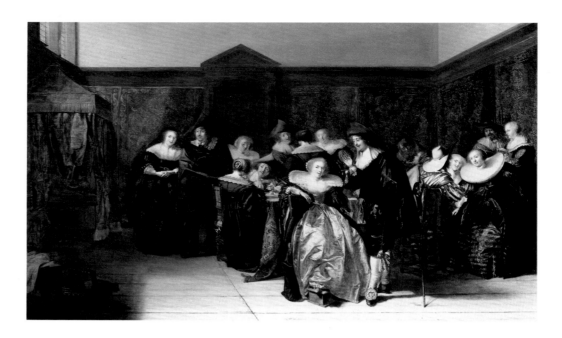

636 Pieter Codde
Elegant Ladies and Gentlemen in an Interior
Signed and dated 1631. Panel, 52 × 85 cm.
Rijksmuseum, Amsterdam

637 Pieter Codde
Family in an Interior
Signed and dated 1643. Canvas, 133 × 191.5 cm.
Gemäldegalerie Alte Meister, Staatliche
Kunstsammlungen, Dresden

Figure Painters

Small or medium-sized paintings of family groups and merrymaking companies became
very popular in Amsterdam. Thomas de Keyser and Jan Miense Molenaer had success with
this type of picture, as did Pieter Codde, who was born in Amsterdam in 1599. Codde's
considerable technical skill is evident in his 1631 picture of an elegant company in an
interior (fig. 636). The grouping is easy, the fashionable clothing rendered with the utmost
care and facility. The heads, miniature in size, are cleverly painted and look almost like
portraits; in pictures of this sort it is often impossible to know whether the faces were
portraits or not. Codde also painted true group portraits, such as his delightful *Family Group
in an Interior* of 1643 (fig. 637), biblical and mythological pictures, and guardroom scenes.
The paintings of soldiers relaxing in their barracks or in taverns are closely related to the
merry-company pictures, yet form a separate genre.

Willem Duyster, who was about the same age as Codde and is sometimes referred to as
his pupil,[19] worked with the same subject matter. He was adept at reproducing satiny
clothing (fig. 638), and sometimes achieved surprising effects of light (fig. 639). His double
brother-in-law Simon Kick—Duyster married Kick's sister, and Kick, Duyster's sister—
came from Delft but worked mainly in Amsterdam, following Codde and Duyster in
theme and style. His work is notable for its fine silver-gray tone. He places many of his
scenes in the waiting rooms of barracks, and in *Soldiers and Women in an Interior* (fig. 640) he

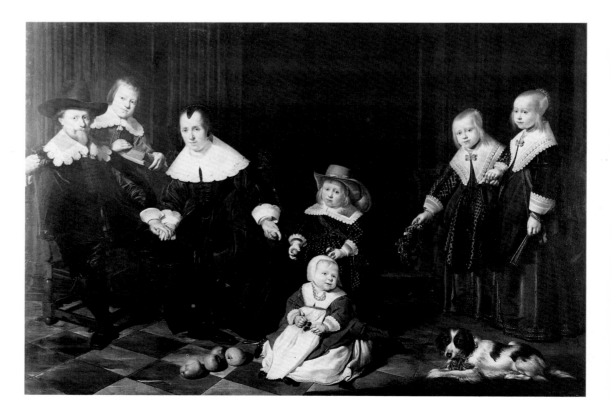

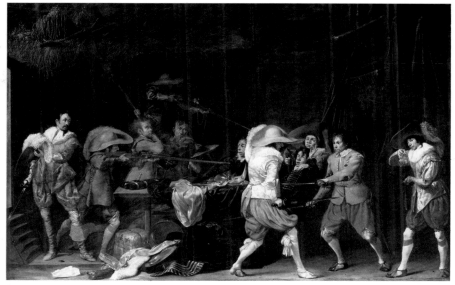

638

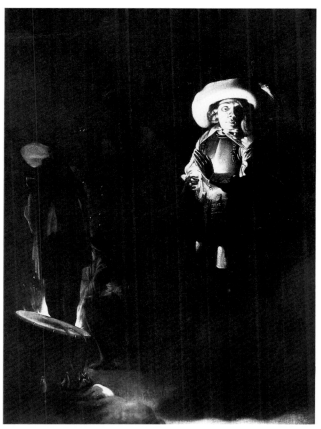

639

638 Willem Duyster
Soldiers Fighting over Booty in a Barn
Signed. Panel, 37.6 × 57 cm. The National
Gallery, London

639 Willem Duyster
Soldiers beside a Campfire
Panel, 45.2 × 33.8 cm. Staatliches Museum,
Schwerin

640 Simon Kick
Soldiers and Women in an Interior
Signed. Panel, 120.3 × 120.3 cm. Private
collection

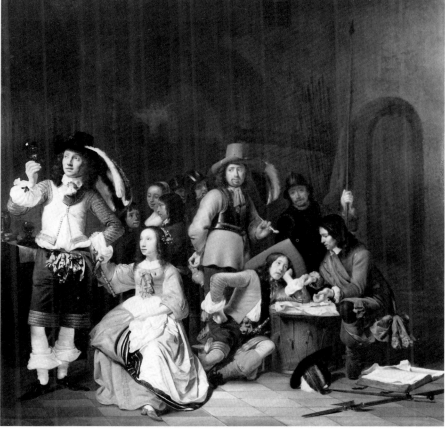

640

introduced a serious note into the usual amorous byplay: the young man at the right, with drawing compass in hand and a large book on the floor beside him, seems to be giving his companion a lesson, probably in cartography.

Apart from the guardroom paintings, most Dutch artists rarely represented military life. Pauwels van Hillegaert, however, specialized in paintings of battles and sieges (see fig. 120), and was a skillful portraitist as well. Born in Amsterdam in 1596, he worked there until his death in 1640. He painted many extant portraits of Prince Maurits and Prince Frederik Hendrik on horseback, usually in small format (see fig. 180); these compositions are known in multiple versions, presumably all from Hillegaert's hand.

Landscape Painters

A good deal was going on in landscape painting in Amsterdam during this period, in a number of styles. The Flemish tradition was long maintained by Alexander Keirincx, a native of Antwerp who settled in Amsterdam about 1636 and died there in 1652. He painted mainly forest scenes or groves of trees combined with a distant view. The ponderous and often fantastically shaped oak trees in his paintings are rendered in much detail, not always to the advantage of the picture (fig. 641).

641 Alexander Keirincx
Landscape with Deer Hunt
Signed and dated 1630. Panel, 68 × 90 cm.
Koninklijk Museum voor Schone Kunsten,
Antwerp

642 Rembrandt van Rijn
Landscape with Approaching Storm
Signed. c. 1638. Panel, 52 × 72 cm. Herzog Anton
Ulrich Museum, Brunswick, West Germany

Rembrandt painted landscapes, too, though they are a small part of his oeuvre. With a few exceptions, they are imagined scenes in which the forces of nature are dramatically contrasted, as in *Landscape with Approaching Storm* (fig. 642); Hercules Segers' landscapes almost certainly influenced him. More important than Rembrandt's few landscape paintings are his landscape drawings and etchings, in which he expressed his deep feeling for the Dutch landscape, especially near Amsterdam. He made many sketches after nature during his wanderings outside the city, primarily between 1645 and 1655,[20] and he derived his etchings from these. Rembrandt's influence as a landscape painter was slight and limited to his immediate circle. Govert Flinck painted a few small landscapes, and Philips Koninck's first efforts in this genre grew directly from Rembrandt's work, although his further development was quite independent.

A completely different trend in landscape art in Amsterdam is represented by Bartholomeus Breenbergh.[21] Born in Deventer in 1598, he was trained in Rome, and in 1633 he is recorded in Amsterdam, where he remained for the rest of his life, dying in 1657. He painted mostly Italianate landscapes with ruins, peopled by small figures acting out biblical or mythological stories. In *Landscape with Silvio and Dorinda* (fig. 643), dated 1635, are blended Dutch and Italian elements. The theme is from Battista Guarini's *Il Pastor Fido* of 1590; about 1635 Frederik Hendrik commissioned Dirck van Lisse, Breenbergh, Poelenburgh, Saftleven, and Bloemaert to make paintings on subjects from this popular pastoral drama. The painting here reproduced is not from the stadholder's collection; Breenbergh seems to have liked the theme and used it more than once.

643

644

Like Breenbergh, Jan Asselijn was formed primarily in Italy. Before leaving for Rome, probably in the early 1630s, he worked in Amsterdam, where he painted cavalry battles in the style of Jan Martszen the Younger, who is thought to have been his teacher. He stayed in Rome for ten years or so, joining the *Bentveughels* and receiving the nickname "Little Crab" because of his deformed left arm; on his way back to the north he made a lengthy stopover in France, where he married in 1644; he arrived in Amsterdam about 1647 and stayed there until his death in 1652. We know what he looked like from Rembrandt's portrait etching of him (fig. 644).

Asselijn was among the most talented of the Dutch Italianate painters, and he continued to develop after his return to Amsterdam. His landscapes, usually with herdsman and cattle, evoke a hushed atmosphere suffused with luminous light (cpl. 645). In addition to his Italian landscapes, he painted several winter scenes and a series of pictures inspired by a dike break: in May 1651 a violent northwestern storm ravaged the St. Anthony or Diemer Dike just east of Amsterdam, causing a flood in the Watergraafsmeer polder, where many people had summer houses and countryseats. Asselijn made paintings of various phases of the flood, from the dike break itself to the situation afterward; his painting of the repair of the damaged dike (fig. 646) is particularly fascinating. Without deviating from reality, he changed certain things: the villages in the distance are true to nature, but the landscape has a southern cast in both its coloring and the fall of light, and the figures in the foreground seem to have arrived straight from Italy. The dike repair is being carried out in the distance at the right.

643 Bartholomeus Breenbergh
Landscape with Silvio and Dorinda
Signed and dated 1635. Panel, 43 × 75 cm. Musée Municipal, Brest

644 Rembrandt van Rijn
Portrait of Jan Asselijn
Signed and dated 1647 or 1648. Etching and drypoint

645 Jan Asselijn
Roman Landscape
Signed. Canvas, 103 × 129 cm. Akademie der Bildenden Künste, Vienna

645

646

646 Jan Asselijn
*Repairing the St. Anthony Dike near Amsterdam
after the Dike Break in May 1651*
Signed. Canvas, 64 × 97 cm. Gemäldegalerie,
Staatliche Museen, West Berlin

647 Aert van der Neer
Woody Landscape with a River
Signed and dated 1635. Panel, 32.4 × 49.5 cm.
Private collection

648 Aert van der Neer
Landscape in Moonlight
Signed. Panel, 46.2 × 63 cm. Mauritshuis, The
Hague

The Dutch landscape was used as a subject by only a few Amsterdam painters. Avercamp had left the city long before, and Cabel, who died in 1631, had no followers of significance. The strong interest the Haarlem painters took in their native landscape did not arise in Amsterdam. The most gifted of the artists who did respond to landscape was Aert van der Neer, born in Amsterdam about 1603 or 1604. Practically nothing is known of his schooling or contacts with other landscape painters. Houbraken, who grants him only a couple of sentences, says he was a "Majoor" in the service of the lords of Arkel,[22] in Gorinchem (Gorcum), a town on the Waal River east of Dordrecht. He may have begun to paint there as an amateur, but he did not make painting his career until he settled in Amsterdam, shortly after 1630. Van der Neer's work is related to that of the brothers Rafael and Jochem Camphuysen, who moved from Gorcum to Amsterdam in the 1620s. The three young men, about the same age, were friends: Aert and Jochem jointly signed a painting they worked on together in 1633,[23] and Rafael was a witness at the baptism of one of van der Neer's children in 1642.

Van der Neer's earliest independent works, of which his *Woody Landscape with a River* of 1635 is a good example (fig. 647), also show the influence of the Coninxloo tradition, represented in Utrecht by Gillis d'Hondecoeter, among others, and in Amsterdam by Alexander Keirincx.[24] Van der Neer, soon finding his own style, began to specialize in a few subjects: winter scenes, and river views illumined by moonlight (a theme also used by Rafael Camphuysen), sunrise or sunset, or very occasionally by firelight. His basic formula for composing his scenes was to choose a point of view from which he could see a river or broad sheet of water extending from right or left into the background; marshy land fills the

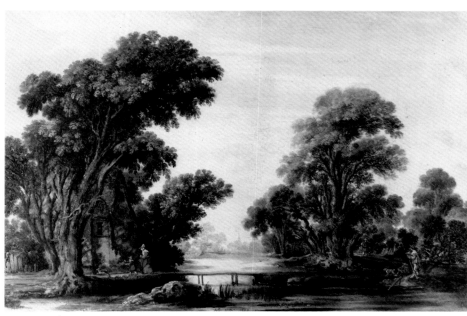

647

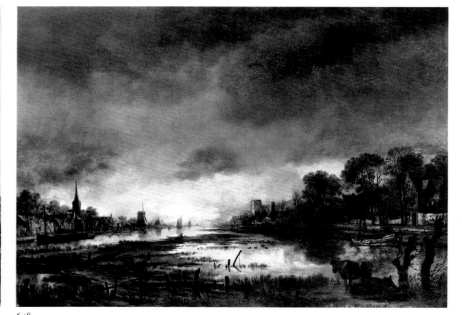

648

foreground, with livestock or a few human figures for animation; low-lying banks follow a random course at either side of the water; and upon these banks appear farm buildings, houses, windmills, and church towers, partly hidden by trees and forming a lively silhouette against the sky (fig. 648).

Van der Neer's landscapes seldom have a topographical location. What fascinated him most was the light of the moon or the sinking sun reflected in the water and coloring the clouds with subtle tints. As trees and bushes, buildings and animals catch the light, their structure is sharply defined, an effect which the artist strengthened here and there by scratching in the paint with the wooden butt of his brush. Van der Neer's tonal values and palette are always sensitive, and, amazingly, he repeated himself without slackening his

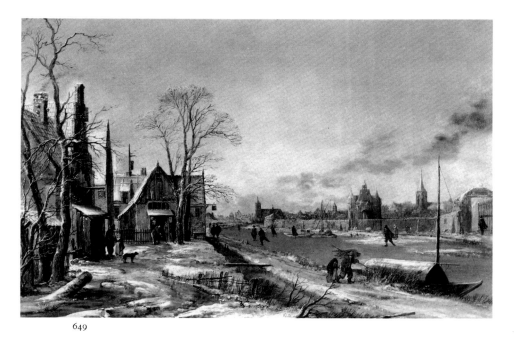

649

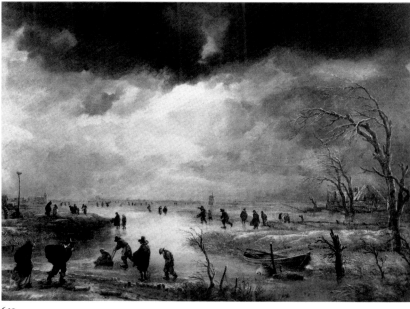

650

649 Aert van der Neer
 Frozen Canal near a Town
 Signed. Panel, 47 × 71 cm. Worcester Art
 Museum, Massachusetts

650 Aert van der Neer
 Snowstorm
 Signed. Canvas, 62 × 76 cm. The Wallace
 Collection, London

651 Govert Camphuysen
 Farm at Sunset
 Signed. Panel, 84 × 115 cm. The Wallace
 Collection, London

quality. Most of those of his paintings which no longer meet a high standard have suffered from injudicious cleaning.

His winter scenes have the same characteristics but include more figures, always vivacious, well painted, and in harmony with the silvery, twinkling light of the snow-covered landscape (fig. 649). A few times van der Neer painted a snowstorm (fig. 650), a rare subject in the Northern Netherlands; he masterfully suggests the driving, biting wind and the excitement of the threatening clouds, some ruddy, and some inky black.

Van der Neer worked hard and produced many pictures, but they brought in only a few guilders apiece, and he could not make ends meet. From 1659 to 1662 he ran a wine shop, an experiment that failed. So he presumably kept on painting—he rarely dated his work—until his death in 1677.

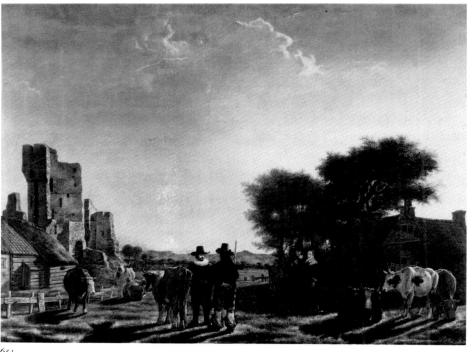

651

305

The work of Govert Camphuysen, a much younger first cousin of Rafael and Jochem, is variable in its quality, yet sometimes shows light effects similar to van der Neer's. Govert's most successful painting is *A Dutch Farm at Sunset* (fig. 651), now in the Wallace Collection in London; his handling of the fall of light, the low rays of the sun playing upon the ruined castle at the left and upon the farm buildings, people, and animals, is original and unusual. Govert left Amsterdam in 1652 to become court painter to King Charles X of Sweden. After a decade in Stockholm he returned to Amsterdam, where he died in 1672.

Marine Painters

Some painters of the new generation in Amsterdam during the second quarter of the seventeenth century became interested in marine painting, a subject which their counterparts in Haarlem chose to ignore. One older Amsterdam painter, Abraham de Verwer, continued his work in this field, and about 1637, when he was working in Paris, he painted various city views (fig. 652); some of these, including a view of the Louvre, were purchased by Frederik Hendrik. De Verwer returned to Amsterdam in 1641 and died there in 1650.

Willem van de Velde the Elder and Simon de Vlieger came from elsewhere in Holland to strengthen the ranks of the Amsterdam marine painters. Van de Velde, born about 1611 in Leiden, arrived first, sometime between 1634 and 1636. We have already discussed the technical aspects of his pen paintings (see p. 150). Van de Velde was an extremely clever draftsman of ships, and the commissions he received were mainly for pictures of sea battles (fig. 653) or of the war fleet, or for portraits of individual ships.

In his pictures of naval engagements, Van de Velde struck out along an entirely new path. Earlier marine artists, who usually painted a battle years after it occurred, had relied on written or oral descriptions; van de Velde, as we have said, sailed with the fleet to observe the action and make sketches firsthand; at least, he used this method regularly beginning in 1653. Before that date he made a series of pen paintings for Admiral Maerten Harpertsz Tromp of naval battles that had taken place considerably earlier. In 1653, however, he went along with Tromp's fleet and sketched the fighting in the Battle of Terheide off the South Holland coast, which took place on the tenth of August. Admiral Tromp was killed and the Dutch fleet scattered in this final encounter in the First Anglo-Dutch Naval War, but casualties of ships and men were so severe on both sides that neither emerged victorious. We know that van de Velde was at the battle because he portrayed himself, drawing in his galliot (see fig. 116a), in the painting he later made from his sketches (see fig. 116); the painting was not completed until 1657. He also testified before a notary that "on the 10 Aug. 1653 [I was] with a galliot in the fleet of the late admiral Tromp when the...battle against the English occurred."[25]

652 Abraham de Verwer
View in Paris with the Hôtel de Nevers and the Louvre
Signed and dated 1637. Panel, 37 × 59,6 cm.
Musée Carnavalet, Paris

653 Willem van de Velde the Elder
Episode from the Second Anglo-Dutch War, the Battle of Bergen, August 12, 1665
Signed and dated 1669. Pen painting on canvas, 84 × 188 cm. Rijksmuseum, Amsterdam

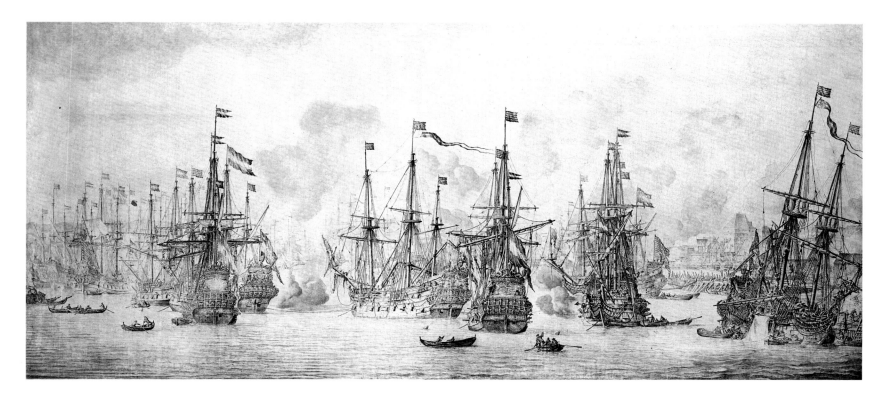

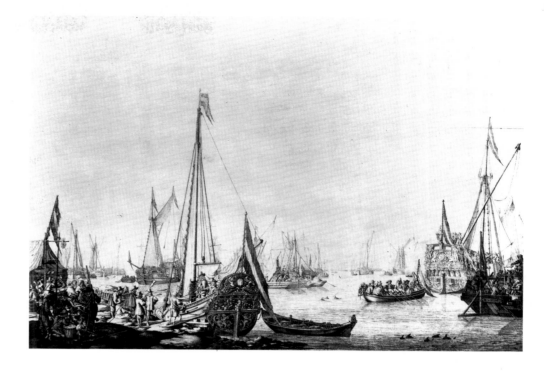

654 Willem van de Velde the Elder
Dutch Yachts in a Harbor
Signed. Panel, 77.2 × 108 cm. National Maritime
Museum, Greenwich, London

655 Simon de Vlieger
Stormy Sea
Signed. c. 1630. Panel, 65 × 102.5 cm. Národní
Galerie, Prague

Van de Velde annotated many of his drawings with pertinent scraps of information, sometimes referring to the painting he planned to make. On one drawing of the Battle of Terheide he wrote "the gentleman yacht," and "this to make on a golden panel for one of the gentlemen and to bring his yacht to the fore." He apparently had a commission from someone—an Admiralty official?—to paint a private vessel during some phase of the fighting. That this would require a slight modification of reality was no great matter: van de Velde composed his paintings in his studio, and added or altered whatever his patron desired. His eyewitness sketches make him one of the first "war photographers," but his paintings were conscious works of art, albeit based on well-observed reality.

Van de Velde's pen paintings show some stylistic development—the horizon becomes lower and the compositions more balanced—but they remain basically the same. He was from beginning to end a sober reporter, a more than competent draftsman who executed his commissions without frills or emotion. His technique did not lend itself to a poetic approach to marine painting. A few times, when the subject was less "technical" than a naval engagement, as in the panel showing yachts of various sorts in a harbor (fig. 654), he was able to evoke a mood, here of relaxation on a pleasant summer day.

Van de Velde had ample opportunity to exercise his talent, for the Dutch and the English fought a second naval war from 1663 to 1667 (one consequence of which was the loss of Nieuw Amsterdam to the English, who renamed it New York). Then, in 1672, England treacherously joined with France to attack the Netherlands on two fronts. French forces successfully invaded by land from the east; but English fleets attacking by sea were defeated by the superior Dutch navy under the command of Admiral Michiel Adriaensz de Ruyter.

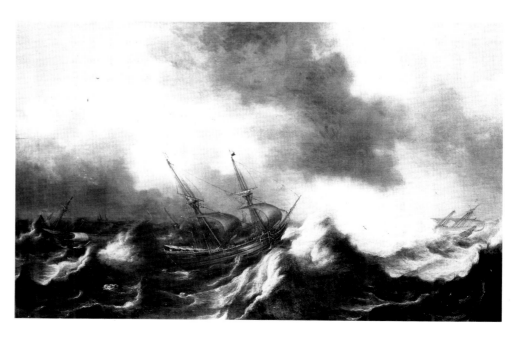

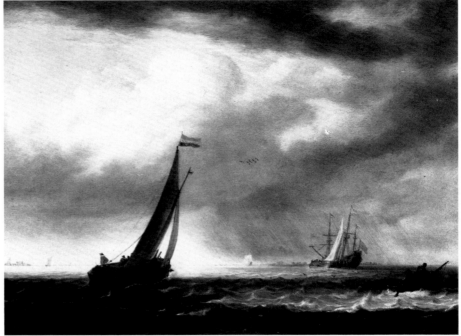

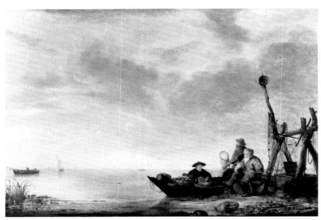

656 Simon de Vlieger
Fishermen on a Bank of an Estuary
Signed. Panel, 41.2 × 59.8 cm. Private collection

657 Simon de Vlieger
Estuary with Ships in Rainy Weather
Signed. Panel, 49 × 65.5 cm. National Maritime
Museum, Greenwich, London

658 Simon de Vlieger
Beach Scene
Signed and dated 1643. Panel, 60.6 × 83.5 cm.
Mauritshuis, The Hague

Nevertheless, the tide had turned for Dutch supremacy of the seas, and the future lay with England. Willem van de Velde went there with his son in 1672 to reap long years of commissions; he died in London in 1693.

The contrast between the art of Willem van de Velde the Elder and Simon de Vlieger's could hardly be greater. Van de Velde was an out-and-out technical ships draftsman, de Vlieger a marine painter for whom clouds, water, and sky were the most important factors. His work shows a spectacular development: he began in a style closely related to Vroom's, with ships being battered by turbulent seas (fig. 655), but soon, most likely under the influence of Porcellis, he began to be concerned with rendering the sea and inland waters more atmospherically. Simplifying his compositions, he calmed the winds, so to speak. The cloudy sky forms a unity with the water, which is sometimes nearly ripple-free (fig. 656)— and here, by rare coincidence, something of Cabel's style seems to have penetrated—or sometimes has gaily dancing wavelets. Using sensitive nuances of gray, de Vlieger can suggest a vaporous atmosphere or an oncing rainstorm (fig. 657).

His talent for atmosphere is important in his beach scenes, too, such as that of 1643 (cpl. 658): setting the darker foreground parts against the delicate grays of the middle zone and the hazy horizon, he creates an impression of enormous distance, deep and wide. His interest

659

660

661

659 Simon de Vlieger
Ships on a Calm Sea
Signed. Panel, 60 × 83 cm. Szépmüvészeti
Múzeum, Budapest

660 Hendrick van Anthonissen
Beach at Scheveningen
Signed. Panel, 32 × 45 cm. Staatliches Museum,
Schwerin

661 Claes Claesz Wou
Ships in a Stormy Sea
Signed. Panel, 66.3 × 115 cm. Szépmüvészeti
Múzeum, Budapest

in ships returns in his last works (fig. 659), but now the atmosphere seems to embrace them. In these paintings he points the way for Willem van de Velde the Younger and Jan van de Cappelle.

De Vlieger worked at first in Rotterdam, where he was born in 1601 and is last mentioned in 1633.[26] He then went to Delft, joining the guild there in 1634. Four years later he moved to Amsterdam and probably stayed until 1650; in that year he bought a house in nearby Weesp, where he died in March 1653. De Vlieger was a versatile painter. Besides his marines he painted landscapes and animals, made cartoons for tapestries, painted the doors of the organ in the Grote Kerk in Rotterdam, and designed stained-glass windows for the Nieuwe Kerk in Amsterdam. Yet his paintings of water and sky remain among the most evocative in Dutch marine art, and in some ways the truest.

The work of Hendrick van Anthonissen, a brother-in-law of Porcellis, is of less importance but often of good quality (fig. 660). The same can be said of Claes Claesz Wou's paintings (fig. 661). Both artists initially worked in Vroom's rather colorful style but later followed the atmospheric styles of Porcellis and de Vlieger. By 1650, when Reinier Nooms, Hendrick Dubbels, Jan van de Cappelle, and Willem van de Velde the Younger also began to develop as painters, Amsterdam had clearly become the center for marine painting.

The still-life painters in Amsterdam played a rather modest role up to 1650. The most interesting of them was Jan Jansz den Uyl, about whom little is known, nor have many of his paintings survived. He sometimes signed still lifes with a little owl (his name in Dutch); in the painting here reproduced (fig. 662), it appears on the neck of the pewter flagon, together with the date 1637. These paintings are characterized by powerful construction, simple composition, and rather large, plain areas in foreground and background that yet do not look empty. Den Uyl's rendering of materials and textures is accomplished; his colors are sober, with a preference for grays and greens, and the white napkin that is nearly always present stands out boldly. Den Uyl must have been highly regarded in his day: Rubens owned paintings by him, and Jan van de Cappelle's estate included eighty-three of his drawings, their subjects unfortunately not specified in the inventory.

It is difficult to establish den Uyl's relationship with the Haarlem still-life painters because we do not know his teacher. His earliest known dated painting, from 1633, already shows full maturity. At present we can only observe that den Uyl's work is too personal and too monumental to reflect the direct influence of Haarlem.

Closely related to den Uyl's still lifes are those of his brother-in-law, Jan Jansz Treck, thought to have been also his pupil. The composition of one of Treck's most beautiful works (cpl. 663), signed in full in tiny red letters on the hem of the napkin and dated 1649, is nevertheless dependent on den Uyl. The whole is in grayish tones, cool bluish gray in the large pewter flagon, and warmer and browner in the background, enlivened by the red strawberries. His handling of the metals, glass, and porcelain is masterly, with a lovely play

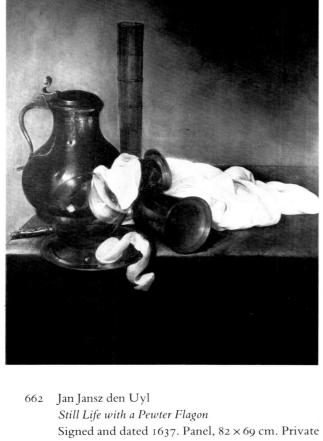

662 Jan Jansz den Uyl
Still Life with a Pewter Flagon
Signed and dated 1637. Panel, 82 × 69 cm. Private collection

663 Jan Jansz Treck
Still Life with a Pewter Flagon and Two Ming Bowls
Signed and dated 1649. Canvas, 76.5 × 63.8 cm. The National Gallery, London

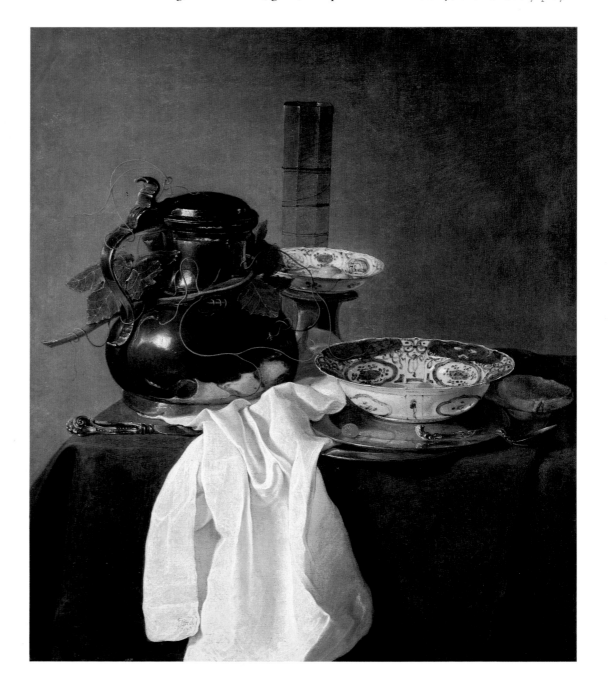

664 Jan Jansz van de Velde
Still Life
Signed and dated 1647. Panel, 64 × 59 cm.
Rijksmuseum, Amsterdam

665 Elias Vonck
Still Life with a Hare, a Heron, and Other Birds
Signed. Canvas, 100 × 92 cm. Rijkmsuseum,
Amsterdam

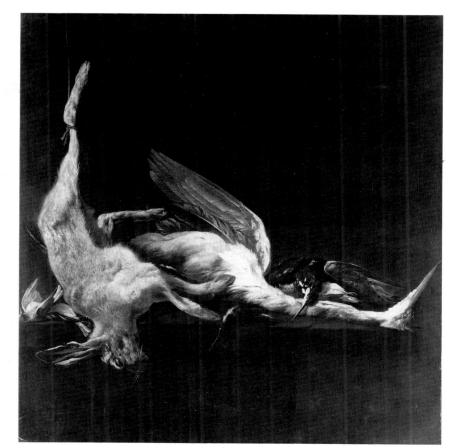
665

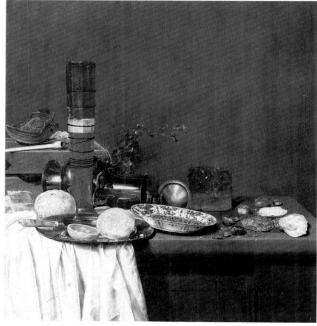
664

666

666 Pieter Potter
Vanitas Still Life
Signed and dated 1646. Panel, 54 × 43 cm.
Rijksmuseum, Amsterdam. On loan from the
City of Amsterdam

of reflections and highlights. The little Chinese bowls, from the late Ming period, began to
be imported into the Netherlands shortly before the date of this painting.

Jan Jansz van de Velde, son of the engraver Jan van de Velde II, was born about 1619 in
Haarlem and may have been trained there, but he presumably worked mainly in
Amsterdam, where he is recorded in 1642. His early work resembles that of the Haarlem
still-life painters; in his mature paintings, after about 1650, he proves himself quite
independent. His backgrounds are often dark, seeming to envelop parts of the objects;
against this darkness the highlights sparkle and glow with unusual brilliance, as in the still
life of 1647 (fig. 664).

The Amsterdammer Elias Vonck, born in 1605, was one of the first still-life painters to
specialize in dead birds. His paintings are carefully composed, displaying song birds and
larger species, sometimes combined with other spoils of the hunt (fig. 665). His son Jan
Vonck worked in precisely the same way.

Finally, there is Pieter Potter, a native of Enkhuizen, an old port on the Zuider Zee, and
the father of the animal painter Paulus Potter. He lived in Leiden from 1628 to 1631, and
must have known the *vanitas* painters working there. In 1631 he settled in Amsterdam as a
painter and as the owner of a factory for embossing and gilding leather. He painted biblical
themes, landscapes, peasant figure pieces, and still lifes. His *vanitas* still lifes (fig. 666) and his
stable interiors with still lifes of pots and pans and other utensils are his most attractive
works.

This sketch of the variety of painting going on in Amsterdam during the second quarter of
the seventeenth century is only an outline that includes the most interesting artists. A throng
of painters from other places, many arriving after their talents had been formed elsewhere,
contributed to the proliferation of new ideas and new ways of painting that made
Amsterdam an exciting center of art at this time.

Painting in the Northern Quarter: 1625–1650

The Northern Quarter is the part of the province of Holland that lies north of the IJ, the old
inlet of the Zuider Zee that forms Amsterdam's harbor. In the seventeenth century the
Northern Quarter sent its own representative to the States of Holland and had its own
Admiralty. Its major ports, Hoorn and Enkhuizen, each held one seat on the board of

directors (known as the Gentlemen XVII) of the United East India Company; Amsterdam had eight, Zeeland four, and Rotterdam and Delft each one; the seventeenth seat was held alternately by the company's smaller chambers and Zeeland. The principal Northern Quarter towns were Alkmaar, Medemblik, Enkhuizen, Hoorn, Edam, Purmerend, and Monnickendam, but only Alkmaar and Hoorn were of any importance to the development of painting.

Alkmaar seems to have profited most from the proximity of Haarlem and Amsterdam, with some flow of artists back and forth. The brothers Caesar and Allart van Everdingen were born in Alkmaar. Allart moved away to pursue his landscape painting elsewhere, but Caesar seems always to have regarded Alkmaar as his home: all told, he spent only about

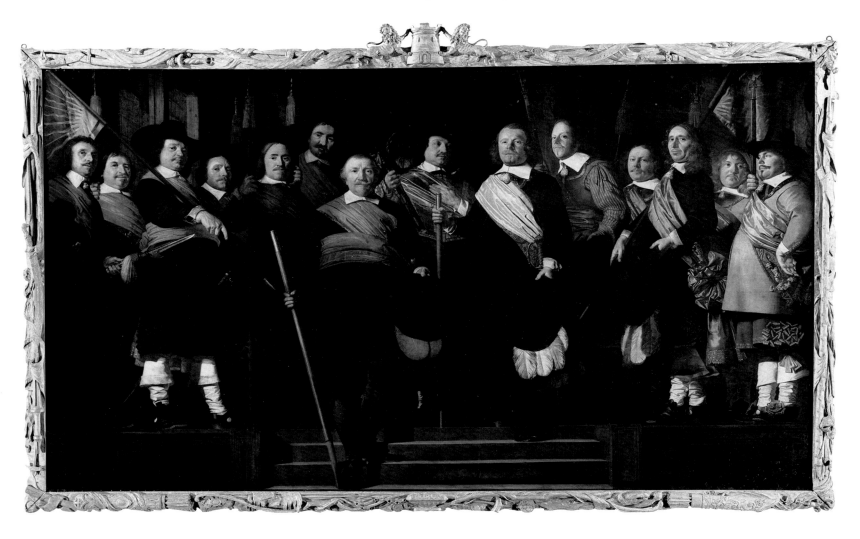

667 Caesar van Everdingen
Officers and Ensigns of the Old Civic Guard, Alkmaar
Dated 1657. Canvas, 199 × 340 cm. Stedelijk Museum, Alkmaar

fifteen years living and working in other places. Many of his portraits and several of his paintings of the local militia are now in the Alkmaar Municipal Museum. In his 1657 civic-guard painting (fig. 667), here reproduced in its original frame with the Alkmaar coat of arms at the top, he broke the otherwise static arrangement by having the captain take a step forward on the stairs, advancing majestically toward the viewer. The company's banners are proudly displayed, and the expressions on the well-characterized faces show that the guardsmen in Alkmaar thought no less of themselves than their counterparts did in Haarlem or Amsterdam.

Lambert Doomer spent his last years in Alkmaar, and Emanuel de Witte and Abraham van Beyeren both worked there for a time. There is no question, however, of a clearly defined school of Alkmaar painters. The local portrait painters produced inferior work, and when the civic guard wanted to order a group portrait, it called in Everdingen or some painter from outside.

Hoorn was the most prosperous of the old Zuider Zee towns, and one of the most important ports of the United East India Company. Yet it remained far behind the larger cities in matters of art. When Jan Albertsz Rotius of Medemblik settled in Hoorn in 1643, he could look for guidance to only two rather mediocre local painters: the history and portrait painter Jacob Waben and the portraitist Dirck Carbasius. Their example was hardly enough for Rotius, who had a definite talent for portraiture, and he turned instead to the Amsterdam painters Nicolaes Eliasz, Bartholomeus van der Helst, and Govert Flinck, and

probably also to Aelbert Cuyp of Dordrecht.[1] It is not known where Rotius received his training; Houbraken's report that he studied under Lastman must be erroneous, since Lastman died when Rotius was nine years old.

Rotius' earliest work, produced between 1644 and 1649, is deeply indebted to Nicolaes Eliasz and has an old-fashioned look. He then seems to have used van der Helst as his model, and his portraits appear more up to date. His family groups, although always rather stiff, have an innocent charm. No wonder that he became a respected master in Hoorn, called upon to paint the likeness of many well-to-do citizens (fig. 668). Between 1648 and 1655 he produced five civic-guard paintings for the Hoorn militia's great hall (see fig. 187), and a few other group portraits. The civic-guard paintings make it clear that Rotius was well

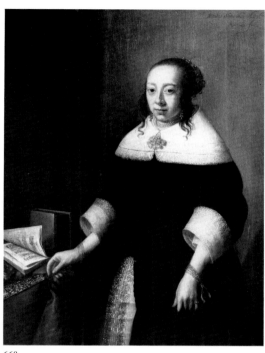

668

669

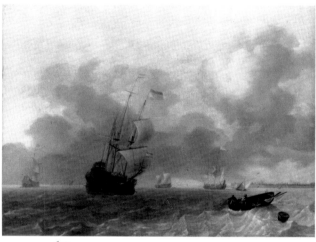

670

668 Jan Albertsz Rotius
Portrait of Lysbeth Veen
Signed and dated 1656. Panel, 68 × 54 cm.
Westfries Museum, Hoorn

669 Caspar van den Bos
Ships off a Coast
Signed. Panel, grisaille, 32 × 46 cm. Private collection

670 Jan Claesz Rietschoof
The Coast near Hoorn
Signed. Canvas, 65 × 49.5 cm. Private collection

acquainted with the work of van der Helst and Flinck in the Amsterdam Kloveniersdoelen. Several still lifes by Rotius are also extant; they call to mind the work of Claesz and Heda in Haarlem. Rotius' son Jacob specialized in still lifes and flower paintings.

Despite the general scarcity of talent there, Hoorn possessed two marine painters. One of them, Caspar (or Gaspar or Jasper) van den Bos, born in 1634, has received little attention, not because he lacked talent, but because he died young and few of his works have survived. Grisailles are all that remain of his oeuvre—oil paintings done exclusively in shades of gray (fig. 669). They differ from the monochromatic pen paintings in being executed with a brush rather than a pen. Van den Bos's grisailles have the look of wash drawings, and are always sensitively painted and full of atmosphere. Houbraken, the only source of information about his life, reports that Caspar, like his father, at first worked as a shipbuilder, "but driven by a great passion for art, he made drawings of seas and still waters with all sorts of vessels, so artistic, neat, and free in treatment as also firmly and flowingly hatched with the butt of his brush, that the painter Bronckhorst has declared to me never to have seen better."[2]

Somewhat later Jan Claesz Rietschoof, a pupil of Ludolf Bakhuysen, was active in Hoorn. He painted views of the sea and beaches. His later paintings became rather hard in coloring, but they often capture the atmosphere of the North Holland coastal area (fig. 670).

Painting in Utrecht: 1625–1650

The Painters around Bloemaert

When we look at the artistic activity in Utrecht from about 1625 to 1650, we are struck by the large number of older artists, already discussed, who continued to dominate the scene. Abraham Bloemaert, Adam Willaerts, Joost Droochsloot, and Gerrit van Honthorst worked throughout this whole quarter-century, and Joachim Wttewael, Paulus Moreelse, and

Roelant Savery, all of whom died about 1638, participated in the artistic events of the first half of the period. The styles of art that engaged these artists, primarily Mannerism and Caravaggism, therefore remained current.

The history painters in Haarlem had altered Mannerism into a Flemish-oriented classicistic style, but in Utrecht it continued to flourish unsullied under the aegis of Bloemaert and Wttewael. Caravaggism had lost its most talented representative when Ter Brugghen died in 1629, and it took on a more local character: the strong contrasts of light remained but the tension of Caravaggio's exciting example disappeared. The Caravaggists, however, are still worthy of consideration, if only because they are the most likely source for Vermeer's beginnings. Their palette—purple, lilac, yellow, light green—and the

671 Abraham Bloemaert
Landscape with John the Baptist Preaching
Signed. c. 1600. Canvas, 139 × 188 cm.
Rijksmuseum, Amsterdam

iridescent effects they had borrowed from Mannerism and continued to use are otherwise rare in Dutch art.

It is remarkable that the art of so elderly a man as Bloemaert—he was sixty-one in 1625 and died in 1651 at the age of eighty-seven—continued to develop. Although this process did not altogether favor his figure paintings, it had some praiseworthy results in his landscapes.[1] Landscape had begun to take a special place in Bloemaert's art shortly after 1600, and he was then indisputably the most original representative of the Mannerist landscape. Restless light effects and strong contrasts, all sorts of movement in composition and detail, and a richly colorful palette—these elements characterize such a work as his *John the Baptist Preaching* (fig. 671), which was probably painted about the turn of the century. The actual theme of this painting is of course country life, with the added excuse for a Bible story (and just perhaps, for a puzzle: find John the Baptist). His first-rate observation of nature formed the basis of imagined landscapes like this one, and, as we have pointed out, observation but not slavish imitation was a Mannerist ideal. Bloemaert's keen eye is apparent in his drawings and in the details of his larger compositions. Over the course of several decades he now and then painted landscapes in this style.

After 1630 a subtle change appears. Although remaining Mannerist in their essence, his landscapes become calmer, the contrasts softer, the movements simpler. The spatial organization expands. Scenes of country life move closer into the foreground, while the Bible story becomes submerged in the background. If it was difficult to discover John the Baptist in the early painting, where are Tobias and the Angel in the 1650 rural landscape (fig. 672) that bears that title now (and always has, so far as is known)? But of greater importance is Bloemaert's continued attention to countless details in the foreground and in the farm buildings so important to the composition, and especially, the new subtlety and luminosity of his palette. The influence of Bloemaert's landscapes on other artists did not last long, but it found expression in the earliest work of Pieter Santvoort and Pieter de

672

674

672 Abraham Bloemaert
Rural Landscape with Tobias and the Angel
Signed and dated 1650. Canvas, 91 × 133 cm.
Gemäldegalerie, Staatliche Museen, East Berlin

673 Hendrick Bloemaert
Paul before King Agrippa
Signed and dated 1635. Canvas, 140 × 178 cm.
Centraal Museum, Utrecht

674 Jan van Bijlert
Canteen Woman
Signed. c. 1640. Canvas, 84.5 × 68 cm. Centraal
Museum, Utrecht

Molijn. Thereafter, Bloemaert was the sole representative of Mannerist landscape painting
in the Northern Netherlands.

Of Bloemaert's four sons who made careers in art, Frederik and Cornelis limited
themselves primarily to engraving. In 1630 Cornelis went by way of Paris to Rome and
stayed there the rest of his life; he died in 1680. Frederik devoted himself exclusively to
making engravings after his father's work. Adriaen was a painter of no great importance.
Only the eldest son, Hendrick, born in 1601, made a name for himself among the Utrecht
painters. After a trip to Italy, he returned to his birthplace to paint and also to take an active
part in the artist's societies. Several times he is mentioned as dean or governor, first of the
St. Luke's Guild and later of the painter's fraternity. His earliest paintings show the direct
influence of Caravaggism, but almost all his other work echoes his father's. He painted
mainly mythological, allegorical, and religious subjects, such as *Paul before King Agrippa* (fig.
673), single-figure pieces, and some portraits.

After studying under Abraham Bloemaert, Jan van Bijlert (born in Utrecht about 1603)
made the traditional trip to Rome. He returned home in 1625, full of what he had seen in
Italy, especially the work of Caravaggio. His earliest paintings, produced between 1624 and
1626, contain straightforward borrowings. Later he adapted himself to the Utrecht
atmosphere. The strong light effects disappear, and he painted many half-length figures,
usually life-size, such as his *Canteen Woman* of about 1640 (fig. 674).

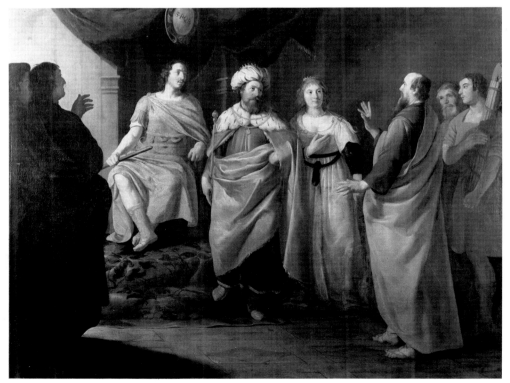
673

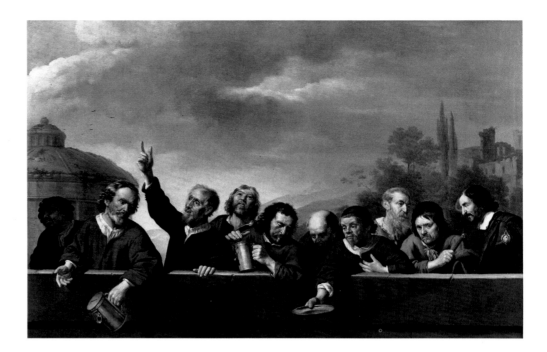

675 Jan van Bijlert
Alms Collectors of the Hiobsgasthuis, Utrecht
Signed. Canvas, 84.5 × 115 cm. Centraal
Museum, Utrecht

There was a close and friendly relationship between the Utrecht painters and the Hiobsgasthuis, the Job Hospital for the poor. It was the painters' custom to present pictures suitable in subject matter to the hospital, and several artists, including Joost Droochsloot and Jan van Bijlert, became regents or wardens. A painting (fig. 675) that Bijlert made for the hospital has been preserved; it depicts a group of nine men leaning over a balustrade to solicit alms; the tenth man, at far right, is the warden, identifiable by the silver Job medal on his left sleeve; remarkably, the background is an Italian landscape. This painting is a good example of the attempts to create illusionistic effects, which were popular in Utrecht. Bijlert was a competent artist, although he appears to have offered few new insights. His later work, usually of small size, includes portraits and scenes from daily life with merrymakers. No trace of Caravaggism remains.

Jan van Bronckhorst and Paulus Bor

During his stay in Rome, about 1621, Jan van Bijlert had shared quarters with two other Utrecht painters, Jan van Bronckhorst and Cornelis van Poelenburgh. Bronckhorst must have left soon afterward, for his name does not appear in the list of founders of the *Bentveughels* in Rome; he may have spent some time in Paris on his way home. By 1626 he was back in Utrecht, and married there in that year.

Bronckhorst was first a designer of stained-glass windows and worked as an engraver on the side. After designing windows in Brussels, he was given a large commission in 1640 for those of the Nieuwe Kerk in Amsterdam; his windows were unfortunately destroyed in the fire of 1645. About five years later Bronckhorst moved to Amsterdam, where he received more commissions for stained-glass windows and participated in the decoration of the town hall. He also painted the shutters of the new organ in the Nieuwe Kerk (see fig. 24). His known paintings were created after 1640. Although he surely produced some of them in Amsterdam, his style is so bound to Utrecht that his work is best discussed here, with the other Utrecht painters.

Bronckhorst's large ceiling decorations for the Amsterdam town hall have some pictorial weaknesses and not always the supple graces desirable in such paintings, yet other works of his are worthy of our full attention. One large canvas that is thought to have hung in an Amsterdam house is entitled *Allegory of Dawn and Night* (cpl. 676),[2] a painting remarkably subtle and silvery in tone. Poelenburgh's influence is clearly evident in the putti and maidens surrounding Aurora (see fig. 683). No doubt a companion piece depicted Afternoon and Evening, to form a cycle of two pictures. Here Aurora, led by Pegasus, has chased away Night, symbolized by the bearded contemplative man in the lower zone. The play of symbolism between the lower and upper scenes is complex: death and life, winter and spring, the elements water and air, and their associated humors, the phlegmatic and the sanguine.

Bronckhorst also emerges as a portrait painter able to achieve surprising effects. His 1656

676 Jan van Bronckhorst
 Allegory of Dawn and Night
 Canvas, 163.5 × 131.1 cm. Wadsworth
 Atheneum, Hartford, Connecticut. Ella Gallup
 Sumner and Mary Catlin Sumner Fund

677 Jan van Bronckhorst
 Portrait of Nicolaes Oetgens van Waveren
 Signed and dated 1656. Canvas, 163 × 132.5 cm.
 Amsterdams Historisch Museum, Amsterdam

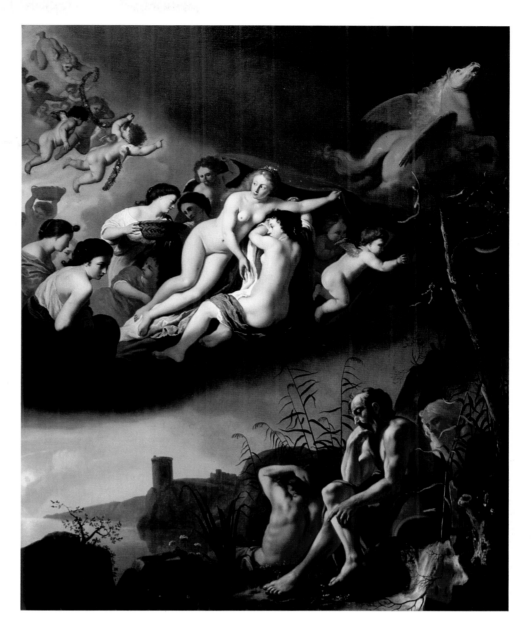

portrait of the young dandy Nicolaes Oetgens van Waveren is painted in refined shades of gray and warm yellow browns (fig. 677). The large planes in which this portrait is conceived show kinship with the work of another painter who, though he worked in Amersfoort, was in close touch with the Utrecht group.

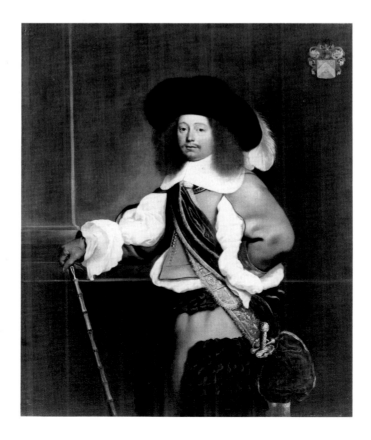

This painter was Paulus Bor, born about 1600 in Amersfoort. He, too, journeyed to Rome, where he was a member of the *Bentveughels* and nicknamed Orlando. Among his earliest known works is his large group portrait of the van Vanevelt family (fig. 678), painted for the Pieters and Bloklands Hospital in Amersfoort, where it still hangs today. The figures are, for 1628, quite old-fashioned in pose, but the faces are seen in large planes, and the modeling of the heads is enhanced by strongly reflected light on the shaded side. Worth noting is that several of Bor's signed works of the early 1630s, such as *Jesus among the Doctors* (fig. 679), are reminiscent of Rembrandt, although the resemblance is based solely on the strong chiaroscuro, not on the manner of painting. The knowledge Bor had acquired in Italy reappears only later, in work which accords primarily with that of Orazio

678

Gentileschi, who in turn was influenced by Caravaggio. A good example from this period is *The Spanish Heathens* (fig. 680), depicting a scene from Jacob Cats's comedy of 1637, *Proefsteen van den Trou-ringh* (Touchstone of the Wedding Ring). This painting, dated 1641, displays Bor's somewhat naive and slightly awkward charm. In subject and composition, it is clearly related to Honthorst.

In 1638 Bor participated in the decoration of Frederik Hendrik's hunting palace, Honselaersdijk, and it was undoubtedly thanks to his fellow townsman Jacob van Campen that he received this commission; again van Campen acted as middleman in the links among Utrecht, Amersfoort, Alkmaar, Amsterdam, and Haarlem. These links are manifest in the correspondences in the work of Bronckhorst and Bor, and of Bor and Caesar van Everdingen—who left Alkmaar to work temporarily in Amersfoort—and through these with the classically oriented Haarlemmers, Pieter de Grebber and Cornelis Holsteyn. Bor was to work again with the latter two; Bronckhorst went on to represent this classicistic trend in Amsterdam.

679

678 Paulus Bor
Portrait of the van Vanevelt Family
Signed and dated 1628. Canvas, 120 × 320 cm.
St. Pieters en Bloklands Gasthuis, Amersfoort

679 Paulus Bor
Jesus among the Doctors
Canvas, 115 × 97,3 cm. Centraal Museum,
Utrecht

680 Paulus Bor
Scene from "The Spanish Heathens"
Signed and dated 1641. Canvas, 123.5 × 147 cm.
Centraal Museum, Utrecht

680

681

Gerrit van Honthorst

682

681 Gerrit van Honthorst
Portrait of Frederik Hendrik and His Wife
Canvas, 213 × 201.4 cm. Mauritshuis, The Hague

682 Nicolaus Knupfer
The Wedding of Tobias and Sarah
Signed and dated 1654. Copper, 29 × 24.5 cm.
Centraal Museum, Utrecht

Gerrit van Honthorst, who worked in Utrecht and at the Orange-Nassau court in The Hague, was another key figure in these interrelationships. One of Caravaggio's most talented followers, he developed in Utrecht, as we have seen (p. 211), into a painter of groups and of joyous half-figures. He underwent a further strong development as a purely decorative painter. In 1628 he spent six months at the English court, where he painted an enormous canvas for Charles I, *Mercury Presenting the Liberal Arts to Apollo and Diana,* the king posing for Apollo and the queen for Diana. Honthorst was honored for this by the presentation of a royal stipend. Later he also worked for the elector of Brandenburg and for Christian IV of Denmark.

Honthorst was one of the few Dutch painters of international renown. In the Netherlands he worked at the court of the Winter Queen and gave lessons to her children. Most important, however, was his official appointment as court painter to Frederik Hendrik and William II. He participated in the decorations of the Rijswijk, Honselaersdijk, and Huis ten Bosch palaces. In 1637 he went to live in The Hague, where he could afford to buy a large house on Westeinde, one of the fashionable streets. After the death of William II in 1650, he returned to Utrecht.

Portraiture became an increasingly large part of his work, and he was a foremost representative of the international court style that arose in emulation of Anthony van Dyck. Honthorst was technically very proficient, and one of the few artists able to handle life-size court portraits, of which his double portrait of Frederik Hendrik and Amalia van Solms is a good example (fig. 681). Yet these works, over-elegant, uninspired, and too smoothly painted, elicit little warmth in the viewer. The distance between Honthorst and his great example, van Dyck, remained unbridged. Samuel van Hoogstraeten admitted that in his prime Honthorst wielded "a spry brush," but "either to please the young ladies, or because profit rocked him to sleep, he lapsed into a rigid smoothness."[3]

There remains to mention one figure painter who stemmed from the school of Bloemaert: Nicolaus Knupfer. He was born about 1603 in Leipzig and, after having studied in Germany, came to live in Utrecht, where he is mentioned as Bloemaert's pupil . A painter of some talent, he concentrated mainly on mythological and biblical pictures, usually small in size: his *Wedding of Tobias and Sarah* (fig. 682), is less than a foot in height. He has become known primarily as Jan Steen's teacher, and Steen certainly had much to thank him for. Knupfer's work has humor and tells a good story.

683 Cornelis van Poelenburgh
The Glorification of St. Catherine of Alexandria
Signed. Panel, 45.2 × 35.5 cm. Centraal Museum,
Utrecht

684 Cornelis van Poelenburgh
The Seven Children of the Winter King and Queen
Signed and dated 1628. Panel, 37.9 × 65.3 cm.
Szépmüvészeti Múzeum, Budapest

Landscape Painters

Cornelis van Poelenburgh, whose work was discussed in the section on the Italianate landscape painters in Part I (see p. 144), returned to Utrecht in 1627 after a long sojourn in Italy. Except for visits to England in the 1630s and a stay there from 1638 to 1641, he made his home in Utrecht, where he died in 1667. He played an active role in the artistic life of the city and several times held the posts of governor and dean in the painters' fraternity. In addition to numerous Arcadian landscapes, he painted portraits and mythological and biblical pictures. He was particularly fond of depicting the inhabitants of Olympus or Heaven: gods holding a feast, or flying cherubim in a round-dance to honor a saint, such as Catharine of Alexandria (fig. 683). Below, there is an earthly (always Italianate) landscape in a sweeping vista, usually with a few awestruck mortals. Poelenburgh's rendition of the nude figures in these small paintings is adroit and set an example for other Utrecht figure painters. His work was highly thought of: many of his paintings hung in the stadholder's court, and the Winter King, too, honored him with commissions. The little painting of the elector's seven children (fig. 684), which exists in several versions, is an excellent example of Poelenburgh's ability to combine the Italianate landscape with portraiture.

When Jan Both returned from Italy in 1641, he brought a new dimension and fresh stimulus to the landscapists in Utrecht. Both had studied under his father, a glass painter, and Abraham Bloemaert. His older brother Andries, who specialized in painting street and market scenes in the manner of Pieter van Laer (Il Bamboccio), either traveled with Jan to Italy or preceded him there; certainly they were together in Rome about 1638. On their return trip to Holland, Andries was drowned in Venice, and Jan came back alone. During the little more than a decade remaining to him, Both gained in refinement and technical skill; he created his best work in Utrecht. He continued to paint landscapes inspired by his Italian experiences. Rocky masses and mountains are always important in these paintings, but trees and groves predominate (fig. 685). A golden light casts a magic glow; tree trunks, foliage, and reedy stalks playfully catch the light and toss it back, and the animated figures are always wholly caught up in this atmosphere. Trees and plants, initially limited to

685 Jan Both
Travelers in an Italian Landscape
Signed. c. 1648–50. Canvas, 87.6 × 106.4 cm. The
Toledo Museum of Art, Ohio. Gift of Edward
Drummond Libbey

686 Carel de Hooch
Landscape with Ruins and Duck Hunters
Signed. Panel, 42 × 63.3 cm. Centraal Museum,
Utrecht

687 Herman Saftleven
Hunters Resting in a Forest
Signed and dated 1647. Canvas, 78 × 68 cm.
Museum Bredius, The Hague. Collection
Gemeentemuseum

685

686

687

indistinct species, can be precisely identified in great variety in his later work. A number of
artists, including the Utrecht painter Willem de Heusch, followed Both's style. Others, like
Adam Pynacker, profited from it.

Carel (Charles) de Hooch was a third landscape painter who settled in Utrecht after a trip
to Italy that included a stay in Rome. He entered the Utrecht guild as a master in 1633. He
painted mostly landscapes with ruins and grottoes, showing himself in a few of these to be a
delightful colorist (fig. 686). He was the father of Pieter de Hooch.

The work of Gijsbert d'Hondecoeter, especially his animal-filled landscapes, can be very
attractive. He studied with his father, Gillis, whose landscapes are echoed in the son's,
sometimes giving them an old-fashioned look. Gijsbert brings a fresh element, however, to
the rendering of poultry and game birds (see fig. 309). His paintings in this category closely
resemble the work of Aelbert Cuyp. Gijsbert's son and pupil, Melchior, carried on the
tradition, depicting poultry with unprecedented perfection.

Herman Saftleven painted landscapes and farm still lifes. In 1632 he moved from
Rotterdam to Utrecht and worked there in many diverse styles. His earliest paintings, both
in subject and manner, are related to Jan van Goyen's, but he broke away from this
influence, for van Goyen's ideas found little response in Utrecht. Saftleven's work also
contains traces successively of Bloemaert, Breenbergh, Poelenburgh, and Both. His own
refreshing originality crops up occasionally, as in the forest landscape of 1647 (fig. 687); an

extant preliminary drawing for this painting has the annotation "Hooge Soerder Bos" (High Soeren Forest, in the neighborhood of Apeldoorn). After 1650 Saftleven limited himself to panoramic, mountainous landscapes.

The work of Claude de Jongh looks amateurish in its rather awkward style. Yet de Jongh's unorthodox manner, suggesting light by a system of fine little dashes and dots, and using such colors as pale green and yellow, can make his work unexpectedly attractive. Little is known about his early life; he became a member of the Utrecht guild and also worked in England, where he painted London views (fig. 688) and made drawings of London and Kent.

Joost Droochsloot, who lived until 1666, had one pupil who deserves mention here: Jacob

688 Claude de Jongh
Old London Bridge
Signed and dated 1630. Panel, 50.8 × 167.6 cm.
The Iveagh Bequest, Kenwood, London

689 Jacob Duck
Woman Ironing
Signed. Panel, 42.5 × 33.5 cm. Centraal Museum,
Utrecht

Duck. Duck was the Utrecht representative of the group which specialized in painting interiors peopled with soldiers, family groups, and domestic scenes, usually in small format. His work shows closer affinity with that of such painters as Anthonie Palamedesz, Codde, Duyster, and Kick than with his teacher's. Duck mastered a remarkable palette, building up his pictures primarily in brownish and grayish tones, then adding bright color accents. His handling of light is interesting: in perhaps his most remarkable domestic interior, *Woman Ironing* (fig. 689), he makes ordinary cloth scintillate and dull metals and straw sparkle. The archway which frames the scene and the dark stairway in the right background enhance the sense of intimacy.

Artistic life in Utrecht during the second quarter of the century remained dominated by the ideas of the older painters. The number of Utrecht artists who still considered Italy to be essential in finishing their studies is striking, and as a result the native Dutch element that emerges so clearly in other centers scarcely existed in Utrecht at all.

Painting in Delft: 1625–1650

The dividing line between the painters in Delft and those in The Hague is not always easy to define during the first quarter of the seventeenth century, but in the second quarter the differences become more obvious. The Hague developed into a true seat of government, with a constant flow of political figures both native and foreign, and life there was not the same as in other Dutch cities. Delft, on the other hand, was much less cosmopolitan. The stadholder's court had been based there only from 1572 to 1584, not long enough to make much cultural impact, but its departure left an unfilled gap. Moreover, Delft's prosperity as a trading center, with its port Delfshaven on the canalized Schie River, was now threatened by the rise of Rotterdam. With its active though not very powerful memberships in the United East India Company, the Northern Company (founded in 1614 to exploit whaling), and the West India Company, Delft maintained its hold on some of its commercial activities.

Its principal industry, however, was tapestry weaving. François Spiering, a Flemish refugee, had established the first factory in Delft in 1592, which quickly began to turn out tapestries of high quality, so expensive, to be sure, that only the wealthiest patrons could

purchase them. About 1604 Spiering was joined by Karel van Mander the Younger, whose father had designed cartoons for the factory, and whose own association with the tapestry business continued with ups and downs until his death in 1623. Spiering died in 1630, but his factory was continued by his sons, Aert and Pieter, and after 1635 by Maximiliaen van der Gucht, under whom the business flourished anew, delivering tapestries to such important clients as Frederik Hendrik, the municipal governments of Delft and Leiden, and Queen Christina of Sweden.

Second, and of growing importance during the first half of the seventeenth century, was the pottery industry. The importation of Chinese porcelain by the United East India Company aroused a demand for decorated tableware that the Delft potters quickly seized upon. The discovery of new clays and the introduction of improved techniques in the 1620s enabled them to manufacture superior products at competitive prices, and by the middle of the century delftware was famous throughout the Netherlands and selling well abroad. Artists of varying capability produced designs for both the tapestry and the faience industries. But despite the success of these industries, both required a large capital outlay and a relatively small labor force, so that Delft's population was not swelled by an influx of new workers. The town retained its quiet charm, was sufficiently prosperous, but remained outside of the mainstream.

Portrait, Landscape, and Still-Life Painters

Painting blossomed in this period with a comparable modesty. The older portraitists Michiel van Miereveld and Willem van Vliet continued to work, but no new portrait painters of any significance appeared. Nor was much going on in landscape art, except for Jacob van Geel, who worked in Delft from 1626 to about 1632. Before that he had lived in Middelburg, where he painted landscapes in the Flemish tradition, and though he evinced a clear interest in trees and woods, he did not develop his personal style until he came to Delft. Why he moved there is unknown: perhaps he was fleeing from his creditors in Middelburg, for van Geel's life is one long story of financial and marital difficulties. In 1632 he is mentioned as being in Dordrecht, and after that he is known only from one painting, dated 1638.

690 Jacob van Geel
Landscape with a Water Mill
Signed and dated 1637. Panel, 31.9 × 50.7 cm.
Herzog Anton Ulrich Museum, Brunswick, West Germany

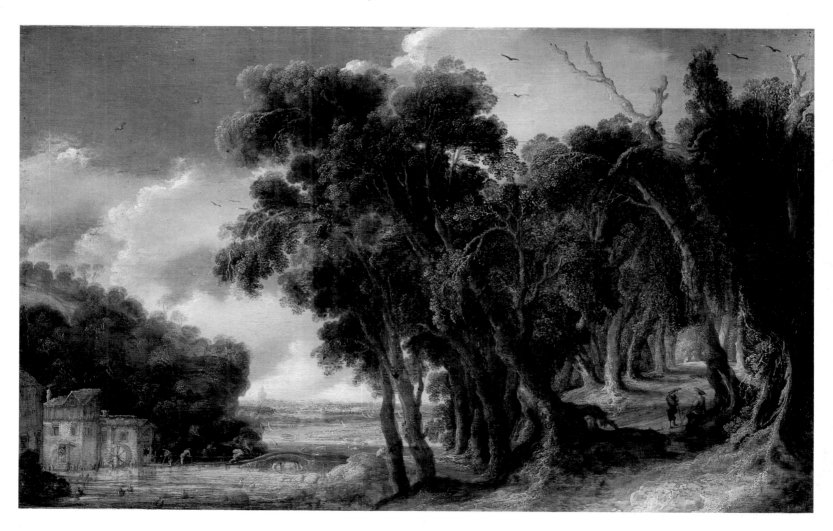

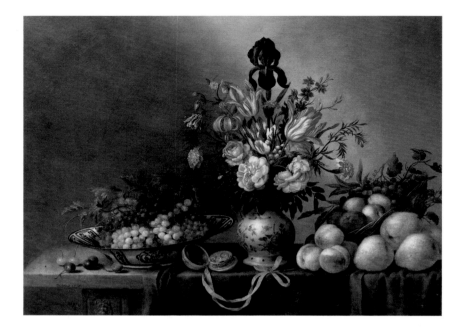

691 Dirck van der Mast
Still Life with Flowers and Fruit
Signed and dated 1656. Panel, 68.5 × 92.5 cm.
Private collection

Van Geel's landscapes, almost always small in size, are fantasy views with trees of erratic growth, the branches and half-rotten trunks often overgrown with moss and ivy (cpl. 690). They are painted in a wide range of greens, the light scintillating on foliage and trunks rendered with little touches of white, yellow, and rose. Van Geel evokes an atmosphere of secrecy, sometimes also of melancholy. He can be compared in interest and effect only with Hercules Segers, but as far as is known these two artists had no contact with each other.

After van Geel's departure, Simon de Vlieger settled in Delft, in 1634, but only for about three years. Since no landscape or marine painters of any consequence worked in Delft for some time afterward, it can be assumed that van Geel and de Vlieger made no impact.

Still-life painting likewise stirred little interest in Delft. Willem Delff, painter of kitchen still lifes, lived there until 1638, and Balthasar van der Ast, after his years in Utrecht, worked in Delft after about 1632 until his death in 1657. Van der Ast without doubt kept busy and must have painted some of his exceptionally attractive flower pieces and still lifes of shells in Delft; yet in general he merely continued to embroider on these old themes, which had reached their peak in Middelburg at the beginning of the century. Only rarely (see fig. 424) does he seem to try a new approach in floral painting. What little work is known of another Delft still-life painter, Dirck van der Mast, such as his *Still Life with Flowers and Fruit* of 1656 (fig. 691), is completely in Van der Ast's manner and must have originated under his direct influence. The Leiden *vanitas* school was represented for a decade or so by Harmen van Steenwijck, who returned to Delft, his birthplace, about 1644 after a stay in Leiden.

History and Architectural Painters

Two history painters of distinctly different styles, Leonard Bramer and Christiaen van Couwenbergh, were active in Delft. Both had completed their schooling in Italy, and in that respect they resemble the Utrecht painters. Delft and Utrecht seem to have shared a bond in matters of art: Michiel van Miereveld was educated in Utrecht, van der Ast lived there for thirteen years, and later the early style of Johannes Vermeer would show influences of the Utrecht school.

In 1614, when he was eighteen years old, Leonard Bramer went on a long pilgrimage that led him to Rome by way of Arras, Amiens, Paris, Aix-en-Provence (in 1616), Marseille, Genoa, and Livorno. Afterward he visited other art centers in Italy, including Mantua and Venice, where his stays perhaps had particular importance for his later development because he may have encountered Domenico Feti, a disciple of Caravaggio and Elsheimer, who worked in both of these cities at the end of his life, dying in Venice in 1624. A certain kinship with Feti's work can be seen in Bramer's.

By 1628 Bramer was back in Delft, where, except for a second trip to Rome in 1648, he remained until his death in 1674. He was an esteemed artist and citizen and received many official commissions from the municipality, the stadholder, and other authorities. His Italian experience seems to have had an appeal for his patrons. He dared to paint large-scale

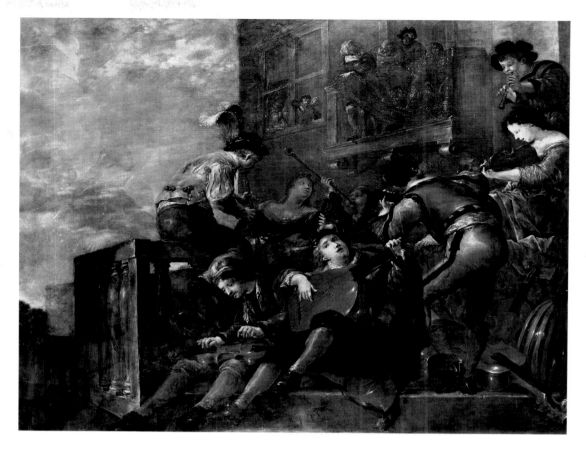

692 Leonard Bramer
A Group of Musicians
Signed. Canvas, 208 × 215 cm. Private collection

693 Leonard Bramer
The Queen of Sheba before King Solomon
Signed. Panel, 74 × 109.5 cm. Formerly Staatliche
Kunstsammlungen, Dresden. Destroyed during
World War II

frescoes, the only Dutch artist who was so bold, as far as we know. Bramer decorated the
hall of the Nieuwe Doelen in Delft in this technique (he was himself a sergeant in the local
militia). Considering the damp Dutch climate, his patrons were rightly hesitant about a
technique so foreign to the Netherlands, and Bramer was required to keep these paintings in
good repair; he restored them several times, but after his death they deteriorated. He also
painted frescoes in a private home in Delft. For other local buildings, he made large-scale
decorations in the oil-paint technique, and his *Group of Musicians* (fig. 692) gives an
impression of his style. He painted this large picture on a canvas that had been used before,
and some figures from the first painting have bled through the surface of the second,
particularly noticeable in the sky section at the left.

A few ceiling paintings, poorly preserved, are left to indicate Bramer's accomplishments
as a monumental painter, but his extant easel paintings give us a better idea of his talents.
These pictures testify to spontaneity and imagination, and also to a nervous, fluent manner
of drawing. His treatment of light is exciting, as is the way he lets figures loom up out of
darkness. One of his most beautiful paintings, *The Queen of Sheba before King Solomon* (fig.
693), was destroyed when Dresden was bombed in World War II; besides having a dramatic
composition, it showed Bramer's skill at rendering light reflections on embossed vessels and
other costly objects. He undoubtedly brought his loose and somewhat undulating style of

694 Christiaen van Couwenbergh
Bacchanal
Signed and dated 1626. Canvas, 134 × 166 cm.
Private collection

695 Christiaen van Couwenbergh
Rape of a Negress
Signed and dated 1632. Canvas, 104 × 127 cm.
Musée des Beaux-Arts, Strasbourg

695

696 Anthonie Palamedesz
Portrait of a Man
Signed and dated 1655. Canvas, 81 × 69 cm.
Westfälisches Landesmuseum, Münster

697 Anthonie Palamedesz
Company Dining and Making Music
Signed and dated 1632. Panel, 47.4 × 72.6 cm.
Mauritshuis, The Hague

696

painting back with him from Italy. Later he also worked in the manner of the Utrecht Caravaggists.

The other Delft history painter renowned in his time was Christiaen van Couwenbergh, whose name today is scarcely remembered; the initials *C.B.* on paintings in the Oranjezaal in the Huis ten Bosch went long unidentified as his monogram (*CouwenBergh*).[1] To have been chosen to decorate the Oranjezaal—and Honselaersdijk, Huis ter Nieuburch, and the Oude Hof in The Hague as well—is evidence that he was among the elite, in the good favor of Jacob van Campen and his circle. It is no surprise that Couwenbergh's oeuvre, insofar as it can be reconstructed,[2] is closely related to that of the Utrecht and Haarlem history painters.

694

His father, a Fleming from Mechelen, was a silversmith who settled in Delft, where Christiaen was born in 1604. After a trip to Italy, Couwenbergh returned home and in 1630 married Elisabeth van der Dussen, daughter of a burgomaster of Delft. In 1647 Couwenbergh moved to The Hague, and in 1654 he left permanently for Cologne. Paintings by him are known from 1624 onward. The early works, such as *A Bacchanal* of 1626 (fig. 694), follow the style of the Utrecht Caravaggists; his later ones are more in the manner of the classically oriented painters around van Campen. Most extraordinary in theme is a fairly large painting of 1632 which shows three young men disporting themselves with a Negress (fig. 695). The seventeenth-century Dutch were not shy of erotic depictions, but this one goes beyond the usual bounds. Again, one wonders who ordered it.

697

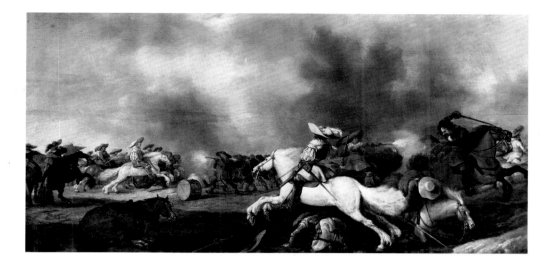

698 Palamedes Palamedesz
Battle Scene
Signed and dated 1638. Panel, 42 × 78.5 cm.
Kunsthistorisches Museum, Vienna

699 Gerrit Houckgeest
Architectural Fantasy
Signed and dated 1638. Canvas, 122.5 × 154 cm.
National Gallery of Scotland, Edinburgh

One of Michiel van Miereveld's pupils in Delft was Anthonie Palamedesz, born there in 1601. Although portraiture was not his main area of activity, Palamedesz regularly painted portraits of good quality throughout his career, more or less following the fashion of the day: they were more and more smoothly painted as time went on, always with light-gray backgrounds (fig. 696). Palamedesz' greater fame, however, was as a painter of interiors and guardroom scenes, family scenes, and merrymakers, such as his *Company Dining and Making Music* of 1632 (fig. 697). His work in this genre is similar to the subjects treated by Pieter Codde and Willem Duyster, but slightly lower in standard, and later, when he often repeated himself, the quality diminishes. At the end of his life he moved to Amsterdam, where he died in 1673.

Anthonie's younger brother, Palamedes Palamedesz, was his pupil and specialized in cavalry battles closely related to those of Esaias van de Velde and Jan Martszen the Younger. These paintings contain scenes of lively action; they are well drawn and lucid in color (fig. 698).

Three artists who became prominent as architectural painters just after the middle of the century were Gerrit Houckgeest, Hendrick van Vliet, and Emanuel de Witte. All of them had previously worked in Delft, yet only Houckgeest is known to have made architectural paintings before 1650. After a stay in The Hague, where he presumably was a pupil of the painter-architect Bartholomeus van Bassen, Houckgeest went to Delft in 1635 and remained there painting imaginary interiors (fig. 699). He did not begin to create his high-quality

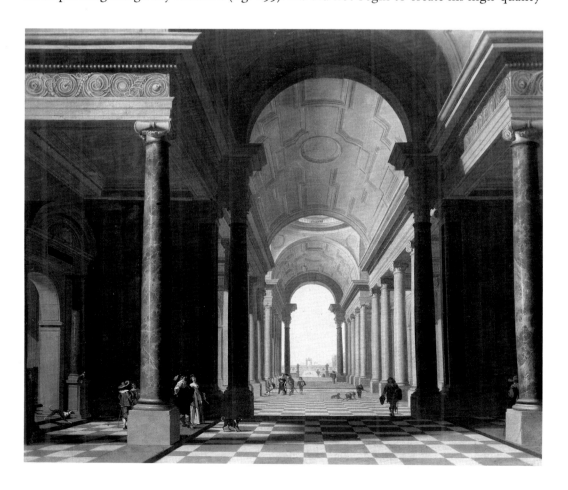

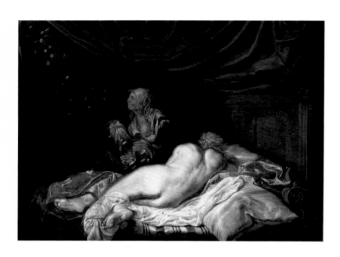

realistic church interiors until after 1650. The second painter, Hendrick van Vliet, studied under his uncle, Willem van Vliet, and Michiel van Miereveld. Of his work from before 1650, only a number of portraits and a few figure paintings of moderate quality are known. The third, Emanuel de Witte, arrived in Delft from Rotterdam about 1640, apparently aspiring at that time to become a history and portrait painter, for his known work from before 1650 includes some portraits as well as paintings with biblical and mythological subjects, such as *Zeus Visits Danaë as a Shower of Gold* of 1641 (fig. 700), with the gold falling in coins. The work of these three painters will be further examined in Part IV.

Paulus Potter

With some hesitation I propose here to discuss Paulus Potter. Perhaps he should be included in a later chapter; had he lived longer, he would naturally belong in the post-1650 period, but he died at twenty-nine in 1654, and as much of his work is dated before 1650 as after. There is also a dilemma concerning the city to which he most belonged. He was born in Enkhuizen in 1625, but his father, the painter Pieter Potter, moved the family to Amsterdam in 1631; Paulus no doubt studied with him and possibly with Claes Moeyaert as well. In 1646 Paulus was enrolled in the St. Luke's Guild in Delft; three years later he was working in The Hague, where he lived next door to Jan van Goyen; in 1652 he went to Amsterdam, persuaded by the wealthy physician Nicolaes Tulp, Rembrandt's earlier patron, who wanted Paulus to paint an equestrian portrait of his son—this painting is now

700 Emanuel de Witte
 Zeus Visits Danaë as a Shower of Gold
 Signed and dated 1641. Panel, 40.5 × 54 cm.
 Private collection

701 Paulus Potter
 Farm
 Signed and dated 1649. Panel, 81.3 × 116.4 cm.
 Hermitage, Leningrad

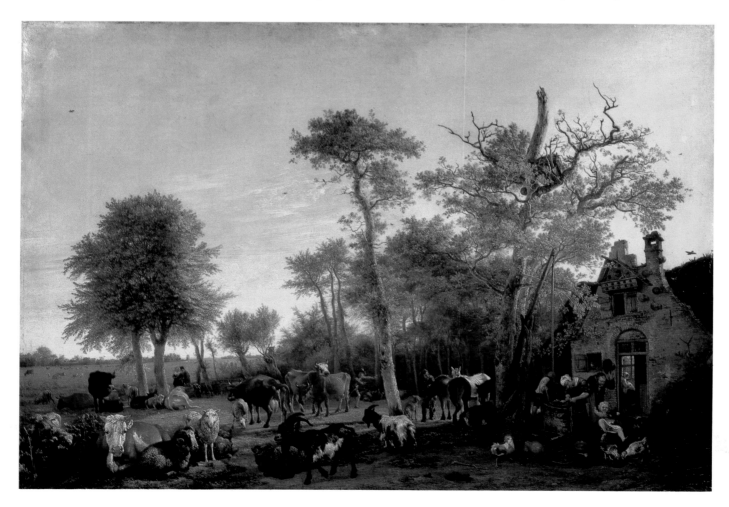

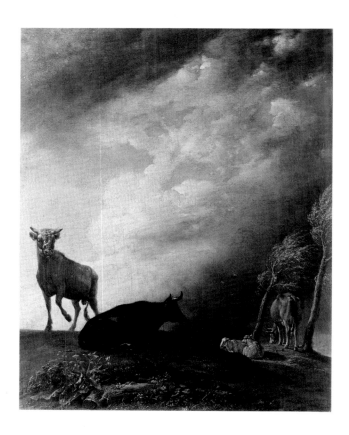

702 Paulus Potter
Cattle and Sheep in a Stormy Landscape
Signed and dated 1647. Panel, 46.3 × 37.8 cm.
The National Gallery, London

703 Paulus Potter
Dogs in an Interior
Signed and dated 1649. Canvas, 115 × 147 cm.
Private collection

in the Six Collection in Amsterdam, passed down by Jan Six, son-in-law of Nicolaes Tulp and another of Rembrandt's patrons.

Thus Potter's art is not bound to any specific locality. He was an animal painter pure and simple, and he assimilated the traditions of this genre in his own highly individual way. He portrayed Dutch livestock in their natural surroundings without any biblical or mythological story, though even he succumbed to representing the Orpheus legend once or twice. Potter had an infallible sense of atmosphere and lighting, and the time of day and the weather conditions can generally be clearly identified in his pictures: the light of early morning (cpl. 701), or an occasional rising storm (fig. 702). His name is always burdened, of course, with the authorship of *The Young Bull* (see fig. 307), now in the Mauritshuis in The Hague, a canvas of huge format and excellent qualities. This painting has been so famous for so long that the inclination now is to talk slightingly of it. Yet whoever looks at the picture without prejudice cannot help being impressed by the talent of the twenty-two-year-old artist who painted it.

In addition to horses, cows, and sheep, Potter painted pigs and goats. He also produced a few portraits of dogs (fig. 703) that are more comical than beautiful, yet absolutely true to life, and evidence of a remarkable interest shared by the painter and his patrons.

Though Potter's active life was short, his influence was considerable. The animal paintings of the slightly older Carel Du Jardin owe much to him, while the work of the talented Adriaen van de Velde is unthinkable without Potter's model. Many other painters of lesser quality were inspired by Potter's work, and he continued to offer an enlightening example for animal painters in the eighteenth and nineteenth centuries.

Painting in The Hague: 1625–1650

The Hague had been the governmental center of the county of Holland since the thirteenth century, and in the sixteenth century it became the residence of the stadholder of the province of Holland, the representative of the Spanish sovereign. When the Republic of the United Netherlands arose in 1579, The Hague remained the seat of government and the center of the judicial system. The cities and their ruling burgomasters had *de facto* power in the Republic, and it is therefore surprising that the only city which was not really a city, which had never been granted the rights and privileges of a city, should become the seat of government. Perhaps The Hague was the right place precisely because it had no voice in political events, no municipal rights, and no representation in the Provincial States.

In the seventeenth century The Hague was called the "largest village in Europe," and in

704 Jacob van der Croos
View of The Hague, with Twenty Scenes in the Neighborhood
Signed and dated 1663. Center panel, 64.5 × 123.5 cm; border panels, 17.5 × 32 cm (each). Gemeentemuseum, The Hague

Jacob van der Croos's view of the early 1660s (fig. 704) it still looks rural, at least in the outskirts. The town, being unwalled, was defenseless, and had no harbor or industry; it depended for its livelihood entirely on the presence of the stadholder's court and the government bureaucracy. It was divided roughly into two parts: the service district, where the tradesmen and townspeople lived, and the court and government district, whose residents were for the most part outsiders—political representatives from other cities and provinces, envoys of foreign powers, high military officers, and the court circle, which consisted mainly of noble families.

There was no master plan like Amsterdam's for the expansion of The Hague, but new and restored buildings were necessary to house the increasing number of governmental departments and employees—early delegates to the States-General lodged in boardinghouses, openly discussing delicate political matters in the hearing of strangers and foes. Amsterdam made the first move to stop this leakage by building, in 1618, a "logement" for its civil servants assigned to The Hague, and other cities soon followed suit. New neighborhoods sprang up around the center of the city, and new canals were dug and streets laid out. The most conspicuous activity, however, was the construction of private mansions, many with extensive gardens. Jacob van Campen set his mark, as we have seen, on the magnificent town houses of Johan Maurits of Nassau-Siegen and Constantijn Huygens, and his classical style was followed by other Hague architects.

During the stadholdership of Frederik Hendrik, The Hague was a very sociable city. The high season was the winter, for the stadholder left for military campaigning in the summer. The leaders of Hague society were undeniably the exiled elector Frederick V of the Palatine and his wife, Elizabeth Stuart, the Winter King and Queen of Bohemia (see p. 39). Upon their arrival in 1620 they had been given an elegant house in the best neighborhood, a monthly stipend of ten thousand guilders, and a regal household of two hundred servants and fifty horses. Their clothes were the most fashionable, their parties the most eagerly attended. They were also the center of exciting intrigues, for the German Protestant nobles were constantly plotting to restore Frederick to his throne, but when their hopes seemed about to be realized in 1632, Frederick died somewhere near Heidelberg on his way to Bohemia. Elizabeth Stuart continued to live in The Hague in great style and increasing debt for the next thirty years, long enough to return to England after the Glorious Restoration of her nephew Charles II in 1660.

Frederik Hendrik achieved the nearest thing to a royal court that the Northern Netherlands had ever known, or in fact would ever know. His enthusiasm for art and his ability to attract and learn from the distinguished people he employed set a definite stamp on The Hague, as did the continuous flow of foreign diplomats and delegates from all corners of the Republic. Village or not, The Hague had an international air, and this found a degree of expression in the art of painting.

Adriaen van de Venne

In 1625 Adriaen van de Venne moved from Middelburg to The Hague, probably to be closer to the court circles. In Middelburg he had already received court commissions: about 1617 he painted portraits of the stadholder Maurits and his younger brother, Frederik Hendrik; in 1618 he made a picture of both princes at the horse market in Valkenburg; and the Oranges appear in other pre-1625 works which they almost certainly commissioned themselves. In 1625 van de Venne painted Prince Maurits on his deathbed, and in 1628 he made a large canvas in grisaille of the Winter King and Queen with their entourage (see fig. 28). The grisaille technique came ultimately to supplant color entirely in his paintings.

The subjects van de Venne worked on in The Hague were mainly allegorical, moralistic, or biblical, such as his *Adoration of the Magi* of 1644 (fig. 705). From 1621 on, but increasingly after arriving in The Hague, he sought to set these themes in the life of the poorest sector of the population—beggars, vagabonds, and peasants. Most of these paintings (all in grisaille) have such titles as "All Poor," "Poor Luxury" (see fig. 161), "Mad Misery," "Poverty Seeks Mischief," "Miserable Legs Carry the Poor" (see fig. 98), which the smoothly painted, pithy scenes depict clearly. It is difficult to say whether his social conscience moved van de Venne to choose these subjects; they seem to reflect his interest in the unfortunates of his day, and are otherwise extremely rare in Dutch art.

Presumably the subjects were connected with van de Venne's activities as an illustrator. His brother was a publisher, and Adriaen had already illustrated books while in Middelburg—the *Emblemata of Zinnewerk* (Emblems or Work of the Mind) of 1624 by Johannes de Brune, and writings by Jacob Cats published in 1618, 1621, 1622, and 1625. Both de Brune and Cats were highly moralistic writers, and van de Venne adapted himself as their illustrator. Cats states in the foreword to his 1625 book *Houwelyck* (Marriage) that he and van de Venne conferred personally about the illustrations. Cats tended to put his moral lessons in everyday form and to draw examples from daily life, and van de Venne captured this in clever and witty drawings (engraved by various hands), which found their continuation in his grisailles, such as *Gentleman at His Toilet* (fig. 706). All told, the association between Cats and van de Venne lasted over forty years.

Van de Venne's manner of painting and his choice of subject matter did not directly

705 Adriaen van de Venne
The Adoration of the Magi
Signed and dated 1644. Panel, 76 × 107 cm.
Nationalmuseum, Stockholm

706 Adriaen van de Venne
Gentleman at His Toilet
Dimensions and whereabouts unknown

706

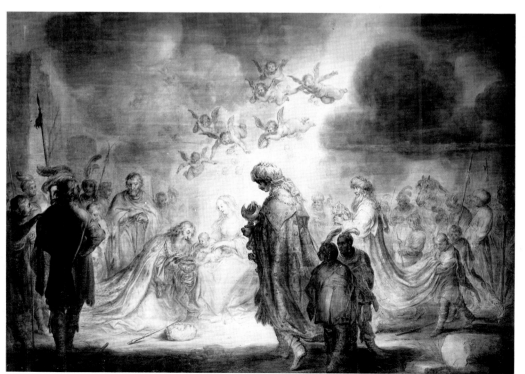

705

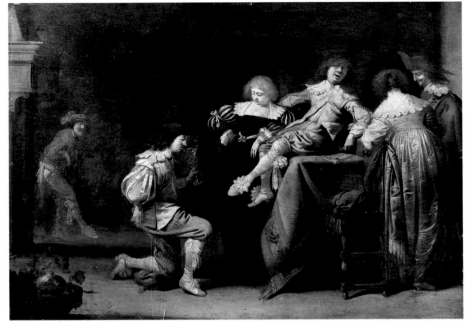

707

707 Pieter Quast
Merry Company
Signed. Panel, 42.7 × 58.8 cm. Kunsthalle,
Hamburg

708 Daniel Mijtens
Portrait of Thomas Cletscher
Signed and dated 1643. Panel, 71.5 × 55 cm.
Gemeentemuseum, The Hague

709 Daniel Mijtens
Portrait of Anna Hoeufft
Signed and dated 1643. Panel, 71.5 × 55 cm.
Gemeentemuseum, The Hague

attract any followers. Pieter Quast, who lived in The Hague for some years in the 1630s, may have taken something from him, although Quast's fairly loose touch and most of his low-life figures remind us rather of Adriaen Brouwer and Adriaen van Ostade, while his more elegant types, as seen in his *Merry Company* (fig. 707), recall Anthonie Palamedesz.

Portrait Painters

During the second quarter of the century, the period of Frederik Hendrik's stadholdership, a few older portrait painters were still working in The Hague. Jan van Ravesteyn, who had moved there from Delft, continued to be active until he was very old (he died in 1657 at the age of eighty-seven), but his late style underwent few changes. Evert Crijnsz van der Maes, of whom far too little is known, also lived until his eightieth year, dying in 1656. Daniel Mijtens, after his long stay in London, lived in The Hague from 1634 until his death in 1647, aged fifty-seven; it is a question whether he did much painting there, for only a few portraits from his Hague period are known. These include his last known works, pendant portraits dated 1643 (figs. 708 and 709); they are well painted but rather traditional.

Of greater importance to portraiture in The Hague was the arrival of Gerrit van Honthorst, whose successful career we have already traced. Suffice it to recall here that he was one of the few artists in the Netherlands with the technical skill to paint large-format court portraits and portrait groups (see fig. 681). Honthorst tried to emulate Anthony van Dyck's court style of portraiture. The two artists must have met during one of van Dyck's

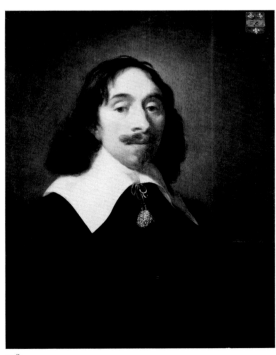

708

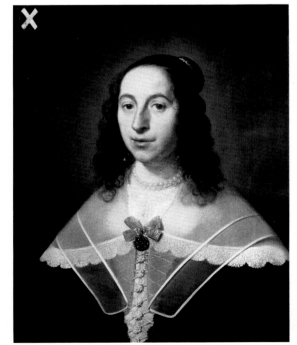

709

710 Anthony van Dyck
Portrait of the Painter Frans Snijders
Canvas, 144.5 × 107 cm. The Frick Collection,
New York

visits to The Hague in 1628–29 and 1632; van Dyck's portrait drawing of Honthorst now exists only in a copper engraving.[1]

Van Dyck was born in Antwerp in 1599 and stayed there until 1620. He was trained in Rubens' studio and became the master's assistent for a time. In 1620 he paid a short visit to the English court, and the next year traveled from Antwerp to Italy, where he remained until 1627. After a brief return to his birthplace, he settled in England in 1632 and became court painter to Charles I. From time to time he visited the Netherlands and Paris, but his major activity was in London, where he died in 1641. His enormous energy and rapid brush enabled van Dyck to create an imposing number of portraits and history paintings during his relatively short life. His portraits in particular, such as that of his Antwerp colleague Frans Snijders (fig. 710), are important for Dutch art. They are painted with unusual skill and fluency, great suppleness, and a wholly assured touch, giving his figures a natural elegance and liveliness. His palette, rather sober in his Italian works, became lighter and brighter in England.

Whereas Honthorst remained far behind this elegant execution and flowing technique, another Dutch artist, Adriaen Hanneman, was able to capture more of van Dyck's style and introduce it at The Hague. A member of a distinguished Hague family, Hanneman studied under Anthonie van Ravesteyn. In 1623 he went to London, where he was closely in touch with a Dutch painter living there, Cornelis Jonson van Ceulen (see p. 343). Jonson van Ceulen's work, as well as that of Daniel Mijtens, may have influenced Hanneman's development. When van Dyck arrived in England in 1632, he and Hanneman worked in the same surroundings and for the same clientele for the next five years. That Hanneman was overshadowed by van Dyck goes without saying; that he modeled himself after the greater master and profited permanently from his influence is attested by the portraits he made after he returned to The Hague in 1637. His trio of pretty, fashionable young ladies (fig. 711) is probably a portrait group, not an allegory of the senses, as it is sometimes interpreted. Hanneman's palette is browner and more opaque than van Dyck's, yet his work is sometimes mistaken for the Flemish master's, as in the case of the canvas bearing the portraits of Constantijn Huygens and his five children, each in a separate medallion (fig. 712). This painting was purchased by the Mauritshuis in 1882 as a work by Anthony van Dyck; subsequent research restored it to Hanneman. The painting is dated 1640, the year of

711 Adriaen Hanneman
Three Ladies in Company
Signed. Canvas, 140 × 209 cm. Herzog Anton
Ulrich Museum, Brunswick, West Germany

712 Adriaen Hanneman
*Portrait of Constantijn Huygens and His Five
Children*
Dated 1640. Canvas, 204 × 173 cm. Mauritshuis,
The Hague

711

712

713 Jan Mijtens
Family Portrait
Signed and dated 1638. Canvas, 78 × 106 cm.
Musée National du Château de Versailles

714 Jan Mijtens
Pieter Stalpaert van der Wiele and His Family
Signed and dated 1645. Canvas, 128 × 163 cm.
Gemeentemuseum, The Hague

Hanneman's entrance into the Hague guild, but it was probably painted earlier, in memory of Huygens' wife, who had died in 1637.[2]

In 1640 Hanneman married Maria van Ravesteyn, a niece of his first teacher. He was active in Hague art circles, being for many years a governor of the local St. Luke's Guild, while at the same time strongly supporting the movement for artists to secede from the guild and establish their own fraternity. When this separation did take place and the Confrerie Pictura was established in 1656, he was chosen its first dean. His financial circumstances were excellent until the end of his life, when he ran into monetary difficulties; he died in 1671.

Next to Hanneman, Jan Mijtens was the most talented painter of court portraits. His uncle, Daniel Mijtens, is thought to have been his teacher. Besides individual portraits, he specialized in portrait groups set in a landscape, a form of portraiture that demanded high technical skill: the figures had to be variously posed in full length; the faces had to be recognizable although usually small; the compositions and treatment of light were complicated. Mijtens succeeded in all respects. Despite van Dyck's influence, and certainly that of the Fleming Gonzales Coques in the family scenes, he remained true to his specifically Dutch style of painting.

A charming portrait group by Jan Mijtens dates from as early as 1638 (fig. 713). Although this painting has suffered slightly from time, it is a splendid example of his earliest work and his talent. The colors have been kept light, and the composition is animated.[3] The relationship of the figures to each other leaves something to be desired, but Mijtens had

713

714

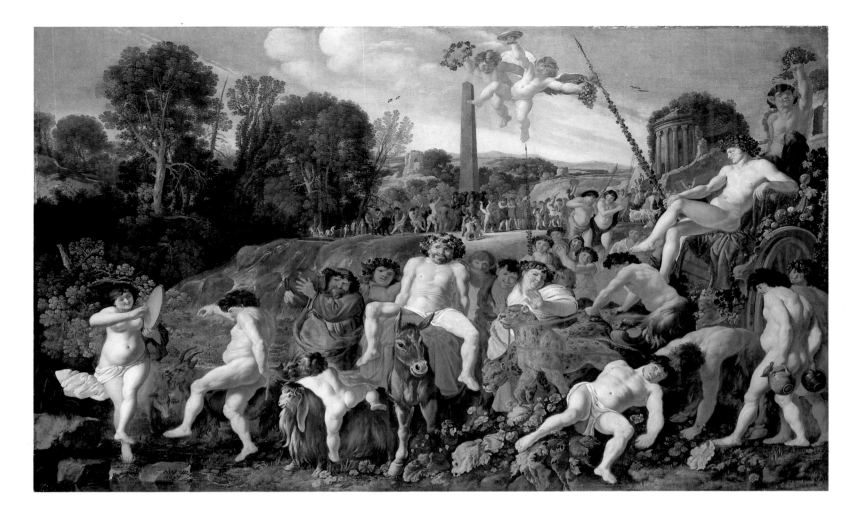

715 Moyses van Uyttenbroeck
Feast of Bacchus
Signed and dated 1627. Canvas, 125 × 206 cm.
Herzog Anton Ulrich Museum, Brunswick, West
Germany

716 Moyses van Uyttenbroeck
Arcadian Landscape
Panel, 44 × 65 cm. State-owned Art Collections
Department, The Hague

overcome this by the time he painted the family portrait of 1645 (fig. 714), now in The
Hague's Gemeentemuseum.

One is inclined to connect Hanneman and Mijtens, because of their light palettes and
fluent manner, with the post-1650 period of Dutch art. The largest part of their activities
indeed falls into that period, yet it is striking—and for this reason I discuss them fully at this
point—that the peak of development for both of them came shortly before 1640. In the
renaissance of Dutch portraiture, The Hague was clearly in advance of the rest of the
country.

Landscape, Marine, and Still-Life Painters

Landscape art in The Hague was represented primarily by two painters who had completely
different approaches: Moyses van Uyttenbroeck and Jan van Goyen. The former was born
in The Hague and presumably lived there until his death in 1648; the latter moved to The
Hague from Leiden about 1632. Uyttenbroeck belonged among the artists who more or less
followed Paulus Bril and Adam Elsheimer, painting fantasy landscapes with strong Italian
elements and a heroic aspect, the figures playing an essential role. Uyttenbroeck's landscapes
can be poetic as well. They are stage settings for Old Testament stories and mythological
scenes, most of the latter on themes from Ovid's *Metamorphoses* and thus playgrounds for
nymphs, satyrs, and other companions of Bacchus (cpl. 715). Uyttenbroeck's emphasis on
the story and the figures might classify him among the history painters. Being both a
landscape and a figure painter, he met higher requirements than those demanded of a
landscapist alone. It is no wonder that he was among the participants in decorating
Honselaersdijk,[4] Frederik Hendrik's splendid new hunting castle. Before that, Uyttenbroeck
had already attracted the court's attention, for some of his works are listed in the 1632–34
inventory of the stadholder's art collection.

At first he emphasized the figures more strongly than the landscape in his work, and his
early compositions show a kinship to Claes Moeyaert's paintings. As landscape grew in
importance to him, Uyttenbroeck usually furnished it increasingly with ruins and classical
structures, but sometimes there are Dutch aspects to his Arcadian scenes (fig. 716). Did he
ever go to Italy? There is no documentary evidence that he did, and the Elsheimer-like
elements in his work could have come from Goudt's prints.

717 Jan van Goyen
Panoramic View of a River
Signed and dated 1641. Panel, 32 × 44.5 cm.
Rijksmuseum, Amsterdam

Jan van Goyen had no interest in Uyttenbroeck's flights of fancy: he wanted to draw and paint exactly what he saw in the Dutch landscape around him. We have already mentioned his work several times, but it was during his years in The Hague that he reached the peak of his powers. Why he moved from Leiden to The Hague is not known. Perhaps, as a Catholic, he did not feel entirely free in Leiden, the bulwark of Calvinism, and went to The Hague because religion was not there a burning issue. Jan Lievens and Jan de Heem, also Catholics, left Leiden at about the same time, but no factual evidence clarifies this question.

Van Goyen received very little for his paintings, and his efforts to improve his financial condition in other ways included dealing in real estate and speculating in tulip bulbs; he was also an appraiser and auctioneer. He had varying success in these activities—his tulip venture was particularly disastrous, but his luck in real estate seems to have been a little better at times: in 1625 he paid 1,075 guilders for the house in Leiden that he shortly sold to Porcellis for 1,200 guilders.[5] Despite his apparently boundless optimism, he barely held out in the long run, and was constantly in debt. When he died in 1656 the auction of his unsold art work and the six houses he still owned brought in just enough to cover his obligations.

Van Goyen had three daughters; one presumably died young, and the others, Maria and Margaretha (Grietje), married, respectively, the still-life painter Jacques de Claeuw and Jan Steen.

Jan van Goyen had a passion for drawing. Dated drawings are known from every year of his active life. The earliest sketches are in pen and ink; later he used black chalk almost exclusively. Most of the sketches seem to have been made out-of-doors, rapidly noting landscapes, buildings, and figures. Several of his sketchbooks have survived intact, and his travels can be reconstructed from the recognizable places he drew; besides roaming about Holland, he journeyed south of Brussels and east to the neighborhood of Emmerich on the Rhine, near the Dutch-German border.[6] Sometimes he worked out his drawings in detail, and he used a few of these literally in his paintings,[7] but we must assume that most of the

718

718 Jan van Goyen
Winter Scene
Signed and dated 1653. Panel, 28.3 × 43 cm. The
National Gallery, London

719 Jan van Goyen
View of Haarlem Lake
Signed and dated 1656. Panel, 39.5 × 54.2 cm.
Städelsches Kunstinstitut, Frankfurt am Main

720 François Knibbergen
Panorama in the Countryside
Signed. Canvas, 97 × 140 cm. Rijksmuseum,
Amsterdam

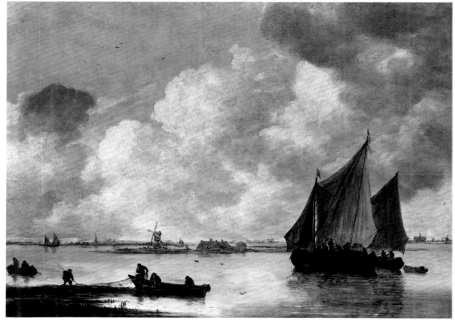

719

paintings, save for the purely topographical subjects, were freely composed in the studio, the drawings used for subordinate parts.

As we have seen, van Goyen's palette was rather bright and colorful at first, and the narrative character of his landscapes was enhanced by many small figures (see fig. 473). About 1627–29 his palette became more limited, with predominately brown, ocher, and green tints; the figures obtrude less in the composition. Village views and dune landscapes appear, along with landscapes having water as an important element (see fig. 510).

During the years that followed he alternated between sober and more colorful tones, but grew stronger in evoking an atmosphere that captures the great spaciousness of the Dutch landscape (cpl. 717). The paintings he created at the end of his life are masterpieces of an art that is quintessentially Dutch—panels like the spirited, fluidly painted *Winter Scene* of 1653 (fig. 718). Dating from his last year, 1656, is the magnificent *View of Haarlem Lake* (fig. 719), with a towering sky and an endless vista over the waterland; accentuating the vastness of this panorama are the boats and figures darkly silhouetted in the foreground.

Van Goyen had a strong influence on other landscape painters in The Hague. François Knibbergen, who had traveled to Italy and initially painted Italian-inspired landscapes, was in The Hague from 1629 to 1636 at least and possibly longer. While there, under van Goyen's influence, he changed over to the Dutch type of landscape, painted in a limited range of colors (fig. 720).

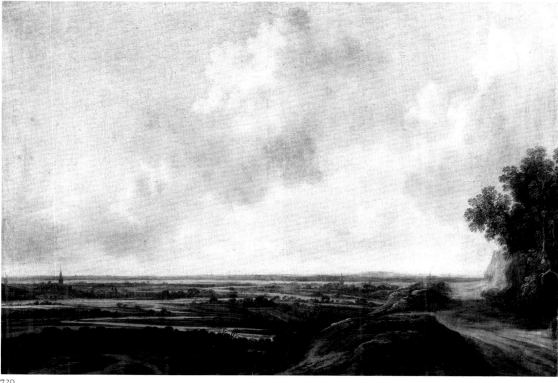

720

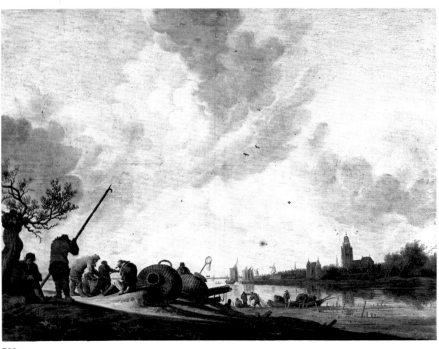

721

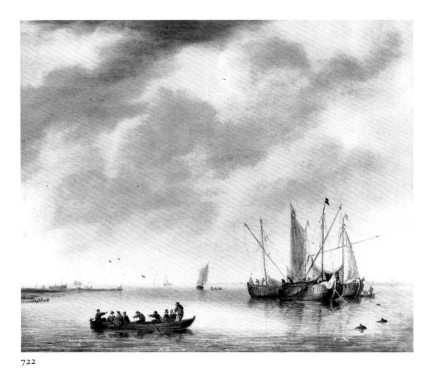

722

721 Antonie van Croos
Landscape with Fishermen
Signed and dated 1651. Canvas, 86.5 × 110 cm.
Szépmüvészeti Múzeum, Budapest

722 Willem van Diest
Calm Water
Signed and dated 1651. Panel, 33 × 36.5 cm.
Kunsthistorisches Museum, Vienna

723 Frans de Momper
Winter Landscape
Signed. Panel, 68.5 × 93.5 cm. Private collection

723

Antonie van Croos, van Goyen's neighbor in The Hague, also painted landscapes in brown and ocher tints; later his palette tends more to grayish-blue. His work is permeated with traces of van Goyen, but remains of lesser quality because he possessed neither van Goyen's assurance and smoothness of touch nor his ability to capture the atmosphere in its many aspects. Yet van Croos produced admirable paintings, such as the large *Landscape with Fishermen* (fig. 721), in which the grayish blues predominate, with a few red and yellow accents in the clothing of the foreground figures enlivening the whole composition.

The marine painter Willem van Diest, one of the founders of the Confrerie Pictura, was well thought of in The Hague. His work—sea, coastal, and river views, mainly in shades of gray—places him among the Porcellis group. His "rough seas," for instance, recall the work

724 Pieter de Putter
Still Life with Freshwater Fish
Signed and dated 1644. Canvas, 93.5 × 114 cm.
Private collection

of van Goyen and Pieter Mulier; his "calm waters" (fig. 722) are more closely related to de Vlieger's paintings. In the latter van Diest shows special sensitivity for color and tone. His son, Jeronimus, worked in his father's style.

The Fleming Frans de Momper lived for some time in The Hague during the 1640s, and although his Flemish background can always be seen in his work, he clearly came under van Goyen's influence. His often powerful landscapes and river scenes, of which his *Winter Landscape* is a good example (fig. 723), are painted primarily in pure and rather rosy browns.

Still-life painters were meagerly represented in The Hague. Jacques de Claeuw lived there from 1646 to 1650, but is mentioned in Leiden in 1651. Pieter de Putter probably spent most of his life in The Hague; he specialized in still lifes of freshwater fish (fig. 724), usually painted in brownish and grayish tones, with touches of green and light blue sometimes reflecting the glints of light on the scales. His work, however, can also be coarse and uninteresting.

Painting in Dordrecht: 1625–1650

About 1648 Jan van Goyen painted a small panel with a view of Dordrecht from across the water of the Merwede River (fig. 725). Dordrecht (often abbreviated to Dordt) is the oldest city in the province of Holland, its municipal rights having been granted in 1220. Although it was still prosperous in the seventeenth century, its greatest period was past. It owed its early rise and development to its favorable location on the delta of the Rhine and Maas rivers, with excellent access to the sea. As an ancient city, Dordrecht enjoyed many privileges, including the highly important staple right which it had gained in 1299: shipments of wine, grain, wood, and certain other goods had to be unloaded in Dordrecht and assessed for duties, payable there, before being allowed to continue. This right led to great local prosperity, but perhaps also to the town's decline: shippers began to look for less costly transshipment ports. One such port was Amsterdam, which began to take over some of the Dordt trade during the sixteenth century. In the seventeenth century Dordt's upstart neighbor, Rotterdam, attracted still more. The people of Dordrecht, however, could take pride in their city's having been chosen as the site of the great National Synod of 1618–19; biased though it was, the synod codified Reformed Church worship and instigated the translation of the Bible into the Dutch language, the magisterial *Statenbijbel* of 1637.

Dordrecht did not reach a competitive level in painting until quite late. Jacob Gerritsz Cuyp, born in 1594, was the first seventeenth-century Dordt painter of any real interest, the son of Gerrit Gerritsz Cuyp, a glass engraver and painter from Venlo, who entered the Dordrecht St. Luke's Guild in 1585. Jacob Gerritsz, after being presumably first taught by his father, became (according to Houbraken) the pupil of Abraham Bloemaert in Utrecht. Such a course of study is plausible: Cuyp's work, in its coloring and choice of subject, shows a relationship with that of the Utrecht school. Cuyp became a history and portrait painter,

725 Jan van Goyen
View of Dordrecht
Signed and dated 164(8?). Panel, 40 × 61.5 cm.
Private collection

339

726

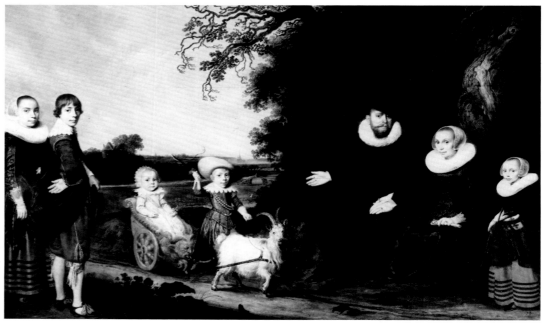

727

728

726 Jacob Gerritsz Cuyp
Portrait of a Child
Signed and dated 1630. Panel, 115 × 86 cm.
Musée de Picardie, Amiens

727 Jacob Gerritsz Cuyp
Family Portrait
Signed and dated 1631. Panel, 106 × 173 cm.
Musée des Beaux-Arts, Lille

728 Jacob Gerritsz Cuyp and Aelbert Cuyp
Family (by Jacob) *in a Landscape* (by Aelbert)
Signed and dated 1641. Canvas, 155 × 245 cm.
The Israel Museum, Jerusalem

producing particularly meritorious work in the latter category. His portraits are plastic and
personal in style (fig. 726). His manner of painting is careful, rather draftsmanlike, with
thinly applied paint. His family portraits—often full-length and in a landscape (fig. 727)—
prove him to be a fluent painter with a vivid palette. Often he enlivens these family
portraits with goats, dogs, and sheep, attesting to his interest as a painter of animals. There is
no doubt that his son Aelbert, born in Dordrecht in 1620, inherited this interest. Aelbert was
his father's pupil and at times his collaborator. In the *Family Group in a Landscape* of 1641
(fig. 728), the figures were probably done by Jacob Gerritsz, the landscape almost certainly
by Aelbert. Aelbert's portrait of Jacob Trip (fig. 729), moreover, is painted wholly after his
father's example; it may even have been begun by the father and finished by the son.

Aelbert Cuyp, though active as a portraitist, is of major importance for landscape
painting, always with animals in evidence. His earliest works, dating from shortly before
1640, are painted primarily in a yellowish-brown and light green color scheme; this palette
and his choice of subjects indicate his close relationship also with Jan van Goyen, as can be
seen from his *Landscape with a Canal* (fig. 730). Somewhat later, about the mid-1640s, his
manner of painting and preferred type of landscape undergo a distinct change that can be
explained only by contact with the Utrecht Italianate landscape painters.[1] Cuyp must have
been in Utrecht or otherwise in touch with the painters working there. His father had
probably studied in Utrecht, and that city's Mariakerk appears in one of Aelbert's early
works; his poultry and animal paintings, moreover, recall those of Gillis d'Hondecoeter.[2]
Since Aelbert Cuyp's work was painted for the most part after 1650, we will defer our
discussion of his development to Part IV (see p. 415).

729

730

729 Aelbert Cuyp
Portrait of Jacob Trip
Signed and dated 1652. Panel, 57.5 × 65.5 cm.
Private collection

730 Aelbert Cuyp
Landscape with a Canal
Signed. Panel, 40 × 45 cm. Städelsches
Kunstinstitut, Frankfurt am Main

731 Benjamin Cuyp
The Angel at the Tomb of Christ
Signed. Panel, 115 × 84 cm. Nationalmuseum,
Stockholm

732 Paulus Lesire
The Widow's Mite
Signed and dated 1632. Panel, 44 × 33 cm.
Collection Daan Cevat, Guernsey

Jacob Gerritsz Cuyp's father, Gerrit Gerritsz Cuyp, married twice and had two more sons who chose careers in art. His namesake Gerrit the Younger, born in 1603, became a glazier and painter, but his work is of little interest to us here. Benjamin, born in 1612, who also turned to painting, produced work so idiosyncratic that it stands almost alone in seventeenth-century art. His technique was to apply very liquid paint with rapid, sometimes quite wild brushstrokes. He used few colors: brown, yellow-brown, a few dull green tints, and an occasional rusty red accent. His manner of painting was virtuoso, but because his modeling was weak, Benjamin Cuyp never achieved great results. He often painted low-life subjects—peasants, vagabonds, and so on—and many biblical pictures as well. Rembrandt's influence is apparent in these latter paintings, where the compositions and the strong chiaroscuro indicate that Cuyp must have known his work. Elements in *The Angel at the Tomb of Christ* (fig. 731) were clearly borrowed from the *Resurrection* that Rembrandt painted for Frederik Hendrik's Passion series (see fig. 70); someone indeed added a false Rembrandt signature to this painting. Most of Benjamin Cuyp's work, however, was probably influenced more by Abraham Bloemaert than by Rembrandt.[3] There are many extant paintings by Benjamin Cuyp; he was undoubtedly a rapid worker.

The Dordrecht painter Paulus Lesire, or Delesire, was probably a pupil not only of Jacob Gerritsz Cuyp but also of Rembrandt. His early work, at least, such as a little signed painting of 1632 entitled *The Widow's Mite* (fig. 732), shows Rembrandt's undoubted influence. Son of an Englishman, whose name is spelled Augustin Lesyre in the 1611 roster of the Dordrecht guild, Paulus Lesire was enrolled as a master in the guild in 1631. If he did

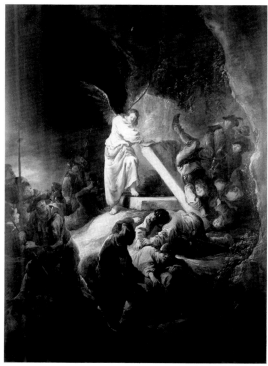

731

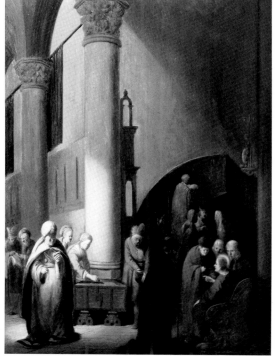

732

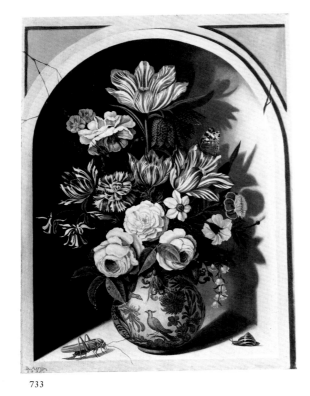

733

733　Bartholomeus Assteyn
Vase of Flowers
Signed and dated 1635. Panel, 53 × 41 cm. Private collection

734　Dirck van Delen
Company Making Music in Interior
Signed and dated 1632. Panel, 96 × 130.5 cm. Residenzgalerie, Salzburg

735　Dirck van Delen
A Family beside the Tomb of William I in the Nieuwe Kerk, Delft
Signed and dated 1645. Panel, 74 × 110 cm. Rijksmuseum, Amsterdam

study under Rembrandt, therefore, it was prior to that date, and in Leiden. During his career in Dordrecht, Lesire painted mainly portraits and a number of large civic-guard pieces of respectable quality. From 1648 on he is recorded in The Hague.

Another Dordrecht artist, the portrait painter Pieter Verelst, also went to The Hague. He had joined the Dordrecht guild in 1638, but was living in The Hague by 1643.

In 1631 Bartholomeus Assteyn, born in 1607 in Dordrecht, entered the guild. He lived in Dordrecht at least until 1667, but there is no trace of him after that date. He specialized in flower and fruit paintings that are more or less akin to the work of Balthasar van der Ast. At first his colors and forms were rather hard, as in his *Vase of Flowers* of 1635 (fig. 733), but later he achieved greater suppleness and a softer palette.

Painting in Middelburg: 1625–1650

Painting in Middelburg did not go well after 1625. Adriaen van de Venne, the most versatile artist, left town in 1625, and the talented flower painter Balthasar van der Ast had already moved away, following his brother-in-law Ambrosius Bosschaert and family to Utrecht.

The most interesting newcomer on the island of Walcheren was Dirck van Delen. Born in 1604 or 1605 in Heusden, a town in North Brabant, he settled in 1626 in Arnemuiden, a small port close to Middelburg. From 1639 to 1665 he is listed in the Middelburg guild, but he continued to live in Arnemuiden, became a burgomaster, and died there in 1671.

Van Delen was almost exclusively an architectural painter: fantasy perspectives, both indoors (fig. 734) and out (see fig. 323), and realistic interiors. The figures always present in these pictures were probably painted by other artists; the names of Dirck Hals, Anthonie Palamedesz, Pieter Codde, and Jan Olis have been suggested. Collaboration of this sort at least implies that van Delen did not lead an isolated life, but kept in touch with artists and artistic events in Holland. This is confirmed by his paintings of the great hall of the Binnenhof in The Hague and of William I's tomb in Delft. His style, however, shows no traces of outside influences. From having been a rather dry follower of the work of Hendrick Aertsz and the Steenwijcks, he developed an independent style, refined in his use of color and his harmonious compositions. The only artist who may have influenced him was Bartholomeus van Bassen in The Hague.

Van Delen's ability to balance his art on the brink of reality and fantasy is well exemplified by the interior view, painted in 1645, of William the Silent's monumental tomb in the Nieuwe Kerk in Delft (fig. 735). Van Delen painted the tomb itself exactly, but he omitted the four corner obelisks; the view of the choir also does not agree with reality. In the right foreground appears a family group, a couple with two young sons. We wonder who they were, and why the artist portrayed them in this curious context.

Johannes Goedaert not only continued the Middelburg tradition of floral painting but also earned renown as an entomologist. In a three-volume work, *Metamorphosis naturalis*,

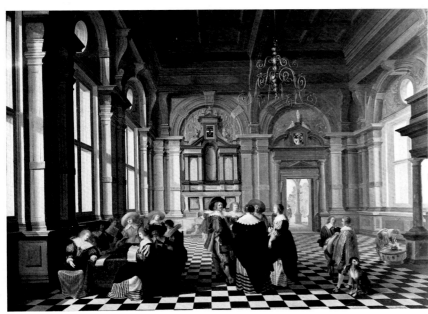

734

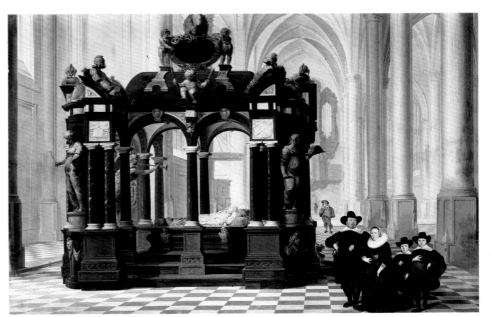

735

published in Middelburg between 1660 and 1669, he described and illustrated the metamorphosis of insects. His flower paintings bear witness to his sharp powers of observation, but are otherwise composed in the earlier Middelburg manner of Bosschaert and van der Ast. Goedaert also painted sensitive views of the Zeeland landscape (fig. 736).

The only portrait painters in Zeeland during this period, such as Willem Eversdijck, son of Cornelis, had no more than local importance. For Middelburg, therefore, the arrival of Cornelis Jonson van Ceulen, Adriaen Hanneman's friend, was most welcome, although he did not stay long. Jonson came from a Cologne family that had settled in Amsterdam in the sixteenth century but moved to England about 1568. He was born in London in 1593, and since 1618 had been a popular portraitist in the court circles of James I and Charles I,

737

738 739

736 Johannes Goedaert
View of the Island of Walcheren with the Castle Westhoven
Signed. Panel, 31 × 43 cm. Victoria and Albert Museum, London

737 Cornelis Jonson van Ceulen
The Family of Arthur, Lord Capel
Signed. c. 1639. Canvas, 162 × 263 cm. National Portrait Gallery, London

738 Cornelis Jonson van Ceulen
Portrait of Willem Baron van Liere
Signed and dated 1651. Canvas, 108 × 84 cm. Centraal Museum, Utrecht

739 Cornelis Jonson van Ceulen
Portrait of Maria van Liere-van Reigersbergen
Signed and dated 1651. Canvas, 108 × 83 cm. Centraal Museum, Utrecht

attracting such distinguished patrons as Arthur, Lord Capel and his family (fig. 737). The beginning of the Civil War in England in 1642 no doubt disrupted his career, and in 1643 his name first appears in the lists of the Middelburg St. Luke's Guild. Three years later he is recorded in Amsterdam, but he maintained his contacts in Middelburg and was chosen to paint the governors of the militia there in 1650. He also received commissions in The Hague. He worked in Utrecht from 1652 until his death about a decade later.

Most of Jonson van Ceulen's elegant portraits, often in oval format, are in English collections, but his pendant portraits of Willem Baron van Lieve and his wife (figs. 738 and 739) are now in the Centraal Museum in Utrecht. They date from 1651 and clearly show the artist's indebtedness to Anthony van Dyck. The background of Jonson's portraits, often painted in bluish or greenish tints, distinguish them from most Dutch portraits.

Painting in Leeuwarden: 1625–1650

Art in Leeuwarden, capital of Friesland, received a new stimulus in 1620 when the painter Lambert Jacobsz came to live there. He was a native of Amsterdam, where his father was a well-to-do cloth merchant. The family, members of the close-knit Mennonite sect, participated in the artistic and intellectual life of Amsterdam, and Lambert Jacobsz never lost touch with his co-religionists. In Leeuwarden he became lay preacher for the flourishing Mennonite congregation, a position that required no theological training.

Lambert Jacobsz must have studied painting in Amsterdam, but his teacher is not known. From a poem by Vondel—who was a family friend—it can be assumed that he completed

741

740 Lambert Jacobsz
Isaac and Rebecca
Signed and dated 1624. Panel, 75.5 × 105 cm.
Fries Museum, Leeuwarden

741 Lambert Jacobsz
The Apostle Paul
Signed and dated 1629. Canvas, 114 × 101 cm.
Fries Museum, Leeuwarden

740

his study by travel in Italy. Pictorial elements from Amsterdam and Italy alike can be detected in his few signed works. His biblical pictures in landscapelike surroundings, such as *Isaac and Rebecca* of 1624 (fig. 740), have a resemblance to the work of the Lastman-Pynas group in Amsterdam, and the landscapes are an important part of these paintings. He also produced strongly painted single-figure pieces—*The Apostle Paul* (fig. 741), for instance—which in type, composition, and fall of light recall the Utrecht Caravaggists.

The 1637 inventory of Jacobsz' estate supplies evidence of his activities as an art dealer. We have mentioned (p. 273) his close business relations with Hendrick Uylenburgh in Amsterdam, and no doubt he was Uylenburgh's chief Frisian outlet. At the time of his death, Jacobsz owned at least six copies after Rembrandt, presumably executed at Uylenburgh's studio. Jacobsz' two most important pupils, Jacob Backer and Govert Flinck, left Leeuwarden to pursue their careers in Amsterdam, as did his son, Abraham van den Tempel, who later became an esteemed portrait painter there.

Jacobus Sibrandi Mancadan may also have studied under Lambert Jacobsz, although there is no evidence or even a clear indication of his having done so, or of his having been a pupil of Moyses van Uyttenbroeck in The Hague, or of having traveled to Italy, all of which is sometimes asserted. Very little is known about his early life, save that he was born in the Frisian village of Minnertsga in 1602. He may well have been self-taught and begun to paint only when somewhat advanced in years. He concentrated almost exclusively on landscapes, alternating Frisian with Italianate themes, usually including a few figures.

Mancadan was a prosperous man, and in 1637–39 he was burgomaster of Franeker, in 1645 of Leeuwarden. Presumably he began his career as a painter after that. The scenes he took from his own surroundings (figs. 742 and 743) may be based on the southeast corner of Friesland, where he owned a farm and acreage. These pictures attest to an unrestrained, original observation of the landscape. His imaginary landscapes in the Italianate style (fig. 744) also have a highly individual character; they are painted in muted, translucent colors that vary from brown to yellowish brown and brownish green; his touch is careful yet free, and he often scratched in the paint to accentuate the structure of roots and branches.

There were otherwise few painters in Friesland worthy of mention in the context of

742 Jacobus Sibrandi Mancadan
Landscape with a Sandy Road in Friesland
Signed. Panel, 29.5 × 63 cm. Fries Museum,
Leeuwarden

743 Jacobus Sibrandi Mancadan
Landscape with Farms in Friesland
Signed. Panel, 29.5 × 63 cm. Fries Museum,
Leeuwarden

744 Jacobus Sibrandi Mancadan
Mountainous Landscape with Waterfall and Figures
Signed. Panel, 45 × 37.5 cm. Rheinisches
Landesmuseum, Bonn

742

743

744

Northern Netherlands art. The portraitist Wybrand de Geest continued to work until his
death in 1667. Petrus Schotanus, son of a clergyman, painted portraits, landscapes, and
especially still lifes having *vanitas* motifs and strongly moralistic overtones, emphasized by
extensive inscriptions (see fig. 246); his painting technique is rather coarse. The still lifes by
Dirck de Horn are far more interesting: his style is vigorous and his light effects striking; he
spreads the fruit, vegetables, and dead game over the whole pictorial surface, in the Flemish

745 Dirck de Horn
Still Life with Cauliflower and Dead Game
Signed. Canvas, 74 × 87 cm. Fries Museum,
Leeuwarden

746 Wigerus Vitringa
Marine View with Ship of the Frisian Admiralty
Signed and dated 16(8?)5. Canvas, 122 × 155 cm.
Fries Museum, Leeuwarden

manner (fig. 745). Finally, mention should be made of Wigerus Vitringa, although he did not become active until the fourth quarter of the seventeenth century and lived into the eighteenth. He was born in Leeuwarden in 1657, and pursued a successful career in law, advancing to the honorable post of advocate of the Frisian high court. Yet he found time for art, and his oil paintings, watercolors, and drawings—all marine views—are respectable in quantity and excellent in quality (fig. 746).

We have reached the end of another of our arbitrary periods in Dutch seventeenth-century art. Politically, the signing of the Treaty of Münster in 1648 marked the true and distinct end of an era, but artistically the transition from the first to the second half of the century flowed smoothly by. The Golden Age of Dutch art was in full swing: as many masterpieces were to be created after 1650 as had been painted in the years before.

PART IV

747 Gerrit van Honthorst
Portrait of Willem II, Prince of Orange
Canvas, 117.2 × 92.6 cm. Mauritshuis, The Hague

The Republic in the Third Quarter of the Seventeenth Century

The spectacular eighty-year struggle of the puny Dutch Republic against mighty Spain, brought to an end at last by the Treaty of Münster in 1648, appealed so vividly to the imaginations of later generations that it has been commonly thought that the Dutch, having slain the dragon, lived peacefully ever after. This misconception has also sometimes prevailed in appraisals of the art of the latter half of the seventeenth century:

Vermeer's art reflects the happiness and the self-contained character of the Dutch bourgeoisie after their aggressive spirit had somewhat calmed down, and they began to relax and enjoy the fruits of their fathers' and grandfathers' activities. Dutch life shortly after the middle of the century is distinguished by a quiet, peaceful and domestic atmosphere which Vermeer, better than anyone else, depicted in his beautiful interiors.

So wrote Rosenberg and Slive in 1966.[1] But let us take a closer look at the thirty years that followed the Treaty of Münster.

In 1648, all prospects seemed rosy. The Republic was at the peak of its powers, an acknowledged leader among nations, with commercial interests throughout the whole world. With little interference, the Dutch merchant fleets dominated the sea routes to east and west, north and south. Yet this dominance was exactly why the Republic became deeply involved in the European power struggle, and why the eagerly desired rest and peace remained out of reach.

The country's total income continued to grow, but because the economic and political structure became increasingly oligarchic, the profits accrued to only a tiny group. Mercantile interests had to be defended against foreign competition much more vigorously than in the second quarter of the century, when the Dutch had virtual supremacy at sea and moreover made vast profits by seizing every opportunity offered by the war, including trading with their enemies. The Treaty of Münster had been promoted and pushed through largely by the merchant-rulers of the Netherlands, led by those of Amsterdam, who had lost all sympathy with the money-devouring armies that permitted the stadholders to play political games and advance their dynastic ambitions. The only politics the merchants wished to indulge in must be subordinate to economic and commercial interests, which were synonymous with their own.

Internally, this attitude had already brought on a conflict with the new stadholder, William II (fig. 747), who had succeeded his father, Frederik Hendrik, in 1647. The stadholder's strength depended mainly on a state of war: as commander in chief of the army and navy, he possessed real powers. Furthermore, his income was determined to a large extent by his legal share of any war booty his military forces (and privateers) could capture. William II was only twenty-one when his father died. He was a perhaps intelligent yet extremely frivolous young man, yearning for power, and moreover surrounded by a clique of highly untrustworthy advisers who had shoved the honest Constantijn Huygens into the background. Their efforts were soon aimed at reopening hostilities with Spain, on the ground of the 1635 alliance with France, which had not joined in the rounds of peacemaking in Westphalia but was still at war with the old enemy.

The maintenance of the army in peacetime was one of the immediate points of difference between the stadholder and the regents of the Dutch cities. Anti-Orangist Amsterdam wanted to get rid of the foreign mercenaries who made up the bulk of the military, not only because they were very expensive, but also because these troops, in the stadholder's

hands, might be set against the city itself. William II, like his uncle and father before him, wanted to keep his army, and indeed tried to use force to get his way. In 1650 he imprisoned a number of his most prominent opponents and sent his cousin Willem Frederik, stadholder of Friesland, to attack Amsterdam. The attack fizzled out (the army lost its way in a fog), but a thoroughly alarmed Amsterdam gave in. The prince was permitted to keep his mercenaries, and the powerful Amsterdam burgomasters who had most resisted him, the brothers Andries and Cornelis Bicker, had to resign their posts. William II's sudden death from smallpox a few months later prevented worse from occurring. The prince's young widow, Mary Stuart, elder daughter of the recently beheaded Charles I of England, gave birth to a son, William III, on November 14, 1650, a week after her husband died.

748 Caspar Netscher
Portrait of Johan de Witt
Signed and dated 1667. Panel, rounded at the top,
50.5 × 35 cm. Private collection

749 Caspar Netscher
Portrait of Wendela Bicker
Signed and dated 1667. Panel, rounded at the top,
50.5 × 35 cm. Private collection

The province of Holland was ready to leap into the breach caused by the stadholder's death, and at once seized the reins of government. At a "Grand Assembly" held early in 1651, the Holland delegates more or less dictated the terms: neither the newborn Orange prince nor anyone else was to be appointed stadholder (although Willem Frederik kept his post in Friesland); the States of the United Netherlands reaffirmed their individual sovereignty; and each province agreed thenceforth to maintain its own military force. This, the merchant-rulers proudly proclaimed, was the "true freedom." The new policy had two important consequences in what has come to be known as the first stadholderless period (the second occurred in the eighteenth century, after the death of William III in 1702). First, the stadholder's traditional right to appoint the highest municipal magistrates now fell to the States-General, which did nothing about it. From then on there was no counterbalance to the growing power of a small group of regents, who saw to it that the influential and financially advantageous municipal offices were kept within their own elite circle. Second, the provincialization of the army led to a virtual breakdown of national defense on land; no longer badgered by a commander in chief for a constant new supply of equipment and men, the provinces pared their military budgets to the bone. The navy was retained and strengthened, for the merchant-regents of Holland and Zeeland needed it. But the first two factors of "true freedom" were to prove disastrous in 1672, when France invaded the United Netherlands.

Now, as in the days of Johan van Oldenbarnevelt, the political leadership of the Republic came once more into the hands of the advocate of Holland. In 1653 Johan de Witt, then twenty-seven years old and advocate of Dordrecht, was vested with this top-ranking office. A jurist of keen intelligence, schooled also in mathematics and philosophy, he fulfilled his difficult task with cool sagacity. De Witt possessed great willpower and tact, was incorruptible—an exceptional trait at that time—and, through his marriage to Wendela Bicker, a niece of Andries and Cornelis Bicker, gained the essential financial and political

support of the Amsterdam patricians. Caspar Netscher painted pendant portraits of the de Witts in 1667 (figs. 748 and 749).

The government initially wanted to implement a foreign policy based on the Republic's neutrality after the war with Spain; in essence, this was a wish for complete freedom of the seas for Dutch shipping and mercantile enterprise. But the country was now a great international power, envied and feared by many rivals who did not intend to let the Dutch have everything their way. The Republic thus had to maneuver among so many dangerous reefs that a collision was often unavoidable, and in fact it spent more than half of the thirty years that followed the Treaty of Münster in a state of hostilities.

First of all, unrestricted passage of the Danish Sound remained vital to Dutch trade with the Baltic area, and the situation there was precarious. The Polish king, supported by the Danes, had laid claim to the Swedish throne, and in 1655 the so-called Fourth Northern War broke out. Whereas ten years before the Dutch had sided with the Swedes but had been able to get by with a mere show of naval force, this time they chose for Denmark and sent a fleet which decisively defeated the Swedes and brought an end to the war in 1660. Free passage through the Sound was again guaranteed, but the price was unremitting vigilance.

Farther abroad—at the ends of the earth—the Dutch had their hands full protecting what Boxer has called their "seaborne empire."[2] The whaling grounds and the base at Spitsbergen were constantly subject to Arctic weather conditions, and piracy was so bad that Dutch naval squadrons had to be sent to escort returning whalers, the regular fishing fleets, and the intercontinental merchant fleets. Both the United East India Company (VOC) and the West India Company (WIC) were permitted (required) by charter to maintain their own military forces and to arm their ships. But their backers at home were loath to spend more than absolutely necessary on defensive measures; lines of communication and supply were long and difficult to maintain; and other nations roamed the seas looking for soft spots. Dutch bases in the East Indies were relatively safe, although the local populations proved often hostile, the Portuguese still held the island of Timor, and the Spanish remained close by in the Philippines. The greatest rivalry between the Portuguese and the Dutch was in Ceylon (Sri Lanka), where the struggle for domination went on from 1638 to 1658, with the Dutch finally winning. The VOC also had forts and factories, as the trading posts were called, on the Malabar and Coromandel coasts of India, some of them within cannon range of the English and French posts there. Efforts to establish relations with China were consistently repulsed, but there was a thriving Dutch colony on Formosa (Taiwan) from 1624 to 1661, when a Chinese warlord wiped it out. Longer lasting, and probably the chief entrepôt for Oriental wares and tea, was the tiny VOC settlement on the island of Deshima in the bay of Nagasaki; in 1639 the Tokugawa emperor expelled the Spanish and Portuguese missionaries who had been vigorously proselytizing throughout Japan since the sixteenth century, and closed off all foreign trade except with China and, to a strictly limited extent, the VOC. For more than two hundred years—until the American commodore Matthew Perry appeared in 1853—Japan's only contact with the West was through the Dutch at Deshima.

The VOC's charter of 1602 had granted the company the monopoly of all Dutch trade and navigation east of Africa's Cape of Good Hope (where, because of the sailing hazards, it did not establish a victualing station until 1652) and west of South America's Strait of Magellan (though no Dutch merchantmen plied the Pacific); the 1621 charter of the WIC gave the same rights for the west coast of Africa and the eastern regions of the Americas, and also did not limit the company's military activities merely to defense. From the beginning, therefore, the WIC made free and aggressive use of the right of "honest privateering," at first against Spain and later against newly independent Portugal, which was out to regain its lost maritime glory. The arena of contest was three-sided: ships bearing European goods and provisions sailed from continental ports to their fortified trading stations along the Gulf of Guinea in West Africa, where they traded these commodities for gold, ivory, and increasingly for slaves; with their new cargoes they set sail for the Americas, especially the Caribbean area (between 1640 and 1660 the Dutch-held island of Curaçao was the largest slave market in the West Indies) and the northeastern coasts of Brazil; the "black and white ivory" was offloaded and exchanged for plantation products, mainly cane sugar and tobacco, and the merchantmen were ready for the voyage home.

The sailing ships and the settlements were never safe from the elements, disease, and attack. The healthiest but least prosperous Dutch base was Nieuw Amsterdam on Manhattan Island. The most promising was Pernambuco and the harbor of Recife in Brazil: this colony flourished from 1637 to 1644 under the governor-generalship of Count Johan Maurits of Nassau-Siegen and was the only place in any of the Dutch possessions east or west where the art of painting was actively pursued (see fig. 39). After the count's forced recall (the WIC regents thought him too extravagant), Netherlands Brazil declined and easily fell to the Portuguese in 1654. The Dutch held on to Curaçao and a few other islands of the Lesser Antilles.

The greatest threat to the prosperity and welfare of the United Netherlands, however, came not from foes in distant seas but from their near neighbors, England and France. England was beginning to settle down under Oliver Cromwell and needed to recoup some of its losses. London merchants in 1651 forced Parliament to pass the Act of Navigation, which stipulated that goods could be imported into England only in English ships or in those of the country of origin, that English coastal waters were forbidden to foreign shipping, and that fish and fish products could be brought in only by English fishing boats. This act seriously attacked Dutch conceptions of the free and open seas, and was in effect a declaration of economic war. Military action soon followed: the First Anglo-Dutch Naval War broke out in the summer of 1652. For two years the battles raged back and forth across the Channel, with the English gradually gaining the upper hand. In the final engagement, off the South Holland village of Terheide, one of the Republic's finest admirals, Maerten Harpertsz Tromp, was killed (see fig. 116). The Dutch economic losses were also enormous, for the English succeeded in blockading the Dutch coast and in capturing many merchant vessels. The treaty that ended the war upheld the Act of Navigation; moreover, Cromwell insisted upon a secret addendum that excluded the four-year-old William III of Orange from all future office in the Republic. The States-General rejected this demand, but Johan de Witt, acting for the States of Holland, accepted it. De Witt's policy from then on was aimed at a strong fleet, friendship with Louis XIV's France, and reasonable relations with Spain, whose sovereignty over the Southern Netherlands no longer much bothered the Dutch: they had come to like a buffer state between themselves and the unpredictable French.

In the years that followed, Dutch shipping continued to be hampered by the English protectionist measures. Great hopes were placed on the restoration of Charles II to the English throne in 1660, for during his exile he had spent considerable time in the Netherlands as guest of his sister Mary, the stadholder's widow, and his aunt Elizabeth, the Winter Queen. In fact, he began his triumphal return at The Hague, where extravagant homage was paid him and his wishes ascertained for a suitable token of respect—the famous "Dutch Gift" (see p. 47)—for which the States of Holland put up 600,000 guilders and the States-General another 300,000. All this was to no avail; the king soon became openly hostile to the Dutch. The Act of Navigation was broadened and sharpened, and the Company of Royal Adventurers of England Trading to Africa (later, the Royal Africa Company) was founded in outright competition with the Dutch West India Company. To add insult to injury, in 1662 Charles II married Catharine of Braganza, sister of Afonso VI of Portugal, thus linking the Netherlands' most determined competitors.

Prodded by the extreme aggression of the Royal Adventurers, nominally a private enterprise but actually backed to the hilt by the English government, a second naval war became unavoidable. This conflict, waged from 1665 to 1667, at first went badly for the Dutch, but Johan de Witt's clever diplomacy brought help from France and a treaty with Denmark that opened the Sound to Dutch ships but closed it to the English. England itself was afflicted with troubles: the great plague of 1665, the great fire in London in 1666, and a rebellion brewing in Scotland. Then, in June 1667, the Dutch brought off a brilliant coup: their fleet under Admiral Michiel de Ruyter sailed up the Thames and the Medway to the naval base at Chatham, destroying most of the English fleet anchored there, and seizing as prize the flagship *The Royal Charles* (the decorated stern of which is now in the Amsterdam Rijksmuseum). The people of London panicked, fearing that they would be next. Peace was not difficult to conclude. The Dutch won some economic concessions, but had to give up Nieuw Amsterdam (which the English had seized three years before in the name of the duke of York) in exchange for tropical Guyana (Surinam), on the north coast of South America.

At about the same time in France, Louis XIV's new and powerfully rising controller-general, Jean-Baptiste Colbert, was instituting far-reaching protectionist regulations that seriously harmed Dutch trade. Then in 1670 there occurred what Johan de Witt had presumably always anticipated and feared, had worked continuously to avoid, yet could not prevent: France and England, in deepest secrecy, joined in a pact against the United Netherlands.

Meanwhile, the internal situation in the Republic was slowly altering. The guardianship of William III had long been a matter of dissension between his grandmother, Amalia van Solms, and his mother, Mary Stuart. When the latter died in 1661, Amalia took steps to rid the prince of the British clique around him, and in 1666 the States-General accepted him as "Child of the State" and undertook his education in political matters. The pro-Orange party in the Republic was now strengthened by the growing popularity of the young prince and by disenchantment with de Witt's policies, which were blamed for the economic crises arising from the naval wars. To combat this opposition to "true freedom," the States of Holland in 1667 proclaimed the "Eternal Edict," by which Holland (reluctantly followed by the other provinces) abolished the stadholdership to the end of time. But the public enthusiasm for William III could not be dampened. In 1668 the prince, then eighteen years old, permitted himself to be installed as first noble of Zeeland, and in 1670 he became a member of the Council of State, the government's highest advisory body.

As long as de Witt had been able to play off France against England, he had kept domestic policy in hand as well, but when the French-English pact became known in 1672, he lost control. In the spring of that year England, France, Münster, and Cologne declared war on the Republic, and a massive attack was launched by land and sea. The vestigial provincial armies of the Dutch could put up no resistance. Well-trained French troops crossed the Rhine and took Utrecht, and only the Holland Water-Line—the system permitting defensive inundation of polders from Amsterdam, via Woerden, to the Biesbosch area of the Rhine-Maas delta—separated the French from the heart of the Republic. In the face of such danger, the sovereign States rallied as of old around their Orange prince. William III was named captain-general of the army and, in the panic that followed the French invasion, was quickly chosen to be stadholder. De Witt's career was finished with his life: on August 10, 1672, in The Hague, a mob brutally murdered him and his brother Cornelis, a naval officer.

At sea, the Dutch under Admiral de Ruyter held firm, first defeating the combined English-French fleet and later preventing an attempted landing on the North Holland coast. William III gained the initiative in the land warfare and operated with signal success. He also found allies among his country's one-time enemies, the king of Spain and the Holy Roman emperor. The naval war was the soonest over, for the English Parliament refused to provide further funds after the defeat of their fleet, and in 1674 peace was declared with England, Münster, and Cologne. The war with France dragged on for another four years; de Ruyter was killed in a battle with the French in the Mediterranean; the stadholder, a true Orange, wanted to keep on fighting even at the end, but he was overruled by the States-General.

From this summary it is clear that there was no question of peaceful calm in the Dutch Republic after the 1648 Treaty of Münster. Moreover, the continuing wars encroached ever deeper upon economic life, much deeper than the last twenty-five years of the war against Spain had done. When the merchant fleets could not sail regularly, thousands of already impoverished men were thrown out of work and forced to beg for a living, and the middle classes were also severely victimized. Seventeenth-century Dutch statistics reveal the extent of commercial stagnation. During the Second Anglo-Dutch Naval War, for example, the number of Dutch ships sailing through the Danish Sound dropped in one year from 1,362 to 364, then slowly rose again. The Republic's debentures sank thirty percent in 1672. More in general, the annual yields from customs duties and convoy licenses in Amsterdam, which reflect the ups and downs of commercial activity, show how much prosperity was undermined by armed conflict—the naval wars of 1652–54, 1665–67, and 1672–74, in particular, which have been called "the first wars waged mainly for economic reasons in European history."[3]

Artists, too, suffered as the hard times brought a decline in the market for paintings.

Some had to flee for their lives— the still-life painter Jan Davidsz de Heem, for instance, who was working in Utrecht when the French overran that city, but managed to escape to Antwerp. Some, like the elder and younger Willem van de Veldes, read the economic signs correctly and got out while they still could. Rembrandt's well-known financial difficulties, to which we will return, were certainly exacerbated by the economic conditions. Perhaps less generally known is that Johannes Vermeer was nearly bankrupted by the war of 1672–74. A year after his death in 1675, his widow, in a petition for financial clemency to the High Council of Delft, stated that "her husband during this war with the Kingdom of France for the last several years was able to earn very little or nothing at all, and also the art work which he had purchased and in which he dealt, he had to dispose of with very great loss." [4]

The gap between the rich and the poor, already visible in the first half of the century, grew wider during the latter half. The wealthy also ceased to invest their profits solely in commercial enterprises, but began increasingly to buy real estate and government securities—in the vocabulary of economics, they ceased to be entrepreneurs and became rentiers. The Bourse and the Discount Bank in Amsterdam did business on an unprecedented scale. Countless country villas were built in the Watergraafsmeer, the polder just to the west of Amsterdam, in Kennemerland northwest of the city, and south along the Amstel and Vecht rivers. Town houses became larger and more richly furnished, and the vogue was for all things French.

There is little doubt that the art of painting during the second half of the century was influenced by these cultural shifts. The question is, to what degree and in what way, and the answer cannot be categorical. The wealthiest patrons clearly became more elite and more francophile in their taste. To satisfy their demands, some artists began producing a sort of "exclusive" art, which gained in refinement but lost in originality. The many painters who did not follow this line continued to work in the strong old bourgeois tradition, building on the past yet interpreting it anew.

Painting in Amsterdam: 1650–1680 (I)

Amsterdam in 1650 was the place to be. The Hague was the seat of government in the United Netherlands, but Amsterdam claimed the title of world center, if not center of the world. Its heart was the Dam Square, built on and around the foundations of the medieval dam across the mouth of the Amstel River. The most important political, judicial, commercial, and social activities took place there. The four burgomasters ruled the city from their chamber in the tower of the decrepit old town hall on the west side of the Dam; down below was the pillared law court, where trials were open to the public. The Weighhouse stood in the center of the square, with officials ready to assay and tax the wares brought in by the lighters, barges, and fishing boats tying up in the Damrak or inner harbor. Perishables—butter and cheese, freshwater fish, ocean fish—were immediately sold at the markets on the Dam. Hendrick de Keyser's Bourse or stock and commodities exchange, built in 1611, spanned the water of the Rokin at the southeast corner; diagonally across from it was the Gothic Nieuwe Kerk, dating from the early fifteenth century. There were houses on all four sides of the square, some very old and built of wood, most with shops or offices below and living quarters above.

The greatest activity on the Dam in 1650 was the construction of the new town hall,

750 Johannes Lingelbach
*The Dam at Amsterdam with the New Town Hall
under Construction*
Signed and dated 1656. Canvas, 122.5 × 206 cm.
Amsterdams Historisch Museum, Amsterdam

751 Gerrit Berckheyde
The Town Hall on the Dam, Amsterdam
Signed and dated 1673. Panel, 43 × 63 cm.
Amsterdams Historisch Museum, Amsterdam.
On loan from the Rijksmuseum

behind the old one. In 1648, after a decade of planning and preparation, the burgomasters had given their master architect, Jacob van Campen, the signal to start; the first stone was laid in that year, and the first of 13,659 wooden piles was driven into Amsterdam's soggy bottom, which otherwise could not support the huge weight of the structure. Then, in 1652, the old town hall burned down in a spectacular fire; it would have had to be razed anyway, but its loss was inconvenient, forcing the municipal government into temporary quarters. The ceremonial opening of the new town hall took place in 1655, although the building was far from finished. Johannes Lingelbach's view of the Dam (fig. 750), painted in 1656, shows, from left to right, the new town hall with only the lower stories completed; the Nieuwe Kerk; the Weighhouse; the boats tied up in the Damrak; and the tower of the Oude Kerk jutting up behind the quayside warehouses. At the right, among the lively crowd on the square, are turbaned Orientals, in all likelihood merchants from Turkey or Persia come to trade in Amsterdam.

It took fifty years more and 8,500,000 guilders to complete the town hall inside and out, but the result was worth the effort, for this was the largest and most beautiful public building (as opposed to royal palaces) constructed during that period in all of Europe. To the Amsterdammers, it was the eighth wonder of the world. Gerrit Berckheyde painted the town hall in its pristine glory in 1673 (fig. 751), when its fabric of Bentheim sandstone was still almost marble-white in color, and the trimmings were freshly gilded. He also painted a view of the rear façade, from the flower market on the Nieuwe Zijds Voorburgwal, with Artus Quellinus' famous statue of Atlas towering overhead (see fig. 333).

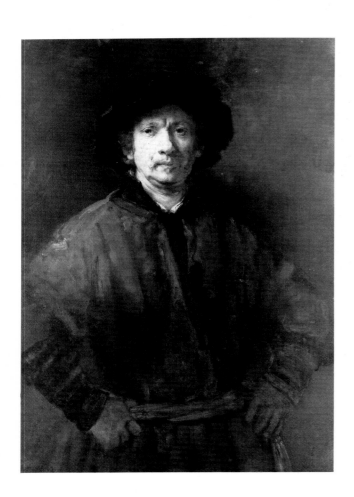

752 Rembrandt van Rijn
Self-Portrait
Signed and dated 1652. Canvas, 112 × 81.5 cm.
Kunsthistorisches Museum, Vienna

The town hall was not the only large-scale construction work in Amsterdam during the second half of the seventeenth century, for the great expansion plan of 1609 (see p. 164), which had been left half completed in 1625, was resumed in 1658 and continued for decades. The municipal public-works department was responsible for digging and shoring up the semicircular canals and constructing the bridges and roadways, but the houses along the canals and streets were built and sold by private contractors (carefully controlled by the burgomasters). Many of these houses, especially on the Herengracht and Keizersgracht, were larger and more elegant than those built earlier, and reflected the established wealth and increasingly refined taste of their owners.

The painters of Amsterdam lived and worked amid the bustle of the energetic city. Some recorded what was going on, others seem to have been oblivious to it. Gifted artists continued to arrive, joining those already in residence; the newcomers now came mostly from other Dutch towns, but some came from abroad. Among them were novices as well as already accomplished painters. In our discussion of painting in Amsterdam during this period, we shall first take up what might be called the old guard of history and portrait painters—Rembrandt and Bartholomeus van der Helst and their followers. In a later chapter, after we have looked at their careers in other places, we will consider those who did not arrive in Amsterdam until after mid-century, but who generally stayed there for the rest of their lives—such painters as Jacob van Ruisdael of Haarlem, Pieter de Hooch of Delft, Gabriel Metsu of Leiden, and Willem Kalf of Rotterdam.

Rembrandt van Rijn: Years of Maturity

Even after 1650 Rembrandt was unmistakably one of the most important and respected artists in Amsterdam. This is true not only in our eyes, but in those of his contemporaries as well. Yet in speaking about his life, writers have often wished to make it appear that Rembrandt was more or less written off by his contemporaries after 1642, the year he painted *The Night Watch* and mourned Saskia's death. This faulty interpretation stems in part from nineteenth-century romantic writers, for whom unrecognized talent was an attribute essential to genius, and in part from the undisputed fact that Rembrandt did not participate in the new trends in painting that began to arise about 1650.

We know that he enjoyed great repute abroad. Prominent foreign guests in the Netherlands, such as Cosimo III de' Medici in 1667, wanted to visit him, and he received commissions from as far away as Sicily, where Don Antonio Ruffo thought his own collection incomplete without some work by the famous Dutch master. In Amsterdam, too, Rembrandt's prestige held up, as attested by the important commissions he continued to receive, although the number of his pupils declined. Most of the aspiring young painters opted for the new art.

In the early 1650s Rembrandt painted many portraits and single figures. If, during the forties, he had sometimes been inclined to paint carefully and with considerable detail, he now took a new path in diametrical opposition to the steadily increasing classicism all around him. He executed these later portraits with a broad brushstroke and remarkably little attention to detail, often treating the clothing and the hands very sketchily, and keeping the background vague and dark. This applies to paintings he presumably made for himself, such as his 1652 self-portrait (fig. 752), and also to what were undoubtedly commissioned works, such as the portrait of Nicolaes Bruyningh (fig. 753). Warm tones prevail in these paintings. The powerfully painted faces receive the light and are molded by

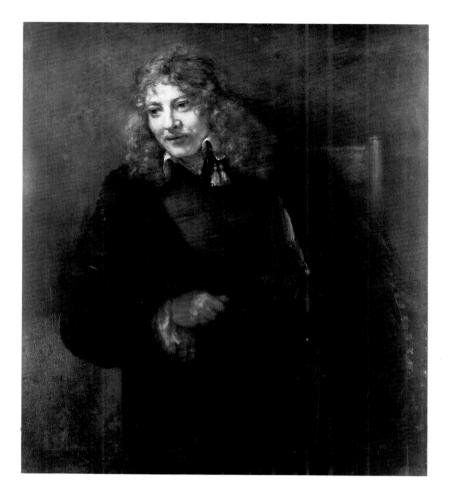

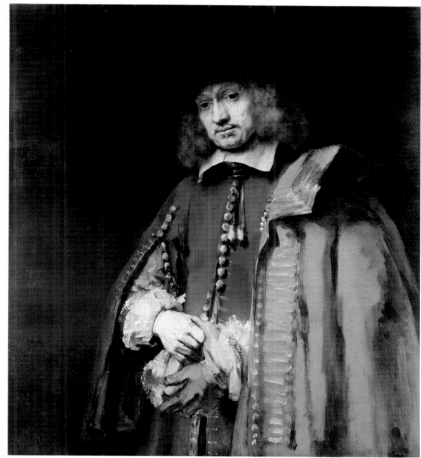

753 Rembrandt van Rijn
Portrait of Nicolaes Bruyningh
Signed and dated 1652. Canvas, 107.5 × 91.5 cm.
Staatliche Kunstsammlungen, Kassel

754 Rembrandt van Rijn
Portrait of Jan Six
1654. Canvas, 112 × 102 cm. Six Collection,
Amsterdam

the surrounding darkness, which veils and softens all other details. When Rembrandt portrayed Jan Six in 1654 (fig. 754), his manner of painting was almost Impressionistic. This portrait, perhaps the finest he ever made, displays an exceptionally daring brushstroke and phenomenal assurance of touch combined with a masterful liveliness of composition: Six stands with a great red cloak draped casually on one shoulder; he is pulling on his left gauntlet as, with his head slightly bowed, he looks directly and enigmatically at the viewer. A wealthy patrician and later burgomaster of Amsterdam, Jan Six befriended Rembrandt and other painters.

Rembrandt seems to have abandoned this virtuoso and spontaneous technique after painting his portrait of Six. A bit of it can be found in the broadly sketched figure in *Woman Bathing in a Stream* (fig. 755), in which the direct and unaltered brushstrokes seem to lead a life of their own. But most of his other works appear to have caused him more difficulty; it is as if Rembrandt, in the course of painting, changed his mind and chose to sacrifice spontaneity for effects more carefully thought out. This is certainly true of the large canvas depicting Bathsheba receiving King David's letter (fig. 756), painted the same year as Six's portrait: X-ray photographs reveal that Rembrandt drastically changed the pose of Bathsheba's head, which originally was held erect.[1] He painted her body with utmost sensitivity, the warm flesh tints contrasting beautifully with the white cloth on which Bathsheba is seated and the letter she holds in her hand.

The years after 1655 were extraordinarily fruitful for Rembrandt. In 1656 he began a large biblical painting, *Jacob Blessing the Sons of Joseph* (fig. 757), in which his manner of painting varies widely. Scholars agree that he worked on this canvas for a long time. The face and clothing of Asenath, Joseph's wife, are painted in a way that strongly resembles his technique and style a decade later.

Also in 1656, Rembrandt completed his second *Anatomy Lesson* (see fig. 206), this time on commission from Dr. Joan Deyman, Dr. Nicolaes Tulp's successor as praelector in anatomy of the Amsterdam Surgeon's Guild. Dr. Deyman is shown dissecting the cadaver of Joris Fonteyn, alias Black Jan, who had been hanged for robbery and murder on January 27, 1656. As we noted before (p. 114), the picture was severely damaged by a fire in 1723 in the guild's anatomical theater, and had to be trimmed down to about a quarter of its original size. A sketch that Rembrandt made (see fig. 207), presumably in connection with the design of the frame or the hanging of the painting, gives an idea of the composition, which was quite different from that of his first *Anatomy Lesson* (see fig. 205). In 1632 he had placed

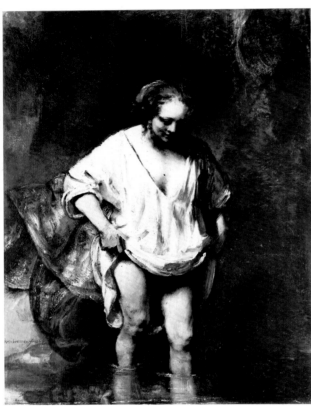

755

755 Rembrandt van Rijn
Woman Bathing in a Stream
Signed and dated 1655. Panel, 61.8 × 47 cm. The
National Gallery, London

756 Rembrandt van Rijn
Bathsheba
Signed and dated 1654. Canvas, 142 × 142 cm.
Musée du Louvre, Paris

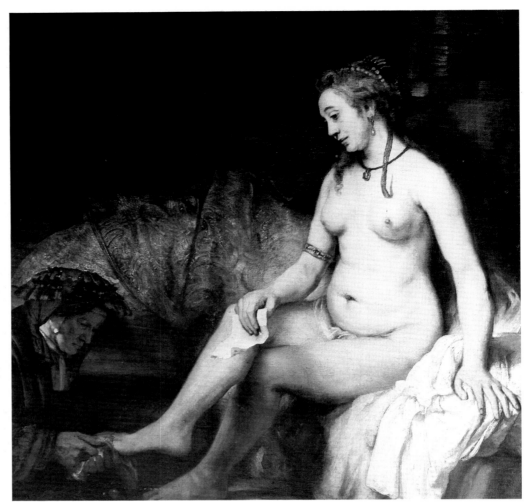

756

the corpse on the diagonal, but now he put it on the center axis of the painting, so that the soles of the feet confront the viewer. Maximum foreshortening of this sort had been attempted by many artists. The strong and broadly painted feet form a dark contrast with the white sheet that covers the legs and lower torso. The abdomen is a gaping hole, from which the viscera have been removed; the arms lie alongside the body; and the head, which Deyman is dissecting to demonstrate the brain, is somewhat elevated. Rembrandt succeeded fully in his powerful perspective effect. Deyman stands directly behind the body, and the other surgeons were arranged in groups of four on either side. This symmetrical composition must have given the work a static, monumental character. The surviving fragment remains extremely impressive despite the damage; the original canvas was undoubtedly one of the most magnificent group portraits in Dutch art.

The 1650s were a particularly productive period for Rembrandt as etcher and draftsman. His creative power did not diminish, though this was a time of great personal difficulty. Financial problems finally forced him in 1656 to apply for *cessio bonorum* or legal insolvency (one degree short of full bankruptcy). His expensive house in the Sint-Antoniebreestraat, purchased under heavy mortgage in 1639, had long been a burden to him: he was in arrears on his mortgage payments, failed to collect money owed him, and borrowed more than he could pay back. In addition he had suffered "losses in trade as well as damages and losses at sea," as he stated in his petition to the court, probably referring to his art dealing and to shares he apparently owned in ships: the 1652–54 naval war with England was disastrous for Dutch merchant shipping, and many investors lost heavily. There was a sharp increase in the number of bankruptcies in Amsterdam during these years.[2] Rembrandt seems thus to have been a victim of his own poor business sense and of the unlucky times rather than of a drop in artistic appreciation.

His plea for insolvency was granted, which meant that all his possessions—his house, his furniture, his studio appurtenances, his large and valuable art collection, everything except the minimum necessary to keep him alive and able to work—had to be sold to pay his creditors. The sales brought in far less than the property was worth. The house, stripped bare, did not go until the end of 1660, and Rembrandt meanwhile lived there with Titus, his and Saskia's only surviving child, and with Hendrickje Stoffels and her little daughter by Rembrandt, Cornelia. Since a regulation of the Amsterdam St. Luke's Guild barred

757 Rembrandt van Rijn
Jacob Blessing the Sons of Joseph
Signed and dated 1656. Canvas, 175.5 × 210.5 cm.
Staatliche Kunstsammlungen, Kassel

758 Rembrandt van Rijn
Self-Portrait
c. 1659–60. Canvas, 114.3 × 94 cm. The Iveagh
Bequest, Kenwood, London

Rembrandt from resuming his work as art dealer, Titus and Hendrickje formed a partnership to deal in art; they retained Rembrandt as adviser, and the firm became owner of everything he produced. In this way he was protected from his creditors and from his own tendency to be careless about money matters. When he moved with his family to their new house on the Rozengracht, the art shop was set up there.

During the last ten years of his life, up to his death in 1669, Rembrandt continued to work industriously. He almost abandoned etching, however, and did not make as many drawings as before. His paintings differ widely in nature and quality. A series of heads of the Apostles shows such great variety in the style of painting that he must either have permitted his few remaining pupils to help him or produced work of uneven quality himself, perhaps to supply stock for the art shop. Yet his self-portrait in working garb, with palette, brushes, and maulstick (fig. 758), is exceptionally strong and attests to wholly mature mastery. The manner of painting differs in the various parts of this portrait, from the well-worked-out head to the summary treatment of clothing and attributes; here the background darkness does not swallow up details, as in the 1652 portraits; rather it is as if Rembrandt with masterful nonchalance could not be bothered to render specific structure or textural nicety. He perhaps never finished this portrait.

His painting was not confined to work for the shop. He still received portrait commissions, including one for portraits of the armaments magnate Jacob Trip and his wife, Margaretha de Geer. More important by far, however, were his two "public" commissions,, the first for a painting to decorate the new town hall, which we will consider shortly, and the second for a group portrait of the "sampling" officials of syndics of the drapers' guild (see fig. 199). It was the duty of the sampling board to inspect and certify the quality of textiles manufactured in Amsterdam; the guild headquarters were in the Cloth Hall on the Groenburgwal, and it is thought that at least one or two group portraits of earlier syndics hung there before Rembrandt began his work. He must have known beforehand that the painting would be hung high, for the low horizon and foreshortened perspective indicate that spectators would be looking up at the picture. The asymmetry of the composition is remarkable, especially since the heads of the six men portrayed are almost at the same level. The movement of the second figure from the left introduces an element of suspense: is he just standing up, or just sitting down? This tension is heightened by the glance he receives from his right-hand neighbor, and to a certain extent from the hatless attendant; the other syndics look straight ahead, drawing in and involving the viewer. This effect has led to the hypothesis that Rembrandt wanted to portray his syndics as if seated before an audience and

759 Rembrandt van Rijn
Portrait of a Couple, known as *The Jewish Bride*
Signed and dated 16(..). c. 1665–67. Canvas,
121.5 × 166.5 cm. Rijksmuseum, Amsterdam. On
loan from the City of Amsterdam

reacting to its presence. Seventeenth-century traditions regarding corporation portraits rule out this interpretation,[3] but its origin is easy to understand, given the natural animation of the poses, gestures, and facial expressions of the figures. Yet what a time Rembrandt had in achieving this naturalness! X-ray photographs have revealed the drastic changes he made before arriving at the desired result.[4] He completed the work in 1662, affixing his stippled signature and the date on the glowing red tablecloth. The signature at upper right, with the year 1661, was added later by an unknown hand.

Another of Rembrandt's works that tantalizes the viewer is the painting popularly known as *The Jewish Bride* (fig. 759), undoubtedly one of the most fascinating and pictorially exciting of all his creations. It will probably never be possible to determine whether this painting is a true double portrait of some unknown couple, or a picture of a man and woman posing as biblical or historical figures, or a representation of some specific biblical story (Isaac and Rebecca or Jacob and Rachel, for example).[5] Nor do we know when it was painted: the last two digits of the date have disappeared. Yet whatever its subject matter or date, this painting is Rembrandt's most glorious expression of his love for warm, rich colors glowing luminously against a darker background. He used both brush and palette knife, letting the substance of the paint itself contribute magnificently to the final effect.

The Paintings for Amsterdam's New Town Hall

The manner of painting in *The Jewish Bride,* which is almost completely contrary to contemporary ideals of classicistic art theory, emerges strongly in the painting that Rembrandt made for the new town hall: *The Nocturnal Conspiracy of the Batavi under Claudius Civilis.*[6] In looking at this work, however, we must consider in greater detail than before (see p. 50) the general decorative scheme for this monumental building. Unlike the Oranjezaal in the Huis ten Bosch, which was dedicated to the memory and glorification of one man, the stadholder Frederik Hendrik, the new town hall was conceived as a monument to the city of Amsterdam, symbolizing the republican form of government, or "true freedom." A truly public building, its largest and most richly decorated space was the Burgerzaal or Hall of the Citizens with its surrounding galleries, open to all visitors; and none of the many decorations honored a contemporary person, however distinguished. As a functional building as well, the themes were chosen to symbolize the duties of the civil and judicial authorities who worked there: good government should be run by wise rulers, for the people. These rulers were not emperors or kings; the Amsterdam city fathers preferred to identify themselves with consuls of the Roman Republic, chosen to represent the people, and with Moses, God's lawgiver.

The final decisions concerning every aspect of the town hall—from the master plan to the last nut and bolt—rested with the burgomasters. They were assisted by the most competent advisers available. For their future historians, however, they left disappointingly little documentation of how they reached their decisions. No one knows whether they fired Jacob van Campen in 1654 or whether he walked out, or for what reason in either case. There is no archival evidence to support the assumption, now generally accepted, that artists were invited to compete for the painting commissions, and that other collections today possess some of the paintings that lost out. Nevertheless, it is quite clear from the building as it now exists, with its inner and outer decorations intact, that a specific, coherent scheme governed its adornment.

The plan of the new town hall called in the first place for sculpture to complement van Campen's classicistic architecture, with statuary and reliefs to adorn both the exterior and the interior of the building. In the Northern Netherlands, devoid of stone and metal, the art of monumental sculpture was little practiced, and a search had to be made abroad for a sculptor of sufficient competence and experience to undertake the enormous commission. The choice fell on Artus Quellinus the Elder, of Antwerp, who had studied in Rome during the 1630s under the Flemish sculptor Frans Duquesnoy and become acquainted with the work of Bernini. Quellinus came to Amsterdam in 1650 and lived there for the next fourteen years. The municipality gave him a disused convent as his studio, so that he had plenty of working space for himself and his team of assistants, yet it is remarkable that he completed his assignment in so short a time and so masterfully. His sculptures for the town hall are in the Baroque style, exuberant yet restrained, and in complete harmony with the architecture and with the conceptions of his patrons.

Paintings to ornament the public halls and chambers had also been contemplated since the beginning, and here there was no scarcity of local talent—if anything, a superfluity. One problem was in making a choice, and among others there was the demand (no doubt insisted upon by the St. Luke's Guild, which never ceased trying to extend and enforce its ancient regulations) that participants be *poorters* or citizens of Amsterdam. Presumably partly for this reason, a number of artists long resident in the city who had not purchased their citizenship, including Ferdinand Bol, Jan van Bronckhorst, and Nicolaes van Helt Stockade, hastily did so in 1652.[7] This requirement was later slackened, so that non-Amsterdam artists such as Jacob Jordaens of Antwerp could be given commissions.

How much say Jacob van Campen had in selecting the artists is not known, nor can his influence be taken for granted in view of his sudden departure in 1654 (he died three years later at his estate near Amersfoort). Nevertheless, some of the painters he had worked with previously were now engaged by the Amsterdam city fathers. Jan van Bronckhorst and Cornelis Holsteyn, members respectively of the Utrecht and Haarlem schools of classicistic painters, with experience in painting ceilings, received commissions to do ceilings in the town hall; their results were adequate but hardly distinguished. The artists chosen to make paintings for the walls included Ferdinand Bol, Govert Flinck, Thomas de Keyser, Jan Lievens, Nicolaes van Helt Stockade, and Willem Strijcker, nicknamed Brassemary (roughly, Greedyguts). A document of 1658 reveals that Flinck, Bol, Strijcker, and van Helt Stockade knew each other well enough to draw together from nude female models.[8]

We can here treat only the paintings commissioned for two areas in the town hall: the burgomasters' assembly chamber, and the galleries of the Burgerzaal. The former has two beautiful marble fireplaces, one at either end of the room, and Ferdinand Bol and Govert Flinck received the commissions to paint large chimney pieces to hang above them. Five

760　Ferdinand Bol
The Intrepidity of Gaius Fabricius Luscinus in
Pyrrhus' Army Camp
Signed and dated 1656. Canvas, 485 × 350 cm.
Former Town Hall, now Royal Palace,
Amsterdam

preliminary studies, both drawn and painted, survive to show the various stages of Bol's
approach to his assignment.[9] In 1656 he delivered his finished work, *The Intrepidity of Gaius*
Fabricius Luscinus in Pyrrhus' Army Camp (fig. 760); the theme came from Plutarch's *Lives of*
Famous Greeks and Romans, translated into Dutch in 1601. The story is told of the Roman
consul Gaius Fabricius Luscinus who, in 280 B.C., went to the camp of the enemy, King
Pyrrhus of Epirus, to negotiate peace terms. Pyrrhus first tried to bribe him, then to frighten
him by suddenly producing an elephant, but the consul remained calm and said, "Neither
your gold yesterday nor your monster today can sway me." There was an obvious parallel
between the virtuous Roman and what the burgomasters expected of themselves and
wanted others to see in them. To make sure that everyone understood, they got the poet
Joost van den Vondel to compose for each painting a quatrain that explained the story and
pointed out the moral, and these were inscribed on the woodwork under the pictures.

Perhaps even more to the burgomasters' taste was Govert Flinck's painting, *Marcus Curius*
Dentatus, Who Scorned His Enemy's Gold and Chose a Meal of Turnips Instead (fig. 761), also
delivered in 1656. The story is again from Plutarch, and concerns a consul who was not
only honest and brave but lived frugally as well, as a good Calvinist burgomaster should.
The painting was executed with greater skill than Bol's piece. With this and his other
history paintings, Flinck made a name for himself, outstripping Bol in popularity as well as
the painters who were working in the increasingly modish light colors, a trend represented
by Nicolaes van Helt Stockade's *Joseph Provides His Brothers with Grain* (fig. 762), painted in
1656 for the municipal treasurer's office in the town hall. Flinck mingled easily with people
of high estate, including the burgomasters de Graeff, and was often called upon to paint
their portraits. He was also a rapid worker. For these reasons, seemingly, the city fathers in

761 Govert Flinck
Marcus Curius Dentatus Who Scorned His Enemy's
Gold and Chose a Meal of Turnips Instead
Signed and dated 1656. Canvas, 485 × 377 cm.
Former Town Hall, now Royal Palace,
Amsterdam

762 Nicolaes van Helt Stockade
Joseph Provides His Brothers with Grain
Signed and dated 1656. Canvas, 175 × 175 cm.
Former Town Hall, now Royal Palace,
Amsterdam

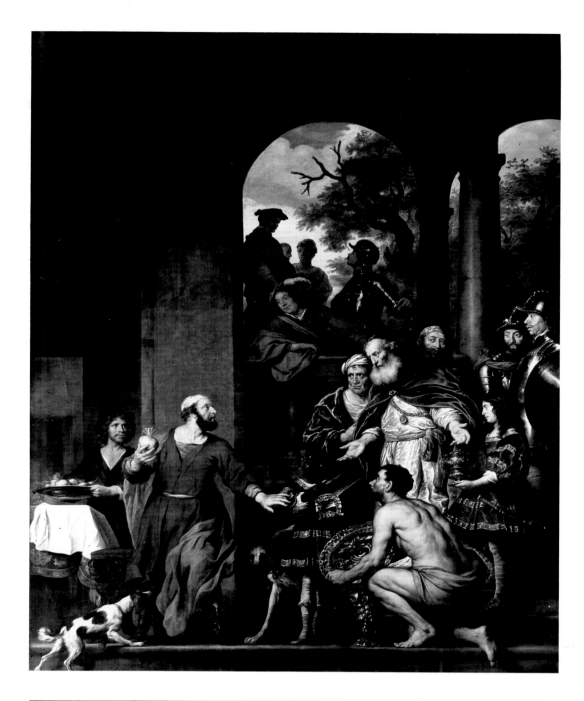

1659 awarded him the largest and most prestigious commission ever given a Dutch artist: the order for twelve huge paintings, eight to be placed in the elongated lunettes under the arches at the corners of the public galleries surrounding the Burgerzaal, and four in the sickle-shaped lunettes under the arched entries from the galleries into the hall.

The central theme chosen for these pictures, as we have seen, again drew a parallel between past and present: the revolt recorded by Tacitus (*Historiae,* IV, 13) of the Germanic tribe known as the Batavi against their overlords, the Romans, in A.D. 69–70.[10] The Batavi had lived in the region north of the Rhine delta, thus well within the territory of the Dutch Republic, and their rebellion seemed justifiably comparable to that of the Northern Netherlands against Spain. There had long been a lively interest in this subject. In 1610 Hugo de Groot or Grotius,[11] Holland's most brilliant jurist and a pioneer exponent of international law, published *De antiquitate reipublicae Batavae,* in which he used the story of the Batavi to establish the strongest possible precedents for the war with Spain. The States-General celebrated the declaration of the Twelve Years' Truce in 1609, through which the Republic gained its first recognition as a national entity, by commissioning Otto van Veen to paint twelve episodes from the story as decoration for their assembly chamber in The Hague (see p. 48). And the United East India Company in 1619 selected the name Batavia (present-day Jakarta) for their principal trading post in Java. The idea was therefore not original with the Amsterdam burgomasters, who seem to have been influenced in what they wanted the paintings to look like by the book *Batavorum cum Romanis Bellum,* published in Antwerp in 1612, with thirty-six etchings by the Italian artist Antonio Tempesta after compositions by van Veen.[12]

The burgomasters' instructions to Flinck are not known, but he had already produced sketches of four of the Batavian episodes for them in the summer of 1659, and he set to work immediately on his oil painting of the first of these, *The Conspiracy of Claudius Civilis.* Death overtook him early in February 1660, little more than two months after he started. His good friend Joost van den Vondel wrote an elegy "To Govert Flinck," the last of many poems about him:[13]

Thus lived Apelles Flinck, torn from the city too soon away,
Just when he, chartered by the noble Government,
Should decorate the magnificent town hall with histories,
As related by Tacitus in days of yore,
Which taught Rome to bow before Batavian right.
Crown this Painter-Hero with eternal bays.

With Flinck's death the burgomasters had to revise their commission, and they decided to award it to several artists. The first three selected were Jacob Jordaens of Antwerp, Jan Lievens, and Rembrandt. Rembrandt was assigned the *Conspiracy* episode; Lievens, *Brinio Promoted to General* (see fig. 46); and Jordaens, *The Victory of the Batavi over the Romans* and later *The Peace between the Romans and the Batavi.*

Rembrandt approached his subject with his usual thoroughness and originality. He no doubt reread Tacitus' account of Gaius Julius Civilis, chief of a tribe allied to Rome but suffering under Roman injustice, who called together the leaders of neighboring tribes and incited them to unite in revolt. Tacitus said three things of special interest to Rembrandt: Civilis was blinded in one eye; the conspiracy took place in the middle of the night; and the tribesmen swore a "barbarous oath." These elements all appear in the painting he finished and delivered to the town hall in 1661: *The Nocturnal Conspiracy of the Batavi under Claudius Civilis,* which survives now only as a fragment (fig. 763). The towering figure of the one-eyed Civilis dominates the lamp-lighted scene, and the oath is sworn by the crossing of mighty swords, rather than by the gentlemanly handshaking introduced by Otto van Veen and followed by other artists.

Rembrandt's work must have been hanging in its proper place in the town hall in 1662, for it is mentioned in Melchior Fokkens' description of Amsterdam published in the summer of that year. At some point, however, disagreement about it presumably arose, though no documentation clarifies what the trouble was—Rembrandt either wanted or was requested to make alterations on it—and the painting was removed. On August 28, 1662, he declared before a notary that he would settle certain debts with the money due him for "the

764 Gallery in the Amsterdam Town Hall (now Royal Palace) with the lunette where Jurriaen Ovens' *Claudius Civilis* hangs today

765 Rembrandt van Rijn
Sketch of the Conspiracy of the Batavi
c. 1661. Pen and bister, wash, some white body color, rounded at the top, 19.6 × 18 cm. Staatliche Graphische Sammlung, Munich

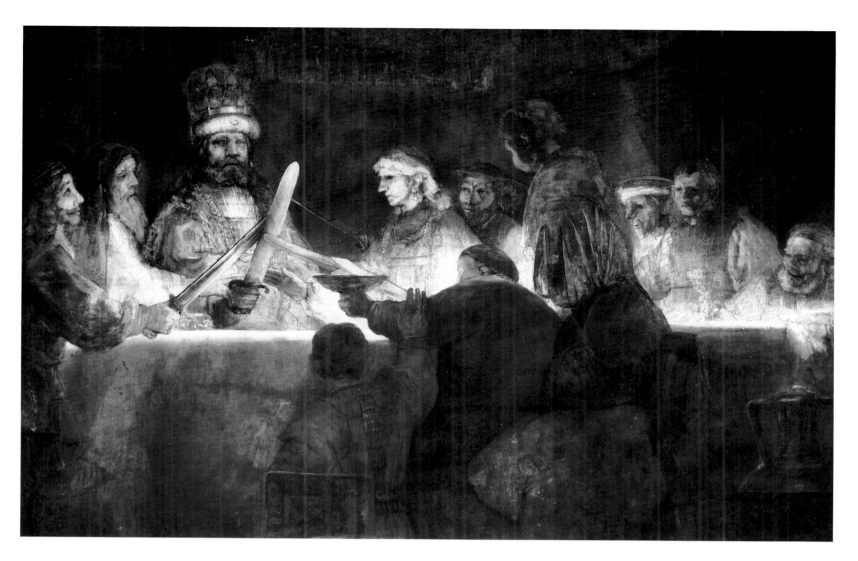

763 Rembrandt van Rijn
*The Nocturnal Conspiracy of the Batavi under
Claudius Civilis*
1661. Canvas, 196 × 309 cm. Nationalmuseum,
Stockholm

piece of painting at the town hall" and the "repainting" of it. But the canvas was not
returned to its assigned place, and in September the burgomasters, who were expecting
important guests, hastily commissioned Jurriaen Ovens to complete the painting that Flinck
had begun. Ovens complied, finishing the work in less than a week and receiving 48
guilders. His totally uninspired result still hangs in the Burgerzaal gallery (fig. 764), where
Rembrandt's masterpiece should be hanging today.

Rembrandt was now left with a painting measuring nearly 6 by 6 meters (about 19 by 19
feet), for which there was no market except the town hall. He apparently did his
"repainting," making many alterations that are visible in X-ray examination, before he (or
someone else) cut the canvas down to its present size. All that remains to give an idea of the
original composition is this remnant, now in the Nationalmuseum in Stockholm (it was sold
to a Swedish merchant for 60 guilders at an auction in Amsterdam in 1734), and a small
sketch (fig. 765) noted down by Rembrandt on the back of a funeral notice, presumably
before the alterations.[14] Only by using our imagination can we envision how this strongly
lighted central group of conspirators must have loomed out of the surrounding darkness like
a spotlighted scene on a stage—a stage high up under one of the town-hall arches.
Rembrandt's conception can only be called intensely dramatic.

While it is true that Rembrandt's painting perhaps did not accord with his patrons'
classicistic ideals, the fact that it was never put back in place almost certainly resulted from
reasons other than his contemporaries' lack of understanding and appreciation. More likely,
he did not work quickly enough—a fault of which he was often accused—and the
burgomasters lost patience, especially since they wanted everything ready for their guests.
There may also have been dispute about payment, for Rembrandt seems to have been
charging extra for alterations,[15] whereas, as their extant commissions to Lievens and
Jordaens make plain, the city fathers expressly stipulated that under no circumstances would
they pay more than the agreed upon, original price, 1,200 guilders.

The whole project of providing paintings for the great lunettes of the galleries continued
to prove troublesome, and no further commissions were granted after 1665. Only the four
paintings on canvas, by Jordaens, Lievens, and Ovens, were completed for the large lunettes;
Jordaens painted two more for the small lunettes; and in 1697 an Antwerp artist known

only as Le Grand painted in fresco two further large scenes; the other four spaces remain empty to this day. It is not certain whether the failure to complete the program was due to the disappointing reception of the paintings or to financial considerations. Even if the paintings had all been masterpieces, their location was so bad—so high and so poorly lighted—that they could hardly be seen.

Rembrandt's Pupils on Their Own

Rembrandt's best pupils did him credit in that they learned to think independently and to develop their individual talents. Govert Flinck was one of these, and we should look at his

766 Govert Flinck
Portrait of Gerard Pietersz Hulft
Signed and dated 1654. Canvas, 130 × 103 cm.
Rijksmuseum, Amsterdam

767 Govert Flinck
Allegory in Memory of Frederik Hendrik
Signed and dated 1654. Canvas, 307 × 189 cm.
Rijksmuseum, Amsterdam

accomplishments during the last decade of his life apart from his work for the town hall. He ranked among the most celebrated portrait and history painters of Amsterdam, and his best portraits help us to understand his great popularity, for they are skillfully painted and clearly attest to the new trend in taste. A good example is the portrait of Gerard Pietersz Hulft of 1654 (fig. 766), painted in an oval with a surrounding still life of books, documents, maps, nautical instruments, and natural history specimens—symbols of Hulft's interests and activities. Son of an Amsterdam brewer, Hulft first studied and practiced law and became municipal clerk, then went successfully to sea, and ended up as the VOC's chief counselor and director-general of the East Indies.

But Flinck's total oeuvre seems today of uneven quality. Many of his portraits fall short in composition and expressiveness, as do his allegorical and historical paintings of a more official nature: he received commissions from the Orange-Nassau court in The Hague, and especially from Frederik Hendrik's son-in-law, Friedrich Wilhelm, the "Great Elector" of Brandenburg. The same is true of his *Allegory in Memory of Frederik Hendrik* (fig. 767),

768 Ferdinand Bol
Portrait of a Young Man
Signed and dated 1652. Canvas, 128 × 99 cm.
Mauritshuis, The Hague

769 Ferdinand Bol
Portrait of a Boy
Signed and dated 1652. Canvas, 150 × 174.5 cm.
Castle Howard Collection, York

which he painted in 1654 for Amalia van Solms's private suite in the Huis ten Bosch: his portrait of the mourning widow is well executed, but the rest of the picture lacks strength.

Ferdinand Bol, another of Rembrandt's pupils of the 1630s, continued to display dependence on his master until about 1650, and then his work began to swing away from Rembrandt. Bol's new approach is more evident in his portraits than in his history paintings. One of his most successful efforts is his 1652 *Portrait of a Young Man* (fig. 768); he follows the "modern" trend in his fairly smooth manner of painting and in the elegantly relaxed pose of the model leaning his arm on a balustrade. Bol's palette, however, remains Rembrandtesque, and the landscape in the background also slightly resembles his teacher's work. During the 1650s, interestingly enough, Rembrandt's pupils were the only ones to combine an elegant portrait with a landscape background (see fig. 598), although as far as is known Rembrandt himself painted only one such portrait, that of Clement de Jonghe. Many of Bol's portraits after 1650 have this compositional scheme, the landscape sometimes being replaced by architectural motifs. His charming *Portrait of a Boy* (fig. 769), also painted in 1652, is quite exceptional; here Bol is truly on his own, without a trace of Rembrandt's influence. His talent for still life is evident from the arrangement of the glass and lemons on the table.

Bol's work, unfortunately, failed to maintain this strong development. He repeated himself in his history paintings,[16] the figures increasingly losing their reality and conviction. The portraits, too, diminish in warmth and personality. Yet he remained a popular, well-paid painter and received important commissions. He owned a magnificent collection of paintings, including works by Rembrandt, Ruisdael, Porcellis, Kalf, den Uyl, Molijn, and many others. On October 8, 1669, the day of Rembrandt's burial, Bol was busy drawing up a marriage contract with the wealthy widow Anna van Arckel, who became his second wife. In 1673 he was appointed a regent of the Oude Zijds Huiszittenhuis, and was portrayed in this function (at far right) in Pieter van Anraedt's group portrait of 1675 (see fig. 864). No dated works by Bol are known after 1669; he seems to have given up painting after his second marriage, perhaps because he no longer had to depend on his brushes for income.

Rembrandt's best pupils display a conspicuous similarity in their later development: Gerbrand van den Eeckhout followed almost the same path as Govert Flinck and Ferdinand

770 Gerbrand van den Eeckhout
Portrait of Jan van de Cappelle (?)
Signed and dated 1653. Canvas, 74.6 × 57.5 cm.
Private collection, Amsterdam

771 Gerbrand van den Eeckhout
Sophonisba Receives the Poisoned Goblet
Signed and dated 1664. Canvas, 248 × 197 cm.
Herzog Anton Ulrich Museum, Brunswick, West
Germany

Bol. His few extant portraits of the 1650s show a continuing relationship with Rembrandt in color and treatment of light, as in his 1653 portrait thought to be of the marine painter Jan van de Cappelle (fig. 770); later his manner of painting becomes cooler and harder, with the light evenly distributed, revealing everything. Van den Eeckhout's many history paintings perhaps remain most strongly bound to Rembrandt in composition and execution, but the colors are increasingly in the light tones of the new mode. The subject matter of nearly half of these paintings comes from the Old Testament, a source not often used by his contemporaries. Although van den Eeckhout was a competent figure painter, the persons appearing in the history pictures lack inner tension and therefore conviction, so that the scenes look staged, the figures mere actors. His weaknesses are particularly evident

770

772 Gerbrand van den Eeckhout
Elisha and the Shunammite Woman
Signed and dated 1664. Canvas, 110 × 155 cm.
Szépmüvészeti Múzeum, Budapest

773 Gerbrand van den Eeckhout
Mountain Landscape
Signed and dated 1663. Canvas, 52 × 65.3 cm.
Private collection

771

772

773

in his largest canvases, such as his rendition of a story from Livy (XXX,15), *Sophonisba Receives the Poisoned Goblet* (fig. 771). In many of his less ambitious works, of which *Elisha and the Shunammite Woman* is a good example (fig. 772), he remained one of Rembrandt's truest followers.

Landscape was often an important element in van den Eeckhout's biblical paintings, and he made many landscape drawings. One of his few extant landscape paintings, the *Mountain Landscape* of 1663 (fig. 773), occupies a special place in the art of this genre because of the relaxed touch with which it is painted and its fascinating play of colors—yellowish and brownish tints accentuated here and there with cool gray and clear blue highlights. This painting is closely related to the work of Roelant Roghman, whom van den Eeckhout

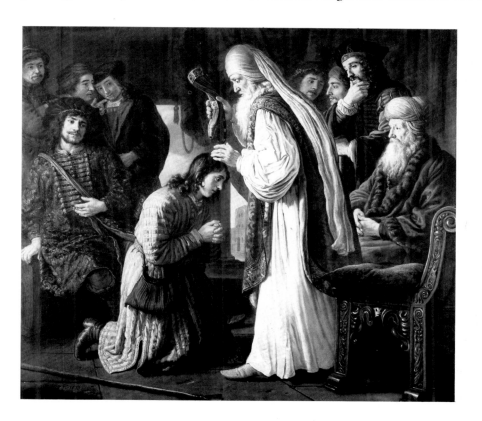

774 Jan Victors
David Being Anointed by Samuel
Signed and dated 1653. Canvas, 180 × 201 cm.
Herzog Anton Ulrich Museum, Brunswick, West
Germany

775 Jan Victors
The Village Butcher
Signed. Canvas, 66.3 × 95.5 cm. Private collection

probably knew well. Houbraken says of Roghman: "In his time he was, along with Gerbrand van den Eeckhout, a great friend of Rembrandt."[17]

Jan Victors had come to Rembrandt's studio a bit before van den Eeckhout, but their work is in some ways similar. Victors' many biblical paintings are strongly dependent on Rembrandt, but his figures, more than those of van den Eeckhout, give the impression of being stage actors—of people in costume playing their roles (fig. 774). His treatment of light is rather erratic. These shortcomings are less obvious in the scenes of daily life in which he gradually began to specialize. Victors liked to paint village scenes, with butchers (fig. 775), tooth-pulling dentists, and other practitioners going about their trade in the open air, surrounded by onlookers. His work is unequal in quality, but in his most successful paintings he subdued his colors and achieved a surprisingly pleasant atmosphere.

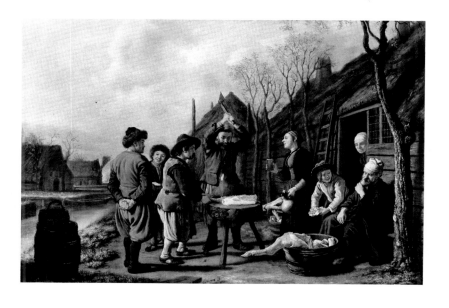

About 1650 Rembrandt had a number of interesting pupils. Houbraken reports: "Nicolaes Maes, born in Dordrecht in the year 1632, learned drawing in his youth under an ordinary master and painting under Rembrandt, but he early departed from this manner of painting, the more so because he turned to portraiture and well understood that young ladies in particular take more pleasure [in being painted] in white than in brown."[18] Houbraken errs in the birth date (Maes was born in 1634), and does not tell us when Maes studied with Rembrandt, but by December 1653 the young artist was back in Dordrecht, where he stayed until 1673 and then returned to Amsterdam. He can be recognized as Rembrandt's pupil only by his drawings and by the strong chiaroscuro and warm palette of his paintings.

776 Barend Fabritius
 Portrait of a Young Man (Self-Portrait?)
 Signed and dated 1650. Canvas, 70.5 × 56 cm.
 Städelsches Kunstinstitut, Frankfurt am Main

777 Barend Fabritius
 Peter in the House of Cornelius
 Signed and dated 1653. Canvas, 91 × 116 cm.
 Herzog Anton Ulrich Museum, Brunswick, West
 Germany

778 Barend Fabritius
 *Portrait of Willem van der Helm with his Wife and
 Son*
 Signed and dated 1656. Canvas, 148 × 127.5 cm.
 Rijksmuseum, Amsterdam

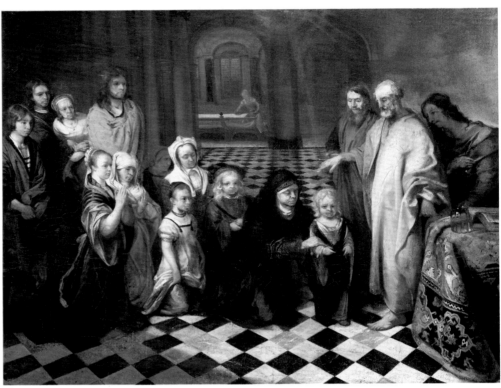

777

776

778

Barend Fabritius, younger brother of Carel Fabritius, may have worked for a short time in Rembrandt's studio, but he was then already a partly trained painter. Barend wandered about, and it is difficult to follow his development. Moreover, for want of better solutions, many paintings from the Rembrandt school are attributed to him, so that his image remains clouded. He was born in 1624 in Midden-Beemster, a town in a newly drained polder in North Holland, and at first lived alternately there and in Amsterdam. Later he seems to have been in Delft, where Carel had settled, although two of his children were born in Midden-Beemster in 1653 and 1655. He was also in Leiden about this time and joined the guild there. Three or four years later he went back to Midden-Beemster, but in 1663 he

779 Willem Drost
Noli Me Tangere
Signed. Canvas, 95.4 × 85.4 cm. Staatliche
Kunstsammlungen, Kassel

780 Willem Drost
Bathsheba
Signed and dated 1654. Canvas, 101 × 86 cm.
Musée du Louvre, Paris

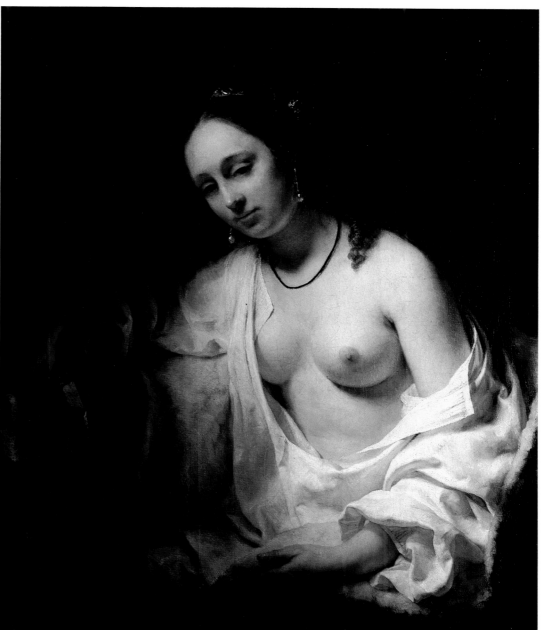

780

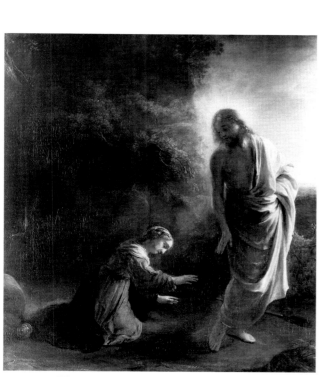

779

worked for a Leiden church. Finally he moved to Amsterdam, where he died in 1673. Fabritius' early work in particular, such as his presumed self-portrait of 1650 (fig. 776), has something of Rembrandt about it, but *Peter in the House of Cornelius* (fig. 777), painted three years later, shows the influence of the Delft school. Though his figures are rather weak, his palette is bright and warm. His portrait of the Leiden municipal architect Willem van der Helm with his wife and infant son (fig. 778) dates from 1656, when Fabritius was in Rembrandt's birthplace but seems to have forsaken whatever he had learned from the master in Amsterdam.

Willem Drost, according to Houbraken, was another of Rembrandt's pupils, and he spent some time in Rome, perhaps about 1655–60.[19] Little else is known about him. He may have been of German extraction: a man's portrait now in the Metropolitan Museum of Art, New York, bears the signature "Wilhelm Drost." As far as can be deduced from his extant signed works, scant in number, Drost came under Rembrandt's direct influence. This is especially apparent in the composition, color, and handling of light in *Noli Me Tangere* (fig. 779), which is unfortunately now in bad condition. His beautiful *Bathsheba* in the Louvre (cpl. 780), dated 1654, can also be linked directly with Rembrandt's work at about this time, although here Drost's own individuality dominates: his palette is cooler, his manner of painting smoother than Rembrandt's. The varying gradations of white and gray in the clothing harmonize exceptionally well with the lovely skin tones.

Rembrandt had no pupils of great importance between about 1655 and 1661, the year Aert de Gelder arrived. The master's manner of painting seemed no longer to appeal to most of the younger generation. But if Rembrandt could have chosen the best possible applicant for his last pupil, he would have found none better than the sixteen-year-old Aert. Born in Dordrecht in 1645, de Gelder had begun his studies about 1660 under Samuel van

781 Aert de Gelder
 Esther at Her Toilet
 Canvas, 110.5 × 116 cm. Private colletion

782 Jan Lievens
 Mars and Venus
 Signed and dated 1653. Canvas, rounded at the
 top, 146 × 156 cm. Staatliche Schlösser und
 Gärten, West Berlin

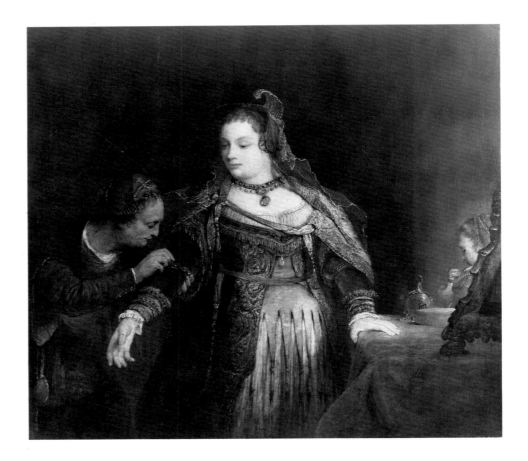

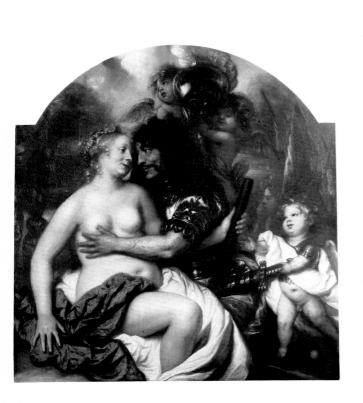

Hoogstraeten, his fellow townsman and Rembrandt's former pupil, who may have
encouraged the boy to go to Amsterdam. We do not know how long he stayed, but it must
have been several years, after which he returned to Dordrecht. Of all of Rembrandt's pupils
de Gelder was and remained most deeply under his influence. He worked directly at odds
with the new trends, following Rembrandt's style and colors, treatment of light and dark,
and choice of subject matter, as can be seen in his *Esther at Her Toilet* (fig. 781). He must
have witnessed, and perhaps participated in, the creation of some of Rembrandt's most
important works: *The Conspiracy of Claudius Civilis*, *The Syndics*, and possibly *The Jewish
Bride*. We shall meet him again in Dordrecht.

Jan Lievens

Few Amsterdam artists of distinction, outside of Rembrandt's circle, were history painters
during the third quarter of the seventeenth century. Those who were fall mainly into the
group that received commissions for the town hall: Lievens, van Helt Stockade,
Bronckhorst, Holsteyn, and Strijcker. The work of Gerard de Lairesse, which signaled a
true renewal, will be discussed in the concluding chapter.

 Jan Lievens had perhaps the most important role in Amsterdam of all these artists, though
his activity was least bound to that city. Having begun his career along with Rembrandt in
Leiden, Lievens thereafter kept on the move. J.J. Orlers, the burgomaster-historian of
Leiden, reports that he went to England in 1632, and it is likely that he did, although no
documents or paintings substantiate Orlers' statement. About 1635 Lievens settled in
Antwerp, joined the guild, and remained until 1644, with a break about 1639 or 1640, when
he painted a *Scipio Africanus* for the Leiden town hall. From 1644 to 1653 he is listed in
Amsterdam, but in 1650 he painted a large canvas, *The Five Muses*, for the Huis ten Bosch.
After 1653 he lived and worked in The Hague, where he was one of the founders of the
artists' confraternity Pictura; in Amsterdam, where he executed commissions for the new
town hall in 1656 and 1661; and in Leiden, where he made two paintings for the
Rijnlandshuis in 1666 and 1669. He died in Amsterdam in 1674.

 Lievens never lived up to his extremely promising debut in Leiden, where Huygens had
deemed him a sort of prodigy. During his nine years in Antwerp he came under many
influences. His history paintings, such as the *Mars and Venus* of 1653 (fig. 782), show the
impact of Rubens' work, while his portraits are more in van Dyck's style. His fascinating,
fluently painted landscapes (fig. 783), by contrast, in some ways recall those by Adriaen
Brouwer. Lievens' portraits are often very clever and capable—he was an excellent

783 Jan Lievens
Landscape
Panel, 28 × 41 cm. Fondation Custodia
(Collection F. Lugt), Institut Néerlandais, Paris

784 Jan Lievens
Portrait of Sir Robert Kerr, First Earl of Ancram
1652. Canvas, 62 × 51.5 cm. Scottish National
Portrait Gallery, Edinburgh. On loan from the
Marquess of Lothian

draftsman, etcher, and engraver—yet they seem to us now rather superficial, lacking Rembrandt's warmth and van der Helst's perfection. A pleasant exception is his 1652 portrait of Sir Robert Kerr, first earl of Ancram (fig. 784), who lived in self-imposed exile in Amsterdam after the execution of Charles I. Ancram took due note of Lievens' vanity, and wrote to his son about this portrait: "You may be sure of a good one. He [Lievens] is the better because he has so high a conceit of himself that he thinks there is none to be compared with him in all Germany, Holland, nor the rest of the seventeen Provinces." [20]

Portrait Painters: Bartholomeus van der Helst and His Followers

All the painters of histories also engaged in the financially worthwhile art of portraiture. Bartholomeus van der Helst, who confined himself almost entirely to this field, remained without doubt the most successful of the Amsterdam portraitists. In the 1650s, after gaining widespread renown with his early civic-guard paintings (see fig. 624), he received more commissions for group portraits than any other artists: between 1650 and 1656 he painted five regents pieces, while Jacob Backer, Ferdinand Bol, Jurriaen Ovens, and Rembrandt each had only one group-portrait commission. Van der Helst was also often called upon to do portraits of private individuals. His double portrait of Abraham del Court and his wife, Maria de Keerssegieter (see fig. 174), epitomizes his mastery: here is complete technical control, a precision that leaves nothing to the imagination, a pleasant use of colors, a brilliant rendering of cloth, and suitable symbolism. Del Court, a wealthy Amsterdam cloth merchant, was a Huguenot, and since van der Helst's first commission had been to portray the regents of the Walloon Orphanage (see fig. 617) and he was buried in the Walloon church, it may safely be assumed that the artist himself was a member of the Huguenot community.

Van der Helst's work is not all equally strong, and he may have used assistants to help carry out his innumerable commissions; it is known, for instance, that in 1652 he hired a man named Marcus Waltusz to work for him ten hours a day for one year. [21] Yet van der Helst succeeded in maintaining a high level of workmanship, as is evident from his fashionable portraits of Samuel de Marez and his wife, Margaretha Trip (figs. 785 and 786); the combined architectural and landscape motifs in the background accorded completely with the taste and style of the 1660s. Only at the end of van der Helst's career is there any sign of less well-conceived compositions and uneasy color combinations. He died in Amsterdam in 1670.

Van der Helst's smooth painting style, perfect technique, and clarity of form and draftsmanship have been variously evaluated by art connoisseurs. Throughout the eighteenth century and the first half of the nineteenth his art was highly prized, and his *Celebration of the Peace of Münster*, as we have seen, was preferred to Rembrandt's *Night Watch*. A turnabout came with Impressionism, whose adherents gave the palm to Rembrandt and Frans Hals and wrote off van der Helst's work as clever but superficial, without real content.

Van der Helst seems to have had few pupils; at least, no portrait painters of any importance emerged from his studio. His son Lodewijk worked in his father's manner, but

785

786

785 Bartholomeus van der Helst
Portrait of Samuel de Marez
Signed. Canvas, 132 × 112 cm. Private collection

786 Bartholomeus van der Helst
Portrait of Margaretha Trip
Signed. Canvas, 132 × 112 cm. Private colletion

787 Abraham van den Tempel
Portrait of Jan van Amstel and His Wife, Anna Boxhoorn
Signed and dated 1671. Canvas, 142 × 181 cm.
Museum Boymans–van Beuningen, Rotterdam

his art remained at a much lower level. It is therefore all the more striking to observe the impact of van der Helst's portrait art on painters who were not his pupils.

One of those most strongly influenced was Abraham van den Tempel, son of Lambert Jacobsz of Leeuwarden; he lived in Amsterdam from 1660 until his death in 1672. His work frequently resembles van der Helst's so closely that the one can be mistaken for the other. Van den Tempel's portrait of the naval captain Jan van Amstel and his wife, Anna Boxhoorn, with their little black servant (fig. 787) is an excellent example of his late style.

Nicolaes van Helt Stockade's portraits also show van der Helst's influence. Born in Nijmegen in 1614, this artist traveled in France and Italy and spent some time in Antwerp before settling in 1652 in Amsterdam, where he died in 1669. Besides landscapes and individual group portraits, he produced large history paintings, including three for the new town hall. One of his pleasantest pieces is his portrait of himself holding hands with his wife and surrounded by their many children, including three little "angels" floating in the draperies (fig. 788).

Van der Helst's influence appears again in the work of Isaac Luttichuys. This artist was born in London in 1616 but is recorded in Amsterdam as early as 1638, and remained there

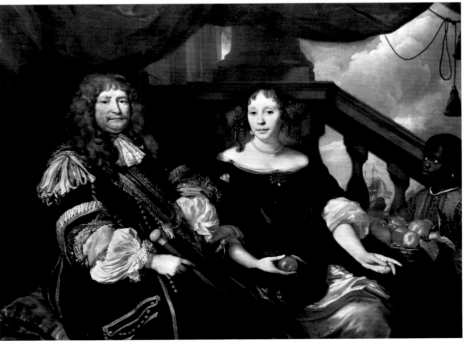

787

372

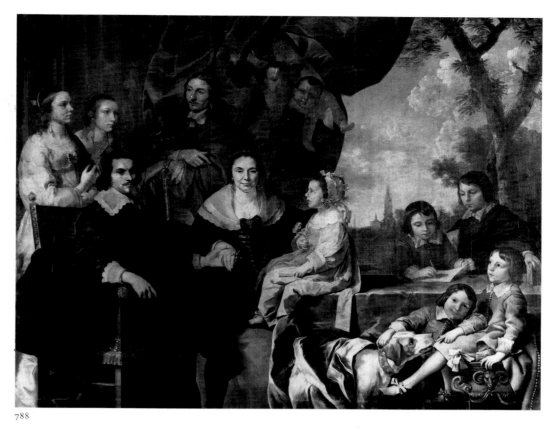
788

788 Nicolaes van Helt Stockade
Portrait of the Artist with His Family
Signed. Canvas, 220 × 269 cm. Muzeum
Narodowe, Warsaw

789 Isaac Luttichuys
Portrait of a Young Man
Signed and dated 1654. Panel, 57 × 40 cm.
Nationalmuseum, Stockholm

790 Isaac Luttichuys
Portrait of a Young Woman
Signed and dated 1654. Panel, 57 × 40 cm.
Nationalmuseum, Stockholm

the rest of his life, dying in 1673. His portraits (figs. 789 and 790) are elegant and refined.

Adriaen Backer is one of the few Amsterdam portraitists who developed independently of van der Helst. It is assumed that he studied under his uncle, Jacob Backer; he then worked for several years in Rome, and is documented in Amsterdam from 1669 on. If we use the number of group-portrait commissions as a yardstick for measuring an artist's popularity, Backer must be ranked high: between 1670 and his death fourteen years later he made at least five regents paintings, among them one commissioned by the Surgeons' Guild and another by the regentesses of the Burgher Orphanage (fig. 791). He was also awarded a commission to make a very large painting on wood for the Burgerzaal of the new town hall, a work that Houbraken praised highly, though in its present deteriorated condition this painting does not make a strong impression. Backer possessed great technical skill and a good feeling for color and composition, and his brushwork is flowing. It is puzzling that so little of his work is known today.

Of the other painters who received commissions for group portraits before 1685, Pieter van Anraedt, Abraham van den Tempel, Wallerand Vaillant, and Jan de Baen should be mentioned. Anraedt was a Deventer painter who worked only briefly—from 1673 to

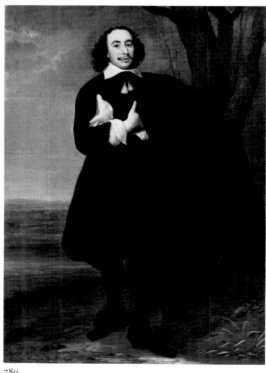

789

790

791

792

791 Adriaen Backer
Regentesses of the Burgher Orphanage, Amsterdam
Signed and dated 1683. Canvas, 193 × 282 cm.
Amsterdams Historisch Museum, Amsterdam

792 Wallerand Vaillant
Regentesses of the Walloon Orphanage, Amsterdam
Signed and dated 1671. Canvas, 217 × 203 cm.
Maison Descartes, Amsterdam.
On loan from the Régence Hospice Wallon

1675—in Amsterdam. Jan de Baen, a pupil of Jacob Backer, worked primarily in The Hague. Vaillant was a native of Rijssel (Lille) southwest of Antwerp, and came by way of Middelburg and Frankfurt to Amsterdam, where he lived from 1665 on. Many of his clients belonged to the community of Southern Netherlanders in Amsterdam, and apart from van der Helst, he was the only artist commissioned to do a group portrait of the regentesses of the Walloon Orphanage (fig. 792). Vaillant was one of the few artists in Holland who successfully produced pastel portraits, and he excelled also in mezzotints.

Landscape Painters

Landscape art in Amsterdam continued to thrive in great variety during the third quarter of the seventeenth century. Aert van der Neer, the only important member of the older generation of landscapists, remained active almost to the end of his long life; he died in 1677, at the age of about seventy-three.

Although Rembrandt himself painted relatively few landscapes, several landscape specialists were members of his circle. Foremost among these was Philips Koninck, who was trained by his older brother Jacob in Rotterdam and came to Amsterdam about 1640, the same year he married. Houbraken lists him as a pupil of Rembrandt, but Koninck reached Amsterdam at too old an age to have entered into a traditional master-pupil relationship. Since Rembrandt's studio was like an academy, however, it is possible that Konink worked there. He almost certainly belonged to Rembrandt's circle of friends, and the master's influence is clearly discernible in his earliest paintings and in his drawings. Seventeenth-century sources indicate that Koninck was more appreciated by his contemporaries for his portraits and figure paintings than for his landscapes, whereas it is the landscapes that we prefer today, because in them he developed his own personal style. His specialty was the panoramic landscape: from a high viewpoint, he gives a broad vista over a mainly flat landscape, a river always winding through it up to the horizon (cpl. 793, and see fig. 292). Trees and bushes provide horizontal accents, yet rarely intersect the horizon. The composition is enlivened by houses and farm buildings, sometimes also by villages and towns. The human figure is usually of subsidiary importance.

The panoramic landscape was not a new idea, having belonged to the standard program of landscape art since the time of Pieter Bruegel the Elder. But up to and including the work of Rembrandt, such landscapes had generally been imaginary and majestic, and more natural vistas appeared only in early drawings and prints. Philips Koninck gave all this a new dimension. He painted in large format, creating broad landscapes whose details were based on direct observation of nature. By his exciting use of color, daring brushwork, and extraordinarily successful balance between land and sky, he made an essential contribution to Dutch landscape art. He died in Amsterdam in 1688.

793　Philips Koninck
Extensive Landscape with a Hawking Party
Canvas, 132.5 × 160.5 cm. The National Gallery,
London

A similar bold palette is found also in the landscapes by Roelant Roghman. It is striking as well as strange that this artist, born in 1627, has received so little attention as a painter: he is known almost wholly for his topographical drawings. Even Stechow mentions Roghman's name only once in his distinguished *Dutch Landscape Painting*, and then in passing. Roghman has probably been overlooked because he painted only fantasy landscapes. His style is remarkably broad, and he worked with color accents in light blue, orange-red, and yellow. What is otherwise fascinating about his landscapes is the movement, expressed in the brushstroke and in all the forms: the great jutting crags, dancing water, and breeze-swept trees, for instance, of his *Mountainous Landscape* (fig. 794). His work strongly recalls the landscapes by his Italian contemporary Salvator Rosa, and those by Alessandro Magnasco, who worked a generation later. Whether Roghman was ever in Italy, as is sometimes suggested, remains uncertain, but not his friendship with Rembrandt and with Gerbrand van den Eeckhout, whose rare landscapes somewhat resemble Roghman's.

794

794 Roelant Roghman
Mountainous Landscape
Signed. Canvas, 80.5 × 100 cm. Rijksmuseum,
Amsterdam

795 Lambert Doomer
The Pont Neuf at Angers
Panel, 60 × 83.5 cm. Musée du Louvre, Paris

796 Lambert Doomer
Thistle, Pumpkin, and a Goat
Signed and dated 1675. Panel, 62.5 × 44 cm.
Statens Museum for Kunst, Copenhagen

795

796

Lambert Doomer also belonged to the group of landscape painters around Rembrandt. His father was a well-known Amsterdam frame maker, who had himself and his wife portrayed by the master in 1640, and sent his son to study with him. In 1646, Lambert visited his brother in Nantes, and then, together with Willem Schellinks, traveled back home through the Loire valley and Paris. His trips along the Rhine in Germany, and in Bavaria and Switzerland, during which he made many drawings, may have been taken on commission from the collector Laurens van der Hem. Doomer's few extant paintings are mostly topographical, portraying places he visited on his travels, such as Angers (fig. 795). They are often dark in tone, the buildings almost silhouetted against the lighter sky. He also produced broadly painted compositions that might be called landscape still lifes: goats being herded in a hilly landscape where thistles and melons or gourds fill the foreground (fig. 796).

These landscape painters can be considered the Rembrandt school, but many other artists in Amsterdam worked as landscapists. For the most part they—and the still-life painters and the painters of domestic figure pieces as well—came originally from elsewhere in the Netherlands, and we must first look at other art centers in this period before discussing these artists within the Amsterdam framework.

Painting in Haarlem: 1650–1680

The Haarlem school of painting in the third quarter of the seventeenth century, and especially at the beginning of that period, was largely characterized by the work of older artists. The group of portraitists was gradually whittled down, Hendrick Pot and Pieter Soutman both dying in 1657, Johannes Verspronck in 1662, and Frans Hals, active to the last, in 1666. The landscapist Salomon van Ruysdael lived until 1670, the still-life painter Willem Heda until 1680, and the painter of peasant life Adriaen van Ostade until 1685. In the rising younger generation were several extremely talented painters, among them Claes Berchem, Jacob van Ruisdael, and Philips Wouwerman, who kept the Haarlem art world alive and exciting, although Ruisdael left about 1656 or 1657 for Amsterdam, followed a bit later by Berchem. Because the remaining artists were less versatile in subject matter and style—after Frans Hals there were few portrait painters of any distinction, and no sea painters at all—Haarlem, though still vital, lost the leading position it had held during the first half of the century.

Portrait Painters: Frans Hals and Others

Frans Hals kept working deep into his seventies and perhaps (since his exact birth date is not known) into his eighties. Although he rarely dated his paintings, a number of portraits can be assigned with certainty to the period after 1650. Yet his commissions must have diminished, for in 1662 he was granted an annual stipend by the municipality.

Hals continued on his proven way in his manner of painting, and no trace of the new trends can be found in his portraits except for a very occasional use of lighter and brighter colors. On the contrary; whereas in other centers the "flattering brush" came more and more into fashion, Hals worked with increasing freedom and boldness. With daring strokes he set down lights and shadows that suggest a form only from a distance, but then magnificently. A splendid example is his lively portrait of the Amsterdam minister Herman Langelius (fig. 797), in which the brushstrokes are nearly wild in application. Langelius, an eloquent preacher, died in 1660 at the age of forty-six, so that the painting undoubtedly dates from the late fifties. It is interesting that an Amsterdammer sought out Hals to paint his portrait; as usual we don't know the reason, but the commission indicates that between 1655 and 1660, with van der Helst at the peak of his popularity, Hals remained appreciated. A poem published in 1660, however, voices criticism of the Haarlem artist.[1] Even if we skip over the customary complaint that no painter ever captures the true spirit of the person portrayed, and also ignore the traditional rivalry between Amsterdam and Haarlem, the verse remains an unusually harsh judgment of Hals's way of painting:

How dare you, old Hals, try to paint Langhelius?
Your eyes are too weak for his erudite rays,
And your stiff hand too rough and art-less
To portray the superhuman and peerless
Understanding of this man and teacher.
Let Haarlem boast of your art and early masterpieces,
Our Amsterdam will join with me to say aright
That you have not half caught the essence of this light.

Frans Hals's last large commissions, presumably about 1664, were for two group portraits of the regents and regentesses of the Old Peoples' Home in Haarlem (fig. 798 and cpl. 799). It has sometimes been stated, incorrectly, that Hals was forced to spend the last years of his life in this institution, a misconception that has led to much that has been written since the nineteenth century about the biting sarcasm with which Hals portrayed these officials, to avenge their alleged bad treatment of him. Such stories are complete fabrications and have been unequivocally disproved.[2] We can safely assume that the relationship between Hals and his patrons was perfectly straightforward, and that certain facets of the portraits, such as the "drunkenness" of the regent with his hat askew, are to be otherwise interpreted: this regent's expression was probably due to facial paralysis, not intoxication, and tilted hats appear in other seventeenth-century portraits. Nevertheless, Hals employed an extremely

797 Frans Hals
Portrait of Herman Langelius
Signed. c. 1660. Canvas, 76 × 63 cm. Musée de Picardie, Amiens

798, 799 Frans Hals
Regents of the Old People's Home, Haarlem
1664. Canvas, 172.5 × 256 cm
Regentesses of the Old People's Home, Haarlem
1664. Canvas, 170.5 × 249.5 cm. Frans Hals
Museum, Haarlem

unconventional manner of painting in these large canvases. His rendering of the hands, for instance, with a minimum of formal shaping, is quite extraordinary, given the general taste in portraiture at that time. Only Rembrandt, working with other ideas in mind, permitted himself a comparable freedom. Compositionally, Hals introduced no new ideas in his late paintings; it can even be argued that, compared with developments in spatial organization in Amsterdam, his design was behind the times.

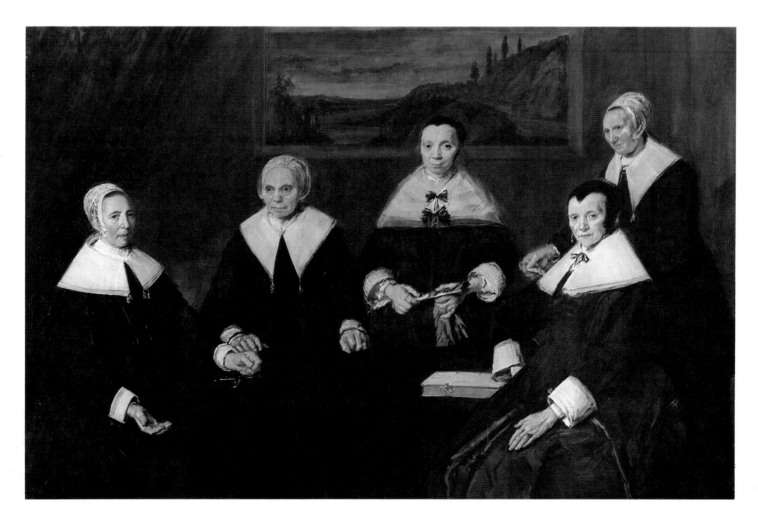

800 Jan de Bray
 Portrait of a Boy
 Signed and dated 1654. Panel, 59.5 × 47 cm.
 Mauritshuis, The Hague

801 Jan de Bray
 Regents of the Children's Charity Home, Haarlem
 Signed and dated 1663. Canvas, 187.5 × 249 cm.
 Frans Hals Museum, Haarlem

801

800

802 Jan de Bray
 Regents of the Leper Hospital, Haarlem
 Signed and dated 1667. Canvas, 142 × 197.5 cm.
 Frans Hals Museum, Haarlem

803 Jan de Bray
 Regentesses of the Leper Hospital, Haarlem
 Signed and dated 1667. Canvas, 141 × 197.5 cm.
 Frans Hals Museum, Haarlem

A young portrait painter meanwhile coming to the fore in Haarlem was Jan de Bray, son and pupil of the painter-architect Salomon de Bray. Portraits by Jan are known from 1650 onward, and he worked also as a history painter. His early portraits bear witness to a personal, uncomplicated approach. The 1654 *Portrait of a Boy* (fig. 800) is surprisingly direct and charming. This painting shows little trace of Hals's influence—not in the treatment of the face, but perhaps a bit in the pose. De Bray developed into a portraitist worthy of respect. His touch was sure, and he had no trouble with form and plasticity. In 1663 he was commissioned to paint the regents of the Children's Charity Home in Haarlem (fig. 801), and the following year he portrayed the regentesses of that institution, having previously made a painting of the newly admitted orphans being given food and clothing (see fig. 57).

Three years later de Bray received a commission to paint the men and women governors of the Haarlem Leper Hospital (figs. 802 and 803). He had more or less kept to the traditional Haarlem compositional scheme in his first two group portraits, but now he chose a new solution: he grouped the figures in each painting around a table placed short side foremost, in this way creating a deeper spatial effect, to which the solid verticals in the background contribute. De Bray otherwise adapted himself to the classicistic ideas: lighter colors throughout, and, in the picture of the regentesses, an even distribution of light.

De Bray further demonstrated his technical skill in his history paintings. The little panel, dating from 1659, of Judith about to decapitate Holofernes (fig. 804) reveals his instinct for

802

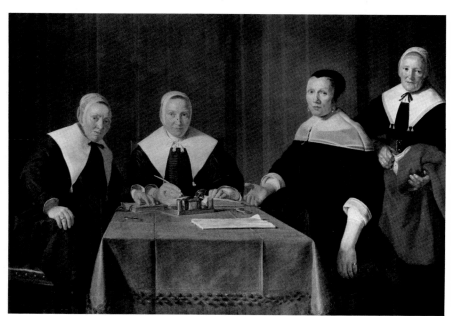

803

804 Jan de Bray
Judith and Holofernes
Signed and dated 1659. Panel, 40 × 32.5 cm.
Rijksmuseum, Amsterdam

805 Jan de Bray
The Banquet of Anthony and Cleopatra
Signed and dated 1669. Canvas, 248 × 190 cm.
Currier Gallery of Art, Manchester, New
Hampshire

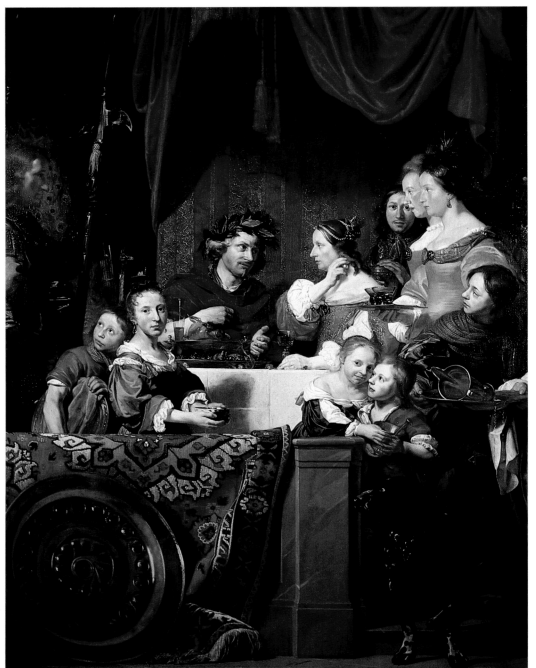

805

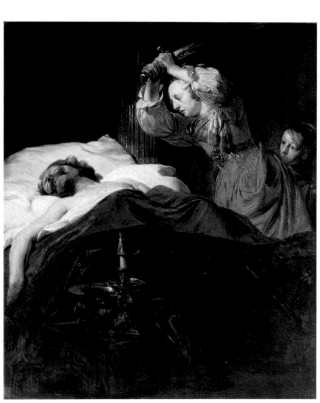

804

Baroque drama and is of high painterly quality. The figures in his history paintings often
look like portraits, which appears to have sometimes been the case: scholars have established
that in his large *Banquet of Anthony and Cleopatra* of 1669 (cpl. 805), de Bray portrayed his
parents in the leading roles, and himself (at the left, with a halberd) and his brothers and
sisters as the lesser figures.[3] The story, from Pliny, concerns Cleopatra's wager with
Anthony that she can consume a meal costing 10,000,000 *sesterces*, which she accomplishes
by melting a valuable pearl in vinegar and drinking it. The painting has certain
weaknesses—the rather stiff figures in the upper row at the right—but it is a splendid
example of de Bray's versatility and of his ability to handle large figure pieces. He was the
only important portrait painter left in Haarlem after Frans Hals died, and no one else came
along later. De Bray died in 1697.

Landscape Painters: Ruisdael, Berchem, and Their Followers

The Haarlem landscape painters were a considerably more varied and animated group than
the portraitists, and the most talented of them all was Jacob van Ruisdael, son of the frame
maker-painter-art dealer Izaack van Ruysdael (see p. 242). Jacob, who was born in 1628 or
1629, grew up in exceedingly favorable surroundings for a future painter: around him he
could watch the best landscape painters at work. First, there was his uncle Salomon, who
was at the peak of his powers in the 1630s and would continue to be an important painter in
Haarlem for years to come. Then there were the elder Ruysdaels' contemporaries, Pieter de
Molijn and Cornelis Vroom, both of whom worked in Haarlem until 1661; Claes Berchem,

806

806 Izaack van Ruysdael (?)
Village Scene with a Bleaching Field
Signed and dated 1646. Canvas, 102 × 127 cm.
Private collection

807 Jacob van Ruisdael
Sandy Path between Trees
Signed. Canvas, 42 × 45 cm. Museum
Boymans-van Beuningen, Rotterdam

808 Jacob van Ruisdael
Sandy Path in the Dunes
Signed. c. 1652. Panel, 32 × 42.5 cm.
Rijksmuseum, Amsterdam. On loan from the
City of Amsterdam

eight or nine years older than Jacob van Ruisdael and one of the most gifted of the
Italianate landscape painters, who worked mainly in Haarlem; and Allart van Everdingen,
who returned full of new ideas from his trip through Scandinavia to settle in Haarlem in
1644. So in the years 1645–55, as in 1612–13, Haarlem became the mecca for a group of
first-rate landscape painters.

It is generally assumed that Jacob was taught by both his father and his uncle. Up to now,
no extant work can be ascribed with certainty to Izaack unless it be a sunny and well-
painted townscape signed "I.V. Ruisdael" and dated 1646 (fig. 806). If this really is from the
father's hand, the early work of his son is in accord with it. But some of Jacob's earliest
paintings, from 1645 and 1646, such as the *Sandy Path between Trees* (fig. 807), correspond so
closely to works by Cornelis Vroom that direct contact and mutual influence between these
two painters may be assumed; a 1651 painting by Vroom now in Copenhagen shows
something of what he must have learned from Ruisdael.

During his career Jacob van Ruisdael undertook every kind of landscape within the
known scope of that genre. He began by painting the dune landscapes and forest views in
the immediate neighborhood of Haarlem. His early painting style is detailed, the foliage so
meticulously reproduced that each species of tree can be recognized. His colors are natural;

807

808

809 810

809 Jacob van Ruisdael
 Bentheim Castle
 Signed and dated 1651. Canvas, 99 × 82.5 cm.
 Private collection

810 Claes Berchem
 Landscape with Bentheim Castle
 Signed and dated 1656. Canvas, 138 × 103 cm.
 Gemäldegalerie Alte Meister, Staatliche
 Kunstsammlungen, Dresden

811 Claes Berchem
 Landscape with Resting Shepherds
 Signed and dated 1646. Panel, 46.8 × 56 cm.
 Szépmüvészeti Múzeum, Budapest

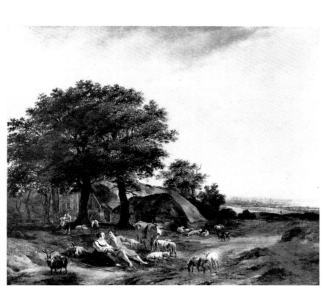

811

tonal painting, in which the palette is kept to a minimum range, never appealed to him. The motifs in such paintings as *Sandy Path in the Dunes* of 1652 (fig. 808) are borrowed from nature. Ruisdael seems to have painted what he saw, making no marked effort to create compositions of his own.

In 1646 Ruisdael painted the first of his numerous views of Egmond aan Zee, a fishing village in the dunes along the North Holland coast, giving new evidence of his interest in different kinds of Dutch landscape. The version we reproduce (see fig. 284) is undated, but belongs to the early period. The whole scene is backlighted. The village huddles at the foot of its church, whose massive brick tower juts into the sky. The lively silhouette of the tower and the low houses with the light skimming playfully over their red-tiled roofs—an effect Ruisdael later used in his famous views of Haarlem—stands out sharply against the calm, sunset-bright sea.

Ruisdael developed rapidly. In the early 1650s he took a trip to western Germany, perhaps with Claes Berchem, who, according to Houbraken, was Ruisdael's good friend and more than once painted the figures in his landscapes.[4] On this journey Ruisdael presumably made sketches (now lost) which he later transformed into paintings that attest to a surprising view of nature and a highly original way of setting down his ideas—"surprising" and "original" because Ruisdael, veering away from his predecessors, reveals a predilection for the romantic and the monumental, and an ability to assimilate these into realistic, recognizable landscapes. His 1651 interpretation of the landscape around Bentheim Castle just over the German border introduced a new grandeur into Dutch art (fig. 809). He continued for the rest of his life to paint views of the castle in at least twelve different versions.[5] Berchem's rendition of the same scene (fig. 810), though painted in 1656 and dominated by his typical Italianate staffage, lends credence to the assumption that the artists had traveled together some years earlier.

Jacob van Ruisdael moved to Amsterdam about 1656 and spent the rest of his life there. The further development of his art will therefore be discussed in the second part of our chapter on that city (see p. 462).

The work of Claes Berchem, often called Nicolaes Berchem, is very different from Ruisdael's, although the two artists shared a many-sided interest in their subject and great technical and compositional skill. Berchem was the son of the Haarlem still-life painter

382

Pieter Claesz. According to Houbraken, he studied under his father and later under Jan van Goyen, Claes Moeyaert, Pieter de Grebber, Jan Wils, and Jan Baptist Weenix. Weenix was a year younger than Berchem, however, so it seems unlikely that he was his teacher. In 1642 Berchem entered the Haarlem St. Luke's Guild. Whether or not he then went to Italy remains uncertain. In the absence of trustworthy documentary evidence, only the artist's work can provide clues about his foreign travel, but it is extremely difficult to prove that a painter knew a particular type of landscape—in this case, Italianate—from personal observation and not from seeing the work of others. Berchem's work is so often suffused with a wonderfully natural southern atmosphere that he may be cautiously assumed to be one of the Dutch artists who knew the Italian landscape at first hand.[6] The most probable

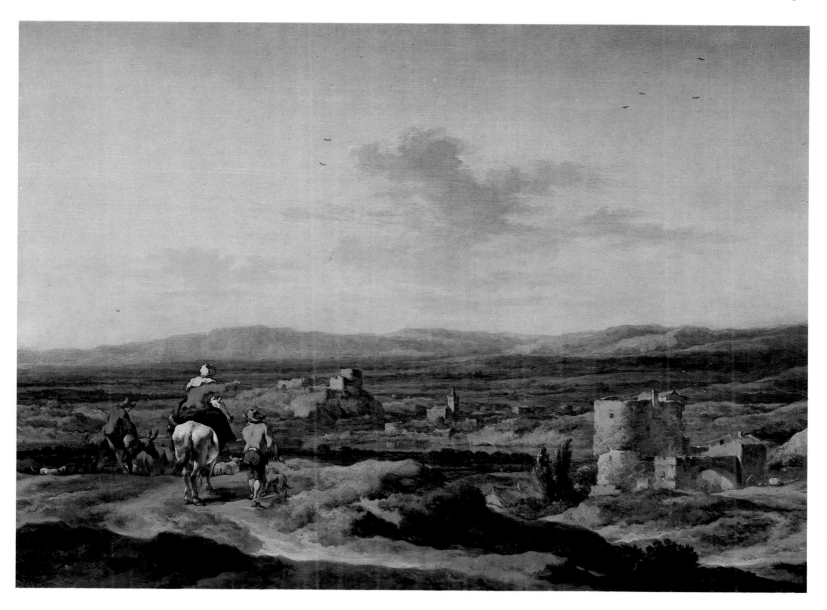

812　Claes Berchem
Italian Landscape with Ruins and Figures
Signed and dated 1655. Canvas, 33.5 × 44.7 cm.
English Royal Collections. Copyright reserved

dates for his stay in Italy are thought to be either 1642–43, when he may have traveled with Weenix, or, more likely, about 1653–54.

In his choice of subject matter and of the figures with which he peopled his landscapes, Berchem's earliest paintings, from about 1644 to 1650, show the influence of the Italian street scenes popularized by Pieter van Laer, who was in Haarlem in 1639–42. The work of Jan Both and Jan Baptist Weenix, members of the Utrecht Italianate school, appears also to have influenced Berchem from time to time, as did the Dutch type of landscape, which he rendered in his bucolic *Landscape with Resting Shepherds* (fig. 811).

Berchem's style changed during the 1650s, and especially after 1655 the Italian landscape emerges in full glory with a distinctly personal touch in his paintings, though traces remain of Both's influence and Jan Asselijn's now appears in the treatment of light. A warm, radiant light bathes the broad *Italian Landscape with Ruins and Figures* of 1655 (cpl. 812), with a river coursing through the valley and blue hills rising in the distance. The illumination in *The Three Droves* (fig. 813) is entirely different, for Berchem uses a subtle and evocative backlighting that, like the brownish-orange tones of the painting, is reminiscent of Both's work. The herders and their flocks show Berchem's mastery of figure painting. His Italian

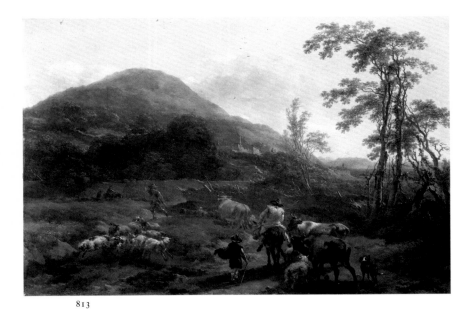

813

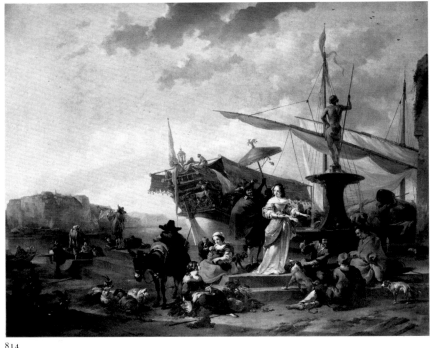

814

813 Claes Berchem
The Three Droves
Signed and dated 1656. Panel, 44 × 66.5 cm.
Rijksmuseum, Amsterdam

814 Claes Berchem
The Old Port of Genoa
Signed. Canvas, 84 × 105 cm. The Wallace
Collection, London

815 Guillam Dubois
Woody Landscape
Signed and dated 1649. Panel, 59 × 82 cm. Herzog
Anton Ulrich Museum, Brunswick, West
Germany

harbor scenes, such as *The Old Port of Genoa* (fig. 814), gave him even greater opportunity to exploit his talent for figures and to contrast sparkling light with deep shadows.

Berchem is recorded in Amsterdam in 1660 and in 1677, and probably settled there permanently after 1677. His *Allegory on Amsterdam* (see fig. 76) reveals one more side of his talents; he was considerably experienced in allegorical subjects, for he was an excellent draftsman and etcher and received commissions to design allegorical decorations for some of the maps being published in Amsterdam, by Claes Jansz Visscher, among others.

Jacob van Ruisdael and Claes Berchem represent two currents in landscape art, each having its followers in Haarlem. A remarkably large number of painters worked in Ruisdael's immediate sphere of influence, artists less gifted than he, yet sometimes making attractive paintings, and it would be unjust to omit them.[7] Moreover, we must constantly bear in mind that the best works of these lesser artists may become attributed to greater masters, in this case to Ruisdael, the original signatures all too often eliminated or altered.

Guillam Dubois was probably several years older than Ruisdael (his birthplace and date are unknown) but both were registered in the Haarlem guild in the same year, 1648. Dubois' choice of landscape themes was much like Ruisdael's—forest views, dune landscapes, beach views—and he also produced mountain landscapes in the manner of Allart van Everdingen. When he managed to capture a good fall of light, as in his *Woody Landscape* of 1649 (fig. 815), his work has poetic value.

Cornelis Decker, born in Haarlem sometime before 1623, concentrated mainly on painting rural dwellings, taking special care to render the structure of the roofing, whether

815

816 Cornelis Decker
Farmhouse beside a Canal
Signed and dated 1652. Panel, 47 × 63.5 cm.
Private colletion

817 Roelof van Vries
Cottages along a Forest Path
Signed. Panel, 61 × 84.7 cm. Städelsches
Kunstinstitut, Frankfurt am Main

tiled or thatched, and of the brick walls or plank sidings (fig. 816). A number of his interiors of weavers' workshops have also survived. Also among the landscape painters were Jacob van Ruisdael's first cousin Jacob Salomonsz van Ruysdael, Roelof van Vries (fig. 817), Gerrit van Hees (fig. 818), Gillis and Salomon Rombouts (fig. 819), and Klaas Molenaer (fig. 820), the last two also painters of winter landscapes.

Whereas these painters seldom achieved more than middling results, another artist following in Ruisdael's footsteps, Jan Vermeer II van Haarlem, produced more noteworthy work. He was not related to the famous Johannes Vermeer of Delft. An almost exact contemporary of Ruisdael, this Jan Vermeer specialized in panoramic vistas, always viewed inland from the coastal dunes (fig. 821). His paintings have spaciousness and atmosphere,

816

817

819

818

818 Gerrit van Hees
Landscape with Cottages
Signed and dated 1650. Panel, 76 × 106.5 cm.
Frans Hals Museum, Haarlem

819 Salomon Rombouts
Cottage among Trees near a Pool
Signed. Panel, 54 × 46.5 cm. Museum
Boymans-van Beuningen, Rotterdam

820 Klaas Molenaer
Bleaching Fields
Signed. Panel, 35 × 47 cm. Museum
Boymans-van Beuningen, Rotterdam

820

821

821 Jan Vermeer II van Haarlem
View of the Dunes
Signed. Panel, 33 × 63 cm. Gemäldegalerie Alte
Meister, Staatliche Kunstsammlungen, Dresden

822 Claes Hals
View of Haarlem from the Dunes
Signed. Canvas, 66 × 83.5 cm. Private collection

823 Hendrick Mommers
Italian Peasants Resting
Signed. Canvas, 81 × 105 cm. Nationalmuseum,
Stockholm

824 Willem Romeyn
Italian Landscape with Cattle and Herdsmen
Signed. Panel, 35 × 41 cm. Private collection

822

with well-observed cloudy skies and on the ground broad shaded areas interspersed with
great sun-drenched patches. Claes Hals, one of Frans Hals's five sons, also painted a few
small masterpieces of this sort, such as his *View of Haarlem from the Dunes* (fig. 822).

Among the group painting more Italianate landscapes were Hendrick Mommers and
Willem Romeyn, both pupils of Berchem. Mommers' pleasant scenes, usually set near
antique ruins and other buildings, have vegetable vendors or shepherds and flocks, and
almost always a woman in a large, broad-brimmed hat (fig. 823). Romeyn specialized in
small pictures of cattle and sheep grazing in a mountainous landscape (fig. 824).

The paintings by Jan Wijnants are more attractive. He was born in Haarlem at an

823

824

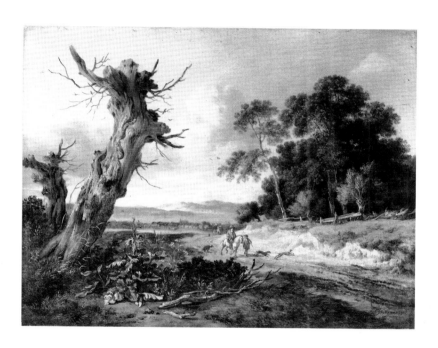 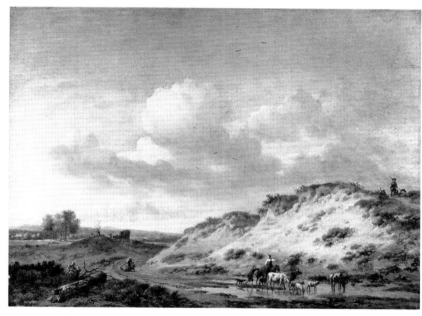

825 Jan Wynants
Landscape with Two Dead Trees
Signed. Panel, 29 × 36.8 cm. The National
Gallery, London

826 Jan Wynants
Peasants Driving Cattle and Sheep by a Sand Hill
Signed. Panel, 28.6 × 38.1 cm. The National
Gallery, London

unestablished date, but probably about 1620–25. His early works are more or less related to those of Decker and Dubois, but he later began to specialize exclusively in dune landscapes and, no doubt under the influence of the Italianate painters, to introduce a more southern light and atmosphere into this purely Dutch landscape type. Wijnants was a prolific painter, though much of his work is mediocre, with clichés such as a large stump or pollard willow appearing repeatedly in the foreground of his compositions. At his best, however, as in his two small panels in the National Gallery, London (figs. 825 and 826), he achieves unexpected effects by a restrained use of color and an interesting fall of light. The figures in his works were usually painted by other artists, particularly his pupil Adriaen van de Velde or Johannes Lingelbach. In 1660 Wijnants moved to Amsterdam, where he died in 1684.

Philips Wouwerman's work sometimes so closely resembles Wijnants' that confusion can arise. They must have influenced each other; it is not clear who was the giver, who the taker, but there is no question of which was the more talented artist. Wouwerman, born in Haarlem in 1619, seems to have been gifted by nature with the ability to paint effortlessly and with phenomenal technique, almost never slackening in quality. He was a sensitive colorist with a feeling for atmosphere and narrative. Most of his paintings are on panels of small format, and his landscapes, silver-gray and blond in tone, are peopled with many little figures, acutely observed as they go about their activities. From the beginning Wouwerman delighted in painting horses, so much so that a white horse has sometimes been considered, incorrectly, as his trademark. No other Dutch artist painted horses in so many different contexts and with so much skill as he. At first he portrayed ordinary, rather bony animals, such as *The Gray Horse* (fig. 827), but later he preferred more spirited horses, depicting them in army camps, cavalry charges, and hunting parties (fig. 828). These scenes full of action reveal his great talent for composition in their structure and variety.

Wouwerman enjoyed enormous success during his lifetime; his work was sought after and commanded high prices. His fame extended well into the nineteenth century, and Russian, German, and English collectors continued to vie over his paintings, which satisfied their taste for a light palette, elegant subject matter, and technical perfection. Two of Wouwerman's brothers, Pieter and Jan, were also painters; Jan's work is inferior, but Pieter occasionally approaches Philips' competence.

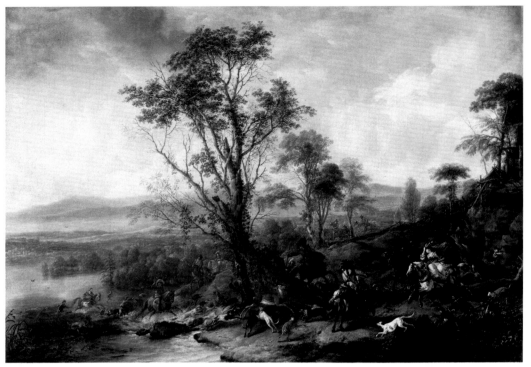

828

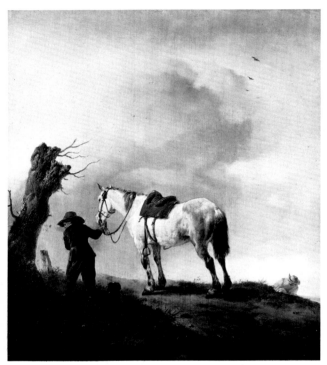

827

827 Philips Wouwerman
The Gray Horse
Signed. Panel, 43.5 × 38 cm. Rijksmuseum,
Amsterdam

828 Philips Wouwerman
Stag Hunt
Signed. Canvas, 75 × 104.2 cm. The National
Gallery, London

829 Adriaen van Ostade
An Alchemist
Signed and dated 1661. Panel, 34 × 45.2 cm. The
National Gallery, London

Technical skill came to be almost a keynote of Dutch painting in the second half of the seventeenth century. There is much to be admired, but one must wonder today about how far the cult of technical perfection may have gone toward killing inspiration (a word rarely employed with reference to painting in the seventeenth century). The matter seems to rest in an uneasy balance, with sterile perfection on one side and, on the other, the mastery of a technique that supports and enhances the product without dominating it. It is clear that nineteenth-century taste tipped the scales in favor of technique until Impressionism swung them the other way, yet as late as 1910 von Wurzbach called Philips Wouwerman "an extraordinary, a phenomenal talent, a genius without peer."[8]

Figure Painters: Adriaen van Ostade and His Followers, and Jan Steen

Adriaen van Ostade's post-1650 work displays this urge for perfection. At first it is not disturbing, for his control of color and tone was excellent. *An Alchemist* of 1661 (fig. 829) is a fine example of his ability to combine precision of detail with a strong feeling for space and light. The colors are restrained: grays, blue-grays, and browns in many subtle tints, and accents in local colors. The figures and objects in the background are subdued in tone and a bit less defined, increasing the depth of the picture.

Two years later Ostade produced *A Painter in His Studio* (cpl. 830); with its sensitive treatment of light, this painting gives an idea of what a seventeenth-century studio must

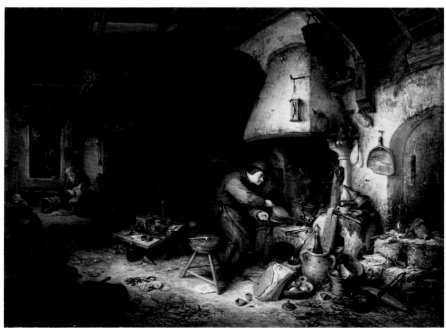

829

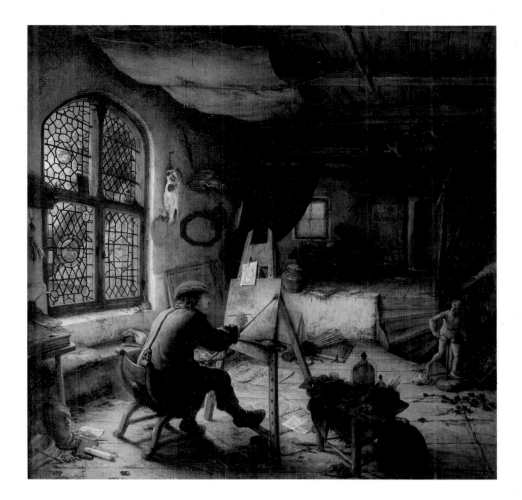

830 Adriaen van Ostade
A Painter in His Studio
Signed and dated 1663. Panel, 38 × 35.5 cm.
Gemäldegalerie Alte Meister, Staatliche
Kunstsammlungen, Dresden

831 Adriaen van Ostade
Peasants in a Tavern
Signed and dated 1679 (1674?). Panel, 49.5 × 62.5
cm. Gemäldegalerie Alte Meister, Staatliche
Kunstsammlungen, Dresden

have looked like. The painter is working on a panel placed on an easel, with a clamped-up
sketch to go by. He is supporting his arm on a maulstick, and beside him on a plank atop a
broken stool are bottles of oil and turpentine, extra brushes, rags, and other paraphernalia.
More equipment, including a jointed wooden manikin, lies scattered about the room. Light
falls through a large window on the left, and to improve the reflection the artist has hung a
big sheet of white cloth on the ceiling. In the background a pupil is grinding pigments.

The figures in Ostade's paintings are usually all the same type. He was apparently more
interested in his models' activities than in their individual characteristics, and he liked to tell
a story. His work after 1670 tends to be somewhat lighter and brighter in tone than his
earlier paintings, but he maintained a high standard in his best pieces, such as *Peasants in a
Tavern* (fig. 831). Where his work falls short is in the watercolor drawings that he made at
the end of his life. These watercolors are so carefully worked out that they can be
considered independent works of art, yet they lack tension, and the colors and details no
longer function harmoniously within the whole.

Cornelis Dusart, one of Ostade's last and youngest pupils (he was born in 1660), took

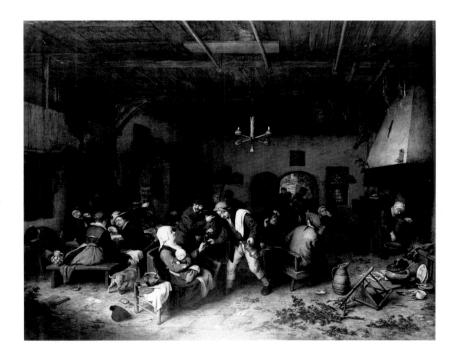

over his master's weaknesses rather than his strengths. Some of his paintings—*The Organ Grinder* of 1681 (fig. 832), for instance—are deceptively close to works by Ostade, but Dusart's compositions are usually weaker and his handling of color less well balanced. It is known from the inventory of his estate and other contemporary documents that Dusart completed a number of paintings left unfinished by Ostade at the time of his death in 1685.[9]

A much earlier pupil, Cornelis Bega (born about 1632), developed a more personal style. On his mother's side, Bega was a grandson of Cornelis van Haarlem. In 1653 he joined Vincent Laurensz van der Vinne's leisurely journey through Germany and Switzerland (see p. 59), but no traces of this trip show in his work. He liked to paint interiors with groups of peasants, and Ostade's direct influence in these paintings is very clear, but Bega nevertheless set his own stamp on his work by often using a palette of almost pastel colors, with reds and pinks combined with blues and grays. His most personal and attractive paintings are those depicting only one or a few persons in an interior, such as his dozing young woman of 1663 (fig. 833). His rendering of figures is strong in his paintings and in his many drawings.

An eighteenth-century source reports that Jan Steen also studied under Adriaen van Ostade.[10] To judge from Steen's early work, this information is probably correct. More important for Haarlem, however, is the fact that he lived there for about eight years, from 1661 to 1669. The problem lies in determining what he accomplished in Haarlem, and what effect, if any, the town and its painters had on his work during these years.

Despite a number of dated paintings, scholars have not yet been able to draw up a trustworthy chronology of Steen's oeuvre. He was amazingly versatile and had the ability to make works of extremely varied character and style within a short span of time. A division into approximately early, middle, and late works can be set up, and there has recently been a quite successful attempt to establish greater chronological exactitude.[11] It is now certain that Steen's Haarlem period was a particularly productive one, and that his quality then was remarkably high. Yet the influence of the Haarlem milieu is not specific, save that the breadth with which he painted *The Way You Hear It Is the Way You Sing It* (fig. 834) may be derived in part from Frans Hals. Steen can hardly have avoided knowing Hals's work, and he provides his own evidence that he did know it: hanging on the wall in several of Steen's interiors is his reproduction of Hals's rendition of *Peeckelhaering*, a popular character of comic theatrics. Steen was apparently too independent, however, to let himself be influenced very long by anybody.

If Haarlem left few traces on Steen, he in turn left little mark on the painters there. Occasional elements in Egbert van Heemskerck's paintings indicate that he knew Steen's work. Heemskerck was a pupil of Pieter de Grebber but was later strongly influenced by Jan Miense Molenaer. Hendrick Mommers' pupil Richard Brakenburg, born in 1650, was just old enough to profit from Steen's presence in Haarlem, and was clearly influenced by

832 Cornelis Dusart
The Organ Grinder
Signed and dated 1681. Panel, 29 × 23.5 cm.
Städelsches Kunstinstitut, Frankfurt am Main

833 Cornelis Bega
Woman in an Interior
Signed and dated 1663. Canvas, 36 × 27 cm.
Private collection

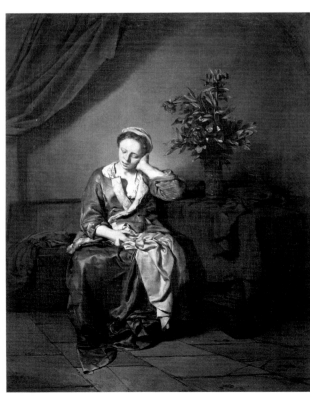

833

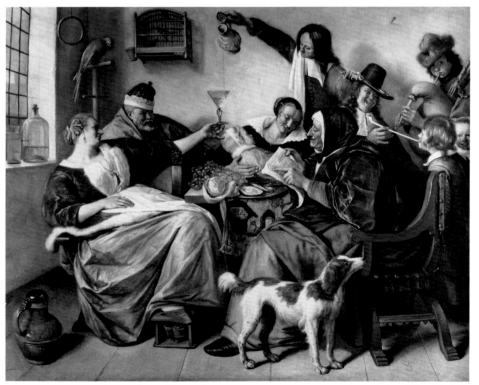

834

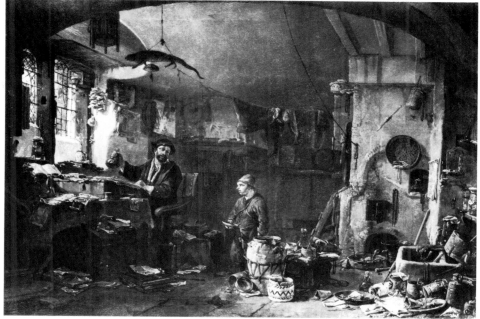

836

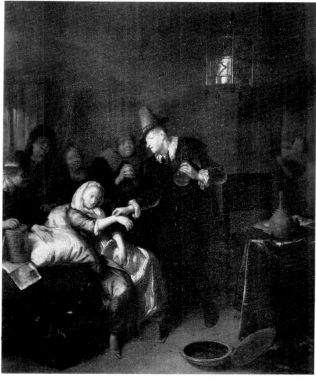

835

835 Richard Brakenburg
The Doctor's Visit
Signed and dated 1696. Canvas, 47 × 40.5 cm.
Museum Boymans–van Beuningen, Rotterdam

836 Thomas Wijck
An Alchemist
Signed. Canvas, 39 × 56 cm. Formerly Staatliche
Kunstsammlungen, Dresden. Destroyed during
World War II

837 Salomon van Ruysdael
Still Life with Game Birds
Signed and dated 1661. Canvas, 112 × 85 cm.
Musée du Louvre, Paris

◁

834 Jan Steen
"The Way You Hear It Is the Way You Sing It"
Canvas, 134 × 163 cm. Mauritshuis, The Hague

him. As his *Doctor's Visit* (fig. 835) makes evident, however, Brakenburg's talent was too slight to make him a worthy successor to Steen.

The other Haarlem painters who chose daily life as their subject were of minor importance. Thomas Wijck was the best of these, and he followed the Italianates for his open-air scenes and Adriaen van Ostade for his interiors. These interiors, usually with a philosopher or an alchemist (fig. 836), are crammed with excessively glittering objects that create an uneasy effect.

Still-Life Painters

Of Haarlem still-life painters, Willem Claesz Heda survived until 1680 or 1682, but after 1665 no signed works by him are known, and it is uncertain how long he continued to paint. Nor do we know of any late works by his son and pupil Gerrit Heda or by another pupil, Maerten Boelema de Stomme (the Mute), both of whom followed their master closely in style and developed no points of view of their own.

There was indeed little to animate still-life painting in Haarlem. Salomon van Ruysdael

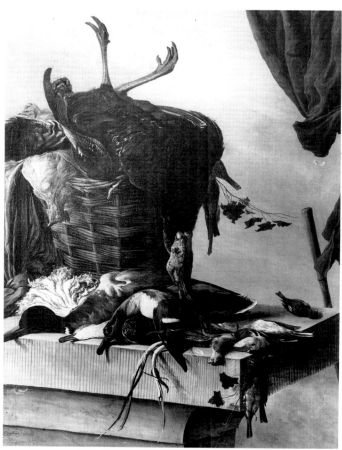

837

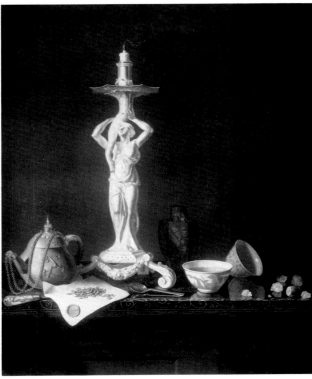

840

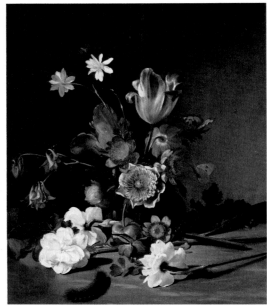

838

839

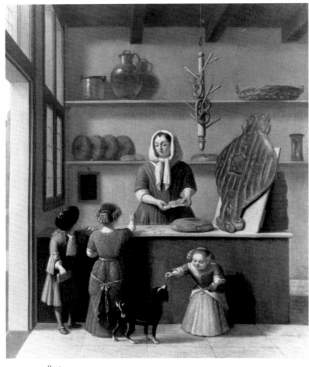

841

838 Dirck de Bray
Still Life with Flowers
Signed and dated 1674. Panel, 41 × 35 cm. Private
collection, Netherlands

839 Jozef de Bray
Still Life in Praise of Pickled Herring
Signed and dated 1656. Panel, 57 × 48.5 cm.
Gemäldegalerie Alte Meister, Staatliche
Kunstsammlungen, Dresden

840 Pieter van Roestraten
Still Life with Expensive Objects
Canvas, 72 × 59.5 cm. Museum Boymans-
van Beuningen, Rotterdam

841 Job Berckheyde
The Baker's Shop
Signed. Canvas, 48 × 39.5 cm. Allen Memorial
Art Museum, Oberlin College, Ohio

produced a few striking still lifes of dead game birds (fig. 837), and Dirck de Bray, brother
of Jan de Bray and known primarily for his woodcuts and etchings, made some attractive
still lifes, including game and flower pieces (fig. 838); his contrasts of light are very subtle.
Another de Bray brother, Jozef, also painted still lifes, among them the delightful *In Praise
of Pickled Herring* (fig. 839), which he rendered in several versions. Vincent Laurensz van der
Vinne, a pupil of Frans Hals who painted landscapes and portraits, made a few *vanitas* still
lifes, but very little of his work has been preserved. All of these artists seem to have painted
still lifes only sporadically.

Interesting work was produced by Pieter van Roestraten, another pupil of Frans Hals,
one of whose daughters he married in 1654. Roestraten's figure paintings are not important,
but he developed an original style in his still lifes: he painted portraits, as it were, of
expensive and exotic objects—fine porcelain and silver, pearl-handled knives, rare
geological specimens—arranged simply on a tabletop or stone slab. Sometimes he added
such *vanitas* elements as a burning candle (fig. 840). Roestraten should perhaps not be
counted as a Haarlem painter, for his marriage took place in Amsterdam, and he later went
to London, where he died in 1700.

Townscape Painters: The Berckheyde Brothers

The Berckheyde brothers of Haarlem contributed a special type to architectural painting.
Developing from the accomplishments of their fellow townsman Pieter Saenredam, and
quite independent of Jan van der Heyden's work in Amsterdam, they became highly
satisfying and individualistic painters of the townscape.

Job Berckheyde, born in 1630, was the elder of the two and the more versatile. In
addition to townscapes and church interiors, he painted burghers figure pieces such as *The
Baker's Shop* (fig. 841), and biblical scenes. His view of the Oude Gracht in Haarlem (fig.
842), depicting a canal now filled in, is perhaps the most attractive of his townscapes,
attesting to his fresh eye for the city scene. He sometimes sought his subject matter in
Amsterdam, and his view of the Amsterdam Bourse (see fig. 342) shows his able handling
of strongly contrasting light values.

Gerrit, Job's junior by eight years, was presumably trained by him. While still young, the
brothers took a long trip up the Rhine, visiting Cologne and Heidelberg. Gerrit's views of
German cities, such as the exceptionally pleasant little street scene in Cologne (fig. 843), are
probably souvenirs of this journey. Gerrit painted exclusively townscapes, mostly of
Haarlem, Amsterdam, and The Hague; church interiors (see fig. 23); and a few views of
country manors. Within these limits, and despite his enormous productivity, he reached and
maintained an unusually high level, even in repeated versions of such subjects as the Grote
Markt in Haarlem (fig. 844) and the Amsterdam town hall (see fig. 751). The tone of his
paintings is mainly light and sunny, but he was also skilled at backlighted views that cast
fascinating, heavy shadows (fig. 845). Job and Gerrit Berckheyde lived in the same house in
Haarlem, tended by their sister; Job died in 1693, Gerrit in 1698.

842

843

844

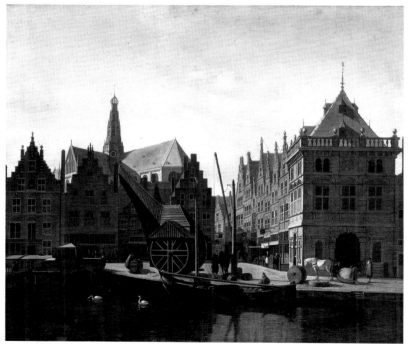

845

842 Job Berckheyde
 The Oude Gracht, Haarlem
 Signed and dated 1666. Panel, 44.5 × 39.5 cm.
 Mauritshuis, The Hague

843 Gerrit Berckheyde
 Street in Cologne with the Apostelkirche
 Signed. Canvas, 53 × 63 cm. Staatliches Museum,
 Schwerin

844 Gerrit Berckheyde
 The Grote Markt with the St. Bavo Church, Haarlem
 Signed and dated 1696. Canvas, 69.5 × 90.5 cm.
 Frans Hals Museum, Haarlem. On loan from the
 State-owned Art Collections Department

845 Gerrit Berckheyde
 View of the Weigh House and the St. Bavo Church,
 Haarlem
 Signed and dated 1667. Panel, 44 × 53 cm. Musée
 de Douai, France

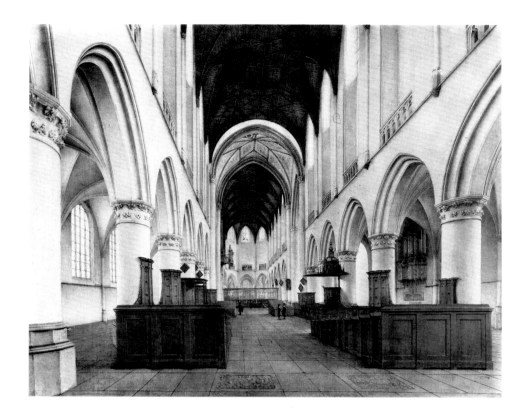

846 Isaac van Nickelen
Interior of the St. Bavo Church, Haarlem
Signed. Canvas, 106 × 124.5 cm. Private
collection

In addition to the Berckheydes, Isaac van Nickelen painted church interiors, almost always choosing St. Bavo's in Haarlem as his subject (fig. 846). He was obviously influenced by Saenredam. The Haarlem church painters differ from those of Delft: they work with limited contrasts of light and usually select a fairly simple point of view, seldom devising illusionistic effects.

Gerard Ter Borch and Other Painters in Zwolle, Deventer, and Kampen

Our major reason for turning our attention to the eastern area of the seven United Provinces can be stated quite simply: Gerard Ter Borch lived and worked there. Otherwise the old IJssel towns—so called because they lie along the IJssel river—contributed virtually no distinguished painters, but by contrast produced a good many experts in sculpture and the applied arts—goldsmiths and silversmiths, brass founders, and glaziers. Zwolle, Deventer, and Kampen are very old towns that were flourishing vigorously when Amsterdam was only a fishing village. Deventer was mentioned as a trading center in the ninth century, gained municipal rights in 1143, and prospered greatly as a Hansa town in the thirteenth century. Together with Zwolle, it was the center of the secular religious movement, founded by Gerhard Groote about 1380, known as the Brothers of the Common Life or the Modern Devotion, one of the founts of humanism. In the sixteenth century the IJssel towns were overshadowed economically by those of Holland, but Zwolle and Deventer remained prosperous.

Geographical isolation does not explain the dearth of painters in this region, for the connections with Amsterdam were excellent, and a lively trade existed along the route from the west via the Zuider Zee and the IJssel River to the German hinterland. Indeed, as Ter Borch's experiences prove, there was no question of isolation. Gerard traveled more widely in his youth than almost any other painter of his time, and he took full advantage of everything Holland offered. Later, as a mature artist living in Deventer, he received commissions from wealthy families in the western provinces and had direct influence on figure painters in Amsterdam and elsewhere.

The first of the eastern Dutch painters to make a mark was Hendrick Avercamp, who studied in Amsterdam, as we have seen (p. 197). After his return to his birthplace, Kampen, in 1613, he quietly proceeded to work away at his favorite theme, recreation in a wintry landscape. If he felt isolated, and there is no real reason to think that he did, it came more likely from his disability of muteness than from his remoteness from lively art centers. Hendrick found a follower in his nephew, Barent Avercamp, who was considerably less talented. Barent's ice scenes have a certain charm (fig. 847), not for their painterly qualities

847 Barent Avercamp
Winter Landscape
Signed. Panel, 19 × 31 cm. Gemäldegalerie,
Staatliche Museen, West Berlin

848 Gesina Ter Borch
A Banquet Out-of-Doors
c. 1660. Watercolor and gouache, 25.4 × 37 cm.
Print Room, Rijksmuseum, Amsterdam

848

849

849 Moses Ter Borch
Portrait of His Father, Gerard Ter Borch the Elder
Dated 1660. Black and white chalk on blue paper,
29.5 × 23.3 cm. Print Room, Rijksmuseum,
Amsterdam

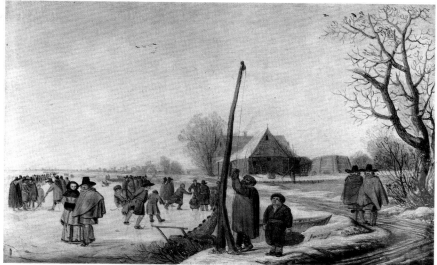

847

but for the general attractiveness of the subject and for his rather naive portrayal of the figures.

Barent Avercamp and Gerard Ter Borch were near contemporaries—Avercamp was born about 1612–13, Ter Borch in 1617, and they died within two years of each other—but there is a world of difference in their work. A good deal is known about both of their lives, and Gerard Ter Borch is perhaps the best-documented Dutch artist of the seventeenth century: hundreds of drawings, letters, and albums belonging to the Ter Borch family have been preserved. This rich collection was stored in a house the family had owned in Zwolle and remained intact until 1886, when it was placed in auction; the Print Room of the Rijksmuseum was able to purchase almost all of it.

Gerard Ter Borch was born in Zwolle, the eldest son of wealthy parents. His father, Gerard Ter Borch the Elder, had tried his hand at drawing and painting in his youth, and had made a trip to Rome. In 1621 he was appointed receiver of customs and licenses in Zwolle, an important civil-service post, and apparently gave up his artistic efforts, but he remained interested in art and in his collection of drawings. He passed on his artistic flair to three of his thirteen children—to Gerard, son of his first marriage, and then to Gesina and Moses, children of his third. Gesina's talent was modest, but the many drawings in her albums, often accompanied by poems, give a unique picture of a well-to-do, art-minded family of the period. She recorded family events—parties (fig. 848), visits, illnesses, and deaths. Excellent drawings by Moses, such as his portrait "drawn from life" of his father (fig. 849), have been preserved, but this gifted young man joined the Dutch navy and died in the famous raid on Chatham led by Admiral de Ruyter in 1667.

The young Gerard Ter Borch thus grew up in ideal surroundings, and his father did everything possible to assure him the best education. He early recognized the boy's talent and proudly noted on a drawing by the nine-year-old Gerard: "My son Gerrit drew this from life on 24 April anno 1626 in Zwolle" (fig. 850). Gerard's drawings permit us to trace his development step by step, from his eighth year on. From the start he was strongly interested in horses, town views, and above all people.

In 1633 Gerard, then sixteen, made his first trip to Amsterdam, and later in that year he became a pupil of Pieter de Molijn in Haarlem. This choice of teacher is somewhat puzzling, for, certainly at that time, Molijn was primarily a landscape painter, though he sometimes made small figure pieces. Gerard finished his apprenticeship in two years and was taken into the Haarlem guild as master in 1635. Drawings from this period clearly show the influence of the Haarlem school, in both style and choice of subject. Gerard then set out for London, on the first of several trips abroad. While there he worked for his uncle, the engraver Robert van Voerst (his mother's brother), and became acquainted at first hand with portraiture in the elegant court style and in particular with Anthony van Dyck's portraits.

A letter from the elder Ter Borch (fig. 851) at this time is full of delightful details. Gerard's father writes that he is sending a trunk containing, among other things, garters, handkerchiefs, woolen caps, and lengths of cloth "for your everyday clothing," and, most important, a *leeman* or artist's manikin, with the following instruction: "Don't let him lie around, as he has done here, but draw a lot: big and turbulent compositions." More

850

851

850 Gerard Ter Borch
Standing Officer
Dated 1626. Black chalk, 13 × 13 cm. Print
Room, Rijksmuseum, Amsterdam

851 Letter of Gerard Ter Borch the Elder to his son
Gerard, July 3, 1635. Fondation Custodia
(Collection F. Lugt), Institut Néerlandais, Paris

852 Gerard Ter Borch
Portrait of a Gentleman
c. 1640. Copper, 48 × 35 cm. Virginia Museum
of Fine Arts, Richmond. Gift of Mrs. A.D.
Williams, 1949

853 Gerard Ter Borch
Portrait of a Lady
c. 1640. Copper, 48 × 35 cm. Virginia Museum
of Fine Arts, Richmond. Gift of Mrs. A.D.
Williams, 1949

drawing materials were in the trunk: "I'm sending you drawing cases full of your new long brushes, 2 books of paper, black chalk and all the clean paints, and 6 of Mattham's pens." The letter ends with classic paternal advice: "Therefore serve God in all things, and be polite, humble, and obliging toward everyone, and it will go well with you."[1]

Robert van Voerst died of the plague in 1636, and Gerard returned to Zwolle, to depart soon afterward on a long trip to Italy and presumably on to Spain. Drawings and letters from this period have not survived, nor did Italian art have any discernible influence on Ter Borch's style. There are traces in his later portrait style, however, of his sojourn in Spain, which may not have followed immediately upon his visit to Italy but definitely did take place: he is thought to have carried out portrait commissions in Spain. At last, after a possible stay in France and the Southern Netherlands, Ter Borch returned in 1640 to Holland, where he worked in Amsterdam until 1645 and for a time in Haarlem. By then he had made a name as a portrait painter, specializing in miniature-like, bust-length portraits and small full-length portraits (figs. 852 and 853). He continued to produce portraits of the latter type throughout his entire career, depicting his model standing in a space whose shadows and a few horizontal lines define an empty, neutral background. These full-length portraits are similar in type to the work of Hendrick Pot and Pieter Codde, but Ter Borch achieved an elegance and a degree of monumentality through this spatial organization that presumably must be attributed to knowledge he picked up in England and Spain and from

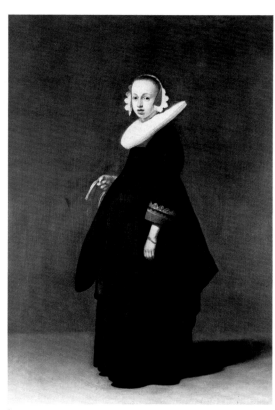

852

853

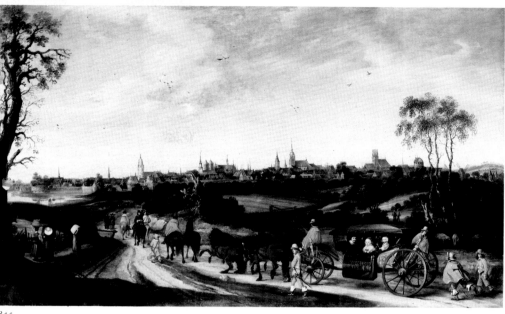

855

854 Gerard Ter Borch
Soldiers Playing Trictrac
c. 1640. Panel, 42.5 × 56 cm. Kunsthalle, Bremen

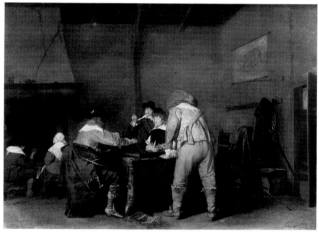

854

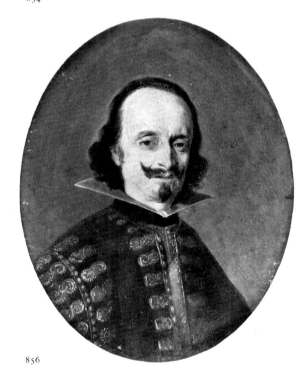

856

855 Gerard Ter Borch
The Arrival of Adriaen Pauw at Münster
Signed. c. 1646. Canvas, 98.5 × 159 cm.
Westfälisches Landesmuseum, Münster. On loan
from the City of Münster

856 Gerard Ter Borch
*Portrait of Don Caspar de Bracamonte y Guzman,
Conde de Peñeranda*
Copper, oval, 10.5 × 9 cm. Museum
Boymans-van Beuningen, Rotterdam

857 Gerard Ter Borch
*The Swearing of the Oath of Ratification of the
Treaty of Münster, May 15, 1648*
Signed and dated 1648. Copper, 45.4 × 58.5 cm.
The National Gallery, London

the Flemish portraitists. At this time, in addition to portraits, he also painted barrack-room scenes, of which his *Soldiers Playing Trictrac* (fig. 854) is representative; such themes were favorites with Pieter Codde and Willem Duyster, and their work probably influenced Ter Borch.

His proficiency as a portraitist won him the opportunity in 1646 to accompany Adriaen Pauw, now a powerful Amsterdam burgomaster, to the peace negotiations with Spain which were just beginning in Münster. As we pointed out above (p. 228), the Dutch insisted upon full diplomatic recognition at these meetings, and Pauw's arrival at Münster as a representative of the States of Holland is ceremonially recorded (fig. 855). Pauw is seated like a prince, with his wife and daughter, in a high-wheeled carriage drawn by six horses and escorted by red-clad lackeys and outriders. Ter Borch executed the figures in this painting; the landscape and the view of Münster were painted by another artist, who signed with the initials *G.V.H.* (Gerrit van der Horst?).[2]

Ter Borch made many small portraits in Münster, at first of the Dutch Republic's representatives and later of the Spaniards.[3] The most important Spanish envoy, the count of Peñeranda (fig. 856), engaged him as a member of his household, an appointment which enabled Ter Borch to attend the closing ceremony on May 15, 1648. He recorded the ratification of the peace treaty in a painting of uncommonly small size for the large number

857

858

860 Gerard Ter Borch
Woman Reading a Letter (Gesina Ter Borch?)
c. 1660–62. Canvas, 45 × 33 cm. The Wallace
Collection, London

860

of portraits it contains (cpl. 857). He accurately represented the room where the final meeting took place, the council chamber of the Münster town hall, but in arranging the persons present, he understandably permitted himself some license: the envoys were actually seated in a closed circle, but Ter Borch rearranged them into a semicircle. His portraits are so accurate that twenty-two of the seventy-seven delegates and onlookers have been identified.[4] The Dutch delegation stands at the left, taking the oath by raising their right hands; the Spanish delegation is on the right, Peñeranda holding a copy of the treaty and swearing on the Bible held by his chaplain. Adriaen Pauw is second to the right in the front row of the Dutch ambassadors. Ter Borch portrayed himself at far left, looking over the shoulder of the man with the plumed hat; years later he repainted his own face, presumably to show himself older.

Considering the extraordinarily difficult problem confronting him, Ter Borch acquitted himself admirably in this painting. As a rendition of a historic event of utmost importance to the Republic, it occupies a unique place in Dutch art. Ter Borch had not painted it on commission, but on his own, and when he tried to sell it for the enormous price of 6,000 guilders, there were no takers. He kept it himself, and eventually the painting came into the possession of a family member, Hendrick Ter Borch, burgomaster of Deventer; after then passing through many hands, it has ended up in the National Gallery, London.

Ter Borch was not the only artist who went to Münster in search of portrait commissions. Pieter Holsteyn of Haarlem and the Flemish painter Anselm van Hulle, then in the service of the stadholder Frederik Hendrik, were also there and painted many portraits. Except for brief trips elsewhere, Ter Borch stayed in Münster for two years, leaving in 1648. Thereafter he worked in Haarlem, Deventer, The Hague, Zwolle, and Kampen. During this period he concentrated mainly on pictures of daily life, scenes with only one or a few figures in interiors with vaguely defined backgrounds. His *Woman Spinning* (fig. 858), symbolizing domestic virtue, gives evidence of the technical mastery he had by this time attained. He occasionally departed from his standard themes: about 1654 he painted a stable scene with a man currying a horse (fig. 859). His palette in this little panel is a refined harmony of the most delicate grays and browns.

He came into his full powers as a painter about 1654, the year in which he married and settled in Deventer. In his studio there he created the many paintings that made him justifiably famous—portraits as well as scenes from the life of well-to-do burghers. His *Woman Reading a Letter* (fig. 860), perhaps a portrait of his sister Gesina, shows that even genteel young ladies had household tasks. Particularly intriguing are Ter Borch's paintings of interiors with two or three figures bound in some high-tension yet ostensibly unruffled relationship that excludes the viewer and makes him wonder what is going on. To heighten the effect of mystery, Ter Borch sometimes cleverly portrayed one of the protagonists (usually a woman) from the rear. This device allowed him to exercise his exquisite talent for rendering rich and gleaming cloth. The quiet, almost formal mood of these paintings is further strengthened by scattered light, from an invisible source; the figures are placed in

858 Gerard Ter Borch
Woman Spinning
Panel, 34.5 × 27.5 cm. Museum Boymans-
van Beuningen, Rotterdam. Collection Willem
van der Vorm

859 Gerard Ter Borch
Horse Stable
Panel, 43 × 49 cm. Private collection

861 Gerard Ter Borch
The Letter
Signed. Shortly after 1660. Canvas, 82.8 × 69.2
cm. English Royal Collections. Copyright
reserved

862 Gerard Ter Borch
Portrait of a Young Man; Full-Length
Canvas, 67.3 × 54.3 cm. The National Gallery,
London

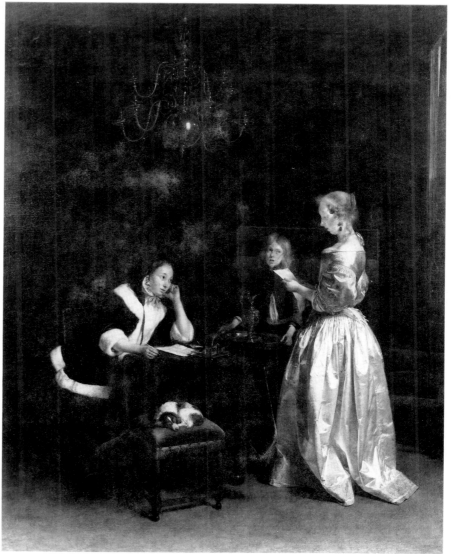

861

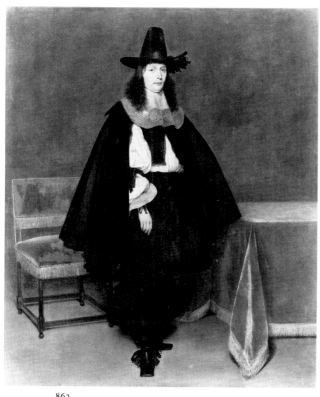

862

this light with the utmost subtlety and delicacy. All of these elements are marvelously present in the painting now succinctly called *The Letter* (fig. 861), to be interpreted in any way the viewer likes. There is one clue: Ter Borch's symbolism, like that of many of his contemporaries, usually has amorous overtones.

His most perfect interior scenes date up to about 1660; thereafter he concentrated more and more on portraits. His models continue to stand in a nearly empty space, which in the best paintings looks anything but empty because of the play of shadows on floor and wall. Though his gift for portraiture does not flag, he reveals limitations in his constant repetitions of this compositional scheme. After a time he began to furnish the space with a few pieces of furniture, the same furniture in picture after picture. His patrons doubtless took their portraits home and hung them on their own walls, so they were probably not bothered by this repetition. And these patrons, like the young man now in the National Gallery (fig. 862), knew that they had been portrayed in good likeness, in their most fashionable clothes.

Ter Borch had a good deal of influence on other painters of *galante* scenes. Some of these were his pupils, of whom Caspar Netscher was the most important. During his apprenticeship, from about 1655 to 1659, Netscher made many copies of his master's work.

863 Pieter van Anraedt
 Still Life
 Signed and dated 1658. Canvas, 67 × 59 cm.
 Mauritshuis, The Hague

864 Pieter van Anraedt
 Regents of the Oude Zijds Huiszittenhuis,
 Amsterdam
 Signed and dated 1675. Canvas, 237 × 425 cm.
 Rijksmuseum, Amsterdam. On loan from the
 City of Amsterdam

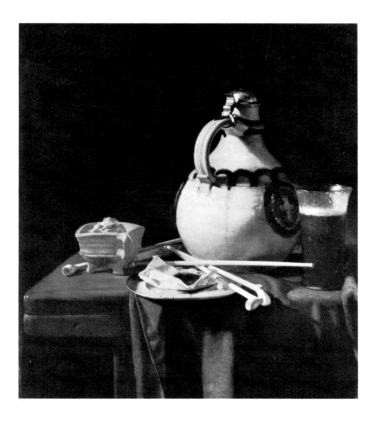

The work of Frans van Mieris, Gabriel Metsu, Jacob Ochtervelt, and Eglon van der Neer reveals their knowledge of Ter Borch's compositions.

Pieter van Anraedt, member of a Deventer family, was another of Ter Borch's pupils, probably at about the same time as Netscher. After that he may have worked for a while in Amsterdam: a beautiful still life by him—an exception in his work—dated 1658 (fig. 863), shows the direct influence of Jan Jansz van de Velde. Anraedt made his career, however, as a portrait painter in Deventer. His early portraits betray a certain dependence on Ter Borch, but he later developed his own style. In 1674 and in 1675 he received commissions to do regents paintings in Amsterdam (fig. 864) and Haarlem, respectively.

Johannes van Cuylenburch was a native of Zwolle whose townscapes are pleasant but not very strong (fig. 865). He and Ter Borch must have known each other, for on one occasion they painted pictures of a knife grinder's family that are virtually identical. Cuylenburch was a son of Gerrit Lambertsz, an excellent sculptor and one of Hendrick de Keyser's most

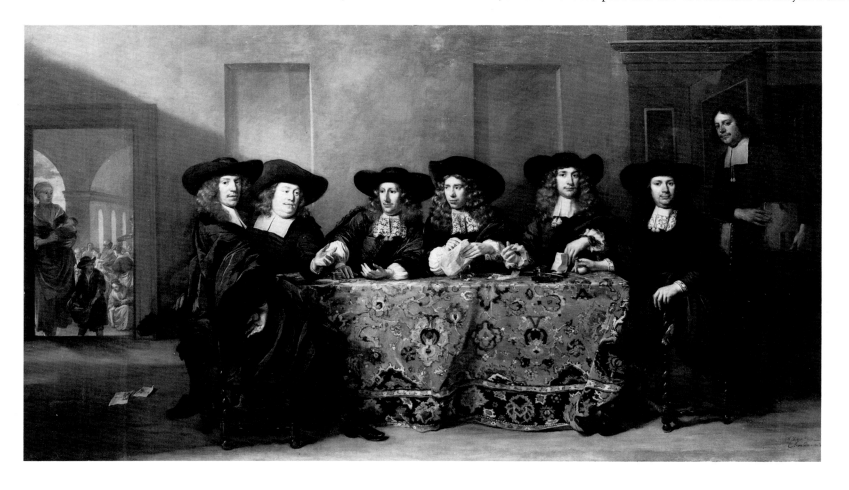

865

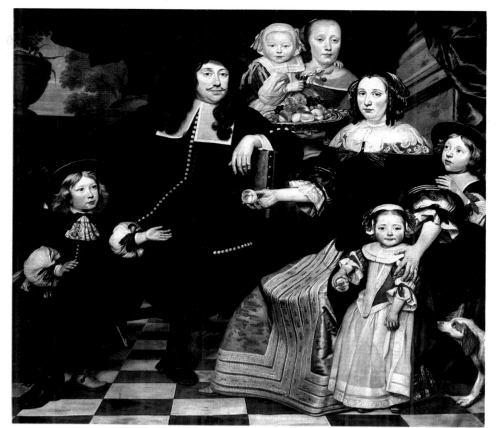

866

867

865 Johannes van Cuylenburch
The Lutteke Gate, Zwolle
Signed. Canvas, 71 × 60 cm. Provinciaal
Overijssels Museum, Zwolle

866 Hendrick ten Oever
Portrait of a Family
Signed and dated 1669. Canvas, 194 × 208 cm.
Provinciaal Overijssels Museum, Zwolle. On
loan from the Rijksmuseum, Amsterdam

867 Hendrick ten Oever
Landscape near Zwolle with Bathing Figures
Signed and dated 1675. Canvas, 66.5 × 87 cm.
National Gallery of Scotland, Edinburgh

important colleagues. They worked together in Amsterdam and in Denmark, where they
executed the sculptural decorations for Frederiksborg Castle. Lambertsz later returned to
Zwolle, his birthplace.

Hendrick ten Oever was also a painter active in Zwolle. He probably received his first
training from the portraitist Eva van Marle, many of whose works are preserved in Zwolle
and Kampen. In 1659 ten Oever went to Amsterdam to study under his cousin, Cornelis de
Bie, of whom only a few paintings are known; after de Bie's death in 1664, ten Oever
settled in Zwolle. He was a versatile painter of portraits, still lifes, historical scenes, figure
pieces, and landscapes. His portraits are acceptable in quality, though somewhat hard (fig.
866); his landscapes are much stronger, and in some of them, such as *Landscape near Zwolle
with Bathing Figures* (fig. 867), he shows a remarkable personality and daring. The
backlighting in this picture is particularly effective, the rays of the setting sun reflected in
the water of the river, and the town silhouetted against the horizon. Cows rest on the banks
and in the watery meadows, while a man and a woman and three youths have climbed out
of the water after a swim, and a fourth lad seems about to jump in. Ten Oever's later works
diminish in strength and invention. Some of his best paintings are thought to be erroneously
attributed to such artists as Paulus Potter and Aelbert Cuyp.

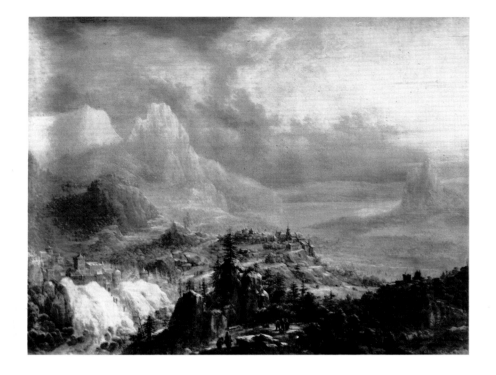

868 Herman Saftleven
Mountain Landscape in Winter
Panel, 52.5 × 68.5 cm. Muzeum Narodowe,
Poznan

Painting in Utrecht: 1650–1680

Even after the middle of the seventeenth century, the Utrecht school remained dominated by its older painters, so that much of the art produced there has an old-fashioned look. Joost Droochsloot and Adam Willaerts both lived to a ripe age, the former dying in 1666 at the age of eighty, the latter in 1664 at eighty-seven. And the following generation worked in their footsteps: Hendrick Bloemaert (died 1672) in those of his father, Abraham; Abraham Willaerts (died 1669) in those of his father, Adam. Even a painter like Cornelis van Poelenburgh, representative of an important new trend in his youth, shows little development later and continued to work in the old vein until his death in 1667. Willem de Heusch never became more than a friendly follower of Jan Both; and Herman Saftleven, always rather weak, endlessly painted technically clever and very detailed panoramas of mountain landscapes crisscrossed by rivers, sometimes varied by winter mists and snows (fig. 868). Two painters, however, powerfully enlivened this rather drab situation: Jan Davidsz de Heem and Jan Baptist Weenix.

We last encountered de Heem as he was departing for Antwerp in 1636 (see p. 267). Since most artists made the trek at that time in the other direction, the Flemish painters usually heading for the freer art centers of the Northern Netherlands, we may wonder what de Heem sought in the south. His contemporary Joachim von Sandrart said that he was attracted by the great variety of exotic fruit available in Antwerp,[1] and de Heem's work in his Antwerp period makes it clear that he indeed delighted in painting such fruit. But surely he had other motivations. One of the strongest must have been the presence in Antwerp of three important still-life painters: Frans Snijders, Adriaen van Utrecht, and Daniel Seghers. These artists had all been closely associated with Rubens, and were at the peak of their own careers. Seghers specialized in flower still lifes and *guirlandes*; Snijders and van Utrecht (and their followers, such as Jan Fijt and Pieter Boel) produced magnificently mounted still lifes, masterfully painted on a scale and richness never approached in Holland (see fig. 269). De Heem seems to have felt at home, and before long he too was painting opulent compositions wholly in the Antwerp style (fig. 869). Under the influence of Daniel Seghers, he also painted flower pieces and garlands of fruit and flowers (fig. 870), following the tradition established by Jan "Velvet" Bruegel.

De Heem had already had some experience with floral painting, but the example of the Antwerp artists now inspired him to a freer, more spacious composition (fig. 871). His fabulous technique is unmistakable in these flower still lifes: each flower is perfect in its drawing, color, and plasticity, while the bouquet as a whole has new vivacity and naturalness. He kept the backgrounds dark, so that the bouquets emerge as a luminous blaze of color. The flowers at the back are veiled in half shadows to enhance the illusion of depth.

De Heem's work had an immediate impact on Dutch still-life and floral painters. He

869 Jan Davidsz de Heem
Still Life
Signed. Canvas, 79 × 104 cm. The Wallace
Collection, London

870 Jan Davidsz de Heem
Garland of Flowers and Fruit
Signed. Canvas, 58.8 × 80 cm. Staatliche
Kunsthalle, Karlsruhe

871 Jan Davidsz de Heem
Fruit beside a Vase of Flowers
Signed. Canvas, 100 × 75.5 cm. Gemäldegalerie
Alte Meister, Staatliche Kunstsammlungen,
Dresden

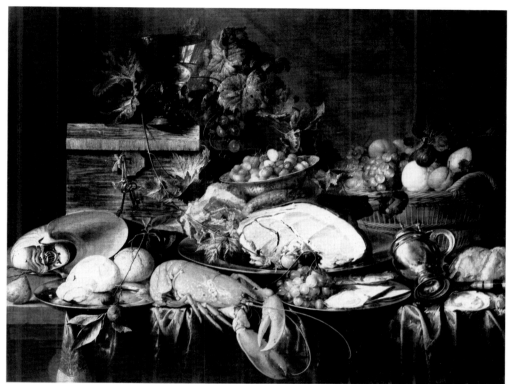

869

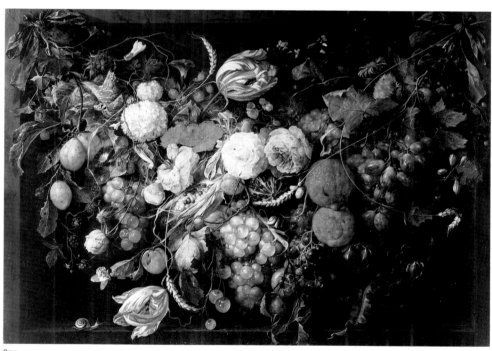

870

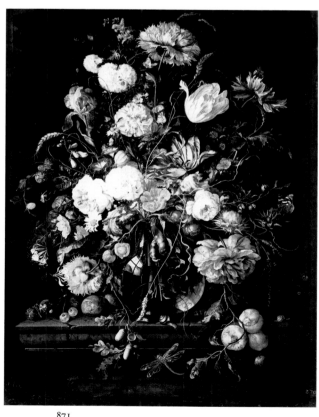

871

presumably kept up his ties with the north, and his paintings were widely known there.
About 1658 he apparently left Antwerp to work in other places, and once again in his
birthplace, Utrecht, where he is registered as a member of the painters' fraternity from 1669
to 1672. The French invasion of the Dutch Republic and occupation of Utrecht in 1672, as
we reported, forced him to flee back to Antwerp, where he died in 1684.

De Heem's return to Utrecht gave the younger artists there a chance to study his
methods. Abraham Mignon, who had been a pupil of the Frankfurt flower painter Jacob

Marrel (who had himself worked in Utrecht), sought out de Heem to perfect himself in still-life art, and developed into a very competent and faithful follower. Mignon painted floral garlands and bouquets (fig. 872), and was especially adept at combining flowers and plants with small animals and insects (fig. 873). Some of his works seem overladen, but his technical skill is amazing. Mignon worked mainly in Utrecht and at times in Germany. All the Dutch flower painters, not only in Utrecht, underwent de Heem's influence. His son, Cornelis de Heem, made his career in Antwerp, ably continuing in his father's style.

Jan Baptist Weenix was the second painter of great distinction who worked in Utrecht after mid-century. Born in Amsterdam in 1621, he had been a pupil of Claes Moeyaert there and later probably of Abraham Bloemaert in Utrecht. He went to Italy about 1642

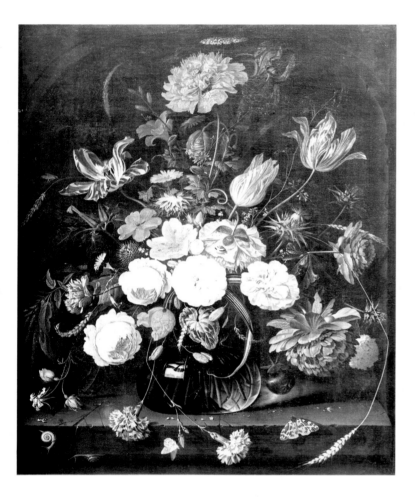

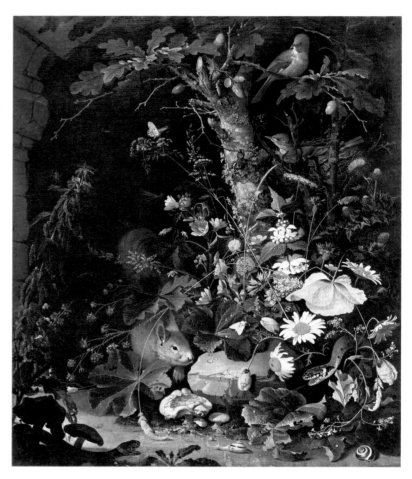

872 Abraham Mignon
Vase of Flowers
Signed. Canvas, 78 × 62 cm. Ashmolean
Museum, Oxford

873 Abraham Mignon
Flowers, Animals, and Insects
Signed. Canvas, 60 × 50.5 cm. Musées Royaux
des Beaux-Arts de Belgique, Brussels

and worked in Rome for four years. Along with Jan Asselijn and Carel Du Jardin, he was a member of the *Bentveughels* (see p. 144) and was dubbed "Rattle" because he stuttered; Claes Berchem may also have been with him in Rome for part of this time. Upon his return to Holland, Weenix worked in Amsterdam before settling in Utrecht in 1649. He developed into one of the best of the Italianate painters, specializing in landscapes and harbor views, always with emphasis on the human figures.

Weenix had a strong feeling for composition, and his works evince a monumental equilibrium of structure and distribution of light. He was also a good colorist. A handsome example of his work is *Coast Scene with Classical Ruins* (fig. 874), which is signed and dated "Gio. Batta Weenix 1649 16 Sep."; he liked to italianize his given names to Giovanni Battista. The clothing of the couple in the foreground is in fine shades of yellowish gray, red, and light yellow; the man's jacket is painted in *changeant* yellows and blues; clear blue is in the saddle of the rearing horse and in the hosiery of the man holding the dog. The background is rendered in subtly nuanced tints which contrast beautifully with the heavily shaded parts at the left. Weenix's originality is also evident in compositions of a wholly different nature, such as his still lifes (see fig. 264) and *The Vagabond* of 1650 (fig. 875). His career in Utrecht was cut short by his untimely death about 1660 at the age of thirty-nine.

Weenix was married to Justina d'Hondecoeter, daughter of Gillis and sister of Gijsbert d'Hondecoeter. Gijsbert's son Melchior, born in Utrecht in 1636, was a pupil first of his father and then of his uncle, Weenix. Melchior came naturally by his talent for painting poultry, for his grandfather and father were experts in depicting birds and animals, and this gift, combined with the training of his uncle, a master of technique and color, enabled

874 Jan Baptist Weenix
Coast Scene with Classical Ruins
Signed and dated 1649. Canvas, 85 × 110 cm. The
Wallace Collection, London

875 Jan Baptist Weenix
The Vagabond
Signed and dated 1650. Canvas, 59.2 × 70 cm.
Private collection

876 Melchior d'Hondecoeter
Fight between a Rooster and a Turkey
Signed and dated 1668. Canvas, 128.5 × 159.5 cm.
Staatliche Kunstsammlungen, Kassel

Melchior to develop to his fullest potential. He had excellent powers of observation and could catch the movement of his birds in full action, as in the dramatic *Fight between Rooster and Turkey* (fig. 876). Houbraken says that Melchior could train a rooster to hold any desired pose.[2] Whether or not this tale is true, Hondecoeter's paintings make it seem perfectly possible. One of his techniques for animating his composition was to allow plants or animals to be cut off at the edge of the painting. Such abrupt cutoffs, which were not generally used in painting until the invention of photography, give the effect of a snapshot, of great naturalness.

In addition to poultry yards (see fig. 310) and still lifes with game birds and hunting equipment, Hondecoeter also painted large, decorative murals. Several of these canvases are now in the Alte Pinakothek, Munich (fig. 877). They were made originally for Driemond, a

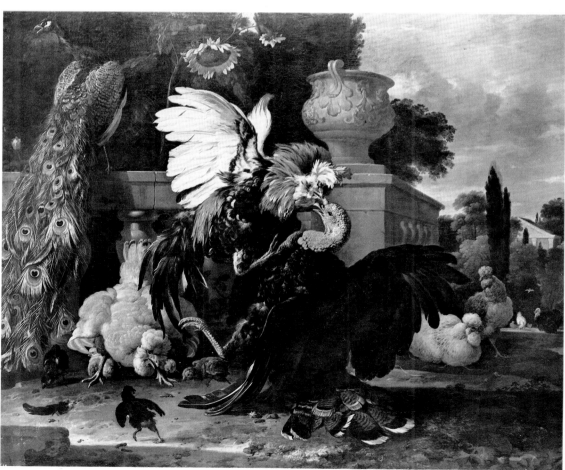

877

877 Melchior d'Hondecoeter
Two parts of a mural from Driemond, near
Weesp
Canvas, 338.5 × 188.5 cm and 338 × 209 cm. Alte
Pinakothek, Munich

large country house near Weesp, designed in 1642 by the talented Amsterdam architect Philips Vinckboons II and purchased and redecorated about 1671 by the merchant Adolph Visser. Visser must have been a great admirer of Hondecoeter, for he owned about fifty of his works. Melchior had meanwhile, after a short period in The Hague, moved to Amsterdam, where he obtained his citizenship in 1668. Two years later he painted the imaginative *Birds on a Balustrade* (cpl. 878), with its unexpected view of Amsterdam's new town hall in the background; the balustrade in the foreground reminds us of his Utrecht origin. This painting—perhaps a satire on the haughtiness of the Amsterdam city fathers?— was undoubtedly hung high, to make the perspective work correctly.

Jacob Gillig was a Utrecht still-life specialist. He began his career as a merchant and then became warder of the jail, which stood next door to the fish market. This happenstance may have inspired him to paint fish still lifes, or he may have been encouraged to do so by his father-in-law, the marine painter Adam Willaerts. In Gillig's work there is talent and professionalism, but he did not venture beyond his limited subject matter. His fish still lifes are beautifully painted, with subtle tints of gray, blue, and rose, enlivened by the silvery sparkle of the scales (fig. 879). He was the last artist in the seventeenth century to specialize in this subject.

879 Jacob Gillig
Still Life with Fish
Signed and dated 1678. Panel, 47 × 68 cm.
Centraal Museum, Utrecht

879

406

878 Melchior d'Hondecoeter
*Birds on a Balustrade, with the Amsterdam Town
Hall in the Background*
Signed and dated 1670. Canvas, 183.5 × 162 cm.
Amsterdams Historisch Museum, Amsterdam

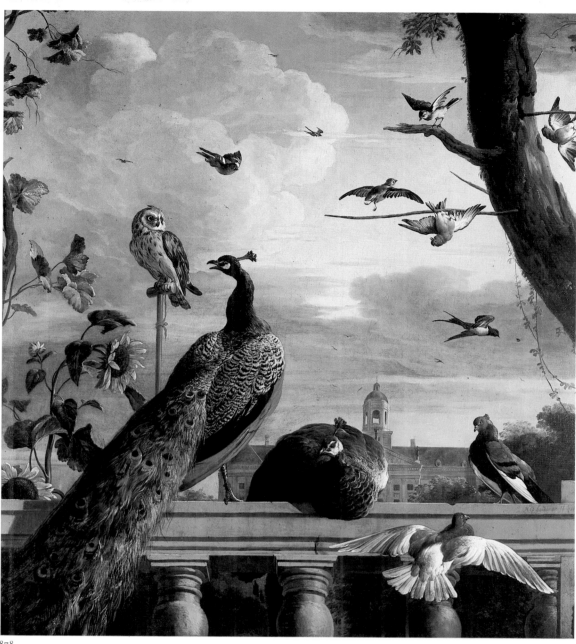

878

Painting in Rotterdam: 1620–1680

We have thus far mentioned Rotterdam only incidentally. At the beginning of the
seventeenth century it was little more than a small port at the mouth of the Maas, of
virtually no cultural significance. A few print publishers there were enlarging their
activities, but the only painter worth mentioning was Willem Büytewech, who was born in
Rotterdam about 1591–92, trained in Haarlem, and returned home in 1617 to work until
his death in 1624. By then Rotterdam had begun to grow vigorously—its population
increased from about 7,000 in 1550 to nearly 60,000 in 1675—and in time it surpassed its
much older commercial rivals, Delft and Dordrecht. It had been a stronghold of
Remonstrant politicians in the old days of Johan van Oldenbarnevelt, and Adriaen Pauw
later won his first political spurs there. But Rotterdam seemed unable to come alive
artistically. Most of the painters born there left town as soon as possible: Simon de Vlieger
went to Amsterdam in 1634, Herman Saftleven to Utrecht in 1632, Willem Kalf at a young
age to Paris and then to Amsterdam, and Pieter de Hooch to Delft. Jacob Ochtervelt
worked much longer in Rotterdam before he too, at the end of his life, moved to
Amsterdam. Despite all this, Rotterdam experienced a sort of upswing in the arts during the
1630s and afterward.

One subject can be identified quite specifically with this city: peasant interiors, usually of
the cottage-and-barn type, displaying strong still-life elements. The exact origin of this type
of painting, known as "stable interiors," is not clear. It may have been introduced by the
still somewhat mysterious François Ryckhals, who worked in Middelburg and Dordrecht as
well as Rotterdam, presumably before 1633.[1] Among his known works is a still life with a

880 François Ryckhals
Still Life with Gold and Silver Vessels
Signed and dated 1640. Panel, 70 × 117 cm.
Szépmüvészeti Múzeum, Budapest

881 François Ryckhals
Interior of a Farmhouse
Signed and dated 1637. Panel, 37.7 × 53.3 cm.
Staatliche Kunsthalle, Karlsruhe

880

881

882 Cornelis Saftleven
Feeding the Chickens in a Cottage
Signed and dated 1678. Panel, 49.5 × 66 cm.
Formerly Staatliche Kunstsammlungen, Dresden.
Destroyed during World War II

883 Cornelis Saftleven
Satire on the Trial of Johan van Oldenbarnevelt
Signed and dated 1663. Canvas, 63 × 86 cm.
Rijksmuseum, Amsterdam

great array of gold, silver, and pewter vessels and other objects (fig. 880); he also painted scenes set in a corner of a barn or run-down farmhouse, with crockery, baskets, pots and pans, and vegetables spread out at one side (fig. 881). An inconspicuous human figure and some poultry or a cat are often included in the scene.

The Saftleven brothers, Cornelis and Herman, attempted this subject matter in the 1630s, although Herman's development was primarily as a landscape painter after he moved to Utrecht in 1632. Cornelis may also have worked for a while in Utrecht, but his further activity was in Rotterdam. Of modest talent, he nevertheless produced varied and interesting work. *Feeding the Chickens in a Cottage* (fig. 882) is a good example of his stable interiors; he also painted peasant scenes in the manner of the Flemish masters, landscapes with cattle, and biblical, historical, and allegorical pictures. His *Trial of Johan van Oldenbarnevelt* (fig. 883) is one of the extremely rare instances of satirical history painting in the Northern Netherlands, although satires were turned out abundantly as prints. Saftleven was perhaps here inspired by the work of his Flemish contemporary David Teniers; prints of Teniers' satirical paintings, in which human beings are depicted as animals, were highly popular in the north. Saftleven portrays the judges who pronounced Oldenbarnevelt's death sentence as animals: Nicholaes Kromhout, the president of the court, is the elephant, and the Amsterdam burgomaster Reinier Pauw is a peacock (a play on his name).[2] On the wall hangs a sheet of paper with the words *Trucidate Innocentia* (Murdered Innocence). Saftleven made this painting in 1663, forty-four years after Oldenbarnevelt's execution.

Pieter de Bloot, who was several years older than the Saftleven brothers, painted stable interiors complete with still lifes that are directly related to those by Cornelis Saftleven. He also painted landscapes in Jan van Goyen's style. De Bloot's work is of extremely uneven

882

883

884

quality, and often appears hasty and sloppy. Yet occasionally he reached a respectable level, as in his *Christ in the House of Martha and Mary* (fig. 884), with its well-painted and well-lighted still life.

Egbert van der Poel worked in his birthplace, Delft, and in Rotterdam, where he died in 1664. He too painted peasant scenes in the Rotterdam manner, sometimes out-of-doors but usually inside, as in his *Lovers in a Barn* (fig. 885). He made his name principally for his nocturnal "bonfires": spectacular conflagrations painted in many variations, but always in the same, easily recognizable style (fig. 886). They include many people, some fighting the blaze, others huddled around their salvaged possessions. The little figures are drawn crisply and capably, their contours outlined by the light from the fire. Van der Poel also proved himself a good figure painter in his beach scenes and rarer winter views (fig. 887).

884 Pieter de Bloot
Christ in the House of Martha and Mary
Signed and dated 1641. Panel, 44 × 63 cm. Museu
Nacional de Arte Antiga, Lisbon

885 Egbert van der Poel
Lovers in a Barn
Signed and dated 1648. Panel, 59.5 × 75.5 cm.
Formerly Staatliche Kunstsammlungen, Dresden.
Destroyed during World War II

886 Egbert van der Poel
Church on Fire
Signed and dated 1658. Panel, 46.3 × 62 cm.
Muzeum Narodowe, Warsaw

887 Egbert van der Poel
Winter Scene
Signed. Panel, 35 × 44 cm. Private collection

885

886

887

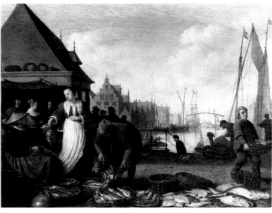

889

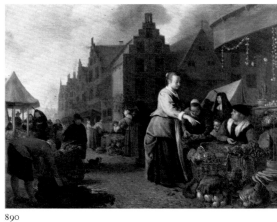

890

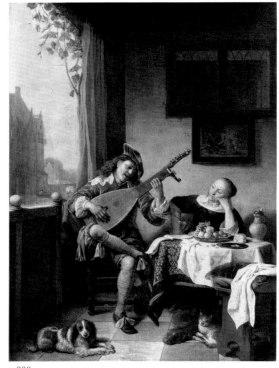

888

891 Hendrick Martensz Sorgh
Storm on the River Maas
Signed and dated 1668. Panel, 47.5 × 64.5 cm.
Rijksmuseum, Amsterdam

892 Julius Porcellis
Rough Water
Signed. Panel, 30 × 38 cm. Städelsches
Kunstinstitut, Frankfurt am Main

Hendrick Martensz Sorgh, a native of Rotterdam, lived there all his life. He too painted stable interiors with still lifes wholly in the Rotterdam tradition and was one of the most talented artists in this group, though his work varies in its quality. Like van der Poel he did not limit himself to this subject, but stepped out in other directions, making domestic figure paintings, such as *The Lute Player* (fig. 888), that reflect the influences of the Delft and Leiden schools. His specialty, however, was street and market scenes, with busy shoppers, vendors, and displays of vegetables and fish, as in his two paintings, undoubtedly companion pieces, of the Rotterdam fish and vegetable markets (figs. 889 and 890), which are among the best examples of this genre. Sorgh succeeded in blending the elements of his scenes into a harmonious and atmospheric whole. His palette ranges from predominating browns to colorful but never gaudy hues.

Sorgh also made portraits and a few marine paintings, the latter conforming in conception and coloring to the tonal type created by Jan Porcellis in the 1630s. Sorgh's *Storm on the River Maas* (fig. 891) stems from 1668, a very late date for a marine painting of this type. Yet it is hardly surprising that he continued so long in the Porcellian manner, for Porcellis lived in Rotterdam for a time, and his son Julius was perhaps born and certainly worked there. Julius was his father's faithful follower; the modulated grays of his paintings emphasize the atmosphere created by the broad surfaces of Dutch waters (fig. 892).

Jacob Bellevois was another Rotterdam marine painter. He spent brief periods elsewhere, probably working in Gouda about 1671 and in Hamburg in 1673. His favorite subject was the wide mouth of the Maas River, with views of Rotterdam or Dordrecht in the background (fig. 893) or as more striking compositional elements in the foreground. Gray tones predominate in his paintings, and sky and water form an atmospheric unity that is directly derived from the Porcellis school. But Bellevois is often more interested in ships and boats than in the sea. A large East Indiaman often appears in his pictures, with colorful flags waving on the masts and countless little figures on deck and in the rigging, all playfully silhouetted against the sky. Bellevois was not a great master, but his work has undeniable charm, and he painted his ships skillfully.

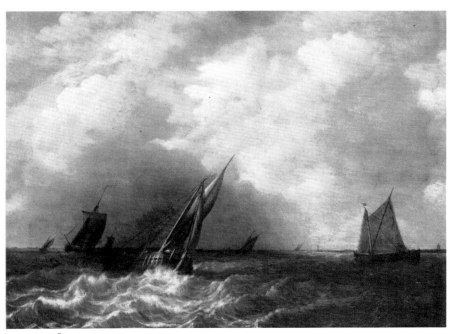

891

892

888 Hendrick Martensz Sorgh
The Lute Player
Signed and dated 1661. Panel, 51.5 × 38.5 cm.
Rijksmuseum, Amsterdam

889 Hendrick Martensz Sorgh
Fish Market, Rotterdam
Signed and dated 1654. Panel, 30.5 × 40.2 cm.
Staatliche Kunstsammlungen, Kassel

890 Hendrick Martensz Sorgh
Vegetable Market, Rotterdam
Signed and dated 1653. Panel, 30.4 × 40.2 cm.
Staatliche Kunstsammlungen, Kassel

893

893 Jacob Bellevois
The Maas near Dordrecht
Signed and dated 1668. Canvas, 60 × 77 cm.
Museum Bredius, The Hague. Collection
Gemeentemuseum

894 Lieve Verschuier
Ships in the Roads
Signed and dated 1661. Canvas, 83.5 × 134 cm.
Bayerische Staatsgemäldesammlungen, Munich

The work of Lieve Verschuïer has a stronger personal character. Verschuier, born in Rotterdam about 1630, was some ten years younger than Bellevois, and his paintings reflect the change in taste that took place around mid-century and influenced marine painters along with other artists. He turned away from tonal painting toward strong light effects, which led to sharpened contrasts and a new color scheme. He studied partly in Amsterdam, perhaps under Simon de Vlieger, and spent several years in Italy before returning to his birthplace. These two sides of his training are both apparent in his work: there are elements from the Amsterdam school of marine painters in many of his compositions, such as *Ships in the Roads* of 1661 (cpl. 894), but he seems to have adopted his light effects from what he learned in Italy. His predominant colors are bluish grays and yellow combined with brick-red, especially when he was depicting scenes at sunrise or sunset. For some reason he usually

894

895

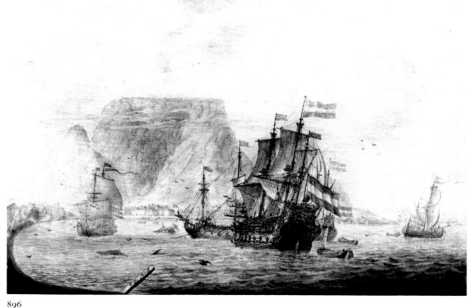

896

rendered waves with stereotypic monotony, yet at the same time he was reproducing fantastic light effects in the sky, daring in their color and manner of painting, as in his sunrise view of the Italian coast (fig. 895).

Verschuier's work may have influenced that of two other Rotterdam marine painters, Jacob de Gruyter and Hendrick de Meyer. De Meyer also painted many beach scenes.

It is interesting to discover that several pen painters were active in and around Rotterdam. This technique, first used by Heerman Witmont and Willem van de Velde the Elder to portray ships and naval events (see p. 150), was taken over by Cornelis Mooy (fig. 896), who worked in Rotterdam during the third quarter of the century, and somewhat later by his fellow townsman Cornelis Bouwmeester and by Adriaen van der Salm, who painted in nearby Delftshaven. The work of these artists differs little stylistically from their models, and since most of it was produced in the first quarter of the eighteenth century, it is beyond the scope of this book.

Like Hendrick Sorgh, other Rotterdam painters often tackled a wide range of dissimilar subjects or combined established subjects in unexpected ways. The relatively small number

897 Ludolf de Jongh
Portrait of a Young Boy
Signed and dated 1661. Canvas, 98 × 71.4 cm.
Virginia Museum of Fine Arts, Richmond

898 Ludolf de Jongh
View in Rotterdam, with the Tower of the St. Laurenskerk
Panel, 93 × 111 cm. Museum Boymans-van Beuningen, Rotterdam. On loan from the Estate of Dr. A. Bredius

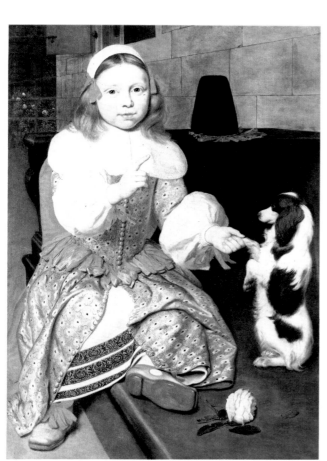

897

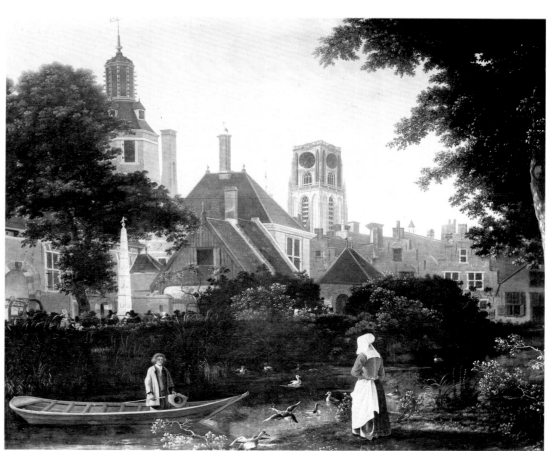

898

of painters in Rotterdam may explain their tendency to try their hand at anything; no competitive pressures were driving them into specialization. Ludolf de Jongh, for example, painted individual and group portraits, interiors with figures, street scenes, townscapes, landscapes with hunting parties, and so on. According to Houbraken, he was a pupil of Cornelis Saftleven in Rotterdam, of Anthonie Palamedesz in Delft, and of Jan van Bijlert in Utrecht, and he also spent seven years in France. It is difficult to get an impression of his work because few signed paintings are known. Moreover, paintings that are considered too weak to be by a famous painter (such as Pieter de Hooch) are often ascribed to him, distorting our image of de Jongh. A most attractive example of his talent is the *Portrait of a Young Boy* (fig. 897) in the Virginia Museum, Richmond. He frequently achieved interesting light effects in his indoor and outdoor scenes; one of the pleasantest is his rather rustic view of Rotterdam, with the tower of the St. Laurenskerk in the background (fig. 898), a panel that is not signed but is firmly attributed to him. De Jongh's work is thought to have influenced the young Jacob Ochtervelt and Pieter de Hooch.[3]

Ochtervelt was the Rotterdam specialist in painting domestic figures. His correct dates have only recently been established.[4] He was born in Rotterdam in 1634. Houbraken says that he and Pieter de Hooch were apprenticed in the same years, about 1650, to Claes Berchem (presumably in Haarlem), a contention supported by Berchem's evident influence on Ochtervelt's earliest known work, a hunting party of 1652. By 1655 Ochtervelt was back in Rotterdam, where he lived until 1672, when he is recorded in Amsterdam; he died there in 1682.

Ochtervelt painted some portraits and portrait groups, but his most important works are companies in interiors, usually elegant figures often attended by a servant; sometimes a seller of fish or fruit appears, as in his *Buying Grapes* of 1669 (fig. 899). His painting style is refined, his handling of cloth subtle, and his color preference tends toward light blues, light reds, and pinks in combination with browns and black. The figures in his paintings strike elegant, often affected poses—the men, their wigged heads slightly atilt, seem almost to be making dance steps—which perhaps adds to the refinement of the scene but also gives it a slight air of decadence. The *Music-Making Company* (fig. 900) is a good example of his work, showing his relationship to Pieter de Hooch, Gerard Ter Borch, and Frans van Mieris.

Anthonie de Lorme, one of Rotterdam's few specialists, chose to paint church interiors. Like those of so many others in this field, his early interiors were imaginary, done in the manner of Hendrick van Steenwijck the Younger. De Lorme perhaps studied with Jan van

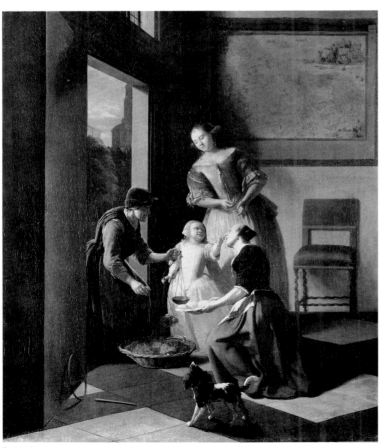

899

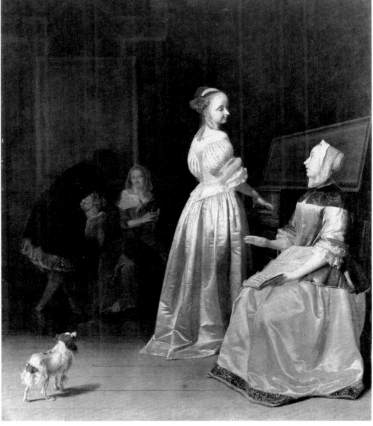

900

901 Anthonie de Lorme
Interior of the St. Laurenskerk, Rotterdam
Signed and dated 1657. Canvas, 65.5 × 50.2 cm.
Private collection

902 Gerrit van Vucht
Still Life with Drum, Banner, and Skull
Signed. Panel, 32.5 × 28 cm. Private collection

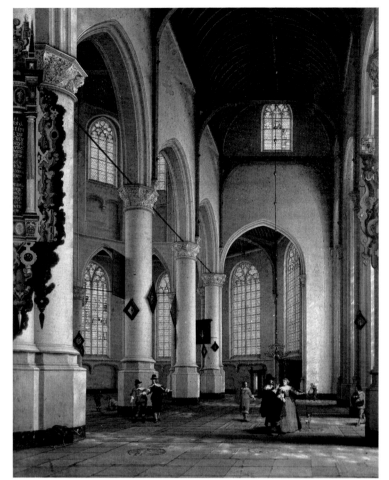

901

902

903 Abraham Hondius
A Heron Attacked by Hounds
Signed and dated 1661. Panel, 24 × 35 cm. Musée
des Beaux-Arts, Caen

904 François Verwilt
Jupiter and Antiope
Signed. Panel, 38.5 × 48 cm. Dulwich Picture
Gallery, London

(der) Vucht, a relatively unimportant Rotterdam painter of fantasy architecture. At virtually the same time as the Delft church painters, de Lorme shifted to painting actual interiors, almost always views inside the Rotterdam St. Laurenskerk (fig. 901). He painted his interiors competently, but never reached the level of the Delft artists. The tone of his paintings is often rather bluish gray.

Gerrit van Vucht, son of de Lorme's presumed teacher, was also a specialist, and in his own way: one of the few still-life painters in Rotterdam, he certainly painted the smallest of such pictures. He managed to get a great deal into them with no sense of crowding. Arranged on top of a table or cabinet, his still lifes include *vanitas* pieces and little breakfasts; fruit, plants, and fish; silver, pewter, and glass; lots of books, and a violin. The panels are charming in their diminutive size, but only middling in quality (fig. 902).

The work of Abraham Hondius, who moved to Amsterdam about 1660 and on to England some six years later, is at times related to that of Ludolf de Jongh. Hondius concentrated on hunting scenes, especially with attacking hounds (fig. 903). He also painted biblical pictures.

903

904

Finally, we must mention François Verwilt, who was a pupil of Cornelis van Poelenburgh. He painted portraits and peasant groups and was perhaps the only artist in Rotterdam to venture into Arcadian landscapes, as exemplified by his *Jupiter and Antiope* (fig. 904). After 1661 he lived and worked in Middelburg.

Painting in Dordrecht: 1650–1680

Aelbert Cuyp and His Followers

An art-loving visitor in Dordrecht at the middle of the seventeenth century would no doubt have wanted to see a painting by Aelbert Cuyp, who turned thirty in 1650 and had begun to find his style. Cuyp had developed under his father's guidance and then absorbed influences from various landscape and animal painters. No direct contacts can be demonstrated, but he was presumably first inspired by Jan van Goyen and Aert van der Neer, then by Gillis d'Hondecoeter, and later by such Italianate landscape painters as Jan Both and Adam Pynacker. Cuyp nearly always signed his works but rarely dated them, so that his exact progress is hard to follow; the paintings he produced about 1650, however, show that he had hit upon a happy blend of landscape and animal painting, with light as both a unifying and a dominating element. With this light he acknowledged the decisive influence of the Italianates.

The essence of his work in this period is encapsulated in *Cattle Watering* (fig. 905). Cuyp has chosen a viewpoint so low that the silhouette of the animals against the luminous river and sky determines the composition. The cattle are given shape and life by fine little lines and flecks of light illumining their bodies and heads, and sharp streaks of light define the reeds in the foreground. The sky is full of tumbling clouds, the river is calm and serene. Cuyp's manner of painting is direct and assured, and he applies his radiant paint with always visible brushstrokes.

The composition is simple and the format modest in *Cattle Watering*, but Cuyp had no fears about undertaking much larger and more ambitious landscapes, one of the most perfect examples being *River Landscape with Horseman and Peasants* (fig. 906). Strong contrasts of light and dark appear in the foreground, where branches and foliage, though mostly in shadow, are just touched by the low sunlight. The distant prospect recedes in the most subtly nuanced tonal gradations, becoming ever hazier toward the horizon, so that there is a strong suggestion of depth as well as of atmosphere. Cuyp's refined sensitivity to depth and misty atmosphere, which he possessed to the highest degree among Dutch

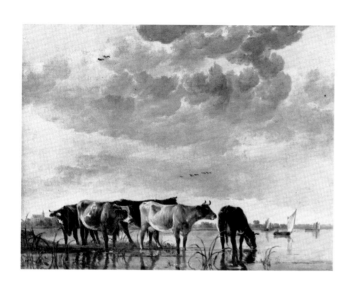

905 Aelbert Cuyp
Cattle Watering
Signed. c. 1650–55. Panel, 59 × 74 cm.
Szépmüvészeti Múzeum, Budapest

906 Aelbert Cuyp
River Landscape with Horseman and Peasants
Signed. c. 1655–60. Canvas, 123 × 241 cm. Private collection

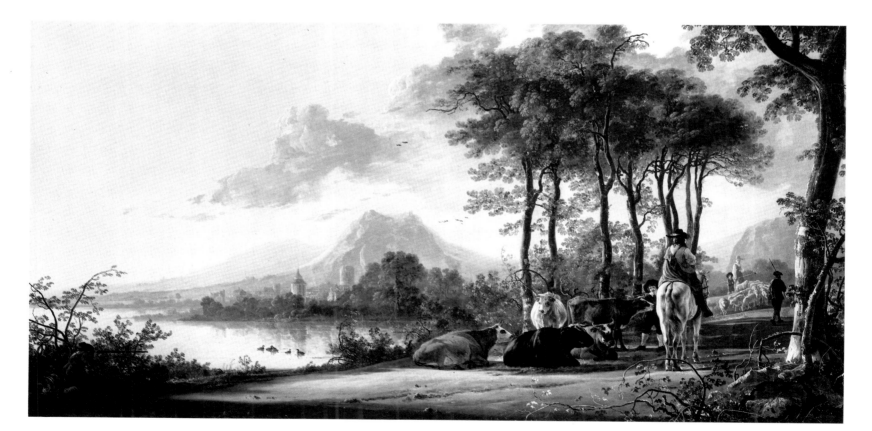

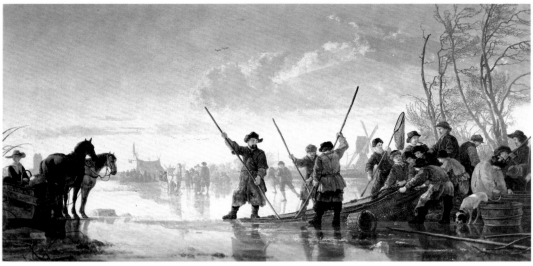

907

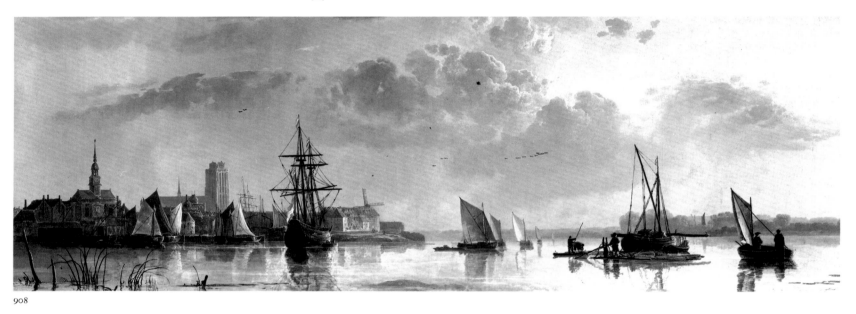

908

907 Aelbert Cuyp
Fishermen on the Frozen Maas near Dordrecht
Signed. Panel, 69.5 × 121 cm. Private collection

908 Aelbert Cuyp
View of Dordrecht
c. 1655. Canvas, 68.5 × 190 cm. The National
Trust, London

909 Aelbert Cuyp
Portrait of a Rider on the Beach
Panel, 81 × 108 cm. Private collection, England

painters, is also seen in his *Fishermen on the Frozen Maas near Dordrecht* (fig. 907), though on the whole his human figures are less convincing than his animals and landscapes.

Mood and light, exquisite contrasts of light and dark, adaptation of brushwork to attain the desired effect: all these are sublimely fused in Cuyp's great *View of Dordrecht* (fig. 908), a subject he painted in several versions. In this one, the sky at the left hangs lead-gray above the city, then slowly merges toward the right into more pronounced cloud formations, their edges stained yellow-rose by the setting sun. Light outlines the contours of the buildings,

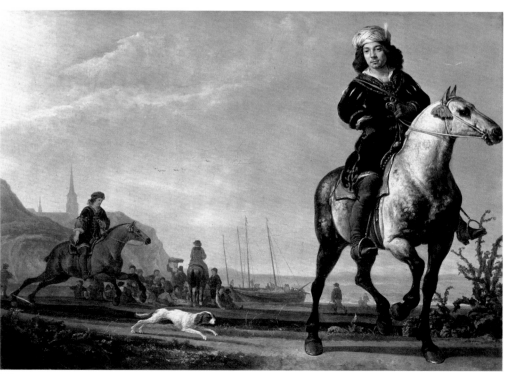

909

boats, and figures, and seems to settle upon the water. The scene has been set down without hesitation, without alteration. "Purity" might be a name for this masterpiece.

The major part of Cuyp's oeuvre consists of landscapes, of many different kinds: moonlight scenes, gales and storms, distant panoramas, and always the richly varied river views. He was also active in other categories of painting. His portraits show his father's influence, though Aelbert introduced stronger light effects (see fig. 729); most of these paintings are fairly early in date. Later we find equestrians that undoubtedly were intended as portraits (fig. 909). It is known that Cuyp was not above painting signboards. And to round off his oeuvre, he painted poultry; his portrait of the famous duck named Sijctghen (fig. 910) is one of the most curious of this genre. The two-part verse at upper left reads as follows:

910 Aelbert Cuyp
Portrait of the Duck Sijctghen
Signed. 1647. Panel, 43.7 × 54 cm. Private collection

911 Abraham Calraet
A White Horse in a Riding School
Signed. Panel, 40 × 52 cm. Dulwich Picture Gallery, London

I was hatched in Werckendam
I was young and good when here I came
 In the poultry yard without a mate
 I have lived for twenty years to date
Some hundred eggs per year I've laid
Therefore I get my portrait made
 My broken bones have healed again
 Healthy and gay I've always been
And when I, Sijctghen, meet my fate
Write down how old, and give the date
 1647.

Anno fifty, the thirtieth day
Of October—folks cry alas
Sijctghen's death has truly come to pass
At the age of twenty-three
 1650.

It is unlikely that Cuyp accepted commissions for signboards and duck's portraits—Sijctghen's picture was certainly ordered by her proud owner—to earn his daily bread, for he came into a considerable inheritance when his parents died in the early 1650s, and in 1658 he married Cornelia Bosman, granddaughter of the renowned theologian Gomarus, and took his place among the Dordrecht patricians. He held offices in religious organizations and on municipal boards, and could permit himself a country estate, called Dordtwijk. He died in 1691.

Cuyp attracted little following in the seventeenth century, and what he had was confined to Dordrecht. In the eighteenth century his art found continuity in wallpaper painting and in a late epigone, Jacob van Stry, who imitated his work, often deceptively. But in general the Dutch public paid Cuyp slight attention. The English became interested in him in the eighteenth century, with the result that nearly all of his important work was sold to English collectors. Some of it has subsequently ended up elsewhere, particularly in the United States, but anyone wishing to know Cuyp's work must seek it out in England.

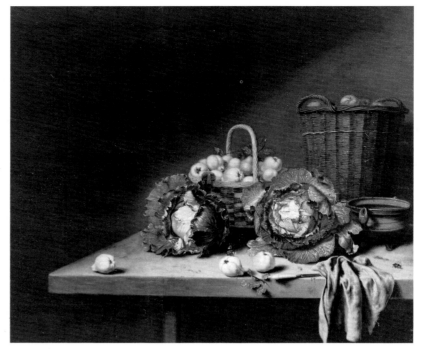

913

912

912 Abraham Calraet
Still Life with Peaches and Grapes
Signed. Canvas, 89 × 73 cm. Mauritshuis, The
Hague

913 Hubert van Ravesteyn
Kitchen Still Life
Signed. Panel, 33 × 37.8 cm. Dordrechts
Museum, Dordrecht

The Calraet brothers of Dordrecht were among the few who became Cuyp's pupils and direct followers. Houbraken mentions the younger, Barend, as a pupil, but his work is fairly insignificant. The elder, Abraham, born in 1642, was more talented and learned a great deal from his master. His favorite subject was horses and riders (fig. 911), but he also painted attractive still lifes—simple compositions of fruit. His *Still Life with Peaches and Grapes* (fig. 912) shows his skill at rendering the downy skin of peaches, a fruit he included in many of his pictures. His custom of signing with his initials, *A.C.*, sometimes led to his work being attributed to Aelbert Cuyp. He continued to paint almost until his death in 1722.

Hubert van Ravesteyn was another Dordrecht still-life painter. His compositions are uncomplicated and nearly always include smoking equipment. The charm of his work lies in its rather naive simplicity. There is delicate brushwork in his only known kitchen still life (fig. 913), which bears a resemblance to the still lifes in stable interiors that were being painted at about the same time in nearby Rotterdam.

Samuel van Hoogstraeten

Few seventeenth-century Dutch artists seem to have been much interested in art theory or, if they did think about it, to have applied their ideas to their paintings. Samuel van Hoogstraeten of Dordrecht was an exception to this rule. We have already met him (together with Carel Fabritius) as a pupil of Rembrandt in Amsterdam, probably during the 1640s. He returned home about 1648; three years later he journeyed to Vienna, where he was received by the Holy Roman emperor, Ferdinand III. The emperor particularly admired one of Hoogstraeten's deceptively realistic still lifes, and awarded him the gift of a golden chain and medallion. In 1652 Hoogstraeten went on to Rome, but soon returned to Vienna. He was back in Dordrecht in 1654, spent the years 1662–66 in London, and must have worked thereafter in The Hague, where he had been enrolled in the Pictura confraternity as early as 1658 and is still mentioned in 1671, but he finally returned to his birthplace. Hoogstraeten, an erudite man, was a poet and essayist as well as a painter, and was appointed provost of the Holland mint. For us, his most important writing is his *Inleyding tot de Hooge Schoole der Schilderkonst* (Introduction to the Advanced School of Painting; see p. 61), published in 1678, the year of his death.

His pupil Arnold Houbraken later reported that Hoogstraeten painted subjects of every kind. He is known today primarily for his portraits and perspective studies, and for a few figure and history paintings. His portraits are good though rather cool and stiff (fig. 914), and his limitations in this field are particularly apparent in his group portraits. He twice painted the masters and wardens of the Holland mint at Dordrecht, once in 1657 and again in 1674; in the second picture he included himself in the first row, wearing his golden chain from Ferdinand III (fig. 915). Hoogstraeten's great interest in perspective problems comes out most clearly in his architectural paintings (fig. 916), and he delighted in deceiving his

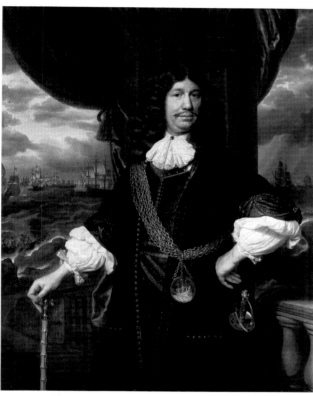

914

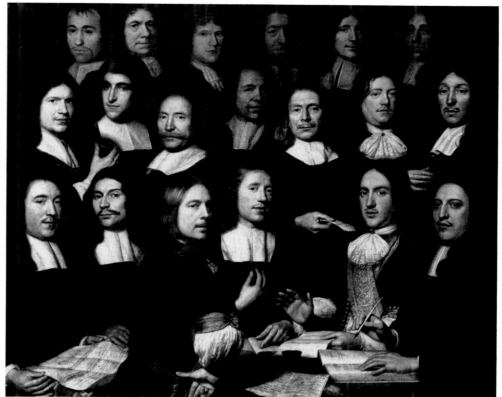

915

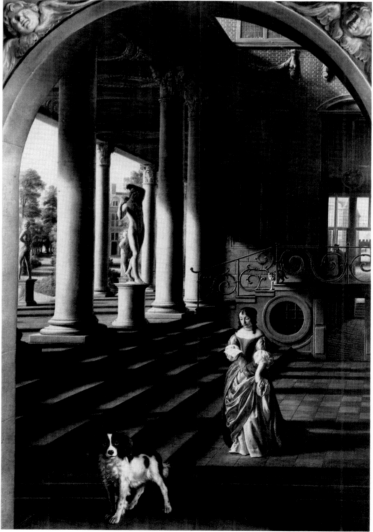

916

914 Samuel van Hoogstraeten
 *Portrait of Mattheus van den Broucke, Governor of the
 East Indies*
 Signed. Canvas, 142 × 111 cm. Rijksmuseum,
 Amsterdam

915 Samuel van Hoogstraeten
 *Masters and Wardens of the Holland Mint at
 Dordrecht, 1674*
 Canvas, 138.5 × 166 cm. Dordrechts Museum,
 Dordrecht

916 Samuel van Hoogstraeten
 Architectural Fantasy
 Signed. Canvas, 241.5 × 179 cm. Mauritshuis, The
 Hague

viewers with clever little *trompe-l'oeils*. His artifices reached a high point with his wonderful perspective boxes (see fig. 339).

Carel Fabritius and Hoogstraeten were alike fascinated by illusionistic effects. Rembrandt showed a similar interest when, in a *Holy Family* of 1646, he painted a frame around the domestic scene and partly closed it off with a painted curtain (see fig. 629). The possibility should definitely not be excluded that Fabritius and Hoogstraeten remained in touch with each other after leaving Rembrandt's studio.

917 Nicolaes Maes
Abraham Dismissing Hagar and Ishmael
Signed and dated 1653. Canvas, 87.5 × 70 cm.
The Metropolitan Museum of Art, New York.
Gift of Mrs. Edward Brayton, 1971

918 Nicolaes Maes
The Listening Girl
Signed and dated 1656. Canvas, 86 × 72 cm. The
Wallace Collection, London

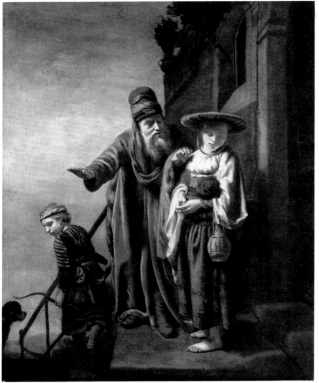

917

918

919 Nicolaes Maes
Old Woman in Prayer, also called *Prayer without
End*
Signed. c. 1655. Canvas, 134 × 113 cm.
Rijksmuseum, Amsterdam. On loan from the
City of Amsterdam

Nicolaes Maes

Nicolaes Maes was another Dordrecht native who became Rembrandt's pupil (see p. 368). Born in 1634, he was seven years younger than Hoogstraeten, and it is assumed that he entered the studio about 1650. He returned to Dordrecht at the end of 1653 and stayed there for the next two decades, then settled in Amsterdam for the rest of his life. Until fairly recently there was a great uncertainty about Maes's earliest work, because no autograph dated paintings from before 1654 had been found. In 1972, however, a small painting dated 1653, depicting *Abraham Dismissing Hagar and Ishmael* (fig. 917), was published.[1] On the basis of this work in the Metropolitan Museum of Art, New York, attempts are now being made to attribute to Maes several other paintings usually thought to have originated in Rembrandt's studio. The influence of the master is clear in the 1653 painting, as is the direction in which the young Maes would develop: toward figure painting in a small format.

Maes's figure paintings have domestic life as their motif, especially women busy in the house or caring for children. A narrative element is often present—probably intended moralistically—such as a girl eavesdropping from a stairway on an amorous conversation in the kitchen below, while the master and mistress of the house sit decorously at the drawing-room table (fig. 918). In *The Listening Girl* Maes displays his keenness for perspective and optical illusion. Here there is a tendency toward strong light effects (taken over from Rembrandt) combined with his interest in tricks of perspective (inspired by the Delft painters). Whether Maes had direct contacts with Delft—with an artist such as Pieter de Hooch, for instance—is not known; Hoogstraeten might well have introduced them to one another.

Maes used a very personal color scheme from the beginning: shiny deep black together with various tints in clear warm red. This is seen in *The Listening Girl* in the ebony of the newel post and the large cabinet at the right, and in the red cloak hanging in the foreground and the other reds of the girl's bodice and apron. His manner of painting is careful but never altogether slick; by keeping his contours rather vague, he creates a feeling of atmosphere and tangible reality. There are not many domestic interiors in his total oeuvre, and all seem to come from about 1654–59. He occasionally painted on a somewhat larger scale, as in *Old Woman in Prayer* (fig. 919), where the beautifully executed textures as well as the immediacy of the narrative element are evidence of the high level of his talents.

919

420

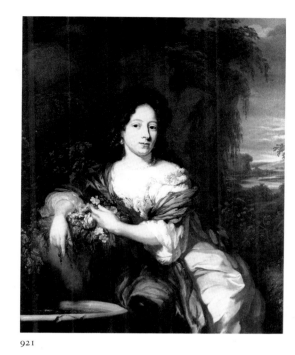

921

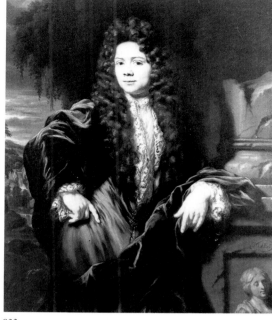

922

920

920 Nicolaes Maes
Portrait of Jacob de Witt
Signed and dated 1657. Panel, 75 × 61 cm.
Dordrechts Museum, Dordrecht

921 Nicolaes Maes
Portrait of Magdalena de la Court
Signed. Canvas, 69 × 57 cm. Museum
Willet-Holthuysen, Amsterdam. Backer
Foundation

922 Nicolaes Maes
Portrait of Willem Backer
Signed. Canvas, 69 × 57 cm. Museum
Willet-Holthuysen, Amsterdam. Backer
Foundation

923 Cornelis Bisschop
Girl Peeling an Apple
Signed and dated 1667. Panel, 70 × 57 cm.
Rijksmuseum, Amsterdam

924 Reynier Coveyn
The Milkwoman
Signed. Panel, 62 × 51 cm. Museum Bredius, The
Hague. Collection Gemeentemuseum

Maes was an excellent portraitist, as can be seen by his "conterfeytsel" of Jacob de Witt,
burgomaster of Dordrecht and father of Johan and Cornelis de Witt (fig. 920). The portrait
is painted powerfully, with broad strokes, and captures the essence of the sitter's
physiognomy. In time Maes adapted himself to the current fashion, painting his models in
elegant poses, preferably against a parklike background and with much use of draperies
(figs. 921 and 922). These later portraits, usually small in size, do not have the warmth of his
earlier work, yet they attest to a degree of virtuosity that he retained for a long time.

Cornelis Bisschop, born in Dordrecht in 1630, was a pupil of Ferdinand Bol but can be
reckoned a follower of Nicolaes Maes. His interiors with one or two figures, such as *Girl
Peeling an Apple* (fig. 923), are very suggestive of Maes, though Bisschop's palette is
sometimes lighter and more silvery; these paintings also are by far his best work, but he
painted portraits and history pieces. Another of Maes's disciples was Reynier Coveyn, who
was born in Antwerp in 1636. His figure paintings—*The Milk Woman*, for example (fig.
924)—are so exactly in the style of Maes that they are usually attributed to that master.

Aert de Gelder

Rembrandt's third pupil from Dordrecht was the young Aert de Gelder, who, as we have
seen (p. 369), had already had lessons from Samuel van Hoogstraeten before going to
Amsterdam in 1661. Besides Hoogstraeten's presumed encouragement, de Gelder must have
decided himself to study with Rembrandt, whom he admired so greatly that his own style

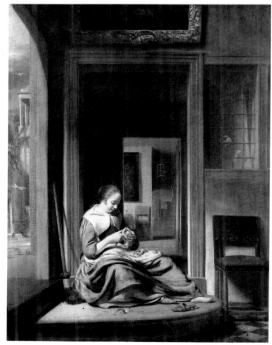

923

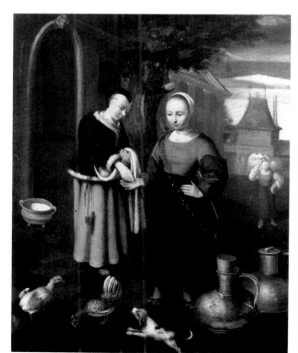

924

925

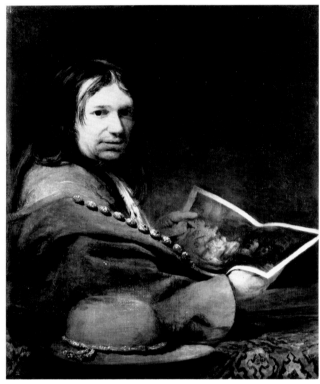

926

925 Aert de Gelder
Christ Presented to the People
Signed and dated 1671. Canvas, 152 × 191 cm.
Gemäldegalerie Alte Meister, Staatliche
Kunstsammlungen, Dresden

926 Aert de Gelder
Self-Portrait
Signed. Canvas, 79 × 64 cm. Hermitage,
Leningrad

927 Aert de Gelder
Vertumnus and Pomona
False signature and date: Rembrandt 1649.
Canvas, 93.5 × 122 cm. Národní Galerie, Prague

and manner of painting became intimately related to his master's. De Gelder's *Christ Presented to the People* of 1671 (fig. 925) harks back directly to the composition of Rembrandt's *Ecce Homo* etching, and the artist painted his self-portrait holding a copy of Rembrandt's *Hundred Guilder Print* in his hands (fig. 926).

Back in Dordrecht after his apprenticeship, de Gelder apparently tried to model his way of living after Rembrandt's: he started a collection which, according to Houbraken, consisted of "all sorts of clothing, hangings, shooting and stabbing instruments, suits of armor, and so on."[2] He used these furnishings in his biblical and mythological paintings. In these works, following Rembrandt's late style, de Gelder employed a technique that ran completely counter to classicistic principles: he applied his paint thickly, using a palette knife, and then scratched into the paint with the wooden butt of his brush (again, as Rembrandt had done from his youth) in order to strengthen the structure or form of an

927

928 Godfried Schalcken
Candle-Light Scene: a Man Offering a Gold Chain and Coins to a Girl Seated on a Bed
Signed. Copper, 15.5 × 18.9 cm. The National Gallery, London

929 Godfried Schalcken
Venus at Her Toilet
Signed. Canvas, 70.5 × 54 cm. Staatliche Kunstsammlungen, Kassel

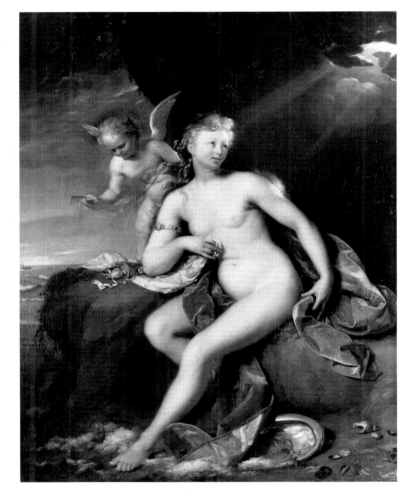

object or figure. The results of this technique can be seen in *Vertumnes and Pomona* (cpl. 927), which bears a false Rembrandt signature and date; the story depicted, popular with Dutch artists since the time of Goltzius, is of Pomona's seduction by Vertumnus, Roman god of the seasons, disguised as an old woman.

It would be incorrect and unjust to consider Aert de Gelder a mere epigone of Rembrandt. He was the only painter to build on Rembrandt's late style, eschewing classicism, and he arrived at a distinctly personal mode of expression and palette, in which light reds, orange, and greens are harmoniously combined. He continued to work into the third decade of the eighteenth century, and died at Dordrecht in 1727.

One last Dordrecht painter deserves mention. Godfried Schalcken, born in 1643, studied first with Hoogstraeten and then with Gerrit Dou. Dou had so great an influence on him that Schalcken became the Dordrecht representative of the Leiden school of "fine" painters (see p. 432), employing their manner of painting, small formats, and subject matter. Scenes by candlelight, a favorite theme with Dou, became a sort of specialty of Schalcken's (fig. 928); he even produced candlelight portraits. He eventually mingled the Leiden style with a more international and elegant approach. Besides his figure paintings, which often have a witty and erotic tinge, and his portraits, he painted allegorical, historical, and mythological pictures, such as his lovely *Venus at Her Toilet* (fig. 929). Schalcken was very successful, and toward the end of his life he worked in The Hague—painting, among other works, a candlelight portrait of the stadholder William III—London, and Düsseldorf, where he was a court painter to the elector of the Palatine, Johann Wilhelm.

930 Daniel de Blieck
Interior of the St. Pieterskerk, Middelburg
Signed and dated 1653. Panel, 83.5 × 103.5 cm.
Private collection

931 Hendrick Berckman
Portrait of a Young Man
Signed and dated 1656. Panel, 104.8 × 81.2 cm.
Museum Mayer van den Bergh, Antwerp

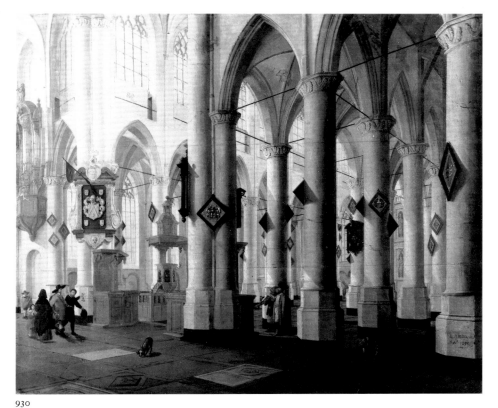
930

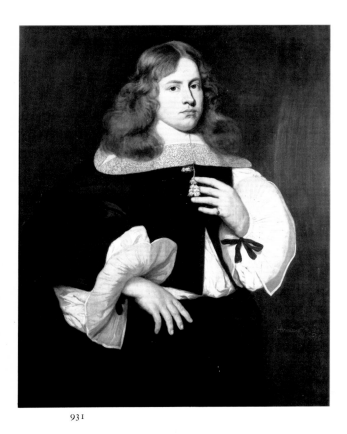
931

932 Adriaen Coorte
Still Life of Asparagus
Signed and dated 1699. Paper on panel, 29 × 22
cm. Ashmolean Museum, Oxford

932

Painting in Middelburg: 1650–1680

The decline of painting in Middelburg had become apparent as early as the second quarter of the seventeenth century, and the situation did not improve after 1650. Little remained of the flourishing artistic life of the first decades of the century. One of the older painters, Dirck van Delen, was still working in an old-fashioned style in nearby Arnemuiden. The painter-entomologist Johannes Goedaert continued to produce his attractive flower pieces and landscapes, but he too adopted no innovations.

The Middelburg architect Daniel de Blieck provides a positive note in this somber picture. Little is known of his life, but from 1648 to 1668 he is listed as a painter in the local guild records. At first he painted imaginary architecture, then he shifted after 1651—at about the same time as the Delft group—to realistic depictions of church interiors, usually of Middelburg churches. Art historians have credited him with an interior of the St. Laurenskerk in Rotterdam, but this is based on a mistaken identification.[1] De Blieck shows an affinity with the Delft painters Gerrit Houckgeest and Hendrick van Vliet in his composition and color. By choosing a standpoint looking diagonally into the nave, he achieved an interesting play of lines (fig. 930). As an architect, he naturally had complete mastery of perspective.

The most important Middelburg portrait painter of this period was Hendrick Berckman, who probably had been a pupil of Philips Wouwerman in Haarlem and later worked under Thomas Willeboirts and Jacob Jordaens in Antwerp. Although he is said to have painted cavalry battles and figure pieces, he is known today exclusively as a portraitist. His 1656 *Portrait of a Young Man* (fig. 931) shows his work to be competent but rather dry and unimaginative. Group portraits he made of the Vlissingen and Middelburg militia companies, mentioned by Cornelis de Bie in 1661,[2] have unfortunately been lost. Count Hendrick of Nassau, governor of Hulst in southern Zeeland, commissioned Berckman to make official portraits that were often used as the basis for prints.

Little is known about Laurens Craen except that he worked in Middelburg for several decades after 1655, and that he painted pleasant still lifes. His work is more or less linked in color and composition to that of the Haarlem circle around Claesz and Heda, but de Heem seems also to have influenced him.

A late development of the Middelburg still-life tradition is found in the work of Adriaen Coorte. His origins, like those of Laurens Craen, are obscure, but there are reasons for placing him in Middelburg at the end of the seventeenth century.[3] His still lifes, always of a few kinds of fruit, shells, or a bunch of asparagus (fig. 932) on a ledge against a dark background, fall outside the time span of this book, but they are too charming to be omitted.

Painting in Leiden: 1650–1680

Artistic life in Leiden during the first half of the seventeenth century had its ups and downs, as we have mentioned. Important painters worked there, but many soon left to pursue their careers elsewhere. The most interesting years were around 1630, when the art of the old guard—Jacob van Swanenburgh, David Bailly, and Joris van Schooten—was enlivened by the presence of such younger artists as Jan Porcellis, Jan van Goyen, Jan de Heem, Jan Lievens, and Rembrandt van Rijn.

The only painter who continued the Rembrandt tradition in Leiden was Karel van der Pluym, born in 1625. His father belonged to a prominent Leiden family, and his mother

933 Karel van der Pluym
 The Rich Man and the Pauper
 Signed. Panel, 43.2 × 54.6 cm. Private collection

was Cornelia van Suijtbroeck, a sister of Rembrandt's mother. It is natural to assume that Karel studied under his famous cousin in Amsterdam, and his style bears this out. In 1648 he became a member of the Leiden guild. His choice of subject, palette, and treatment of light all clearly show Rembrandt's influence. Typical of his work is *The Rich Man and the Pauper* (fig. 933), which at one time bore a forged Rembrandt signature. The quality of van der Pluym's work, however, is but a weak echo of his master's. Still, the family ties remained strong: van der Pluym was appointed guardian of Rembrandt's son in a 1665 lawsuit involving Titus' inheritance, and he designated Titus as one of his heirs, but the young man died first.

Gerrit Dou was one of the few constant factors in Leiden. After his apprenticeship under the young Rembrandt in the late 1620s, he remained in the university town and became the leader of the school of "fine" painters, which kept going until late in the century and had considerable influence and following into the eighteenth century. Before turning to Dou and his disciples, however, we must first look at a singular native son of Leiden who returned after a long absence to spend his last years in his birthplace.

Jan Steen

Jan Steen carved a special niche for himself in seventeenth-century Dutch art. To most of us today, his work epitomizes the cheerful bourgeois life of his time, and it has disproportionately determined our idea of what that life was like. At the same time, the strongly moralizing nature of his work has been disregarded, so that we only half see what he painted. Perhaps that was also true of his contemporaries. To judge from the low prices he was forced to charge for his pictures, the scant attention he received from the writers on art, and the minimal following he attracted, Jan Steen seems to have been almost a prophet without a country. All responsible scholars now agree that his notorious libertinism is a fable launched mainly by Houbraken and magnified by erroneous interpretations of his work. The enormous number of paintings that Steen produced is evidence in itself of his industry and seriousness as a painter.

Misinterpreted or not, Steen's art is extremely popular at present, and his popularity is based on several attractive traits: his open and predominantly happy narrative ability, technical perfection, and masterful use of color. He was a born storyteller, with a moral sense that is surprising even in a century drenched with morality. Practically all of his paintings of daily life point a moral—his quiet scenes as well as his famous scenes of sloppy or "Jan Steen" housekeeping and rowdiness. And to insure that everyone understood, he often included an inscription or some other device in his pictures. In *Easy Come, Easy Go* (see cpl. 101), he painted the motto on the mantelpiece; in *The Way You Hear It* (see fig. 834), an admonition against setting a bad example for children, he wrote the words of a didactic song, from which the painting takes its title, on the paper held by the old woman. We will run across other examples in our further discussion.

Steen seems to make his message clear with such deliberate signs in his pictures, but his vocabulary of forms is so varied that, in addition to the obvious things, all sorts of clues and *double entendres* remain to puzzle and tantalize us. Moreover, some of the figures he regularly moves onto center stage derive straight from the seventeenth-century popular theater in Holland, which was greatly influenced by the Italian *commedia dell'arte*.[1] These figures, costumed and posturing, were immediately recognized by contemporary viewers, but must be deciphered by later observers. By introducing them in his paintings, Steen knew he could immediately arouse a laugh or point a moral—one that is largely lost on us unless we happen to be versed in the plays of his time. A contemporary would have identified without hesitation the physician in *The Sick Woman* (fig. 934), for instance, as a well-known theatrical medico. The man is wearing clothes seen only on the stage: Spanish cap or biretta, doublet, and small pleated ruff dating from about 1570, hose from 1600, and 1620 shoes. The doctor's visit is obviously not serious, and the patient is not ill, but suffering from love pangs.

Like so many of his contemporaries, Steen apparently had no trouble at all with the technique of painting. He seems to play with composition, coloring, and textures, and at the same time to be observing acutely and then setting down the gestures and facial expressions. Granted his inherent talent, how did he learn to paint so well? Little is known about his education. He was born in 1626 in Leiden, son of the prosperous brewer Havick Steen. In 1646 Jan enrolled as a student at Leiden University, but probably did not pursue his academic studies long, for two years later he was one of the founders of the Leiden St. Luke's Guild. His apprenticeship as a painter must therefore have been completed between about 1640 and 1648. Since contemporary sources are silent on this matter, we have to depend on a later and not completely reliable writer, Jan Campo Weyerman, whose four volumes on the lives of Dutch painters were published between 1729 and 1769.[2] Weyerman says that Steen's teachers were Nicolaus Knupfer of Utrecht, Adriaen van Ostade of Haarlem, and Jan van Goyen of The Hague. Steen's work does show a certain affinity with Knupfer's, particularly in the choice of subject and partly in the placing of figures. His early work also shows Ostade's influence. As for van Goyen, we know that Steen married his daughter Margaretha (Grietje) in 1649. Whether there was also a master-pupil relationship between father- and son-in-law is difficult to determine. Steen's early works have landscape elements, and he sometimes experimented with painting landscapes, but these hardly point specifically in van Goyen's direction.

After their marriage, Jan and Grietje lived in The Hague until 1654 and then they may have moved to Delft, where Jan's father helped him to lease a brewery. This venture soon failed, and in 1656 Steen is recorded in Warmond, close to Leiden, where he had always kept up his contacts, including paying his guild dues (which enabled him to sell his work in Leiden). In 1661 the Steens moved to Haarlem; by now the family was probably enlarged by Jan and Grietje's five children, and one pleasure in viewing his paintings is trying to identify them all. Grietje died in 1669, and Jan's father the next year. Jan inherited Havick Steen's house in Leiden, so he moved back to his birthplace, remarried in 1673, and spent the rest of his life there, dying in 1679.

We have pointed out (p. 390) the difficulty in establishing a chronology of Steen's work, since he dated so few paintings and frequently varied his style. His oeuvre is further clouded by uncertain attributions: his paintings were being forged as early as the eighteenth century,[3] and many of the qualitatively poorer works assigned to him were probably done by other artists, honest or not. In general it may be assumed that he at first used a fairly

934 Jan Steen
The Sick Woman
Signed. Canvas, 76 × 63.5 cm. Rijksmuseum, Amsterdam. On loan from the City of Amsterdam

935 Jan Steen
The Market for Freshwater Fish, The Hague
Signed and dated 1654. Panel, 59 × 71.5 cm. Gemeentemuseum, The Hague

936

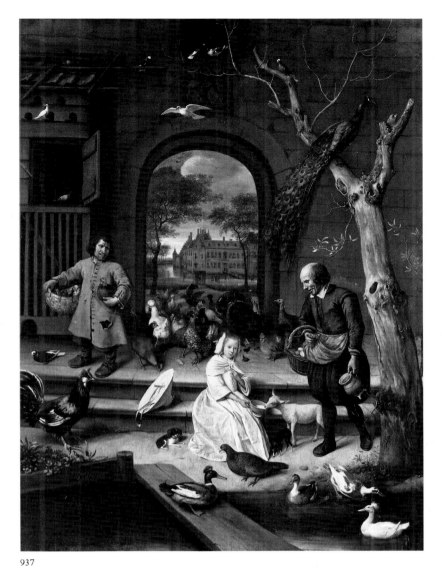

937

936 Jan Steen
The so-called *Burgomaster of Delft*
Signed and dated 1655. Canvas, 82.5 × 68.5 cm.
Private collection

937 Jan Steen
The Poultry Yard
Signed and dated 1660. Canvas, 107.4 × 81.4 cm.
Mauritshuis, The Hague

938 Jan Steen
Girl Eating Oysters
Signed. c. 1658–60. Panel, rounded at the top,
20.5 × 14.5 cm. Mauritshuis, The Hague

938

narrow range of colors, with brown and gray ground tones predominating, and that his figures somewhat resemble those of Adriaen and Isack van Ostade. A number of scenes set in landscape-like surroundings and a few market pictures fall within this early period. Toward the end of his stay in Warmond, Steen's work becomes more varied in color, and this trend reaches full maturity in Haarlem, as does his development as a figure painter. There may be a hint of Frans Hals's influence in his occasional broader touch. During his last period, after 1670, Steen lightened his palette more or less in accordance with the prevailing taste, and he also became a bit more up-to-date in the rendering of his figures, so that the total effect of his late paintings is surprisingly playful and lighthearted.

One of Steen's certain early works, dated 1654, is *The Market for Freshwater Fish, The Hague* (fig. 935); this market was held on the little square at the foot of the Grote or Jacobskerk. Steen handled such subjects as this only at the beginning of his career. In 1655, when he had his brewery in Delft, he painted the so-called *Burgomaster of Delft* (fig. 936), in any event a portrait of a prosperous burgher and his young daughter on their front stoop, being accosted by a beggarwoman and her child. This painting was undoubtedly a commission, as was the large picture known as *The Poultry Yard* (fig. 937), which Steen painted at the end of his sojourn in Warmond. In this truly remarkable painting he portrays either little Bernardina Margriet van Raesfelt (born about 1650) or Jacoba Maria van Wassenaer (born 1654), each of whom lived for a while about this time in Oud Teilingen Castle near Warmond—the building seen in the background through the archway. The child is sitting on the steps by the duck pond, giving a lamb a drink of milk, watched by two menservants, one a dwarf. All around them are a wonderful assortment of birds and poultry and two minuscule dogs. Steen's versatility is evident in every aspect of this painting. His portrait of the girl and his characterization of the servants show complete mastery. The colors are light, and, as usual in his work, he avoids strong contrasts and deep shadows by lighting the whole scene evenly.

Steen was just as good with small, almost miniature, compositions. The *Girl Eating Oysters* (cpl. 938), a panel measuring only about 8 by 5 3/4 inches, delights us with the sensitive face of the girl and the subtly gleaming still life; only the background is kept rather sketchy. He used a somewhat looser touch in another small panel, *The Music Lesson* (fig. 939). The composition is again simple, the picture's quality lying in the serene light, the color scheme, and the intense concentration of the two figures. The theme is not just a music lesson, of course, though the moral is a bit obscure. Perhaps a warning to young girls not to be led astray? The amorous implication is clear from the partly veiled painting of Venus and Amor on the back wall, and the highly suggestive key, while a theatrical origin is implied by the sixteenth-century garb of the music master, who is no doubt appearing here in some role well known to contemporary viewers.

Among Steen's masterpieces of the Haarlem period is the large panel *The Effects of*

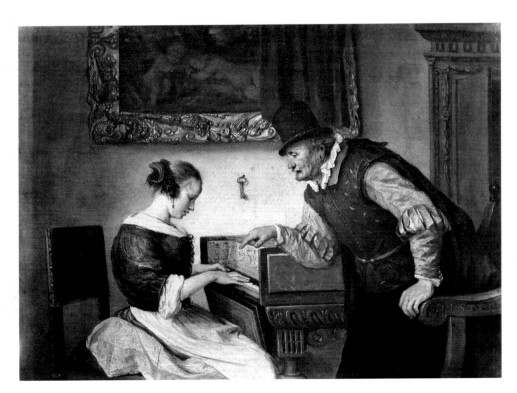

939 Jan Steen
The Music Lesson
Signed. Panel, 37 × 48 cm. The Wallace
Collection, London

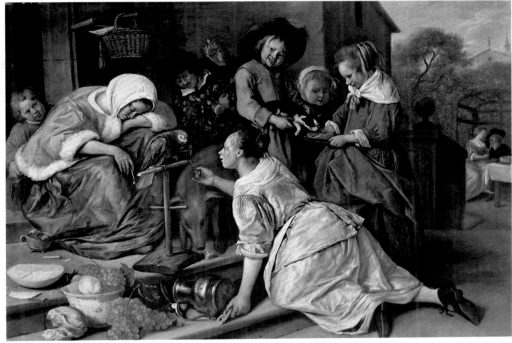

940

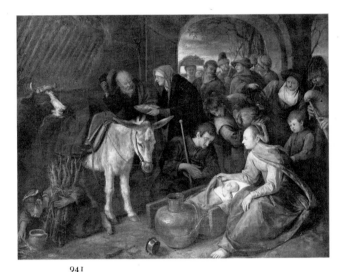

941

940 Jan Steen
The Effects of Intemperance
Signed. c. 1663–65. Panel, 76 × 106.5 cm. The
National Gallery, London

941 Jan Steen
The Adoration of the Shepherds
Signed. Canvas, 53 × 64 cm. Rijksmuseum,
Amsterdam

942 Jan Steen
Samson Mocked by the Philistines
Signed. Canvas, 134 × 199 cm. Walhraf Richartz
Museum, Cologne

Intemperance (fig. 940). This painting is of exceptional quality in its color and brushwork,
and it also shows a new compositional approach, the figures now taking up nearly all the
pictorial space. The moral is clear: the children run wild because of their parents'
immoderation—the mother has fallen asleep with a pipe in her hand, while the father is
dallying in the arbor in the right background. The biggest girl is giving wine to the parrot,
the boy farthest left is stealing from his mother, the next one feeds roses to the pig (there is
an old Dutch saying, a variant on Matthew 7:6, "Don't strew roses before the swine"), and
the other three children let the cat eat the pie. The kneeling girl wears a marvelously
painted light-yellow skirt and a light-blue bodice with orange ribbons binding the sleeve,
and she is holding a pretzel that becomes part of the still life on the steps.

In addition to scenes of daily life, Steen painted many biblical pictures.[4] Religious subject
matter never kept him from being himself: he seasoned his Bible stories with as much
humanity, humor, and lively detail as his secular scenes. One example is *The Adoration of the
Shepherds* (fig. 941), which, on the basis of the predominant brown coloring and the types of
figures, must be considered an early work. Another, much later example is *Samson Mocked
by the Philistines* (fig. 942), probably dating from the late 1660s. This is one of Steen's most
exuberantly Baroque paintings. The treacherous Delilah has cut off Samson's hair, and the
curly locks lie scattered on the floor; the giant is so helpless that even a little boy can hold
him fast. The whole scene looks theatrical, as if set on a stage with the actors emoting and

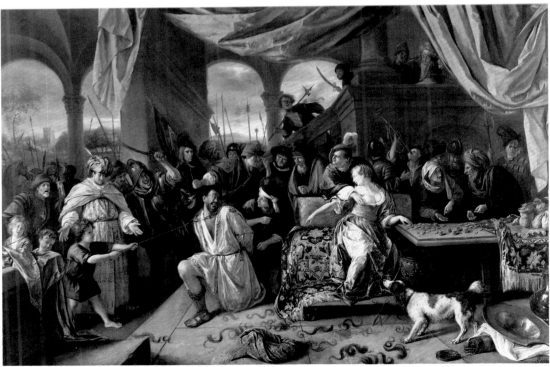

942

943 Jan Steen
The School
c. 1670. Canvas, 83.8 × 109.2 cm. National
Gallery of Scotland, Edinburgh. On loan from
the Duke of Sutherland Collection

944 Jan Steen
The Marriage at Cana
Signed and dated 1676. Canvas, 77 × 108 cm. The
Norton Simon Foundation, Pasadena, California

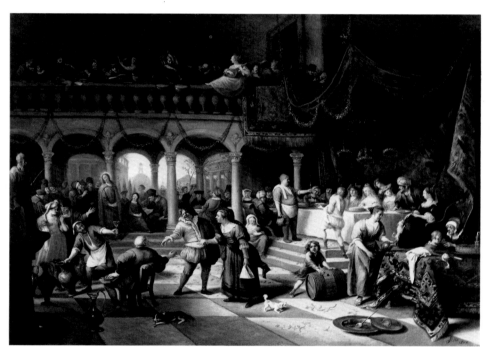

the curtain about to ring down. Melodramatic productions were presented by the chambers
of rhetoric that still flourished in Haarlem and Leiden, and a 1618 play by Abraham de
Koninck called *The Tragedy of Samson* enjoyed long popularity. Steen painted other pictures
with a theatrical setting, and these, along with his stock characters, support the assumption
that he was indeed influenced by the theater of his day.[5]

One of Steen's favorite subjects was school life, which gave him an opportunity to
exercise his gift for portraying children. We can safely say that no other painter in the
seventeenth century, and probably none before or after, was able to capture the movements
and expressions of children so convincingly as Steen. He gathered a great group together in
his painting *The School* (fig. 943), and then proceeded to weave his story. The schoolmaster
is busy sharpening his pen, while his wife concentrates on helping a boy to read. This gives
all the other children a chance to enjoy themselves fighting, playing, or sleeping, as the boy
in the foreground is doing so contentedly, his head resting on a hat atop a wooden school
box. Jan Steen is here making fun of the master, who is so rapt in what he is doing that he
ignores the pupils. The key to the picture is the owl sitting on its wall-perch at the right,
beside a candle lantern, and looking down superciliously at a little boy who holds up a pair
of spectacles. We have encountered this symbolism before (see p. 122): the old adage,
"What good are candle and glasses if the owl doesn't want to see." The painting is light and
clear, with many gradations of gray enlivened by pale pinks and blues, a palette that
indicates a date of about 1670.

The Marriage at Cana of 1676 (fig. 944) exemplifies the last phase of Steen's career. It is probably the fourth or fifth of the six versions he is known to have made on this theme, taken from John 2:1–11, which he uses to celebrate both the first miracle of Jesus, turning water into wine, and the festivities that accompany a wedding. He distributes a multitude of relatively small figures with ease and naturalness throughout the pictorial space, revealing once again his complete mastery of his art.

"Fine" Painters

Jan Steen's influence on other painters in Leiden was at most indirect and temporary, although many artists there undertook domestic figure pieces. Foremost among these were the followers of Gerrit Dou, who have come to be known as the Leiden school of "fine" painters because of their meticulous attention to detail, almost invisible brushwork, and the high finish of their usually small paintings. Dou was himself the most painstaking of them all, and some of his admirers followed him only partway.

Quiringh Brekelenkam, who specialized in domestic figure paintings, shows some connections with Gerrit Dou in his choice of subject matter, but his palette and manner of painting are quite different. He joined the Leiden guild in 1648, married in the same year, and spent the rest of his life in Leiden. His subjects come from the simple life of the lower middle class: women doing household tasks, market scenes, shoemakers, and tailors in their workshops (fig. 945). His manner of painting is thin and rather fluent, with a fine glaze. This has caused his paintings to suffer over the years, especially when inexpertly handled, and in many of them the delicate nuances are now lost. In the rare works that are well preserved, Brekelenkam proves a competent painter sensitive to color and the treatment of light.

Gabriel Metsu is a painter of far greater importance, though his beginnings are obscure. Even Houbraken complained that little was known of his life: "For all that we know about it, is that he was born in Leiden in the year 1615."[6] He does however mention Metsu among Gerrit Dou's pupils. As it happens, both of these bits of information are probably

945 Quiringh Brekelenkam
Interior of a Tailor's Shop
Signed and dated 1653. Panel, 60 × 85 cm.
Worcester Art Museum, Massachusetts

incorrect. Metsu's earliest known painting, dating from 1645, shows no resemblance to Dou's work, and from notarial statements by Metsu himself about his age, it must be concluded that he was born in 1629.[7] The puzzle nevertheless remains that in 1644, when he was presumably only fifteen years old, Metsu joined with other Leiden painters to agitate for a St. Luke's Guild, which was finally founded in 1648.

Metsu's work does not begin to emerge clearly until the 1650s, and then with a decidedly Utrecht flavor. His absence from Leiden about 1650, recorded in the guild registers, can therefore presumably be linked with a stay in Utrecht.[8] Of the painters working there, those most likely to have influenced him are Nicolaus Knupfer and Jan Baptist Weenix, for Metsu's work at this time shows broad, flat brushwork and strong movement in the

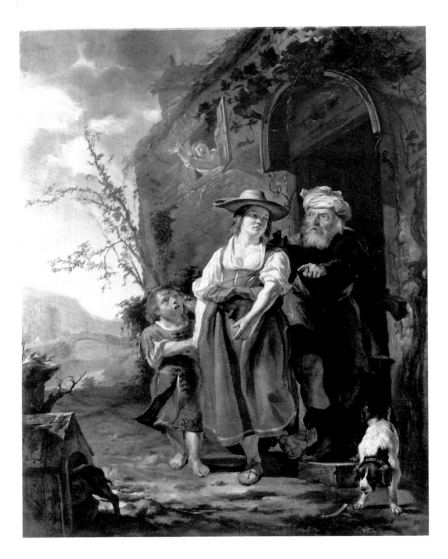

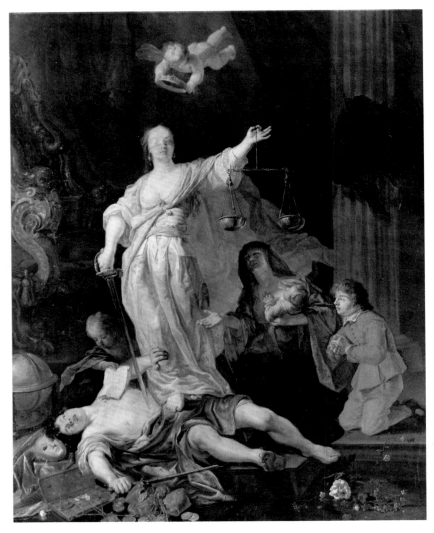

946 Gabriel Metsu
Abraham Dismisses Hagar and Ishmael
Signed. c. 1653. Canvas, 115 × 89 cm. Municipal Museum De Lakenhal, Leiden

947 Gabriel Metsu
Justice Protecting the Widow and Orphans
Signed. c. 1651–54. Canvas, 153 × 120.5 cm. Mauritshuis, The Hague

composition and pose of the figures (fig. 946). An allegorical picture, *Justice Protecting the Widow and Orphans* (fig. 947), is highly reminiscent of Knupfer. From these and other paintings that must be dated approximately in these years, it appears that Metsu had great interest in historical subjects, whether or not he wanted to become primarily a history painter. He was able—as will later be evident—to take advantage of the work of others, yet to assimilate borrowed motifs in his own way. From 1654 to the middle of 1657 he was in Leiden, but then left to settle in Amsterdam, where he subsequently reached the peak of his powers.

Houbraken's statements about Frans van Mieris, unlike those about Metsu, seem to be trustworthy. He reports that van Mieris, son of a Leiden goldsmith, studied successively under Jacob Toorenvliet, Gerrit Dou, Abraham van den Tempel, and again Gerrit Dou. He further comments (with italics to indicate a direct quotation): "It was no long before he outstripped all his fellow pupils, so that Dou often called him *the Prince of his Pupils* and said: *that he carried away the crown from them all.*"[9] This praise seems to be justified by the nature and quality of van Mieris' oeuvre. He not only continued Dou's work—taking over the motif of a scene viewed through an arched window—but surpassed it in many ways. In the first place, he was more versatile. He painted allegorical and Arcadian subjects in addition to scenes of daily life, and in style he did not at all limit himself to Dou's model. Even at the beginning of his career, when he entered the Leiden guild in 1658, he shows close affinity

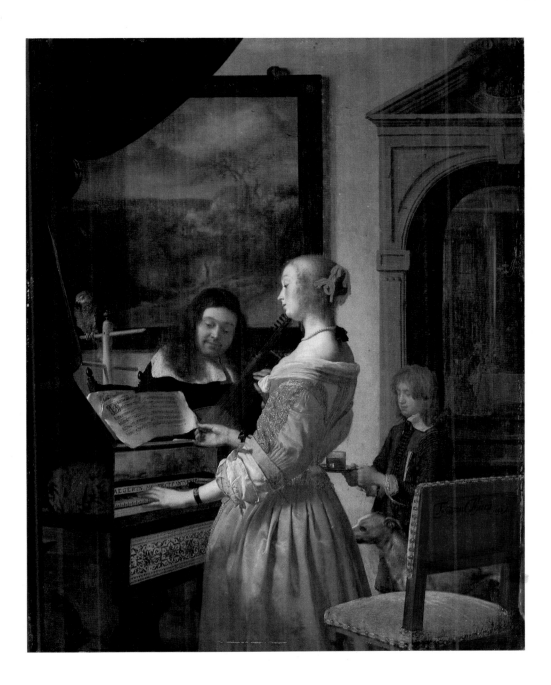

948 Frans van Mieris
Musical Entertainment
Signed and dated 1658. Panel, 31.5 × 24.6 cm.
Staatliches Museum, Schwerin

with the Delft school. His *Musical Entertainment* of that year (cpl. 948), besides being an exceptionally well-balanced piece for a young painter, possesses clear Delftian traits in the handling of light and composition, with the curtain in the left foreground and the chair in the right functioning as a strong *repoussoir* for the intimate scene. This painting calls Vermeer strongly to mind, but any influence by him at this time is impossible to establish.

Houbraken spins out his long account of van Mieris with anecdotes, among others of Frans's relationship with his "very good friend" Jan Steen, who, the writer claims, was a bad influence and plied the younger artist with liquor. Houbraken seems to have taken a special, priggish dislike to Jan Steen and is certainly not to be believed in all he says, but he is probably right here, in that the two painters were friends. In a number of van Mieris' works, Steen's influence seems to be discernible, although it would perhaps be more accurate to speak of a mingling of influences. For instance, in *The Doctor's Visit* (fig. 949), van Mieris could have picked up the theme from Dou or Steen or any number of other artists who used it; the composition, with two figures filling a good deal of a fairly restricted pictorial space, comes from Dou, and probably also the still life; but the clothing of the figures and their gestures, particularly the girl's limp right hand, are reminiscent of Steen. There are two authentic versions of this painting, one in the Kunsthistorisches Museum, Vienna, and the other in the Glasgow Art Gallery and Museum; both are painted on gilded copper and dated 1657. Van Mieris presumably gave the doctor his own features and the woman those of Cunera van der Cock, whom he married in that year. At least one of the paintings may have been a wedding present to her.

A painting such as *The Cloth Shop* of 1660 (fig. 950) gives the impression that van Mieris also knew the work of Ter Borch. This picture is full of *double entendres*, perhaps broader

433

950

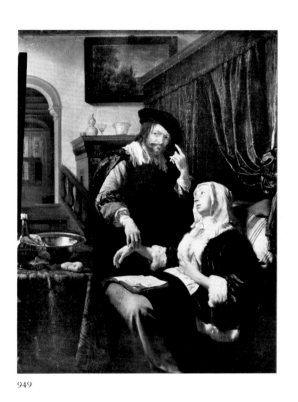

949

than those the Deventer artist liked to use. The officer seems to be making the most of the "goods" on sale,[10] and the room in which the scene takes place is certainly no ordinary cloth shop. Van Mieris painted this picture, which Houbraken describes, for Leopold Wilhelm, the art-loving archduke of Austria, who attempted to lure him to Vienna. He also received commissions from Ferdinand II, grand duke of Tuscany, and from Karel Lodewijk, son of the Winter King and his successor as elector of the Palatine. But van Mieris preferred to remain in Leiden, and worked there until his death in 1681. At the end of his career, however, from about 1670 on, his work lost power, becoming enamel-like and often

951

952

949 Frans van Mieris
The Doctor's Visit
Signed and dated 1657. Copper, 33 × 27 cm.
Kunsthistorisches Museum, Vienna

950 Frans van Mieris
The Cloth Shop
Signed and dated 1660. Panel, rounded at the top,
54.5 × 42.7 cm. Kunsthistorisches Museum,
Vienna

951 Pieter van Slingeland
A Tailor's Workplace
Panel, 55 × 45 cm. The Israel Museum, Jerusalem

952 Domenicus van Tol
Girl with a Chicken
Signed. Panel, 49 × 37 cm. Staatliche
Kunstsammlungen, Kassel

953 Abraham van den Tempel
The Maid of Leiden Crowned by Minerva
Signed and dated 1650. Canvas, 176 × 221 cm.
Municipal Museum De Lakenhal, Leiden

954 Abraham van den Tempel
Portrait of Jan Antonides van der Linden
Signed and dated 1660. Canvas, 88.5 × 71 cm.
Municipal Museum De Lakenhal, Leiden

repetitious. The Leiden school of "fine" painters was nevertheless deeply indebted to him. Both of his sons, Willem and Jan, and his grandson known as Frans van Mieris II patterned their work wholly on his but never matched him.

Pieter van Slingeland, one of Dou's pupils, can also be counted as a Leiden "fine" painter. His best work, such as *A Tailor's Workplace* (fig. 951), approaches that of his master and of Frans van Mieris. Slingeland was in addition a portrait painter of some talent.

Domenicus van Tol was a nephew and pupil of Gerrit Dou, and followed his master's teachings to the letter, even going so far as to copy him. Most of van Tol's paintings, small in size, depict figures enclosed by an arched window; *Girl with a Chicken* (fig. 952) is a good example of his best work. He also painted portraits.

Portrait, Still-Life, and Landscape Painters

A more important portrait painter was Abraham van den Tempel, who, as we have seen (p. 344), studied under his father, Lambert Jacobsz, in Leeuwarden. In 1648 van den Tempel was living in Leiden and married there; he took his name from the gable stone of his house "Den Tempel." In 1650–51 he painted several large allegorical pictures for the governors' chamber of the Leiden Lakenhal or Cloth Hall; one of these is *The Maid of Leiden Crowned by Minerva* (fig. 953), which still hangs in the Lakenhal Museum. Just before he left Leiden for Amsterdam in 1660, van den Tempel must have completed his portrait of Jan Antonides van der Linden (fig. 954), professor of medicine, anatomy, and botany at Franeker University in Friesland and later professor of medicine at Leiden; this portrait served in 1665 as model for Rembrandt's last known print. Arie de Vois, a pupil of van den Tempel in Leiden, used the small formats typical of that city for his finely drawn portraits, Arcadian landscapes with mythological figures, and half-length figures drinking or smoking, such as his *Merry Fiddler* (fig. 955). He should be classified as a "fine" painter.

Jacob van der Merck came to live in Leiden about 1658, after having been in Delft, Dordrecht, and The Hague. In Leiden he painted, among other things, a number of forceful, chic portraits of civic-guard captains (fig. 956), as well as a regents group portrait.

Still-life painting, except for *vanitas* pictures, did not take much hold in Leiden, and the second half of the seventeenth century brought forth no strong representatives of this field. Nonetheless, several Leiden still-life painters are worthy of our attention. The *vanitas* symbolism continued to be of major importance in their work, and David Bailly's 1651

954

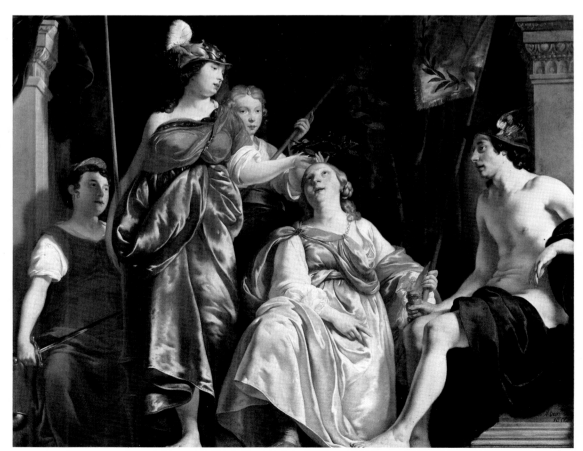

953

435

955 Arie de Vois
The Merry Fiddler
Signed. Panel, 26 × 21 cm. Rijksmuseum,
Amsterdam

956 Jacob van der Merck
Portrait of Gerrit Leendertsz van Grootvelt
Signed and dated 165(7?). Canvas, 220.5 × 111
cm. Municipal Museum De Lakenhal, Leiden

portrait of an artist posed beside many *vanitas* attributes (see fig. 252) may possibly represent a pupil or young colleague of his in Leiden.

Pieter de Ring's work was mainly determined by the influence exercised upon it by his teacher, Jan Davidsz de Heem, the first of the Leiden *vanitas* painters. De Ring concentrated on still lifes with fruit and costly objects (see fig. 243), strongly reminiscent of de Heem in composition, coloring, technique, though the colors are harder and the technique much less refined. In his *vanitas* still life of 1650, de Ring has arranged a snuffed candle, a globe, books, coins, writing material, and scientific instruments (fig. 957). As was his custom, he signed the work with a ring, and then added his name and initials. The vertical format of the 1650 painting and the relative narrowness of the space containing the objects were innovations in this genre, later taken over by Edwaert Collier.

Collier—his name is also sometimes spelled Colyer or Kollier—was probably born in Breda but worked primarily in Leiden; he also spent some time in London and perhaps in Haarlem. His earliest known work is dated 1644, his last 1706. In the main he painted *vanitas* still lifes with books, globes, and musical and nautical instruments (fig. 958). He took pains to render documents and books as accurately as possible, and he always included little slips of paper with appropriate texts (here, the classic *Vanitas, vanitatum*). His relatively early works are of reasonably good quality, but his manner of painting became steadily drier, and he repeated himself endlessly.

The still lifes by Jacques Grief, called "de Claeuw" (The Claw), are much more interesting pictorially. De Claeuw was married to another of Jan van Goyen's daughters, Maria, and was thus a brother-in-law of Jan Steen. A native of Dordrecht, he worked there

957 Pieter de Ring
Vanitas
Signed and dated 1650. Canvas, 77 × 61 cm.
Private collection

958 Edwaert Collier
Vanitas
Signed. Canvas, 50.5 × 60 cm. Municipal
Museum De Lakenhal, Leiden

959 Jacques de Claeuw
Still Life
Signed and dated 1641. Panel, 21.5 × 28 cm.
Private collection

960 Abraham Begeyn
Plants, Butterflies, and Birds
Signed. Canvas, 62.4 × 54.8 cm. Herzog Anton
Ulrich Museum, Brunswick, West Germany

957

958

and in The Hague before going in 1651 to Leiden, where he remained for some time. His still lifes, usually with a strong *vanitas* slant, are often painted with an extraordinarily loose touch (fig. 959). His early work shows some relationship with that of Abraham van Beyeren, who was living in The Hague when de Claeuw was there. His remarkably free manner of painting disappears in his later work in Leiden, but he remains a good colorist. He produced a few flower paintings, which are particularly attractive.[11]

Landscape painters were few in Leiden during the second half of the century. Abraham Begeyn, born there about 1637 and a member of the Leiden guild from 1655 to 1667, painted pleasant, rather Italianate landscapes with cattle, and sometimes also with reptiles, insects, and birds (fig. 960), in the manner of Otto Marseus van Schrieck. Begeyn traveled widely and later became court painter to the elector of Brandenburg, for whom he painted large decorative canvases.

960

959

961 Adriaen Beeldemaker
The Hunter
Signed and dated 1653. Canvas, 185.5 × 224 cm.
Rijksmuseum, Amsterdam

962 Gerrit Houckgeest
Interior of the Nieuwe Kerk, Delft
Signed and dated 1650. Panel, 125.7 × 89 cm.
Kunsthalle, Hamburg

The Rotterdam artist Adriaen Beeldemaker worked in Leiden after 1650, apart from various interludes elsewhere. He painted a few regents pieces in Leiden, but is best known for his landscapes with hunting scenes, the most successful of which is the large canvas *The Hunter* (fig. 961), now in the Rijksmuseum, Amsterdam.

Painting in Delft: 1650–1680

Architectural Painters

In the chapter on Delft in Part III we introduced three painters—Gerrit Houckgeest, Hendrick van Vliet, and Emanuel de Witte—who worked there in the 1640s in a diversity of subject matter. Suddenly, about 1650, they all began to paint realistic church interiors. The leader in this abrupt shift was almost certainly Houckgeest, the only one of the three who had experience in architectural painting. The change in his work is striking. Up to 1650 he painted architectural fantasies (see fig. 699) completely in the style of his presumed teacher, the Hague architect-painter Bartholomeus van Bassen, a follower of Paul Vredeman de Vries. Seemingly from one day to the next, Houckgeest switched over to painting architecturally accurate pictures of the interiors of existing Delft churches (fig. 962). He moreover began to use perspective in a new, unprecedented way:[1] instead of the traditional view down the length of the nave with the vanishing point on the middle axis of the painting, he chose to view a church from some random point, thereby gaining interesting, complicated patterns of columns and arches having two vanishing points, left and right of the middle. This oblique viewpoint permitted a far more natural-looking composition and opened up a world of perspectival possibilities.

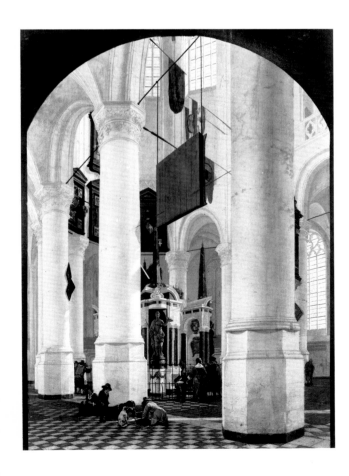

Pieter Saenredam had been painting realistic church interiors since 1628, the only Dutch artist then doing so. Houckgeest may have known his work, but no influence of Saenredam can be traced in his paintings. Saenredam's main concern was always a true portrait of a church space, with the perspective as nearly accurate as possible, although he sometimes manipulated certain features to create an effect he desired. The Delft painters used perspective correctly, but they seem to have been more interested in optical illusion. This interest conformed to general tendencies in Delft to which I will soon return.

It is striking that the first works in the new style often contain an important sepulchral monument, such as the tomb of William I of Orange in the Nieuwe Kerk or that of Piet

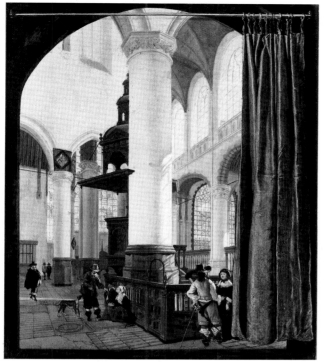

963

963 Gerrit Houckgeest
Interior of the Oude Kerk, Delft
Signed and dated 165(.). Panel, 49 × 41 cm.
Rijksmuseum, Amsterdam

964 Hendrick van Vliet
Interior of the St. Pieterskerk, Leiden
Signed and dated 1652. Panel, 97.5 × 82 cm.
Herzog Anton Ulrich Museum, Brunswick, West
Germany

965 Emanuel de Witte
Interior of the Oude Kerk, Delft
Signed and dated 1651. Panel, rounded at the top,
61 × 44 cm. The Wallace Collection, London

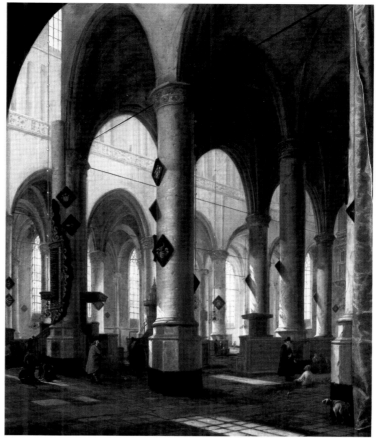

964

Hein in the Oude Kerk in Delft. William the Silent's tomb had been the subject of earlier paintings: van Bassen first painted it in 1620, in imaginary surroundings (see fig. 463), and Dirck van Delen made his version, also with an altered environment, in 1645 (see fig. 735). But about 1650–51 the demand for pictures of such tombs seems to have increased. Houckgeest made four known realistic versions of William I's tomb, and other painters also chose it as a theme. Popular demand may therefore have led in part to the true-to-nature church interiors beginning to be painted in Delft.[2]

Houckgeest's paintings are blond in tone. Avoiding strong contrasts of light and dark he was still able beautifully to capture the in-falling light, sifted and focused through high windows, which forms sunny patterns on the floor. Usually there are a few people wandering about, talking or looking, but seldom participating in a church service. His little *Interior of the Oude Kerk, Delft* (fig. 963), now in the Rijksmuseum, is one of his most charming efforts.[3] The large green curtain pulled to the right greatly enhances the illusionistic effect and sense of depth.

Houckgeest left Delft about 1652. He had married a wealthy woman and no longer had to depend on painting for a livelihood. He settled in Bergen op Zoom, a small town on the Schelde estuary in North Brabant. Although he continued to paint, he limited himself to motifs of the Oude Kerk and the Nieuwe Kerk in Delft, using drawings he had made when he lived there. He died in 1661.

The earliest known church interiors by Hendrick van Vliet date from 1652, and the general assumption that they were influenced by Houckgeest's work is no doubt correct. In any event, two of the 1652 paintings contain a green curtain as an illusionistic element. Moreover, the vantage point van Vliet assumes for viewing an interior is the same as that in Houckgeest's compositions. Van Vliet however uses stronger contrasts of light and dark, so that his palette tends also to be heavier, as can be seen in his *Interior of the St. Pieterskerk, Leiden* (fig. 964).

Emanuel de Witte eventually went even further than van Vliet in using light-dark contrasts. He left Delft very soon, probably in the spring of 1651, and only a minimal part of his extensive oeuvre in the field of church interiors originated there, but his interest in the subject nevertheless stems from Delft. His *Interior of the Oude Kerk, Delft* of 1651 (fig. 965) shows some of his similarities to and differences from Houckgeest. Both artists arch the top of their paintings of this interior, and arches are important in their compositions. Both view the scene from an oblique angle, but de Witte draws closer in to it, so that his space is more compact. And whereas the people in Houckgeest's painting seem to be visitors to the

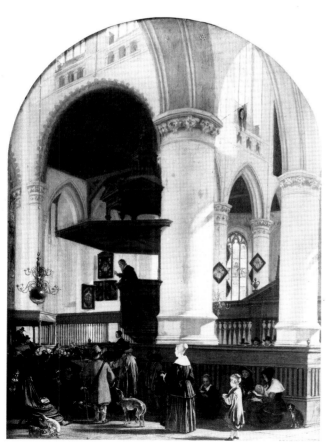

965

church, those in de Witte's are a congregation, listening intently to a sermon. De Witte has been called the initiator of the realistic church interior in Delft. Yet considering Houckgeest's prior interest in the subject and the dates on his paintings, we are inclined to believe that to him should go the credit.

Carel Fabritius

The strong illusionism in the work of such Delft painters as van Vliet and de Witte, and of Samuel van Hoogstraeten in Dordrecht as well, may have been stimulated by Carel Fabritius, who came to Delft in or about 1650. Fabritius became famous as a painter of "perspectives." In his description of Delft, published in 1667, Dirck van Bleyswijck called him "an outstanding and excellent painter... quick and sure in the use of perspective," and Arnold Houbraken echoed this commendation in 1718; Hoogstraeten twice mentions that Fabritius painted illusionistic murals in private houses in Delft.[4] Hoogstraeten and Fabritius, as we have seen (p. 298), were fellow pupils of Rembrandt about 1641; during his career Hoogstraeten time and again demonstrated his fascination with optical illusions and the problems of perspective, and it is only natural to think that he shared this interest with Fabritius. Unfortunately, only one true perspective painting by Fabritius is known to survive: the curious little 1652 *View in Delft* with a dealer in musical instruments in the left foreground (fig. 966). The intent of this work is unknown (it may have been designed for a perspective box of some kind), but the deliberate distortions clearly make it at least an experiment in perspective or wide-angle vision, presumably undertaken with the aid of a double-concave lens.[5]

Fabritius' original and imaginative bent developed gradually. After leaving Rembrandt's studio, he lived, like his brother Barend, in both his birthplace Midden-Beemster and in Amsterdam. His early works (see fig. 635) reveal the force of his master's influence. The first sign of his independent development is the portrait of the Amsterdam silk merchant Abraham de Potter (fig. 967). The inscription on this painting reads "Abraham de Potter Æ 56 C. Fabritius 1640 f," but the last digit of the date is controversial; as de Potter was born in 1592, a date of 1648 or 1649 seems more reasonable. Fabritius departs from Rembrandt in this portrait by keeping the background light; the master preferred a dark background to enhance the illuminative power of the skin tones. It is characteristic of Fabritius that he abandoned the Rembrandtesque effect and sought for a plasticity and spaciousness based less on contrasts than on careful observation of the interacting values of light. But then again, his portrait of a young man (cpl. 968) is strongly reminiscent of Rembrandt's manner of painting: compare it with *A Girl at a Window* of 1645 (see fig. 630). Although Fabritius here uses rather strong contrasts, he plainly tried to bring the background—a peeling plaster wall—into play with the face of the man portrayed. The date of this painting is uncertain, but in view of its distinct ties with Rembrandt's work, it must almost surely be before 1650. There is insufficient evidence to support the frequent assumption that it is a self-portrait.

Both the Midden-Beemster and Delft registers record Fabritius' second marriage in 1650, listing him and his bride as residents of Delft. He entered the Delft guild in 1652. His very scanty late works seem to reveal a growing absorption with exploring the subtleties of light

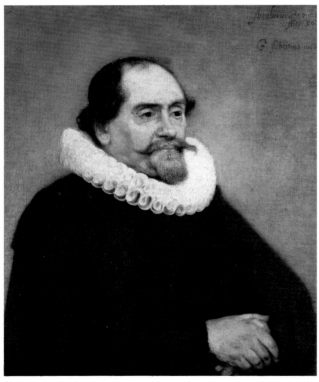

967

966 Carel Fabritius
View in Delft, with a Musical Instrument Seller's Stall
Signed and dated 1652. Canvas on panel, 15.4 × 31.6 cm. The National Gallery, London

967 Carel Fabritius
Portrait of Abraham de Potter, Amsterdam Silk Merchant
Signed and dated 1640. Canvas, 68.5 × 57 cm. Rijksmuseum, Amsterdam

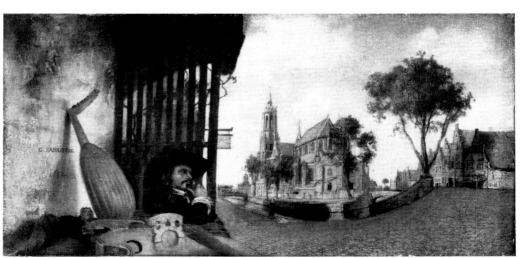

966

968 Carel Fabritius
Portrait of a Young Man (Self-Portrait?)
Signed. Panel, 65 × 49 cm. Museum
Boymans-van Beuningen, Rotterdam

969 Carel Fabritius
The Sentry
Signed and dated 1654. Canvas, 68 × 58 cm.
Staatliches Museum, Schwerin

970 Carel Fabritius
The Goldfinch
Signed and dated 1654. Panel, 33.5 × 22.8 cm.
Mauritshuis, The Hague

968

tints and gradations of grays and ochers to evoke a feeling of atmosphere and space. *The Sentry* of 1654 (fig. 969) is a beautiful example of this approach, but perhaps the most evocative of all his paintings is the lovely little *Goldfinch* of the same year (fig. 970). Painted on a thick plank, *The Goldfinch* was presumably for a *trompe-l'oeil* door or panel for a cabinet.[6] It is a splendid example of the magic of Fabritius' illusions, attained not by all-inclusive detail but by smoothly painted, meticulous observation of light.

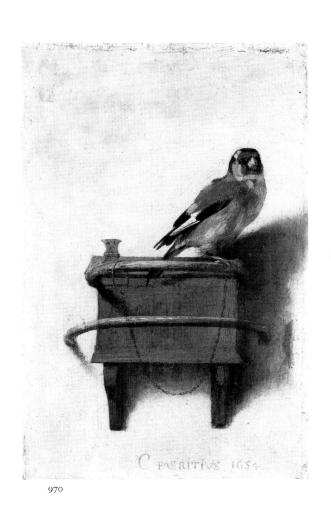

970

969

971 Egbert van der Poel
View of Delft after the Explosion of 1654
Signed and dated 1654. Panel, 36.2 × 49.5 cm.
The National Gallery, London

972 Pieter de Hooch
A Soldier and a Serving Girl with Cardplayers
Signed. Canvas, 58 × 71 cm. Wallraf Richartz
Museum, Cologne

On October 12, 1654, according to Bleyswijck, Carel Fabritius was painting the portrait of Simon Decker, former sexton of the Oude Kerk, when the arsenal of the States of Holland and West-Friesland in Delft blew up, leveling almost half of the town and killing many people, including the artist, his sitter, and his mother-in-law. It also destroyed almost all of Fabritius' paintings, at least his recent ones. The aftermath of the explosion was painted by Daniel Vosmaer and by Egbert van der Poel (fig. 971), and the demand for their pictures was apparently so great that they repeated them in many nearly identical versions.

Pieter de Hooch

Fabritius' feeling for illusion and especially his sensitive use of natural light formed part of the basis for the development of the Delft school, which reached its peak in the work of Pieter de Hooch (as he originally spelled his name, later changing it to de Hoogh) and Johannes Vermeer. De Hooch, the elder of the two artists, was born in Rotterdam in 1629. According to Houbraken, he and Jacob Ochtervelt became pupils of Claes Berchem (presumably in Haarlem) at the same time.[7] He may thereafter have returned to Rotterdam and come under the influence of Ludolf de Jongh.[8] A document of 1653 records him as a *dienaar* (servant) and painter working for Justus de La Grange, a cloth merchant who lived in Delft and Leiden; in 1655 de La Grange owned ten of de Hooch's paintings.[9] The artist was married in 1654 in Delft to Anna (Jannetje) van den Burch, and a year later became a member of the Delft guild. He lived in Delft until about 1660, then moved to Amsterdam. No trace of him has been found in the archives after 1672, when his seventh child was

973 Pieter de Hooch
Courtyard of a House in Delft
Signed and dated 1658. Canvas, 73.5 × 60 cm.
The National Gallery, London

974 Pieter de Hooch
The Cardplayers
Signed and dated 1658. Canvas, 77.3 × 67 cm.
English Royal Collections. Copyright reserved

baptized, until the registry of his death in 1684 as an inmate of the Amsterdam insane asylum.[10]

De Hooch's earliest known dated paintings are from 1658; relatively little is known about his style before this date, though a number of paintings with guardroom or tavern scenes, such as *A Soldier and a Serving Girl with Cardplayers* (fig. 972), are attributed to him on stylistic grounds. These pictures are mostly brownish-yellow in tone. Presumably after his marriage, de Hooch began to devote himself to scenes of daily life: rooms of well-to-do burghers, with the housewife busy at domestic tasks, children walking about, and little groups of people talking together. He also portrayed groups out-of-doors, in the intimacy of courtyards, with a doorway giving a glimpse of a little street or a canal in the background (fig. 973). Previous figure painters had focused attention almost entirely upon the figures, keeping their backgrounds neutral; de Hooch's great contribution is his careful definition of the surroundings, working these out so that they become essential to the composition and extending them into another dimension through glimpses into other rooms or to the outside. The often strongly illusionistic character of these rooms and courtyards—both motifs appear as early as 1658—suggests his awareness of the interest in Delft in optical illusion and perspective, and in particular of Carel Fabritius' efforts in this field. The relationship to Vermeer's work is not immediately traceable, because the dating of that master's paintings is so uncertain. We must assume that de Hooch probably slightly antedates Vermeer in domestic figure painting, but that later the two artists influenced each other.

De Hooch's palette rapidly became clearer and brighter, yet it retained a warm tone and was enlivened by his increasing use of pure, unmixed hues, especially clear red and clear blue. He constantly explored the interaction of light and space, using techniques of perspective construction to achieve certain optical effects, but subtly modulating the view by his sensitive awareness of color, atmosphere, and natural light as it falls on and plays about figures and objects. A look at what he does with light in the courtyard scene just mentioned and in the interior environment of *The Cardplayers* (fig. 974) reveals that his goal was to give an impression of tangible reality, of complete naturalness. His urge for naturalism, however, was not toward a "photographic" reproduction of a situation: no matter how specific de Hooch's spaces seem to be, they have been contrived, put together out of ever-varying combinations of fragments of reality imaginatively reorganized.

The paintings de Hooch created in Delft between 1658 and 1661 are the best balanced and most harmonious in his oeuvre. He never surpassed the warmth and intimacy, the serenity

975 Pieter de Hooch
Domestic Interior
c. 1659–60. Canvas, 92 × 100 cm. Gemäldegalerie,
Staatliche Museen, West Berlin

976 Pieter de Hooch
Musical Party in a Courtyard
Signed and dated 1677. Canvas, 83.5 × 68.5 cm.
The National Gallery, London

of pictures like the *Domestic Interior* of about 1659–60 (fig. 975). After he went to Amsterdam in 1661, he continued to produce excellent work, yet he moved steadily toward greater elegance of subject matter. His work became structurally weaker and the coloring less subtle. *A Musical Party in a Courtyard* of 1677 (cpl. 976) shows his decline in quality, which became particularly evident after 1670, when for some unknown reason, probably financial, he stepped up his production. His last paintings are dated in the year of his death, 1684.

Johannes Vermeer

Johannes (Jan) Vermeer, born in 1632 in Delft, was three years younger than Pieter de Hooch. His father had been a silkworker and at one time called himself an art dealer, but he was primarily an innkeeper, prosperous enough to enable his son to study art. Where and under whom Jan studied is not known. His teacher may have been Leonard Bramer, the most important and respected history painter in Delft at that time. Bramer and Vermeer certainly knew each other, for when the haughty mother of Catharina (Trijntje) Bolnes, the girl Vermeer wanted to marry, refused her permission to the match, Bramer called on her with a notary and another witness to put in a good word for Jan. The mother relented, and the marriage took place on April 5, 1653. On December 29 of that year, Vermeer entered the Delft St. Luke's Guild as master painter.

Vermeer's early works suggest that he may have had at least part of his training under some Utrecht master. There had long been a firm bond between the Delft and Utrecht painters, and Vermeer was definitely interested in the Utrecht Caravaggists: he included Dirck van Baburen's painting *The Procuress* (see fig. 441) in two of his interiors, as a picture within a picture. Yet the distinctly Italian orientation of his early work, as seen in *Christ in the House of Martha and Mary* (fig. 977), cannot be explained simply as deriving from a relationship with Utrecht. Until new information becomes available about Vermeer's schooling, speculation about it is futile.

Regarding the circumstances of his life, we have just enough data to permit the outlines

977 Johannes Vermeer
Christ in the House of Martha and Mary
Signed. Canvas, 160 × 142 cm. National Gallery of Scotland, Edinburgh

of a biography. He was elected four times as a *hoofdman* or governor of the Delft guild, in 1662, 1663, 1670, and 1671. Financially, he seemed to be sound at first, for he and his mother inherited his father's inn in 1652, and his wife came from a fairly well-to-do family. Vermeer dealt in art and testified as an expert witness in 1672 in a notorious affair involving the prominent art dealer Gerrit Uylenburgh, son of Rembrandt's old friend Hendrick Uylenburgh. Uylenburgh had sold some Italian paintings to the elector of Brandenburg, who returned all but one, claiming that they were false. The dealer proceeded to get expert opinions from artists in Amsterdam, The Hague, and Delft, most of whom certified the authenticity of the paintings, but Vermeer and another Delft painter declared them to be "a lot of trashy and bad paintings."[11] As far as is known, the sale never went through. Some of

978 Johannes Vermeer
The Matchmaker
Signed and dated 1656. Canvas, 143 × 130 cm.
Gemäldegalerie Alte Meister, Staatliche
Kunstsammlungen, Dresden

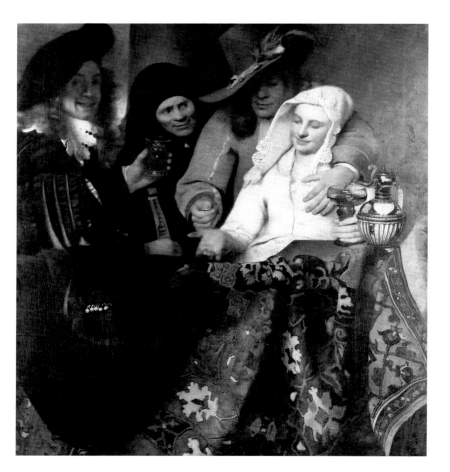

the extant documents relating to Vermeer concern his worsening financial condition, and, as we have pointed out (p. 352), the economic repercussions of the French invasion of the Dutch Republic in 1672 virtually bankrupted him. Vermeer died, aged forty-three, in December 1675 and was buried in the Oude Kerk in Delft. He left behind his widow and eight minor children, two sons and six daughters; three or four other children had perished in infancy.

The chronology of Vermeer's work presents a problem, because only three paintings are dated: *The Matchmaker* (also called *The Procuress*) of 1656 (fig. 978), *The Astronomer* of 1668, and *The Geographer* of 1669. His earliest works are thought to be *Diana and Her Companions*, *Christ in the House of Martha and Mary*, and *The Matchmaker*. These three works make it apparent that Vermeer originally wanted to be a history painter: they are all large in size; the figures dominate the composition; in nearly every other respect the pictures diverge from his later work. Different currents clearly influenced the young Vermeer: the composition of the *Diana* is closely akin to a painting by the Amsterdam figure painter Jacob van Loo; *Christ in the House of Martha and Mary* displays a relationship with Southern Netherlandish and Italian masters in its broad brushwork, undulating folds of cloth, and composition; and *The Matchmaker* is linked compositionally and in setting with the Utrecht Caravaggists.

Vermeer's interests must have undergone a drastic change soon after he painted *The Matchmaker* in 1656; thenceforth he directed his talent primarily to painting domestic scenes of small format with one or two figures—the figures and the interior itself becoming the major elements of the composition. Was it the work of Pieter de Hooch that inspired this turnabout? One of Vermeer's first paintings in the new style, *Officer and Laughing Girl* (fig.

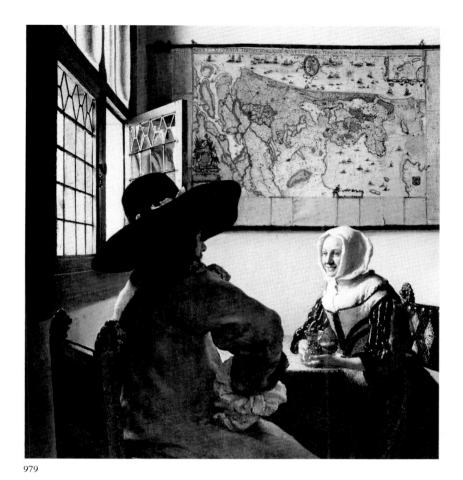

979

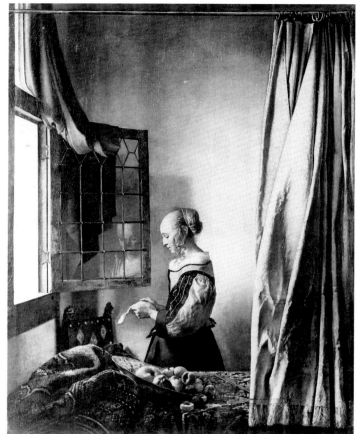

980

979 Johannes Vermeer
Officer and Laughing Girl
Canvas, 51.3 × 46.6 cm. The Frick Collection,
New York

980 Johannes Vermeer
Young Woman Reading a Letter at a Window
Canvas, 83 × 64.5. Gemäldegalerie Alte
Meister, Staatliche Kunstsammlungen, Dresden

981 Johannes Vermeer
The Kitchenmaid
Canvas, 45.5 × 41 cm. Rijksmuseum, Amsterdam

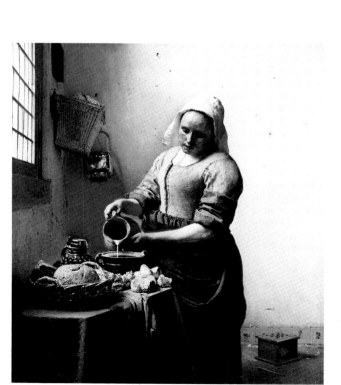

981

979), seems to support an affirmative answer: it is almost as if he had swung the two figures in de Hooch's *Soldier and Serving Girl* (see fig. 972) into new positions in another room, and his picture is even closer compositionally to de Hooch's other supposedly early tavern and guardroom scenes. But Vermeer immediately establishes his originality by simplifying the composition and by moving the figures nearer to the viewer. This painting and the surely almost contemporaneous *Young Woman Reading a Letter at a Window* (fig. 980) also exemplify his new fascination with illusionism. This element is stronger in the latter work, with the still life in the foreground acting as *repoussoir*, the evocative curtain motif (which Vermeer must have borrowed from the Delft painters of church interiors), and the girl's face mirrored in the windowpanes. The effect of space is continued and strengthened toward the back by the meticulously rendered light that falls on the figure and the walls. The great simplicity of the composition, with its single figure, is marvelous.

To capture the fall of light on the heavy texture of the Persian carpet in the foreground of *Young Woman Reading a Letter*, Vermeer used the pointillist or stippling technique, and he employed it again to more brilliant effect in the still life on the table in *The Kitchenmaid* (fig. 981). Here, too, he has stripped the composition to its barest essentials and suffused the whole scene with an almost palpable light. Tranquillity and concentration emanate from these paintings. The person portrayed is always rapt in whatever she is doing, and the slightest movement is caught and held in its immediacy.

Probably soon after painting these domestic interiors, Vermeer essayed his first exterior, *The Little Street* (fig. 982). He evidently could have found his model in works by de Hooch and Fabritius, from whose ashes, as predicted in a poem quoted by Bleyswijck, Vermeer would rise like a new phoenix. *Een stuckie schildery* (a little painting) and *twee schildery-tronijen* (two heads) by Fabritius were among Vermeer's effects when he died.[12] But both Fabritius and de Hooch resorted to rather complicated tricks of perspective, and de Hooch freely wove together realistic and imaginary strands, whereas Vermeer achieved an equally strong effect by much simpler means. There is evidence that *The Little Street* portrays the houses that he could see from a window at the back of his own dwelling on the Marktveld in Delft.[13] These houses had been marked for demolition, and he may have wanted to record them before they were razed. The painting probably represents a "real" scene, and Vermeer has compounded its reality out of light and color. Yet he keeps strict control: there are no strong contrasts, the light and coloring are natural.

The much larger *View of Delft* (cpl. 983) is directly connected to *The Little Street* in color and technique, and it too is true to life. The view is from the south bank of the Schie River

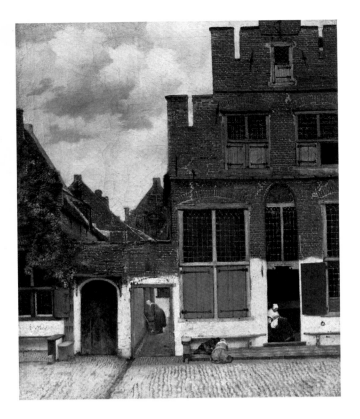

982 Johannes Vermeer
The Little Street
Signed. Canvas, 54.3 × 44 cm. Rijksmuseum,
Amsterdam

983 Johannes Vermeer
View of Delft
Signed. c. 1658. Canvas, 98.5 × 117.5 cm.
Mauritshuis, The Hague

looking toward the Rotterdam and Schiedam gates, with the bridge across the Oude Gracht between them. The tower farthest left is that of the Oude Kerk, while the Gothic mass of the Nieuwe Kerk tower catches the sun on the right. The time is early morning: the hands of the clock on the Rotterdam gate point to ten minutes past seven. The cloud-filtered sunlight moves in from the right, the east, warming the roofs and casting scintillating *pointillé* highlights on the old brick buildings and on the craft moored in the river. From *The Little Street*, his first experiment in the new field of townscape painting, Vermeer leaps as it were into full mastery with his *View of Delft*. This brilliantly painted townscape, with its wealth of harmonious colors and subtle observation of light, is unique in Dutch art.

There has long been speculation about whether, in these and other of his paintings, Vermeer made use of that ancient optical device, the camera obscura, which was recommended by many writers on perspective. Recent studies have described distinct and unmistakable phenomena in his work that indeed point to the use of this instrument,[14] but that he went beyond it is also undeniable. Vermeer employed every means at his command to make a scene come alive, as it actually was, so that the viewer would feel he was looking at reality. This striving, shared by Fabritius and de Hooch and the church painters as well, played an extremely important role in Delft, and we can understand Vermeer's composition and use of light and color only by keeping it in mind.

If we assume that these paintings by Vermeer belong to the period before about 1661, we can observe his refinement of technique and construction in the works that must have followed. At about this time Vermeer may have become acquainted with the work of the rising young Leiden "fine" painter, Frans van Mieris. He returned in any event to interior scenes and softened his modeling and his light effects. He also took up again his theme of a single female figure caught in the act of looking in a mirror as she ties on her pearl necklace, opening a window, or, more than once, reading a letter. The Rijksmuseum's *Woman Reading a Letter* (fig. 984) is a rare symphony of blues. The palette and carefully balanced composition make this one of Vermeer's most beautiful paintings.

Vermeer introduces symbolism into his true-to-nature depiction in the little painting *Woman Weighing Gold* (fig. 985). In this variation on the old goldweigher theme—the

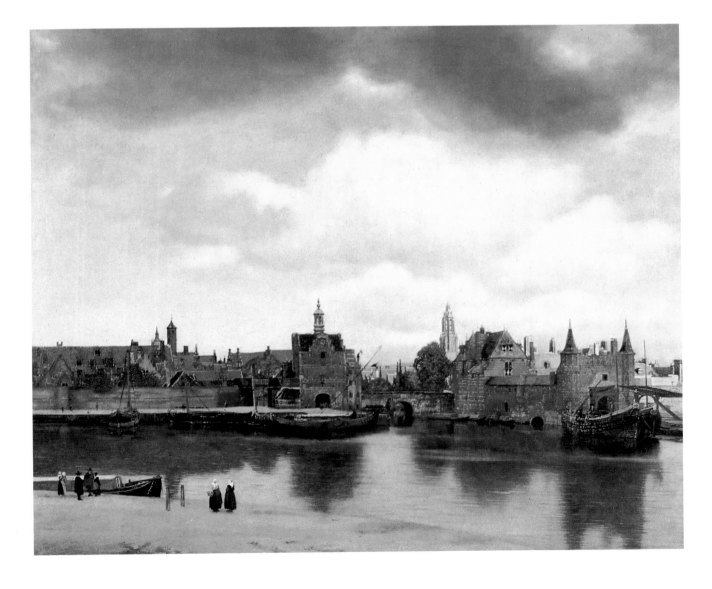

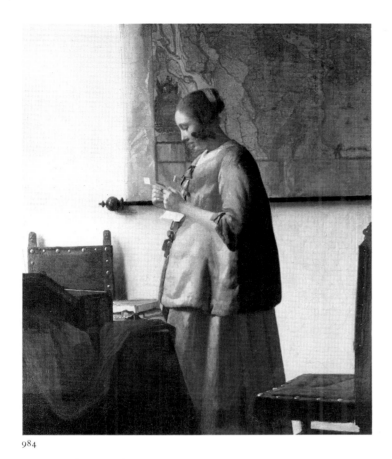

984

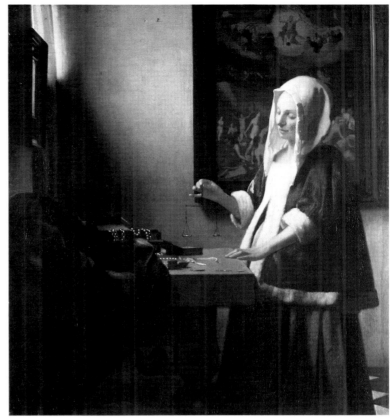

985

984 Johannes Vermeer
Woman Reading a Letter
c. 1662–63. Canvas, 46.5 × 39 cm. Rijksmuseum,
Amsterdam. On loan from the City of
Amsterdam

985 Johannes Vermeer
Woman Weighing Gold
Canvas, 42.5 × 38 cm. National Gallery of Art,
Washington, D.C. Widener Collection, 1942

986 Johannes Vermeer
The Art of Painting
Signed. Canvas, 120 × 100 cm. Kunsthistorisches
Museum, Vienna

young woman carefully balancing the scales, the pearl necklace spilling out of the jewelry
box, the gold coins on the table, and the painting of the Last Judgment hanging in the
background—is Vermeer's warning of the transiency of earthly beauty and wealth.
Symbolism becomes stronger and more overt in his later work; his earlier work should be
more thoroughly examined in this respect.

There can be no question about the meaning of Vermeer's painting of an artist in his
studio (fig. 986). This work is without doubt the same as the one his mother-in-law fought
so hard to keep when twenty-six of his paintings had to be sold to pay his widow's debts in

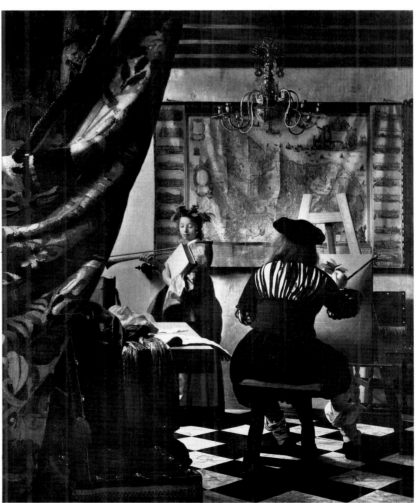

986

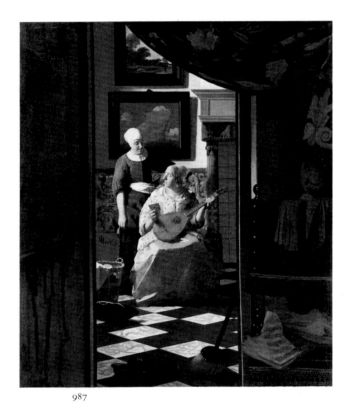

987

987 Johannes Vermeer
The Love Letter
Signed. Canvas, 44 × 38.5 cm. Rijksmuseum,
Amsterdam

1677; in her notarized claim of ownership it is described as "the piece... wherein the Art of Painting is portrayed."[15] As if enjoined to silence, the viewer is permitted to glance past the heavy curtain and chair that form a *repoussoir* in the left foreground, into the studio, where the model stands posed and the artist sits facing her with his back turned to us. The girl wears a laurel wreath and holds a trumpet and a book, the attributes of Clio, Muse of history; the painter is clad in "historical" (pseudo-Burgundian) clothing. Real as it looks, the scene is in fact an allegory and the painter a personification responding to the highest calling of his art, that of painting inspired by history.[16]

The Love Letter (fig. 987) in some respects resembles *The Art of Painting*, but the symbolism is less lofty. Again, as in Dirck Hals's *Young Woman Holding a Letter (Love Requited)* (see fig. 100), the calm seascape on the wall affords a clue to the correct interpretation, as does the lute, symbol of the music of love. Vermeer at this time also painted simpler compositions of great intimacy, of which *The Lace Maker* (cpl. 988) is one of the most appealing. The strong, richly colored *repoussoir* sets off the light-encircled figure of the woman absorbed in her work. This small painting is a jewel.

A Young Woman Standing at a Virginal (fig. 989) is generally assigned to the last phase of Vermeer's development. It, too, is clearly symbolical. The virginal often appears in pictures with amorous themes, and on the wall the large painting of Amor holding up one card conveys the message, Be true to one only.[17] Love is the subject of this painting. The technique of the late works is always refined and subtle, but no new realistic elements appear.

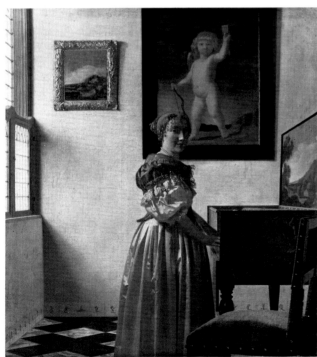

989

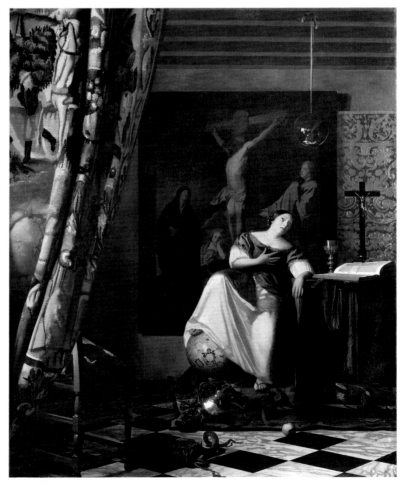

990

988 Johannes Vermeer
The Lace Maker
Signed. c. 1670–71. Canvas on panel, 24 × 21 cm.
Musée du Louvre, Paris

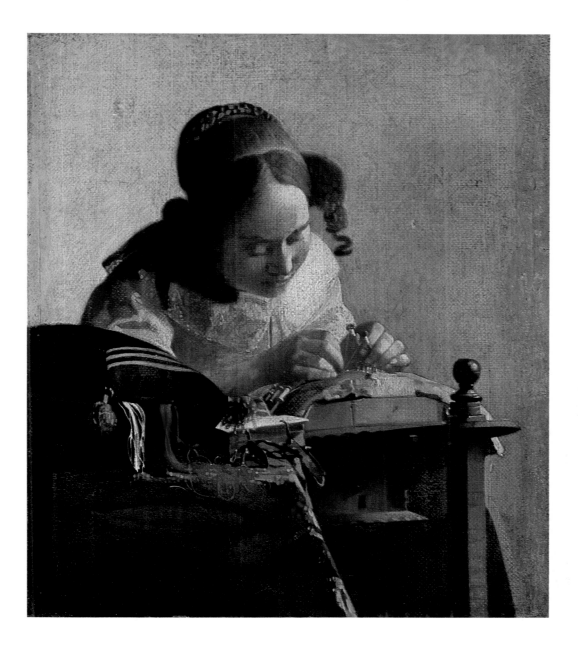

◁

989 Johannes Vermeer
Young Woman Standing at a Virginal
Signed. Canvas, 51.7 × 45.2 cm. The National
Gallery, London

990 Johannes Vermeer
Allegory of the New Testament
Canvas, 116 × 90 cm. The Metropolitan Museum
of Art, New York. Friedsam Collection

Vermeer was a Catholic, and it is thought that one of his last paintings, *Allegory of the New Testament* (fig. 990), was probably commissioned by a wealthy Catholic patron. The picture lacks the serenity and concentration of his earlier work, but is disappointing primarily because Vermeer's magisterial control of light seems to have failed him.

Vermeer presumably painted very slowly. His technique was not one that could be hurried, and he must have thought each painting through in every aspect. We appreciate the calm perfection of his works, but some contemporaries judged differently. The French nobleman Balthasar de Monconys made a trip through the Dutch Republic in 1663, and wrote in his diary: "In Delft I visited the Painter Vermeer, who did not have any of his work on hand; but we saw one at the house of a baker for which he had paid six hundred *livres*, although it had just one figure, and I think six *pistoles* would have been more than enough."[18] The Delft baker apparently had a better eye for Vermeer's art than the Frenchman did. It may have been this same baker who, after the painter's death, accepted two of his works to cover a debt of 617 guilders. In the catalog of a sale held in Amsterdam in 1696, no fewer than twenty-one paintings by Vermeer are listed. Three others are mentioned elsewhere. The descriptions of these works are exact enough to allow the reasonably sure identification of extant paintings, so that Vermeer's oeuvre as known today is virtually identical with the works then described. It may thus be concluded that little of his work has been lost, and that the owners have always taken good care of his paintings, even though, until his art was rediscovered about 1850, Vermeer had been virtually forgotten for generations.

Other Figure Painters

With Ter Borch in Deventer, van Mieris and Metsu in Leiden, and de Hooch and Vermeer in Delft, domestic figure painting reached heights difficult to surpass; further advance in this

991 Hendrick van den Burgh
Graduation Ceremony at the University of Leiden
Signed. c. 1650. Canvas, 71.5 × 59 cm.
Rijksmuseum, Amsterdam

992 Cornelis de Man
The Game of Chess
Signed. Canvas, 97.5 × 85 cm. Szépmüvészeti
Múzeum, Budapest

991

992

993

993 Jan Verkolje
The Proposition
Signed. Canvas, 70 × 66 cm. Gemäldegalerie Alte
Meister, Staatliche Kunstsammlungen, Dresden

994 Jacobus Vrel
View in a Town with a Baker's Shop
Panel, 53 × 40 cm. Wadsworth Atheneum,
Hartford, Connecticut. Ella Gallup Sumner and
Mary Catlin Sumner Fund

genre was no longer possible. It is not surprising that the painters who continued to choose the same themes lapsed into uninteresting imitation or uninspired attempts at originality.

The Delft painter Hendrick van den Burgh joined the guild there in 1649, which indicates that he was probably several years older than de Hooch and Vermeer. Little signed work by him is known, and to him has fallen the doubtful honor of functioning as a sort of catchall for de Hooch's unaccepted paintings. Moreover, false paintings that once were incorrectly attributed to de Hooch now bear, just as incorrectly, van den Burgh's label. He certainly worked in de Hooch's style, and if he happened to be less talented than that master, he could nevertheless produce attractive paintings quite independently. One of these is his pleasant rendition of a graduation ceremony at Leiden University (fig. 991).

More is known about another Delft artist, the versatile Cornelis de Man. He must have

994

played an important role in the town's artistic life, for between 1657 and 1696 he is recorded many times as a guild official. De Man painted portraits, figure pieces, a few church interiors, and possibly some marine views. His portraits are rather stiff, and though his figure paintings are on the whole well drawn, they lack atmosphere, and his palette is chilly. *The Game of Chess* (fig. 992), in any event, is a good example of his style.

Jan Verkolje, a native of Amsterdam, lived after 1672 in Delft, where he specialized in mythological scenes and interiors with fashionably dressed figures, as in *The Proposition* (fig. 993). His work is closely akin to that of Metsu and Caspar Netscher, and especially Ter Borch. Verkolje was a good draftsman and colorist, but no innovator.

It is a puzzle whether the mysterious Jacobus Vrel, about whose life nothing is known, should be counted among the Delft painters, where the intimate character of his mostly small panels and the fact that his work was once sold under the name of Vermeer have usually placed him. His interiors are without exception weakly drawn and not particularly interesting, but his town views have the naive charm of so-called primitive paintings—so much charm that we gladly overlook the lack of technique. Vrel is unexcelled in depicting everyday street scenes of Dutch towns, with shops and markets, and people going calmly about their business (fig. 994). The type of architecture he painted suggests that his center of activity should be sought not in Delft but in more southerly areas of the Netherlands.[19]

Portrait and Still-Life Painters

Few portrait painters of any importance worked in Delft. In addition to Cornelis de Man, Anthonie Palamedesz remained long active and produced good portraits especially after 1650 (see fig. 696). Of Michiel Nouts's portraits, only a few are known today. His *Portrait of a Woman* (fig. 995), signed and dated 1656, is remarkably strong and beautifully lighted. Painted in large planes, it belongs firmly within the Delft tradition in conception, color, and treatment of light. Unfortunately there is no biographical information about Nouts.[20]

The still-life painter Willem van Aelst returned to Delft in 1656 after having worked for many years in France and Italy, but within a few months he left for Amsterdam. The talented flower painter Maria van Oosterwijck also worked in Delft for some time before she too moved to Amsterdam, where she was living in 1675. Maria's grandfather was a Delft pastor, and her father followed that calling in the nearby village of Nootdorp. Apparently it was not considered improper for a clergyman's daughter to become a painter, and Maria's family seems to have encouraged her, for she had a room in her grandfather's

995 Michiel Nouts
Portrait of a Woman
Signed and dated 1656. Canvas, 108 × 85.5 cm.
Rijksmuseum, Amsterdam

996 Maria van Oosterwijck
Vase of Flowers with Shells
Signed. Canvas, 72 × 56 cm. Gemäldegalerie Alte Meister, Staatliche Kunstsammlungen, Dresden

house that she used as a studio. Houbraken deals with her rather extensively, calling her "demure and extraordinarily pious, yet merry and exceptionally industrious."[21] He reports that she studied under Jan Davidsz de Heem, which accords with the style of her flower still lifes: they are close to de Heem in composition and treatment of light. Maria was indubitably talented; her floral paintings are beautiful in drawing and color and spacious in composition (fig. 996). She often added a *vanitas* element to her still lifes, as well as occasional inscriptions in that vein. Her work was extremely popular. According to Houbraken she had many clients, including Louis XIV, Emperor Leopold I, and the king of Poland. Her paintings commanded high prices, and there is documentary evidence that she used some of her money to purchase freedom for Dutch sailors captured by the Barbary pirates and held as slaves in Algiers. Whether Willem van Aelst indeed courted her, as Houbraken reports, can regrettably not be verified.

Painting in The Hague: 1650–1680

Almost the entire third quarter of the seventeenth century, from 1650 to 1672, is known in Dutch history as the first stadholderless period. National leadership, as we have seen, lay in the hands of the States-General and the advocate of Holland, Johan de Witt. The question is whether this situation influenced the artistic life of The Hague. There was a general sobering of atmosphere: the theaters were closed in 1650 and not permitted to reopen until seven years later; they were again banned from 1662 to 1678. But the government's puritanical tendencies had to give way to the demands of diplomatic protocol, and before long the States-General were receiving foreign ambassadors with almost the pomp and ceremony of Frederik Hendrik's days. Although there was no stadholder, the stadholder's court remained, split between the dowager Amalia van Solms and William II's widow, Mary Stuart, called the princess royal. Amalia was absorbed in the decoration of the Oranjezaal from 1648 until its completion in 1654; her commissions for new paintings to decorate the private apartments of the Huis ten Bosch seem to have stopped in 1654 also, although as late as 1671 she commissioned Caspar Netscher to portray her in her widow's weeds.[1] Other court portraits recorded the visages of the young William III and the many children of Elizabeth of Bohemia, the Winter Queen. In 1656 the artists of The Hague were able to persuade the municipal authorities to license their new guild, the Confrerie Pictura—an optimistic sign for the professional painters. There is thus little reason to suppose that the city's artistic life declined appreciably during the stadholderless period.

Portrait and Figure Painters

As before, The Hague remained most attractive to portrait painters. Adriaen Hanneman and Jan Mijtens were kept busy until their deaths in 1671 and 1670, respectively, producing stylish and well-painted individual and group portraits, such as Hanneman's *Portrait of a Lady in White* (fig. 997) and Mijtens' *Family Group* (fig. 998). Pieter Nason had arrived in 1639 from Amsterdam and abandoned his old-fashioned style of portraiture for the new mode, admirably represented by his *Portrait of a Doctor of Medicine* (fig. 999).

The first important newcomer to the Hague portraitist circle was Jan de Baen, who arrived in 1660. A native of Haarlem, he had studied under Jacob Backer in Amsterdam. Houbraken says that de Baen was enticed to The Hague by an "art-loving gentleman," but

997 Adriaen Hanneman
Portrait of a Lady in White
Signed and dated 1661. Canvas, 121 × 94 cm.
Herzog Anton Ulrich Museum, Brunswick, West
Germany

998 Jan Mijtens
*Family Group: A Husband and Wife with Children
and Attendants*
Signed and dated 1661. Canvas, 137 × 167 cm.
National Gallery of Ireland, Dublin

999 Pieter Nason
Portrait of a Doctor of Medicine
Signed and dated 1665. Canvas, 90 × 68 cm.
Dulwich Picture Gallery, London

more interesting is his remark that de Baen, after completing his training, had to decide
which style he wished to pursue: "The brush art of Ant. van Dyk was highly esteemed, and
that of Rembrandt also found many followers. He stood dozing long at this crossroads, not
knowing which way was best to go, yet chose the manner of the first, as being of more
lasting nature, as his model."[2] To a young artist of the 1650s it was thus not self-evident
which way the art of his own time would swing, but de Baen gauged his talent accurately;
he adopted the international style of van Dyck's manner of painting mingled with steadily
increasing French influences, and he soon made his name at home and abroad. Among his
patrons in The Hague was Count Johan Maurits of Nassau-Siegen, and he worked also for

1000 Jan de Baen
Portrait of Hieronymus van Beverdinck,
Paymaster-General
Signed and dated 1670. Canvas, 156 × 121.5 cm.
Rijksmuseum, Amsterdam

1001 Jan de Baen
The Directors of the United East India Company,
Hoorn
Signed and dated 1682. Canvas, 238 × 292.5 cm.
Westfries Museum, Hoorn

Charles II of England and for Friedrich Wilhelm, the elector of Brandenburg, who tried in
vain to lure him to Berlin. Although de Baen limited himself primarily to individual
portraits of distinguished persons, such as the paymaster-general Hieronymus van
Beverdinck (fig. 1000), he also made a few group portraits: the syndics of the Leiden cloth
guild in 1675, the directors of the Hoorn branch of the United East India Company in 1682
(fig. 1001), and the regents and regentesses of the Amsterdam Spinning House (a
correctional institution for women) in 1684. For the Dordrecht town hall he painted an
allegory of Cornelis de Witt, one of the town's most famous sons; the work was destroyed
in 1672 during the riots that followed the lynching of the de Witt brothers in The Hague.
De Baen was a worthy successor to Hanneman and Mijtens, and his popularity as a

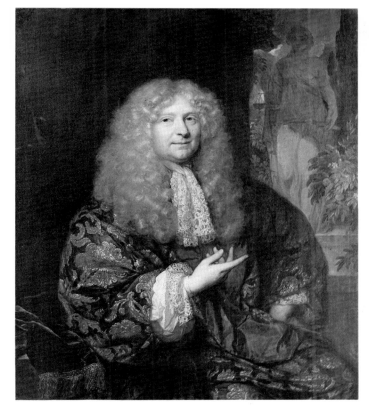

1002

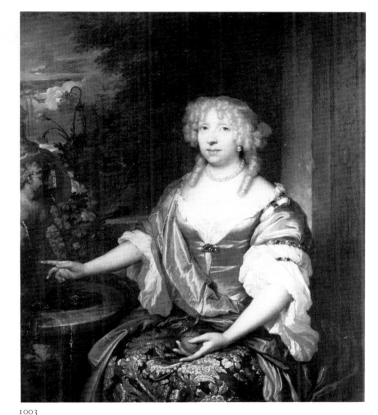

1003

1002 Caspar Netscher
Portrait of a Gentleman
Signed and dated 1680. Canvas, 52 × 44 cm.
Gemäldegalerie, Staatliche Museen, West Berlin

1003 Caspar Netscher
Portrait of a Lady
Signed and dated 1679. Canvas, 53 × 44 cm.
Gemäldegalerie, Staatliche Museen, West Berlin

1004 Caspar Netscher
Company Making Music
Signed and dated 1665. Panel, 44 × 36 cm.
Mauritshuis, The Hague

portraitist in The Hague was challenged by only one other painter, Caspar Netscher.

Netscher was born about 1635–36, but his birthplace cannot be definitely established. He was a pupil of Gerard Ter Borch for a time, and then traveled in France; he was married in Bordeaux in 1659. Having settled in The Hague in 1662, he soon freed himself of his master's influence and began to paint portraits in a French-oriented manner that shows closer relationship to the late style of Nicolaes Maes than does the work of other Hague painters: his elegant portraits are of rather small size, usually with a parklike landscape in the background that is partly hidden by draperies, as in his pendant portraits of a gentleman and a lady (figs. 1002 and 1003). Netscher was clever technically and had no trouble with hands and faces; he was also a master in rendering rich silk and brocaded cloth. In time, however, his approach weakened and clearly became routine.

Netscher's company paintings, which he continued to produce until about 1670, show Ter Borch's influence for much longer than his portraits do. He indeed went through an early spell of copying his master's work, from which some figures seem to have wandered

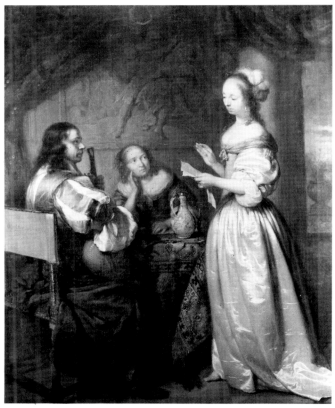

1004

457

1005 Caspar Netscher
The Lace Maker
Signed and dated 1664. Canvas, 34 × 28 cm. The Wallace Collection, London

1006 Joris van der Haagen
View of Cleves
Signed. Canvas, 147.5 × 187 cm. State Museum Twenthe, Enschede

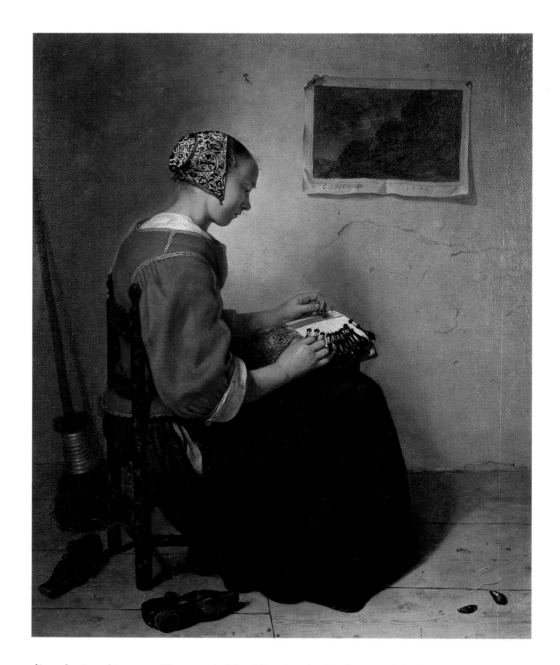

directly into his own (fig. 1004). Yet Netscher had other models than Ter Borch; he must also have known well the work of Frans van Mieris and Gerrit Dou. He is best in his simple scenes, such as *The Lace Maker* (cpl. 1005), where the delicate brushwork and the modest yet exciting palette are undisturbed by his frequent urge for perfection of detail. Netscher's son Constantijn worked wholly in his father's style.

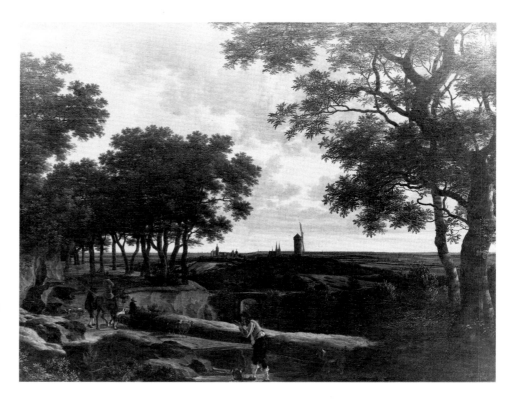

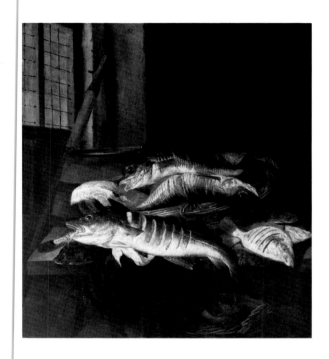

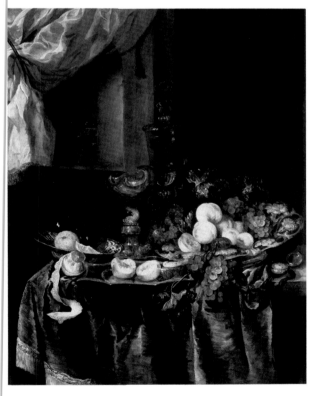

1007 Abraham van Beyeren
 Still Life of Fish
 Signed. Canvas, 100 × 89 cm. Ashmolean
 Museum, Oxford

1008 Abraham van Beyeren
 Banquet Still Life
 Signed and dated 1655. Panel, 114 × 85 cm.
 Worcester Art Museum, Massachusetts

No other figure painters of any distinction emerged in The Hague, and landscape painters were also scarce. Jan van Goyen died in 1656, and Carel Du Jardin worked there for only two years, about 1656–58. That left only Joris van der Haagen, who is important mainly as a topographical draftsman. He came to The Hague about 1640 and entered the guild three years later. His landscape paintings, views of Holland and in the neighborhood of Cleves, vary in quality but demonstrate his interest in trees grouped against a broad vista and in lively effects of light (fig. 1006).

Abraham van Beyeren and Other Still-Life Painters

Abraham van Beyeren was by far the most important still-life painter in The Hague. He was born there in 1620 or 1621 and lived there for much of his life, but to judge from his many moves, his spirit was restless. In 1639 he was married in Leiden, and the next year he joined the guild in The Hague. After the death of his first wife he married Anna van den Queborn, daughter of a Hague portrait painter, in 1647; the couple moved to Delft in 1657, but six years later they were back in The Hague. In 1669 van Beyeren seems to have left his birthplace again to work variously in Amsterdam, Alkmaar, Gouda, and Overschie, where he died in 1690. Van Beyeren's work apparently attracted little notice. His paintings brought low prices at auctions and other sales. During his lifetime he was always in financial trouble, and only later, probably because he was van den Queborn's son-in-law, does he seem to have fared somewhat better. There are no other contemporary references to him; even Houbraken has nothing to offer.

Van Beyeren concentrated on several specific subjects: fish still lifes, *pronk* or ornate still lifes with extremely diverse objects, *vanitas* still lifes, flower pieces, and river views. He almost always signed his works with his monogram *AVB f.*, but the scarcity of dated works makes it nearly impossible to establish a chronology of his oeuvre. Some of his fish still lifes are dated between 1655 and 1666,[3] some of the ornate still lifes from 1651 on; but none of his known floral still lifes or marine paintings is dated and presumably they were not bound to any particular period of his life. Fairly often in the fish still lifes a background window or door gives a view of the sea or of a beach that resembles his marine pieces.

Van Beyeren's teacher is unknown, but in general it is assumed that he learned the fundamentals of painting from the Hague painter of still lifes Pieter de Putter, who married another of van den Queborn's daughters. Stylistically, van Beyeren seems to have been influenced by the still-life painter Jacques de Claeuw. His marine views, on the other hand, are linked to the work of such tonal painters of seascapes and landscapes as Jan Porcellis and Jan van Goyen.

Even in his earliest fish still lifes, van Beyeren proves himself master of a smooth, fairly broad, and assured touch; he impeccably renders the quivering, half-transparent flesh of the fish and the glitter of their wet scales or skin (fig. 1007). He seems to have painted these creatures for the sheer joy of it.

Van Beyeren's other still lifes, ranging from rather modest little repasts to the most sumptuous "banquets," display the high quality of his art even more convincingly. In the ornate still lifes he could give complete expression to his technique and to his compositional and visual powers. Gold and silver, porcelain and crystal, velvet and silk, flowers and fruit and crustaceans—all are perfectly observed and rendered according to their different natures and textures. Jan Davidsz de Heem had established the foundations for this form of still life, but there is no question of imitation here. Van Beyeren had his own style. The *Banquet Still*

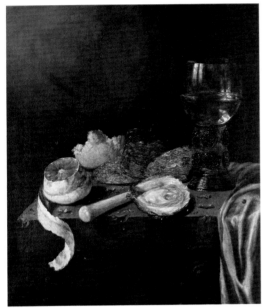

1009

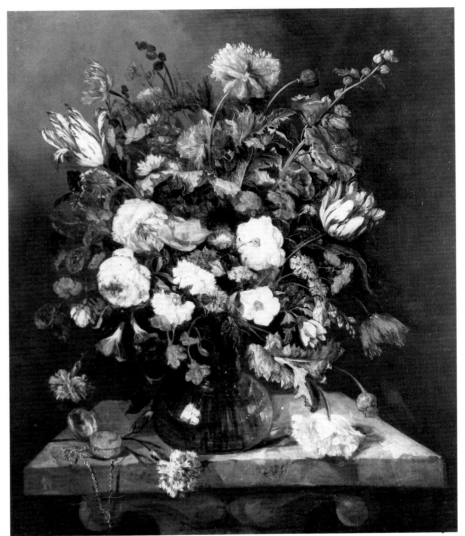

1010

1009 Abraham Susenier
 Little Breakfast with Oysters
 Signed and dated 1666. Canvas, 41 × 34 cm.
 Ashmolean Museum, Oxford

1010 Abraham van Beyeren
 Vase of Flowers
 Signed. Canvas, 80 × 69 cm. Mauritshuis, The
 Hague

1011 Abraham van Beyeren
 Boats in a Gale
 Signed. Panel, 80 × 110 cm. Private collection

Life in the Worcester Art Museum (fig. 1008)—painted on a panel, quite exceptional for a
piece of its size—dates from 1655 and is perhaps one of the most beautiful examples of his
talent. The brushwork is exceptionally free, as can be clearly seen in the velvet tablecloth,
and the coloring, which can be rather hard in some of his works, is here balanced
harmoniously. Van Beyeren almost always used the same basic compositional scheme: a
covered table overladen with costly objects, the tallest of these—usually a glass or a richly
worked silver pitcher—placed in the middle or slightly to the right. The center of gravity is
always at the right, counterbalanced at the left by a niche or a curtained window partly
blocking the view. An open pocketwatch often symbolizes the transiency of all the lovely

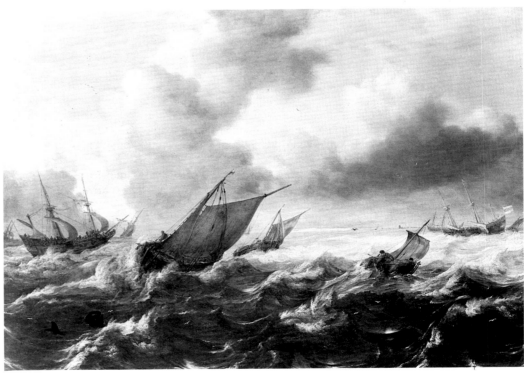

1011

460

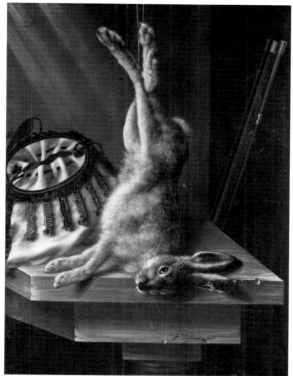

1013

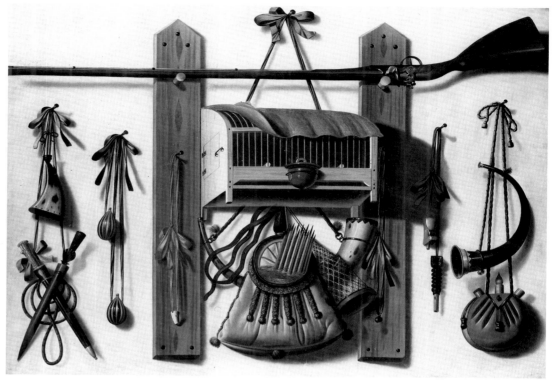

1012

1012 Johannes Leemans
 Still Life with a Gun and Fowling Equipment
 Signed and dated 1684. Canvas, 114.3 × 156.2 cm.
 Hunterian Art Gallery, University of Glasgow.
 Smillie Collection

1013 Jacob Biltius
 Still Life with a Dead Hare
 Signed and dated 1670. Canvas, 65.5 × 50 cm.
 Statens Museum for Kunst, Copenhangen

1014 Simon Verelst
 Still Life of Flowers
 Signed. Canvas, 35 × 28 cm. Ashmolean
 Museum, Oxford

1014

objects spread out around it. *Vanitas vanitatum* is inscribed on one of the large ornate still lifes,[4] and the beautiful, loosely painted *Vase of Flowers* (fig. 1010), with its pocketwatch, was almost certainly intended as a *vanitas*. Inexplicably, van Beyeren's still lifes found little following.

Van Beyeren's gray-toned marine paintings could hardly differ more in subject matter from the ornate still lifes, and yet they share the same free, loose touch. The water is always in motion, and although the waves tend to be somewhat stereotyped, van Beyeren captured the turbulence of the sea in such paintings as *Boats in a Gale* (fig. 1011).

Abraham Susenier, born about 1620 in Leiden and working from 1640 to 1646 in The Hague, is one of the few painters there who seem to have been influenced by van Beyeren's still lifes; since his monogram was *AB.S*, his signature has sometimes been misread for Abraham van Beyeren's. Susenier's *Breakfast Piece with Oysters* (fig. 1009) is more or less in van Beyeren's style. He also painted shell still lifes and some beach views.

Isaac van Duynen, active in The Hague in 1677–81, and Pieter Verbeeck, who must have worked there about the same time or somewhat earlier, followed van Beyeren in painting fish still lifes, but were qualitatively not on his level.

The Hague still-life painter Johannes Leemans devoted himself exclusively to *trompe-l'oeils*, mainly of hunting equipment. He arranged his objects to hang against a wall of unfinished wooden planks or light-colored plaster (fig. 1012). By well-observed effects of light and shadow and meticulous attention to the smallest detail, he gave his paintings a deceptively true-to-nature look. The Hague-born Jacob Biltius painted similar *trompe-l'oeils* and still lifes of hunting equipment and game, such as his *Still Life with a Dead Hare* (fig. 1013). After 1660 Biltius worked in Maastricht and Amsterdam. Dead game and birds were the subject also chosen by Cornelis Lelienberg, who composes his works with the animals suspended against a darker wall or lying on a tabletop (see fig. 263). He was a master in rendering the complex structure of birds' feathers and the soft pelts of hares and rabbits. In his early work especially, Lelienberg's palette is delicate, with silvery grays and warm brown tints predominating. His later works are less restrained, the compositions livelier, in the style of such Flemish painters of game still lifes as Jan Fijt and Pieter Boel.

Simon Verelst, son of the portrait painter Pieter Verelst, also produced meritorious still lifes of wild game and birds, but his special forte was floral painting, at which he attained great success. He moved to London when he was twenty-five and made his career there. His elegant flower still lifes, asymmetrical in arrangement and limited to a relatively small number of flowers (fig. 1014), are particularly attractive.

Amsterdam cannot be denied first place as an artistic center during the third quarter of the seventeenth century. The number of painters working there is amazing. We have looked at the work of the old guard (p. 352), and will now discuss the newcomers and their followers in the younger generation, some of them natives and others drawn to the city from outside.

Jacob van Ruisdael and His Circle of Landscape Painters

Jacob van Ruisdael, who had moved to Amsterdam from Haarlem about 1656, is recorded as living there in 1657 in the Beursstraat near the Dam. His motives for the move are unknown. Soon after he arrived in Amsterdam he took into his household the orphan Meindert Lubbertsz—a boy who would later become famous under the name of Hobbema.

There is a curious chapter in Ruisdael's life that has not yet been, and perhaps can never be, satisfactorily explained. It is best to dispose of it before we turn to his paintings. Along with his prolific production of landscape paintings, Ruisdael presumably also pursued an interest in medicine. Houbraken reported: "His father... had him in his youth... learn the practices of the science of Medicine, [and] he was so far advanced in this that he performed various manual operations in Amsterdam with great success."[1] Houbraken's statement seems confirmed by an entry in the register of Amsterdam physicians indicating that one "Jacobus Ruijsdael" obtained a medical degree at the University of Caen on October 15, 1676.[2] If this refers to the painter Jacob van Ruisdael, he probably went to Caen because it was easier to get a degree than at Leiden University, the only Dutch university offering medical study at that time. Jacob was about forty-eight years old in 1676, and his production of paintings then began to lag: was he giving more time to medicine? No one knows, and the inescapable fact remains that of all the names in the physicians' register, only his has been crossed out, apparently in the same ink originally used to write it in.

In Haarlem, Ruisdael had painted mostly dune landscapes and forest views; in Amsterdam he expanded his repertoire to include landscapes of nearly every kind. Since he seldom dated his works, their chronology is difficult to establish. He seems to have continued to elaborate on forest views, now giving them a romantic monumentality, as in *Bog in a Forest* (fig. 1015). Mountain landscapes also began to take an important place in his work, among them Scandinavian views (fig. 1016) which owe their origin to Allart van Everdingen, who settled in Amsterdam in 1657 and introduced this new type of landscape.

That Ruisdael did not forget his birthplace is borne out by a number of distant views of Haarlem. This subject apparently became one of his specialities, for a 1669 inventory lists "a little Haarlem by Ruysdael."[3] To paint these vistas, of which the Zürich *Bleaching Fields near Haarlem* is a beautiful example (cpl. 1017), Ruisdael took his standpoint on top of a dune and used a slightly lower slope in the foreground as *repoussoir*, then directing his glance

1015 Jacob van Ruisdael
Pool in a Forest
Signed. Canvas, 73 × 99 cm. Leningrad, Hermitage

1016 Jacob van Ruisdael
Rocky Landscape in Scandinavia
Signed. Canvas, 104 × 127 cm. The Wallace Collection, London

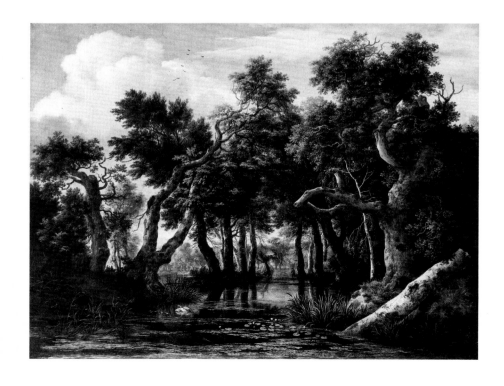

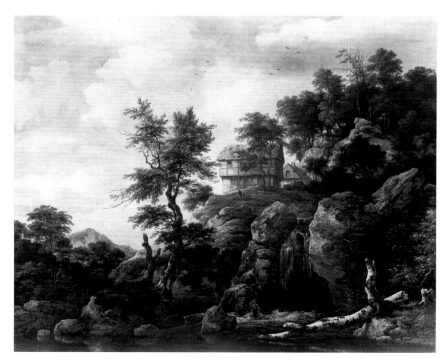

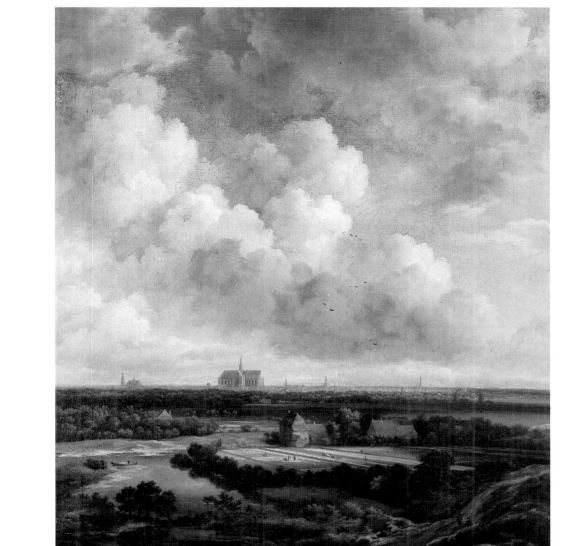

1017 Jacob van Ruisdael
Bleaching Fields near Haarlem
Signed. Canvas, 62.2 × 55.2 cm. Kunsthaus,
Zurich. Dr. L. Ruzicka Foundation

inland. The flat countryside stretching out to the horizon and filled with bodies of water, meadows, bleaching fields, and houses is transected by hedges and rows of trees; behind lies Haarlem, the great St. Bavo's church looming above the red-roofed, partly sun-struck houses and the windmills on the town wall. Majestic clouds pile up in a limitless sky overhead.

It is assumed that these "open" landscapes—in contrast with the forest and mountain views—were created mostly after 1670, but, as the 1669 inventory indicates, Ruisdael had already been painting views of Haarlem. The possibility remains that Philips Koninck's panoramic landscapes (see cpl. 793) may have inspired him, yet Ruisdael treated the subject in a personal way: his paintings are usually smaller than Koninck's, and the vertical format he used is unusual for a panorama. Vertical pictures became popular in the second half of the seventeenth century, but Ruisdael probably chose this shape for the scope it gave to his soaring skies.

The open view and clear, fresh atmosphere are also found in Ruisdael's beach scenes, such as his view of the beach and dunes at Scheveningen on a windy day (fig. 1018). Adriaen van de Velde's somewhat earlier treatment of this theme (see cpl. 1041) may have served him as model, since there is a strong kinship in composition and atmosphere.

In Ruisdael's rare marine views—actually more often of broad inland waters, such as the Haarlemmermeer and the IJ—a vigorous breeze is always blowing, stirring up the waves (fig. 1019). Clouds cast dark shadows on the water, enhancing the feeling of great space. Ruisdael's talent for depicting weather conditions also got full play in his winter landscapes, which are not in the old tradition of cheerful recreation on the ice, but of the bitter cold and the dark clouds that threaten more severe storms (fig. 1020).

In the meantime he continued to paint mountain landscapes, forest views, and his popular waterfalls—paintings that show his almost inexhaustible fantasy and compositional innovation. Yet precisely in this sort of landscape, portraying nature imagined rather than observed and experienced, he lost much of his sensitivity. The feeling of spaciousness is replaced by a certain heaviness and hardness that break the earlier mood.

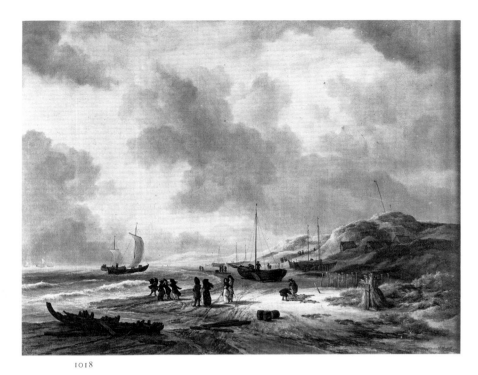

1018

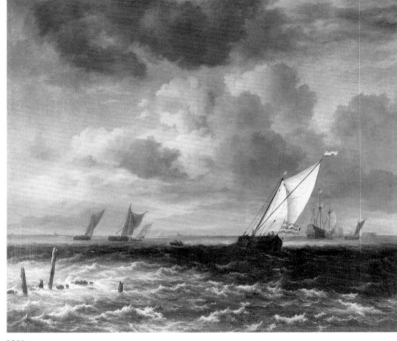

1019

1020

Ruisdael also painted townscapes, always of Amsterdam, sometimes as panoramic views, sometimes of scenes within the city. He may have painted his *View of the Dam and the Damrak* (see fig. 335) from his house on the south side of the Dam, where he moved about 1670 and, presumably, where he died in 1682.

The work of Allart van Everdingen, younger brother of Caesar, is closely related to Ruisdael's. Ruisdael borrowed the Scandinavian landscape theme directly from Everdingen, and Everdingen in turn seems to have felt the impact of Ruisdael's strong individuality. Born in Alkmaar in 1621, Everdingen was the elder of the two by seven or eight years. He served his apprenticeship in Utrecht under Roelant Savery, from whom he may have inherited his interest in mountain landscapes, and then studied further under Pieter de Molijn in Haarlem.[4] In 1640–44 he traveled in Sweden and Norway, doubtless in the employ of the Amsterdam munitions magnates, the Trip and de Geer families, whose cannon foundry Julitabroeck was the subject of a huge painting by Everdingen (see fig. 65). The mountainous landscapes with rushing waterfalls that the young painter saw in Scandinavia made so deep an impression on him that he continued to paint these motifs long after he returned home; his *Landscape with a Sawmill* (fig. 1021) is typical of these works. When he got back Everdingen worked first in Haarlem, but settled in Amsterdam in 1657 and died there in 1675. Besides rocky masses and waterfalls, he also painted gentler aspects of the Scandinavian landscape, one of the most beautiful examples of which is the *Hilly Landscape* (fig. 1022) with its subtly attuned gradations of green. The jutting spruce trees in the left foreground and the towering clouds above the farthest hills evoke a sense of vast distance. Everdingen also produced a number of marine paintings.

1021

1022

1018 Jacob van Ruisdael
The Beach at Scheveningen
Canvas, 84 × 110 cm. Musée Condé, Chantilly

1019 Jacob van Ruisdael
A Rough Sea
Signed. c. 1670. Canvas, 107 × 124.5 cm. Museum
of Fine Arts, Boston. William Francis Warden
Fund

1020 Jacob van Ruisdael
Winter Scene
Signed. Canvas, 44.5 × 55 cm. Private collection,
West Germany

1021 Allart van Everdingen
Landscape with Sawmill
Signed. Canvas, 71.5 × 102 cm. Kunsthistorisches
Museum, Vienna

1022 Allart van Everdingen
Hilly Landscape
Signed. Canvas, 72.8 × 102.2 cm. Kunsthalle,
Hamburg

By far the most important of the many painters in Jacob van Ruisdael's circle was his pupil Meindert Hobbema, born in Amsterdam in 1638. In July 1660 Ruisdael attested in the presence of an Amsterdam notary that the orphan Meindert Lubbertsz had "served and learned for several years" with him, and that Meindert had used his money "neither improperly nor recklessly but thriftily and decently." This declaration was a sort of account rendered to Meindert's guardian.[5] Hobbema, as the young artist soon began calling himself—how and why he came by that name is not known—was powerfully influenced by his teacher, who was only ten years his senior. Some of Hobbema's themes and compositions are directly derivative from Ruisdael, and a landscape now in Melbourne is virtually a copy of a Ruisdael etching.[6] This dependence lasted until about 1662, when Hobbema began to develop his own style. The two painters kept in close touch, however, and in 1668 Ruisdael appeared as witness (more or less equivalent to a best man) at Hobbema's marriage to a housemaid in the service of the Amsterdam burgomaster Lambert Reynst.

Hobbema was a less versatile painter than Ruisdael, and considerably more limited in his choice of subject matter. Most of his pictures are of woody landscapes in which a few small figures play inconspicuous roles. His *Woody Landscape with Farmhouse* of 1663 (fig. 1023) already shows his basic compositional scheme, which he used over and again: large trees in the foreground that bespeak his continuing indebtedness to Ruisdael, and beyond the water a sun-drenched landscape with farmhouses half hidden by trees, attesting to his own more poetic approach. The motif of *The Water Mill* (fig. 1024) also stems from Ruisdael, but the mood of this landscape is wholly Hobbema's; *View of the Haarlem Lock and the Herring Packers' Tower* (fig. 1025) is one of his rare ventures outside his narrow range. Within his limits Hobbema attained unusual heights, becoming an outstanding landscape painter. His

1023 Meindert Hobbema
Woody Landscape with Farmhouses
Signed and dated 1663. Canvas, 99 × 131 cm. The
Wallace Collection, London

1024 Meindert Hobbema
The Water Mill
Signed and dated 1670. Canvas, 81 × 109.5 cm.
The Art Institute of Chicago

1025 Meindert Hobbema
View of the Haarlem Lock and the Herring Packers'
Tower, Amsterdam
Signed. Canvas, 77 × 98 cm. The National
Gallery, London

1026 Meindert Hobbema
The Ruins of Brederode Castle
Signed and dated 1671. Canvas, 82 × 106 cm. The
National Gallery, London

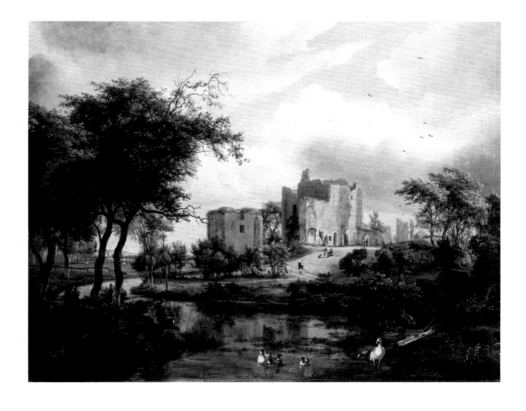

handling of foliage is animated and evocative: light seems to dance through the leaves. He boldly juxtaposed greens in many gradations, and added loose touches of grays and blues to heighten the effect. His treatment of light can brilliantly capture the atmosphere of a half-cloudy summer day.

After his marriage Hobbema was appointed municipal wine gauger: his duty was to measure imported wines and oils so that they could be sold by Amsterdam standards. His new post apparently kept him busy, but he did not give up painting as is sometimes assumed. A number of paintings date from the period after 1668, including the 1671 view of the ruins of Brederode Castle near Haarlem (fig. 1026), a landscape with a view of Deventer, and most particularly *The Avenue, Middelharnis* (cpl. 1027), the latter two dating

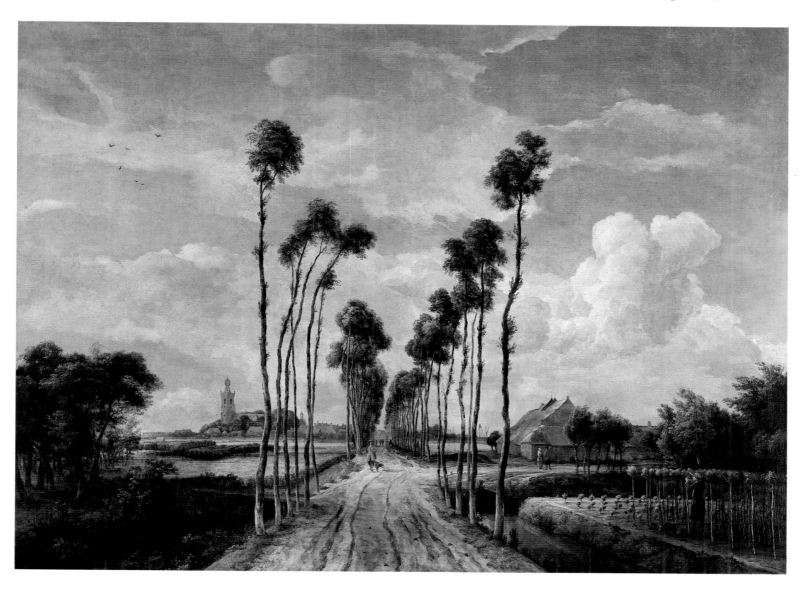

1027 Meindert Hobbema
The Avenue, Middelharnis
Signed and dated 1689. Canvas, 103.5 × 141 cm.
The National Gallery, London

from 1689.[7] *The Avenue* is a masterpiece of Dutch landscape art. Perhaps because he was now painting fewer pictures, Hobbema here ventures away from his sometimes almost trite compositional patterns. Other painters had used the motif of a straight road, but he centers upon it as if by revelation. The eye moves down the road, pauses to notice the side road branching right, then proceeds straight ahead between the tall, plumelike trees whose strong verticals transect the flat, horizontal countryside, at last approaching the little town of Middelharnis with its church tower like a beacon in the distance. The freshness and originality of *The Avenue* at the late date of 1689 crown Hobbema's work but in other ways rang out the great period of seventeenth-century landscape painting. Hobbema died in 1709.

Jan van Kessel should perhaps also be counted as a pupil of Ruisdael. He painted mainly distant views, forest landscapes, northern landscapes, and some town views—subject matter strikingly close to that of Ruisdael, whose influence is apparent as well in van Kessel's execution. Philips Koninck and Hobbema, who was godfather to van Kessel's second son, may have contributed further to the younger artist's development. Van Kessel was overshadowed by these great landscape painters, but his work nevertheless has a personal and sympathetic quality, evident in his view of the bleaching fields with Haarlem in the distance (fig. 1028). He is moreover another example of a talented pupil whose best works

1028

1028 Jan van Kessel
Bleaching Fields in the Dunes with Haarlem in the Distance
Signed. Canvas, 115 × 130 cm. Musées Royaux des Beaux-Arts de Belgique, Brussels

1029 Emanuel Murant
Village Street with a Shepherd and Sheep
Signed. Panel, 38 × 51.5 cm. Residenzgalerie, Salzburg

1030 Anthonie van Borssum
Panorama near Schenkenschans
Signed and dated 1666. Canvas, 90.5 × 126 cm. Kunstmuseum, Düsseldorf

1029

1030

1031

1031 Carel du Jardin
Landscape with Cattle
Signed and dated 1655. Canvas, 54 × 44 cm. Musée du Louvre, Paris

may have been, or may still be, passed off under the more famous and expensive name and often the false signature of his master.

Emanuel Murant, a pupil of Philips Wouwerman, was more or less connected to the Ruisdael circle. His landscapes include peasant houses, often abundantly inhabited by small livestock, and may easily be recognized for their extraordinary detail: he renders every leaf, twig, and blade of grass, and every brick and tile of his buildings (fig. 1029).

Anthonie van Borssom, who was presumably one of Rembrandt's pupils, painted highly diversified landscapes. His early work is compositionally reminiscent of Murant's; later he added distant views to his repertoire, assigning an important place in the picture to herdsmen and cattle in the foreground, as in his *Panorama near Schenkenschans* (fig. 1030).

Italianate Landscape Painters

After 1650 the painters specializing in Italianate landscapes began to converge more and more on Amsterdam. Claes Berchem of Haarlem, one of the most important representatives of his group, is mentioned in Amsterdam in 1660, and he settled there in 1677. His pupil Carel Du Jardin, only a year or two younger than Berchem, had returned to Amsterdam in 1652, possibly after visiting Rome. Perhaps he was the Carel du Gardin, merchant of Amsterdam, who is recorded in the archives as preparing for a trip to Paris in 1650; his whereabouts and activities until 1652 are not known, but after that date he was active mainly in Amsterdam and sometimes in The Hague. In 1675 he traveled to North Africa and is recorded in Rome and in Venice, where he died in 1678.

Du Jardin was no trailblazer. He based his landscapes on those of Berchem and Jan Asselijn, and was influenced by Paulus Potter in his depiction of animals. Yet his talent was real, and his paintings, usually small in size, are delicate in execution and treatment of light. A warm, sunny atmosphere pervades his landscapes, where animals drowse contentedly (fig. 1031). Du Jardin also painted biblical subjects (see p. 67), excellent portraits, and was not afraid to undertake large commissions. His 1669 group portrait of the regents of the

1032 Carel du Jardin
Regents of the Spinning House, Amsterdam
Signed and dated 1669. Canvas, 225 × 390 cm.
Rijksmuseum, Amsterdam. On loan from the
City of Amsterdam

1033 Adam Pynacker
Seacoast in Italy
Signed. Panel, 35.7 × 63.5 cm. Hermitage,
Leningrad

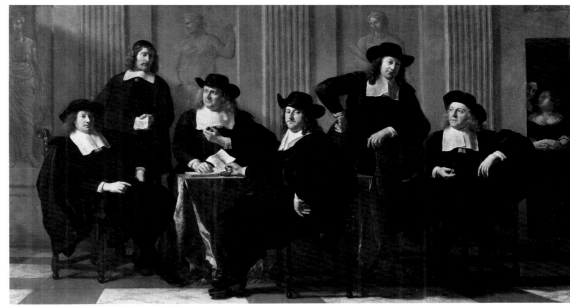

1032

1033

Amsterdam Spinning House (fig. 1032) is among the most successful of the later regents paintings; it felicitously combines classicistic restraint with a translucent fall of light.

Adam Pynacker may also have come to Amsterdam about 1660, after spending three years in Italy and working for a time in Delft and Schiedam. His landscapes of the 1650s are distinctively calm and atmospheric (fig. 1033), some showing the influence of Jan Asselijn, others that of Jan Both. About 1660, probably coincident with his arrival in Amsterdam, Pynacker's style underwent a drastic change. His landscapes become restless and almost capricious, the trees taking on a life of their own, with branches and foliage that twist and twine, and a vivid light playing over the scene. In the *Landscape with Sportsmen and Game* (cpl. 1034), sunlight sifts through the trees, brushing the white birch trunks to set them off sharply against the deep shadows. The effect is lively and sparkling, and Pynacker's originality is further underlined by his use of colors, predominantly blue-greens and blue-grays.

1034 Adam Pynacker
Landscape with Sportsmen and Game
Signed. Canvas, 130 × 195 cm. Dulwich Picture Gallery, London

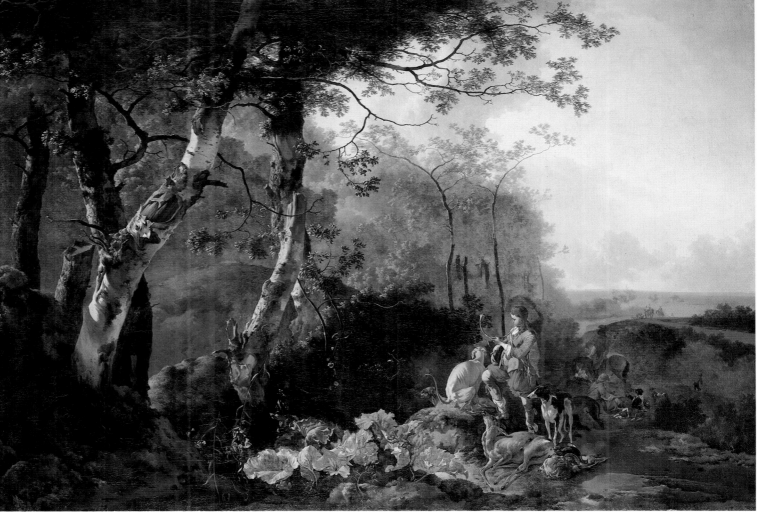

1034

469

1035

1036

1035 Jan Hackaert
 Forest Path with Horsemen and Hunters
 Canvas, 70.6 × 64 cm. Private collection

1036 Jan Hackaert
 The Lake of Zurich
 Signed. Canvas, 82 × 145 cm. Rijksmuseum,
 Amsterdam

1037 Johannes Lingelbach
 Street Scene near the Forum in Rome
 Signed and dated 1656. Canvas, 117 × 91 cm.
 Collection the Marquess of Bath, Longleat
 House, Warminster, Wiltshire

1038 Johannes Lingelbach
 Harbor Scene
 Signed and dated 1669. Canvas, 155 × 191 cm.
 Städelsches Kunstinstitut, Frankfurt am Main

Jan Hackaert, too, rendered the play of light and shadow under tall trees in paintings like *Forest Path with Horsemen and Hunters* (fig. 1035); as in Hobbema's *The Avenue, Middelharnis*, the perspective in this composition recedes down a long, tree-lined lane. Hackaert had traveled in Switzerland, where he made many drawings, and very likely in Italy as well. Most of his work was heavily influenced by Jan Both and is of average quality, but occasionally he outdid himself, as in his panoramic view *The Lake of Zurich* (fig. 1036); the location used to be identified incorrectly as Lake Trasimeno near Perugia.[8] This type of landscape was unusual in Dutch art and was certainly painted from personal observation. The shifting planes of the landscape are rendered with great sensitivity, and the subtle coloring avokes space and atmosphere.

Johannes Lingelbach, born about 1624 in Frankfurt on Main, probably came to Amsterdam as a youth. In 1642 he traveled by way of France to Rome, where he stayed several years, then returned in 1650 to Amsterdam through Germany. Lingelbach can hardly be counted among the landscape painters, although he did paint Italianate landscapes. Figures were more important to him, and he followed Pieter van Laer in choosing his subjects from Roman street life (fig. 1037). Like Jan Baptist Weenix he was also fascinated by the bustle of harbor scenes, with ships moored at the quays and colorfully clad people swarming about (fig. 1038). Lingelbach was an excellent figure painter and storyteller, but his work varies in quality, and his handling of paint and color can be erratic. His penchant

1037

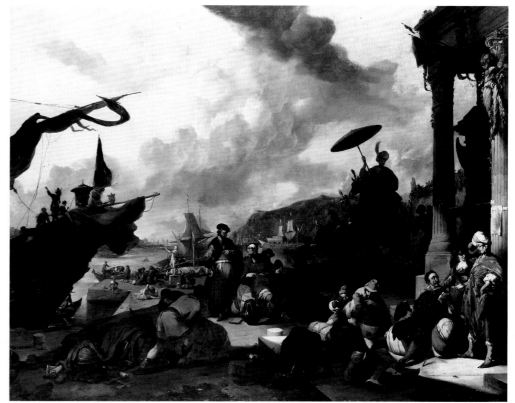

1038

for Italian street scenes enabled him to people the Dam with a lively throng in his painting showing Amsterdam's new town hall under construction (see fig. 750). He often added the figures to views by landscape painters.

Finally, among the group of Italianate landscape painters in Amsterdam was Frederick de Moucheron, who studied under Jan Asselijn and then worked in Lyon and Paris. He married in Amsterdam in 1659 and settled down there. His work is generally rather dry, yet it can have pleasant, undeniably decorative qualities, as seen in his *Landscape with Ruined Tower and Figures* (fig. 1039).

Other Landscape Painters

Ruisdael's circle of landscape painters can usually be clearly distinguished from the Italianate landscapists by their choice of subject and use of light and color, but a number of other painters are more difficult to categorize. Adriaen van de Velde, for instance, seems to have painted his native Dutch landscape and the Italian landscape with equal pleasure and ease. Son of Willem van de Velde the Elder, he was born in Amsterdam in 1636, three years after his brother, Willem the Younger. His father and his brother took to the sea, but Adriaen remained on land. Many different influences helped to shape his work, but none dominated it. He presumably was first trained by his father and then, according to Houbraken, became a pupil of Jan Wijnants in Haarlem. Adriaen painted animals and figures as well as he painted landscapes, and he freely alternated among these subjects, sometimes giving the major role to animals, sometimes to the landscape, or to the human figure. He often painted the incidental figures for the landscapists Wijnants, Jacob van Ruisdael, and Meindert Hobbema, and for such townscapists as Jan van der Heyden.

The generally high quality of van de Velde's work always attracts the viewer. His colors, extremely varied, are fresh and warm yet never gaudy. One of his most beautiful and subtle pieces is *Meadow with Cattle near a Farmhouse* (fig. 1040), which evokes the spirit of Paulus Potter with the utmost refinement. Potter had spent the last two years of his life, 1652–54, in Amsterdam, and van de Velde may have known him, for Potter's influence is apparent in other works by Adriaen, especially his animal compositions. Van de Velde may or may not have been to Italy; his cleverly painted Italianate landscapes are warm and sunny, yet they lack the pure atmosphere of his sparkling little *Meadow with Cattle*, which is certainly based on firsthand observation of the Dutch countryside. The same feeling of direct contact with nature prevails in the sun- and breeze-swept *Beach at Scheveningen* of 1658 (cpl. 1041), now in Kassel; another version of this scene, painted two years later, is now in the collection of the Queen of England.

1039 Frederick de Moucheron
Landscape with Ruined Tower and Figures
Signed. Canvas, 66 × 77.1 cm. Glasgow Art Gallery and Museum. Archibald McLellan Bequest, 1854

1040 Adriaen van de Velde
Meadow with Cattle near a Farmhouse
Signed and dated 1666. Canvas on panel, 63 × 78 cm. Gemäldegalerie, Staatliche Museen, West Berlin

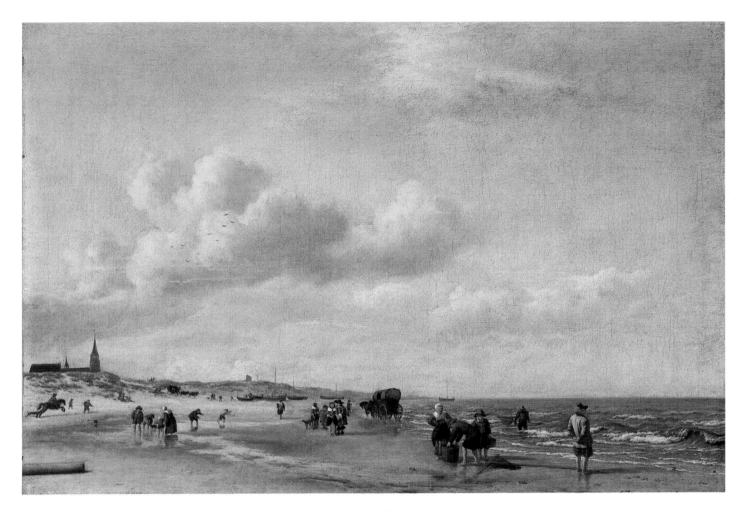

1041 Adriaen van de Velde
The Beach at Scheveningen
Signed and dated 1658. Canvas, 50 × 74 cm.
Staatliche Kunstsammlungen, Kassel

1042 Adriaen van de Velde
Recreation on the Ice near a City Wall
Signed and dated 1669. Canvas on panel,
33 × 40.5 cm. Gemäldegalerie Alte Meister,
Staatliche Kunstsammlungen, Dresden

His brother Willem was also painting somewhat similar beach scenes at about this time, the figures in them attributed to Adriaen.

Van de Velde's winter scenes round off the seasons in his landscape painting. The atmosphere is the sunny yet biting cold of good skating weather, which draws Dutchmen out on the ice (fig. 1042). The execution of these pictures is almost too perfect, making them look a bit like illustrations, without the subtleties of his best work.

Adriaen van de Velde died young, at age thirty-six, in 1672. The amount and variety of his output indicate his diligence. His followers were chiefly among the animal painters who continued more or less in the Italianate style: Dirck van Bergen, Johannes van der Bent, Jacob van der Does and his son, Simon van der Does. None of these painters approached van de Velde in talent.

Jacob Esselens' beach scenes, such as *Fishermen on the Beach with Boats and Catch* (fig. 1043),

1043 Jacob Esselens
Fishermen on the Beach with Boats and Catch
Signed. Canvas, 50.3 × 63 cm. Statens Museum
for Kunst, Copenhagen

1044 Jacob Esselens
Hunting Party on a Riverbank
Signed. Canvas, 85 × 111 cm. Museum
Boymans–van Beuningen, Rotterdam

can be linked to a degree with Adriaen van de Velde's, although the hazy atmosphere is also reminiscent of Simon de Vlieger. Esselens' Arcadian landscapes are less original, but his Dutch landscapes have greater charm, their often unusual, poetic lighting suggesting the sun's rays streaming through moisture–laden air. The brightly lighted middle ground of *Hunting Party on a Riverbank* (fig. 1044) sets off the fashionably dressed figures shaded by the foreground tree; figures in rich clothing almost always play a role in his compositions. As a painter, Esselens was perhaps a dilettante: he is recorded in the Amsterdam archives as a merchant, and his dealings in velvets and silks led him to travel extensively, to Italy, England, Scotland, and elsewhere.[9]

Another great traveler was the painter, draftsman, etcher, and poet Willem Schellinks, who was born in Amsterdam in 1627. Together with Lambert Doomer, he made a tour along the Loire and the Seine in 1646,[10] and between 1661 and 1665 he visited England, France, Italy, Malta, Germany, and Switzerland. On these trips he made many drawings of landscapes and scenic views. He was back in Amsterdam in 1665 and married the widow of the engraver Dancker Danckerts.

Schellinks was a skillful artist, working easily in the style of other, mostly Italianate, masters, and perhaps for this reason his paintings are difficult to trace. Many of them moreover no longer bear his name; his *City Wall in the Winter* (fig. 1045), for instance, long carried Jan Asselijn's monogram, and only after restoration was Schellinks' monogram

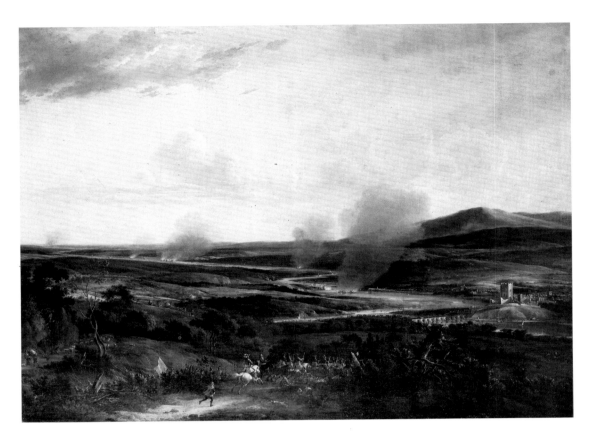

1045 Willem Schellinks
City Wall in the Winter
Signed. Canvas, 74 × 105 cm. Rijksmuseum,
Amsterdam

1046 Willem Schellinks
The Burning of the English Fleet near Chatham
Signed. Canvas, 159 × 212 cm. School of
Navigation, Amsterdam

found beneath the forged signature. Many of the drawings he made on his journeys were collected by the wealthy Amsterdam merchant Laurens van der Hem (see p. 59). It is possible that Schellinks has sketched abroad on commission from the States-General, for salient features of the landscape are emphasized in many of the drawings—strategic points that would have interested the government's intelligence service. After the famous raid on Chatham in 1667, during the Second Anglo-Dutch Naval War, Schellinks painted phases of the action in multiple versions, one of which is *The Burning of the English Fleet* (fig. 1046), which stresses the Dutch triumph by showing an English military contingent arriving too late. He based these paintings on drawings he and Esselens had previously made of the landscape around Chatham. After Schellink's death in 1678, a large number of his unfinished paintings were completed by Frederick de Moucheron and Claes Berchem.

Marine Painters

Many of the landscape painters we have just discussed—Jacob van Ruisdael, Allart van Everdingen, Adriaen van de Velde, Jacob Esselens—ventured with their river views and beach scenes into the domain of the marine painters. By 1650 Amsterdam had become without question the center for this field of art. Simon de Vlieger lived there from 1638 to 1650, then moved to nearby Weesp, where he spent the last years of his life within easy reach of his friends and colleagues in Amsterdam. De Vlieger had played a decisive role in the development of marine painting, and the impressive advance of this genre in the second half of the seventeenth century is unthinkable without him. He influenced Hendrick Dubbels and Jan van de Capelle, and Willem van de Velde the Younger was his pupil.

Relatively little is known about Dubbels' life. He is mentioned several times in the Amsterdam archives—once as a shopkeeper—but it is not certain whether the Hendricus Dubbels who was buried in the Noorderkerk in 1676 was the painter or someone else of that name. Dubbels' paintings are seldom dated, but a distinct development can be traced in his work. He began in the grayish tonal style of Simon de Vlieger (fig. 1047); later he used a more colorful palette, presumably under the influence of Willem van de Velde the Younger. A masterpiece from this later period is his large painting of a Dutch fleet in the Texel roads—the deep-water anchorage off the North Holland island of Texel (fig. 1048); the ships can be tentatively identified as the fleet commanded by Admiral van Wassenaer van Obdam during the Second Anglo-Dutch Naval War. Dubbels brilliantly demonstrates his skill in painting waves. He was an expert in many phases of marine painting: calm seas or gales, harbors, inland waters, and coastal views. He also painted a few winter scenes. His work is occasionally so similar to Jan van de Cappelle's that they have been confused.

1047 Hendrick Dubbels
Seascape
Signed. Canvas, 50 × 49.5 cm. Staatliches
Museum, Schwerin

1048 Hendrick Dubbels
A Dutch Fleet in the Texel Roads
Signed. Canvas, 140 × 196 cm. Amsterdams
Historisch Museum, Amsterdam

Jan van de Cappelle, born in Amsterdam in 1626, is one of the few individuals who practiced painting only as a sideline or perhaps solely for pleasure, yet he must be ranked among the great Dutch artists of the seventeenth century. His father was a prosperous dyer, and Jan himself is listed in the municipal archives as a crimson dyer and merchant. At his death he possessed 40,720 guilders in gold and money, 52,000 guilders in bonds, eight houses and several city lots, a pleasure boat moored in the yacht harbor near the old municipal inn for seamen, and an imposing collection of paintings and drawings. He was indubitably a wealthy man, who in no way depended upon painting for his income.

The high quality of van de Cappelle's art collection is evident from the inventory of his estate made soon after his death on December 22, 1679.[11] We can list only a selection of the works he owned. Of landscapes and marines alone, he had about 10 paintings and more than 300 drawings by Esaias van de Velde, 9 paintings and 1,300 drawings by Simon de Vlieger, 16 paintings by Jan Porcellis, and 10 paintings and 400 drawings by Jan van Goyen. There were also 5 paintings by Hercules Segers and 7 by Rembrandt, as well as about 500 Rembrandt drawings which van de Cappelle may have purchased at the insolvency sale in 1658. About 900 drawings by Hendrick Avercamp are listed, and 3 paintings by Rubens.

Van de Cappelle's portrait was painted by Rembrandt, Frans Hals, and by Gerbrand van den Eeckhout (see fig. 770), probably his friend, who provides the following valuable information: in 1654 van den Eeckhout wrote a quatrain in the *album amicorum* of one Jacobus Heyblocq praising van de Cappelle's art, heading it with the words "on the painting-art of Johannes van de Cappelle, which he taught to himself for his own pleasure."[12] There is no reason to doubt van den Eeckhout, but if van de Cappelle indeed taught himself, he leaned heavily on Simon de Vlieger's work as his model. He must have owned virtually all of that master's drawings, and the inventory lists a copy he had painted after de Vlieger—and a copy after Porcellis as well, we must add.

Van de Cappelle's few dated paintings range between the years 1644 and 1663; the

1049

1049 Jan van de Cappelle
 River Scene with a Large Ferry and Numerous
 Vessels at Anchor
 Signed. Canvas, 122 × 154.5 cm. The National
 Gallery, London

1050 Jan van de Cappelle
 Evening Calm
 Signed. Panel, 47.5 × 59 cm. Wallraf Richartz
 Museum, Cologne

1051 Jan van de Cappelle
 Ships off the Coast
 Canvas, 72.5 × 87 cm. Mauritshuis, The Hague

absence of dated works thereafter may indicate that he had given up painting. De Vlieger's influence is apparent in the silvery tonality that characterizes van de Cappelle's work, but even de Vlieger cannot match him in capturing the vaporous luminosity of the Dutch atmosphere. Van de Cappelle usually paints in a broad manner, with effective highlights on the boats and figures. The contrast between the silver-gray sky and the heavy brown accents of the sailing vessels is masterful in such paintings as *River Scene with a Large Ferry and Numerous Vessels at Anchor* (cpl. 1049), as is the reflection of clouds, masts, and sails in the calm water. He also painted less ambitious pictures of fishing boats and other craft near the shore, the fishermen busy at their tasks and the whole scene enveloped in an elusive, misty atmosphere sometimes made radiant by a sunset (fig. 1050). Great rainclouds tower over his beach scene, *Ships off the Coast* (fig. 1051), an unaccustomed wind filling the sails and

1050

1051

1052

1052 Jan van de Cappelle
Winter Landscape
Signed. Panel, 56.5 × 45.7 cm. Private collection,
England

1053 Reinier Nooms, called Zeeman
Ships at Anchor
Signed and dated 1658. Canvas, 47.5 × 56.5 cm.
Akademie der Bildenden Künste, Vienna

1054 Reinier Nooms, called Zeeman
Amsterdam Merchantmen in the Mediterranean
Signed. Canvas, 52 × 68 cm. Amsterdams
Historisch Museum, Amsterdam

ruffling van de Cappelle's usually quiet waters as three figures on the beach (one holding a dog) wait for their luggage to be hauled ashore. Presumably during the 1650s, in line with de Vlieger's tendency in his last period, van de Cappelle began to add more ships and boats to his pictures and to produce what are known as "parade marines": vessels moored in a long row. There is great feeling of depth in these paintings. Van de Cappelle's palette becomes warmer in his later work, and the silvery sheen becomes more golden. His rare winter landscapes (fig. 1052) are something like Jacob van Ruisdael's, but more silvery in tone and more delicate in mood.

Van de Cappelle's contemporary and fellow townsman Reinier Nooms worked in a completely different style. He usually signed his works with his nickname, *Zeeman* (Seaman), no doubt to indicate that he was or had been a professional sailor. Nooms's primary interest was in ships and the activities around them: merchantmen in the Amsterdam harbor, surrounded by smaller craft—lighters, sailboats, and rowboats filled with curious passengers (fig. 1053). All these vessels are accurately rendered according to type and function. Nooms also made a series of etchings that illustrates the types of ships and boats.

From his many paintings of harbors, towns, and coastlines in the Mediterranean area, we can assume that Nooms traveled there extensively. His topographical works were less strong, but he excelled in catching the mood of the southern coasts. With his feeling for color and his crisp, matter-of-fact manner of painting, he achieved superior effects of light. One of his favorite subjects was a ship undergoing repairs, either careened on a beach or in the sea just offshore, with floats attached (fig. 1054). He also painted a number of naval battles. Nooms died in Amsterdam in 1664.[13]

Of all the Dutch marine painters, Willem van de Velde the Younger is without doubt the best known, and justifiably so. Present-day taste may prefer the work of Simon de Vlieger and Jan van de Cappelle, but in the seventeenth century any painting by Willem van de Velde was automatically considered the best. The van de Velde family was living in Leiden in 1633 when Willem was born, but moved to Amsterdam three years later. The lad had his

1053

1054

first lessons from his father, already famed for his pen paintings, and he then studied with Simon de Vlieger, mostly or wholly in Weesp. In 1652 Willem married a Weesp girl, but the marriage soon failed, and in 1656 he married Magdalena Walraven of Amsterdam.

There are dated works by van de Velde from 1653 on. The earlier ones, such as *Ships in a Calm* (fig. 1055), clearly show de Vlieger's influence, and in his color and composition van de Velde long remained indebted to his master. His beach views, especially *The Shore at Scheveningen* (fig. 1056), painted about 1660, certainly hark back in composition to de Vlieger, but how these paintings relate to those of Jacob van Ruisdael and Adriaen van de Velde is an unresolved question. All three artists seem to have been interested in the subject at about the same time, and they all based their compositions on de Vlieger's but introduced sunnier atmospheres and brighter colors.

The striving for a bright, sunny atmosphere became characteristic of much of Willem van de Velde's work, particularly the beach and coastal views (fig. 1057) and the marine views in calm weather. He was above all, however, a painter of ship portraits, and in this he bears comparison with the portraitist Bartholomeus van der Helst: both portrayed their models with technical perfection, in a clear light that leaves nothing to the viewer's imagination. Van de Velde demonstrates his complete mastery even in his largest paintings; in *A Dutch Man-of-War Saluting* (fig. 1058), his dominant feeling for light and space does not diminish his portrayal of the ships. The warship in the left foreground is presumably *De Liefde* (Love), Admiral de Ruyter's flagship in 1662; its dark hulk is silhouetted against the light sky and the smoke of the cannon shot, while high in the rigging crewmen hoist sail. The

1055

1056

1058

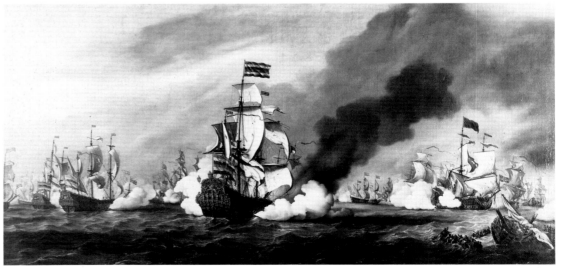

1059

478

placid water mirrors the ships, and the sails of the vessel at the right catch and hold the light.

Van de Velde also painted naval encounters, such as *The Battle of Kijkduin* of 1673 (fig. 1059), rendering them in color much as his father did in black and white. It is known that the two worked together on this kind of painting. When they entered the employ of Charles II of England in 1674, each received a stipend of one hundred pounds a year, the father for "taking and making Draughts of Seafights" and the son for "putting the said Draughts into Colours."[14] The van de Veldes made a number of marine paintings in 1673 for the decoration of Ham House, the duke of Lauderdale's country estate in Petersham, Surrey.

The *View of the IJ Harbor* that the younger van de Velde painted in 1686 (fig. 1060) must have been a special commission from the Amsterdam burgomasters or the harbor masters, in whose meeting chamber it hung, and he no doubt returned temporarily to Holland to paint it. This painting, his largest and most complicated work, shows him still in top form at the age of fifty-three. He was unable to maintain this high level, and during the last two decades of his life (he died in 1707) many of his works became routine, with a harder and less subtly attuned palette. Particularly popular among his later works were pictures of ships fighting against gale-tossed seas (fig. 1061).

Four of van de Velde's children by his second marriage—Willem III, Cornelis, Pieter, and Sara—apparently imitated their father's work, but only a few of their paintings have so far been identified. He also had many other followers and imitators, especially in England, some of whom continued to paint in his style throughout the eighteenth century.

The van de Veldes were not the only artists in Amsterdam who specialized in naval battles. We have already mentioned Reinier Nooms, and Jan Beerstraaten—and perhaps

1062 Jan Beerstraaten
 The Battle of Terheide, August 10, 1653
 Signed. Canvas, 176 × 281.5 cm. Rijksmuseum,
 Amsterdam

1063 Abraham Storck
 The Four-Day Naval Battle between the Dutch and
 English Fleets, June 11–14, 1666
 Signed. Canvas, 80 × 111.5 cm. National
 Maritime Museum, Greenwich, London

other members of his family—also produced limited but good work in this field, as can be seen by Jan's action-filled *The Battle of Terheide* (fig. 1062). The Beerstraatens will be discussed further in the section on townscapes. Abraham Storck rendered another dramatic naval encounter in his *The Four-Day Naval Battle between the Dutch and English Fleets* (fig. 1063), and such lesser masters as Pieter van Soest (active in Amsterdam 1642–67) also contributed to the depicting of Dutch history at sea.

 Next to Willem van de Velde the Younger, Ludolf Bakhuysen was undoubtedly the best known and most renowned marine painter in Amsterdam. Born in Emden, Germany, in 1631, he came to Holland about 1650 for business training, and worked on the side as a calligrapher. Houbraken discusses him at length,[15] saying that his painting teachers were Allart van Everdingen and Hendrick Dubbels. Whether or not this is true, Dubbels certainly influenced him, and he must have profited also from the example of the van de Veldes.

 Dated paintings by Bakhuysen are known from 1658, and he continued diligently to paint almost up to his death in 1708. Houbraken calls him "industrious, quiet, and respectable in his way of life: virtuous by nature and courteous to everyone." Viewed as a whole, his work seems slightly monotonous. The water is often restless, even rough, and the clouds, usually blue-gray in color, build up inevitably on a diagonal (see fig. 315). In his later works the waves look hard as glass, and his colors become rather saccharine, with much pink and pale blue. Nevertheless, the great fame Bakhuysen enjoyed in his lifetime and long afterward is not without foundation. Apart from the rather trite pieces, he could

▷

1064 Ludolf Bakhuysen
 The Haarlem Lake
 Signed. Canvas, 43.5 × 62.5 cm. Amsterdams
 Historisch Museum, Amsterdam

1065 Ludolf Bakhuysen
 Guard Duty on a Town Wall
 Signed. Canvas, 39.7 × 48 cm. Museum der
 Bildenden Künste, Leipzig

1066 Ludolf Bakhuysen
 Portrait of Johan van Broekhuizen
 Signed. Canvas, 45 × 38.6 cm. Private collection

1067 Abraham Storck
 Sailing and Rowing on the Amstel
 Signed. Canvas, 40.5 × 54 cm. Private collection

1068 Abraham Storck
 Mock Battle on the IJ in Honor of Czar Peter the
 Great, 1697
 Signed. Canvas, 66 × 92 cm. Nederlandsch
 Historisch Scheepvaartmuseum, Amsterdam

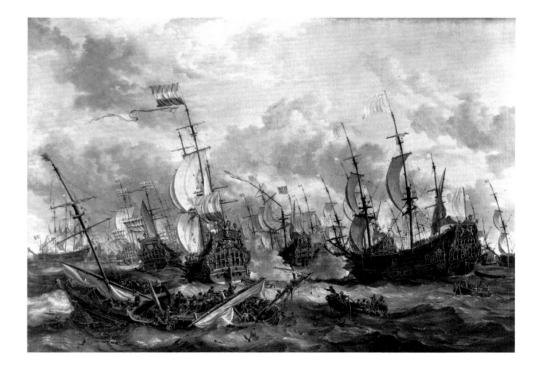

1064

1065

1066

well observe the moods of nature, as in his view of Haarlem Lake (fig. 1064). Suddenly we can believe Houbraken's assertion that Bakhuysen, when a storm threatened, would "step sometimes into a stageboat and let himself be carried to the mouth of the Sea, in order to observe the crash of the Seawater against the coast, and the changes of Air and Water under these conditions." He could also capture nature in a quieter mood, on a still evening as soldiers keep guard on a town wall overlooking the sea, while those off duty play cards in the shadow of a large cannon (fig. 1065); boats pass by so closely that their sails seem to touch the wall. Bakhuysen was also a portraitist, one of his works being a portrait of the erudite Commander Johan van Broekhuizen (fig. 1066) who took part in the raid on Chatham, and who has been called the last Dutch Renaissance poet.

Three members of the Amsterdam artistic community were the Storck (Sturck or Sturckenburg) brothers, Johannes, Jacobus, and Abraham. Practically none of Johannes' work has survived, and only a few paintings can be ascribed to Jacobus with any certainty. A great deal of Abraham's output, however, still exists. Born in 1644 in Amsterdam, he was the youngest of the brothers and the best known. He painted naval battles (see fig. 1063) and imaginary harbor views, but his undisputed specialty was depicting recreational sailing and boating on the Amstel and Vecht rivers (fig. 1067). He was always around for the popular water festivals, such as the "admiral sailing" on the IJ and the mock naval battle staged in honor of Czar Peter the Great, who visited Amsterdam in 1697–98. Storck made a painting of the colorful event (fig. 1068), and then repeated it over and over, virtually without alteration. He, or perhaps his brother Jacobus, also painted a number of less colorful, less playful views of the Amsterdam canals and inner harbor.

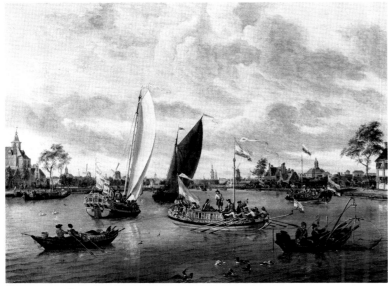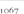

1067

1068

In a city as water-rich as Amsterdam, it was perhaps natural for some of the marine painters—Reinier Nooms, Jan Beerstraaten, Abraham Storck—to undertake townscapes as well. Nooms's work in this area is particularly noteworthy; being an accomplished etcher, he could carry on the tradition of the printmakers who were the first to depict the buildings, canals, and streets of the city. About 1645 Nooms etched a series of eight "New and Original Representations of the City Gates of Amsterdam" and another series of twelve "Different Ships and Views of Amsterdam," including, as number 8, *The Naarden Ferry* (fig. 1069). It is difficult to determine how soon thereafter he began to paint townscapes.

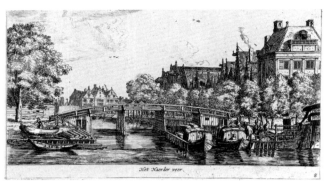

1069

1070

1069 Reinier Nooms, called Zeeman
The Naarden Ferry, Amsterdam
c. 1645. Etching, from a series of twelve

1070 Jan Beerstraaten
The Ruins of the Old Town Hall of Amsterdam after the Fire of July 7, 1652
Signed. 1653. Canvas, 110 × 144 cm.
Rijksmuseum, Amsterdam

1071 Abraham Beerstraaten
View of the Noorderkerk, Amsterdam
Signed. Canvas, 93 × 125 cm. Amsterdams Historisch Museum, Amsterdam

1072 Jan Wijnants
View of the Herengracht, Amsterdam
Signed. c. 1660–62. Canvas, 67.5 × 82 cm. The Cleveland Museum of Art, Ohio. Gift of Harry D. Kendrick

Several members of the Beerstraaten family—good friends of the Storcks—painted many aspects of Amsterdam, but it is difficult to determine just how many were painters and what they produced.[16] Jan Beerstraaten, born in 1622, was the most visible and the most talented. His earliest known work is his 1653 view of Amsterdam's fire-ravaged old town hall (fig. 1070). His townscapes and views of castles (see fig. 331) are the most important part of his oeuvre, which also includes a few naval battles, beach views, and fantasy views of strange harbors. His topographically accurate townscapes are in general painted quite fluently and with a good sense of proportion, and in his many winter views his feeling for atmosphere comes through most successfully. His figures are often weak, and his work as a whole is uneven in quality.

1071

1072

1073 Jacob van Ruisdael
 View on the Amstel, Looking toward Amsterdam
 Signed. c. 1675–80. Canvas, 52 × 66 cm.
 Fitzwilliam Museum, Cambridge, England

We can also be sure about Abraham, Jan's son, who was born in 1643 and worked in his father's style, with sometimes, however, a burst of originality. His *View of the Noorderkerk, Amsterdam* (fig. 1071) is unique among Amsterdam townscapes: the snowcapped church stands majestically in the middle of a long row of stepped-gable houses, and the wintry trees droop over a cheerful scene on the ice below.

The existence of one Anthonie Beerstraaten remains uncertain: a painting in Utrecht that is always ascribed to him merely bears the initials *A.B.*, which is not conclusive. There also are paintings attributed to one Johannes Beerstraaten on the grounds that they are dated later than 1666 (the year of Jan's death), but these dates have been questioned and now appear to be earlier than once thought, so that the paintings may after all be by Jan, who sometimes signed himself Johannes. The works of Jan and his son Abraham are so closely related that they cannot be told apart unless they bear signatures.

Other Amsterdam painters contributed valuable townscapes. Johannes Lingelbach made an extraordinarily fine view of the Dam in 1656 (see fig. 750), and another Italianate painter, Jan Wijnants, surprises us with a view of the Herengracht (fig. 1072) that presumably must be dated about 1660–62.[17] This painting is exceptional in having as its subject the canal itself and not the houses, which are only partly visible through the trees. When Jan van der Heyden took up this theme a short time later, his emphasis was almost always on the houses. We have already discussed Jacob van Ruisdael as a painter of townscapes, especially his views of the Dam and Damrak (see fig. 335). He also made several panoramas, combining a bird's-eye view with the old-fashioned town profile (fig. 1073), that clearly show his qualities as a landscape painter. And lastly there is Hobbema's beautiful *View of the Haarlem Lock and the Herring Packers' Tower* (see fig. 1025), his only known townscape.

Jan van der Heyden

When Jan van der Heyden began to paint, the shift of the townscape from the form seen in prints to the painted view had just occurred. He was born in 1637 in Gorcum; his Mennonite parents then moved by way of Zaltbommel to Amsterdam, where they settled in 1650. Jan's development, therefore, took place wholly in Amsterdam, and when he was married there in 1661, he registered himself as a painter.

Van der Heyden devoted relatively little time to painting, however. He was very gifted technically and liked nothing better than inventing things, his two most famous inventions being street lighting and the fire engine. On November 19, 1668, he presented the Amsterdam municipal authorities with a plan "to provide the whole City on dark nights with lights, in order to prevent the loss of many people who fall into the water in the dark and drown."[18] The plan was carefully worked out in both its method and its organization. It recommended that oil-filled lanterns should be placed at specific locations and lighted in a particular way, turned on and off at set times. The city fathers accepted his plan and in 1669

1074

1074 Jan van der Heyden
Demonstration of the New Fire Hoses, from
*Description of the Newly Discovered and Patented
Hose Fire Engine and Her Way of Putting Out Fires*
Etching and engraving

1075 Jan van der Heyden
View of the Dam, Amsterdam
Signed. Panel, 68 × 55 cm. Amsterdams
Historisch Museum, Amsterdam

1076 Jan van der Heyden
View of the Westerkerk, Amsterdam
Signed. Panel, 41 × 59 cm. The Wallace
Collection, London

appointed him to carry it out, giving him the title of superintendent and director of municipal lighting, and the munificent salary of 2,000 guilders per year. A good organizer, van der Heyden acquitted himself admirably of the project; in all, 2,556 lanterns were placed, some on poles and some on the front of buildings, and they continued to function until 1840. Amsterdam became the best-lighted city in the world, and van der Heyden's system was adopted in many other cities, including Berlin.

In 1672 he developed an invention of even greater benefit to society. After lengthy experimentation he built a fire engine equipped with pump-driven hoses; this machine was truly revolutionary, for since time immemorial the main method of fighting fires had been by pails of water handed from man to man. Jan and his brother Nicolaes, who collaborated on the project, were named chiefs of the Amsterdam fire department. In 1691 Jan van der Heyden and his son Jan, who succeeded his deceased uncle, published a richly illustrated book entitled *Description of the Newly Discovered and Patented Hose Fire Engine and Her Way of Putting Out Fires...* One plate from the book, engraved after van der Heyden's design, dramatically demonstrates the new equipment (fig. 1074).

1075

1076

Van der Heyden is extensively documented as an inventor, but barely mentioned in contemporary sources as a painter. Where or whether he had any training in art is unknown. His earliest dated painting is a still life of 1664, yet when he was married three years before he already called himself a painter. His early works may have been some undated landscapes, perhaps old-fashioned in style. He came into his own only after he began to paint townscapes.

With his decidedly technical talent and seemingly endless patience, van der Heyden gave a new turn to the town view that was decisive for this genre and would remain its model for more than a century. His townscapes and views of country houses are painted with the utmost care and accuracy: every brick is defined, the light and shadow worked out for each detail. Van der Heyden's greatest contribution, however, is not this technical virtuosity, but his ability to subordinate detail to the totality of the painting. In two masterful little views of the Dam (fig. 1075) and the Westerkerk in Amsterdam (fig. 1076) he permitted himself certain compositional liberties—the scale and location of the buildings do not accord exactly with those on the actual site. But here the deviation is slight; he often went much further, painting fantasy townscapes based on reality in only a few parts.

Van der Heyden's earliest known architectural paintings date from 1666, and he created his best works in the twenty years that followed. His townscapes were highly admired during his lifetime, especially when they were populated with figures by some other good painter—Adriaen van de Velde, for instance. The secretary to Ferdinand II, grand duke of Tuscany, wrote to his master's Amsterdam agent Ferroni, instructing him to buy a van der Heyden painting, but only if it had figures.[19] Van der Heyden did not limit himself to Amsterdam, but painted views of Delft, Antwerp, Brussels, and several German cities as well, and of country estates and castles.

During the last decades of his long life—he lived until 1712—van der Heyden retired to some extent from public office, but he kept on painting to the end. Most of his late works are still lifes: minutely rendered interiors themselves set up as still lifes, with books, globes, instruments, and such curiosities as a strung-up armadillo carcass (fig. 1077). They are a continuation of the *vanitas* theme, but rather dry in execution.

Architectural Painters

Emanuel de Witte was almost the only artist in Amsterdam to paint church interiors. His earliest known interior is his view in the Oude Kerk, Delft, dated 1651 (see fig. 965); already it displays remarkable qualities in the treatment of perspective and light, and the figures are well executed. De Witte presumably left Delft in 1651 for he is recorded in Amsterdam in January 1652. He worked there for the rest of his life—a life that cannot have been very happy. After 1658 his financial condition became deplorable. His wife set her daughter (by an earlier marriage) to stealing; both were apprehended, and the wife was banished from the city, the girl sentenced to a year in the Spinning House. From then on de Witte experienced one difficulty after another, many of them seemingly brought upon himself. In 1660 he contracted with an Amsterdam notary to hand over everything he painted in exchange for room, board, and 800 guilders a year; as might be expected, he broke his contract, was sued by the notary, and had to indenture himself several times more. Houbraken goes extensively into de Witte's miserable circumstances and states that the artist committed suicide at the age of eighty-five,[20] but he was probably ten years younger.

The unfortunate circumstances of de Witte's life no doubt contributed to the uneven quality of his work, but his best paintings are amazingly beautiful. He always used fairly strong contrasts of light and dark, far stronger than those of other painters of church interiors. Sunlight sifts through the windows to play subtly upon columns and floor; de Witte's manner of painting brilliantly evokes the space and atmosphere of the churches. He was an excellent figure painter as well, and equally important for the architecture in his compositions are the people walking about in the church or listening to a sermon, the reds and blues of their clothing providing unexpected colorful accents.

De Witte made a few paintings of the Delft churches after 1652, but his major interest was focused on the churches of Amsterdam—the Oude Kerk and the Nieuwe Kerk, and after about 1680 the Portuguese Synagogue (fig. 1078), built in 1671–75 for the Amsterdam community of Sephardic Jews. He also constructed imaginary interiors, deriving his

1077 Jan van der Heyden
Corner of a Room with Rarities on Display
Signed and dated 75 Jar. Panel, 75 × 63.5 cm.
Szépmüvészeti Múzeum, Budapest

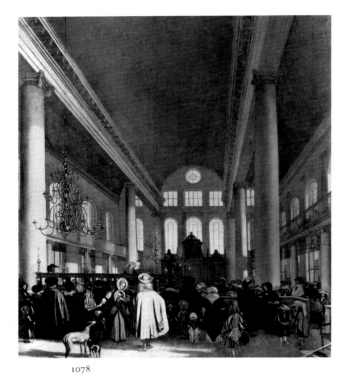

1078

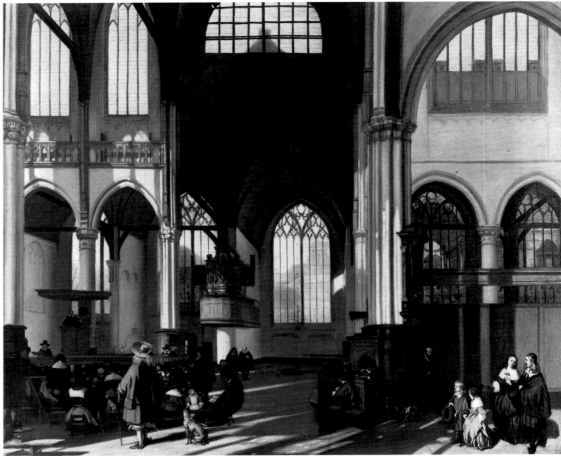

1079

1078 Emanuel de Witte
Interior of the Portuguese Synagogue, Amsterdam
Formerly signed and dated 1680. Canvas,
110 × 99 cm. Rijksmuseum, Amsterdam

1079 Emanuel de Witte
Interior of the Oude Kerk, Amsterdam
Canvas, 129 × 149 cm. Amsterdams Historisch
Museum, Amsterdam. On loan from the Oude
Kerk Foundation

1080 Emanuel de Witte
The Small Fish Market, Amsterdam
Signed and dated 1678. Canvas, 47 × 54.5 cm.
Wadsworth Atheneum, Hartford, Connecticut.
Ella Gallup Sumner and Mary Catlin Sumner
Fund

elements from existing churches. He did not use only one compositional scheme: his vantage point may give a perspective view both left and right, or permit the axis of the composition to coincide with the long reach of the nave. One wall of the church sometimes takes up the whole pictorial surface, as in his *Interior of the Oude Kerk, Amsterdam* (fig. 1079), one of his most beautiful works in tone and atmosphere. Although his paintings are always carefully executed, his brushwork remains highly individual, its fluidity contributing to the liveliness of the picture. Even in his late works—dated paintings are known up to 1689—de Witte retains many of his best qualities.

He also painted a number of animated market scenes. In these his talents as a figure painter emerge, and he proves himself a good still-life painter as well in his arrangements of fish and poultry. Here, too, he often works with strong chiaroscuro. By placing the foreground figures so close that they are seen only at half length, he creates a powerful *repoussoir* that lends great depth to the scene and at the same time enlivens it in a manner suggesting the "realism" of photography. A good example of this is *The Small Fish Market, Amsterdam* (fig. 1080).

1080

1081 Emanuel de Witte
Interior with a Lady Playing at the Virginal
Canvas, 77.5 × 104.5 cm. Museum Boymans-
van Beuningen, Rotterdam. On loan from the
State-owned Art Collections Department

De Witte also painted portrait groups and domestic interiors with one or two figures. His effort to reproduce an almost tangible effect of space, clearly evident in his church interiors and market scenes, is further emphasized in *Interior with a Lady Playing at the Virginal* (cpl. 1081). The woman is performing in the foreground room, while a man, who has placed his clothing on a chair, peeps out of a curtained bed at the left. The open door gives a glimpse into the rooms behind, and finally to a view of trees through a rear window. De Witte arranged everything in this painting to create the strongest possible spatial effect: the rooms that open into each other (an unlikely floor plan for a Dutch house), the pattern of the marble floor, the alternating bands of strong light and shadow cast by the light from the right. He also took great care with illusionistic effects in the mirror's reflections and in the still life on the table. This painting suggests that de Witte's period in Delft had been decisive for his interest in perspective and illusionism, and it does much to confirm Houbraken's remark that he was famous in his time "for his knowledge of Perspective."

De Witte's influence on Amsterdam painters can be briefly summarized. He had only one pupil, Hendrick van Streeck, and lived in his house for some time to teach him the principles of architectural painting. Van Streeck, however, contributed nothing to advancing the theme of the church interior. De Witte's work was influential in a more general sense, but to a degree that is difficult to determine. The Berckheyde brothers certainly knew his paintings, and Job in particular was probably indebted to de Witte for his coloring and treatment of light and shadow.

Figure Painters

De Witte's domestic interiors were too few to have much influenced other artists, and indeed the evidence is striking that nearly all the painters of this subject matter in Amsterdam had previously worked elsewhere for a considerable time. The truly important developments were taking place outside of Amsterdam: in Delft, with de Hooch and Vermeer; in Leiden, with Dou, van Mieris, and the young Metsu; and in Deventer, with Ter Borch.

Of these masters, Metsu arrived in Amsterdam in 1657 and entered upon the most fruitful

1082

1083

1082 Gerbrand van den Eeckhout
The Music Lesson
Signed and dated 1655. Canvas, 76 × 64.5 cm.
Statens Museum for Kunst, Copenhagen

1083 Jacob van Loo
Musical Party
Signed. Canvas, 76 × 65 cm. Hermitage,
Leningrad

1084 Jacob van Loo
Susanna and the Elders
Signed. Canvas, 77.5 × 65 cm. Glasgow Art
Gallery and Museum

decade of his short life. De Hooch, as we have seen (p. 445), arrived in 1661 and his work
slowly declined to a level far beneath that of his Delft period. Ter Borch did not move to
Amsterdam, but his work was well known there for his themes were almost immediately
adopted, implying his direct contact with the Amsterdam painters. No doubt he also
painted his portraits of Amsterdam burghers in that city.

Two of the oldest Amsterdam artists specializing in domestic figure paintings after 1650
were Gerbrand van den Eeckhout and Jacob van Loo. Eeckhout produced smoothly painted
company pieces, usually of cardplayers or musical groups (fig. 1082), small paintings that are
fresh in color and lively in movement. The architecture of the interior space was relatively
unimportant to him, which links him with the older generation. Jacob van Loo was more

1084

1085 Jan van Noordt
The Continence of Scipio
Signed and dated 1672. Canvas, 103 × 88 cm.
Rijksmuseum, Amsterdam

1086 Gabriel Metsu
The Sleeping Sportsman
Signed. Canvas, 42 × 37 cm. The Wallace
Collection, London

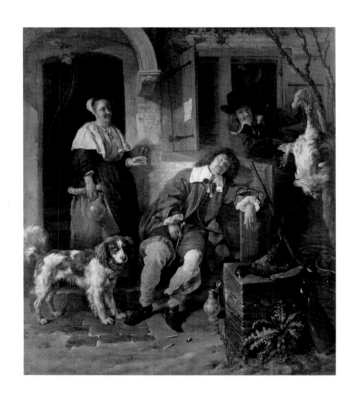

elegant and fashionable in his company paintings (fig. 1083). It is difficult to estimate his influence on the development of the genre—he had lived in Amsterdam since 1642—but he made a definite contribution with his fluently painted society pieces and his biblical and mythological pictures, often wonderfully sensual, such as *Susanna and the Elders* (fig. 1084). Van Loo was also a clever portraitist. He left Amsterdam for Paris in 1661 and worked there with great success, attracting a following of young painters who later made names for themselves. The work of Jan van Noordt in Amsterdam was related to van Loo's, but was looser in treatment (fig. 1085). Van Noordt also made portraits and domestic figure paintings.

Gabriel Metsu was about twenty-eight when he came to Amsterdam from Leiden. As always, he was stimulated by other painters and picked up ideas from them. Here and there in his work we recognize figures and motifs inspired by Ter Borch or sometimes by Dou, new approaches possibly suggested by Maes and later by Vermeer. It is not a question of gratuitous copying, but rather of assimilation: partly because of his technique, Metsu's paintings never lose their individuality. When he first settled in Amsterdam, he maintained the fluid, somewhat broad manner of his Leiden years; when at last he began to use a finer brush, it was in a technique quite distinct from that of the Leiden "fine" painters.

In Leiden, Metsu had been interested in history painting. In Amsterdam, he limited himself almost exclusively to the domestic figure piece, ranging from compositions with a few figures in intimate surroundings to more complicated pictures. Despite his great skill, these latter paintings look a bit cluttered. In *The Sleeping Sportsman* (fig. 1086), for instance, the narrative element, with its undisguised erotic overtones,[21] and the emphasis on every detail seem to disturb the unity: the work is stronger in its parts—notice the beautifully painted head of the dog—than in its whole.

This objection does not pertain to Metsu's less involved compositions, of which *The Sick Child* (cpl. 1087) is perhaps the most poignant example. If Metsu sometimes lacks in concentration, that is certainly not the case here, for in its handling of light and color this painting is sublime. To search for influences in this work is to arrive indubitably at the Delft school. Metsu's mastery is apparent also in *The Oyster Eaters* (fig. 1088), datable to the early 1660s. He has rendered the different textures of fur and cloth, of silver and glass, of shells and wood and horn, with great refinement and accuracy. The drinking horn is that of the Amsterdam St. Sebastian or Archers' Guild.

Metsu occasionally painted portraits, more or less in the form of a company piece. A

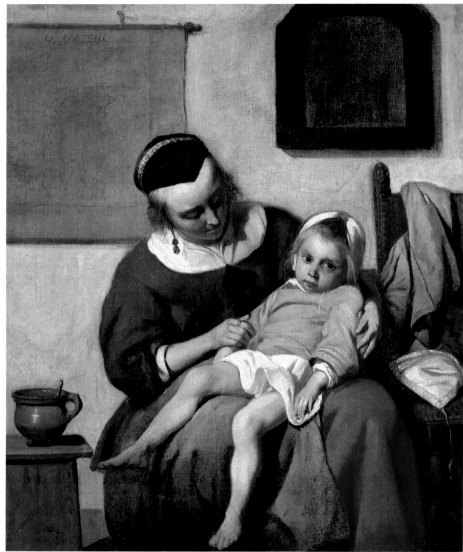

1087 Gabriel Metsu
The Sick Child
Signed. c. 1660. Canvas, 32.2 × 27.2 cm.
Rijksmuseum, Amsterdam

1088 Gabriel Metsu
The Oyster Eaters
Signed. Panel, 56 × 41 cm. Hermitage, Leningrad

1089 Gabriel Metsu
Portrait of the Geelvinck Family
Signed. c. 1662. Canvas, 72 × 97 cm.
Gemäldegalerie, Staatliche Museen, West Berlin

1087

beautiful example that shows yet another side of his talent is his portrait of the Geelvinck
family (fig. 1089). Group portraits in a domestic setting were a specialty of Flemish painters
such as Gonzales Coques, and in the eighteenth century they became popular in the
Netherlands and in England, where they were known as "conversation pieces."

Besides Gerbrand van den Eeckhout there were few other native Amsterdammers among

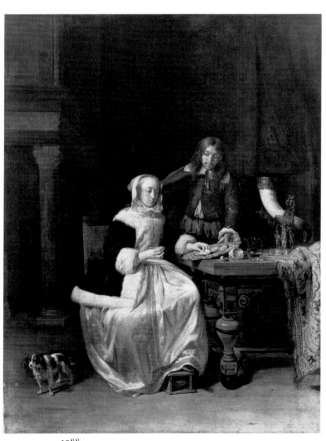

1088

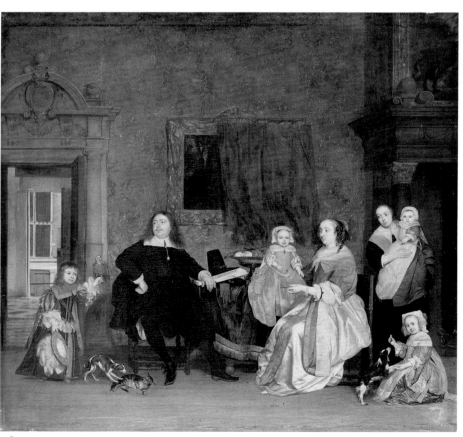

1089

490

1090

1091

1090 Barent Graat
 A Young Couple on a Garden Terrace
 Canvas, 78.5 × 66.5 cm. Residenzgalerie,
 Salzburg. On loan from the Czernin Collection

1091 Eglon van der Neer
 A Lady Washing Her Hands
 Signed and dated 1675. Panel, 49 × 39.5 cm.
 Mauritshuis, The Hague

the figure painters, and it suffices here to mention Barent Graat and Eglon van der Neer. Graat was one of those artists not quite original enough to reach the top yet often capable of excellent work. He, too, has suffered the common fate: in the course of time his best works have come to be attributed to, and sold under the names of, better-known painters. In his case these masters are probably Gerard Ter Borch and Frans van Mieris, whose work Graat's most resembles. He was a superior draftsman and seems to have founded his own drawing academy in Amsterdam, where he spent his whole life. He chose landscapes and historical episodes as subjects for his paintings, but his best works, often remarkably harmonious in color, are his domestic figure pieces and his portraits. The portraits, beautifully represented by *A Young Couple on a Garden Terrace* (fig. 1090), are mostly of full-length figures in a landscape or an interior, and they belong in the category of "company" portraits. They are always small in size and show Graat's great technical skill.

 Eglon van der Neer, son of the landscape painter Aert van der Neer, studied first with his father and then with Jacob van Loo, after which he traveled in France. Upon his return in 1659, he worked in Rotterdam, The Hague, Amsterdam, and for a while in Brussels. His base remained Amsterdam until 1690, when he went to Düsseldorf as court painter to Johann Wilhelm, the elector Palatine. He died there in 1703. Van der Neer excelled in figure paintings in the style of van Mieris and Ter Borch. His drawing ability and his rendering of cloth textures are good, but his manner of painting is less sensitive, often giving to his work an impression of hardness. He followed the custom of including symbolic meaning in his interior scenes. *A Lady Washing Her Hands* (fig. 1091) almost surely conveys the message of virtue (washing symbolizing innocence, or the cleansing from sin) opposed to vice (the negative, erotic scene in the background). Van der Neer also painted many biblical and historical pictures and landscapes, all in small format. Through him the style of the Leiden "fine" painters passed to his talented pupil Adriaen van der Werff.

 The Rotterdammer Michiel van Musscher was trained by Abraham van den Tempel and Gabriel Metsu in Amsterdam and by Adriaen van Ostade in Haarlem. After returning to his birthplace for a short time, he settled in Amsterdam in 1668. Like Metsu and Graat, he painted full-length portraits and portrait groups in interiors. In his work mingle the styles of his masters; though he never attained a very high level, his paintings often have the naive, disarming charm that is abundantly evident in his double portrait of the calligrapher-etcher-painter-schoolmaster Michiel II Comans and his wife (fig. 1092); Comans displays a sample

1093

1092

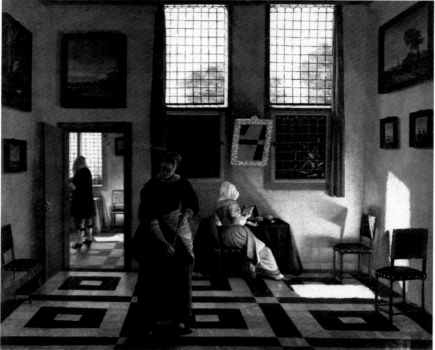

1094

1092 Michiel van Musscher
 Portrait of Michiel II Comans and His Third Wife,
 Elisabeth van der Meersch
 Signed and dated 1669. Canvas, 71 × 63 cm.
 Rijksmuseum, Amsterdam

1093 Esaias Boursse
 Interior with a Woman beside the Hearth
 Signed and dated 1656. Canvas, 52 × 58 cm. The
 Wallace Collection, London

1094 Pieter Janssens Elinga
 Interior with a Painter, a Woman Reading, and a
 Housemaid
 Signed. Canvas, 83.7 × 100 cm. Städelsches
 Kunstinstitut, Frankfurt am Main

of his penmanship which reads, "Know Thyself and Beware of Avarice." Musscher's later
work unfortunately tends to be hard and insensitive in color and manner of painting.

More in the style of Pieter de Hooch were the interiors with figures painted in
Amsterdam by Esaias Boursse and Pieter Janssens Elinga. Boursse traveled widely—to Italy,
and on trips in the service of the Dutch East India Company—but his work reveals nothing
of these experiences. He died at sea in 1672. He is close in his subject matter to the Delft
painters and Jacobus Vrel: interior scenes with a few figures busy at household tasks.
Though his figures are rather clumsily drawn, his work is often attractive. His best painting
by far is *Interior with a Woman beside the Hearth* (fig. 1093), built up primarily in shades of
gray, blue-gray, and yellow-brown and composed with the greatest harmony, almost in the
manner of a still life.

Boursse was weak at rendering figures and even weaker with faces, but the painter-
musician Pieter Janssens Elinga, a native of Bruges, avoided painting the human face as
much as possible. His interiors are reminiscent of de Hooch's, except that almost all of his
figures turn their backs to the viewer. His strengths and shortcomings are evident in *Interior
with a Painter, a Woman Reading, and a Housemaid* (fig. 1094). He also painted still lifes in the
style of Jan Jansz van de Velde, and in these the limitations of his drawing ability and faulty
perspective are less obvious.

Still-Life Painters

During the first half of the seventeenth century Amsterdam played a modest role in still-life painting, but after 1650 this altered drastically. Jan Jansz van de Velde, who produced his best work after that date, was presumably still working in the city. Of utmost importance for future developments, however, was the arrival of Willem Kalf, one of the few still-life painters acknowledged as a great master by his contemporaries.

Kalf was born in Rotterdam in 1619, the son of a wealthy cloth merchant who also held several municipal posts. His education is not known: Houbraken says the artist was born in Amsterdam, and names Hendrick Pot of Haarlem as his teacher.[22] This information is generally held to be unreliable; Kalf's apprenticeship under François Ryckhals of Middelburg seems more likely. In 1642 Kalf is documented in Paris, where he lived in Saint-Germain-des-Prés, the quarter favored particularly by Flemish painters. He was back in Rotterdam in 1646. For the next five years there is no trace whatsoever of him, but in 1651 he appears in Hoorn, where he married Cornelia Pluvier, a cultivated young woman of good family: she was expert in calligraphy and diamond engraving on glass, wrote poetry, and played the spinet, and she knew many of the poets of the day. The couple must have moved to Amsterdam soon after their marriage.

Kalf's work can be divided into two distinct phases: in his Parisian period he painted peasant interiors and also still lifes; in his Amsterdam period he created the ornate still lifes upon which his great fame rests.

The interiors of barns and peasant dwellings that Kalf painted in Paris are similar to the "stable interiors" produced in the 1630s by such Rotterdam artists as Cornelis and Herman Saftleven, Hendrick Sorgh, and Pieter de Bloot, and elsewhere by François Ryckhals and Pieter Potter. Kalf's paintings, always small in size, depict peasant interiors; against one wall, usually on the right side, a rustic still life is arranged of kegs, pots and pans, household equipment, and vegetables. A figure is often dimly visible in the background shadows (fig. 1095), and the chiaroscuro effect is generally rather strong. His technique is both smooth and spontaneous, the highlights effectively distributed. Kalf occasionally painted exteriors also, designed on approximately the same plan.

Kalf's true still lifes of this period, unlike the peasant interiors, are large in size and display all sorts of ornamental objects: richly worked silver or gilt bowls and pitchers carelessly

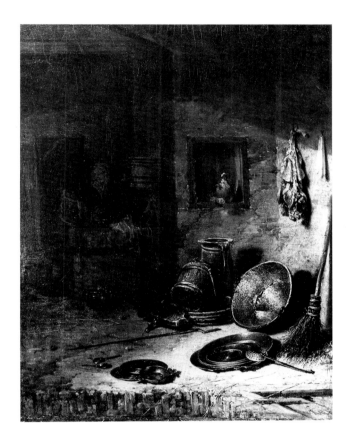

1095 Willem Kalf
Kitchen Still Life
Signed. Panel, 26.5 × 21 cm. Gemäldegalerie Alte Meister, Staatliche Kunstsammlungen, Dresden

1096 Willem Kalf
Still Life with Costly Vessels
Signed and dated 1643. Canvas, 114.5 × 85.5 cm. Wallraf Richartz Museum, Cologne

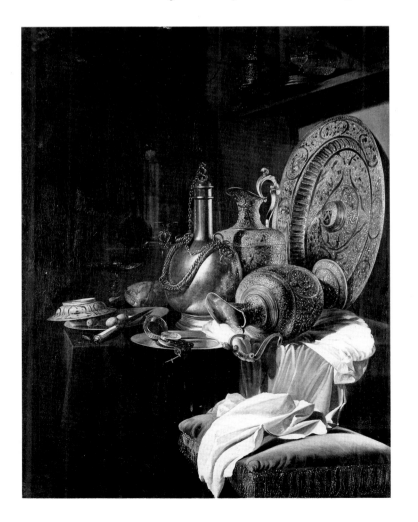

493

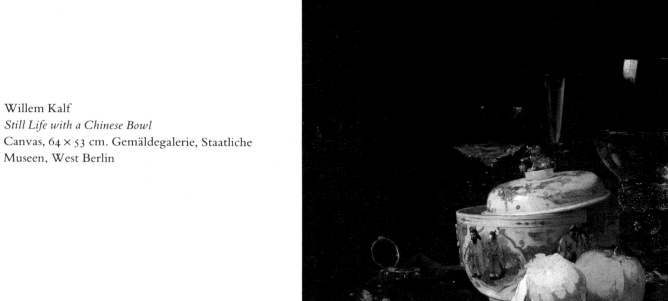

1097 Willem Kalf
 Still Life with a Chinese Bowl
 Canvas, 64 × 53 cm. Gemäldegalerie, Staatliche
 Museen, West Berlin

grouped together, some lying on their sides (fig. 1096). Many of these, especially the silver pilgrim flask, reappear regularly in his paintings, their material textures beautifully handled. Kalf was fascinated by rich, glowing lusters and scintillating highlights, and reproduced them with excellent effects of plasticity and depth. Since he often includes a gold or silver pocketwatch in the display, these paintings are surely a combination of ornate and *vanitas* still lifes. At this time François Ryckhals was probably the only painter interested in the same subjects as Kalf—stable interiors, and combined ornate and *vanitas* still lifes (see figs. 880 and 881)—and for this reason Ryckhals is thought to have been Kalf's teacher.

The gap in our knowledge of Kalf's life between 1646 and the early 1650s applies equally to his work, for no paintings are dated from then either. The works of his Paris period found followers in France but not demonstrably in Holland; he may have ventured in other directions after his return home, or even given up painting for a while.

The earliest still life from the Amsterdam period is dated 1653, but Kalf had probably begun to paint in his new style a year or so before. His Amsterdam still lifes are linked with those of Paris, yet in them a remarkable change has occurred. The compositions are calmer, very few objects are overturned, and the total display now consists of a smaller number of objects and fruits, albeit still nearly always arranged on a wooden or marble tabletop partly covered with an oriental carpet. He continues to use the same objects again and again: a richly sculptured silver ewer, a goblet in a costly *bekerschroef* or screw-on base, a nautilus cup. A bowl or a vase of Chinese porcelain often reappears, the cool blue and white harmonizing superbly with the warmer tints of a lemon or an orange (cpl. 1097). The background wall, sometimes hollowed with a niche, is so dark that the objects come alive against it, sparkling with highlights. The interrelationship of the objects, already achieved by their arrangement, is further enhanced by the well-observed play of reflections. It is incredible that Kalf, limiting the number of objects and repeatedly using the same ones in only slightly varied displays, always attained such high quality. Relatively few of his

1098 Willem Kalf
Still Life with the Drinking Horn of the St. Sebastian Guild, Amsterdam
Signed. c. 1653. Canvas, 86.4 × 102.2 cm. The National Gallery, London

1099 Jurriaen van Streeck
Still Life
Signed and dated 16(..). Canvas, 83 × 101 cm. Private collection

1100 Barent van der Meer
Still Life with Negro Boy
Signed. Canvas, 150.7 × 117.6 cm. Alte Pinakothek, Munich

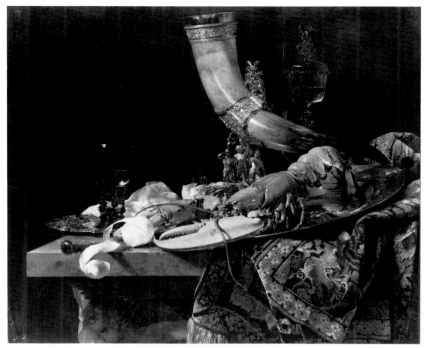

1098

Amsterdam paintings are sumptuous in their composition; the format is usually vertical, occasionally horizontal. A lovely example of the latter format is the still life in which the drinking horn of the Amsterdam St. Sebastian Guild is the center of interest (fig. 1098)—the same horn that Gabriel Metsu used in his *Oyster Eaters* (see fig. 1088). Kalf's work is painted with a broad touch, and he brings in unusually vivid coloring with the bright orange-red of the lobster and the multicolored Persian carpet.

Kalf's most productive decade was from 1653 to 1663. After that he apparently painted less and less, and about 1680 he stopped completely. He remained active as an art dealer and appraiser, however, until his death in 1693.

Of the painters influenced by Kalf, Jurriaen van Streeck's work was closest to his. Van Streeck's compositions are somewhat more laden and less balanced, and in spatial effects he cannot match Kalf. Nevertheless, in his best work (fig. 1099), van Streeck approaches his great model. The Danish painter Ottomar Elliger the Elder worked in Amsterdam for several years and came under Kalf's influence. And Barent van der Meer of Haarlem, who lived in Amsterdam after 1683, shows great indebtedness to Kalf in his still lifes (fig. 1100).

Willem van Aelst settled in Amsterdam a few years after Kalf. He had studied in his birthplace, Delft, under his uncle, Evert van Aelst, then spent the years 1645–49 in France. Proceeding to Italy, he became court painter to Ferdinand II de' Medici, grand duke of Tuscany. He reached Amsterdam in 1657 and presumably spent the rest of his life there, dying in 1683.

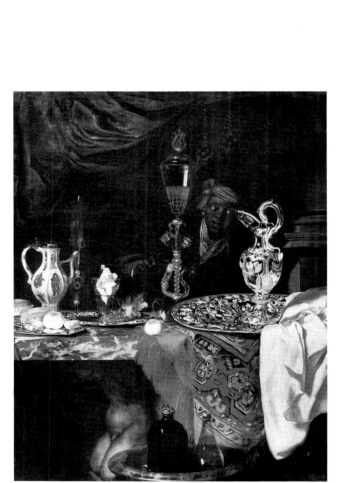

1100

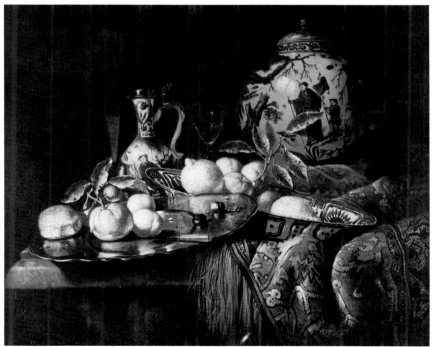

1099

Van Aelst's sojourn in France and Italy seems to have had particular influence on his palette. He remains wholly Dutch in his choice of subject matter—mostly still lifes with hunting equipment and dead game, ornate still lifes, and flower paintings—but he deviates from the Dutch tradition in his use of color, employing a great deal of cool blue, dark purple, and green. He liked to sign his paintings with his italianized first name, Guillmo.

Van Aelst's technique is subtle and clever, but he paints in so smooth a manner that the objects look chilly and stiff, an effect strengthened by the cool colors. In an ornate still life of 1659 (fig. 1101) his very kinship with Kalf in the composition brings out the great difference between the painters in their warmth and treatment of textures. Van Aelst's floral paintings can also have a perfection that verges on sterility. Yet he was an innovator in the

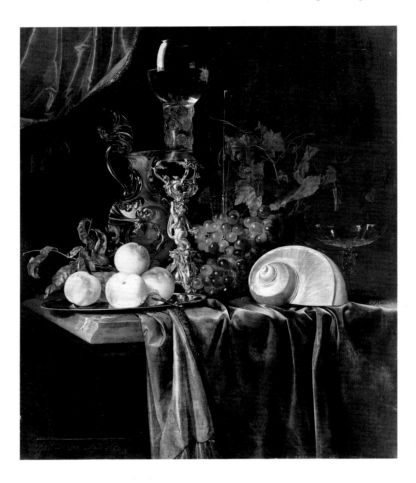 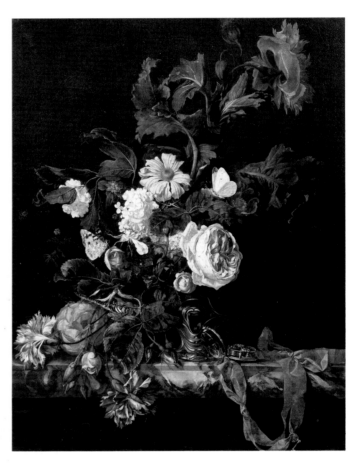

1101 Willem van Aelst
 Banquet Still Life
 Signed and dated 1659. Canvas, 86.3 × 72 cm.
 Gemäldegalerie, Staatliche Museen, East Berlin

1102 Willem van Aelst
 Still Life with Flowers
 Signed and dated 1663. Canvas, 62.5 × 49 cm.
 Mauritshuis, The Hague

composing of flower pieces, breaking with tradition by introducing an asymmetrical scheme with vigorous diagonals (fig. 1102). This new composition soon attracted many followers, who also took over van Aelst's strong light effects. His great technical skill and highly developed decorative sense, seen in his *Hunting Still Life* of 1668 (cpl. 1103), likewise influenced the painters of still lifes of game and shooting paraphernalia.

The tendency toward the decorative is even more evident in the work of Jan Weenix, son of Jan Baptist Weenix, who was active in Amsterdam, Utrecht, and Düsseldorf. Weenix was fond of arranging his dead game and birds against a parklike background that included urns, sculptured putti, and other garden ornaments (fig. 1104), following the example not so much of van Aelst as of Melchior d'Hondecoeter, who worked in Amsterdam from 1663 on and produced hunting still lifes in addition to his characteristic paintings of poultry.

The flower painters in Amsterdam included Elias van den Broeck, who had been a pupil of Simon Kick's son Cornelis, but shows that he was more influenced by van Aelst, especially in composition. Another of Cornelis Kick's pupils, Jacob van Walscapelle, who moved from Dordrecht to Amsterdam in his youth, also seems to have been inspired less by his master than by Jan Davidsz de Heem. Nicolaes Lachtropius, active in Amsterdam until 1687, worked in van Aelst's style. And van Aelst had a brilliant pupil in Rachel Ruysch. The work of this talented Amsterdam flower painter will be considered briefly in the last chapter, though it falls outside the chronology of this book. Suffice it here to say that specifically in floral painting the seventeenth-century tradition was to continue unchanged for generations.

It is unlikely that Abraham van Beyeren's sojourn in Amsterdam from 1669 to 1674 had any importance for his own development as a still-life painter; his style had reached its high

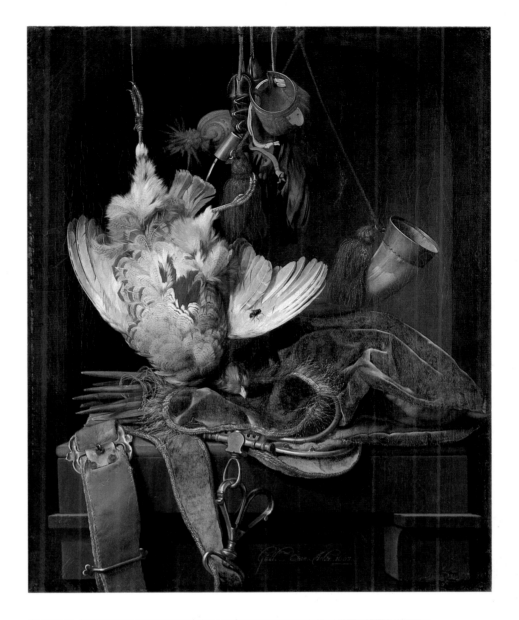

1103 Willem van Aelst
Hunting Still Life
Signed and dated 1668. Canvas, 68 × 54 cm.
Staatliche Kunstsammlungen, Karlsruhe

1104 Jan Weenix
Still Life with Dead Hare
Signed and dated 1682 (1683?). Canvas,
101 × 78.5 cm. Staatliche Kunstsammlungen,
Karlsruhe

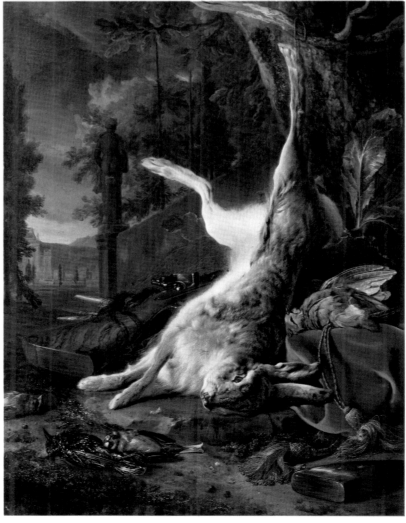

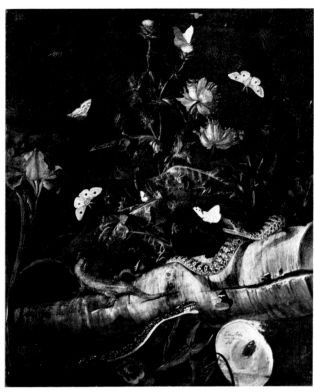

1105

1105 Otto Marseus van Schrieck
 Poppies, Thistles, Butterflies, Snakes, and Lizard
 Signed. Canvas, 82.8 × 64.9 cm. Staatliche
 Schlösser und Gärten, West Berlin

1106 Otto Marseus van Schrieck
 Burdock Bush
 Signed. Panel, 40 × 55.7 cm. Radishchev Art
 Museum, Saratov, U.S.S.R.

1106

point in the 1650s, when he was working in The Hague and Delft. Nor does he seem to have much influenced the Amsterdam still-life painters.

Tangential to the still life, yet certainly a separate genre, is the depiction of reptiles and insects in their natural surroundings. This subject appealed especially to Amsterdam artists, and the best representative was Otto Marseus van Schrieck. Willem van Aelst visited him and Matthias Withoos in Italy, where they were specializing in painting reptiles and insects, few interesting species of these occurring in the Netherlands. Withoos returned to his birthplace, Amersfoort, in 1653; van Schrieck accompanied van Aelst, and both settled in Amsterdam in 1657.

Van Schrieck was a member of the *Bentveughels* in Rome and got the nickname Sniffer, according to Houbraken, "because he sniffed around everywhere for strange-colored or speckled snakes, lizards, caterpillars, spiders, spinnerets, and strange plants and herbs." Houbraken further reports, firsthand from van Schrieck's widow, that "he put these animals on a piece of low land outside Amsterdam where they would thrive best, and to this end he fenced them in and fed them daily."[23] From the inventory of van Schrieck's estate,[24] it appears that he made countless drawings of his animals and plants for later use in his paintings, in which the settings are imaginary but based on careful observation. A competent painter, van Schrieck was evidently a naturalist as well. His pictures, which may sometimes have symbolic meaning,[25] are enchanting, mysterious. The animals and plants seem caught in a sudden ray of sunshine in a dark forest (fig. 1105), their exotic colors and shapes adding to the charm of the works.

Van Schrieck set an example for a good many followers. Willem van Aelst made a painting or two in his style, and Melchior d'Hondecoeter, Rachel Ruysch, Elias van den Broeck, and several others elaborated on the theme. But van Schrieck remains the most original of them all. Only he thought of giving a stellar role to the common prickly burdock, with its beautifully marked, serrated leaves (cpl. 1106). A caterpillar crawls jauntily along a leaf's sharp edge, butterflies and a dragonfly flutter about, and a lizard and a snake keep watch in the shade. The Sniffer was a true observer in the age of observation, and his art slips easily and naturally into the great mosaic of painting that distinguishes the Dutch Golden Age. To the world's good fortune, the works of the painters of that time have spread far and wide: Otto Marseus van Schrieck's *Burdock Bush* is number 59 in the inventory of the Radishchev Museum in Saratov, in the heart of the Soviet Union.

The Transition to the Eighteenth Century

The rounding-off date for the painting in this book has been set at 1680—that is to say, only those painters who produced their most important work before or close to that year have been discussed. In the evolution of painting, any time limit will of necessity be an arbitrary one, but in the course of Dutch art a clear stagnation can be observed during the 1670s and 1680s: the new generation was innovative in only a few ways and their art definitely lacked the quality of their predecessors.

Most of the painters we now deem the most important representatives of the Golden Age were dead by 1680, or no longer active. Frans Hals died in 1666, Gabriel Metsu in 1667, Philips Wouwerman in 1668, Rembrandt van Rijn in 1669, and no works by Ferdinand Bol are known after that year. During the 1670s, Bartholomeus van der Helst died in 1670, Jan Lievens in 1674, Johannes Vermeer and Gerrit Dou in 1675, and Jan van de Cappelle and Jan Steen in 1679. In 1681 died Frans van Mieris and Gerard Ter Borch, followed by Jacob van Ruisdael in 1682, Claes Berchem in 1683, Jan Davidsz de Heem and Pieter de Hooch in 1684, Adriaen van Ostade in 1685. Philips Koninck died in 1688 and Abraham van Beyeren in 1690, but neither had done much, if any, painting for years. The same is true of Aelbert Cuyp (died 1691), Emanuel de Witte (died 1692), and Willem Kalf (died 1693). Nicolaes Maes (died 1693) remained active longer, as did Melchior d'Hondecoeter (died 1695) and Gerrit Berckheyde (died 1698). Willem van de Velde the Younger lived until 1707, but had long since settled in England. Meindert Hobbema, who died in 1709, painted very little during the last decades of his life; his *Avenue, Middelharnis* of 1689 (see cpl. 1027) is an unusually late and splendid example in the seventeenth-century tradition. Jan van der Heyden survived until 1712 and continued to paint to the end; his latest townscape is dated 1684, but he painted still lifes that bear the years 1711 and 1712.

More important than this summing-up, however, is the question: did these older artists, during the last stages of their careers, strike out on new paths and make new contributions, or did they simply continue to follow the traditional way? The answer in general is that once they had found their respective styles and subject matter, they stuck to them; only a few adapted themselves to new norms and forms. These included some of the portrait painters, Nicolaes Maes for example (see fig. 178), because a portraitist must follow the fashion of the times. Melchior d'Hondecoeter also kept up, developing his talent for the decorative art that became increasingly fashionable (see cpl. 878). But most painters at best maintained their old standards and at worst retained only vestiges of their former power.

And what about the new generation of painters? We can best get an idea of them by tracing them out according to their subject matter. In portrait painting we see a continuous line that proceeded from a healthy tradition and adjusted to the changing taste; yet it was unmistakably marked by a decrease in quality which did not revive until after the first quarter of the eighteenth century, when Cornelis Troost (1696–1750) painted the bewigged burghers of Amsterdam with great skill and wit, and a few other artists specialized in small-format family groups, a genre that had existed in the seventeenth century but did not become popular until the eighteenth.

The painters of domestic interiors based themselves primarily on the work of Gerrit Dou and Frans van Mieris, whose immediate successors remained productive for quite a long time. Jan Verkolje kept the tradition alive in Delft until his death in 1693; Eglon van der Neer did the same in Amsterdam until his departure in 1690 for Düsseldorf, where he died in 1703; and likewise Godfried Schalcken in Dordrecht, who died there in 1706. The next generation mainly followed in their footsteps. The most popular compositions, always in small format, were intimate domestic scenes or one or two figures seen through an arched window. Technically, these paintings are often adept; in other respects they are weaker extracts from the work of the seventeenth-century masters. Willem van Mieris (1662–1747), son of Frans, is typical of this group, although he occasionally introduced a new theme, such as a young traveling entertainer displaying a puppet case at an inn (fig. 1107).

There was little or no activity in figure painting of peasants after Cornelis Dusart, disciple of Adriaen van Ostade, died in 1704. The subject no longer—actually, it never had—fitted the pattern of classicistic art theory, which deemed only the beautiful and the elevated to be worthy of artistic representation.

The landscape painters were able to renew their tradition to some degree. Van Goyen and

1107 Willem van Mieris
Interior of an Inn with a Young Traveling Entertainer Displaying a Puppet Case
Signed and dated 1718. Panel, 57.8 × 49 cm.
Private collection

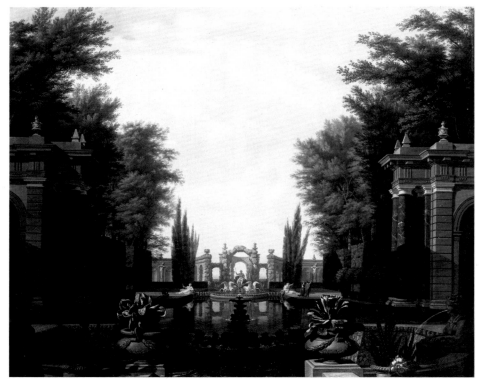
1108

1109

Ruisdael had no following and Hobbema and Cuyp found theirs only much later, but the painters of strongly decorative landscapes continued to develop. Isaac de Moucheron (1667–1744) became one of the leaders in this field with such works as *Park with a Pool and a Fountain* (fig. 1108). The Arcadian landscape, too, appealed to the taste of the time, and the flower painter Jan van Huysum (1682–1749) turned to that genre with success (fig. 1109). The increasing demand for painted wall hangings led to the founding of the wallpaper industry, and many of the decorative landscape painters found new employment there. Marine painting, however, went into a serious decline. There was no question of revival, merely of loss of quality.

Traditional seventeenth-century still-life painting in its different aspects disappeared almost entirely, except for the decorative hunting still life (see cpl. 1103) and flower painting. An unbroken line in floral painting stretches from Jan Davidsz de Heem and Willem van Aelst to the late eighteenth century and even into the nineteenth. Justus van Huysum (1659–1716), his son Jan, and Rachel Ruysch (1663–1750) not only maintained the tradition in Amsterdam but reached new heights with their amazing technique and artistic sensitivity (figs. 1110 and 1111). Remarkably, yet perhaps understandably, museums today tend to hang the works of these painters in the seventeenth-century galleries, and writers include them in studies of seventeenth-century art.

1108 Isaac de Moucheron
 Park with a Pool and a Fountain
 Signed. Canvas, 130 × 160 cm. Museum
 Willet-Holthuysen, Amsterdam

1109 Jan van Huysum
 Arcadian Landscape
 Signed and dated 1728. Canvas, 53.5 × 73.5 cm.
 Amsterdams Historisch Museum, Amsterdam

1110 Jan van Huysum
 Flower Piece
 Signed and dated 1724. Panel, 78.5 × 59 cm.
 Private collection

1111 Rachel Ruysch
 Flower Piece
 Signed and dated 1715. Canvas, 75 × 60 cm. Alte
 Pinakothek, Munich

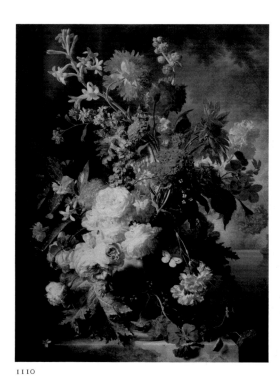
1110

1111

1112 Isaac Ouwater
View of the Westerkerk, Amsterdam
Signed and dated 1778. Canvas, 53.3 × 63.5 cm.
National Gallery of Ottawa, Canada

1113 Aert de Gelder
The Way to Golgotha
Signed. c. 1715. Canvas, 72 × 60 cm. Staatsgalerie,
Schloss Johannisburg, Aschaffenburg

1114 Adriaen van der Werff
The Judgment of Paris
Signed and dated 1712. Panel, 56 × 49.5 cm.
Formerly Staatliche Kunstsammlungen, Dresden.
Destroyed during World War II

1112

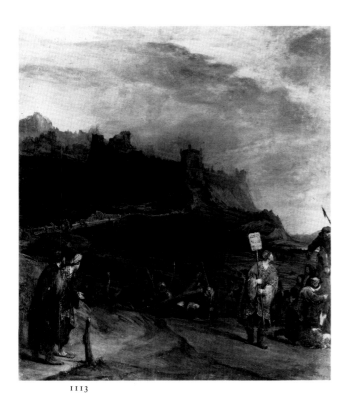

1113

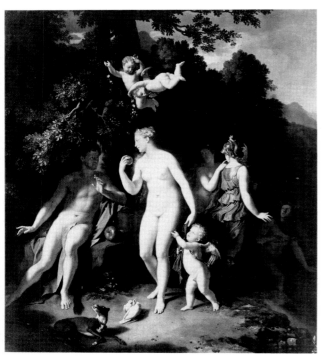

1114

The cards fell differently for the architectural painters. As the church interior vanished from the repertory, the townscape gained in popularity. The topographical town portrait had not developed until the second half of the seventeenth century, and the best painters in this field—the Berckheydes, Jan van der Heyden, and the less-gifted Abraham Storck— worked long at their proven motifs without introducing new elements. Eighteenth-century artists linked up effortlessly with these forerunners, and as the interest in national topography rose steadily, the new generation could develop favorably. Yet Berckheyde and especially van der Heyden remained their brilliant and unattainable models. When, a century after van der Heyden, Isaac Ouwater (1750–1793) portrayed the Amsterdam Westerkerk (fig. 1112), it is clear whose example he was following (see fig. 1076).

It is something of a surprise to find that the breakthrough in this rather somber situation came from the ranks of the history painters. The revival in history painting was motivated, moreover, by a theory of art: the principles and rules that had been formulated in the last quarter of the seventeenth century and set down by Gerard de Lairesse in his *Groot Schilderboek* (Great Book of Painting) of 1707. Not all the history painters immediately grasped the new opportunities, as becomes plain when we examine three artists of the transition period: Aert de Gelder (1645–1727), Adriaen van der Werff (1659–1722), and Gerard de Lairesse himself (1641–1711).

Aert de Gelder, Rembrandt's last and most faithful pupil, would not have concerned himself with new ideas even if he knew about them, for he worked more or less in isolation in Dordrecht (see p. 421). He remained true to his master, yet he was certainly more than a follower and his later work gained a new, personal quality in its color, treatment of paint, and imaginative reconstruction of history, as can be seen in *The Way to Golgotha* (fig. 1113).

Adriaen van der Werff was the antithesis of de Gelder. A native of Rotterdam, he studied under Eglon van der Neer and at an early age began to paint in the style of the Leiden "fine" painters—in his own way. Technically he was not important, though his smoothly brushed little paintings with their enamel-like surfaces, often painted on copper, are refined in color and elegantly made. He also painted portraits. But his speciality was biblical and mythological scenes, such as *The Judgment of Paris* (fig. 1114), with female nudes in the approved classicistic style. He satisfied the norms of his time in his use of color, manner of painting, and choice of subject, and achieved success at home and abroad. Johann Wilhelm, the elector Palatine, who was a patron of Dutch artists, as we have seen, appointed van der Werff court painter in 1696 and later raised him to the nobility. Van der Werff built upon the seventeenth-century tradition in history painting, but he gave it a form of his own that accorded with the standards and the theories of his time.

Gerard de Lairesse was the oldest of these three painters and a true reformer of art. Born in Luik (Liège) in the Southern Netherlands in 1641, he developed precociously and received commissions at an early age. Subsequent troubles made him take refuge in 's-Hertogenbosch, however, and he was persuaded by the art dealer Gerrit Uylenburgh to settle in Amsterdam, where he purchased his citizenship in 1667. He admits in his *Groot*

Schilderboek that he initially felt the impact of Rembrandt's work: "I will not deny that I felt a special attraction to his manner; but I had no sooner begun to appreciate the infallible rules of this art than I was obliged to retract my error."[1] He must have soon come in contact in Amsterdam with a group of people interested in French classicistic ideas, the "infallible rules" of which led him drastically to alter his manner of painting.

A few portraits by Lairesse are known (fig. 1115), but he devoted himself mainly to history painting and to such decorative art as wall hangings and ceiling paintings.[2] He was presumably the first to paint ceiling pieces on canvas; Jan van Bronckhorst and Nicolaes van Helt Stockade had worked directly on wood for their ceiling paintings in the Amsterdam town hall, and Gerrit van Honthorst's ceiling pieces are also on panel (see fig. 34). But Lairesse brought more than this technical renewal; he made repeated experiments with mirrors and ingenious apparatus to determine the scientific rules of perspective that govern the design of ceiling paintings, to make a room seem to open up into a view of the sky, an effect he achieved magnificently in his *Allegory of Dawn* (fig. 1116). Ceiling pieces by him are known from the beginning of the 1670s. He made a three-part ceiling painting in 1672 for the house of the Amsterdam burgomaster Andries de Graeff, and a series of such paintings about 1675 for the Amsterdam Leper Asylum. More commissions followed in Amsterdam and beyond. Meanwhile he continued to produce regular easel paintings, nearly always on mythological themes, such as *Achilles and the Daughters of Lykomedes* (fig. 1117). Lairesse became blind about 1690; unable to paint, he concentrated instead on art theory. From then until his death in 1711 he lectured on that subject in the art room of the Amsterdam town hall. His theoretical writings are basically compilations of these lectures.

Lairesse has a bad name with certain latter-day admirers of seventeenth-century Dutch art, who consider his classicistic ideas, which he also put into practice, to be treason against the very essence of Dutch painting. And his name becomes even more heinous through his criticism of Rembrandt in such remarks as "Away with fumbling, grubbing, and messing: attack your work with a manly hand. But not like Rembrandt or Lievens... so that the sap runs down the piece like dung."[3] Wurzbach says of the *Groot Schilderboek*: "This nearly wholly worthless book is directed against naturalism and preaches artistic principles [of the sort] that might be expected of an academic who had never been to Italy."[4] Martin declares that he read "with shock what the influential Lairesse dictated," and goes on to say, "Alas, as the times changed, Lairesse's theories, which spanned the whole domain of painting, exercised ever greater influence on artists, so that eventually they knew no better than to keep to the rules. In this way they rocked each other to sleep."[5]

It is remarkable that these admirers of seventeenth-century Dutch art did not realize that the top had been reached, that further advance might be impossible for an art that had bloomed so richly and vigorously for almost a century. Of the three transitional artists mentioned here, only Lairesse broke completely with the old tradition and actually proposed something new in its place. His ideas were taken over by other history painters such as Jacob de Wit who developed them further.

1115 Gerard de Lairesse
Portrait of an Unknown Man, Aged about 40
Signed and dated 1682. Canvas, 141 × 115 cm.
Staatliche Kunstsammlungen, Kassel

1116 Gerard de Lairesse
Allegory of Dawn
Ceiling painting. Canvas, 290 × 680 cm.
Rijksmuseum, Amsterdam

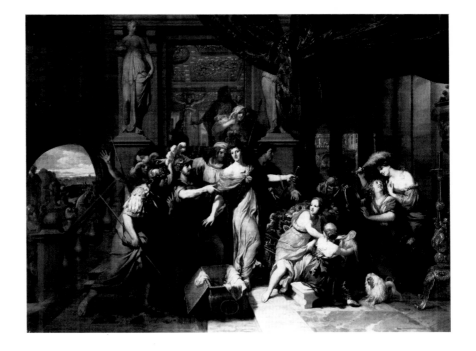

1117 Gerard de Lairesse
Achilles and the Daughters of Lykomedes
Signed. Canvas, 81 × 104 cm. Herzog Anton
Ulrich Museum, Brunswick, West Germany

Martin's remark, "In this way they rocked each other to sleep," voices something deeper than an antipathy to Lairesse, and his choice of words does not seem to me accidental. He is implying an overall degeneration of the Dutch Republic that began in the third quarter of the seventeenth century. The decline of the Republic's political and economic power was attributed in the nineteenth century to the "drowsing off" of Holland's spirit of enterprise. Merchants were blamed for eating up the profits of the Golden Age, for investing in land and shares rather than plowing back their gains into new ventures. In his allegorical story *Jan, Jannetje en Hun Jongste Kind* (Jan, Jannetje, and Their Youngest Child), published in 1842, the writer E.J. Potgieter satirized the decline of the Netherlands after the glorious Golden Age by contrasting Jan and Jannetje's two elder sons, Jan Compagnie and Jan Crediet, with their youngest, Jan Salie (perhaps so named for *saliemelk* or herbal milk); Compagnie and Crediet are paragons of strength, resolution, and enterprise (the alleged virtues of the seventeenth century), while Jan Salie represents the spoiled lounger thought typical of the eighteenth century. The Dutch of Potgieter's time tended to accept this fantasy as the literal truth.

The nineteenth-century image of the decline is admittedly not far off the mark, but it needs some revision. The Republic's economic situation had begun to show signs of decline in a number of sectors as early as the second half of the seventeenth century, but there were periods of revival, too, as during the decade 1680–90. External factors, over which the Dutch had little control, were also of major importance: the wars with England and France signified that other international powers would no longer tolerate the unlimited freedom of the Dutch on the high seas. This struggle continued throughout the eighteenth century. The situation in all of Europe worsened at this time: populations everywhere were either static or in decline, bringing serious consequences to agriculture, and an epidemic of cattle plague proved nearly disastrous to food supplies.

The strongly negative picture drawn by nineteenth-century historians and art scholars of the last quarter of the seventeenth and the whole of the eighteenth century was accepted as valid until far into the twentieth century. Yet equally strong was their idealization of the Golden Age. Two years after he had introduced Jan Salie, Potgieter brought back the same theme in his essay "Het Rijksmuseum te Amsterdam," but the weakling in this case is eighteenth-century painting, and the hero is the great golden art of the age before, symbol of the power that Potgieter's own age must strive to regain. That golden gleam outshone all the shadows in the glorious period as well as the positive aspects of the art that followed.

We need not fear that the reevaluation of this picture which is now taking place will harm the esteem we feel for the painters of the Golden Age. The work they bequeathed to us withstands all critical examination by the instruments of modern technology. And the more we understand of the painters' thoughts and ways, the deeper becomes our insight into the times in which they lived. And their art will speak to us with ever greater conviction.

Notes

Bold numbers refer to pages.

Part I

Introduction

12. 1. R. van Luttervelt, "De zeeslag bij Bergen, een penschilderij van Willem van de Velde de oude," *Bulletin van het Rijksmuseum* 10 (1962), pp. 16–30.
13. 2. A. Bredius, "Hercules Seghers," *Oud Holland* 16 (1898), p. 7.

Preliminaries, Historical and Artistic

16. 1. Geoffrey Parker, *The Dutch Revolt* (Harmondsworth, 1981), pp. 26–27.
18. 2. E.R. Meyer, "Jan van Scorels 'Nieuwe Manier,'" *Oud Holland* 70 (1955), pp. 189–93.

Iconoclasm and Revolt: 1566–1588

21. 1. Karel van Mander, *Het Schilder-Boeck*, 2d ed. (Haarlem, 1618), p. 172a.
26. 2. H. Bonger, *De dichter van het Wilhelmus; een kritische beschouwing* (Amsterdam, 1979).
26. 3. J.R. Fruin, *Tien jaren uit den tachtigjarigen oorlog, 1588–1598* (Amsterdam, 1861).

The Artist's Social Position

27. 1. A. Luzio, *La galleria dei Gonzaga venduta all'Inghilterra nel 1627–28* (Milan, 1913).
27. 2. Karel van Mander, *Het Schilder-Boeck*, 2d ed. (Haarlem, 1618), p. 176b.
27. 3. Ibid., p. 195a.
28. 4. J. Denucé, *Bronnen voor de geschiedenis van de Vlaamse kunst* I: *Kunstuitvoer in de 17e eeuw te Antwerpen. De Firma Forchoudt* (Antwerp/Amsterdam, 1931).
30. 5. Van Mander, *Het Schilder-Boeck*, pp. 169b–170a.
30. 6. Lydia de Pauw-de Veen, *De begrippen "schilder," "schilderij" en "schilderen" in de zeventiende eeuw* (Brussels, 1969), p. 17.
30. 7. D.O. Obreen et al., *Archief voor Nederlandsche kunstgeschiedenis ...* V (Rotterdam, 1877–90), p. 189.
30. 8. A. Heppner, "De verhouding van kunstschilder tot decoratieschilder in de 17de eeuw: Holsteyn en Van Pillecum," *Oud Holland* 61 (1946), pp. 47–58; Arnold Houbraken, *De Groote Schouburgh der Nederlantsche Konstschilders en Schilderessen ...* I (Amsterdam, 1718–21), p. 242.
30. 9. E. Taverne, "Salomon de Bray and the Reorganisation of the Haarlem Guild of St. Luke in 1631," *Simiolus* 6 (1972–73), pp. 50–69.
30. 10. For an excellent analysis of the artist's position in the guild, which essentially rectifies older views, see "Schilderen is een ambacht als een ander. Verslag van een onderzoek rond Philips Angels *Lof der Schilder-Konst* en het zeventiende-eeuwse Noordnederlandse schildersgilde," *Proef* 3 (1973–75), pp. 124–44; H. Montias. "The Guild of St. Luke in 17th-Century Delft and the Economic Status of Artists and Artisans," *Simiolus* 9 (1977), pp. 93–105.
30. 11. G.J. Hoogewerff, *De geschiedenis van de St. Lucasgilden in Nederland* (Amsterdam, 1947); R.W. Scheller, "Nieuwe gegevens over het St. Lukasgilde te Delft in de zestiende eeuw," *Nederlands Kunsthistorisch Jaarboek* 23 (1972), pp. 41–48.
31. 12. See J.G. van Dillen, *Bronnen tot de geschiedenis van het bedrijfsleven en het gildewezen van Amsterdam* I (The Hague, 1929), p. 664, no. 1124; I.H. van Eeghen, "Het Amsterdamse Sint Lucasgilde in de 17de eeuw," *Jaarboek Amstelodamum* 61 (1969), pp. 65–102.
31. 13. J. Verbeek, "De beeldende kunst in Overijssel," in *Geschiedenis van Overijssel* (Deventer, 1970), p. 339.
32. 14. Van Mander, *Het Schilder-Boeck*, I, 23, p. 1b.
32. 15. A.H. Kan and G. Kamphuis, *De jeugd van Constantijn Huygens door hemzelf beschreven* (Rotterdam/Antwerp, 1946), p. 65.
32. 16. Van Mander, *Het Schilder-Boeck*, p. 172b.
32. 17. De Pauw-de Veen, *De begrippen*, p. 31.
32. 18. Walter L. Strauss and Marjon van der Meulen, *The Rembrandt Documents* (New York, 1979), p. 154.
32. 19. Johan E. Elias, *De vroedschap van Amsterdam 1578–1795* I (Haarlem, 1903–5), pp. xliii and 287.
33. 20. J.G. van Dillen, *Amsterdam in 1585. Het kohier der capitale impositie van 1585* (Amsterdam, 1941).
33. 21. J.G. Frederiks and P.J. Frederiks, *Kohier van den tweehonderdsten penning voor Amsterdam en onderhoorige plaatsen over 1631* (Amsterdam, 1890).
33. 22. J. Bruyn, "Een onderzoek naar 17de-eeuwse schilderijformaten, voornamelijk in Noord-Nederland," *Oud Holland* 93 (1979), pp. 96–115.
33. 23. P. Haverkorn van Rijsewijk, "Simon Jacobsz. de Vlieger," *Oud Holland* 9 (1891), pp. 221–24.
34. 24. H. Floerke, *Studien zur niederländischen Kunst- und Kulturgeschichte. Die Formen des Kunsthandels, das Atelier und der Sammler in den Niederlanden vom 15.–18. Jahrhundert* (Munich/Leipzig, 1905), p. 54.
34. 25. Obreen, *Archief* II, pp. 71–93.
34. 26. W. Martin, *Het leven en de werken van Gerrit Dou beschouwd in verband met het schildersleven van zijn tijd* (Leiden, 1901), p. 105.
35. 27. Neil MacLaren, *The Dutch School*, National Gallery Catalogues (London, 1960, pp. 192–93.

The Patrons

36. 1. C.W. Bruinvis, "Het orgel in de Groote Kerk te Alkmaar," in *Feestuitgave ter gelegenheid van het honderdjarig bestaan van het Natuur- en Letterkundig Genootschap "Solus Nemo Satis Sapit"* (Alkmaar, 1882).
38. 2. J.H.A. Engelbrecht, "Het orgel uit de Amsterdamsche schuilkerk 'In 't Boompie,'" *Nederlands Kunsthistorisch Jaarboek* 11 (1960), pp. 185–207; A. Blankert, "Schilderijen," in *Kunstbezit Parkstraat*, exhibition catalogue Gemeentemuseum (The Hague, 1978), pp. 5–14.
38. 3. J.Q. van Regteren Altena, "Grotten in de tuinen der Oranjes," *Oud Holland* 85 (1970), pp. 33–44.
40. 4. F.W. Hudig, *Frederik Hendrik en de kunst van zijn tijd* (Amsterdam, 1928).
40. 5. S.W.A. Drossaers, "Inventaris van de meubelen van het Stadhouderlijk kwartier met het Speelhuis en van het Huis in het Noordeinde te 's-Gravenhage," *Oud Holland* 47 (1930), pp. 193–236 and 241–76.
40. 6. A.H. Kan and G. Kamphuis, *De jeugd van Constantijn Huygens door hemzelf beschreven* (Rotterdam/Antwerp, 1946), pp. 73–74.
40. 7. D.F. Slothouwer, *De paleizen van Frederik Hendrik* (Leiden, 1945).
41. 8. G. Kamphuis, "Constantijn Huygens, bouwheer of bouwmeester?" *Oud Holland* 77 (1962), pp. 151–80.
42. 9. D.P. Snoep, "Honselaersdijk: restauraties op papier," *Oud Holland* 84 (1969), pp. 270–94.
42. 10. J.A.L. de Meyere, "Nieuwe gegevens over Gerard van Honthorst's beschilderd plafond uit 1622," in *Jaarboek Oud-Utrecht* (Utrecht, 1976), pp. 7–29.
44. 11. C.W. Fock, "Nieuws over de tapijten, bekend als de Nassause Genealogie," *Oud Holland* 84 (1969), pp. 1–28.
44. 12. J.G. van Gelder, "De schilders van de Oranjezaal," *Nederlands Kunsthistorisch Jaarboek* 2 (1948–49), pp. 118–64; T.H. Lunsingh Scheurleer, "De woonvertrekken in Amalia's Huis in het Bosch," *Oud Holland* 84 (1969), pp. 29–66.
44. 13. Beatrijs Brenninkmeyer-de Rooij, "Notities betreffende de decoratie van de Oranjezaal in Huis ten Bosch," *Oud Holland* 96 (1982), pp. 133–90.
45. 14. *Maurits de Braziliaan*, exhibition catalogue Mauritshuis (The Hague, 1953).
47. 15. Denis Mahon, "Notes on the 'Dutch Gift' to Charles II," *Burlington Magazine* 91 (1949), pp. 303–5 and 349–50; ibid. 92 (1950), pp. 12–18.
47. 16. H. Rössing, "Amsterdam op het Louvre door Ludolph Bakhuysen," *Kunstkronijk* N.S. 18 (1877), pp. 30–33.
48. 17. H.E. van Gelder, "Abraham de Verwer levert een schilderij van den Slag bij Gibraltar," *Oud Holland* 62 (1947), pp. 211–13.
48. 18. D.O. Obreen et al., *Archief voor Nederlandsche kunstgeschiedenis ...* V, pp. 66–67.
49. 19. C.J. Gonnet, "Oude schilderijen in en van de Stad Haarlem," *Oud Holland* 33 (1915), pp. 132–44.
50. 20. A. Blankert, *Kunst als regeringszaak in Amsterdam in de 17e eeuw. Rondom schilderijen van Ferdinand Bol*, exhibition catalogue Royal Palace, Amsterdam (Lochem, 1975).
50. 21. Katherine Fremantle, *The Baroque Town Hall of Amsterdam* (Utrecht, 1959).
51. 22. *Jaarrekening 1641, extra ordinaire uitgaven* I, Municipal Archives, Zwolle. Verbal information by B. Dubbe.
51. 23. Obreen, *Archief* II, p. 134.
51. 24. R. van Luttervelt, "Herinneringen aan Michiel Adriaenszoon de Ruyter in het Rijksmuseum," *Bulletin van het Rijksmuseum* 5 (1957), p. 60.
52. 25. Blankert, *Kunst als regeringszaak*, pp. 38–39.
52. 26. *Arm in de Gouden Eeuw*, exhibition catalogue Amsterdams Historisch Museum (Amsterdam, 1965).
53. 27. B. Haak, "Regenten en regentessen, overlieden en chirurgijns, Amsterdamse groepsportretten van 1600 tot 1835," *Antiek* 7 (1972–73), pp. 81–116.
54. 28. R. van Luttervelt, "Joost Cornelisz. Droochsloot en zijn werken voor het Sint Barbara- en Laurentiusgasthuis te Utrecht," *Nederlands Kunsthistorisch Jaarboek* 1 (1947), pp. 113–36.
56. 29. *Hofjes in Nederland* (Haarlem, 1977), pp. 143 and 149.
57. 30. J. Six, "Nicolaes Eliasz Pickenoy," *Oud Holland* 4 (1886), p. 85.
59. 31. A. van Schendel, "Een stille plantage in Suriname, door Dirck Valkenburg, 1707," *Bulletin van het Rijksmuseum* 11 (1963), pp. 80–86.
59. 32. B. Sliggers, Jr., ed., *Dagelijkse aentekeninge van Vincent Laurensz. van der Vinne* (Haarlem, 1979).
59. 33. *The World on Paper. Cartography in Amsterdam in the 17th Century*, exhibition catalogue Amsterdams

Historisch Museum (Amsterdam, 1967), pp. 80–83.

59. 34. J.L.A.A.M. van Ryckevorsel, "De teruggevonden schilderij van Rembrandt: de Juno," *Oud Holland* 53 (1936), pp. 271–74; N. de Roever, "Herman Becker, koopman en kunstkenner," in *Uit onze oude Amstelstad* III (Amsterdam, 1891), pp. 110ff.

60. 35. Vincenzo Ruffo, "Galleria Ruffo nel secolo XVII in Messina," *Bolletino d'Arte* 10 (1916), pp. 21, 95, 165, 284, and 269ff.; G.J. Hoogewerff, "Rembrandt en een Italiaansche maecenas," *Oud Holland* 35 (1917), pp. 129–48.

Theories of Art

60. 1. Philips Angel, *Lof der Schilder-Konst* (Leiden, 1642), p. 32; he borrowed this list from the 1641 Dutch edition of Junius, *De pictura veterum*, pp. 87–88. See also H. Miedema, "Philips Angels Lof der Schilder-Konst," *Proef* 3 (December 1973), pp. 27–33.

61. 2. A. Ellenius, *De arte pingendi; Latin Art Literature in Seventeenth-Century Sweden and Its International Background* (Uppsala/Stockholm, 1960), pp. 33–55.

61. 3. See Miedema in *Proef* 1973, pp. 28–29. An approach similar to that of Junius is to be found also in G.J. Vossius, *De quatuor artibus popularibus* (Amsterdam, 1650).

61. 4. The booklet itself gives no clues to the occasion of the speech or the reason for its publication; see "Schilderen is een ambacht als een ander. Verslag van een onderzoek rond Philips Angels *Lof der Schilder-Konst* en het zeventiende-eeuwse Noordnederlandse schildersgilde," *Proef* 3 (1973–75), pp. 124–44. The 52-line panegyric written by the Amsterdam painter Werner van den Valckert to celebrate St. Luke's Day in 1618 is occasional verse pure and simple, but is was also published; see E.R.M. Taverne, "Een Amsterdams Lucasfeest in 1618," *Simiolus* 4 (1970), pp. 19–27.

62. 5. M.H. Bottenheim, "Een Nederlandse versie van Leonardo da Vinci's Trattato della Pittura," *Bulletin van het Rijksmuseum* 9 (1961), pp. 26–29.

62. 6. Karel van Mander, *Het Schilder-Boeck*, "Grondt," 2d ed. (Haarlem, 1618), pp. 45–55; Samuel van Hoogstraeten, *Inleyding tot de Hooge Schoole der Schilderkonst: anders de Zichtbaere Werelt* ... (Rotterdam, 1678), pp. 216–29; Gerard de Lairesse, *Het Groot Schilderboek* ... I (Amsterdam, 1707), pp. 205–24.

62. 7. Gaius Plinius Secundus, *Naturalis historia*, also called *Historia mundi*, of A.D. 77, was one of the most important sources for seventeenth-century Dutch writers on art.

62. 8. P.O. Kristeller, "The Modern System of the Arts," in *Ideas in Cultural Perspective* (New York, 1962), pp. 145–206; for occasional borrowings from jurisprudence, E.H. Kantorowicz, "The Sovereignty of the Artist. A Note on Legal Maxims and Renaissance Theories of Art," in *De Artibus Opuscula XL. Essays in Honor of Edwin Panofsky* I (New York, 1961), pp. 267–80.

62. 9. J.N. Jacobsen Jensen, *Reizigers te Amsterdam* (Amsterdam, 1919) gives a chronological list of travelers' accounts of visits to Amsterdam published up to the middle of the nineteenth century.

62. 10. G.J. Hoogewerff and J.Q. van Regteren Altena, *Arnoldus Buchelius, Res Pictoriae* (The Hague, 1928). In their introduction, the authors state that parts had already been published by G. van Ryn in *Oud Holland* 5 (1887), pp. 143–54 and 312. Buchelius' *Diarium* was integrally published by G. Brom and L.A. van Langeraad (Amsterdam, 1907). His *Trajecti Batavorum Descriptio* ... was published by S. Muller Fzn in *Bijdragen en Mededeelingen van het Historisch Genootschap* 27 (1906), pp. 131–268.

62. 11. Richard Carnac Temple, ed., *The Travels of Peter Mundy in Europe and Asia, 1608–1667* IV: *Travels in Europe: 1639–1647* (London, 1925), p. 70; E.S. de Beer, ed., *The Diary of John Evelyn* (Oxford, 1935), p. 39.

62. 12. G.J. Hoogewerff, *De twee reizen van Cosimo de' Medici prins van Toscane door de Nederlanden (1667–1669)* (Amsterdam, 1919).

63. 13. Pieter Fransz de Grebber, *Regulen: Welcke by een goet Schilder en Teyckenaer geobserveert en achtervolght moeten werden* ... (Haarlem, 1649), published by P.J.J. van Thiel in *Oud Holland* 80 (1965), pp. 126–31. Van Thiel suggests that the artistically printed sheet may have been the printer Pieter Casteleyn's proof of mastery for his guild; Casteleyn worked in Haarlem from 1649 to 1676.

63. 14. This matter is discussed by H. Miedema in his review of J.A. Emmens, *Rembrandt en de regels van de kunst* (Utrecht, 1968) in *Oud Holland* 84 (1969), pp. 249–56. To date, no one has dared tackle the subject "Tradition and renewal in seventeenth-century Dutch writings on art theory." I am grateful to Dr. Miedema for his stimulating comments during my writing of this chapter, and to him and Dr. A. Blankert for their thoughtful reading of the completed text.

63. 15. Van Mander, *Het Schilder-Boeck*, "Grondt," chapter 8; Hoogstraeten, *Inleyding*, pp. 135–41 (much shorter); Lairesse, *Groot Schilderboek* I, pp. 343–72.

63. 16. A. Bredius, *Künstler-Inventäre; Urkunden zur Geschichte der holländischen Kunst des XVIten, XVIIten und XVIIIten Jahrhunderts*, 8 vols. (The Hague, 1915–22).

63. 17. H. Miedema, *Karel van Mander. Den grondt der edel vry schilder-const*, 2 vols. (Utrecht, 1973), a new edition with a translation into modern Dutch and a commentary. In *Karel van Mander. Het leven der oude antijcke doorluchtighe schilders* (Amsterdam, 1977), Miedema discusses all of van Mander's sources.

63. 18. Ellenius, *De arte pingendi*, pp. 33–55.

64. 19. F. Junius, *Schilder-Boeck, behelsende de Schilder-konst der Oude* ... (Middelburg, 1641), pp. 62–63.

64. 20. A.H. Kan and G. Kamphuis, *De jeugd van Constantijn Huygens door hemzelf beschreven* (Rotterdam/Antwerp, 1946), p. 65.

64. 21. Hoogstraeten, *Inleyding*, p. 320.

64. 22. Miedema, *Karel van Mander. Den grondt*, pp. 310 and, especially, 462.

64. 23. Angel, *Lof*, pp. 49–50. Van Mander, *Het Schilder-Boeck*, "Grondt," p. 1 recto, formulates the difference as follows: "But a great Mountain rises between Painter and Painter." Hoogstraeten (*Inleyding*, p. 76) makes a joke about it: "When the Painter ... who specialized in Cypress trees was requested by a survivor of a Shipwreck to paint a picture of this sad Sea-accident, he asked him if he wouldn't like to have a Cypress tree in it."

64. 24. Van Mander, *Het Schilder-Boeck*, "Grondt," p. 15.

64. 25. Hoogstraeten, *Inleyding*, pp. 75–87.

65. 26. Junius, *Schilder-Boeck*, p. 3.

65. 27. Hoogstraeten, *Inleyding*, p. 87.

65. 28. Lairesse, *Het Groot Schilderboek* I, pp. 115–22; see also pp. 47–50: "Het Ordineeren der Geschiedenissen."

65. 29. Kan and Kamphuis, *De jeugd van Constantijn Huygens*, p. 73.

65. 30. Hoogstraeten, *Inleyding*, p. 192; see also Lairesse, *Het Groot Schilderboek* I, p. 45.

65. 31. Hoogstraeten, *Inleyding*, p. 178; Angel, *Lof*, p. 34; Lairesse, *Het Groot Schilderboek* I, p. 47.

65. 32. The first to acknowledge this phenomenon was A. Blankert in *Ferdinand Bol 1616–1680. Een leerling van Rembrandt* (The Hague [1976]), pp. 41–45.

65. 33. Hoogstraeten, *Inleyding*, p. 116.

65. 34. Lairesse, *Het Groot Schilderboek*, I, p. 43; van Mander, *Het Schilder-Boeck*, "Grondt," p. 9 verso.

65. 35. Hoogstraeten, *Inleyding*, p. 178. See also Angel, *Lof*, pp. 17–18.

65. 36. H. Gerson and I.H. van Eeghen, *Seven Letters by Rembrandt* (The Hague, 1961), p. 34. The letter is dated January 12, 1639.

65. 37. Hoogstraeten, *Inleyding*, pp. 26–30; van Mander, *Het Schilder-Boeck*, "Grondt," pp. 8–10.

65. 38. Angel, *Lof*, p. 34.

66. 39. Hoogstraeten, *Inleyding*, p. 189; van Mander, *Het Schilder-Boeck*, "Grondt," p. 17. For the composition of a history painting, as described by van Mander and put into practice by Lastman and, later, Rembrandt, see B.P.J. Broos, "Rembrandt and

Lastman's *Coriolanus*: the History Piece in 17th Century Theory and Practice," *Simiolus* 8 (1975–76), pp. 199–228.

66. 40. Hoogstraeten, *Inleyding*, pp. 192–193.

66. 41. Angel, *Lof*, pp. 36–37; Hoogstraeten, *Inleyding*, p. 193. This subject is discussed by J.A. Emmens in *Rembrandt en de regels van de kunst* (Utrecht, 1968), pp. 111–15. Emmens' interpretation of Hoogstraeten's statements, however, differs slightly from my own.

66. 42. Angel, *Lof*, p. 37. See also Lairesse, *Het Groot Schilderboek*, I, pp. 50–51.

67. 43. E. Duverger, "Abraham van Diepenbeek en Gonzales Coques aan het werk voor de stadhouder Frederik Hendrik, Prins van Oranje," *Jaarboek van het Koninklijk Museum voor Schone Kunsten* 12 (Antwerp, 1972), pp. 181–237.

67. 44. The print—with the same theme (Bartsch 496)—is in the Albertina, Vienna; A. Bartsch, *Le peintre graveur* XVII (Vienna, 1818), p. 141. See also E. Brochhagen, *Karel Dujardin* (Cologne, 1958), pp. 72–74.

67. 45. Hoogstraeten, *Inleyding*, p. 195. Hence Angel's advice to follow nature rather than somebody else; Angel, *Lof*, p. 53.

67. 46. Hoogstraeten, *Inleyding*, p. 170.

68. 47. Translation of P.P. Rubens' preface in Junius, *Schilder-Boeck*.

68. 48. Lairesse, *Het Groot Schilderboek*, I, p. 51.

68. 49. Van Mander, *Het Schilder-Boeck*, "Grondt," chapter 7: "Van de Reflecty / Reverberacy / teghenglans oft weerschijn"; Hoogstraeten, *Inleyding*, pp. 257–73; Lairesse, *Het Groot Schilderboek*, I, pp. 247–336.

68. 50. Hoogstraeten, *Inleyding*, p. 227.

68. 51. Van Mander, *Het Schilder-Boeck*, "Grondt," p. 55; Angel, *Lof*, p. 43; Hoogstraeten, *Inleyding*, p. 276; Lairesse, *Het Groot Schilderboek*, I, pp. 315–19.

68. 52. Van Mander, *Het Schilder-Boeck*, "Grondt," chapter 10: "Van Laken oft Draperinghe"; Hoogstraeten, *Inleyding*, pp. 229–30; Lairesse, *Het Groot Schilderboek*, I, pp. 214–24; Angel, *Lof*, p. 55.

68. 53. Van Mander, *Het Schilder-Boeck*, "Grondt," chapter 3: "Analogie, Proportie, oft maet der Lidmaten eens Menschen Beeldts"; Hoogstraeten, *Inleyding*, book two, part four: "Van de welschaepenheyt, Analogie, ofte proportie, in 't gemeen"; Junius, *Schilder-Boeck*, pp. 243–61; Lairesse, *Het Groot Schilderboek*, I, pp. 20–28: "Van de Schoonheid."

68. 54. Van Mander, *Het Schilder-Boeck*, "Grondt," p. 42 verso.

69. 55. Hoogstraeten, *Inleyding*, p. 94; Lairesse, *Het Groot Schilderboek*, I, pp. 106–10.

69. 56. Lairesse, *Het Groot Schilderboek*, I, p. 108. The painting itself was lost long ago. An old copy is in the National Gallery, London (cat. no. 1868). See C. Gould, *The Sixteenth-Century Italian Schools*, National Gallery Catalogues (London, 1975), pp. 150–52.

69. 57. Van Mander, *Het Schilder-Boeck*, "Grondt," chapter 4; see also Miedema, *Karel van Mander. Den Grondt*, pp. 447ff.; Hoogstraeten, *Inleyding*, pp. 115–21; Lairesse, *Het Groot Schilderboek*, I, pp. 25–35.

69. 58. Van Mander, *Het Schilder-Boeck*, "Grondt," p. 20.

69. 59. Ibid., chapter 6: "Wtbeeldinghe der Affecten / passien / begeerlijckheden / en lijdens der Menschen"; see also Miedema, *Karel van Mander. Den Grondt*, pp. 492–94; Junius, *Schilder-Boeck*, pp. 279–97; Hoogstraeten, *Inleyding*, pp. 108–15; Lairesse, *Het Groot Schilderboek*, I, pp. 65–71 and 97–99.

69. 60. Hoogstraeten, *Inleyding*, pp. 292–93.

69. 61. Angel, *Lof*, p. 15.

70. 62. Hoogstraeten, *Inleyding*, p. 319.

Realism and Symbolism

71. 1. E. Haverkamp Begemann, *Willem Buytewech* (Amsterdam, 1959), p. 15.

73. 2. Roemer Visscher, *Sinnepoppen* (Amsterdam, 1614), pp. iv–v.

73. 3. Arnold Houbraken, *De Groote Schouburgh der Nederlantsche Konstschilders en Schilderessen* ... I (Amsterdam, 1718–21), p. 39.

74. 4. *'t Kan verkeren. Gerbrand Adriaensz. Brederode 1585–1618*, exhibition catalogue Amsterdams Historisch Museum (Amsterdam, 1968), p. 86.

75. 5. This and the following examples are taken from E. de Jongh, *Zinne- en minnebeelden in de schilderkunst van de zeventiende eeuw* (n.p., 1967).

75. 6. Samuel van Hoogstraeten, *Inleyding tot de Hooge Schoole der Schilderkonst: anders de Zichtbaere Werelt …* (Rotterdam, 1678), p. 90.

76. 7. E. de Jongh, "Erotica in vogelperspectief. De dubbelzinnigheid van een reeks 17de-eeuwse genre-voorstellingen," *Simiolus* 3 (1968–69), pp. 22–74.

Something to Paint

77. 1. A.H. Kan and G. Kamphuis, *De jeugd van Constantijn Huygens door hemzelf beschreven* (Rotterdam/Antwerp, 1946), p. 73.

77. 2. Karel van Mander, *Het Schilder-Boeck*, 2d ed. (Haarlem, 1618), chapter 5, pp. 6b–9b.

77. 3. Samuel van Hoogstraeten, *Inleyding tot de Hooge Schoole der Schilderkonst: anders de Zichtbaere Werelt …* (Rotterdam, 1678), pp. 78 and 87.

77. 4. Gerard de Lairesse, *Het Groot Schilderboek … I* (Amsterdam, 1707), pp. 165–66.

78. 5. See also *God en de Goden. Verhalen uit de bijbelse en klassieke oudheid door Rembrandt en zijn tijdgenoten*, exhibition catalogue Rijksmuseum (Amsterdam/The Hague, 1981).

78. 6. Lairesse, *Het Groot Schilderboek*, I, p. 45.

78. 7. J. Bruyn, *Rembrandt's keuze van Bijbelse onderwerpen* (Utrecht, 1959); Chr. Tümpel, "Studien zur Ikonographie der Historien Rembrandts. Deutung und Interpretation der Bildinhalte," *Nederlands Kunsthistorisch Jaarboek* 20 (1969), pp. 107–98.

78. 8. H. van de Waal, *Drie eeuwen vaderlandse geschied-uitbeelding 1500–1800. Een iconologische studie*, 2 vols. (The Hague, 1952).

79. 9. T.M. Duyvené de Wit-Klinkhamer, "Een vermaarde zilveren beker," *Nederlands Kunsthistorisch Jaarboek* 17 (1966), pp. 79–103.

80. 10. Philips Angel, *Lof der Schilder-Konst* (Leiden, 1642), pp. 46–47.

80. 11. *God en de Goden*, p. 214.

82. 12. See also E.H. Gombrich, "Truth and Stereotype," in *Art and Illusion* (London, 1960), pp. 55–78.

84. 13. L.J. Rogier, *Eenheid en scheiding*, 2d ed. (Utrecht/Antwerp, 1968), pp. 101ff.

85. 14. Max J. Friedländer, *Landscape, Portrait, Still-Life: Their Origin and Development*, trans. R.F.C. Hull (New York, n.d.), p. 154.

85. 15. W. Martin, *De Hollandsche schilderkunst in de zeventiende eeuw I: Frans Hals en zijn tijd* (Amsterdam, 1935), p. 55.

85. 16. *Tot Lering en Vermaak. Betekenissen van Hollandse genrevoorstellingen uit de zeventiende eeuw*, exhibition catalogue Rijksmuseum (Amsterdam, 1976).

85. 17. Hoogstraeten, *Inleyding*, pp. 77–78.

85. 18. I am grateful to Dr. H. Miedema who convinced me of the acceptability of this term.

86. 19. It is interesting that an engraving after Pieter Brueghel of a scene of recreation on the ice with many figures is entitled "De slibberachtigheyt van 's menschen leven" (The Slipperiness of Human Life). *Tot Lering en Vermaak*, p. 22.

86. 20. Konrad Renger, *Lockere Gesellschaft. Zur Ikonographie des verlorenen Sohnes und von Wirtshausszenen in der niederländischen Malerei* (Berlin, 1970).

86. 21. *Historisch perspectief van het Hollandse "genre," geillustreerd aan enkele thema's*, Kunsthistorisch Instituut, University of Amsterdam (Amsterdam, 1977–78).

91. 22. Ingvar Bergström, "Rembrandt's Double-Portrait of Himself and Saskia at the Dresden Gallery. A Tradition Transformed," *Nederlands Kunsthistorisch Jaarboek* 17 (1966), pp. 143–69; A. Mayer-Meintschel, "Rembrandt und Saskia im Gleichnis vom verlorenen Sohn," *Jahrbuch Staatliche Kunstsammlungen Dresden* (1970–71), pp. 39–57.

92. 23. See S. Alpers, "Brueghel's Festive Peasants," *Simiolus* 6 (1972–73), pp. 163–76; S. Alpers, "Realism as a Comic Mode: Low-Life Painting Seen through Bredero's Eyes," *Simiolus* 8 (1975–76), pp. 115–44, and, especially, H. Miedema's fierce criticism in "Realism and Comic Mode: the Peasant," *Simiolus* 9 (1977), pp. 205–19.

93. 24. Van Mander, *Het Schilder-Boeck*, p. 153b.

93. 25. Hans Kaufmann, "Die fünf Sinne in der niederländischen Malerei des 17. Jahrhunderts," in *Kunstgeschichtliche Studien* (Breslau, 1944), pp. 133–57.

96. 26. J.A. Emmens, "Natuur, Onderwijzing en Oefening. Bij een drieluik van Gerrit Dou," in *Kunsthistorische opstellen* II (Amsterdam, 1981), pp. 5–22.

98. 27. Arnold Houbraken, *De Groote Schouburgh der Nederlantsche Konstschilders en Schilderessen … II* (Amsterdam, 1718–21), p. 276.

98. 28. Hoogstraeten, *Inleyding*, pp. 75–77 and 85–87.

98. 29. Lairesse, *Het Groot Schilderboek*, II, p. 5.

98. 30. Van Mander, *Het Schilder-Boeck*, p. 196a.

99. 31. Rose Wishnevsky, *Studien zum "portrait history" in den Niederlanden* (Munich, 1967); M. Loutitt, "The Romantic Dress of Saskia van Ulenborch: Its Pastoral and Theatrical Associations," *Burlington Magazine* 115 (1973), pp. 317–26.

99. 32. John Bulwer, *Chirologia or the Natural Language of the Hand* (London, 1644).

99. 33. A. Bredius, "Michiel Jansz van Mierevelt. Eene nalezing," *Oud Holland* 26 (1908), pp. 1–7 and 11.

99. 34. J. Richard Judson, "A New Insight into Cornelis Ketel's Method of Portraiture," *Master Drawings* 1 (1963), pp. 38–41; S.J. Gudlaugsson, *Gerard ter Borch* I (The Hague, 1959–60), p. 138; ibid. II, cat. nos. 159, 160, 174, 179; A. Blankert, "Invul-portretten door Caspar en Constantyn Netscher," *Oud Holland* 81 (1966), pp. 263–69.

100. 35. Van Mander, *Het Schilder-Boeck*, p. 213a.

102. 36. *In het zadel. Het Nederlandse ruiterportret van 1550 tot 1900*, exhibition catalogue Fries Museum, Noordbrabants Museum, and Drents Museum (Leeuwarden/'s-Hertogenbosch/Assen, 1980).

103. 37. A. Riegl, *Das holländische Gruppenporträt*, 2 vols. (Vienna, 1931).

105. 38. Van Mander, *Het Schilder-Boeck*, p. 191b.

106. 39. Seymour Slive, *Frans Hals* I (New York/London, 1970–74), p. 136.

108. 40. Rijksmuseum, Amsterdam, on loan from the de Graeff family.

108. 41. A. Bredius, "Een acte over het schuttersstuk van 1642 door Nicolaes Elias," *Oud Holland* 13 (1895), pp. 180–81; J. Six, "Een teekening van Bartholomeus vander Helst," *Oud Holland* 27 (1909), p. 147.

108. 42. B. Haak, "Regenten en regentessen, overlieden en chirurgijns, Amsterdamse groeps-portretten van 1600 tot 1835," *Antiek* 7 (1972–73), pp. 81–116.

112. 43. B.W.T. Nuyens, "Het ontleedkundig onderwijs en de geschilderde anatomische lessen van het chirurgijnsgilde te Amsterdam in de jaren 1550–1798," *Jaarverslag Koninklijk Oudheidkundig Genootschap in Amsterdam* (1928), pp. 45–90; G. Wolff-Heidegger and A.M. Cetto, *Die anatomische Sektion in bildlicher Darstellung* (Basel/New York, 1967).

115. 44. Lydia de Pauw-de Veen, *De begrippen "schilder," "schilderij" en "schilderen" in de zeventiende eeuw* (Brussels, 1969), p. 141ff.; E. de Jongh, ed., *Still Life in the Age of Rembrandt*, exhibition catalogue Auckland City Art Gallery, New Zealand (1982), pp. 14 and 16; Lairesse, *Het Groot Schilderboek* II, p. 259.

115. 45. Lairesse, *Het Groot Schilderboek* II, p. 259.

115. 46. *Boeket in Willet*, exhibition catalogue Museum Willet-Holthuysen (Amsterdam, 1970), with an introduction by S. Segal; S. Segal, *Een bloemrijk verleden*, exhibition catalogue Kunsthandel P. de Boer and Noordbrabants Museum (Amsterdam/'s-Hertogenbosch, 1982).

116. 47. J. Bruyn and J.A. Emmens, "De zonnebloem als embleem in een schilderijlijst," *Bulletin van het Rijksmuseum* 4 (1956), pp. 3–9.

116. 48. Ingvar Bergström, *Dutch Still-Life Painting in the Seventeenth Century* (New York, 1956), pp. 12–14.

117. 49. Kjell Boström, "De oorspronkelijke bestemming van Ludger Tom Rings stillevens," *Oud Holland* 67 (1952), pp. 51–55.

117. 50. F.W.T. Hunger, "Acht brieven van Middelburgers aan Carolus Clusius," in *Archief van het Zeeuws Genootschap der Wetenschappen* (Middelburg, 1925), pp. 110ff.

118. 51. G. Crivelli, *Giovanni Breughel, pittor fiammingo, o sue lettere e quadrele esistenti presso l'Ambrosiana* (Milan, 1868), pp. 63–64.

118. 52. L.J. Bol, "Een Middelburgse Brueghel-groep I," *Oud Holland* 70 (1955), pp. 1–20, especially 3–6.

118. 53. Hunger, "Acht brieven," pp. 110ff.

119. 54. Van Mander, *Het Schilder-Boeck*, p. 206a.

119. 55. A work dated 1606 is in a private collection in England; see L.J. Bol, *"Goede onbekenden." Hedendaagse herkenning en waardering van verscholen, voorbijgezien en onderschat talent* (Utrecht, 1982), p. 46, fig. 1.

121. 56. J.A. Emmens, "Eins aber ist nötig: Zu Inhalt und Bedeutung von Markt- und Küchenstücken des 16. Jahrhunderts," in *Album Amicorum J.G. van Gelder* (The Hague, 1973), pp. 93–101; A. Grosjean, "Towards an Interpretation of Pieter Aertsen's Profane Iconography," *Konsthistorisk Tidskrift* 43 (1974), pp. 121–43.

125. 57. E. de Jongh, "Realisme en schijnrealisme in de Hollandse schilderkunst van de zeventiende eeuw," in *Rembrandt en zijn tijd*, exhibition catalogue Palais des Beaux-Arts (Brussels, 1971), pp. 143–94.

125. 58. B. Haak, "De vergankelijkheidssymboliek in zestiende-eeuwse portretten en zeventiende-eeuwse stillevens in Holland," *Antiek* 1 (1968), pp. 23–30, and *Antiek* 2 (1968), pp. 399–411; Ingvar Bergström and M.L. Wurfbain, *IJdelheid der ijdelheden. Hollandse vanitas-voorstellingen uit de zeventiende eeuw*, exhibition catalogue Municipal Museum De Lakenhal (Leiden, 1970).

126. 59. Cesare Ripa, *Iconologia* (1593), p. 289. This work gives directions on how to paint such concepts as magnanimity, chastity, fidelity, and abundance.

127. 60. Ingvar Bergström, "De Gheyn as a *Vanitas* Painter," *Oud Holland* 85 (1970), pp. 143–57.

134. 61. E.H. Gombrich, "The Renaissance Theory of Art and the Rise of Landscape," in *Norm and Form* (London/New York, 1971), pp. 107–21.

135. 62. Don Felipe de Guevara, *Comentarios de la Pinturas* (Madrid, 1788).

135. 63. H. Miedema, *Karel van Mander. Den grondt der edel vry schilder-const* II (Utrecht, 1973), pp. 408–10 and 537.

135. 64. Ibid., pp. 535ff.

136. 65. See especially T.J. Beening, *Het landschap in de Nederlandse letterkunde van de Renaissance* (Nijmegen, 1963).

138. 66. Maria Simon, *Claes Jansz. Visscher* (Freiburg im Breisgau, 1958); see also Wolfgang Stechow, *Dutch Landscape Painting of the Seventeenth Century* (London, 1966), pp. 16–17.

141. 67. Georg Poensgen, "Arent Arentsz. (genannt Cabel) und sein Verhältnis zu Hendrik Avercamp," *Oud Holland* 41 (1923–24), pp. 116–35.

141. 68. Hans Kaufmann, "Jacob van Ruysdael 'Die Mühle von Wijk bei Duurstede,'" in *Festschrift für Otto Simson zum 65. Geburtstag* (Frankfurt, etc., 1977), pp. 379–97.

142. 69. E.R.M. Taverne, *In 't land van belofte: in de nieuwe stad. Ideaal en werkelijkheid van de stadsuitleg in de Republiek 1580–1680* (Maarssen, 1978), thesis no. 8.

143. 70. I. Ledermann, *Beitrage zur Geschichte des romantischen Landschaftsbildes in Holland und seines Einflusses auf die nationale Schule um die Mitte des 17. Jahrhunderts* (dissertation in typescript, Berlin, 1920), pp. 167ff.

143. 71. A. Blankert, *Nederlandse 17e-eeuwse italianiserende landschapschilders / Dutch 17th Century Italianate Landscape Painters*, revised and enlarged edition of exhibition catalogue Centraal Museum, Utrecht, 1965 (Soest, 1978), with a comprehensive bibliography.

144. 72. H.J. Nalis, "Bartholomeus Breenbergh: aantekeningen over zijn leven en verwanten," *Vereeniging tot Beoefening van Overijsselsch Regt en Geschiedenis. Verslagen en Mededelingen* 87 (1972), pp. 62–81, stating for the first time the exact date of birth.

144. 73. G.J. Hoogewerff, *De Bentvueghels* (The Hague, 1952).

146. 74. Axel Janeck, *Untersuchung über den holländischen Maler Pieter van Laer, genannt Bamboccio* (Würzburg, 1968).

148. 75. Van Mander, *Het Schilder-Boeck*, p. 202b.

149. 76. W. Martin, *De Hollandse schilderkunst in de zeventiende eeuw* I: *Frans Hals en zijn tijd* (Amsterdam, 1935), p. 259.

151. 77. See also J. Richard Judson, "Marine Symbols of Salvation in the Sixteenth Century," in *Essays in Memory of Karel Lehmann* (New York, 1964).

151. 78. T. Krielaart, "Symboliek in zeegezichten," *Antiek* 8 (1973–74), pp. 568–69.

152. 79. Heinz Roosen-Runge, "'Naer het leven': zum Wirklichkeitsgehalt von Pieter Saenredams Innenraumbildern," in *Festschrift für Wilhelm Eiler* (Wiesbaden, 1967), pp. 469–88; F. Witteckmanns, *Pieter Janszoon Saenredam: Das Problem seiner Raumform* (Recklinghausen, 1965); Walter A. Liedtke, "Saenredam's Space," *Oud Holland* 86 (1971), pp. 116–41.

152. 80. Uwe M. Schneede, "Interieurs von Hans und Paul Vredeman," *Nederlands Kunsthistorisch Jaarboek* 18 (1967), pp. 125–66; Friedrich Thöne, "Werke des Hans Vredeman de Vries in Wolfenbüttel," *Pantheon* 20 (1962), pp. 248–55.

153. 81. Samuel Marolois, *Perspective, dat is: de doorsichtige ... Nu nieuws uyt de Fransche in onse Nederlandsche tale over-geset ...* (Amsterdam, 1638).

154. 82. Arthur K. Wheelock, Jr., "Gerard Houckgeest and Emanuel de Witte: Architectural Painting in Delft around 1650," *Simiolus* 8 (1975–76), pp. 167–85.

155. 83. Timothy Trent Blade, "Two Interior Views of the Church in Delft," *Museum Studies, The Art Institute of Chicago* 6 (1971), pp. 34–50; *Die Sprache der Bilder, Realität und Bedeutung in der niederländischen Malerei*, exhibition catalogue Herzog Anton Ulrich Museum (Brunswick, 1978), cat. nos. 16 and 40.

155. 84. *Opkomst en bloei van het Noordnederlandse stadsgezicht in de 17de eeuw / The Dutch Cityscape in the 17th Century and Its Sources*, exhibition catalogue Amsterdams Historisch Museum and Art Gallery of Ontario (Amsterdam/Toronto, 1977).

156. 85. *The World on Paper. Cartography in Amsterdam in the 17th Century*, exhibition catalogue Amsterdams Historisch Museum (Amsterdam, 1967).

160. 86. G. Roosegaarde Bisschop, "De geschilderde maquette in Nederland," *Nederlands Kunsthistorisch Jaarboek* 7 (1956), pp. 167–217.

161. 87. Susan Koslow, "De wonderlijke Perspectyfkas: an Aspect of Seventeenth Century Dutch Painting," *Oud Holland* 82 (1967), pp. 35–56; see also *Art in Seventeenth-Century Holland. A Loan Exhibition*, exhibition catalogue National Gallery (London, 1976), p. 56, and Neil MacLaren, *The Dutch School*, National Gallery Catalogues (London, 1960), pp. 191–95.

161. 88. Hoogstraeten, *Inleyding*, pp. 274–75.

161. 89. Fred Leeman, Michael Schuyt, and Joost Elffers, *Anamorphoses. Games of Perception and Illusion in Art* (New York, 1976).

161. 90. Arthur K. Wheelock, Jr., "Carel Fabritius: Perspective and Optics in Delft," *Nederlands Kunsthistorisch Jaarboek* 24 (1973), pp. 63–83.

Part II

The Turning Century: Economic Growth and Military Gains

163. 1. Walter L. Strauss and Marjon van der Meulen, *The Rembrandt Documents* (New York, 1979), p. 345.

The Turning Century: The Development of Painting

168. 1. Karel van Mander, *Het Schilder-Boeck*, 2d ed. (Haarlem, 1618), p. 199a.

168. 2. Ibid., p. S ij.

168. 3. E.K.J. Reznicek, *Die Zeichnungen von Hendrick Goltzius* I (Utrecht, 1961), pp. 215ff.

168. 4. P.J.J. van Thiel, "Cornelis Cornelisz. van Haarlem as a Draughtsman," *Master Drawings* 3 (1965), pp. 123–54.

169. 5. H. van de Waal, "Nieuwe bijzonderheden over Carel van Mander's Haarlemschen tijd," *Oud Holland* 54 (1937), pp. 21–23.

170. 6. E.K.J. Reznicek, "Het begin van Goltzius' loopbaan als schilder," *Oud Holland* 75 (1960), pp. 30–49.

171. 7. A. Bredius, *Künstler-Inventäre; Urkunden zur Geschichte der holländischen Kunst des XVIten, XVIIten und XVIIIten Jahrhunderts* VII (The Hague, 1921), p. 273.

171. 8. G.T. van IJsselsteyn, *Geschiedenis der tapijtweverijen in de Noordelijke Nederlanden* II (Leiden, 1936), pp. 61–73, nos. 154–56.

173. 9. Van Mander, *Het Schilder-Boeck*, p. 196a.

173. 10. Ibid., p. 190b.

173. 11. Ibid., p. 191b; H. Miedema and M. Spies, *Karel van Mander (1548–1606). De Kerck der Deucht* (Amsterdam, 1973), p. 7; Wolfgang Stechow, "Sonder Borstel oft Pinseel," in *Album Amicorum J.G. van Gelder* (The Hague, 1973), pp. 310–11; J. Richard Judson, "A New Insight into Cornelis Ketel's Method of Portraiture," *Master Drawings* 1(1963), pp. 38–41.

174. 12. P.J.J. van Thiel, "Een vroeg schilderij van Gerrit Pietersz. Swelinck," *Oud Holland* 78 (1963), pp. 67–70.

174. 13. J. Briels, *De Zuidnederlandse immigratie, 1572–1630* (Haarlem, 1978).

174. 14. E. Plietzsch, *Die Frankenthaler Maler* (Leipzig, 1910).

175. 15. Van Mander, *Het Schilder-Boeck*, p. 184b.

The Twelve Years' Truce

176. 1. H. Edema van der Tuuk, *Johannes Bogerman* (Groningen, 1868), p. 12 .

Painting and the Graphic Arts during the Truce

182. 1. G.L.M. Daniëls, "Een 'Memento Mori' van Floris van Schooten," *Antiek* 10 (1975–76), pp. 273–79.

183. 2. H.P. Baard, *Frans Hals' Schuttersmaaltijd der officieren van de Sint Jorisdoelen Anno 1616* (Leiden, 1948), p. 25.

183. 3. Seymour Slive, *Frans Hals* I (New York/London, 1970), p. 46.

184. 4. E. Haverkamp Begemann, *Willem Buytewech* (Amsterdam, 1959), pp. 7–10.

185. 5. J.G. van Gelder, *Jan van de Velde, 1593–1641, teekenaar-schilder* (The Hague, 1933), p. 35.

188. 6. See for a comprehensive discussion of these writers and poets Reinder P. Meijer, *The Literature of the Low Countries* (Assen, 1971).

190. 7. E.R.M. Taverne, "Een Amsterdams Lucasfeest in 1618," *Simiolus* 4 (1970), pp. 19–27.

194. 8. N. de Roever, "Drie Amsterdamsche schilders (Pieter Isaaksz, Abraham Vinck, Cornelis van der Voort)," *Oud Holland* 3 (1885), p. 172.

194. 9. P.J.J. van Thiel, "Moeyaert en Bredero: a Curious Case of Dutch Theatre as Depicted in Art," *Simiolus* 6 (1972–73), pp. 29–49.

198. 10. I.H. van Eeghen, "Meerhuizen of de Pauwentuin en Arent Arentsz., genaamd Cabel," *Maandblad Amstelodamum* 54 (1967), pp. 219–21.

200. 11. Samuel van Hoogstraeten, *Inleyding tot de Hooge Schoole der Schilderkonst: anders de Zichtbaere Werelt ...* (Rotterdam, 1678), p. 312.

201. 12. J.G. van Gelder, "Hercules Seghers erbij en eraf," *Oud Holland* 65 (1950), pp. 216–26, and 68 (1953), pp. 149–57.

202. 13. L.J. Bol, *Die holländische Marinemalerei des 17. Jahrhunderts* (Brunswick, 1973), pp. 36ff.

203. 14. It is a misapprehension to take 1657 (or after) —a date based on a still life with cat that Clara Peeters supposedly signed and dated 1657 (see N.R.A.

Vroom, *De schilders van het monochrome banketje* Amsterdam, [1945], pp. 116–17, fig. 101)—as the date of her death. In my opinion, the painting is by Pieter Claesz, who signed it with his monogram PC.

203. 15. E. Greindl, *Les peintres flamands de nature morte au XVIIe siècle* (Brussels, 1956), p. 37.

203. 16. Ingvar Bergström, *Dutch Still-Life Painting in the Seventeenth Century* (New York, 1956), p. 108, fig. 98.

204. 17. A.W. IJzerman, *De 80-jarige oorlog, Ver-beeld verledem* I (Leiden, n.d.), pp. 31 and 51, fig. 24.

204. 18. G.T. van IJsselsteyn, *Geschiedenis der tapijtweverijen in de Noordelijke Nederlanden* II (Leiden, 1936), pp. 55–64.

204. 19. Auction Sotheby's, London, June 24, 1964; copper, 8 x 6.5 cm, signed and dated 1606.

205. 20. L.J. Bol, "Een Middelburgse Brueghel-groep I," *Oud Holland* 70 (1955), pp. 1–20; L.J. Bol, *The Bosschaert Dynasty* (Leig-on-Sea, 1960).

205. 21. *Deutsche Maler und Zeichner des 17. Jahrhunderts*, exhibition catalogue Staatliche Museen (Berlin, 1966), pp. 31ff.

205. 22. For identification: Bergström, *Dutch Still-Life Painting*, p. 70.

209. 23. P.J.J. van Thiel, "De aanbidding der koningen en ander vroeg werk van Hendrick ter Brugghen," *Bulletin van het Rijksmuseum* 19 (1971), pp. 91–116.

215. 24. R. van Luttervelt, "Joost Cornelisz. Droochsloot en zijn werken voor het Sint Barbara- en Laurentiusgasthuis te Utrecht," *Nederlands Kunsthistorisch Jaarboek* 1 (1947), pp. 113–36.

216. 25. A.H. Kan and G. Kamphuis, *De jeugd van Constantijn Huygens door hemzelf beschreven* (Rotterdam/Antwerp, 1946), pp. 76–77.

218. 26. *Portrait of Cardinal Ferry Carondelet and His Secretary*, Collection Thyssen Bornemisza, Villa Favorita, Lugano.

Part III

Painting in Haarlem: 1625–1650

230. 1. Seymour Slive, *Frans Hals* I (New York/London, 1970), pp. 21–22.

232. 2. A. Bredius, "De geschiedenis van een schuttersstuk," *Oud Holland* 31 (1913), pp. 81–84.

233. 3. Slive, *Frans Hals* III, p. 49.

233. 4. Claus Grimm, *Frans Hals. Entwicklung, Werkanalyse, Gesamtkatalog* (Berlin, 1972). Although Grimm's conclusions on the subject of authenticity have to be considered with some reservation, I think he has a sound critical insight where the genrelike figures are concerned.

233. 5. Slive, *Frans Hals* I, pp. 145–52.

235. 6. E. Haverkamp Begemann, *Willem Buytewech* (Amsterdam, 1959), pp. 49–50.

235. 7. P.J.J. van Thiel, "Marriage Symbolism in a Musical Party by Jan Miense Molenaar," *Simiolus* 2 (1967–68), pp. 91–99.

235. 8. C.C.J. von Gleich, "Huismuziek in de Gouden Eeuw. Musicerend gezelschap door Jan Miense Molenaer," *Openbaar Kunstbezit* 10 (1966), no. 9.

237. 9. Arnold Houbraken, *De Groote Schouburgh der Nederlantsche Konstschilders en Schilderessen ...* I (Amsterdam, 1718–21), pp. 318–33.

238. 10. B. Schnackenburg, "Die Anfänge des Bauerninteriors bei Adriaen van Ostade," *Oud Holland* 85 (1970), pp. 158–69.

238. 11. B. Schnackenburg and H. Gerson, "Rembrandt en de schilderkunst in Haarlem," in *Miscellania J.Q. van Regteren Altena* (Amsterdam, 1969), pp. 138–42; R. Klessmann, "Die Anfänge des Bauerninteriors bei den Brüdern Ostade," *Jahrbuch der Berliner Museen* 2 (1960), pp. 92–115.

239. 12. B. Haak, "Adriaen van Ostade, landschap met oude eik," *Bulletin van het Rijksmuseum* 12 (1964), pp. 5–11.

241. 13. G.S. Keyes, *Cornelis Vroom: Marine and Landscape Artist* I (Alphen aan den Rijn, 1975), p. 172.

241. 14. J.G. van Gelder, "Cornelis Vroom, een on-bekend landschap," *Oud Holland* 77 (1962), pp. 56–57.

241. 15. E. Haverkamp Begemann, "Cornelis Vroom aan het Meer van Como," *Oud Holland* 82 (1967), pp. 65–67.

242. 16. H.F. Wijnman, "Het leven der Ruysdaels," *Oud Holland* 49 (1932), pp. 49–69, 173–81, and 258–75.

243. 17. A. Bredius, "Heeft van Goyen te Haarlem gewoond?" *Oud Holland* 37 (1918), pp. 125–27.

251. 18. J.Q. van Regteren Altena, "De tekeningen van Pieter Jansz. Saenredam," introduction to *Pieter Jansz. Saenredam*, exhibition catalogue Centraal Museum (Utrecht, 1961); Walter A. Liedtke, "Saenredam's Space," *Oud Holland* 86 (1971), pp. 116–41.

252. 19. D.F. Slothouwer, *De paleizen van Frederik Hendrik* (Leiden, 1945), p. 307.

252. 20. P.T.A. Swillens, "Rubens' bezoek aan Utrecht," *Jaarboekje Oud Utrecht* (1945–46), pp. 105–25.

252. 21. *Peter Paul Rubens. Maler mit dem Grabstichel / Rubens und die Druckgraphik*, exhibition catalogue Wallraf Richartz Museum (Cologne, 1977).

252. 22. J.G. van Gelder, "Rubens in Holland in de zeventiende eeuw," *Nederlands Kunsthistorisch Jaarboek* 3 (1950–51), pp. 103–50.

253. 23. F.H.C. Weijtens, *De Arundel-Collectie. Commencement de la fin Amersfoort 1655* (Utrecht, 1971).

253. 24. Quotation in van Gelder, "Rubens in Holland," p. 128.

254. 25. Slothouwer, *De paleizen van Frederik Hendrik*, pp. 300–301.

256. 26. Schnackenburg and Gerson, "Rembrandt en de schilderkunst in Haarlem," p. 140.

Painting in Leiden: 1625–1631

262. 1. A.H. Kan and G. Kamphuis, *De jeugd van Constantijn Huygens door hemzelf beschreven* (Rotterdam/Antwerp, 1946), pp. 78–79.

263. 2. A. van Schendel, "Het portret van Constantijn Huygens door Jan Lievens," *Bulletin van het Rijksmuseum* 11 (1963), pp. 5–10; A.A.E. Vels Heijn, "Portret van Constantijn Huygens. Jan Lievens (1607–1674)," *Openbaar Kunstbezit* 14 (1970), no. 13.

264. 3. B. Haak, "Nieuw licht op Judas en de Zilverlingen van Rembrandt," in *Album Amicorum J.G. van Gelder* (The Hague, 1973), pp. 155–58.

265. 4. A. Bredius, "Rembrandtiana," *Oud Holland* 33 (1915), pp. 126–28.

266. 5. J. Bruyn, "David Bailly, 'fort bon peintre en pourtraicts et en vie coye,'" *Oud Holland* 66 (1951), pp. 161–62.

266. 6. Ingvar Bergström, *Dutch Still-Life Painting in the Seventeenth Century* (New York, 1956), p. 165; idem, "De Heem's Painting of His First Dutch Period," *Oud Holland* 71 (1956), pp. 173–83.

267. 7. H.-U. Beck, *Jan van Goyen* I (Amsterdam, 1972), I, p. 29.

267. 8. Christopher White, *The Dutch Pictures in the Collection of Her Majesty the Queen* (Cambridge, 1982), pp. xv and 94–95.

270. 9. Arnold Houbraken, *De Groote Schouburgh der Nederlantsche Konstschilders en Schilderessen ... II* (Amsterdam, 1718–21), pp. 5–6.

270. 10. J.A. Emmens, "Natuur, Onderwijzing en Oefening. Bij een drieluik van Gerrit Dou," in *Kunsthistorische opstellen* II (Amsterdam, 1981), pp. 5–22.

270. 11. Houbraken, *De Groote Schouburgh* III, p. 211.

271. 12. J.G. van Gelder, "Jan Emmens als gesprekspartner," *Tirade* 180 (1972), pp. 472–80, with an unfinished essay by Emmens on "De trompetter van Gerard Dou"; E. Snoep-Reitsma, "De Waterzuchtige Vrouw van Gerard Dou en de betekenis van de lampetkan," in *Album Amicorum J.G. van Gelder* (The Hague, 1973), pp. 285–92.

272. 13. Houbraken, *De Groote Schouburgh* II, pp. 3–4.

Painting in Amsterdam: 1625–1650

273. 1. The Bicker and de Graeff families, or the so-called Bicker League, dominated Amsterdam politics for many years and exemplify the intricate interrelationships of the merchant-ruler class, which led to oligarchy. Two of Andries Bicker's brothers, Jan and Jacob, married sisters of Andries and Cornelis de Graeff, the former of whom was in turn married to the daughter of another Bicker brother, Cornelis. Jan Bicker's daughter Wendela, as we shall see, married Johan de Witt. These people all served in many public functions, but the most power was wielded by those repeatedly chosen (by themselves) as burgomasters.

278. 2. H. Gerson and I.H. van Eeghen, *Seven Letters by Rembrandt* (The Hague, 1961).

278. 3. J.I. Kuznetzow, "Nieuws over Rembrandts Danaë," *Oud Holland* 82 (1967), pp. 225–33.

282. 4. Joachim von Sandrart, *L'Academia Todesca della Architectura, Scultura & Pittura: Oder Teutsche Academie der Edlen Bau- Bild- und Mahlerey-Künste ...* (Nuremberg, 1675–79), II, pp. 326ff.

282. 5. Arnold Houbraken, *De Grote Schouburgh der Nederlantsche Konstschilders en Schilderessen ... I* (Amsterdam, 1718–21), p. 256.

282. 6. Walter L. Strauss and Marjon van der Meulen, *The Rembrandt Documents* (New York, 1979), p. 412.

282. 7. E. Haverkamp Begemann, "Rembrandt as Teacher," in *Rembrandt after Three Hundred Years. An Exhibition of Rembrandt and His Followers*, exhibition catalogue The Art Institute of Chicago, The Minneapolis Institute of Arts, The Detroit Institute of Arts (Chicago, 1969), pp. 21–30.

283. 8. Samuel van Hoogstraeten, *Inleyding tot de Hooge Schoole der Schilderkonst; anders de Zichtbaere Werelt ...* (Rotterdam, 1678); p. 26.

283. 9. O.J. de Bruyn Kops, "Vergeten zelfportretten van Govert Flinck en Bartholomeus van der Helst," *Bulletin van het Rijksmuseum* 13 (1965), pp. 20–29.

286. 10. K. Bauch, *Jakob Adriaensz. Backer. Ein Rembrandtschüler aus Friesland* (Berlin, 1926), p. 18.

286. 11. A Crucifixion in Museum Amstelkring, Amsterdam (Bauch no. 23) has long been believed to be an early history painting by Jakob Backer, which would prove that he was not dependent on Rembrandt. B. Bakker has shown that the painting was by Adriaen Backer, of about 1683. See B. Bakker, "De 'Kruisoprichting' in Amstelkring," *De Kroniek van de Vriendenkring van het Rembrandthuis* 20 (1966), pp. 83–90.

287. 12. A. Blankert, *Ferdinand Bol 1616–1680. Een leerling van Rembrandt* (The Hague, n.d.), pp. 12 and 111.

287. 13. Strauss and van der Meulen, *The Rembrandt Documents*, p. 594.

292. 14. D.C. Meyer, Jr., "De Amsterdamsche Schutters-stukken in en buiten het nieuwe Rijksmuseum" II, *Oud Holland* 4 (1886), pp. 204–5.

293. 15. M. Kok, "Rembrandts Nachtwacht, van feeststoet tot schuttersstuk," *Bulletin van het Rijksmuseum* 15 (1967), pp. 116–21.

293. 16. W. Martin, *De Hollandsche schilderkunst in de zeventiende eeuw* I: *Frans Hals en zijn tijd* (Amsterdam, 1935), pp. 218–20.

296. 17. Hoogstraeten, *Inleyding*, p. 176.

298. 18. The very Rembrandtesque painting *The Presentation in the Temple* in Budapest (cat. no. 3828) is dated 1641, not 1671 as mentioned in the catalogue.

300. 19. The reasoning that led to this supposition (by A. Bredius, "Iets over Pieter Codde en Willem Duyster," *Oud Holland* 6 [1888], pp. 187–94, especially 191) is not very convincing.

302. 20. F. Lugt, *Wandelingen met Rembrandt in en om Amsterdam*, 2d ed. (Amsterdam, 1915).

302. 21. H.J. Nalis, "Bartholomeus Breenbergh, aantekeningen over zijn leven en verwanten," *Vereeniging tot Beoefening van Overijsselsch Regt en Geschiedenis. Verslagen en Mededelingen* 87 (1972), pp. 62–81, mentioning (p. 63) the entry in the register of baptisms of the Reformed Church in Deventer of November 13, 1598.

304. 22. Houbraken, *De Groote Schouburgh* III, p. 172.

304. 23. In 1972 at Kunsthandel P. de Boer, Amsterdam.

304. 24. F. Bachmann, "Die Herkunft der Frühwerke des Aert van der Neer," *Oud Holland* 89 (1975), pp. 213–22.

306. 25. Quotation in H.P. Baard, *Willem van de Velde de Oude, Willem van de Velde de Jonge* (Amsterdam, n.d.), p. 26.

309. 26. An apprenticeship with Willem van de Velde the Elder, mentioned by many authors, is virtually impossible, de Vlieger being van de Velde's senior by ten years.

Painting in the Northern Quarter: 1625–1650

313. 1. B.J.A. Renckens, "De Hoornse portretschilder Jan Allertsz Rotius," *Nederlands Kunsthistorisch Jaarboek* 2 (1948–49), pp. 165–234, especially 176.

313. 2. Arnold Houbraken, *De Groote Schouburgh der Nederlantsche Konstschilders en Schilderessen ... II* (Amsterdam, 1718–21), pp. 328–29.

Painting in Utrecht: 1625–1650

314. 1. C. Müller, "Abraham Bloemaert als Landschaftsmaler," *Oud Holland* 44 (1927), pp. 193–208.

316. 2. J. Richard Judson, "Allegory of Dawn and Night," *Wadsworth Atheneum Bulletin* 6 (1966), pp. 1–11.

319. 3. Samuel van Hoogstraeten, *Inleyding tot de Hooge Schoole der Schilderkonst: anders de Zichtbaere Werelt ...* (Rotterdam, 1678), p. 234.

Painting in Delft: 1625–1650

326. 1. J.G. van Gelder, "De schilders van de Oranjezaal," *Nederlands Kunsthistorisch Jaarboek* 2 (1948–49), pp. 118–64.

326. 2. Ibid., pp. 157–64.

Painting in The Hague: 1625–1650

333. 1. O. ter Kuile, *Adriaen Hanneman 1604–1671; een Haags portretschilder* (Alphen aan den Rijn, 1976), p. 21.

334. 2. H.E. van Gelder, *Iconografie van Constantijn Huygens en de zijnen* (The Hague, 1957), pp. 40, 42, 45, and 51–53; Ter Kuile, *Adriaen Hanneman*, p. 54.

334. 3. J. Foucart in *Le siècle de Rembrandt, Tableaux hollandais des collections publiques françaises*, exhibition catalogue Musée du Petit Palais (Paris, 1971), p. 149, no. 151.

335. 4. D.F. Slothouwer, *De paleizen van Frederik Hendrik* (Leiden, 1945), p. 270.

336. 5. H.-U. Beck, *Jan van Goyen* I (Amsterdam, 1972), p. 29.

336. 6. Ibid., pp. 255ff.

336. 7. H.-U. Beck, "Jan van Goyens Handzeichnungen als Vorzeichnungen," *Oud Holland* 72 (1957), pp. 241–50.

Painting in Dordrecht: 1625–1650

340. 1. J.G. van Gelder and I. Jost, "Vroeg contact van Albert Cuyp met Utrecht," in *Miscellania I.Q. van Regteren Altena* (Amsterdam, 1969), pp. 100–102.

340. 2. A. Blankert, *Nederlandse 17e-eeuwse italianiserende landschapschilders* (Soest, 1978), pp. 171–72, note 7, where proof of Cuyp's activity in Utrecht is, mistakenly, based on certain paintings in a lottery in Wijk bij Duurstede (see p. 34): in view of the subject matter, these paintings were very likely by Benjamin Cuyp.

341. 3. W. Martin, *De Hollandsche schilderkunst in de zeventiende eeuw* II: *Rembrandt en zijn tijd* (Amsterdam, 1936), note 321.

Part IV

The Republic in the Third Quarter of the Seventeenth Century

347. 1. Jakob Rosenberg, Seymour Slive, and E.H. ter Kuile, *Dutch Art and Architecture: 1600 to 1800* (Harmondsworth/Baltimore/Ringwood, 1966), p. 114.

349. 2. C.R. Boxer, *The Dutch Seaborne Empire 1600–1800* (London, 1965); for the Dutch in Deshima, see also Frits Vos, "A Distance of Thirteen Thousand Miles; the Dutch through Japanese Eyes," *Delta. A Review of Arts, Life and Thought in the Netherlands* 16

(1973), pp. 2 and 29–46; for the Dutch slave trade in Africa and America, see A. van Dantzig, *Het Nederlandse aandeel in de slavenhandel* (Bussum, 1968).

351. 3. Maurice Ashley, *The Golden Century: Europe 1598–1715* (London, 1969).

352. 4. A. Blankert, *Johannes Vermeer* (Utrecht/Antwerp, 1975), p. 131, no. 42.

Painting in Amsterdam: 1650–1680 (I)

355. 1. Madeleine Hours, "Rembrandt. Observations et présentation de radiographies exécutées d'après les portraits et compositions du Musée du Louvre," *Bulletin du Laboratoire du Musée du Louvre* (1961), pp. 3–43.

356. 2. W.F.H. Oldewelt, "Twee eeuwen Amsterdamse faillissementen en het verloop van de conjunctuur (1636–1838)," *Tijdschrift voor Geschiedenis* 75 (1962), pp. 421–35.

358. 3. H. van de Waal, "De Staalmeesters en hun legende," *Oud Holland* 71 (1956), pp. 61–88.

358. 4. A. van Schendel, "De schimmen van de Staalmeesters. Een röntgenologisch onderzoek," *Oud Holland* 71 (1956), pp. 1–23.

358. 5. C. Tümpel, "Studien zur Ikonographie der Historien Rembrandts," *Nederlands Kunsthistorisch Jaarboek* 20 (1969), pp. 107–98, especially 162–67; M.L. Wurfbain, in *Jaarboek Leiden* 63 (1971), pp. 173–78, identifies the couple as B. Vaillant and Elisabeth van Swanenburgh representing Boas and Ruth.

358. 6. The titles of seventeenth-century Dutch paintings are arbitrary and sometimes vary greatly from writer to writer, period to period, and language to language. The title of Rembrandt's painting for the town hall is no exception. Part of the difficulty here is the name of the Batavian leader. Tacitus just once calls him Claudius Civilis, but otherwise consistently Julius Civilis. In seventeenth-century Dutch art, however, for reasons as yet unexplored, the figure is always called Claudius Civilis, and I have chosen to retain this form. Another example, of a slightly different nature, is the mistaken first name Marcus for the Roman consul Marius Curius Dentatus, hero of Govert Flinck's town-hall painting (see fig. 761). "Marcus" presumably represents no more than an early scribal or typographical error in editions of Plutarch: A. Blankert, *Kunst als regeringszaak in Amsterdam in de 17e eeuw* (Lochem, 1975), p. 17, reproduces a copy of a sixteenth-century mural by Hans Holbein the Younger with the clear inscription "Marc. Curius Dentatus."

359. 7. Blankert, *Kunst als regeringszaak*, p. 19.

359. 8. A. Bredius, *Künstler-Inventäre; Urkunden zur Geschichte der holländischen Kunst des XVIten, XVIIten und XVIIIten Jahrhunderts* IV (The Hague, 1918), p. 1255.

360. 9. Blankert, *Kunst als regeringszaak*, pp. 19–25.

362. 10. For an extensive discussion of the decorations of the town hall, see H. van de Waal, *Drie eeuwen vaderlandse geschied-uitbeelding, 1500–1800. Een iconologische studie* I (The Hague, 1952), pp. 215–38.

362. 11. The Dutch deprived themselves of Grotius' great services when they arrested him along with Johan van Oldenbarnevelt in 1618 and sentenced him to lifelong imprisonment in Loevestein Castle near Dordrecht, from which he made a spectacular escape in a book crate three years later. Grotius spent the rest of his life abroad writing voluminously, in France and later in Sweden, where he died in 1645.

362. 12. H. van de Waal, "Tempesta en de historie-schilderingen op het Amsterdamsche Raadhuis," *Oud Holland* 56 (1939), pp. 49–66.

362. 13. F. Gorissen, "Govert Flinck, der Kleefsche Apelles und seine Vaterstadt Kleve im Werke des Joost van den Vondel," in *Govert Flinck*, exhibition catalogue Haus Koekkoek (Cleves, 1965), pp. 5–14.

363. 14. Opinions on this affair, and on the significance of the small sketch, differ greatly; see B. Haak, "De nachtelijke samenzwering van Claudius Civilis in het Schakerbos," *Antiek* 4 (1969–70), pp. 136–48.

363. 15. Walter L. Strauss and Marjon van der

Meulen, *The Rembrandt Documents* (New York, 1979), p. 500; I.H. van Eeghen, "Wat veroverde Rembrandt met zijn Claudius Civilis," *Amstelodamum* 56 (1969), pp. 145–49.

365. 16. Blankert, *Kunst als regeringszaak*, p. 48.

367. 17. Arnold Houbraken, *De Groote Schouburgh der Nederlantsche Konstschilders en Schilderessen . . .* I (Amsterdam, 1718–21), p. 174.

368. 18. Ibid., II, pp. 273–74.

369. 19. Ibid., III, p. 61; W. Sumowski, "Beiträge zu Willem Drost," *Pantheon* 27 (1969), pp. 372–84.

371. 20. Quotation in *The Orange and the Rose; Holland and Britain in the Age of Observation, 1600–1750*, exhibition catalogue Victoria and Albert Museum (London, 1964), p. 37, no. 41.

371. 21. Bredius, *Künstler-Inventäre* II, p. 400.

Painting in Haarlem: 1650–1680

377. 1. H.F. Waterloos in *Hollandsche Parnas* I (Amsterdam, 1660), p. 408.

377. 2. P.J. Vinken and E. de Jongh, "De boosaardigheid van Hals' regenten en regentessen," *Oud Holland* 78 (1963), pp. 1–26.

380. 3. There exists a version of this painting dated 1652 in the collection of H.M. Queen Elizabeth II. See C. Brown in *Art in Seventeenth-Century Holland. A Loan Exhibition*, exhibition catalogue National Gallery (London, 1976), pp. 27–29, no. 17.

382. 4. Arnold Houbraken, *De Groote Schouburgh der Nederlantsche Konstschilders en Schilderessen . . .* III (Amsterdam, 1718–21), p. 65.

382. 5. Seymour Slive and H.R. Hoetink, *Jacob van Ruisdael* (New York/Amsterdam, 1981), pp. 50–55.

383. 6. A. Blankert, *Nederlandse 17e-eeuwse italianiserende landschapschilders* (Soest, 1978), pp. 147–49.

384. 7. A good survey in L.J. Bol, *Holländische Maler des 17. Jahrhunderts nahe den grossen Meistern. Landschaften und Stilleben* (Brunswick, 1969), pp. 201–25.

388. 8. A. von Wurzbach, *Niederländisches Künstler-Lexikon* II (Vienna/Leipzig, 1906), p. 902.

390. 9. A. Bredius, *Künstler-Inventäre; Urkunden zur Geschichte der holländischen Kunst des XVIten, XVIIten und XVIIIten Jahrhunderts* I (The Hague, 1915), pp. 27 and 29ff.

390. 10. J.C. Weyerman, *De Levens-beschryvingen der Nederlandsche Konst-schilders en Konst-schilderessen . . .* II (The Hague, 1729), p. 348.

390. 11. A well-argued attempt is L. de Vries's *Jan Steen "de kluchtschilder"* (Groningen, 1977).

Gerard Ter Borch and Other Painters in Zwolle, Deventer, and Kampen

396. 1. S.J. Gudlaugsson, *Gerard ter Borch* II (The Hague, 1959–60), pp. 15–16.

397. 2. Ibid., cat. no. 43.

397. 3. I.Q. van Regteren Altena, "The Anonymous Spanish Sitters of Gerard Ter Borgh," *Master Drawings* 10 (1972), pp. 260–63.

398. 4. See Neil MacLaren, *The Dutch School*, National Gallery Catalogues (London, 1960, pp. 35–41; P. Pieper, "Bezwering van de Vrede tussen de Nederlanden en Spanje," in *Gerard Ter Borch: Zwolle 1617–Deventer 1681*, exhibition catalogue Mauritshuis (The Hague, 1974), pp. 84–87.

Painting in Utrecht: 1650–1680

402. 1. Joachim von Sandrart, *L'Academia Todesca della Architectura, Scultura & Pittura: Oder Teutsche Academie der Edlen Bau- Bild- und Mahlerey-Künste . . .* III (Nuremberg, 1675–79), pp. 211–376.

405. 2. Arnold Houbraken, *De Groote Schouburgh der Nederlantsche Konstschilders en Schilderessen . . .* III (Amsterdam, 1718–21), p. 72.

Painting in Rotterdam: 1620–1680

407. 1. A.P.A. Vorenkamp, *Bijdrage tot de geschiedenis van het Hollandsche stilleven in de XVIIe eeuw* (Leiden, 1933), p. 105; L.J. Bol, *"Goede onbekenden." Hedendaagse herkenning en waardering van verscholen,*

voorbijgezien en onderschat talent (Utrecht, 1982), pp. 21–29.

408. 2. For identification of the other figures, see *All the Paintings of the Rijksmuseum in Amsterdam* (Amsterdam/Maarssen, 1976), p. 493.

413. 3. R.E. Fleischer, "Ludolf de Jongh and the Early Work of Pieter de Hooch," *Oud Holland* 92 (1978), pp. 49–67.

413. 4. Susan Donahue Kuretsky, "Two Paintings by Ochtervelt in the Wadsworth Atheneum," *Bulletin of the Wadsworth Atheneum* 5 (1969), pp. 45–54; idem, "The Ochtervelt Documents," *Oud Holland* 87 (1973), pp. 124–41.

Painting in Dordrecht: 1650–1680

420. 1. J. Walsh, Jr., "The Earliest Dated Painting by Nicolaes Maes," *Metropolitan Museum Journal* 6 (1972), pp. 105–14.

422. 2. Arnold Houbraken, *De Groote Schouburgh der Nederlantsche Konstschilders en Schilderessen . . .* III (Amsterdam, 1718–21), p. 207.

Painting in Middelburg: 1650–1680

424. 1. *Zeventiende-eeuwse schilderijen uit de verzameling Willem Russell*, exhibition catalogue Amsterdams Historisch Museum (Amsterdam, 1970), no. 7.

424. 2. C. de Bie, *Het Gulden Cabinet vande Edele vry Schilder-Const . . .* (Antwerp, 1661), p. 414.

424. 3. L.J. Bol, *Adriaen Coorte: A Unique Late Seventeenth Century Dutch Still-Life Painter* (Assen, 1977), pp. 3–6.

Painting in Leiden: 1650–1680

426. 1. S.J. Gudlaugsson, *The Comedies in the Work of Jan Steen and His Contemporaries* (Soest, 1975), p. 14.

426. 2. J.C. Weyerman, *De Levensbeschryvingen der Nederlandsche Konst-schilders en Konst-schilderessen . . .* II (The Hague, 1729), p. 348.

426. 3. L. de Vries, *Jan Steen "de kluchtschilder"* (Groningen, 1977), p. 25.

429. 4. Baruch D. Kirschenbaum, *The Religious and Historical Paintings of Jan Steen* (New York/Montclair, 1977).

430. 5. A. Heppner, "The Popular Theatre of the Rederijkers in the Work of Jan Steen and His Contemporaries," *Journal of the Warburg and Courtauld Institutes* 3 (1939–40), pp. 22–48.

431. 6. Arnold Houbraken, *De Groote Schouburgh der Nederlantsche Konstschilders en Schilderessen . . .* III (Amsterdam, 1718–21), pp. 40–41.

432. 7. A. Bredius, "Iets over de jeugd van Gabriël Metsu," *Oud Holland* 25 (1907), pp. 197–203.

432. 8. S.J. Gudlaugsson, "Kanttekeningen bij de ontwikkeling van Metsu," *Oud Holland* 83 (1968), pp. 13–42; F.W. Robinson, *Gabriel Metsu (1629–1667). A Study of His Place in Dutch Genre Painting of the Golden Age* (New York, 1974), pp. 15 and 89ff.

432. 9. Houbraken, *De Groote Schouburgh* III, p. 2.

434. 10. *Tot Lering en Vermaak. Betekenissen van Hollandse genrevoorstellingen uit de zeventiende eeuw*, exhibition catalogue Rijksmuseum (Amsterdam, 1976), no. 42.

437. 11. L.J. Bol, *Holländische Maler des 17. Jahrhunderts nahe den grossen Meistern. Landschaften und Stilleben* (Brunswick, 1969), pp. 343–44.

Painting in Delft: 1650–1680

438. 1. Arthur K. Wheelock, Jr., "Gerard Houckgeest and Emmanuel de Witte: Architectural Painting in Delft around 1650," *Simiolus* 8 (1975–76), pp. 167–85.

439. 2. See also Arthur K. Wheelock, Jr., *Perspective, Optics and Delft Artists around 1650* (New York/London, 1977), especially pages 235ff.; his suggestion, however, that the popularity of the theme of William I's tomb has to do with the struggle between patriots and Orangists upon the death of William II seems to me very unlikely.

439. 3. The date of this painting must be read as 1650 or 1652, certainly not as 1654 as is done by, among others, I. Manke, *Emanuel de Witte 1617–1692* (Amsterdam, 1963), p. 22.

440. 4. D.E. van Bleyswijck, *Beschryvinge der stadt Delft, betreffende desselfs situatie, oorsprong en ouderdom, opkomst en voortgangh, vermeerderinge van vrijheidt en jurisdictie* ... II (Delft, 1667), p. 852; Arnold Houbraken, *De Groote Schouburgh der Nederlantsche Konstschilders en Schilderessen* ... III (Amsterdam, 1718–21), p. 338; Samuel van Hoogstraeten, *Inleyding tot de Hooge Schoole der Schilderkonst: anders de Zichtbaere Werelt* ... (Rotterdam, 1678), p. 274.
440. 5. Arthur K. Wheelock, Jr., "Carel Fabritius: Perspective and Optics in Delft," *Nederlands Kunsthistorisch Jaarboek* 24 (1973), pp. 63–83; W.A. Liedtke, "The 'View in Delft' by Carel Fabritius," *Burlington Magazine* 118 (1976), pp. 61–73; Wheelock, *Perspective, Optics and Delft Artists,* pp. 4–11 and 191–206.
441. 6. M. Tóth-Ubbens, "Kijken naar een vogeltje," in *Miscellania J.Q. van Regteren Altena* (Amsterdam, 1969), pp. 155–61; M.L. Wurfbain, "Hoe was het 'Puttertje' gebekt?" in *Opstellen voor H. van de Waal* (Amsterdam/Leipzig, 1970), pp. 233–40.
442. 7. Houbraken, *De Groote Schouburgh* II, pp. 34–35.
442. 8. R.E. Fleischer, "Ludolf de Jong and the Early Work of Pieter de Hooch," *Oud Holland* 92 (1978), pp. 49–67.
442. 9. A. Bredius, "Bijdragen tot de biographie van Pieter de Hoogh," *Oud Holland* 7 (1889), pp. 161–68.
443. 10. Peter C. Sutton, *Pieter de Hooch* (New York/Oxford, 1979–80), p. 10.
446. 11. A. Blankert, Rob Ruurs, and W.L. van de Watering, *Johannes Vermeer van Delft 1632–1675* (Utrecht/Antwerp, 1975), p. 127, no. 30.
447. 12. Ibid., p. 130, no. 40.
447. 13. P.T.A. Swillens, *Johannes Vermeer, Painter of Delft 1632–1675* (Utrecht/Brussels, 1950), pp. 93ff.; Blankert, *Johannes Vermeer,* pp. 56–57 and 115–16, note 45.
448. 14. C. Seymour, Jr., "Dark Chamber and Light-filled Room: Vermeer and the Camera Obscura," *Art Bulletin* 46 (1964), pp. 323–31; Daniel A. Fink, "Vermeer's Use of the Camera Obscura—a Comparative Study," *Art Bulletin* 53 (1971), pp. 493–505; Heinrich Schwartz, "Vermeer and the Camera Obscura," *Pantheon* 24 (1966), pp. 170–82; Wheelock, *Perspective, Optics and Delft Artists,* pp. 283, 301, and, for the historical background of this device, 137–47.
450. 15. Blankert, *Johannes Vermeer,* p. 133, no. 51.
450. 16. H. Miedema, "Johannes Vermeers 'Schilderkunst,'" *Proef* (September 1972), pp. 67–76.
450. 17. E. de Jongh, *Zinne- en minnebeelden in de schilderkunst van de zeventiende eeuw* (n.p., n.d.), pp. 49–50.
451. 18. *Journal des voyages de M. de Monconys* II (Lyon, 1666), p. 149.
453. 19. A.H. van Dijk, "Het gat in de gevel," *Zeeuws Tijdschrift* 28 (1978), pp. 98–100.
453. 20. Neil MacLaren, *The Dutch School*, National Gallery Catalogues (London, 1960), pp. 274–75.
454. 21. Houbraken, *De Groote Schouburgh* II, p. 216.

Painting in The Hague: 1650–1680
454. 1. T.N. Lunsingh Scheurleer, "De woonvertrekken in Amalia's Huis in het Bosch," *Oud Holland* 84 (1969), p. 54, note 43.
455. 2. Houbraken, *De Groote Schouburgh* II, p. 305.
459. 3. J. Bernström and Bengt Rapp, *Iconographica* (Stockholm, 1957), pp. 7–34.
461. 4. H.E. van Gelder, *W.C. Heda, A. van Beyeren, W. Kalf* (Amsterdam, 1941), p. 31.

Painting in Amsterdam: 1650–1680 (II)
462. 1. Houbraken, *De Groote Schouburgh* III, p. 65.
462. 2. H.F. Wijnman, "Het leven der Ruysdaels," *Oud Holland* 49 (1932), p. 261; Seymour Slive and H.R. Hoetink, *Jacob van Ruisdael* (New York/Amsterdam, 1981), pp. 19–20.
462. 3. A. Bredius, *Künstler-Inventäre; Urkunden zur Geschichte der holländischen Kunst des XVIten, XVIIten und XVIIIten Jahrhunderts* II (The Hague, 1916), p. 425.

464. 4. Houbraken, *De Groote Schouburgh* II, p. 95; for comment see Alice Davies, *Allart van Everdingen* (New York/London, 1978), pp. 33–35.
465. 5. A. Bredius, "Nog een en ander over Hobbema," *Oud Holland* 33 (1915), pp. 193–98.
465. 6. Wolfgang Stechow, "The Early Years of Hobbema," *Art Quarterly* 22 (1959), pp. 2–18.
467. 7. For comment on the dating, see Neil MacLaren, *The Dutch School*, National Gallery Catalogues (London, 1960), p. 166.
470. 8. Max Pfister, "Trasimenischer See oder Zürichsee? Zu einem Gemälde von Jan Hackaert im Rijksmuseum Amsterdam," *Bulletin van het Rijksmuseum* 20 (1972), pp. 177–81.
473. 9. Bredius, *Künstler-Inventäre* II, p. 549.
473. 10. H.M. van den Berg, "Willem Schellinks en Lambert Doomer in Frankrijk," *Oudheidkundig Jaarboek* 4/11 (1942), pp. 1–31; Wolfgang Schultz, "Schellinks, Doomer und Jan Steen, zu den Schellinks-Zeichnungen im Kupferstichkabinett Berlin," *Pantheon* 28 (1970), pp. 415–23.
475. 11. A. Bredius, "De schilder Johannes van de Cappelle," *Oud Holland* 10 (1892), pp. 26–40.
475. 12. Ibid., p. 30.
477. 13. S. Hart in *Jaarboek Nederlandsch Historisch Scheepvaart Museum* (1968), p. 20.
479. 14. MacLaren, *The Dutch School*, p. 420.
480. 15. Houbraken, *De Groote Schouburgh* II, pp. 236–44.
482. 16. For the spelling of the name and probable identifications and datings, see MacLaren, *The Dutch School*, pp. 12–14.
483. 17. Wolfgang Stechow, "Jan Wijnants, View of the Herengracht, Amsterdam," *Bulletin of the Cleveland Museum of Art* 52 (1965), pp. 164–73; I.H. van Eeghen, "De vier huizen van Cromhoult," *Maandblad Amstelodamum* 53 (1966), pp. 52–59.
483. 18. Helga Wagner, *Jan van der Heyden, 1637–1712* (Amsterdam/Haarlem, 1971), p. 11.
485. 19. Ibid., p. 17.
485. 20. Houbraken, *De Groote Schouburgh* I, pp. 282–87.
489. 21. E. de Jongh, "Erotica in vogelperspectief. De dubbelzinnigheid van een reeks 17de-eeuwse genre-voorstellingen," *Simiolus* 3 (1968–69), pp. 37–38.
493. 22. Houbraken, *De Groote Schouburgh* II, pp. 218–19.
498. 23. Ibid., I, p. 358.
498. 24. Bredius, *Künstler-Inventäre* II, pp. 697–707.
498. 25. A.P. de Mirimonde, "Une nature morte énigmatique de Paolo Porpora du Musée du Louvre," *La Revue du Louvre et des Musées de France* (1978), pp. 145–54.

The Transition to the Eighteenth Century
502. 1. Gerard de Lairesse, *Het Groot Schilderboek* ... I (Amsterdam, 1707), p. 325.
502. 2. D.P. Snoep, "Gérard Lairesse als plafond- en kamerschilder," *Bulletin van het Rijksmuseum* 18 (1970), pp. 159–220.
502. 3. Lairesse, *Het Groot Schilderboek* I, p. 324.
502. 4. A. von Wurzbach, *Niederländisches Künstler-Lexikon* II (Vienna/Leipzig, 1906), p. 7.
502. 5. W. Martin, *De Hollandsche schilderkunst in de zeventiende eeuw* II: *Rembrandt en zijn tijd* (Amsterdam, 1936), p. 495.

Bibliography

by Ellinoor Bergvelt and Michiel Jonker

This bibliography is based on the bibliography in Jakob Rosenberg, Seymour Slive, and E.H. ter Kuile, *Dutch Art and Architecture: 1600 to 1800* (Harmondsworth, 1966), as regards its arrangement as well as its titles. Some sections have been added ("Urban History"), others have been modified ("Art, Artist, and Environment"). Our aim has been to include as many new editions and English translations as possible.

For the period before 1966 we have harmonized the bibliography in Rosenberg, Slive, and ter Kuile with H. van Hall, *Repertorium voor de geschiedenis der Nederlandsche schilder- en graveerkunst* (The Hague, 1936–49) and *Bibliography of the Netherlands Institute for Art History* (The Hague, 1943–). For the period since 1966 we have drawn upon the periodicals *Répertoire d'art et d'archéologie, Zeitschrift für Kunstgeschichte,* and *Simiolus.* Only book reviews containing relevant, additional information are included.

For the "Urban History" section we have made use of W. Nijhoff, *Bibliographie van Noord-Nederlandsche plaatsbeschrijvingen tot het einde der 18de eeuw* (2d rev. ed., The Hague, 1953) and G. van Herwijnen, *Bibliografie van de stedengeschiedenis van Nederland* (Leiden, 1978). Where possible, one early and one recent history of each town is cited.

The "Artists" section includes only artists discussed in the text. In general, the reader is advised to consult the biographies in U. Thieme and F. Becker, *Allgemeines Lexikon der bildenden Künstler* (Leipzig, 1907–50). Articles on a particular painting are omitted; included is any article that places the painting in a wider context, such as in the artist's oeuvre or in his time, or that provides our only information about the artist concerned. A series of articles on individual paintings may be found in the first volumes of *Openbaar Kunstbezit.*

The bibliographical listing was closed on October 1, 1981. A few monographs and articles published since that date have been added.

The bibliographical material is arranged chronologically under the following headings:

I. General History

Geyl, P. *Geschiedenis van de Nederlandsche stam.* 3 vols. Amsterdam, 1930–37.

Huizinga, J. *Holländische Kultur des siebzehnten Jahrhunderts. Ihre soziale Grundlagen und nationale Eigenart.* Jena, 1933. English translation: *Dutch Civilization in the Seventeenth Century and Other Essays.* London, 1968; New York, 1969.

Romein, J., and Romein, A. *De lage landen bij de zee. Geïllustreerde geschiedenis van het Nederlandsche volk van Duinkerken tot Delfzijl.* Utrecht, 1934.

Kuttner, E. *Het hongerjaar 1566.* Amsterdam, 1949.

Boxer, C.R. *The Dutch Seaborne Empire 1600–1800.* London, etc., 1965.

Arm in de Gouden Eeuw. Amsterdam, 1965 (catalogue of exhibition at the Amsterdams Historisch Museum, 1965–66).

Acta historiae Neerlandica; Historical Studies in the Netherlands. Leiden, 1966–71. *Acta historiae Neerlandicae; Studies on the History of the Netherlands.* The Hague, 1972– .

La vie en Hollande au XVIIe siècle. Tableaux, dessins, estampes, argenterie, monnaies, médailles et autres témoignages. Paris, 1967 (catalogue of exhibition at the Musée des Arts Décoratifs, Paris, 1967).

Buck, H. de (and Smit, E.M.). *Bibliografie der geschiedenis van Nederland; samengesteld in opdracht van het Nederlands Comité voor geschiedkundige wetenschappen.* Leiden, 1968.

Haley, K.H.D. *The Dutch in the Seventeenth Century.* London, 1972.

Price, J.L. *Culture and Society in the Dutch Republic during the 17th Century.* London, 1974.

Parker, G. *The Dutch Revolt.* Harmondsworth, 1977.

Algemene geschiedenis der Nederlanden. 15 vols. Haarlem, 1977–83.

Larsen, E., and Davidson, J.P. *Calvinistic Economy and 17th Century Dutch Art.* Lawrence, 1979.

II. Urban History

A. General

Nijhoff, W. *Bibliographie van Noord-Nederlandsche plaatsbeschrijvingen tot het einde der 18de eeuw.* The Hague, 1894, 2d ed. revised by F.W.D.C.A. van Hattum. The Hague, 1953.

Burke, G.L. *The Making of Dutch Towns. A Study in Urban Development from the Tenth to the Seventeenth Centuries.* London, 1956.

Herwijnen, G. van. *Bibliografie van de stedengeschiedenis van Nederland.* Leiden, 1978.

Taverne, E.R.M. *In 't land van belofte: in de nieue stadt. Ideaal en werkelijkheid van de stadsuitleg in de Republiek 1580–1680.* Maarssen, 1978.

B. Towns in Alphabetical Order

Alkmaar

Woude, C. van der. *Kronyck van Alckmaar. Met zyn Dorpen, Ende de voornaamste geschiedenissen desselfs, van 't beginsel der bouwinge der voorsz. Stadt Alckmaar, tot den Jaren 1658* Alkmaar, 1645. Facsimile ed. of 3rd ed. of 1743: Alkmaar, 1973.

Fasel, W.A. *Alkmaar en zijn geschiedenissen. Kroniek van 1600–1813.* Alkmaar, 1973.

Amersfoort

Verhoeven, T., et al. *Rerum Amorfortiarum scriptores duo inediti. Alter auctor incertus; alter cui nomen Theodorus Verhoeven.* Leiden, 1693.

Bemmel, A. van. *Beschrijving der stad Amersfoort* 2 vols. Utrecht, 1760. Facsimile ed.: Zaltbommel, 1969.

Halbertsma, H. *Zeven eeuwen Amersfoort.* Amersfoort, 1959.

Amsterdam

Wagenaar, J. *Amsterdam, in zijne opkomst, aanwas, geschiedenissen, voorregten, koophandel, gebouwen, kerkenstaat, schoolen, schutterije, gilden en regeringe.* 4 vols. Amsterdam, 1760–88. Facsimile ed.: Alphen aan den Rijn/Amsterdam, 1971–72.

Elias, J.E. *De vroedschap van Amsterdam 1578–1795.* 2 vols. Haarlem, 1903–5.

Jacobsen Jensen, J.N. *Reizigers te Amsterdam. Beschrijvende lijst van reizen in Nederland door vreemdelingen vóór 1850.* Amsterdam, 1919. Supplement: Amsterdam, 1936.

d'Ailly, A.E. *Historische gids van Amsterdam.* Amsterdam, 1929. 4th ed. by H.F. Wijnman. Amsterdam, 1971.

Brugmans, H. *Geschiedenis van Amsterdam.* 6 vols. Amsterdam, 1930–33. Revised by I.J. Brugmans. Utrecht/Antwerpen, 1972–73.

d'Ailly, A.E. *Zeven eeuwen Amsterdam.* 6 vols. Amsterdam, n.d. [1944–50].

Barbour, V. *Capitalism in Amsterdam in the 17th Century.* Baltimore, 1950.

Fremantle, K. *The Baroque Town Hall of Amsterdam.* Utrecht, 1959. Reviewed by C. Peeters in *Bulletin Koninklijke Nederlandse Oudheidkundige Bond* 6th s. 14 (1961), pp. 141–52.

Carter, A.C. *The English Reformed Church in Amsterdam in the Seventeenth Century.* Amsterdam, 1964.

Burke, P. *Venice and Amsterdam. A Study of Seventeenth-Century Elites.* London, 1974.

Carasso-Kok, M. *Amsterdam Historisch: een stadsgeschiedenis aan de hand van de collectie van het Amsterdams Historisch Museum.* Bussum, 1975.

Regin, D. *Traders, Artists, Burghers; a Cultural History of Amsterdam in the 17th Century.* Assen, 1976.

Buchbinder-Green, B.J. *The Painted Decorations of the Town Hall of Amsterdam.* Ann Arbor/London, 1976.

Kistemaker, R., and Gelder, R. van. *Amsterdam. The*

Golden Age 1275–1795. New York, 1983.
See also III. C. Patron, Collector, and Art Dealer. Blankert, 1975.

Delft
Bleyswijck, D.E. van. *Beschryvinge der stadt Delft, betreffende desselfs situatie, oorsprong en ouderdom, opkomst en voortgangh, vermeerderinge van vrijheidt en jurisdictie … publijcke gebouwen … .* 2 vols. Delft, 1667. Aenhangsel: n.d. [1674].
Delftse Studiën. Een bundel historische opstellen over de stad Delft geschreven voor dr. E.H. ter Kuile naar aanleiding van zijn afscheid als hoogleraar in de geschiedenis van de bouwkunst. Assen, 1967.

Deventer
Revius, J. *Daventriae illustratae, sive Historiae urbis Daventriensis libri sex.* Leiden, 1650.
Moonen, A. *Korte Chronyke der Stadt Deventer, Van de oudste geheugenis af tot het vredejaer van 1648 … . Deventer, 1688.*

Dordrecht
Balen, M. Jansz. *Beschryvinge der stadt Dordrecht, vervat[t]ende haar begin, opkomst, toeneming en verdere stant opgezocht, in 't licht gebracht en vertoond met vele voorname voorrechten, handvesten, keuren en oude-herkomen.* Dordrecht, 1677.
Dalen, J.L. van. *Geschiedenis van Dordrecht.* 2 vols. Dordrecht, 1931–33.

Enkhuizen
Brandt, G. *Historie der vermaerde zee- en koop-stadt Enkhuisen.* 2d ed., enlarged by S. Centen. 2 vols. Hoorn, 1747. Facsimile ed. with introduction by S.B.J. Zilverberg: Nieuwendijk, 1971.
West-Frieslands Oud en Nieuw 22 (1955).

Gouda
Walvis, I. *Beschryving der stad Gouda, bevattende een verhaal van stadsgrondlegginge, waterstroomen, vryheeren, gelegendheid, hooft-neeringe, rechtsgebied, handvesten, regeeringe, regeerders, overdragten met andere staden, voornaame gebouwen, godshuysen, schoolen, geleerde mannen en beruchte vrome mannen.* 2 vols. Leiden/Gouda, 1714.
Scheygrond, A.; Geselschap, J.E.J.; and Korstanje, L.B. *Gouda zeven eeuwen stad. Hoofdstukken uit de geschiedenis van Gouda uitgegeven bij de herdenking van het 700-jarig bestaan van de stad Gouda in 1972.* Gouda, 1972.

Groningen
Emmius, U. *De Agro Frisiae inter Amasum et Lavicam fl. deque urbe Groninga in eodem agro … .* Groningen, 1605.
Schuitema Meijer, A.T. *Groningen vroeger en nu.* Bussum, 1969.

Haarlem
Ampzing, S. *Beschrijvinge ende lof der stad Haerlem in Holland … .* Haarlem, 1628. Facsimile ed.: Amsterdam, 1974.
Temminck, J.J. *Haarlem vroeger en nu.* Bussum, 1971.
See also IV. B. General. Hofrichter, 1983.

The Hague
Riemer, J. de *Beschryving van 's-Graven-Hage, behelzende deszelfs oorsprong, benaming, gelegentheid, uitbreidingen … als mede de privilegien, handvesten, keuren en wijze der regeringe.* 2 vols. Delft/The Hague, 1730–39. Facsimile ed.: The Hague, 1973.
Gelder, H.E. van. *'s-Gravenhage in zeven eeuwen.* Amsterdam, 1937.
Wit, C. de. *Den Haag vroeger en nu.* Bussum, 1968.

's-Hertogenbosch
Oudenhoven, J. van. *Silva-ducis aucta et renata of een nieuwe ende gantsch vermeerderde beschrijvinge van de stadt van 's-Hertogenbossche.* Amsterdam, 1649.
Lanschot, F.J. van. *De historische schoonheid van 's-Hertogenbosch.* Amsterdam, 1942.

Hoorn
Velius, T. *Chronijk van Hoorn … tot het jaar 1630.* 4th ed., enlarged by S. Centen. Hoorn, 1740.
West-Frieslands Oud en Nieuw 24 (1957).

Kampen
Fehrmann, C.N. *Kampen vroeger en nu.* Bussum, 1972.

Leeuwarden
Gabbema, S.A. *Verhaal van de stad Leeuwarden. Waar in niet alleen den oorsprong des Naams, eerste opkomst, vordere aanwas, en oude geleegenheid der Stad wordt aangeweezen, maar ook de twisten en oorlogen, die zy met de andere Steeden van Friesland ten tijde der Schieringers en Vetkoopers gevoerd heeft … .* Revised by T. Gutberleth. Franeker, 1701.
Leeuwarden 1435–1935. Leeuwarden, 1935.

Leiden
Orlers, J.J. *Beschrijvinge der stad Leyden inhoudende 't begin, den voortgang ende den wasdom der selver … . In desen tweeden druck boven vele vermeerderingen vergroot met een derde deel, inhoudende den staet ende regeringe der stad Leyden.* 3 vols. Leiden, 1614.
Oerle, H.A. van. *Leiden binnen en buiten de stadsvesten. De geschiedenis van de stedebouwkundige ontwikkeling binnen het Leidse rechtsgebied tot het einde van de gouden eeuw.* 2 vols, Leiden, 1975.

Middelburg
Reygersberch, J.J. *Chroniick van Zeelandt, eertijds beschreven door d'Heer Johan Reygersbergen, nu verbetert, ende vermeerdert door M.Z. van Boxhorn … .* 2 vols. Middelburg, 1644.
Unger, W.S. *De geschiedenis van Middelburg in omtrek.* Middelburg, 1954.

Nijmegen
Smetius, J. (and Betouw, J. in de). *Chronijk van de stad der Batavieren. Uit de eigenhandige aantekeningen verbeterd … en vervolgd tot den jare 1784.* Nijmegen, 1785.
Gorissen, F. *Stede-atlas van Nijmegen.* Arnhem, 1956.
Brinkhoff, J.M.G.M. *Nijmegen vroeger en nu.* Bussum, 1971.

Rotterdam
Spaan, G. van. *Beschrijvinge der stad Rotterdam en eenige omleggende dorpen.* Rotterdam, 1698. Revised by H.C. Hazewinkel. Antwerp, 1943.
Hazewinkel, H.C. *Geschiedenis van Rotterdam.* 3 vols. Amsterdam, 1940–42. Reprint (4 vols.). Zaltbommel, 1974–75.

Utrecht
Booth, C. *Korte beschryvinge der Stad Utrecht, beginnende met derselver Opregtinge, en het voornaamste tot deser toe gepasseerden tijd.* Utrecht, 1685.
Struick, J.E.A.L. *Utrecht door de eeuwen heen.* Utrecht/Antwerp, 1968.

Zwolle
Hattum, B.J. van. *Geschiedenissen der stad Zwolle … .* 5 vols. Zwolle, 1767–76.
Vries, T.J. de. *Geschiedenis van Zwolle.* 2 vols. Zwolle, 1954–61.

III. Art, Artist, and Environment

A. The Artist's Social Position
Martin, W. "The Life of a Dutch Artist in the Seventeeth Century," *Burlington Magazine* 7 (1905), pp. 125–28, 416–27; 8 (1905–6), pp. 13–24; 10 (1906–7), pp. 144–54.
Bredius, A. *Künstler-Inventäre; Urkunden zur Geschichte der holländischen Kunst des XVIten, XVIIten und XVIIIten Jahrhunderts.* 8 vols. The Hague, 1915–22.
Hauser, A. *The Social History of Art.* 2 vols. London, 1951. Reprint (4 vols.). London, 1962.
Wittkower, R., and Wittkower, M. *Born under Saturn; the Character and Conduct of Artists: a Documented History from Antiquity to the French Revolution.* New York, 1963. Reviewed by J.A. Emmens in *Art Bulletin* 53 (1971), pp. 427–28.
Emmens, J.A., and Lemmens, G.T.M. *De schilder in zijn wereld. Van Jan van Eyck tot Van Gogh en Ensor.* Delft/Antwerp, 1964 (catalogue of exhibition at Het Prinsenhof, Delft, and the Koninklijk Museum voor Schone Kunsten, Antwerp, 1964–65).
Duverger, E. "Bronnen voor de geschiedenis van de artistieke betrekkingen tussen Antwerpen en de Noordelijke Nederlanden tussen 1632 en 1648," *Miscellanea Jozef Duverger; bijdragen tot de kunstgeschiedenis der Nederlanden* (2 vols., Ghent, 1968), vol. I, pp. 336–73.
Scheller, R.W. "Rembrandt en de encyclopedische kunstkamer," *Oud Holland* 84 (1969), pp. 81–147.
Briels, J.G.C.A. *De Zuidnederlandse immigratie in Amsterdam en Haarlem omstreeks 1575–1630. Met een keuze van archivalische gegevens betreffende de kunstschilders.* Utrecht, 1976.
Montias, J.M. "Painters in Delft, 1613–1680," *Simiolus* 10 (1978–79), pp. 84–114.
See also III. B. Guild and Training. Montias, 1977.

B. Guild and Training
Willigen Pz., A. van der. *Les artistes de Harlem. Notices historiques avec un précis sur la Gilde de St. Luc.* 2d ed. Haarlem/The Hague, 1870. Facsimile ed.: Nieuwkoop, 1970.
Pevsner, N. *Academies of Art; Past and Present.* Cambridge, 1940. 2d ed. New York, 1973.
Hoogewerff, G.J. *De geschiedenis van de St. Lucasgilden in Nederland.* Amsterdam, 1947.
Eeghen, I.H. van. "Het Amsterdamse Sint Lucasgilde in de 17de eeuw," *Jaarboek Amstelodamum* 61 (1969), pp. 65–102.
Taverne, E.R.M. "Een Amsterdams Lucasfeest in 1618," *Simiolus* 4 (1970), pp. 19–27.
———. "Salomon de Bray and the Reorganization of the Haarlem Guild of St. Luke in 1631," *Simiolus* 6 (1972–73), pp. 50–69.
"Schilderen is een ambacht als een ander. Verslag van een onderzoek rond Philips Angels *Lof der Schilderkonst* en het zeventiende-eeuwse Noordnederlandse schildersgilde," *Proef* 3 (1973–75), pp. 124–44.
Montias, J.M. "The Guild of St. Luke in 17th-Century Delft and the Economic Status of Artists and Artisans," *Simiolus* 9 (1977), pp. 93–105.
Bolten, J. *Het Noord- en Zuidnederlandse tekenboek, 1600–1750.* Ter Aar, 1979. Reviewed by P. Knolle in *Simiolus* 11 (1980), pp. 177–81.
Miedema, H. *De archiefbescheiden van het St. Lukasgilde te Haarlem. 1497–1798.* 2 vols. Alphen aan den Rijn, 1980. Reviewed by T.N. Schelhaas in *Oud Holland* 97 (1983), pp. 205–6.
See also III. A. The Artist's Social Position. Montias, 1978–79.

C. Patron, Collector, and Art Dealer
Bredius, A. "De kunsthandel te Amsterdam in de XVIIe eeuw," *Amsterdamsch Jaarboekje* (1891), pp. 54–71.
Floerke, H. *Studien zur niederländischen Kunst- und Kulturgeschichte. Die Formen des Kunsthandels, das Atelier und die Sammler in den Niederlanden vom 15.–18. Jahrhundert.* Munich/Leipzig, 1905. Facsimile ed.: Soest, 1972.
Denucé, J. *Kunstuitvoer in de 17e eeuw te Antwerpen. De Firma Forchoudt.* Antwerp/Amsterdam, 1931.
Lugt, F. "Italiaansche kunstwerken in Nederlandsche verzamelingen van vroeger tijden," *Oud Holland* 53 (1936), pp. 97–135.
———. *Répertoire des catalogues de ventes publiques intéressant l'art ou la curiosité.* 3 vols. The Hague, 1938–64.
Slothouwer, D.F. *De paleizen van Frederik Hendrik.* Leiden, n.d. [1945].
Gelder, J.G. van. "De schilders van de Oranjezaal," *Nederlands Kunsthistorisch Jaarboek* 2 (148–49), pp. 118–64.
———. "De opdrachten van de Oranje's aan Thomas Willeboirts Bosschaert en Gonzales Coques," *Oud Holland* 64 (1949), pp. 40–56.
Mahon, D. "Notes on the 'Dutch Gift' te Charles II," *Burlington Magazine* 91 (1949), pp. 303–5, 349–50; 92 (1950), pp. 12–18, 238.
Bruyn, J., and Millar, O. "Notes on the Royal Collection—III: The 'Dutch Gift' to Charles I," *Burlington Magazine* 104 (1962), pp. 291–94.
Gelder, J.G. van. "Notes on the Royal Collection—IV: The 'Dutch Gift' of 1610 to Henry, Prince of 'Whalis,' and Some Other Presents," *Burlington Magazine* 105 (1963), pp. 541–44.
The Orange and the Rose: Holland and Britain in the Age of Observation, 1600–1750. London, 1964 (catalogue

of exhibition at the Victoria and Albert Museum, London, 1964).

Weijtens, F.H.C. *De Arundel-Collectie. Commencement de la fin Amersfoort 1655.* Utrecht, 1971.

Sass, E.K. *Comments on Rembrandt's Passion Paintings and Constantijn Huygens's Iconography.* Copenhagen, 1971. Reviewed by J. Bruyn in *Oud Holland* 90 (1976), p. 133.

Duverger, E. "Abraham van Diepenbeeck en Gonzales Coques aan het werk voor de stadhouder Frederik Hendrik, prins van Oranje," *Jaarboek van het Koninklijk Museum voor Schone Kunsten Antwerpen* 12 (1972), pp. 181–237.

Drossaers, S.W.A., and Lunsingh Scheurleer, T.H., ed. *Inventarissen van de inboedels in de verblijven van de Oranjes en daarmede gelijk te stellen stukken 1567–1795.* 3 vols. The Hague, 1974–76.

Blankert, A. *Kunst als regeringszaak in Amsterdam in de 17e eeuw. Rondom schilderijen van Ferdinand Bol.* Lochem, 1975 (catalogue of exhibition at the Royal Palace, Amsterdam, 1975).

Logan, A.-M.S. *The "Cabinet" of the Brothers Gerard and Jan Reynst.* Amsterdam/Oxford/New York, 1979. Reviewed by F.L. Bastet in *Simiolus* 11 (1980), pp. 55–57.

William & Mary and Their House. New York, 1979 (catalogue of exhibition at the Pierpont Morgan Library, New York, 1979–80).

Fock, C.W. "The Princes of Orange as Patrons of Art in the Seventeeth Century," *Apollo* 110 (1979), pp. 466–75.

Zo wijd de wereld strekt. Tentoonstelling naar aanleiding van de 300ste sterfdag van Johan Maurits van Nassau-Siegen op 20 december 1979. The Hague, 1979 (catalogue of exhibition at the Mauritshuis, The Hague, 1979–80).

Boogaart, E. van den; Hoetink, H.R.; and Whitehead, P.J.P., ed. *Johan Maurits van Nassau-Siegen. 1604–1679. A Humanist Prince in Europe and Brazil. Essays on the Occasion of the Tercentenary of His Death.* The Hague, 1979.

Peter-Raupp, H. *Die Ikonographie des Oranjezaal.* Hildesheim/New York, 1980.

Brenninkmeyer-de Rooij, B. "Notities betreffende de decoratie van de Oranjezaal in Huis ten Bosch, uitgaande van H. Peter-Raupp, *Die Ikonographie des Oranjezaal,* Hildesheim/New York 1980," *Oud Holland* 96 (1982), pp. 133–90.

See also II. B. Amsterdam. Fremantle, 1959, and Buchbinder-Green, 1976; VI. B. History. Landwehr, 1971, and Snoep, 1975.

IV. Art History

A. Bibliographies

Répertoire d'art et d'archéologie Vols. 1–67. Paris, 1910–63; n.s. vols. 1– . Paris, 1965– .

Zeitschrift für Kunstgeschichte 1– (1932–).

Art Index Vols. 1– . New York, 1933– .

Hall, H. van. *Repertorium voor de geschiedenis der Nederlandsche schilder- en graveerkunst. Sedert het begin der 12de eeuw tot het eind van 1946.* 2 vols. The Hague, 1936–49.

Bibliography of the Netherlands Institute for Art History; Rijksbureau voor Kunsthistorische Documentatie. Vols. 1– . The Hague, 1943– . Facsimile ed.: Amsterdam, 1971– .

Simiolus ... 1– (1966/67–).

Oud Holland 91– (1977–).

B. General

Smith, J. *A Catalogue Raisonné of the Works of the Most Eminent Dutch, Flemish, and French Painters* 9 vols. London, 1829–42.

Bürger, W. [Thoré, T.J.E.]. *Musées de la Hollande.* Amsterdam et La Haye. Paris, 1858.

Fromentin, E. *Les Maîtres d'autrefois Belgique-Hollande.* Paris, 1876. English translation: *The Masters of Past Time; Dutch and Flemish Painting from Van Eyck to Rembrandt.* With introduction and notes by H.

Gerson. London, 1948.

Obreen, D.O., et al. *Archief voor Nederlandsche kunstgeschiedenis: verzameling van meerendeels onuitgegeven berichten en mededeelingen betreffende Nederlandsche schilders, plaatsnijders, beeldhouwers, bouwmeesters, juweliers* 7 vols. Rotterdam, 1877–90. Facsimile ed.: Soest, 1976.

Havard, H. *L'Art et les artistes hollandais.* 4 vols. Paris, 1879–81.

Bode, W. *Studien zur Geschichte der holländischen Malerei.* Brunswick, 1883.

Hofstede de Groot, C. *Beschreibendes und kritisches Verzeichnis der Werke der hervorragendsten holländischen Maler des XVII. Jahrhunderts. Nach dem Muster von John Smith's Catalogue Raisonné zusammengestellt.* 10 vols. Esslingen am Neckar, 1907–28. English translation: *A Catalogue Raisonné of the Works of the Most Eminent Dutch Painters of the Seventeenth Century, Based on the Work of John Smith.* 8 vols. London, 1908–27. Facsimile ed.: 10 parts in 3 vols. Cambridge/Teaneck, 1976 (parts 9 and 10 after the German ed.).

Voss, H. "Vermeer van Delft und die Utrechter Schule," *Monatshefte für Kunstwissenschaft* 5 (1912), pp. 79–83.

Bode, W. von. *Die Meister der holländischen und flämischen Malerschulen.* Leipzig, 1917. 8th ed. revised by E. Plietzsch. Leipzig, 1956.

Friedländer, M.J. *Die niederländischen Maler des 17. Jahrhunderts.* Propyläen Kunstgeschichte 12. Berlin, 1923.

———. *Die altniederländische Malerei.* 14 vols. Berlin/Leiden, 1924–37. English translation: *Early Netherlandish Painting.* 14 vols. Leiden/Brussels, 1967–76.

Martin, W. *De Hollandsche schilderkunst in de zeventiende eeuw.* 2 vols.: *Frans Hals en zijn tijd. Rembrandt en zijn tijd.* Amsterdam,1935–36.

IJsselstein, G.T. *Geschiedenis der tapijtweverijen in de Noordelijke Nederlanden.* 2 vols. Leiden, 1936.

Bloch, V. "Die haarlemer Klassizisten," *Oud Holland* 57 (1940), pp. 14–21.

Boon, K.G. *De schilders voor Rembrandt. De inleiding tot het bloeitijdperk.* Antwerp, 1942.

Gerson, H. *Ausbreitung und Nachwirkung der holländischen Malerei des 17. Jahrhunderts.* Haarlem, 1942. New. ed. with introduction by B.W. Meijer and 90 additional illustrations. Amsterdam, 1983.

Baumgart, F. "Zusammenhänge der niederländischen mit der italienischen Malerei in der zweiten Hälfte des 16. Jahrhunderts," *Marburger Jahrbuch für Kunstwissenschaft* 13 (1944), pp. 187–250.

Friedländer, M.J. *Essays über die Landschaftsmalerei und andere Bildgattungen.* The Hague, 1947. English translation: *Landscape, Portrait, Still-Life; Their Origin and Development.* Oxford, 1949.

Neurdenburg, E. *De zeventiende eeuwsche beeldhouwkunst in de Noordelijke Nederlanden: Hendrick de Keyser, Artus Quellinus, Rombout Verhulst en tijdgenooten.* Amsterdam, 1948.

Bernt, W. *Die niederländischen Maler des 17. Jahrhunderts.* 4 vols. Munich, 1948–62. English translation: *The Netherlandish Painters of the Seventeenth Century.* 3 vols. London/New York, 1970.

Gerson, H. *De Nederlandse schilderkunst.* 3 vols.: *Van Geertgen tot Frans Hals. Het tijdperk van Rembrandt en Vermeer. Vóór en na Van Gogh.* Amsterdam, 1950–61.

Bengtsson, Å., and Omberg, H. *Structural Changes in Dutch 17th Century Landscapes, Still-Life, Genre and Architecture Painting.* Figura 1. Uppsala, 1951.

Gelder, H.E. van. *Guide to Dutch Art.* The Hague, 1952.

Bernt, W. *Die niederländischen Zeichner des 17. Jahrhunderts.* 2 vols. Munich, 1957–58.

Gelder, J.G. van. *Prenten en tekeningen.* Amsterdam, 1958. English translation: *Dutch Drawings and Prints.* London/New York, 1959.

Plietzsch, E. *Holländische und flämische Maler des XVII. Jahrhunderts.* Leipzig, 1960.

MacLaren, N. *The Dutch School.* National Gallery Catalogues. London, 1960.

Gelder, J.G. van. "Two Aspects of the Dutch Baroque. Reason and Emotion," *De Artibus Opuscula XL. Essays in Honor of Erwin Panofsky.* New York, 1961, pp. 445–53.

Rosenberg, J.; Slive, S.; and Kuile, E.H. ter. *Dutch Art and Architecture: 1600 to 1800.* The Pelican History of Art. Harmondsworth/Baltimore/Ringwood, 1966. Rev. eds. 1972, 1977. Reviewed by A. Blankert in *Simiolus* 1 (1966–67), pp. 116–20, and by J. Bruyn in *Art Bulletin* 54 (1972), pp. 219–22.

Bol, L.J. *Holländische Maler des 17. Jahrhunderts nahe den grossen Meistern. Landschaften und Stilleben.* Brunswick, 1969.

Rembrandt after Three Hundred Years. An Exhibition of Rembrandt and His Followers. Chicago, 1969 (catalogue of exhibition at the Art Institute of Chicago, the Minneapolis Institute of Arts, and the Detroit Institute of Arts, 1969–70).

Kuile, O. ter. *500 jaar Nederlandse schilderkunst.* Amsterdam, 1970.

Hubala, E. *Die Kunst des 17. Jahrhunderts.* Propyläen Kunstgeschichte 9. Berlin, 1970.

Nash, J.M. *The Age of Rembrandt and Vermeer; Dutch Painting in the Seventeenth Century.* London, 1972.

Tümpel, A., and Tümpel, C. *The Pre-Rembrandtists.* Sacramento, 1974 (catalogue of exhibition at the E.B. Crocker Art Gallery, Sacramento, 1974).

Asperen de Boer, J.R.J. van. "An Introduction to the Scientific Examination of Paintings," *Nederlands Kunsthistorisch Jaarboek* 26 (1975), pp. 1–40.

Art in Seventeenth Century Holland. A Loan Exhibition. London, 1976 (catalogue of exhibition at the National Gallery, London, 1976). Reviewed by W. Kloek in *Simiolus* 9 (1977), pp. 16–18.

All the Paintings of the Rijksmuseum in Amsterdam. A Completely Illustrated Catalogue. Amsterdam/Maarssen, 1976.

Wetering, E. van de. "Leidse schilders achter de ezels," *Geschildert tot Leyden anno 1626.* Leiden, 1976 (catalogue of exhibition at De Lakenhal, Leiden, 1976–77), pp. 19–31.

Fuchs, R.H. *Dutch Painting.* London/New York, 1978.

Meyere, J.A.L. de. "Utrechtse schilderkunst in de tweede helft van de 16de eeuw." *Jaarboek Oud Utrecht* (1978), pp. 106–91.

Kahr, M.M. *Dutch Painting in the Seventeenth Century.* New York, etc., 1978.

Bruyn, J. "Een onderzoek naar 17de-eeuwse schilderijformaten, voornamelijk in Noord-Nederland," *Oud Holland* 93 (1979), pp. 96–115.

Wright, C. *Paintings in Dutch Museums. An Index of Oil Paintings in Public Collections in the Netherlands by Artists Born before 1870.* London/Totowa/Amsterdam, 1980.

Miedema, H. "Verder onderzoek naar zeventiende-eeuwse schilderijformaten in Noord-Nederland," *Oud Holland* 95 (1981), pp. 31–49.

Bol, L.J. *"Goede onbekenden." Hedendaagse herkenning en waardering van verscholen, voorbijgezien en onderschat talent.* Utrecht, 1982.

Sumowski, W. *Gemälde der Rembrandt-Schüler I. J.A. Backer – A. van Dijck.* Landau-Pfalz, 1983.

The Impact of a Genius. Rembrandt, His Pupils and Followers in the Seventeenth Century. Amsterdam, 1983 (catalogue of exhibition at Kunsthandel K. & V. Waterman, Amsterdam, and the Groninger Museum, Groningen, 1983).

Hofrichter, F.F. *Haarlem: the Seventeenth Century.* Rutgers, 1983 (catalogue of exhibition at The Jean Voorhees Zimmerli Art Museum, Rutgers, 1983).

C. Mannerism

Kauffmann, H. "Der Manierismus in Holland und die Schule von Fontainebleau," *Jahrbuch der Preuszischen Kunstsammlungen* 44 (1923), pp. 184–204. Reviewed by W. Stechow in *Kritische Berichte zur kunstgeschichtlichen Literatur* 1 (1927–28), pp. 54–64.

Antal, F. "Zum Problem des niederländischen

Manierismus," *Kritische Berichte zur kunstgeschicht-lichen Literatur* 2 (1928–29), pp. 207–56. English translation: "The Problem of Mannerism in the Netherlands," *Classicism and Romanticism with Other Studies in Art History*. London, 1966, pp. 47–106.

De triomf van het maniërisme: de Europese stijl van Michelangelo tot El Greco. Amsterdam, 1955 (catalogue of exhibition at the Rijksmuseum, Amsterdam, 1955).

Stechow, W. *Dutch Mannerism; Apogee and Epilogue*. Poughkeepsie, 1970 (catalogue of exhibition at the Vassar College Art Gallery, Poughkeepsie, 1970). Reviewed by L.J. Slatkes in *Art Quarterly* 33 (1970), pp. 420–40.

Lowenthal, A.W. "Wtewael's *Moses* and Dutch Mannerism," *Studies in the History of Art* 6 (1974), pp. 125–41.

Miedema, H. "On Mannerism and *maniera*," *Simiolus* 10 (1978–79), pp. 19–45.

D. Caravaggism

Schneider, A. von. *Caravaggio und die Niederländer*. Marburg, 1933. Facsimile ed.: Amsterdam, 1967.

Gelder, J.G. van. *Caravaggio en de Nederlanden*. Utrecht/Antwerp, 1952 (catalogue of exhibition at the Centraal Museum, Utrecht, and the Koninklijk Museum voor Schone Kunsten, Antwerp, 1952).

Nicolson, B. *The International Caravaggesque Movement; List of Pictures of Caravaggio and His Followers throughout Europe from 1590 to 1650*. Oxford, 1979.

E. "Realism"

Richardson, E.P. "The Romantic Prelude to Dutch Realism," *Art Quarterly* 3 (1940), pp. 40–78.

Boon, K.G. "Romantisch realisme of 'réalisme pur'?"*Maandblad voor Beeldende Kunsten* 22 (1946), pp. 95–103.

Slive, S. "Realism and Symbolism in Seventeenth-Century Dutch Painting," *Daedalus* 91 (1962), pp. 469–500.

Grinten, E.F. van der. "Le cachalot et le mannequin: deux facettes de la réalité dans l'art hollandais du seizième et du dix-septième siècles," *Nederlands Kunsthistorisch Jaarboek* 13 (1962), pp. 149–79.

Reznicek, E.K.J. "Realism as a 'Side Road or Byway' in Dutch Art," *Studies in Western Art; Acts of the Twentieth International Congress of the History of Art* 2: *The Renaissance and Mannerism*. Princeton, 1963, pp. 247–53.

Jongh, E. de. "Realisme en schijnrealisme in de Hollandse schilderkunst van de zeventiende eeuw," *Rembrandt en zijn tijd*. Brussels, 1971 (catalogue of exhibition at the Palais des Beaux-Arts, Brussels, 1971), pp. 143–94.

Miedema, H. "Over het realisme in de Nederlandse schilderkunst van de zeventiende eeuw naar aanleiding van een tekening van Jacques de Gheyn II (1565–1632)," *Oud Holland* 89 (1975), pp. 2–18.

See also VI. E. Peasants and Burghers Figure Paintings. Alpers, 1975–76, and the Iconography section in general.

F. Dutch Artists in Italy

Hoogewerff, G.J. *Nederlandsche kunstenaars te Rome (1600–1725)*. Studiën van het Nederlandsch Historisch Instituut te Rome 3. The Hague, 1942.

———. *De Bentvueghels*. The Hague, 1952.

Schoor, H. van de. "Bentvueghel Signatures in Santa Constanza in Rome," *Mededelingen van het Nederlands Historisch Instituut te Rome* 38 (1976), pp. 77–86.

See also VI. F. Landscape Paintings.

V. Art Literature

A. General

Pauw-de Veen, L. de. *Bijdrage tot de studie van de woordenschat in verband met de schilderkunst in de 17de eeuw*. Ghent, 1957.

Ellenius, A. *De arte pingendi. Latin Art Literature in Seventeenth-Century Sweden and Its International Background*. Uppsala/Stockholm, 1960.

Emmens, J.A., and Levie, S.H. "The History of Dutch Art History," *Criticism and Theory in the Arts*. Edited by R. Ginsberg. Paris, 1963, pp. 1–14.

Schlosser Magnino, J. *La letteratura artistica*. Florence/Vienna, 1964. Originally published as *Die Kunstliteratur*. Vienna, 1924.

Emmens, J.A. *Rembrandt en de regels van de kunst*. Utrecht, 1968. Reprint. Amsterdam, 1979. Reviewed by H. Miedema in *Oud Holland* 84 (1969), pp. 249–56.

Pauw-de Veen, L. de. *De begrippen "schilder," "schilderij" en "schilderen" in de zeventiende eeuw* Brussels, 1969.

Becker, J. "Zur niederländischen Kunstliteratur des 16. Jahrhunderts: Lucas de Heere," *Simiolus* 6 (1972–73), pp. 113–27.

———. "Zur niederländischen Kunstliteratur des 16. Jahrhunderts: Domenicus Lampsonius,"*Nederlands Kunsthistorisch Jaarboek* 24 (1973), pp. 45–61.

B. Sources and Biographical Lexica
Mander, K. van

Mander, K. van. *Het Schilder-Boeck* Haarlem, 1603–4. 2d ed. Haarlem, 1618. Facsimile ed. of 1st ed.: Utrecht, 1969.

Noë, H. *Carel van Mander en Italië. Beschouwingen en notities naar aanleiding van zijn "Leven der dees-tijtsche doorluchtighe Italiaensche Schilders."* The Hague, 1954.

Miedema, H. *Karel van Mander (1548–1606). Het bio-bibliografisch materiaal*. Amsterdam, 1972.

———. *Karel van Mander. Den grondt der edel vry schilder-const*. 2 vols. Utrecht, 1973. Reviewed by E.K.J. Reznicek in *Oud Holland* 89 (1975), pp. 102–28, and by L. de Pauw-de Veen in *Simiolus* 9 (1977), pp. 183–86.

———. "Karel van Mander's 'Grondt der edel vry schilder-const,'" *Journal of the History of Ideas* 34 (1973), pp. 653–68.

———. *Karel van Mander. Het leven der oude antijcke doorluchtighe schilders*. Amsterdam, 1977.

———, and Spies, M. *Karel van Mander (1548–1606). De Kerck der Deucht* [c. 1600]. Amsterdam, 1973.

See also VII. Van Mander.

Huygens, C.

Worp, J.A. "Fragment eener autobiographie van Constantijn Huygens" [1629–1631], *Bijdragen en Mededeelingen van het Historisch Genootschap* 18 (1897), pp. 1–122.

Kan, A.H., and Kamphuis, G. *De jeugd van Constantijn Huygens door hemzelf beschreven*. Rotterdam/Antwerp, 1946.

Buchelius, A.

Hoogewerff, G.J., and Regteren Altena, J.Q. van. *Arnoldus Buchelius "Res Pictoriae." Aanteekeningen over Kunstenaars en Kunstwerken ... 1583–1639*. The Hague, 1928.

Junius, F.

Junius, F. *De pictura veterum libri tres*. Amsterdam, 1637. Dutch translation: *Schilder-Boeck, behelsende de Schilder-konst der Oude* Middelburg, 1641.

Angel, P.

Angel, P. *Lof der Schilder-Konst*. Leiden, 1642. Facsimile ed.: Amsterdam, 1972.

Miedema, H. "Philips Angels *Lof der Schilder-Konst*," *Proef* 3 (1973–75), pp. 27–33.

———. *De terminologie van Philps Angels Lof der Schilder-Konst (1642); alfabetisch en systematisch gerangschikt*. Amsterdam, 1975.

See also III. B. Guild and Training. "Schilderen ..." 1973–75.

Passe, C. van de

Bolten, J. *Crispijn van de Passe. 't Light der Teken en Schilderkonst* (Amsterdam, 1643). Facsimile ed.: Soest, 1973. Reviewed by E. Haverkamp Begemann in *Master Drawings* 11 (1973), pp. 291–93.

See also VII. Van de Passe.

Grebber, P. de

Thiel, P.J.J. van. "De Grebbers regels van de kunst" [1649], *Oud Holland* 80 (1965), pp. 126–31.

Bie, C. de

Bie, C. de. *Het Gulden Cabinet van de Edele vry Schilder-Const* Antwerp, 1661. Facsimile ed. with introduction by G. Lemmens: Soest, 1971.

Félibien, A.

Félibien, A. *Entretiens sur les vies et sur les ouvrages des plus excellents peintres anciens et modernes* 5 vols. Paris, 1666–88.

Goeree, W.

Goeree, W. *Inleyding tot de Praktijck der Algemeene Schilderkonst* Middelburg, 1670. Facsimile ed.: Soest, 1974.

Goeree, W. *Natuurlyk en Schilderkonstig Ontwerp der Menschkunde* Amsterdam, 1682. Facsimile ed.: Soest, 1974.

Sandrart, J. von

Sandrart, J. von. *L'Academia Todesca della Architectura, Scultura & Pittura: Oder Teutsche Academie der Edlen Bau- Bild- und Mahlerey-Künste* Nuremberg, 1675–79. Latin ed. 1683.

Peltzer, A.R. *Joachim von Sandrarts Academie der Bau-, Bild- und Mahlerey-Künste von 1675. Leben der berühmten Maler, Bildhauer und Baumeister*. Munich, 1925.

Hoogstraeten, S. van

Hoogstraeten, S. van. *Inleyding tot de Hooge Schoole der Schilderkonst: anders de Zichtbaere Werelt* Rotterdam, 1678. Facsimile ed.: Utrecht, 1969.

Piles, R. de

Piles, R. de. *Abrégé de la Vie des Peintres* Paris, 1699.

Lairesse, G. de

Lairesse, G. de. *Grondlegginge der Teekenkonst* 2 vols. Amsterdam, 1701.

———. *Het Groot Schilderboek* 2 vols. Amsterdam, 1707. Facsimile ed.: Soest, 1969. French translation: *Le grand livre des peintres*. Paris, 1787. Facsimile ed.: Geneva, 1972.

Kaufmann, G. "Studien zum groszen Malerbuch des Gerard de Lairesse," *Jahrbuch für Aesthetik und allgemeine Kunstwissenschaft* 3 (1955–57), pp. 153–96.

Houbraken, A.

Houbraken, A. *De Groote Schouburgh der Nederlantsche Konstschilders en Schilderessen* 3 vols. Amsterdam, 1718–21; The Hague, 1753. Facsimile ed.: Amsterdam, 1976.

Hofstede de Groot, C. *Arnold Houbraken und seine "Groote Schouburgh" kritisch beleuchtet*. The Hague, 1893.

Weyermann, J.C.

Weyermann, J.C. *De Levens-beschryvingen der Nederlandsche Konst-schilders en Konst-schilderessen*. 4 vols. The Hague, 1729–69.

Horst, D.J.H. ter. "De geschriften van Jan Campo Weyerman. Een bibliografische herziening," *Het Boek* 28 (1944), pp. 227–40.

Hanou, A.J. *Jacob Campo Weyerman, Den Vrolycke Tuchtheer (1729)*. 2 vols, Amsterdam, 1978.

Gool, J. van

Gool, J. van. *De Nieuwe Schouburgh der Nederlantsche Kunstschilders en Schilderessen*. 2 vols. The Hague, 1750–51. Facsimile ed.: Soest, 1971.

Descamps, J.B.

Descamps, J.B. *La vie des peintres flamands, allemands et hollandois* 4 vols, Paris, 1753–64.

Eynden, R. van, and Willigen, A. van der

Eynden, R. van, and Willigen, A. van der. *Geschiedenis der vaderlandsche Schilderkunst sedert de Helft der XVIII Eeuw*. 4 vols. Haarlem, 1816–40.

Immerzeel, J., Jr.

Immerzeel, J., Jr. *De Levens en Werken der Hollandsche en Vlaamsche Kunstschilders, Beeldhouwers, Graveurs en Bouwmeesters* 3 vols. Amsterdam, 1842–43.

Kramm, C.

Kramm, C. *De Levens en Werken der Hollandsche en Vlaamsche Kunstschilders, beeldhouwers, graveurs en bouwmeesters*. 6 vols. Amsterdam, 1857–64. Facsimile ed.: Amsterdam, 1974.

Blanc, C.

Blanc, C. *Histoire des peintres de toutes les écoles depuis la Renaissance jusqu'à nos jours. Ecole hollandaise*. 2 vols. Paris, 1867.

Wurzbach, A. von

Wurzbach, A. von. *Niederländisches Künstler-Lexikon*. 3 vols. Vienna/Leipzig, 1906–11.

Thieme, U., and Becker, F.

Thieme, U., and Becker, F. *Allgemeines Lexikon der bildenden Künstler*. 37 vols. Leipzig, 1907–50. Facsimile ed.: Zwickau, 1964.

Waller, F.G.

Waller, F.G. *Biografisch Woordenboek van Noordnederlandsche graveurs*. The Hague, 1938. Facsimile ed.: Amsterdam, 1974.

Hollstein, F.W.H.

Hollstein, F.W.H. *Dutch and Flemish Etchings, Engravings and Woodcuts, ca. 1450–1700*. Vols. I– . Amsterdam, 1949– .

Nijstad, A. *Nederlandse schilders in publikaties vóór 1700: een register*. The Hague, 1978.

See for drawing books III. B. Guild and Training. Bolten, 1979.

VI. Iconography

A. General

Knipping, J.B. *De iconografie van de Contra-Reformatie in de Nederlanden*. 2 vols. Hilversum, 1939–40. English translation: *Iconography of the Counter Reformation in the Netherlands: Heaven on Earth*. 2 vols. Nieuwkoop/Leiden, 1974.

Praz, M. *Studies in Seventeenth-Century Imagery*. 2 vols. London, 1939–47. 2d ed. Rome, 1964.

Kaufmann, H. "Die Fünfsinne in der niederländischen Malerei des 17. Jahrhunderts," *Kunstgeschichtliche Studien*. Breslau, 1944, pp. 133–57.

Pigler, A. *Barockthemen. Eine Auswahl von Verzeichnissen zur Ikonographie des 17. und 18. Jahrhunderts*. 2 vols. Budapest, 1956. 2d ed. 3 vols. 1974.

Heckscher, W.S., and Wirth, K.-A. "Emblem, Emblembuch," *Reallexikon zur deutschen Kunstgeschichte*. 5 vols. Stuttgart, 1967, pp. 85–228.

Jongh, E. de. *Zinne- en minnebeelden in de schilderkunst van de zeventiende eeuw*. N.p., n.d. [Amsterdam, 1967].

Henkel, A., and Schöne, A. *Emblemata, Handbuch zur Sinnbildkunst des XVI. und XVII. Jahrhunderts*. Stuttgart, 1967. Abridged ed. 1978.

Landwehr, J. *Emblem Books in the Low Countries 1554–1949. A Bibliography*. Utrecht, 1970. Reviewed by J. Becker in *Oud Holland* 87 (1973), pp. 142–43, 146–47.

Waal, H. van de. *Decimal Index of the Art of the Low Countries: D.I.A.L.* Abridged 2d ed. The Hague, 1971.

Becker, J. *"Twee susters soet van aert." Zu Wort und Bild in den Niederlanden im 16. und 17. Jahrhundert*. N.p. [Utrecht], 1975.

Freedberg, D. "The Problem of Images in Northern Europe and Its Repercussions in the Netherlands," *Hafnia Copenhagen Papers in the History of Art* (1976), pp. 25–45.

Die Sprache der Bilder. Realität und Bedeutung in der niederländischen Malerei des 17. Jh. Brunswick, 1978 (catalogue of exhibition in the Herzog Anton Ulrich Museum, Brunswick, 1978).

Alpers, S. *The Art of Describing. Dutch Art in the Seventeenth Century*. London, 1983.

See also IV. E. "Realism." Slive, 1962, and de Jongh, 1971.

B. History

Muller, F. *Beredeneerde beschrijving van Nederlandsche historieplaten, zinneprenten en historische kaarten*. Amsterdam, 1863–82. Facsimile ed.: Amsterdam, 1970.

Waal, H. van de. *Drie eeuwen vaderlandsche geschied-uitbeelding, 1500–1800. Een iconologische studie*. 2 vols. The Hague, 1952. Reviewed by J. Bialostocki in *Art Bulletin* 53 (1971), pp. 262–65.

Blankert, A. "Heraclitus en Democritus: in het bijzonder in de Nederlandse kunst van de 17de eeuw," *Nederlands Kunsthistorisch Jaarboek* 18 (1967), pp. 31–124.

Snoep, D.P. "Van Atlas tot last: aspecten van de betekenis van het Atlasmotief," *Simiolus* 2 (1967–68), pp. 6–22.

Landwehr, J. *Splendid Ceremonies. State Entries and Royal Funerals in the Low Countries. 1515–1791. A Bibliography*. Leiden, 1971. Reviewed by J. Becker in *Quaerendo* 7 (1977), pp. 91–97.

Snoep, D.P. *Praal en propaganda. Triumfalia in de Noordelijke Nederlanden in de 16de en 17de eeuw*. Alphen aan den Rijn, 1975.

Bader, A. *The Bible through Dutch Eyes: From Genesis through the Apocrypha*. Wisconsin, 1976 (catalogue of exhibition at the Milwaukee Art Center, Wisconsin, 1976).

Gods, Saints and Heroes; Dutch Painting in the Age of Rembrandt. Washington, D.C., 1980 (catalogue of exhibition at the National Gallery of Art, Washington, D.C., and the Detroit Institute of Arts, 1980–81).

See also VI. E. Peasants and Burghers Figure Paintings. Renger, 1970.

C. Theater and Literature

Gudlaugsson, S.J. *Ikonographische Studien über die holländische Malerei und das Theater des 17. Jahrhunderts*. Würzburg, 1938.

———. "Bredero's Lucelle door eenige zeventiende eeuwsche meesters uitgebeeld," *Nederlands Kunsthistorisch Jaarboek* 1 (1947), pp. 177–95.

———. "Representations of Granida in Dutch Seventeenth Century Painting," *Burlington Magazine* 90 (1948), pp. 226–30, 348–51, and 91 (1949), pp. 39–43.

't Kan verkeren. Gerbrand Adriaensz. Bredero. 1585–1618. Amsterdam, 1968 (catalogue of exhibition at the Amsterdams Historisch Museum, 1968).

Gelder, J.G. van. "Pastor Fido-voorstellingen in de Nederlandse kunst van de zeventiende eeuw," *Oud Holland* 92 (1978), pp. 227–63.

Kettering, A. *The Dutch Arcadia; Pastoral Art and Its Audience in the Golden Age*. Montclair, 1983.

See also VI. E. Peasants and Burghers Figure Paintings. Alpers. 1975–76; VII. Steen. Heppner, 1939–40.

D. (Group) Portraits

Muller, F. *Beschrijvende catalogus van 7000 portretten van Nederlanders* Amsterdam, 1853. Facsimile ed.: Soest, 1972.

Meijer, D.C., Jr. "De Amsterdamsche schutters-stukken in en buiten het nieuwe Rijksmuseum," *Oud Holland* 3 (1885), pp. 108–22; 4 (1886), pp. 198–211, 225–40; 6 (1888) pp. 225–40; and 7 (1889), pp. 45–58.

Someren, J.F. van, ed. *Beschrijvende catalogus van gegraveerde portretten van Nederlanders Vervolg op Frederik Mullers catalogus van 7000 portretten van Nederlanders*. 3 vols. Amsterdam, 1888–91.

Moes, E. *Iconographia Batava; beredeneerde lijst van geschilderde en gebeeldhouwde portretten van Noord-Nederlanders in vorige eeuwen*. 2 vols. Amsterdam, 1897–1905.

Riegl, A. *Das holländische Gruppenporträt*. 2 vols. Vienna, 1931.

Vries, A.B. de. *Het Noord-Nederlandsch portret in de tweede helft van de 16e eeuw*. Amsterdam, 1934.

Staring, A. *De Hollanders thuis. Gezelschapstukken uit drie eeuwen*. The Hague, 1956.

Hall, H. van. *Portretten van Nederlandse beeldende kunstenaars. Repertorium*. Amsterdam, 1963.

Wassenbergh, A. *De portretkunst in Friesland in de zeventiende eeuw*. Lochem, 1967.

Wishnevsky, R. *Studien zum "portrait histoiré" in den Niederlanden*. Munich, 1967.

Haak, B. *Regenten en regentessen, overlieden en chirurgijns. Amsterdamse groepsportretten van 1600 tot 1835*. Amsterdam, 1972. Also in *Antiek* 7 (1972–73), pp. 81–116, 287–302 (catalogue of exhibition at the Amsterdams Historisch Museum, 1972).

Hinz, B. "Studien zur Geschichte des Ehepaarbildnisses," *Marburger Jahrbuch für Kunstwissenschaft* 19 (1974), pp. 139–218.

Gerson, H. *Hollandse portretschilders van de zeventiende eeuw*. Maarssen, 1975.

In het zadel. Het Nederlandse ruiterportret van 1550 tot 1900 (catalogue of exhibition at the Fries Museum, Leeuwarden; the Noordbrabants Museum, 's-Hertogenbosch; and the Provinciaal Museum van Drenthe, Assen, 1979–80).

Smith, D.R. *Masks of Wedlock. Seventeenth Century Dutch Marriage Portraiture*. Ann Arbor, 1982.

Durantini, M.F. *The Child in Seventeenth-Century Dutch Painting*. Ann Arbor, 1983.

E. Peasants and Burghers Figure Paintings

Plietzsch, E. "Randbemerkungen zur holländischen Interieurmalerei am Beginn des 17. Jahrhunderts," *Wallraf-Richartz-Jahrbuch* 18 (1956), pp. 174–96.

Jongh, E. de. "Erotica in vogelperspectief. De dubbelzinnigheid van een reeks 17de eeuwse genrevoorstellingen," *Simiolus* 3 (1968–69), pp. 22–74.

Renger, K. *Lockere Gesellschaft — Zur Ikonographie des Verlorenen Sohnes und von Wirtshausszenen in der niederländischen Malerei*. Berlin, 1970.

Jongh, E. de. "Vermommingen van Vrouw Wereld in de 17de eeuw," *Album Amicorum J.G. van Gelder*. The Hague, 1973, pp. 198–206.

———. "Grape Symbolism in Paintings of the 16th and 17th Centuries," *Simiolus* 7 (1974), pp. 166–91.

Snoep-Reitsma, E. *Verschuivende betekenissen van zeventiende-eeuwse Nederlandse genrevoorstellingen*. Deventer, 1975.

Jongh, E. de. "Pearls of Virtue and Pearls of Vice," *Simiolus* 8 (1975–76), pp. 69–97.

Bedaux, J.B. "Minnekoorts-, zwangerschaps- en doodsverschijnselen op zeventiende-eeuwse schilderijen," *Antiek* 10 (1975–76), pp. 17–42.

Tot Lering en Vermaak. Betekenissen van Hollandse genrevoorstellingen uit de zeventiende eeuw. Amsterdam, 1976 (catalogue of exhibition at the Rijksmuseum, Amsterdam, 1976).

Alpers, S. "Realism as a Comic Mode: Low-Life Painting Seen through Bredero's Eyes," *Simiolus* 8 (1975–76), pp. 115–44. Response by H. Miedema in *Simiolus* 9 (1977), pp. 205–19, and by S. Alpers in *Simiolus* 10 (1978–79), pp. 46–50.

F. Landscape Paintings

Plietzsch, E. *Die Frankenthaler Maler. Ein Beitrag zur Entwickelungsgeschichte der niederländischen Landschaftsmalerei*. Leipzig, 1910. Facsimile ed.: Soest, 1972.

Bengtsson, Å. *Studies on the Rise of Realistic Landscape Painting in Holland 1610–1625*. Figura 3. Stockholm, 1952. Reviewed by J.G. van Gelder in *Burlington Magazine* 95 (1953), p. 314; reply by Bengtsson in *Burlington Magazine* 95 (1953), p. 396.

Veen, P.A.F. van. *De Soeticheydt des Buyten-Levens, vergheselschapt met de Boucken. Het hofdicht als tak van een georgische literatuur*. The Hague, 1960.

Stechow, W. "Significant Dates on Some Seventeenth Century Dutch Landscape Paintings," *Oud Holland* 75 (1960), pp. 79–92.

Beening, T.J. *Het landschap in de Nederlandse letterkunde van de renaissance*. Nijmegen, 1963.

Italy through Dutch Eyes. Dutch Seventeenth Century Landscape Artists in Italy. Ann Arbor, 1964 (catalogue of exhibition at The University of Michigan Museum of Art, Ann Arbor, 1964).

Stechow, W. *Dutch Landscape Painting of the Seventeenth Century*. London, 1966. Rev. eds. 1968 and 1980. Reviewed by E. Snoep-Reitsma and A. Blankert in *Simiolus* 2 (1967–68), pp. 100–103 and 103–8.

Hasselt, C. van. *Dessins de paysagistes hollandais du XVIIe siècle, de la collection particulière conservée à l'Institut néerlandais de Paris*. 2 vols. Brussels, 1968

(catalogue of exhibition at the Bibliothèque Royale Albert Ier, Brussels; the Museum Boymans-van Beuningen, Rotterdam; the Institut Néerlandais, Paris; and the Kunstmuseum, Bern, 1968–69).

Franz, H.G. *Niederländische Landschaftsmalerei im Zeitalter des Manierismus.* 2 vols. Graz, 1969.

Larsen, E. "The Proof of the Use of Inverted Telescope in Dutch 17th Century Landscape Art," *Gazette des Beaux Arts* 6th s. 119/89 (1977), pp. 172–74.

Blankert, A. *Nederlandse 17e-eeuwse italianiserende landschapschilders / Dutch 17th Century Italianate Landscape Painters.* Soest, 1978 (revised and enlarged edition of catalogue of exhibition at the Centraal Museum, Utrecht, 1965). Original edition reviewed by E. Brochhagen in *Kunstchronik* 18 (1965), pp. 177–85.

Bergvelt, E. "Het Hollandse landschap in de kunst,"*Het land van Holland. Ontwikkelingen in het Noord- en Zuidhollandse landschap.* N.p., 1978, pp. 135–56 (catalogue of exhibition at the Amsterdams Historisch Museum, 1978). Also in *Holland* 10 (1978), pp. 135–56.

Spickernagel, E. "Holländische Dorflandschaften im frühen 17. Jahrhundert," *Städel-Jahrbuch* n.s. 7 (1979), pp. 133–48.

Raupp, H.-J. "Zur Bedeutung und Symbol für die holländische Landschaftsmalerei des 17. Jahrhunderts," *Jahrbuch der Staatlichen Kunstsammlungen in Baden-Württemberg* 17 (1980), pp. 85–110.

Schloss, C.S. *Travel, Trade, and Temptation. The Dutch Italianate Harbor Scene, 1640–1680.* Ann Arbor, 1982.

G. Marine Paintings

Willis, F.C. *Die niederländische Marinemalerei.* Leipzig, n.d. [1911].

Preston, L. *Sea and River Painters of the Netherlands in the Seventeenth Century.* London, 1937.

Bol, L.J. *Die holländische Marinemalerei des 17. Jahrhunderts.* Brunswick, 1973.

H. Architectural Paintings

Jantzen, H. *Das niederländische Architekturbild.* Leipzig, 1910.

Fritz, R. *Das Stadt- und Strassenbild in der holländischen Malerei des 17. Jahrhunderts.* N.p., n.d.

Nederlandse achitectuurschilders 1600–1900. Utrecht, 1953 (catalogue of exhibition at the Centraal Museum, Utrecht, 1953).

Roosegaarde Bisschop, G. "De geschilderde maquette in Nederland," *Nederlands Kunsthistorisch Jaarboek* 7 (1956), pp. 167–217.

Ballegeer, J.P.C.M. "Enkele voorbeelden van de invloed van Hans en Paulus Vredeman de Vries op de architectuurschilders in de Nederlanden gedurende de XVIe en XVIIe eeuw," *Gentse Bijdragen tot de Kunstgeschiedenis en de Oudheidkunde* 20 (1967), pp. 55–70.

Koslow, S. "De wonderlijke Perspectyfkas: an Aspect of Seventeenth Century Dutch Painting," *Oud Holland* 82 (1967), pp. 35–56.

Wheelock, A.K., Jr. *Perspective, Optics and Delft Artists around 1650.* New York/London, 1977. Reviewed by W.A. Liedtke in *Art Bulletin* 61 (1979), pp. 490–96.

Opkomst en bloei van het Noordnederlandse stadsgezicht in de 17de eeuw / The Dutch Cityscape in the 17th Century and Its Sources. Amsterdam/Toronto, 1977 (catalogue of exhibition at the Amsterdams Historisch Museum and the Art Gallery of Ontario, Toronto, 1977–78). Reviewed by L. de Vries in *Simiolus* 9 (1977), pp. 187–89.

Liedtke, W.A. *Architectural Painting in Delft. Gerard Houckgeest, Hendrik van Vliet, Emanuel de Witte.* Doornspijk, 1982.

J. Still Lifes

Warner, R. *Dutch and Flemish Flower and Fruit Painters of the XVIIth and XVIIIth Centuries.* Amsterdam, 1928. 2d rev. ed. 1975.

Vorenkamp, A.P.A. *Bijdrage tot de geschiedenis van het Hollandsch stilleven in de zeventiende eeuw.* Leiden, 1933.

Gelder, J.G. van. "Van Blompot en Blomglas," *Elsevier's Geïllustreerd Maandschrift* 46/91 (1936), pp. 73–82, 155–66.

Vroom, N.R.A. *De schilders van het monochrome banketje.* Amsterdam, 1945.

———. *A Modest Message as Intimated by the Painters of the "Monochrome Banketje."* Amsterdam, 1945. Rev. and enl. ed. (2 vols) Schiedam, 1980.

Gelder, J.G. van. *Catalogue of the Collection of Dutch and Flemish Still-Life Pictures Bequeathed by Daisy Linda Ward.* Ashmolean Museum. Oxford, 1950.

Bergström, I. *Dutch Still-Life Painting in the Seventeenth Century.* New York, 1956. Reviewed by J.R. Martin in *Art Bulletin* 40 (1958), pp. 272–74.

———, and Wurfbain, M.L. *IJdelheid der ijdelheden. Hollandse Vanitas-voorstellingen uit de zeventiende eeuw.* Leiden, 1970 (catalogue of exhibition at De Lakenhal, Leiden, 1970).

Stilleben in Europa. Münster/Baden-Baden, 1979 (catalogue of exhibition at het Westfälisches Landesmuseum, Münster, and the Staatliche Kunsthalle, Baden-Baden, 1979–80).

Emmens, J.A. "'Eins aber ist nötig': Zu Inhalt und Bedeutung von Markt- und Küchenstücken des 16. Jahrhunderts," *Kunsthistorische Opstellen,* vol. 2. Amsterdam, 1981, pp. 189–222.

Jongh, E. de, et al. *Still-Life in the Age of Rembrandt.* Auckland, 1982 (catalogue of exhibition at the Auckland City Art Gallery, 1982).

K. Music

Fischer, P. *Music in Paintings of the Low Countries in the 16th and 17th Centuries.* Amsterdam, 1972.

Raupp, H.-J. "Musik im Atelier. Darstellungen musizierender Künstler in der niederländischen Malerei des 17. Jahrhunderts," *Oud Holland* 92 (1978), pp. 106–29.

VII. Artists in Alphabetical Order
(See for Hofstede de Groot's *Catalogue Raisonné,* IV. B. General.)

Aelst, Willem van

Bredius, A. "Archiefsprokkelingen. Enkele gegevens over Willem van Aelst," *Oud Holland* 54 (1937), pp. 266–67.

Aertsen, Pieter

Kreidl, D. "Die religiöse Malerei Pieter Aertsens als Grundlage seiner künstlerischen Entwicklung," *Jahrbuch der Kunsthistorischen Sammlungen in Wien* 68/n.s. 32 (1972), pp. 43–108.

Grosjean, A. "Toward an Interpretation of Pieter Aertsen's Profane Iconography," *Konsthistorisk Tidskrift* 43 (1974), pp. 121–43.

Moxey, K.P.F. *Pieter Aertsen, Joachim Beuckelaer, and the Rise of Secular Painting in the Context of the Reformation.* New York/London, 1977.

Genaille, R. "Pieter Aertsen, précurseur de l'art Rubénien," *Jaarboek van het Koninklijk Museum voor Schone Kunsten Antwerpen* 17 (1977), pp. 7–96.

Aertsz, Hendrick

Daniëls, G.L.M. "Kerkgeschiedenis en politiek in het perspectief van Hendrick Aerts," *Antiek* 9 (1974–75), pp. 63–69.

Angel, Philips

Bol, L.J. "Philips Angel van Middelburg en Philips Angel van Leiden," *Oud Holland* 64 (1949), pp. 2–19.

See also V. B. Sources and Biographical Lexica. Angel, 1642.

Anraedt, Pieter van

Hoetink, H.R. "Beschouwingen naar aanleiding van een unicum," *Boymans Bijdragen; opstellen van medewerkers en oud-medewerkers van het Museum Boymans-van Beuningen voor J.C. Ebbinge Wubben.* Rotterdam, 1978, pp. 104–10.

Anthonisz, Cornelis

Dubiez, F.J. *Cornelis Anthoniszoon van Amsterdam; zijn leven en werken ca. 1507–1553.* Amsterdam, 1969. Reviewed by E. de Jongh in *Vrij Nederland,* November 15, 1969, p. 9.

Arentsz, Arent, called Cabel

Poensgen, G. "Arent Arentsz. (genannt Cabel) und sein Verhältnis zu Hendrik Avercamp," *Oud Holland* 41 (1923–24), pp. 116–35.

Eeghen, I.H. van. "Meerhuizen of de Pauwentuin en Arent Arentsz., genaamd Cabel," *Maandblad Amstelodamum* 54 (1967), pp. 219–21.

———. "Nogmaals de Pauwentuin," *Maandblad Amstelodamum* 55 (1968), pp. 43–46.

Asselijn, Jan

Steland-Stief, A.C. "Jan Asselyn und Willem Schellinks," *Oud Holland* 79 (1964), pp. 99–110.

———. *Jan Asselyn. Nach 1610 bis 1652.* Amsterdam, 1971. Reviewed by M. Roethlisberger in *Art Bulletin* 54 (1972), pp. 553–55.

———. "Zum zeichnerischen Werk des Jan Asselyn. Neue Funde und Forschungsperspektiven," *Oud Holland* 94 (1980), pp. 213–58.

Assteyn, Bartholomeus

Bol, L.J. "Bartholomeus Assteijn, Dordts schilder van blommen en fruyten," *Oud Holland* 68 (1953), pp. 136–48.

Ast, Balthasar van der

Bol, L.J. "Een Middelburgse Brueghel-groep, III: In Bosschaerts spoor: Balthasar van der Ast …," *Oud Holland* 70 (1955), pp. 138–54.

Avercamp, Barent and Hendrick

Welcker, C.J. *Hendrick Avercamp 1585–1634, bijgenaamd "de stomme van Campen" en Barent Avercamp 1612–1679, "schilders tot Campen."* Zwolle, 1933, New ed., oeuvre catalogue revised by D.J. Hensbroek-van der Poel (up to and including 1976). Doornspijk, 1979.

Baburen, Dirck van

Slatkes, L.J. *Dirck van Baburen (c. 1595–1624), a Dutch Painter in Utrecht and Rome.* Utrecht, 1965.

———. "Additions to Dirck van Baburen," *Album Amicorum J.G. van Gelder.* The Hague, 1973, pp. 267–73.

Backer, Jacob

Bauch, K. *Jakob Adriaensz. Backer. Ein Rembrandtschüler aus Friesland.* Berlin, 1926.

Wijnman, H.F. "De afkomst van Jacob en Adriaen Backer," *Oud Holland* 43 (1926), pp. 289–92.

Badens, Frans

Faggin, G.T. "Frans Badens (il Carracci di Amsterdam)," *Arte veneta* 23 (1969), pp. 131–44.

Bailly, David

Bruyn, J. "David Bailly, 'fort bon peintre en pourtraicts et en vie coye,'" *Oud Holland* 66 (1951), pp. 148–64, 212–27.

Popper-Voskuil, N. "Selfportraiture and Vanitas Still-Life Painting in 17th-Century Holland in Reference to David Bailly's Vanitas Oeuvre," *Pantheon* 31 (1973), pp. 58–74.

Baar, P.J.M. de. "Het overlijden van David Bailly," *Oud Holland* 87 (1973), pp. 239–40.

———. "Van Constschilder tot Schafmeester," *Oud Holland* 89 (1975), pp. 63–64.

Bakhuysen, Ludolf

Hofstede de Groot. *Catalogue Raisonné.* Vol. 7, pp. 211–322.

Kellen Dzn., J.P. van der. "De geboorte-, de sterf- en de begrafenisdata van Ludolf Backhuizen (28.12.1631, 7 en 12.ii.1708) en eenige bijzonderheden omtrent zijn begrafenis," *Oud Holland* 34 (1916), pp. 242–44.

Barendsz, Dirck

Judson, J.R. *Dirck Barendsz. 1534–1592.* Amsterdam, 1970. Reviewed by M. Roethlisberger in *Art Bulletin* 54 (1972), pp. 553–55.

Bassen, Bartholomeus van

Staring, A. "Een raadselachtige kamerbeschildering," *Bulletin van het Rijksmuseum* 13 (1965), pp. 3–13.

Beeck, Jan van der, called Torrentius

Bredius, A. *Johannes Torrentius. Schilder. 1589–1644.* The Hague, 1909.

Rehorst, A.J. *Torrentius.* Rotterdam, 1939.

Steur, A.G. van der. "Johannes Torrentius," *Spiegel Historiael* 2 (1967), pp. 217–24.

Beeldemaker, Adriaen
Veth, G.H. "Aanteekeningen omtrent eenige Dordrechtsche schilders. Aanvulling en verbetering," *Oud Holland* 21 (1903), pp. 111–12.

Beerstraaten, Jan (Johannes)
Oldewelt, W.F.H. "De schilder Johannes Abrahams Beerstraten en zijn naaste familieleden," *Jaarboek Amstelodamum* 35 (1938), pp. 81–87.

Beert, Osias
Hairs, M.-L. "Osias Beert l'Ancien, peintre de fleurs," *Revue belge d'Archéologie et d'Histoire de l'Art* 20 (1951), pp. 237–51.

Bega, Cornelis
Begheyn, P.J. "Biografische gegevens betreffende de Haarlemse schilder Cornelis Bega (ca. 1632–1664) en zijn verwanten," *Oud Holland* 93 (1979), pp. 270–78.

Begeyn, Abraham
See Berchem, Claes.

Bellevois, Jacob
Haverkorn van Rijsewijk, P. "Bellevois. Jacob," *Oud Holland* 9 (1891), pp. 52–55.

Berchem, Claes
Schaar, E. "Berchem und Begeijn," *Oud Holland* 69 (1954), pp. 241–54.
———. *Studien zu Nicolaes Berchem*. Cologne, 1958.
Schatborn, P. "Figuurstudies van Nicolaes Berchem," *Bulletin van het Rijksmuseum* 22 (1974), pp. 3–16.

Berckheyde, Job
Stechow, W. "Job Berckheyde's 'Bakery Shop'" *Allen Memorial Art Museum Bulletin* 15 (1957), pp. 4–14.

Berghe, Christoffel van den
Bol, L.J. "Een Middelburgse Brueghel-groep, V: Christoffel van den Berghe: bloemen en landschap; recuperatie voor een schilder die zijn oeuvre verloor," *Oud Holland* 71 (1956), pp. 183–95.

Beuckelaer, Joachim
Moxey, K.P.F. "The 'Humanist' Market Scenes of Joachim Beuckelaer: Moralizing Exempla or 'Slices of Life'?," *Jaarboek van het Koninklijk Museum voor Schone Kunsten Antwerpen* 16 (1976), pp. 109–87.
Kreidl, D. "Joachim Beuckelaer und der Monogrammist HB," *Oud Holland* 90 (1976), pp. 162–83.
See also Aertsen, Pieter.

Beyeren, Abraham van
See Heda, Willem Claesz.

Bijlert, Jan van
Hoogewerff, G.J. "Jan van Bijlert, schilder van Utrecht (1598–1671)," *Oud Holland* 80 (1965), pp. 3–33.

Biltius, Jacob
Renckens, B.J.A. "Enkele archivalia en opmerkingen over Jacobus en Cornelis Biltius," *Oud Holland* 68 (1953), pp. 238–41.

Bisschop, Cornelis
Brière-Misme, C. "Un petit maître hollandais: Cornelis Bisschop (1630–1674)," *Oud Holland* 65 (1950), pp. 24–40, 104–16, 139–51, 178–92, 227–40.
———. "Notes complémentaires sur Cornelis Bisschop I/II," *Oud Holland* 67 (1952), p. 181, and 68 (1953), pp. 184–86.

Bisschop, Jan de
Gelder, J.G. van. "Jan de Bisschop 1628–1671," *Oud Holland* 86 (1971), pp. 201–88.

Blanckerhoff, Jan Teunisz
Roever, N. de. "Nadere bijzonderheden betreffende Jan Teunisz Blanckerhoff (Jan-Maat)," *Oud Holland* 1 (1883), pp. 86–91.

Bloemaert, Abraham
Müller, C. "Abraham Bloemaert als Landschafts-maler," *Oud Holland* 44 (1927), pp. 193–208.
Delbanco, G. *Der Maler Abraham Bloemaert (1564–1651)*. Strasbourg, 1928.

Bloot, Pieter de
Haverkorn van Rijsewijk, P. "Pieter de Bloot," *Oud Holland* 9 (1891), pp. 62–68.

Boelema, Maerten, called The Mute
Wassenbergh, A. "Een vroeg stilleven van Maerten Boelema de Stomme," *De Vrije Fries* 46 (1964), pp. 110–204.

Bol, Ferdinand
Blankert, A. *Ferdinand Bol 1616–1680. Een leerling van Rembrandt*. The Hague, n.d. [1976]. Reviewed by J. Bruyn in *Oud Holland* 97 (1983), pp. 208–16.
See also III. C. Patron, Collector, and Art Dealer. Blankert, 1975.

Bor, Paulus
Plietzsch, E. "Paulus Bor," *Jahrbuch der Königlich Preussischen Kunstsammlungen* 37 (1916), pp. 105–15.
Bloch, V. "Zur Malerei des Paulus Bor," *Oud Holland* 45 (1928), pp. 22–26.
———. "Orlando," *Oud Holland* 64 (1949), pp. 104–8.
Gudlaugsson, S.J. "Paulus Bor als portrettist," *Miscellanea I.Q. van Regteren Altena*. Amsterdam, 1969, pp. 120–22.
Moltke, J.W. von. "Die Gemälde des Paulus Bor von Amersfoort," *Westfalen* 55 (1977), pp. 147–61.

Borch, Gerard Ter
Gudlaugsson, S.J. *Gerard ter Borch*. 2 vols. The Hague, 1959–60.
Genders, C.J.A. "De bevestiging van de Vrede van Munster, 1648, door Gerard ter Borch," *Spiegel Historiael* 8 (1973), pp. 642–50.
Gerard Ter Borch: Zwolle 1617–Deventer 1681. The Hague, 1974 (catalogue of exhibition at the Mauritshuis, The Hague, 1974). German translation: Münster, 1974 (catalogue of exhibition at the Landesmuseum, Münster, 1974).

Borch, Gesina Ter
Vos, J. "Gesina Ter Borch: schilderes, dichteres en model (1631–1690)," *Overijssel. Jaarboek voor cultuur en historie* 14 (1960), pp. 22–43.

Bosschaert, Abraham and Ambrosius, the Elder and the Younger
Bol, L.J. *The Bosschaert Dynasty, Painters of Flowers and Fruits*. Leigh-on-Sea, 1960.
———. "'Goede onbekenden.' Hedendaagse herkenning en waardering van verschoten, voorbijgezien en onderschat talent. VIII: Schilders van het vroege Nederlandse bloemstuk met kleingedierte als bijwerk (vervolg) Ambrosius Bosschaert de Jonge (1609–1645)," *Tableau* 3 (1980–81), pp. 642–48.

Both, Andries and Jan
Waddingham, M.R. "Andries and Jan Both in France and Italy," *Paragone* n.s. 15 (1964), N. 171, pp. 13–43.
Haverkamp Begemann, E. "The Youthful Work of Andries Both: His Landscape Drawings," *Tribute to Wolfgang Stechow*. New York, 1976, pp. 88–95.
Burke, J.D. *Jan Both: Paintings, Drawings and Prints*. New York/London, 1976. Reviewed by E.J. Sluijter in *Oud Holland* 91 (1977), pp. 296–97.

Boursse, Esaias
Brière-Misme, C. "Un 'intimiste' hollandais Esaias Boursse, 1631–1672," *Oud Holland* 69 (1954), pp. 18–30, 72–91, 150–66, 213–21.
See also Vrel, Jacobus.

Bramer, Leonard
Wichmann, H. *Leonaert Bramer. Sein Leben und seine Kunst. Ein Beitrag zur Geschichte der holländischen Malerei zur Zeit Rembrandts*. Leipzig, 1923.
Peer, A.J.J.M. van. "Leonard Bramer, leermeester van Jan Vermeer?" *Oud Holland* 74 (1959), pp. 241–43.

Bray, Jan and Salomon de
Moltke, J.W. von. "Jan de Bray," *Marburger Jahrbuch für Kunstwissenschaft* 11/12 (1938–39), pp. 421–523.
———. "Salomon de Bray," *Marburger Jahrbuch für Kunstwissenschaft* 11/12 (1938–39), pp. 309–420.
Bloch, V. "Haarlemer Klassizisten," *Oud Holland* 57 (1940), pp. 14–21.
Marel, A. van der. "De kunstschilders De Bray en hun familie," *De Nederlandsche Leeuw* 81 (1964), pp. 6–26.
Taverne, E.R.M. "Salomon de Bray's ontwerp voor de drinkhoorn van Het Loffelijke Gilde van St. Hubert te Haarlem," *Nederlands Kunsthistorisch Jaarboek* 23 (1972), pp. 261–72.

See also III. B. Guild and Training. Taverne, 1972–73.

Breenbergh, Bartholomeus
Stechow, W. "Bartholomeus Breenbergh, Landschafts- und Historienmaler," *Jahrbuch der Preussischen Kunstsammlungen* 51 (1930), pp. 133–40.
Roethlisberger, M. *Bartholomäus Breenbergh, Handzeichnungen*. Berlin, 1969.
Nalis, H.J. "Bartholomeus Breenbergh: aantekeningen over zijn leven en verwanten," *Vereeniging tot Beoefening van Overijsselsch Regt en Geschiedenis. Verslagen en Mededelingen* 87 (1972), pp. 62–81.
Roethlisberger, M. *Bartholomeus Breenbergh: the Paintings*. Berlin/New York, 1981. Reviewed by N. Sluijter-Seijffert in *Oud Holland* 96 (1982), pp. 69–72.
See also Poelenburgh, Cornelis van.

Bronckhorst, Jan van
Hoogewerff, G.J. "Jan Gerritsz. en Jan Jansz. van Bronckhorst, schilders van Utrecht," *Oud Holland* 74 (1959), pp. 139–60.
Judson, J.R. "Allegory of Dawn and Night," *Wadsworth Atheneum Bulletin* 6/2/2 (1966), pp. 1–11.

Brouwer, Adriaen
Höhne, E. *Adriaen Brouwer*. Leipzig, 1960.
Knuttel, G. *Adriaen Brouwer; the Master and His Work*. The Hague, 1962.

Brugghen, Hendrick Ter
Nicolson, B. *Hendrick Terbrugghen*. London, 1958. Reviewed by J.R. Judson in *Art Bulletin* 43 (1961), pp. 341–48.
Slatkes, L.J. *Hendrik Terbrugghen in America*. Dayton, 1965 (catalogue of exhibition at the Dayton Art Institute, 1965, and the Baltimore Museum, 1966).
Thiel, P.J.J. van. "De aanbidding der koningen en ander vroeg werk van Hendrick ter Brugghen," *Bulletin van het Rijksmuseum* 19 (1971), pp. 91–116.
Nicolson, B. "Terbrugghen since 1960," *Album Amicorum J.G. van Gelder*. The Hague, 1973, pp. 237–41.
Jong, E. de. *Een schilderij centraal; de Slapende Mars van Hendrick ter Brugghen*. Utrecht, 1980 (catalogue of exhibition at the Centraal Museum, Utrecht, 1980).

Burgh, Hendrick van den
Goldscheider, L. "Vermeers Lehrer," *Pantheon* 22 (1964), pp. 35–38.
Sutton, P. "Hendrick van der Burch," *Burlington Magazine* 122 (1980), pp. 315–26.

Buytewech, Willem
Haverkamp Begemann, E. *Willem Buytewech*. Amsterdam, 1959.
Willem Buytewech 1591–1624. Rotterdam, 1974 (catalogue of exhibition at the Museum Boymans-van Beuningen, Rotterdam, 1974–75). French translation: Paris, 1975 (catalogue of exhibition at the Institut Néerlandais, Paris, 1975).

Cabel, see Arentsz, Arent

Calraet, Abraham
Dalen, J.L. van. "De familie Van Calraet," *Oud Holland* 42 (1925), pp. 172–75.
Bol, L.J. "'Goede onbekenden,' II: Van Calraet en Susenier," *Tableau* 2 (1979–80), pp. 188–94.

Campen, Jacob van
Swillens, P.T.A. *Jacob van Campen, schilder en bouwmeester 1595–1657*. Assen, 1961. Facsimile ed.: Arnhem, 1979.

Camphuysen, Jochem and Rafael
Bachmann, F. "Die Brüder Rafael und Jochem Camphuysen und ihr Verhältnis zu Aert van der Neer," *Oud Holland* 85 (1970), pp. 243–50.
———. *Der Landschaftsmaler Rafael Govertsz. Camphuysen. Anhang: zwei noch unbekannte Maler aus der Familie Camphuysen*. Munich, 1980.

Cappelle, Jan van de
Bredius, A. "De schilder Johannes van de Cappelle," *Oud Holland* 10 (1892), pp. 26–40, 133–36.
Russell, M. *Jan van de Cappelle, 1624–1679*. Leigh-on-Sea, 1975.

Claesz, Pieter
Thiel, P.J.J. van. "Een stilleven door Pieter Claesz," *Bulletin van het Rijksmuseum* 23 (1975), pp. 119–21.

Codde, Pieter

Dozy, C.M. "Pieter Codde, de schilder en de dichter," *Oud Holland* 2 (1884), pp. 34–67.

Bredius, A. "Iets over Pieter Codde en Willem Duyster," *Oud Holland* 6 (1888), pp. 187–94.

Brandt, P., Jr. "Notities over het leven en werk van den Amsterdamschen schilder Pieter Codde," *Historia* 12 (1947), pp. 27–37.

Béguin, S. "Pieter Codde et Jacob Duck," *Oud Holland* 67 (1952), pp. 112–16.

Coninxloo, Gillis van

Laes, A. "Gillis van Coninxloo, rénovateur du paysage flamand au XVIe siècle," *Annuaire des Musées Royaux des Beaux-Arts de Belgique* 2 (1939), pp. 109–22.

Franz, H.G. "De boslandschappen van Gillis van Coninxloo en hun voorbeelden," *Bulletin Museum Boymans-van Beuningen* 14 (1963), pp. 66–85.

Coornhert, Dirck Volkertsz

Markx-Veldman, I. "Een serie allegorische prenten van Coornhert met een ontwerptekening van Maarten van Heemskerck," *Bulletin van het Rijksmuseum* 19 (1971), pp. 70–76.

Bonger, H. *Leven en werk van D.V. Coornhert.* Amsterdam, 1978.

Coorte, Adriaen

Bol, L.J. "Adriaen Coorte, stillevenschilder," *Nederlands Kunsthistorisch Jaarboek* 4 (1952–53), pp. 193–232.

———. *Adriaen Coorte: a Unique Late Seventeenth Century Dutch Still-Life Painter.* Assen, 1977.

Coques, Gonzales

See Willeboirts, Thomas, and III. C. Patron, Collector, and Art Dealer. Duverger, 1972.

Cornelisz van Haarlem, Cornelis

Stechow, W. "Cornelis van Haarlem en de Hollandsche laat-maniëristische schilderkunst," *Elsevier's Geïllustreerd Maandschrift* 45/90 (1935), pp. 73–91.

Bruyn, J. "Een keukenstuk van Cornelis Cornelisz. van Haarlem," *Oud Holland* 66 (1951), pp. 45–50.

Thiel, P.J.J. van. "Cornelis Cornelisz. van Haarlem as a Draughtsman," *Master Drawings* 3 (1965), pp. 123–54.

Couwenbergh, Christiaen van

Gelder, J.G. van. "De schilders van de Oranjezaal," *Nederlands Kunsthistorisch Jaarboek* 2 (1948–49), pp. 118–64.

Brière-Misme, C. "L'énigme du maître C.B.," *La Revue des Arts* 4 (1954), pp. 143–52.

———. "De nouveau le maître C.B.," *La Revue des Arts* 5 (1955), pp. 231–37.

Cronenburg, Adriaen van

Marlier, G. "Un portraitiste frison du XVIe siècle. Anna ou Adriaen van Cronenburch," *Oud Holland* 51 (1934), pp. 1–10.

Croos, Antonie van

Belonje, J. "Iets over de schilders Anthony en Pieter van der Croos," *Oud Holland* 66 (1951), pp. 234–39.

———. "Meer over Anthony Jansz. van der Croos," *Oud Holland* 82 (1967), pp. 63–65.

Cuylenburch, Johannes van

Verbeek, J. "Johannes van Cuylenburch en zijn vader Gerrit Lambertsz," *Oud Holland* 70 (1955), pp. 67–81.

Cuyp, Aelbert

Reiss, S. *Aelbert Cuyp.* London/Boston, 1975.

Veerman, W.; Groot, J.M. de; and Gelder, J.G. van. *Aelbert Cuyp en zijn familie, schilders te Dordrecht.* Dordrecht, 1977 (catalogue of exhibition in the Dordrechts Museum, 1977–78).

Cuyp, Benjamin

Boström, K. "Benjamin Gerritsz. Cuyp," *Konsthistorisk Tidskrift* 13 (1944), pp. 59–74.

Ember, I. "Benjamin Gerritsz. Cuyp (1612–1652)," *Acta Historiae Artium* 25 (1979), pp. 89–141; "II. Benjamin Cuyp, der Genremaler," *Acta Historiae Artium* 26 (1980), pp. 37–73.

Delen, Dirck van

Blade, T.T. *The Paintings of Dirck van Delen.* Minnesota, 1976.

Delff, Jacob Willemsz and Willem Jacobsz

Franken Dz., D. *L'Oeuvre de Willem Jacobszoon Delff.* Amsterdam, 1872.

Riemsdijk, B.W.F. van. "De portretten van Jacob Willemsz Delf, en zijne drie zoonen," *Oud Holland* 12 (1894), pp. 233–37.

Haverkorn van Rijsewijk, P. "De kunstenaarsfamilie Delff," *Oud Holland* 18 (1900), pp. 190–92.

See also Miereveld, Michiel van.

Diepenbeek, Abraham van

See III. C. Patron, Collector, and Art Dealer. Duverger, 1972.

Doomer, Lambert

Schulz, W. *Lambert Doomer 1624–1700. Leben und Werke.* 2 vols. Berlin, 1972.

———. "Lambert Doomer als Maler," *Oud Holland* 92 (1978), pp. 69–105.

See also Schellinks, Willem.

Dou, Gerrit

Martin, W. *Het leven en de werken van Gerrit Dou beschouwd in verband met het schildersleven van zijn tijd.* Leiden, 1901. English translation: *Gerard Dou.* London, 1902.

———. *Gerard Dou. Des Meisters Gemälde.* Stuttgart/Berlin, 1913.

Snoep-Reitsma, E. "De Waterzuchtige Vrouw van Gerard Dou en de betekenis van de lampetkan," *Album Amicorum J.G. van Gelder.* The Hague, 1973, pp. 285–92.

Emmens, J.A. "Natuur, Onderwijzing en Oefening. Bij een drieluik van Gerrit Dou. *Kunsthistorische opstellen* 2. Amsterdam, 1981, pp. 5–22.

Droochsloot, Joost Cornelisz

Luttervelt, R. van. "Joost Cornelisz. Droochsloot en zijn werken voor het Sint Barbara en Laurentius Gasthuis te Utrecht," *Nederlands Kunsthistorisch Jaarboek* 1 (1947), pp. 113–36.

Drost, Willem

Valentiner, W.R. "Willem Drost, Pupil of Rembrandt," *Art Quarterly* 2 (1939), pp. 294–325.

Pont, D. "De composities 'Ruth en Naomi' te Bremen en te Oxford. Toeschrijving aan Willem Drost," *Oud Holland* 75 (1960), pp. 205–21.

Sumowski, W. "Beiträge zu Willem Drost," *Pantheon* 27 (1969), pp. 372–83.

Dubois, Guillam

Giltay, J. "Guillam Du Bois als tekenaar," *Oud Holland* 91 (1977), pp. 144–65.

Duck, Jacob

Welu, J.A. "Card Players and Merrymakers: a Moral Lesson," *Worcester Art Museum Bulletin* 4 (1975), pp. 8–16.

See also Codde, Pieter.

Dujardin, Carel, see Jardin, Carel Du

Dusart, Cornelis

Trautscholdt, E. "Beiträge zu Cornelis Dusart," *Nederlands Kunsthistorisch Jaarboek* 17 (1966), pp. 171–200.

Duyster, Willem

See Codde, Pieter.

Eckhout, Albert

Thomsen, T. *Albert Eckhout, ein niederländischer Maler und sein Gönner Moritz der Brasilianer; ein Kulturbild aus dem 17. Jahrhundert.* Copenhagen, 1938.

Gelder, H.E. van. "Twee Braziliaanse schildpadden door Albert Eckhout," *Oud Holland* 75 (1960), pp. 5–30.

Nijstad, S. "Johan Maurits, Albert Eckhout en de gezant van Sonho," *Tableau* 2 (1979–80), pp. 80–85.

Eeckhout, Gerbrand van den

Sumowski, W. "Gerbrand van den Eeckhout als Zeichner," *Oud Holland* 77 (1962), pp. 11–39.

Roy, R. *Studien zu Gerbrand van den Eeckhout.* Vienna, 1972 (typescript).

Eliasz, Nicolaes, called Pickenoy

Six, J. "Nicolaes Eliasz. Pickenoy," *Oud Holland* 4 (1886), pp. 81–108.

Elinga, Pieter Janssens

Hofstede de Groot, C. "De schilder Janssens, een navolger van Pieter de Hooch," *Oud Holland* 9 (1891), pp. 266–96.

Brière-Misme, C. "A Dutch Intimist. Pieter Janssens Elinga," *Gazette des Beaux Arts* 6th s. 89/31 (1947 I), pp. 89–102, 151–64; 89/32 (1947 2), pp. 159–76; 90/33 (1948 I), pp. 347–66.

Essen, Hans van

Beuningen, H.J.E. van. "Notities bij een stilleven van Hans van Essen," *Boymans Bijdragen; opstellen van medewerkers en oud-medewerkers van het Museum Boymans-van Beuningen voor J.C. Ebbinge Wubben.* Rotterdam, 1978, pp. 36–43.

Everdingen, Allart van

Davies, A.I. *Allart van Everdingen.* New York/London, 1978.

Everdingen, Caesar Boetius van

Bloch, V. "Pro Caesar Boetius van Everdingen," *Oud Holland* 53 (1936), pp. 256–62.

Fabritius, Barend

Pont, D. *Barent Fabritius, 1624–1673.* Utrecht, 1958.

Sumowski, W. "Zum Werk von Barend und Carel Fabritius," *Jahrbuch der Staatlichen Kunstsammlungen in Baden-Württemberg* 1 (1964), pp. 188–98.

Liedtke, W.A. "The Three 'Parables' by Barent Fabritius with a Chronological List of His Paintings from 1660 Onward," *Burlington Magazine* 119 (1977), pp. 316–27.

Fabritius, Carel

Wijnman, H.F. "De schilder Carel Fabritius (1622–1654). Een reconstructie van zijn leven en werken," *Oud Holland* 48 (1931), pp. 100–141.

Schuurman, K.E. *Carel Fabritius.* Amsterdam, n.d. [1947].

Wheelock, A.K., Jr. "Carel Fabritius: Perspective and Optics in Delft," *Nederlands Kunsthistorisch Jaarboek* 24 (1973), pp. 63–83.

Brown, C. *Carel Fabritius. Complete Edition with a Catalogue Raisonné.* Oxford, 1981.

See also Fabritius, Barend, and Hoogstraeten, Samuel van.

Feddes, Pieter

Vorenkamp, A.P.A., and Wassenbergh, A. "Pieter Feddes Harlingensis. Zeventiende-eeuwsche schilderkunst in Friesland," *Oud Holland* 57 (1940), pp. 1–13.

Flinck, Govert

Bruyn Kops, C.J. de. "Vergeten zelfportretten van Govert Flinck en Bartholomeus van der Helst," *Bulletin van het Rijksmuseum* 13 (1965), pp. 20–29.

Moltke, J.W. von. *Govaert Flinck 1615–1660.* Amsterdam, 1965.

Govert Flinck, der Kleefsche Apelles, 1616–1660. Gemälde und Zeichnungen. Cleves, 1965 (catalogue of exhibition at Haus Koekkoek, Cleves, 1965).

See also II. B. Towns. Fremantle, 1959, and Buchbinder-Green, 1976.

Geel, Jacob van

Müller, C., and Regteren Altena, I.Q. van. "Der Maler Jacob van Geel," *Jahrbuch der Preuszischen Kunstsammlungen* 52 (1931), pp. 182–200.

Bol, L.J. "Een Middelburgse Brueghel-groep, VI: Jacob Jacobsz. van Geel (1584/85–1638 of later)," *Oud Holland* 72 (1957), pp. 20–40.

Geest, Wybrand de

Wassenbergh, A. "Wybrand Simonsz. de Geest," *De portretkunst in Friesland in de zeventiende eeuw.* Lochem, 1967, pp. 30–45.

Gelder, Aert de

Lilienfeld, K. *Arent de Gelder. Sein Leben und seine Kunst.* The Hague, 1914.

———. "Neues über Leben und Werke A. de Gelders," *Kunstchronik und Kunstmarkt* 54, n.s. 30 (1918–19), pp. 131–35.

Fossen, D. van. "Aert de Gelder: an Attribution for the 'Christ Blessing the Children' in London," *Art Quarterly* 33 (1970), pp. 134–46.

Gheyn, Jacob de, II

Regteren Altena, I.Q. van. *Jacques de Gheyn. An Introduction to the Study of His Drawings.* Amsterdam, 1935.

Bergström, I. "De Gheyn as a 'Vanitas' Painter," *Oud Holland* 85 (1970), pp. 143–57.

Judson, J.R. *The Drawings of Jacob de Gheyn II.* New York, 1973.

Heezen-Stoll, B.A. "Een vanitasstilleven van Jacques de Gheyn II uit 1621: een afspiegeling van neostoïsche denkbeelden," *Oud Holland* 93 (1979), pp. 217–50.

Gijsbrechts, Cornelis Norbertus

Gammelbo, P. "Cornelius Norbertus Gijsbrechts og Franciskus Gijsbrechts," *Kunstmuseets Årsskrift* 39–42 (1952–55), pp. 125–56.

Marlier, G. "C.N. Gijsbrechts, l'illusionniste," *Connaissance des Arts* 145 (March 1964), pp. 96–105.

Goedaert, Johannes

Bol, L.J. "Een Middelburgse Brueghel-groep, IX: Johannes Goedaert, schilder-entomoloog … ," *Oud Holland* 74 (1959), pp. 1–19.

Goltzius, Hendrick

Hirschmann, O. *Hendrick Goltzius als Maler 1600–1617.* The Hague, 1916.

Reznicek, E.K.J. "Het begin van Goltzius' loopbaan als schilder," *Oud Holland* 75 (1960), pp. 30–49.

———. *Die Zeichnungen von Hendrick Goltzius.* 2 vols. Utrecht, 1961.

Jost, I. "Goltzius, Dürer et le collectionneur de coquillages Jan Govertsz.," *Revue du Louvre* 18 (1968), pp. 57–64.

Strauss, W.L. *Hendrik Goltzius, 1558–1617; the Complete Engravings and Woodcuts.* 2 vols. New York, 1977. Reviewed by E.K.J. Reznicek in *Simiolus* 10 (1978–79), pp. 200–206.

Goudt, Hendrick

Weizsäcker, H. "Hendrik Goudt," *Oud Holland* 45 (1928), pp. 110–22.

Hoek, D. "Biografische bijzonderheden over Hendrik Goudt (1583–1648)," *Oud Holland* 85 (1970), pp. 54–55.

Goyen, Jan van

Beck, H.-U. *Jan van Goyen 1596–1656. Ein Oeuvre-verzeichnis.* 2 vols. Amsterdam, 1972–73. Reviewed by I.Q. van Regteren Altena in *Oud Holland* 88 (1974), pp. 242–44.

Grebber, Pieter de

Bloch, V. "Haarlemer Klassizisten," *Oud Holland* 57 (1940), pp. 14–21.

Thiel, P.J.J. van. "De Grebbers regels van de kunst," *Oud Holland* 80 (1965), pp. 126–31.

Dirkse, P. "Pieter de Grebber: Haarlems schilder tussen begijnen, kloppen en pastoors," *Jaarboek Haarlem* (1978), pp. 109–27.

Haagen, Joris van der

Haagen, J.K. van der. *De schilders Van der Haagen en hun werk. Met catalogus van de schilderijen en teekeningen van Joris van der Haagen.* Voorburg, 1932.

Hackaert, Jan

Hofstede de Groot. *Catalogue Raisonné.* Vol. 9, pp. 1–47.

Hals, Dirck

Schatborn, P. "Olieverfschetsen van Dirck Hals," *Bulletin van het Rijksmuseum* 21 (1973), pp. 107–16.

Hals, Frans

Jongh, E. de, and Vinken, P.J. "Frans Hals als voortzetter van een emblematische traditie. Bij het Huwelijksportret van Isaac Massa en Beatrix van der Laen," *Oud Holland* 76 (1961), pp. 117–52.

Vinken, P.J., and Jongh, E. de. "De boosaardigheid van Hals' regenten en regentessen," *Oud Holland* 78 (1963), pp. 1–27.

Slive, S. *Frans Hals.* 3 vols. New York/London, 1970–74. Reviewed by E. de Jongh in *Art Bulletin* 57 (1975), pp. 583–87, and by B.P.J. Broos in *Simiolus* 10 (1978–79), pp. 115–23.

Grimm, C. "Frans Hals und seine 'Schule,'" *Münchner Jahrbuch Bildender Kunst* 3rd s. 22 (1971), pp. 146–78.

———. *Frans Hals. Entwicklung, Werkanalyse, Gesamtkatalog.* Berlin, 1972. Reviewed by E. de Jongh in *Art Bulletin* 57 (1975), pp. 583–87.

Roey, J. van. "De familie van Frans Hals. Nieuwe gegevens uit Antwerpen," *Jaarboek van het Koninklijk Museum voor Schone Kunsten Antwerpen* 12 (1972), pp. 145–70.

Jowell, F.S. "Thoré-Bürger and the Revival of Frans Hals," *Art Bulletin* 56 (1974), pp. 101–17.

Thierry de Bye Dólleman, M. "Vier verschillende families 'Hals' te Haarlem," *Jaarboek Centraal Bureau voor Genealogie* 28 (1974), pp. 182–212.

Storm van Leeuwen, J. "The Concept of Pictology and Its Application to Works by Frans Hals," *Authentication in the Visual Arts. A Multidisciplinary Symposium (12.3.1977).* Amsterdam, 1979, pp. 57–92.

Baard, H.P. *Frans Hals.* New York/London, 1981.

Hanneman, Adriaen

Kuile, O. ter. *Adriaen Hanneman 1604–1671; een Haags portretschilder.* Alphen aan den Rijn, 1976.

Heda, Willem Claesz

Gelder, H.E. van. *W.C. Heda, A. van Beyeren, W. Kalf.* Amsterdam, n.d. [1941].

Heem, Jan Davidsz de

Bergström, I. "De Heem's Painting of His First Dutch Period," *Oud Holland* 71 (1956), pp. 173–83.

Mirimonde, A.P. de. "Musique et symbolisme chez Jan-Davidszoon de Heem, Cornelis-Janszoon et Jan II Janszoon de Heem," *Jaarboek van het Koninklijk Museum voor Schone Kunsten Antwerpen* 10 (1970), pp. 241–96.

Hees, Gerrit van

Bredius, A. "De schilder Gerrit van Hees," *Oud Holland* 31 (1913), pp. 67–70.

Helst, Bartholomeus van der

Gelder, J.J. de. *Bartholomeus van der Helst.* Rotterdam, 1921.

See also Flinck, Govert.

Helt Stockade, Nicolaes van

Moes, E.W. "Nicolaes van Helt Stocade," *Amsterdamsch Jaarboekje* (1902), pp. 69–105.

Demonts, L. "Nicolas van Helt Stockade. Nimègue 1614, enterré à Amsterdam le 26 Nov. 1669," *Revue de l'Art Ancien* 68 (1935), pp. 69–84.

Heyden, Jan van der

Wagner, H. *Jan van der Heyden 1637–1712.* Amsterdam/Haarlem, 1971. Reviewed by I.H. van Eeghen in *Maandblad Amstelodamum* 60 (1973), pp. 73–80, and by E.J. Sluyter in *Oud Holland* 87 (1973), pp. 244–52.

Hobbema, Meindert

Michel, E. *Hobbema et les paysagistes de son temps en Hollande.* Paris, 1890.

Bredius, A. "Uit Hobbema's laatste levensjaren," *Oud Holland* 28 (1910), pp. 93–106; 29 (1911), pp. 124–28; and 33 (1915), pp. 193–98.

Broulhiet, G. *Meindert Hobbema (1638–1709) … .* Paris, 1938.

Stechow, W. "The Early Years of Hobbema," *Art Quarterly* 22 (1959), pp. 2–18.

Holsteyn, Cornelis

Heppner, A. "De verhouding van kunstschilder tot decoratieschilder in de 17de eeuw: Holsteyn en Van Pillecum," *Oud Holland* 61 (1946), pp. 47–58.

Hondecoeter, Melchior d'

Bredius, A. "De schilders Melchior de Hondecoeter en Johan le Ducq," *Archief voor Nederlandsche Kunst-geschiedenis* 5 (1882–83), pp. 288–92.

Hondius, Abraham

Hentzen, A. "Abraham Hondius," *Jahrbuch der Hamburger Kunstsammlungen* 8 (1963), pp. 33–56.

Honthorst, Gerrit van

Judson, J.R. *Gerrit van Honthorst. A Discussion of His Position in Dutch Art.* The Hague, 1956.

Braun, H. *Gerard und Willem van Honthorst.* Göttingen, 1966.

Meyere, J.A.L. de. "Nieuwe gegevens over Gerard van Honthorst's beschilderd plafond uit 1622," *Jaarboek Oud-Utrecht* (1976), pp. 7–29.

Hooch, Pieter de

Sutton, P.C. *Pieter de Hooch.* New York/Oxford, 1979–80. Reviewed by E. de Jongh in *Simiolus* 11 (1980), pp. 181–85, and by H.-J. Raupp in *Oud Holland* 96 (1982), pp. 258–62.

Hoogstraeten, Samuel van

Richardson, E.P. "Samuel van Hoogstraeten and Carel Fabritius," *Art in America* 25 (1937), pp. 141–52.

Horst, Gerrit van der

Bredius, A. "Gerrit Willemsz. Horst," *Oud Holland* 50 (1933), pp. 1–8.

Valentiner, W.R. "Zum Werk Gerrit Willemsz. Horst's," *Oud Holland* 50 (1933), pp. 241–49.

Houckgeest, Gerrit

Blade, T.T. "Two Interior Views of the Old Church in Delft" [G. Houckgeest and E. de Witte], *Museum Studies* 6 (1971), pp. 34–50.

Vries, L. de. "Gerard Houckgeest," *Jahrbuch der Hamburger Kunstsammlungen* 20 (1975), pp. 25–56.

Wheelock, A.K., Jr. "Gerard Houckgeest and Emanuel de Witte: Architectural Painting in Delft around 1650," *Simiolus* 8 (1975–76), pp. 167–85.

Jacobsz, Lambert

Wijnman, H.F. "Nieuwe gegevens omtrent den schilder Lambert Jacobsz.," *Oud Holland* 47 (1930), pp. 145–57, and 51 (1934), pp. 241–55.

Halbertsma, M. "Lambert Jacobsz., een Amsterdammer in Leeuwarden," *De Vrije Fries* 52 (1972), pp. 15–25.

Jansz, Govert

Schneider, H. "Een toeschrijving aan Govert Jansz alias Mijnheer," *Oud Holland* 43 (1926), pp. 269–71.

Gelder, J.G. van. "Enkele tekeningen van Govert Jansz., alias Mijnheer," *Miscellanea Jozef Duverger; bijdragen tot de kunstgeschiedenis der Nederlanden.* 2 vols. Ghent, 1968, vol. 2, pp. 519–29.

Jardin, Carel Du

Brochhagen, E. *Karel Dujardin. Ein Beitrag zum Italianismus in Holland im 17. Jahrhundert.* Cologne, 1958.

Jongh, Claude de

Hayes, J. "Claude de Jongh," *Burlington Magazine* 98 (1956), pp. 3–11.

Jongh, Ludolf de

Fleischer, R.E. "Ludolf de Jongh and the Early Work of Pieter de Hooch," *Oud Holland* 92 (1978), pp. 49–67.

Jonson (Johnson, Janssens) van Ceulen, Cornelis

Finberg, A. "A Chronological List of Portraits by Cornelius Johnson or Jonson," *Walpole Society* 10 (1921–22), pp. 1–37.

Kalf, Willem

Grisebach, L. *Willem Kalf 1619–1693.* Berlin, 1974. Reviewed by S.A.C. Dudok van Heel in *Maandblad Amstelodamum* 61 (1974), pp. 95–96.

See also Heda, Willem Claesz.

Keirincx, Alexander

Keyes, G.S. "Landscape Drawings by Alexander Keirincx and Abraham Govaerts," *Master Drawings* 16 (1978), pp. 293–302.

Ketel, Cornelis

Stechow, W. "Cornelis Ketels Einzelbildnisse," *Zeit-schrift für Bildende Kunst* 63 (1929–30), pp. 200–206.

Judson, J.R. "A New Insight into Cornelis Ketel's Method of Portraiture," *Master Drawings* 1 (1963), pp. 38–41.

Keyser, Hendrick de

Neurdenburg, E. *Hendrick de Keyser. Beeldhouwer en bouwmeester van Amsterdam.* Amsterdam, 1929.

Keyser, Thomas de

Oldenbourg, R. *Thomas de Keysers Tätigkeit als Maler, ein Beitrag zur Geschichte des holländischen Porträts.* Leipzig, 1911.

Kick, Simon

Bredius, A., and Bode, W. von. "Der Amsterdamer Genremaler Symon Kick," *Jahrbuch der Königlich Preussischen Kunstsammlungen* 10 (1889), pp. 102–9.

Knupfer, Nicolaus

Kuznetzow, J.I. "Nikolaus Knupfer (1603?–1655)," *Oud Holland* 88 (1974), pp. 169–219.

Koninck, Philips

Gerson, H. *Philips Koninck. Ein Beitrag zur Erforschung der holländischen Malerei des XVII. Jahrhunderts.* Berlin, 1935. New ed. Berlin, 1980.

Laer, Pieter van

Janeck, A. *Untersuchung über den holländischen Maler Pieter van Laer, genannt Bamboccio.* Würzburg, 1968.

Blankert, A. "Over Pieter van Laer als dier- en landschapschilder," *Oud Holland* 83 (1968), pp. 117–34.

Lairesse, Gerard de

Timmers, J.J.M. *Gérard Lairesse.* Vol. 1. Amsterdam, 1942.

Snoep, D.P. "Gérard Lairesse als plafond- en kamerschilder," *Bulletin van het Rijksmuseum* 18 (1970), pp. 159–220.

Lambertsz, Gerrit

See Cuylenburch, Johannes van.

Lastman, Pieter

Freise, K. *Pieter Lastman, sein Leben und seine Kunst. Ein Beitrag zur Geschichte der holländ. Malerei im XVII. Jahrh.* Leipzig, 1911.

Bauch, K. "Frühwerke Pieter Lastmans," *Münchner Jahrbuch der Bildenden Kunst* n.s. 2 (1951), pp. 225–37.

————. "Entwurf und Komposition bei Pieter Lastman," *Münchner Jahrbuch der Bildenden Kunst* 3rd s. 6 (1955), pp. 213–21.

Wittrock, I. "Abraham's Calling. A Motif in Some Paintings by Pieter Lastman and Claes Moeyaert," *Konsthistorisk Tidskrift* 43 (1974), pp. 8–19.

Dudok van Heel, S.A.C. "Waar woonde en werkte Pieter Lastman (1583–1633)?" *Maandblad Amstelodamum* 62 (1975), pp. 31–36.

Broos, B.P.J. "Rembrandt and Lastman's *Coriolanus*: the History Piece in 17th Century Theory and Practice," *Simiolus* 8 (1975–76), pp. 199–228.

Tümpel, A. "'Ruth erklärt Naomi die Treue' von Pieter Lastman. Zur Genese eines typischen Barockthemas," *Niederdeutsche Beiträge zur Kunstgeschichte* 17 (1978), pp. 87–101.

Lesire, Paulus

Bredius, A., and Veth, G.H. "Poulus Lesire," *Oud Holland* 5 (1887), pp. 45–51.

Leyster, Judith

Harms, J. "Judith Leyster. Ihr Leben und ihr Werk," *Oud Holland* 44 (1927), pp. 88–96, 112–26, 145–54, 221–42, 275–79.

Wijnman, H.F. "Het geboortejaar van Judith Leyster," *Oud Holland* 49 (1932), pp. 62–65.

Hofrichter, F.F. *Judith Leyster, 1609–1660.* New Brunswick, 1979.

Lievens, Jan

Schneider, H. *Jan Lievens, sein Leben und seine Werke.* Haarlem, 1932. New ed. with a supplement by R.E.O. Ekkart. Amsterdam, 1973.

Jan Lievens, ein Maler im Schatten Rembrandts. Brunswick, 1979 (catalogue of exhibition at the Herzog Anton Ulrich Museum, Brunswick, 1979). Reviewed by C. Brown in *Burlington Magazine* 121 (1979), pp. 741–46, and by M.L. Wurfbain in *Antiek* 14 (1979–80), pp. 457–62.

Lingelbach, Johannes

Burger-Wegener, C. *Johannes Lingelbach 1622–1674.* Berlin, 1976.

Loo, Jacob van

Schneider, A. von. "Jakob van Loo," *Zeitschrift für Bildende Kunst* 59 (1925–26), pp. 66–78.

Watering, W.L. van de. "On Jacob van Loo's 'Portrait of a Young Woman,'" *Minneapolis Institute Art Bulletin* 63 (1976–77), pp. 32–41.

Lorme, Anthonie de

Haverkorn van Rijsewijk, P. "Anthonie de Lorme," *Oud Holland* 11 (1893), pp. 50–54.

Alting Mees, N. "Aanteekeningen over oud-Rotterdamsche kunstenaars III," *Oud Holland* 31 (1913), p. 245.

Luttichuys, Isaac

Valentiner, W.R. "Isaac Luttichuys. A Little Known Dutch Portrait Painter," *Art Quarterly* 1 (1938), pp. 151–79.

Maes, Nicolaes

Valentiner, W.R. *Nicolaes Maes.* Stuttgart/Berlin/Leipzig, 1924.

Walsh, J., Jr. "The Earliest Dated Painting by Nicolaes Maes," *Metropolitan Museum Journal* 6 (1972), pp. 105–14.

Man, Cornelis de

Brière-Misme, C. "Un émule de Vermeer et de Pieter de Hooch: Cornelis de Man," *Oud Holland* 52 (1935), pp. 1–26, 97–120, 281–82.

Mancadan, Jacobus Sibrandi

Heppner, A. "J.S. Mancadan. Neue Funde, sein Leben und sein Werk betreffend," *Oud Holland* 51 (1934), pp. 210–17.

Boschma, C. "Nieuwe gegevens omtrent J.S. Mancadan," *Oud Holland* 81 (1966), pp. 84–106.

Mander, Karel van

Valentiner, E. *Karel van Mander als Maler.* Strasbourg, 1930.

Miedema, H. *Karel van Mander (1548–1606). Het bio-bibliografisch materiaal.* Amsterdam, 1972.

See also V. B. Sources and Biographical Lexica. Van Mander.

Marrel (Morel, Marellus), Jacob

Bott, G. "Stilleben des 17. Jahrhunderts Jacob Marrell," *Kunst in Hessen und am Mittelrhein* 6 (1966), pp. 85–117.

Metsu, Gabriel

Gabriël Metsu. Leiden, 1966 (catalogue of exhibition at De Lakenhal, Leiden, 1966).

Gudlaugsson, S.J. "Kanttekeningen bij de ontwikkeling van Metsu," *Oud Holland* 83 (1968), pp. 13–43.

Schneede, U.M. "Gabriël Metsu und der holländische Realismus," *Oud Holland* 83 (1968), pp. 44–61.

Robinson, F.W. *Gabriël Metsu (1629–1667). A Study of His Place in Dutch Genre Painting of the Golden Age.* New York, 1974. Reviewed by A.K. Wheelock, Jr. in *Art Bulletin* 58 (1976), pp. 456–59.

Miereveld, Michiel van

Havard, H. *Michiel van Mierevelt et son gendre.* Paris, n.d. [1892].

Mieris, Frans van, the Elder

Hofstede de Groot. *Catalogue Raisonné.* Vol. 10, pp. vii–ix, 1–102.

Naumann, O. "Frans van Mieris as a Draughtsman," *Master Drawings* 16 (1978), pp. 3–34.

————. *Frans van Mieris (1635–1681) the Elder.* 2 vols. Doornspijk, 1981.

Mieris, Willem van

Hofstede de Groot. *Catalogue Raisonné.* Vol. 10, pp. 105–230.

Mignon, Abraham

Noble, M. *Abraham Mignon. 1640–1679. Beiträge zur Stillebenmalerei im 17. Jahrhundert.* Stuttgart, 1972. English translation: *Abraham Mignon. 1640–1679.* Leigh-on-Sea, 1973.

Mijtens, Daniel

Kuile, O. ter. "Daniël Mijtens, 'His Majesty's Picture-Drawer,'" *Nederlands Kunsthistorisch Jaarboek* 20 (1969), pp. 1–106.

Moeyaert, Claes

Thiel, P.J.J. van. "Moeyaert and Bredero: a Curious Case of Dutch Theatre as Depicted in Art," *Simiolus* 6 (1972–73), pp. 29–49.

Tümpel, A. "Claes Cornelisz Moeyaert. Katalog der Gemälde," *Oud Holland* 88 (1974), pp. 1–163, 245–90.

Dudok van Heel, S.A.C. "De schilder Claes Moyaert en zijn familie," *Jaarboek Amstelodamum* 68 (1976), pp. 13–48.

See also Lastman, Pieter.

Molanus, Mattheus

Bol, L.J. "Een Middelburgse Brueghel-groep, V: Mattheus Adolfszoon Molanus: romantiek gepaard met realisme," *Oud Holland* 71 (1956), pp. 196–203.

Molenaer, Jan Miense

Bode, W. von, and Bredius, A. "Der Haarlemer Maler Johannes Molenaer in Amsterdam," *Jahrbuch der Königlich Preuszischen Kunstsammlungen* 11 (1890), pp. 65–78.

Bredius, A. "Jan Miense Molenaer. Nieuwe gegevens omtrent zijn leven en werk," *Oud Holland* 26 (1908), pp. 41–42.

Hinz, B. "Das Familienbildnis des J.M. Molenaer in Haarlem. Aspekte zur Ambivalenz der Porträt-funktion," *Städel-Jahrbuch* n.s. 4 (1973), pp. 207–16.

Molijn, Pieter de

Granberg, O. "Pieter de Molyn und seine Kunst," *Zeitschrift für Bildende Kunst* 19 (1884), pp. 369–77.

Moreelse, Paulus

Jonge, C.H. de. *Paulus Moreelse portret- en genreschilder te Utrecht, 1571–1638.* Assen, 1938.

Moscher, Jacob van

Regteren Altena, I.Q. van. "I. van Moscher," *Oud Holland* 43 (1926), pp. 18–28.

Müller, W.J. "Holländische Flachlandschaft. Über eine Zeichnung des 17. Jahrhunderts in der Kunsthalle zu Kiel," *Jahrbuch des Kunsthistorischen Institutes der Universität Graz* 11 (1976), pp. 41–49.

Mulier, Pieter

Keyes, G.S. "Pieter Mulier the Elder," *Oud Holland* 90 (1976), pp. 230–61.

Muller, Jan

Reznicek, E.K.J. "Jan Harmensz. Muller als tekenaar," *Nederlands Kunsthistorisch Jaarboek* 7 (1956), pp. 65–120.

————. "Jan Harmensz. Muller as Draughtsman: Addenda," *Master Drawings* 18 (1980), pp. 115–33, figs. 1–14.

Musscher, Michiel van

Thiel, P.J.J. van. "Michiel van Musscher's vroegste werk naar aanleiding van zijn portret van het echtpaar Comans," *Bulletin van het Rijksmuseum* 17 (1969), pp. 3–36.

————. "Andermaal Michiel van Musscher: zijn zelfportretten," *Bulletin van het Rijksmuseum* 22 (1974), pp. 131–49.

Nason, Pieter

Brusewicz, L. "The Paintings by Pieter Nason in Polish Collections," *Bulletin du Musée National de Varsovie* 19 (1978), pp. 1–49.

Neer, Aert van der

Bachmann, F. *Die Landschaften des Aert van der Neer.* Neustadt an der Aisch, 1966.

————. "Die Herkunft der Frühwerke des Aert van der Neer," *Oud Holland* 89 (1975), pp. 213–22.

Neer, Eglon van der

Hofstede de Groot. *Catalogue Raisonné.* Vol. 5, pp. 475–525.

Neijn, Pieter de

Gerson, H. "De Meester P.N.," *Nederlands Kunst-historisch Jaarboek* 1 (1947), pp. 95–111.

Netscher, Caspar

Hofstede de Groot. *Catalogue Raisonné.* Vol. 5, pp. 146–308.

Nieulandt, Willem van

Hoogewerff, G.J. "De beide Willem's van Nieulandt, oom en neef," *Mededelingen van het Nederlands Historisch Instituut te Rome* 31 (1961), pp. 57–69.

Hille, P. van. "De familie van Nieuland," *De Vlaamse Stam* 1 (1965), pp. 259–66.

Nooms, Reinier, called Zeeman

Knoef, J. "Reinier Nooms (1623–1667 of '68)," *Elsevier's Geïllustreerd Maandschrift* 29/58 (1919), pp. 221–30.

Noordt, Jan van

Hofstede de Groot, C. "Joan van Noordt," *Oud Holland* 10 (1892), pp. 210–18.

Staring, A. "Weinig bekende portrettisten, III: Joannes van Noordt," *Oud Holland* 61 (1946), pp. 73–81.

Schatborn, P. "Tekeningen van Jan van Noordt," *Bulletin van het Rijksmuseum* 27 (1979), pp. 118–28.

Ochtervelt, Jacob

Kuretsky, S.D. *The Paintings of Jacob Ochtervelt (1634–1682). (With Catalogue Raisonné).* Oxford, 1979. Reviewed by D.B. Hensbroek-van de Poel in *Oud Holland* 97 (1983), pp. 114–16.

Oever, Hendrick ten

Verbeek, J., and Schotman, J.W. *Hendrick ten Oever. Een vergeten Overijssels meester uit de zeventiende eeuw.* Zwolle, 1957.

Oosterwijck, Maria van

Bosboom-Toussaint, A.L.C. *De bloemenschilderes Maria van Oosterwijck.* Leiden, 1862.

Bredius, A. "Archiefsprokkelingen. Een en ander over Maria van Oosterwyck, 'vermaert Konst-schilderesse,'" *Oud Holland* 52 (1935), pp. 180–82.

Lindenburg, R. "Maria van Oosterwyck (1630–1693)," *Delftse Vrouwen van vroeger door Delftse Vrouwen van nu.* Delft, 1975, pp. 42–55.

Ostade, Adriaen and Isack van

Hofstede de Groot. *Catalogue Raisonné.* Vol. 3. pp. 140–556.

Klessmann, R. "Die Anfänge des Bauerninteriors bei den Brüdern Ostade," *Jahrbuch der Berliner Museen* n.s. 2 (1960), pp. 92–115.

Kusnetzov, J. *Catalogue of Adriaen van Ostade Exhibition at the Hermitage.* Leningrad, 1960.

Haak, B. "Adriaen van Ostade, landschap met oude eik," *Bulletin van het Rijksmuseum* 12 (1964), pp. 5–11.

Schnackenburg, B. "Die Anfänge des Bauerninteriors bei Adriaen van Ostade," *Oud Holland* 85 (1970), pp. 158–69.

———. *Adriaen van Ostade. Isack van Ostade. Zeichnungen und Aquarelle.* 2 vols. Hamburg, 1981. Reviewed by P. Schatborn in *Simiolus* 13 (1983), pp. 235–38.

Ovens, Jurriaen

Schmidt, H. *Jürgen Ovens. Sein Leben und seine Werke. Ein Beitrag zur Geschichte der niederländischen Malerei im XVII. Jahrhundert.* Kiel, n.d. [1922].

Schlüter-Göttsche, G. "Die Familienbilder von Jürgen Ovens. Neue Forschungen zu ihrer Identifizierung," *Niederdeutsche Beiträge zur Kunstgeschichte* 13 (1974), pp. 275–96.

———. *Jürgen Ovens. Ein schleswig-holsteinischer Barockmaler.* Heide in Holstein, 1978.

Passe, Crispijn de, I and II

Franken, D. *L'oeuvre gravé des Van de Passe: catalogue raisonné des estampes de Chrispijn senior et junior, Simon Willem, Magdalena et Chrispijn III van de Passe, graveurs néerlandais des 16e et 17e siècles.* Paris, 1881. Facsimile ed.: Amsterdam, 1975.

See also v. B. Sources and Biographical Lexica. Van de Passe.

Pluym, Karel van der

Kronig, J.O. "Carel van der Pluijm: a Little Known Follower of Rembrandt," *Burlington Magazine* 26 (1914–15), pp. 172–77.

Bredius, A. "Karel van der Pluym, neef en leerling van Rembrandt," *Oud Holland* 48 (1931), pp. 241–64.

Poel, Egbert van der

Goldschmidt, A. "Egbert van der Poel und Adriaen van der Poel," *Oud Holland* 40 (1922), pp. 57–66.

Poelenburgh, Cornelis van

Schaar, E. "Poelenburgh und Breenbergh in Italien und ein Bild Elsheimers," *Mitteilungen des Kunsthistorischen Institutes in Florenz* 9 (1959–60), pp. 25–54.

Chiarini, M. "Ipotesi sugli inizi di Cornelis van Poelenburgh," *Nederlands Kunsthistorisch Jaarboek* 23 (1972), pp. 203–19.

Porcellis, Jan and Julius

Walsh, J., Jr. "The Dutch Marine Painters Jan and Julius Porcellis, I: Jan's Early Career," *Burlington Magazine* 116 (1974), pp. 653–62; "II: Jan's Maturity and 'de jonge Porcellis,'" *Burlington Magazine* 116 (1974), pp. 734–45.

Duverger, E. "Nadere gegevens over de Antwerpse periode van Jan Porcellis," *Jaarboek van het Koninklijk Museum voor Schone Kunsten Antwerpen* 16 (1976), pp. 269–79.

Post, Frans

Larsen, E. *Frans Post. Interprète du Brésil.* Amsterdam/Rio de Janeiro, 1962.

Sousa Leão, J. de. *Frans Post 1612–1680.* Amsterdam, 1973.

Post, Pieter

Blok, G.A.C. "Pieter Post, 1608–1669; der Baumeister der Prinzen von Oranien und des Fürsten Johann Moritz von Nassau-Siegen," *Siegerland. Blätter des Vereins für Heimatkunde und Heimatschutz im Siegerland samt Nachbargebieten* (1936–37), pp. 1–92.

Gudlaugsson, S.J. "Aanvullingen omtrent Pieter Post's werkzaamheid als schilder," *Oud Holland* 69 (1954), pp. 59–71.

Pot, Hendrick

Bredius, A., and Haverkorn van Rijsewijk, P. "Hendrick Gerritsz. Pot," *Oud Holland* 5 (1887),

pp. 161–76.

Potter, Paulus

Hofstede de Groot. *Catalogue Raisonné.* Vol. 4. pp. 582–670.

Potter, Pieter

Bredius, A. "Pieter Symonsz. Potter, glaseschrijver, ooc schilder," *Oud Holland* 11 (1893), pp. 34–46.

Pynacker, Adam

Hofstede de Groot. *Catalogue Raisonné.* Vol. 9, pp. 521–68.

Wassenbergh, A. "Het huwelijk van Adam Pijnacker en Eva Maria de Geest," *De Vrije Fries* 49 (1969), pp. 93–95.

Pynas, Jacob

Bauch, K. "Beiträge zum Werk der Vorläufer Rembrandts, III: Die Gemälde des Jakob Pynas," *Oud Holland* 53 (1936), pp. 79–88.

———. "Beiträge zum Werk der Vorläufer Rembrandts, IV: Handzeichnungen des Jakob Pynas," *Oud Holland* 54 (1937), pp.241–52.

Oehler, L. "Zu einigen Bildern aus Elsheimers Umkreis," *Städel-Jahrbuch* n.s. 1 (1967), pp. 148–70.

Pynas, Jan

Bauch, K. "Beiträge zum Werk der Vorläufer Rembrandts, I: Die Gemälde des Jan Pynas," *Oud Holland* 52 (1935), pp. 145–58.

———. "Beiträge zum Werk der Vorläufer Rembrandts, II: Die Zeichnungen des Jan Pynas," *Oud Holland* 52 (1935), pp. 193–204.

See also Pynas, Jacob.

Quast, Pieter

Bredius, A. "Pieter Jansz. Quast," *Oud Holland* 20 (1902), pp. 65–82.

Stanton Hirst, B.A. *The Influence of the Theatre on the Works of Pieter Jansz. Quast.* Madison, 1978.

Queecborne, Daniel van

Luttervelt, R. van. "Portretten van Daniël van den Queeckborne," *Oud Holland* 67 (1952), pp. 199–209.

Wit, C. de. "De hofschilder van Prins Maurits," *Mededelingen van het Gemeentemuseum van Den Haag* 10 (1955), pp. 54–63.

Ravesteyn, Jan van

Bredius, A., and Moes, E.W. "De schildersfamilie Ravesteyn," *Oud Holland* 9 (1891), pp. 207–20; 10 (1892), pp. 41–52.

Rijn, Rembrandt van

Hofstede de Groot, C. *Die Urkunden über Rembrandt (1575–1721).* London, 1906.

Bredius, A. *Rembrandt. The Complete Edition of the Paintings.* New York, 1935. 3rd ed. revised by H. Gerson. London/New York, 1969.

Rosenberg, J. *Rembrandt.* Cambridge, Mass., 1948.

Slive, S. *Rembrandt and His Critics. 1630–1730.* The Hague, 1953.

Scheller, R.W. "Rembrandt's reputatie van Houbraken tot Scheltema," *Nederlands Kunsthistorisch Jaarboek* 12 (1961), pp. 81–118.

Bauch, K. *Rembrandt Gemälde.* Berlin, 1966.

Gerson, H. *Rembrandt Paintings.* Amsterdam, 1968.

Emmens, J.A. *Rembrandt en de regels van de kunst.* Utrecht, 1968. Reprint Amsterdam, 1979. Reviewed by H. Miedema in *Oud Holland* 84 (1969), pp. 249–56.

Haak, B. *Rembrandt: His Life, His Work, His Time.* New York, 1969.

Scheller, R.W. "Rembrandt en de encyclopedische kunstkamer," *Oud Holland* 84 (1969), pp. 81–147.

Strauss, W.L., and Meulen, M. van der. *The Rembrandt Documents.* New York, 1979. Reviewed by B. Broos in *Simiolus* 12 (1981–82), pp. 245–62.

Ring, Pieter de

Moes, E.W. "Pieter de Ring," *Oud Holland* 6 (1888), pp. 175–81.

Kinder, T.T. "Pieter de Ring, a Still-Life Painter in Seventeenth Century Holland," *Indiana University Art Museum* 2 (1979), pp. 26–43.

Roestraten, Pieter van

Kuile, O. ter. "Een Hollands stilleven door Pieter van Roestraeten in 1696 te Londen geschilderd," *Antiek* 4 (1969–70), pp. 196–203.

Rotius, Jan Albertsz

Renckens, B.J.A. "De Hoornse portretschilder Jan Albertsz. Rotius," *Nederlands Kunsthistorisch Jaarboek* 2 (1948–49), pp. 165–234.

Ruisdael, Jacob van

Rosenberg, J. *Jacob van Ruisdael.* Berlin, 1928.

Wiegand, W. *Ruisdael-Studien. Ein Versuch zur Ikonologie der Landschaftsmalerei.* Hamburg, 1971.

Kousnetsov, I. "Sur le symbolisme dans les paysages de Jacob van Ruisdael," *Bulletin du Musée National de Varsovie* 14 (1973), pp. 31–41.

Scheyer, E. "The Iconography of Jacob van Ruysdael's 'Cemetery,'" *Bulletin of the Detroit Institute of Arts* 55 (1977), pp. 133–43.

Kaufmann, H. "Jacob van Ruysdael 'Die Mühle von Wijk bei Duurstede,'" *Festschrift für Otto von Simson zum 65. Geburtstag.* Frankfurt, 1977, pp. 379–97.

Giltay, J. "De tekeningen van Jacob van Ruisdael," *Oud Holland* 94 (1980), pp. 141–208.

Slive, S., and Hoetink, H.R. *Jacob van Ruisdael.* New York/Amsterdam, 1981.

Duparc, F.J. "'Het Joodse kerkhof' van Jacob van Ruisdael," *Antiek* 16 (1981–82), pp. 225–30.

Ruysch, Rachel

Grant, M.H. *Rachel Ruysch.* Leigh-on-Sea, 1956.

Šip, J. "Notities bij het stilleven van Rachel Ruysch," *Nederlands Kunsthistorisch Jaarboek* 19 (1968), pp. 157–70.

Ruysdael, Izaack van

Wijnman, H.F. "Het leven der Ruysdaels," *Oud Holland* 49 (1932), pp. 49–69, 173–81, 258–75.

Simon, K.E. "Isaack van Ruisdael," *Burlington Magazine* 67 (1935), pp. 7–23.

Ruysdael, Salomon van

Niemeijer, J.W. "Het topografisch element in enkele riviergezichten van Salomon van Ruysdael nader beschouwd," *Oud Holland* 74 (1959), pp. 51–56.

Scholtens, H.J.J. "Salomon van Ruysdael in de contreien van Holland's landengte," *Oud Holland* 77 (1962), pp. 1–10.

Stechow, W. *Salomon van Ruysdael. Eine Einführung in seine Kunst mit kritischem Katalog der Gemälde.* Berlin, 1938. 2d rev. ed. Berlin, 1975. Reviewed by Å. Bengtsson in *Konsthistorisk Tidskrift* 46 (1977), pp. 96–97.

Ryckhals, François

Bredius, A. "De schilder François Ryckhals," *Oud Holland* 35 (1917), pp. 1–11.

Bol, L.J. "'Goede onbekenden,' III: F. Ryckhals en omgeving," *Tableau* 2 (1979–80), pp. 304–11.

Saenredam, Pieter

Swillens, P.T.A. *Pieter Janszoon Saenredam. Schilder van Haarlem 1597–1665.* Amsterdam, 1935. Facsimile ed.: Soest, 1970.

Catalogue Raisonné of the Works by Pieter Jansz. Saenredam Utrecht, 1961 (catalogue of exhibition at the Centraal Museum, Utrecht, 1961).

Schwartz, G. "Saenredam, Huygens and the Utrecht Bull," *Simiolus* 1 (1966–67), pp. 69–93.

Liedtke, W.A. "Saenredam's Space," *Oud Holland* 86 (1971), pp. 116–41.

———. "The New Church in Haarlem Series: Saenredam's Sketching Style in Relation to Perspective," *Simiolus* 8 (1975–76), pp. 145–66.

Ruurs, R. "Saenredam: constructies," *Oud Holland* 96 (1982), pp. 97–122.

Saftleven, Cornelis

Schulz, W. *Cornelis Saftleven 1607–1681. Leben und Werke. Mit einem kritischen Katalog der Gemälde und Zeichnungen.* Berlin/New York, 1978.

Saftleven, Herman

Nieuwstraten, J. "De ontwikkeling van Herman Saftlevens kunst tot 1650. Spiegel van stromingen in de Nederlandse landschapschilderkunst," *Nederlands Kunsthistorisch Jaarboek* 16 (1965), pp. 81–117.

Klinge-Gross, M. "Herman Saftleven als Zeichner und Maler bäuerlicher Interieurs. Zur Entstehung des südholländischen Bildtyps mit Stilleben aus ländischem Hausrat und Gerät," *Wallraf-Richartz-Jahrbuch* 38 (1976), pp. 68–91.

Schulz, W. *Herman Saftleven 1609–1685. Leben und Werke. Mit einem kritischen Katalog der Gemälde und Zeichnungen.* Berlin/New York, 1982.

Salm, Adriaen van der

Overeem, J.B. "De schilders A. en R. (van der) Salm," *Rotterdams Jaarboekje* (1958), pp. 1–24, 233–56.

Savery, Roelant

Erasmus, K. *Roelant Savery, sein Leben und seine Werke.* Halle, 1908.

Roelant Savery 1576–1639. Ghent, 1954 (catalogue of exhibition at the Museum voor Schone Kunsten, Ghent, 1954).

Bialostocki, J. "Les bêtes et les humains de Roelant Savery," *Bulletin Koninklijke Musea voor Schone Kunsten* 7 (1958), pp. 69–92.

Franz, H.G. "Zum Werk des Roeland Savery," *Jahrbuch des Kunsthistorischen Institutes der Universität Graz* 15/16 (1979–80), pp. 175–86.

Bol, L.J. "'Goede onbekenden,' IX: Schilders van het vroege Nederlandse bloemstuk met kleingedierte als bijwerk (vervolg) Roelandt Savery (1576–1639)," *Tableau* 3 (1980–81), pp. 753–59.

Schalcke, Cornelis van der

Regteren Altena, I.Q. van, and Bredius, A. "Cornelis Symonsz. van der Schalcke," *Oud Holland* 43 (1926), pp. 49–60.

Schalcken, Godfried

Hofstede de Groot, *Catalogue Raisonné.* Vol. 5, pp. 309–419.

Hecht, P. "Candlelight and Dirty Fingers, or Royal Virtue in Disguise: Some Thoughts on Weyerman and Godfried Schalken," *Simiolus* 11 (1980), pp. 23–38.

Schellinks, Willem

Vries, A.D. de. "Willem Schellinks, schilder, teekenaar, etser, dichter," *Oud Holland* 1 (1883), pp. 150–63.

Berg, H.M. van den. "Willem Schellinks en Lambert Doomer in Frankrijk," *Oudheidkundig Jaarboek* 4/11 (1942), pp. 1–31.

See also Asselijn, Jan.

Schooten, Floris van

Gammelbo, P. "Floris Gerritsz. van Schooten," *Nederlands Kunsthistorisch Jaarboek* 17 (1966), pp. 105–42.

Daniëls, G.L.M. "Een 'Memento Mori' van Floris van Schooten," *Antiek* 10 (1975–76), pp. 273–79.

Schotanus, Petrus

Renckens, B.J.A. "Petrus Schotanus, kerkschilder, 1610–1675," *Gens Schotanus.* Franeker, 1963, pp. 120–28.

Schotanus, A.J. "Petrus Schotanus, bijzonderheden over zijn oeuvre," *Gens Schotanus.* Franeker, 1963, pp. 136–46.

Schrieck, Otto Marseus van

Habicht, V.C. "Ein vergessener Phantast der holländischen Malerei," *Oud Holland* 41 (1923–24), pp. 31–37.

Franchini Guelfi, F. "Otto Marseus van Schrieck a Firenze. Contributo alla storia dei rapporti fra scienza e arte figurativa nel Seicento toscano," *Antichità Viva* 16 (1977), no. 2, pp. 15–26; no. 4, pp. 13–21.

Segers, Hercules

Haverkamp Begemann, E. *Hercules Seghers.* Amsterdam, 1968.

Rowlands, J. *Hercules Segers.* New York/Amsterdam, 1979.

Slingeland, Pieter van

Hofstede de Groot. *Catalogue Raisonné.* Vol. 5, pp. 420–74.

Steen, Jan

Heppner, A. "The Popular Theatre of the Rederijkers in the Work of Jan Steen and His Contemporaries," *Journal of the Warburg and Courtauld Institutes* 3 (1939–40), pp. 22–48.

Gudlaugsson, S.J. *De komedianten bij Jan Steen en zijn tijdgenoten.* The Hague, 1945, English translation: *The Comedians in the Work of Jan Steen and His Contemporaries.* Soest, 1970.

Jan Steen. The Hague, 1958 (catalogue of exhibition at the Mauritshuis, The Hague, 1958–59).

Criegern, A. von. *Ikonografische Studien zu den fröhlichen Gesellschaft Jan Steens.* Tübingen, 1971.

Stechow, W. "Jan Steen's Representations of the Marriage in Cana," *Nederlands Kunsthistorisch Jaarboek* 23 (1972), pp. 73–83.

Vries, L. de. "Achttiende- en negentiende-eeuwse auteurs over Jan Steen," *Oud Holland* 87 (1973), pp. 227–39.

———. *Jan Steen "de kluchtschilder."* Groningen, 1977.

Kirschenbaum, B.D. *The Religious and Historical Paintings of Jan Steen.* New York/Oxford, 1977.

Steenwijck, Harmen van

Bredius, A. "De schilders Pieter en Harmen Steenwijck," *Oud Holland* 8 (1890), pp. 143–48.

Storck, Abraham, Jacobus, and Johannes

Vuyk, J. "Johannes of Jacobus Storck of Sturck?" *Oud Holland* 52 (1935), pp. 121–26.

Eeghen, I.H. van. "De schildersfamilie Sturck, Storck of Sturckenburch," *Oud Holland* 68 (1953), pp. 216–23.

Strijcker, Willem, called Brassemary

Renckens, B.J.A. "Willem Strijcker alias Braessemary," *Oud Holland* 67 (1952), pp. 116–22.

Susenier, Abraham

See Calraet, Abraham.

Swanenburgh, Jacob Isaacsz van

Frimmel, T. von. "Das signierte Werk des Jacob Isaaksz. van Swanenburgh in der Galerie zu Kopenhagen; Der Jacob Isaaksz. van Swanenburgh in der Augsburger Galerie," *Blätter für Gemäldekunde* 2 (1906), pp. 60–61, 94–95.

Swanevelt, Herman van

Waddingham, M. R. "Herman van Swanevelt in Rome," *Paragone* 11 (1960), no. 121, pp. 37–50.

Bodart, D. "La biografia di Herman van Swanevelt scritta da Giovanni Battista Passeri," *Storia dell'Arte* 12 (1971), pp. 327–30.

Sweelinck, Gerrit Pietersz

Bauch, K. "Beiträge zum Werk der Vorläufer Rembrandts, V: Gerrit Pietersz. Swelinck, der Lehrer Lastmans," *Oud Holland* 55 (1938), pp. 254–65.

Thiel, P.J.J. van. "Een vroeg schilderij van Gerrit Pietersz. Swelinck," *Oud Holland* 78 (1963), pp. 67–70.

Sweerts, Michiel

Michael Sweerts en tijdgenoten. Rotterdam, 1958. (catalogue of exhibition at the Museum Boymans-van Beuningen, Rotterdam, 1958).

Bloch, V. *Michael Sweerts. Suivi de Sweerts et les missions étrangères par Jean Guennou.* The Hague, 1968.

Horster, M. "Antikenkenntnis in Michael Sweerts' 'Römischem Ringkampf,'" *Jahrbuch der Staatlichen Kunstsammlungen in Baden-Württemberg* 11 (1974), pp. 145–58.

Tempel, Abraham van den

Wijnman, H.F. "De schilder Abraham van den Tempel," *Uit de Kring van Rembrandt en Vondel. Verzamelde studies over hun leven en omgeving.* Amsterdam, 1959, pp. 39–93.

Tengnagel, Jan

Schneider, H. "Der Maler Jan Tengnagel," *Oud Holland* 39 (1921), pp. 11–27.

Teniers, David

Davidson, J.P. *David Teniers the Younger.* London, 1980.

Ter Borch, see Borch, Ter

Ter Brugghen, see Brugghen, Ter

Tol, Domenicus van

Rammelman Elsevier, W.I.C. "Dominicus van Tol, schilder te Leiden, geb. 1631, overl. 1676," *Archief voor Nederlandsche Kunstgeschiedenis ...* 5 (1882–83), pp. 343–46.

Torrentius, see Beeck, Jan van der

Uyl, Jan Jansz den

Bredius, A. "Jan Jansz. Uyl (een nalezing)," *Oud Holland* 35 (1917), pp. 193–95; 38 (1920), p. 126.

Boer, P. de. "Jan Jansz. den Uyl," *Oud Holland* 57 (1940), pp. 49–64.

Uyttenbroeck, Moyses van

Weisner, U. "Die Gemälde des Moyses van Uyttenbroeck," *Oud Holland* 79 (1964), pp. 189–228.

Vaillant, Wallerand

Grohn, H.W. "Ein neuerworbenes Bildnis der niedersächsischen Landesgalerie Hannover und die Selbstporträts des Wallerant Vaillant," *Niederdeutsche Beiträge zur Kunstgeschichte* 19 (1980), pp. 137–54.

Valckert, Werner van den

Hudig, F.W. "Werner van den Valckert I," *Oud Holland* 54 (1937), pp. 54–66.

Taverne, E.R.M. "Een Amsterdams Lucasfeest in 1618," *Simiolus* 4 (1970), pp. 19–27.

Thiel, P.J.J. van. "Werner Jacobsz. van den Valckert," *Oud Holland* 97 (1983), pp. 128–95.

Velde, Adriaen van de

Hofstede de Groot, *Catalogue Raisonné.* Vol. 4, pp. 452–581.

Schatborn, P. "'De Hut' van Adriaen van de Velde," *Bulletin van het Rijksmuseum* 23 (1975), pp. 159–65.

Velde, Esaias van de

Poensgen, G. *Der Landschaftstil des Esaias van de Velde.* Freiburg, 1924.

Stechow, W. "Esajas van de Velde and the Beginnings of Dutch Landscape Painting," *Nederlands Kunsthistorisch Jaarboek* 1 (1947), pp. 83–94.

Velde, Jan van de

Gelder, J.G. van. *Jan van de Velde, 1593–1641, teekenaar-schilder.* The Hague, 1933.

———. "Jan van de Velde 1593–1641, teekenaar-schilder. Addenda I," *Oud Holland* 70 (1955), pp. 21–40.

Velde, Willem van de, the Elder and the Younger

Hofstede de Groot, *Catalogue Raisonné.* Vol. 7, pp. 1–157.

Baard, H.P. *Willem van de Velde de Oude, Willem van de Velde de Jonge.* Amsterdam, n.d. [1942].

Robinson, M.S. *Van de Velde Drawings: a Catalogue of Drawings in the National Maritime Museum Made by the Elder and the Younger Willem van de Velde.* 2 vols. Cambridge, 1958–74.

Weber, R.E.J. "Willem van de Velde de Oude als topograaf van onze zeegaten," *Oud Holland* 90 (1976), pp. 115–31.

———. "The Artistic Relationship between the Ship Draughtsman Willem van de Velde the Elder and His Son the Marine Painter in the Year 1664," *Master Drawings* 17 (1979), pp. 152–61.

Robinson, M.S. *The Willem van de Velde Drawings in the Boymans-van Beuningen Museum Rotterdam.* 3 vols. Rotterdam, 1979. Reviewed by T.H. Lunsingh Scheurleer in *Oud Holland* 97 (1983), pp. 112–14.

The Art of the Van de Veldes. Paintings and Drawings by the Great Dutch Marine Artists and Their English Followers. London, 1982 (catalogue of exhibition at the National Maritime Museum, London, 1982).

Venant, François

Gelder, J.G. van. "François Venant, schilder, teekenaar," *Oud Holland* 54 (1937), pp. 137–39; 55 (1938), pp. 35–37.

Venne, Adriaen van de

Franken Dz., D. *Adriaen van de Venne.* Amsterdam, 1878.

Knuttel, G. *Das Gemälde des Seelenfischfangs von Adriaen Pietersz. van de Venne.* The Hague, 1917.

Bol, L.J. "Een Middelburgse Brueghel-groep, VII en VIII: Adriaen Pietersz. van de Venne, Schilder en Teyckenaar: A. Middelburgse periode ca. 1614–1625; B. Haagse periode 1625–1662," *Oud Holland* 73 (1958), pp. 59–79, 128–47.

Verelst, Simon

Lewis, F. *Simon Pietersz. Verelst, 1644–1721.* Leigh-on-Sea, 1979.

Vermeer, Johannes

Gowing, L. *Vermeer*. London, 1952. New. ed. New York/Evanston, 1971.

Seymour, C., Jr. "Dark Chamber and Light-Filled Room: Vermeer and the Camera Obscura," *Art Bulletin* 46 (1964), pp. 323–31.

Kühn, H. "A Study of the Pigments Used by Jan Vermeer," *Report and Studies in the History of Art, National Gallery of Art (Washington)* 2 (1968), pp. 153–202.

Fink, D.A. "Vermeer's Use of the Camera Obscura — a Comparative Study," *Art Bulletin* 53 (1971), pp. 493–505.

Welu, J.A. "Vermeer: His Cartographic Sources," *Art Bulletin* 57 (1975), pp. 529–47.

Blankert, A.; Ruurs, R.; and Watering, W.L. van de. *Johannes Vermeer van Delft 1632–1675.* Utrecht/Antwerp, 1975. English translation: Oxford, 1977. Reviewed by A.K. Wheelock, Jr. in *Art Bulletin* 59 (1977), pp. 439–41. and by C. Brown in *Simiolus* 9 (1977), pp. 56–58.

Montias, J.M. "New Documents on Vermeer and His Family," *Oud Holland* 91 (1977), pp. 267–87.

Wheelock, A.K., Jr. "Zur Technik zweier Bilder, die Vermeer zugeschrieben sind," *Maltechnik* 84 (1978), pp. 242–57.

Montias, J.M. "Vermeer and His Milieu: Conclusion of an Archival Study," *Oud Holland* 94 (1980), pp. 44–62.

Seth, L. "Vermeer och van Veens Amorum Emblemata," *Konsthistorisk Tidskrift* 49 (1980), pp. 17–40.

Wheelock, A.K., Jr. *Jan Vermeer.* New York/London, 1981.

Verspronck, Johannes

Ekkart, R.E.O. *Johannes Cornelisz. Verspronck; leven en werken van een Haarlems portretschilder uit de 17de eeuw.* Haarlem, 1979 (catalogue of exhibition at the Frans Hals Museum, Haarlem, 1979).

Verwilt, François

Haverkorn van Rijsewijk, P. "De schilders Adriaan en Frans Verwilt," *Oud Holland* 15 (1897), pp. 513–63.

Victors, Jan

Zafran, E. "Jan Victors and the Bible," *The Israel Museum News* 12 (1977), pp. 92–120.

Vinckboons, David

Goossens, K. *David Vinckboons.* Antwerp/The Hague, 1954. Facsimile ed.: Soest, 1977. Reviewed by S. Slive in *Art Bulletin* 39 (1957), pp. 311–16.

———. "Nog meer over David Vinckboons," *Jaarboek van het Koninklijk Museum voor Schone Kunsten Antwerpen* 6 (1966), pp. 59–106.

Vinne, Vincent Laurensz van der

Sliggers, B., Jr., ed. *Dagelijkse aentekeninge van Vincent Laurensz van der Vinne.* Haarlem, 1979.

Visscher, Claes Jansz

Simon, M. *Claes Jansz. Visscher.* Freiburg im Breisgau, 1958.

Vitringa, Wigerus

Belonje, J. "Iets over den zeeschilder Vitringa," *Oud Holland* 74 (1959), pp. 29–36.

Vlieger, Simon de

Haverkorn van Rijsewijk, P. "Simon Jacobsz. de Vlieger," *Oud Holland* 9 (1891), pp. 221–24; 11 (1893), pp. 229–35.

Heppner, A. "Simon de Vlieger und der 'Pseudo-Van de Venne,'" *Oud Holland* 47 (1930), pp. 78–91.

Kelch, J. *Simon de Vlieger als Marinemaler.* Berlin, 1971.

Voort, Cornelis van der

Six, J. "Cornelis van der Voort. Een eerste poging tot het terugvinden van zijn werk als portretschilder," *Oud Holland* 5 (1887), pp. 1–22.

———. "Cornelis van der Voort," *Oud Holland* 29 (1911), pp. 129–33.

———. "Het monogram van Cornelis van der Voort," *Oud Holland* 36 (1918), pp. 243–46.

Vosmaer, Daniel

Donahue, S. "Daniel Vosmaer," *Vassar Journal of Undergraduate Studies* 19 (1964), pp. 18–27.

Vredeman de Vries, Hans and Paul

Schneede, U.M. "Interieurs von Hans und Paul Vredeman," *Nederlands Kunsthistorisch Jaarboek* 18 (1967), pp. 125–66.

Ehrman, J. "Hans Vredeman de Vries (Leeuwarden 1527–Anvers 1606)," *Gazette des Beaux Arts* 6th s. 121/93 (1979), pp. 13–26.

Vrel, Jacobus

Brière-Misme, C. "Un intimiste hollandais: Jacob Vrel," *Revue de l'Art Ancien et Moderne* 68 (1935), pp. 96–114, 157–72.

Plietzsch, E. "Jacobus Vrel und Esaias Boursse," *Zeitschrift für Kunst* 3 (1949), pp. 248–63.

Régnier, G. "Jacob Vrel, un Vermeer du Pauvre," *Gazette des Beaux Arts* 6th s. 110/71 (1968), pp. 269–82.

Vroom, Cornelis

Keyes, G.S. *Cornelis Vroom: Marine and Landscape Artist.* 2 vols. Alphen aan den Rijn, 1975. Reviewed by P. Biesboer in *Simiolus* 10 (1978–79), pp. 207–10.

Vroom, Hendrick Cornelisz

Russell, M. *Visions of the Sea. Hendrick C. Vroom and the Origins of Dutch Marine Painting.* Leiden, 1983.

Vucht, Jan van (der)

Haverkorn van Rijsewijk, P. "Johannes van Vucht," *Oud Holland* 9 (1891), pp. 39–51.

Walscapelle, Jacob van

Knoef, J. "Jacob van Walscapelle," *Oud Holland* 56 (1939), pp. 261–65.

Weenix, Jan Baptist

Stechow, W. "Jan Baptist Weenix," *Art Quarterly* 11 (1949), pp. 181–99.

Werff, Adriaen van der

Hofstede de Groot. *Catalogue Raisonné.* Vol. 10, pp. 233–304.

Plietzsch, E. "Adriaen van der Werff," *Art Quarterly* 14 (1951), pp. 137–47.

Adriaen van der Werff (1659–1722). Hofmaler des Kurfürsten Johann Wilhelm von der Pfalz. Munich, 1972 (catalogue of exhibition at the Alte Pinakothek, Munich, 1972).

Snoep, D.P., and Thiels, C. *Adriaen van der Werff. Kralingen 1659–1722 Rotterdam.* Rotterdam, 1973 (catalogue of exhibition at the Historisch Museum, Rotterdam, 1973).

Becker, J. "'Dieses emblematische Stück stellet die Erziehung der Jugend vor.' Zu Adriaen van der Werff. München, Alte Pinakothek, Inv. Nr. 250," *Oud Holland* 90 (1976), pp. 77–107.

Wet, Jacob de

Chudzikowski, A. "Les éléments rembrandtesques dans l'oeuvre de Jacob de Wet," *Biuletyn Historii Sztuki* 18 (1956), pp. 428–42.

Wieringen, Cornelis Claesz van

Keyes, G.S. "Cornelis Claesz. van Wieringen," *Oud Holland* 93 (1979), pp. 1–46.

Wijnants, Jan

Hofstede de Groot. *Catalogue Raisonné.* Vol. 8, pp. 427–586.

Willeboirts, Thomas

Gelder, J.G. van. "De opdrachten van de Oranje's aan Thomas Willeboirts Bosschaert en Gonzales Coques," *Oud Holland* 64 (1949), pp. 40–56.

Witte, Emanuel de

Manke, I. *Emanuel de Witte 1617–1692.* Amsterdam, 1963.

———. "Nachträge zum Werkkatalog von Emanuel de Witte," *Pantheon* 30 (1972), pp. 389–91.

See also Houckgeest, Gerrit.

Wouwerman(s), Philips

Hofstede de Groot. *Catalogue Raisonné.* Vol. 2, pp. 249–650.

Wttewael, Joachim

Lindeman, C.M.A.A. *Joachim Anthonisz. Wtewael.* Utrecht, 1929.

Lowenthal, A.W. "Wtewael's *Moses* and Dutch Mannerism," *Studies in the History of Art* 6 (1974), pp. 124–41.

———. *The Paintings of Joachim Anthonisz. Wtewael (1566–1638).* Columbia, 1975.

McGrath, E. "A Netherlandish History by Joachim Wtewael," *Journal of the Warburg and Courtauld Institutes* 38 (1975), pp. 182–217.

Helliesen, S. "Thronus Justitiae, A Series of Pictures of Justice by Joachim Wtewael," *Oud Holland* 91 (1977), pp. 232–66.

Zeeman, see Nooms, Reinier

Index of Artists

532

Acknowledgments

The author and the publisher wish to thank the museums, private collectors, libraries, and archives for permitting the reproduction of paintings, drawings, etchings, and engravings in their collections.

Grateful acknowledgment is also made to the following for the reproductions as listed by number:

Copyright reserved to H.M. Queen Elizabeth II: 159, 172, 176, 460, 486, 568, 812, 861, 974.
Copyright Corvina Archives, Budapest: 508.
Copyright The Frick Collection, New York: 578, 710, 979.
Copyright Municipal Museum, Alkmaar: 25.
Reproduced by courtesy of the Marquess of Bath, Longleat House, Warminster, Wiltshire: 1037.
Reproduced by courtesy of the Trustees of the British Museum: 281, 526, 562.
Reproduced by permission of the Trustees of the Chatsworth Settlement: 627.
Reproduced by courtesy of Christie's London: 462, 394, 409, 647.
Reproduced by permission of the Governors of Dulwich Picture Gallery: 630, 904, 911, 999, 1034.
Reproduced by permission of The Greater London Council as Trustees of the Iveagh Bequest, Kenwood: 688, 758.
Reproduced by courtesy of the Trustees of The National Gallery, London: 22, 23, 30, 73, 75, 182, 290, 323, 331, 339, 408, 437, 455, 505, 515, 582, 584, 597, 628, 638, 663, 702, 718, 755, 793, 825, 826, 828, 829, 857, 862, 928, 940, 966, 971, 973, 976, 989, 1025, 1026, 1056, 1061, 1098.
Reproduced by courtesy of Sotheby Parke Bernet & Co., London: 121, 410.
Reproduced by permission of the Trustees of the Wallace Collection, London: 477, 650, 651, 814, 860, 869, 874, 918, 939, 965, 1005, 1016, 1023, 1055, 1076, 1086, 1093.

Photographic Credits

A.C.L., Brussels: 133, 144, 260, 432, 524, 641, 873, 1028; Jörg P. Anders, West Berlin: 299, 300, 416, 485; Annan, Glasgow: 867, 943; Archives photographiques, Paris: 35, 179, 212, 429; Art Promotion Amsterdam B.V.: 754; Artothek, Planegg (Joachim Blauel): 392, 894; Uipko Berghuis, Alkmaar: 25; Bernard Bijl, Amsterdam: 246, 773, 933; E. Irving Blomstrann, New Britain, Conn.: 1080; A. Brandt, Copenhagen: 471; Jac. ten Broek, Amsterdam: 46, 761, 762; Verlag F. Bruckmann KG, Munich: 263, 297, 533, 693, 836, 882, 885; Brunel, Lugano: 213; Gabriele Busch-Hauck, Frankfurt am Main: 588; Chomon-Perino, Turin: 537; Ronald Cook, London: 229; A.C. Cooper Ltd., London: 394, 409, 462, 647, 748, 749, 661, 930; Deutsche Fotothek, Dresden: 533, 576, 1095, 1114; A. Dingjan, The Hague: 52, 108, 109, 164, 165, 189, 200, 248, 252, 305, 307, 312, 330, 348, 350, 366, 368, 369, 372, 375, 376, 444, 468, 470, 474, 479, 488, 492, 502, 504, 550, 557, 566, 613, 648, 691, 723, 768, 800–803, 824, 838, 842, 844, 913, 916, 947, 953, 954, 956, 958, 959, 1102; Ursula Edelmann, Frankfurt am Main: 166, 306, 349, 719, 832, 1038, 1094; A. Frequin, Voorburg: 98, 101, 113, 161, 174, 258, 271, 309, 313, 326, 371, 414, 519, 704, 708, 709, 714, 787, 807, 819, 834, 840, 856, 858, 895, 968, 970, 983, 1044, 1051, 1081; Peter Garbe, Berlin: 948; Henk Gemmink, 's-Heerenberg: 193; Pieter Gerritse, Zwolle: 19; Giraudon, Paris: 1018; Ton den Haan, Rotterdam: 521; Tom Haartsen, Ouderkerk: 311, 494, 799; Ab. Hakeboom, Deventer: 47; Ifot, Grenoble: 632; Arnold Meine Jansen, Gorssel: 168; The Jones-Gessling Studio, New York: 298; B.P. Keiser, Brunswick: 228, 261, 289, 296, 497, 500, 549, 611, 690, 711, 715, 771, 774, 777, 815, 960, 964, 997, 1117; Ralph Kleinhempel GmbH & Co., Hamburg: 336, 522; Kunsthistorisch Instituut, Utrecht: 122, 532, 534, 544, 545; Landesbildstelle Rheinland, Düsseldorf: 1030; Studio Lemaire, Amsterdam: 158; Zbigniew Malinowski, Cracow: 506; Bildarchiv Foto Marburg, Marburg: 730, 817, 892; Musées nationaux, Paris: 126, 162, 175, 245, 270, 332, 548, 551, 614, 643, 713, 756, 780, 795, 837, 903; National Swedish Art Museums: 493; Pfauder, Dresden: 389; Photo Studios Ltd., London: 141, 517, 518, 725, 769, 809, 833, 875, 901, 909, 910, 1035, 1037, 1052, 1110; Pierrain-Carnavalet, Paris: 652; Frans Popken, Leeuwarden: 466, 467; Gerhard Reinhold, Leipzig-Mölkau: 138, 547, 830; Rheinisches Bildarchiv, Cologne: 315, 972; Rijksbureau voor Kunsthistorische Documentatie, The Hague: 846; H. Romanowski, Warsaw: 142; Royal Academy of Arts, London: 141, 517, 518, 725, 769, 809, 833, 875, 901, 907, 909, 910, 1035, 1037, 1052, 1110; Alfréd Schiller, Budapest: 508; Tom Scott, Edinburgh: 572; Stearns & Sons, Cambridge: 507; Walter Steinkopf, West Berlin: 157, 335, 501, 646, 847, 975, 1002, 1003, 1040, 1089; Stickelmann, Bremen: 854; Stijns, Dordrecht: 256, 915; Rodney Todd-White & Son, London: 159; Cor van Wanrooy, Leiden: 957; John Webb, London: 561.

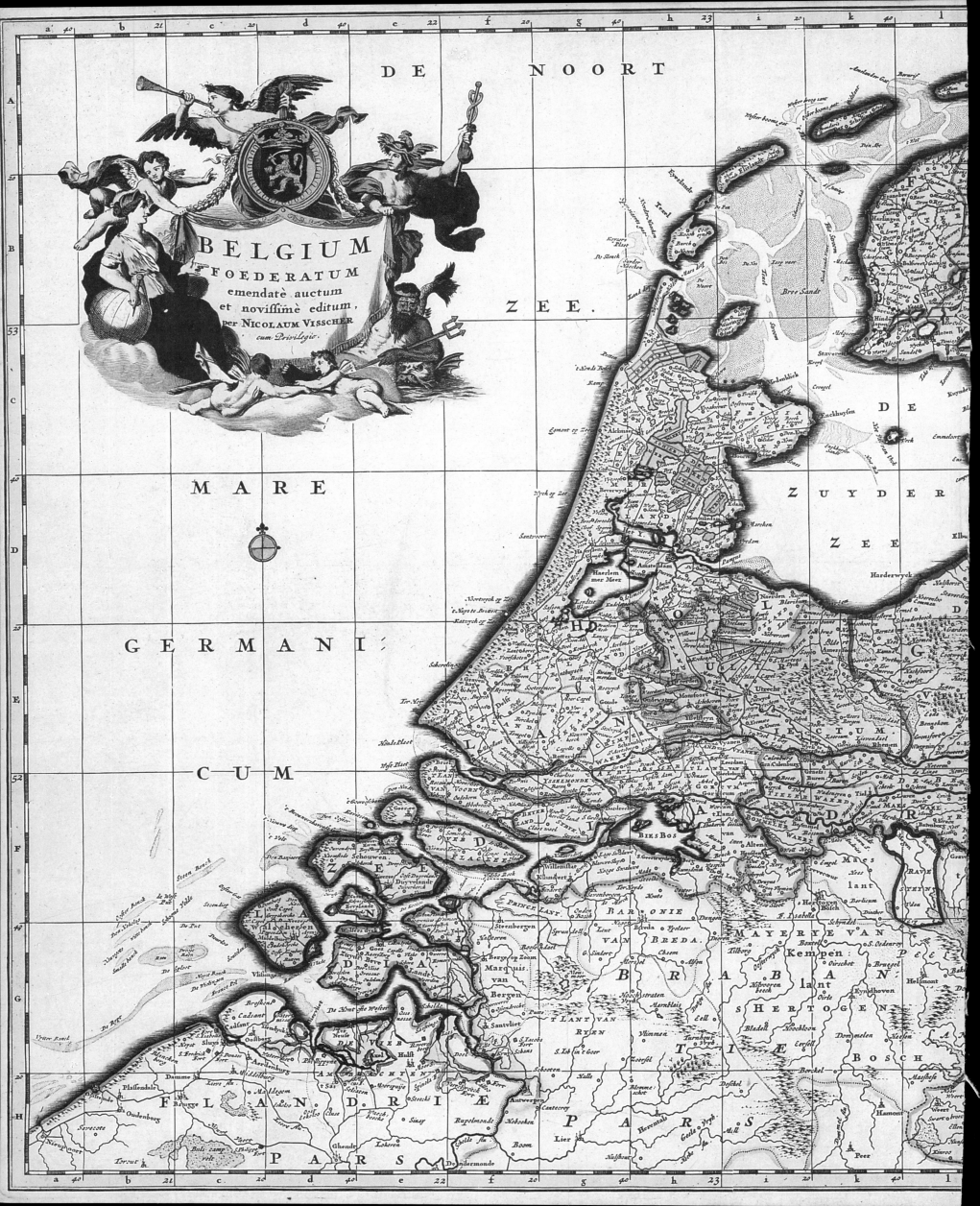

DE NOORT

ZEE.

BELGIUM
FOEDERATUM
emendatè auctum
et noviſſimè editum,
per NICOLAUM VISSCHER
cum Privilegio.

MARE

GERMANI

CUM

ZUYDER

ZEE

Amsterdam

Utrecht

Haerlem
mer Meer

Rotterdam

Goude

ZEE LAND

BIESBOS

VAN BREDA.

MAYERYE VAN

Kempen

BRABAN lant

SHERTOGEN

BOSCH

FLANDRI Æ

PARS

Antwerpen